Ex Libris
London
XII 2009

[signature]

ALEKSANDR
RODCHENKO

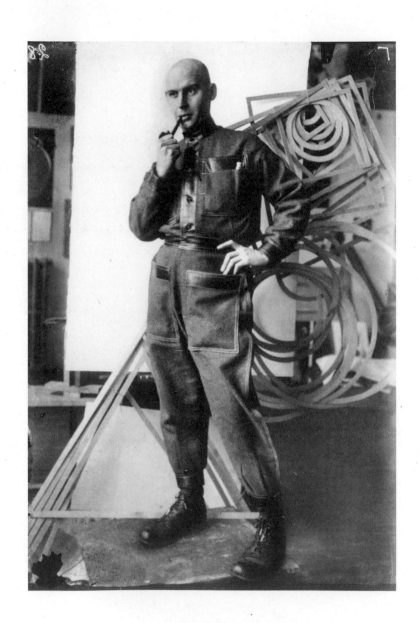

ALEKSANDR RODCHENKO

Edited and with a preface by
Alexander N. Lavrentiev

Translated and annotated by
Jamey Gambrell

With an introduction by
John E. Bowlt

The Museum of Modern Art,
New York

EXPERIMENTS FOR THE FUTURE: DIARIES, ESSAYS, LETTERS, AND OTHER WRITINGS

This book is made possible by
The John Szarkowski Publications Fund.

Produced by the Department of Publications
The Museum of Modern Art, New York

Edited by Cassandra Heliczer
Designed by Gina Rossi
Production by Christina Grillo

Printed and bound by Conti Tipocolor s.p.a., Florence, Italy
This book is typeset in Teuton Fett, designed by Frantisek
Storm in 2002, and Galliard ITC, designed by Matthew
Carter in 1978. The paper is 130 gsm Pigna Neve

Library of Congress Control Number: 2005920060
ISBN: 0-87070-546-6

Published by The Museum of Modern Art,
11 West 53 Street,
New York, New York 10019-5497
www.moma.org

Distributed in the United States and Canada by D.A.P./
Distributed Art Publishers, Inc., New York
Distributed outside the United States and Canada by Thames
and Hudson, Ltd., London

This book is a translation of *Opyty dlia budushchego: dnevniki,
stat'i, pis'ma, zapiski* (Moscow: Grant, 1996).

Cover, front: The cover design of this book is based loosely
on Rodchenko's design for the cover of the journal *Novyi LEF*,
no. 10 of 1927 (see bottom left fig. on p. 200), which incor-
porated his 1927 photograph *Down with Bureaucracy*, repro-
duced here from a print in the collection of The Museum of
Modern Art.

Cover, back, and frontispiece: Rodchenko standing before
dismantled hanging constructions. 1922. Photograph by
Mikhail Kaufman

Printed in Italy

CONTENTS

CHAPTER THREE

FOREWORD AND ACKNOWLEDGMENTS

The relationship between The Museum of Modern Art and Aleksandr Rod-chenko and his family is older than the Museum itself. In January 1928, nearly two years before he became director of the newly founded institution, Alfred H. Barr, Jr., accompanied by Jere Abbott, visited Rodchenko and Varvara Stepanova in their Moscow apartment. From the diaries of Barr and Stepanova, we know that the cultural gap separating the young Americans and Russians was not bridged in a single step. But the encounter initiated what would become a long and fruitful friendship between the Museum and successive generations of the artists' family.

The friendship has flourished thanks above all to the dedication of Rodchenko and Stepanova's daughter, Varvara Aleksandrovna Rodchenko, who was not yet three years old at the time of Barr's visit. After the death of Rodchenko in 1956 and of Stepanova two years later, their only child pre-served their art, their diaries and letters, and other works and documents fundamental to the history of Russian avant-garde art in the years before and after the Bolshevik Revolution of 1917. She held dear her loving father's wish that one day his great work would again be known and celebrated in Russia and the world. In the Soviet years, on the rare occasions when West-ern scholars were able to make their way to Moscow, eager to study the fam-ily archive, they were always graciously received. Because of the collaborative spirit that has prevailed in the archive, what at first was barely a trickle of curiosity has become a flood of publications and exhibitions. And today Rodchenko's achievement is represented in many museum collections, includ-ing the Department of Private Collections of the State Pushkin Museum, in Moscow, and The Museum of Modern Art, in New York. Varvara Rod-chenko has been joined in her selfless mission by her son, Alexander Niko-laevich Lavrentiev—a scholar in his own right, organizer of many exhibitions, and author or editor of countless publications, including this one. All the while, every member of the Rodchenko family has continued to pursue the unfolding experiment in art and design that they inherited from Rodchenko and Stepanova.

In 1998, The Museum of Modern Art presented the first full-scale Rod-chenko retrospective ever to be seen in the United States. In 1996, as prepa-rations for the exhibition were underway, the Rodchenko family published, in Russian, the first comprehensive collection of Rodchenko's writings. The book included a wide range of texts—manifestos, essays, recollections, diaries, letters—and presented a good deal of previously unpublished material. The Museum is proud to publish the English edition of that book and is deeply grateful to the Rodchenko family, yet again, for their indispensable help and guidance in seeing it through.

We are indebted as well to Jamey Gambrell, whose superb translation has met the formidable challenge posed by the great diversity of the texts that are collected here, and whose thoughtful annotations will be a great help to non-Russian readers. The distinguished scholar John E. Bowlt, a longtime friend of the Rodchenko family, has contributed a lively and illuminating introduction, for which we thank him warmly. Thanks also to Alex Lachmann, for his encouragement and assistance throughout the preparation of the book.

The Museum's Department of Publications has done a fine job of seeing the book into print. We are grateful to Cassandra Heliczer, who edited the text; Gina Rossi, who created the handsome design; and Christina Grillo, who supervised the production. Thanks also to Lynn Scrabis for her work on the index. The book has been made possible by The John Szarkowski Publications Fund, an endowment created by the generosity of members of the Committee on Photography and other friends of the Museum.

Aleksandr Rodchenko was a great artist, and this book will be useful to scholars—of his work, of the Russian avant-garde generally, and of the Soviet Union. It would not be surprising, however, if the book found a broader readership. For of course Rodchenko was a human being, too, and his writings trace the arc of a life that was intimately touched by historical events of great scale and gravity. That is, the book is not merely informative but moving—all the more so because its very existence is due to the filial devotion of the author's daughter and grandson.

Glenn D. Lowry
Director

Peter Galassi
Chief Curator, Department of Photography

The Museum of Modern Art

9

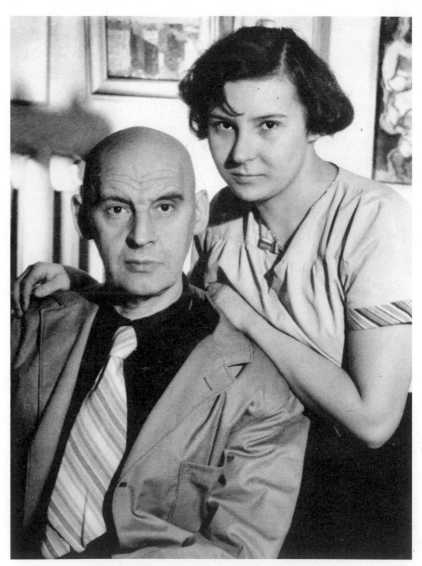

Rodchenko with his daughter, Varvara, 1947. Photograph by V. Kovrigin

LONG LIVE CONSTRUCTIVISM!

John E. Bowlt

Aleksandr Mikhailovich Rodchenko (1891–1956) was active in many disciplines—studio painting, book illustration, commercial design, architecture, three-dimensional construction, poetry, photography, critical commentary, and creative prose—and it is impossible to discuss one aspect of this complex legacy without referring to the other fields of his artistic endeavor.[1] For Rodchenko, each painting, drawing, or design was a special project of uniform force and potential, the sum of which constituted a single artistic equilibrium. The very title of this collection of Rodchenko's writings, *Experiments for the Future: Diaries, Essays, Letters, and Other Writings*, is a clear illustration of this attitude. Not only does the book describe a lifetime of aesthetic and intellectual research, but also, through its mesh of stylistic registers, literary genres, authorial intrusions, and stream of consciousness, it emerges as an experimental confession, at once candid and timorous.

Experiments for the Future tells us much about Rodchenko's artistic psychology, social background, education, and professional career; it also tells us about his family and friends (from his wife, fellow artist Varvara Stepanova— the "Varva," "Varst," "Varstik," "Varvara," and "Khom" of Rodchenko's correspondence—to his closest literary collaborator, Vladimir Mayakovsky), and his working methods and institutional affiliations. This mosaic of diary entries, declarations of intent, reminiscences, autobiography, and correspondence also exposes the contradictions of Rodchenko's character. Soul-searching and introspective on the one hand, and supportive of the social collective and of a public art on the other, Rodchenko oscillated between moods and sentiments, unafraid of a collision between the "romantic" and the "rationalist."[2] He could temper the energy of fantasy and the rhetoric of manifesto with careful protocol and administrative organization, and was able to maintain his position as an international Constructivist in Paris while avowing that his mother was the USSR.[3] But these apparent paradoxes simply testify to the subtlety and artistry of Rodchenko's persona and, as the book's editor, Alexander Lavrentiev, concludes, help us to "see, imagine, and feel the man's soul."[4]

Flexibility, adaptability, and interchangeability were qualities germane to the Constructivist worldview: indeed, artists such as Liubov Popova, Rodchenko, and Vladimir Tatlin were convinced that art (which for them tended to denote abstract painting, construction, and industrial design) was to be universal and multifunctional, no longer a mere ornament or form of entertainment:

> It is time for art to merge with life in an organized fashion [. . . .]
> Down with art as a bright patch on the mediocre life of a propertied man [. . . .]
> Down with art as a means to escape a life that isn't worth living.[5]

Symptomatic of Rodchenko's versatility was his tendency to impose various designations upon his works. A finished studio painting such as *Construction no. 106 (on Black)* (1920), for example, is subtitled *Trapeze Artistry*, and an apparently casual sketch bears the ambitious title *Project for an Air Terminal* (1919).

Still, Rodchenko's rich talent cannot be accommodated within the single category of Constructivism, and, in any case, it would be misleading to try to group his artistic and theoretical production according to rigidly defined periods of pre- and post-Revolutionary activity. Unfortunately, the common interpretation of the October Revolution of 1917 as a clear dividing line in the careers of such artists as Pavel Filonov, Kazimir Malevich, Popova, Rodchenko, and Tatlin is long-standing; and, at first glance, the easy distillation into "before" and "after" might seem justified given the dramatic ways in which the Bolshevik seizure of power affected artistic practice, pedagogy, exhibition management, and censorship. But the argument needs serious qualification: Russian art evolved according to inner dictates that were as vital in the early 1910s as they were in the 1920s, and the essential impulse toward achievements now identified with early Soviet culture, whether "leftist" (i.e., Constructivism) or "rightist" (i.e., Heroic Realism), can be found in precedents well before 1917. Productivism or production art, for example, would not have been possible without Cubo-Futurist book and textile design, while the new realism of Stalin's Russia owed much to the tendentious canvases of the Wanderers group.[6] A ready example of this kind of forced reconciliation is, indeed, at the core of Constructivist design and the involvement of the Russian avant-garde in the applied arts of the early 1920s. Certainly, many of the new artists accepted decorative commissions from the new Soviet Republic, but they did so often on the basis of prior experience—after all, Malevich, Popova, Rodchenko, and Olga Rozanova had all been producing and exhibiting specimens of the applied arts long before they accepted the Bolshevik regime.

[FROM SURFACE TO SPACE]

Be that as it may, how and why Russian artists advanced from planar composition to volumetric construction just before and after the October Revolution is one of the more complex and intriguing questions in the story of modern art. Reasons are legion, but reference to certain key assumptions may help to explain the move in general and Rodchenko's transition in particular. First, there was the general assumption that traditional painting had been "enslaved by common sense" and had turned into a branch of literature rather than painting "as an independent end";[7] second, as the critic Nikolai Punin affirmed in a 1919 lecture on modern art, traditional painting had failed to come to terms with the hallmarks of contemporary life—mechanical speed and the precision of technology;[8] third, the more radical artists argued that the religious and spiritual functions that had long been the prerequisites of painting and sculpture were irrelevant to a new society founded on industrial streamlining and scientific rationality; fourth, artists such as El Lissitzky,

Naum Gabo, and Rodchenko looked to engineering and technological inven-

tion (railroad bridges, natural-gas tanks, the airplane) as expressions of human genius equal, if not superior, to "art"; lastly, as a reflection and glorification of the individual ego, traditional art now seemed foreign to the collective society of international Communism. In the wake of these and other arguments, the Russian avant-garde, spearheaded by Rodchenko and Tatlin, developed their concept of construction as an antidote to the poison of painting. The term "Constructivism," invented in January 1921, was adapted to designate the new tendency and to coincide with the "constructive" vogue in many other fields of endeavor—Socialist construction, cultural reconstruction, formation of a new, streamlined (human) body.

Rodchenko was at the forefront of the movement, and his writings (especially those collected in Chapters Two and Three of this book) bear strong witness both to his awareness of the new system and the need to promote it: "I'll liberate painting," he announced in 1915.[9] Of his many achievements, Rodchenko is remembered perhaps above all for the three monochrome canvases (yellow, red, and blue) that he contributed to the 1921 exhibition $5 x 5=25$, in Moscow, a farewell gesture to what he and his immediate colleagues considered to be the necrotic art of painting. Alexandra Exter, Popova, Rodchenko, Stepanova, and Aleksandr Vesnin dismissed the notion of the painter or sculptor working in the privacy of the studio and maintaining a status of privilege and prestige. Instead, they shared the Constructivist platform, according to which the artist was to cleanse "engineering of aestheticism, dilettantism, superfluity" by replacing the "cosmetic" canon of art with a utilitarian one.[10]

Siding with such Formalist critics of the early 1920s as Boris Arvatov, Aleksei Gan, and Punin, Rodchenko subscribed to the premise that studio painting had run its course and that only three-dimensional construction and utilitarian design could constitute a worthy substitute. The transvaluation was rapid and radical, even though a distinctive and constant feature of Rodchenko's artistic worldview was to question and experiment with the very act of visual perception and reception, whether in early Symbolism or mature Constructivism.

THE SYMBOLIST LEGACY

Between 1910 and 1914 Rodchenko attended the Kazan School of Fine Arts, alma mater of Stepanova, David Burliuk (the "Father of Russian Futurism"), and Nikolai Feshin (now remembered for his scenes of New Mexico), among other luminaries.[11] One of the strongest influences in those first years was the painting of Mikhail Vrubel, Russia's foremost artist of the fin de siècle, whose punctured lines and fragmentary forms also inspired Gabo, the celebrated Constructivist, to assert that "[Vrubel's] genius is responsible for molding the visual consciousness of our generation."[12] (The painter and stage designer Sergei Sudeikin even maintained that "the principles of Cubism, Constructivism, and Surrealism were [. . .] founded by Vrubel. And despite our respect for Picasso, the real beginning of modern painting was Vrubel.")[13] If this is so, where do we locate the common denominator linking Vrubel's haunting visions, such as *The Demon Downcast* (1902; State Tretyakov Gallery,

Moscow), and the Constructivists' geometric assemblages? To Rodchenko the romantic and humanist, Vrubel was a kindred spirit plagued by failure, spiritual dislocation, and lunacy, and when Rodchenko wrote in his diary, "diabolical thoughts gave me no peace" and in a letter to Stepanova, "I will be Picasso's rival in the domain of the Devil," he may well have been meditating on Vrubel's tortured fate.[14]

Like Gabo, Rodchenko, and, later, Tatlin, Vrubel constructed his artifacts using rupture, shift, and imbalance in even the simplest drawings and watercolors of flowers, heads, and garments. In turn, Rodchenko repeated Vrubel's geometry, textural diversity, and architectonic sense in such early paintings and drawings as *Portrait of Natasha* (1913) and *Figure in a Kimono* (1912–13). No doubt, Rodchenko traced his interest in the circle and the curve to the serpentine filigrees of Vrubel's compositions and of Art Nouveau in general. Furthermore, in the graphic decorations of 1913–14, Rodchenko set up intricate counterpoints of ellipses and spheres, which, ultimately, are not so very distant from his later spatial constructions. In other words, Rodchenko had only to subtract the "empirical" elements of "perspective, light and shade, movement, space, and time" from the vignette or ornament to arrive at the simplicity and efficiency of the constructions.[15]

As if to illustrate the legitimacy of this evolution, Rodchenko produced his first compass and ruler drawings, contributing six of them to Tatlin's exhibition *The Store* (*Magazin*), in Moscow, in early 1916. Perhaps remembering his debt to Vrubel and to Vrubel's first "geometric" drawings, Rodchenko wrote five years later in his essay "The Line": "[. . .] the line conquered everything and destroyed the last citadels of painting [. . . .] In the line a new worldview became clear: to build in essence, and not depict [. . .] build new, expedient, constructive structures in life, and not from life and outside of life."[16]

BLACK AND WHITE[17]

Where, to paraphrase Rodchenko, can we locate the "spirit" of his creativity within the "body" of his art?[18] A salient characteristic of Rodchenko's theory and practice is constant concern with the essential construction of things, be they abstract paintings or wood hexagons. For Rodchenko, graphic line rather than color and texture was the structural indicator and common denominator—for, as he explained in "The Line," "[line defines] the main construction of every organism that exists in life, the skeleton [. . .] (or the foundation, carcass, system)."[19] Not surprisingly, therefore, Rodchenko's drawings and paintings of that time, especially the linear compositions of 1920, often rely for their effect on a subtle interaction of linear rhythms—an acrobatic configuration suspended, as it were, above a white or black abyss. Works such as *Construction no. 106 (on Black)* (1920) can be read as prescient trajectories of the trapeze artists that we see in Rodchenko's photographs of the 1930s, such as *Under the Big Tent* (1938) and *Woman Acrobat* (1940). But in pursuing this linear path, Rodchenko seemed also to be skirting a cosmic void, challenging the "nothing" and "blackness" that recurred in his writings and paintings. As he declared in his "System" manifesto of 1919:

> To the toll of the funeral bells of colorist painting, the last "ism" is laid to eternal rest here, the last hope and love collapse, and I leave the house of dead truths.[20]

Such sentiments tend to be associated more with the highly strung sensibility of Symbolism than with Constructivism. Indeed, Rodchenko's interest in black and in black and white is especially insistent in early examples of his *Jugendstil*, such as *The Dancer* (1915), as well as in his photographs of the 1920s and 1930s; and, of course, the quintessential symbol of this monochromatic performance is his cycle of black on black paintings of 1918–19. In sounding the death knell of colorist painting, Rodchenko was, consciously or unconsciously, paying homage to a "black" fashion of the late nineteenth and early twentieth century: the proliferation of the arts of *blanc et noir* (xylography, lithography, engraving); the rapid development of photography and cinematography; and the popularity of African and African-American culture (from Vladimir Markov's monograph on African sculpture to American jazz).[21] To some extent, the color, and concept of, "black" became the distinguishing feature of Russian modernism, whether in painting (Malevich's *Black Square*, 1913) or in poetry (Aleksei Kruchenykh's black cognates in his 1919 transrational play *Gly-gly*—designed, incidentally, by Stepanova). Of course, Rodchenko was aware of these precedents and parallels, for not only did his sentiments echo Malevich's ("I have transformed myself in the zero of form"), his black on black cycle served as a response to Malevich's Suprematist works *Black Square*, *Black Cross*, and *Black Circle*.[22] As *Experiments for the Future* attests, Rodchenko's journal entries for 1918–20 carry many references to his artistic investigations of black ("I'm painting a composition in white and shiny black on a matte black background"),[23] and on one occasion he even hails his black paintings as signaling the "beginning of the new existence of form in space."[24]

For Malevich, *Black Square* was a Royal Gateway to a land "where everything will soon be flat, houses, too," and he regarded the Suprematist paintings as Biblical truths that lay at the foundation of the millennial society he envisioned.[25] Rodchenko, on the other hand, had little interest in the sacrosanct, "finished" work of art—in the notion of the oil or watercolor as an infallible and hallowed object. Rather, he regarded the work as an interim step across an unending space, often symbolized by a line traveling across the plane. His *Expressive Rhythm* of 1943–44 is a persuasive metaphor for this procedure. If Malevich represented the culmination of a traditional attitude toward art as an inspired, alchemical practice to which the artist and the work of art maintained a special aesthetic and philosophical commitment, Rodchenko subscribed wholeheartedly to the tenet "Art is one of the branches of mathematics."[26] While parallel, at least visually, to Malevich's emblematic identification of black with iconic power and white with eternity, the monochromes of the younger avant-gardists, including—along with Rodchenko—Aleksandr Drevin, Vladimir Lebedev, and Pavel Mansurov, tended to be aesthetic or formal statements, elegant and reserved, that avoided the occult nuances of Symbolism and Suprematism.

Commensurate with Vasily Kandinsky's exploration of point and line, Rodchenko began to treat point and line as intrinsic and independent elements.[27] In Rodchenko's paintings and drawings, they now became kinetic machines, establishing trajectories that led organically to his collapsible spatial constructions made from plywood. He wrote in April 1918:

> Projecting vertical planes painted in appropriate colors, and intersecting them with lines of directional depth, I discover that color serves only as a relative means of distinguishing one plane from the other [. . . .]
>
> Building projections in ovals, circles, ellipses, I often distinguish just the edges of the projections with color: thereby I stress the value of the projections [themselves] and the function of color as an auxiliary device and not an end in itself.[28]

In 1920–21 Rodchenko designed six constructions—a square, two circles, a hexagon, an oval, and a triangle—each of which could be folded up into a horizontal plane.

APPLICATION

Profoundly affected by the orientation toward agitational and commercial design in the wake of the October Revolution, Rodchenko directed his energies toward posters, book layout, textile design, and, beginning in 1924, photography. Although such activities did not fully gratify his "volumetric orientation," the encounter with advertising, consumer commodity, material culture, and the force of visual propaganda impelled Rodchenko not only to explore new mediums but to collaborate closely with early Soviet institutions, such as Mosselprom and Dobrolet, and to plan the establishment of state cultural enterprises, such as the Museum of Experimental Technology. For better or worse, Rodchenko placed his art directly in the service of politics, and the alacrity with which he served in various intellectual and administrative capacities within, for example, the Museum Bureau, the Moscow Museum of Painterly Culture, the Institute of Artistic Culture (INKhUK), and the Higher State Artistic-Technical Workshops (VKhUTEMAS) indicates the strength of his political loyalty to the new regime.[29] Perhaps, like Malevich and Tatlin, he viewed the Revolution as global or cosmic, not bound by parochial historical events, rigid calendars, or logistic protocols—which may explain why his diaries and letters rarely mention politicians, parties, or ideologies, and why to be a "bureaucrat" (a status that he ascribed to Natan Altman, Marc Chagall, and Pavel Filonov) is deemed pernicious and offensive.[30]

There were many historical precedents to this sort of combination of aesthetic and political vocabulary; Russian artists before Rodchenko had fulfilled imperial commissions while retaining their artistic individuality. If Rodchenko was now promoting candy—not from the private Einem Corporation but from its nationalized successor, the Red October Factory—the purpose and function remained uniform, i.e., to sell more goods to more people. Incidentally, Rodchenko looked carefully at the diagonal scripts, repeated exclamation marks, and contrasting typefaces that he found in pre-Revolutionary

sources like telephone directories and trade catalogues, adapting them to his own typographical designs and promotional materials for galoshes, cigarettes, and soap. His frontispiece for *LEF* magazine (1923–25), for example, owes much to the truncated letters and stark stylization of Edwardian capitalist advertising.

This collaging of commercial design onto painting and drawing achieved spectacular results at the hands of Rodchenko and his colleagues such as Gustav Klucis, Sergei Senkin, Stepanova, and Solomon Telingater. Rodchenko and Stepanova produced their most exciting collages in 1918–21, when, working as a team, they often divided up picture books, postcards, and pieces of paper, producing parallel collages based on the same images, for example from postcards of the Alexander III Museum of Fine Arts in Moscow (now the Pushkin State Museum of Fine Arts). Rodchenko and Stepanova were eminently capable of composing visual harmony out of advertisements for face powder, teapots, and personal ads, offering them sometimes as independent artifacts, sometimes as book illustrations (such as for Mayakovsky's *Pro eto* [*About This*] of 1923, illustrated by Rodchenko), and sometimes as logos for the new Soviet corporations. Rodchenko's promotion of Soviet products, from the aforementioned candy to airplanes, was just one part of the Constructivists' desire to improve the quality of the object by developing "a new design on the basis of contemporary requirements, both artistic and technological."[31]

Rodchenko's work on commercial icons, placards, and packaging extended his interest in the multiple edition, such as book illustration and photography, where the concept of the "original" or "authentic" image loses much of its traditional force. He also gave special attention to the sketch, convinced that any visual rendering was a mere improvisation that could be changed, duplicated, or trashed as circumstances dictated. At the same time, Rodchenko the Constructivist could be playful and whimsical in art and life, and, while absorbed in the calculation of his spatial constructions, for example, might also seek lighter relief in Dada collage or the combining of low and high registers in commercial and political propaganda (such as his 1925 advertisements for Trekhgornoe beer and Krasnaia Zvezda cigarettes). This tendency might also explain Rodchenko's fascination with *zaum*, the transrational or transmental language of Kruchenykh, Velimir Khlebnikov, and Grigory Petnikov, and with the semantic ambiguities of his friend Mayakovsky. Delighting in the freedom of fantasy, Rodchenko read the Russian Romantic writers Konstantin Fofanov, Alexander Pushkin, and Vasily Zhukovsky, and even composed his own ballads and tales about black knights and fiery kings.

ON STAGE

In broad terms, Rodchenko's advertisements, book illustrations, and posters reflect a commitment to the work of art as a commodity of public consumption. His interior design for a workers' club at the 1925 *Exposition Internationale des Arts Décoratifs et Industriels Modernes*, in Paris, for example, was a Constructivist prototype, exemplifying the "functional construction" of the object.[32] While it is hard to grasp how the ergometric furniture, dividing

screens, and didactic posters could have functioned in this confined space, the workers' club was intended for human usage and interaction. Ultimately, it was a stage on which actors had yet to enter: later on, Rodchenko adapted the chairs and screens to his designs for the Theater of the Revolution—at last, in the theater, Rodchenko was able to transfer his prototypical, modular constructions into a broader public arena and to put into practice what he preached to his students of wood- and metalwork at VKhUTEMAS.

Rodchenko's keen interest in the performing arts, including the circus, is easy to comprehend, since acting, improvising, and extemporizing were central to his artistic psychology. Not only did Rodchenko contribute as designer to some of the more experimental productions of early Soviet theater, he also used his camera to document performances of a very different kind—gymnastic displays, sports meets, military parades, and even air shows. Rodchenko was "born above the stage,"[33] and to him the theater became a natural testing ground where he could experiment with figures and objects in a three-dimensional continuum while hoping that one day the prototypes would be extended into "real life." Motifs from the theater and circus recur throughout the artist's career—from his work for the productions of Oscar Wilde's *Duchess of Padua* (1915) and Mayakovsky's Constructivist play *The Bedbug* (1929) to his painting *The Wrestlers* (1915) and his *Kino-fot* (Cinema photo) magazine covers. Along with Popova and the Stenberg brothers, Rodchenko was a principal exponent of Constructivist design in the Soviet theater, and his photographs of gymnasts, clowns, acrobats, and animal trainers of the 1920s and 1930s constitute a remarkable document of pre–World War II physical culture in the Soviet Union.

The theater also satisfied Rodchenko's recurrent nostalgia for the human form: although his abstract painting and "sculpture" are among the highest achievements of the Russian avant-garde, it is misleading to assume that Rodchenko ignored the figural or figurative element during the late 1910s and early 1920s. Undoubtedly, he identified one function of his stage designs and documentary photographs as a renewal of "readable" content, at loggerheads, paradoxically, with his self-sufficient studio paintings. Indeed, if some of Rodchenko's abstractions can be read as schematic figures, some of his renderings of stage sets and costumes can be perceived virtually as abstract paintings—the costume series Champions of England and France (1919) being a case in point.

From the late 1910s onward, Rodchenko fulfilled a number of commissions for the performing arts, including Aleksei Gan's *We* (1920, not produced) and Dziga Vertov's Kino-Pravda series (1922–23 onward). But it was Mayakovsky's *The Bedbug*, produced by Vsevolod Meyerhold in 1929, that marked Rodchenko's triumphant entry into the theater. Invited by Mayakovsky to design the second part of this satire on the life of the new Soviet bourgeoisie, Rodchenko produced about sixty costumes, sets, and props—simple, undecorated, mechanical, and economical—constituting a "splendid material design."[34] One critic, Pavel Novitsky, also liked the "simple and clear forms created by an industrial and scientific-laboratory technology."[35] Still, if *The Bedbug* was one of Meyerhold's most original productions, it was not

a popular success: Rodchenko's vision of a disciplined, scientific Communist future was so lifeless and hygienic that the spectator was hard put to decide where the parody really stopped.[36] *The Bedbug* was followed by Anatoly Glebov's play *Inga*, staged by Nikolai Gorchakov at the Theater of the Revolution, also in 1929, and two years later by ambitious stage productions of Vertov's 1926 film *The Sixth Part of the World* and *An Army of the World* (the latter for Yury Zavadsky's studio in Moscow)—Rodchenko's only involvement in vaudeville and his last professional theatrical commission.

Whatever the merits of Rodchenko's stage—and textile—designs, it should be remembered that they were often laboratory experiments, destined to remain unadapted to the world at large. Artists such as Rodchenko, directors and producers such as Meyerhold, and architects such as Aleksandr Vesnin believed that the Constructivist idea was democratic and universal. But they were also quick to realize that, in practical terms, their system was at variance with the simple requirements of their mass clientele, who demanded spectacle, ornament, and narrative. Lacking the necessary support system of modern industrial methods and sympathetic consumers, most of the designs were not developed and served merely as semaphores toward a utopian vision.

PHOTOGRAPH AND BE PHOTOGRAPHED![37]

Rodchenko never ceased to "construct" and to express his fundamental desire to experiment—something that his photographic investigations demonstrate with particular clarity. Convinced that photography would cater to the modern exigency for "relevance," Rodchenko published numerous essays on the subject in journals such as *Novyi LEF* (New left front of the arts) and *Sovetskoe foto* (Soviet photography); became a press photographer; and fulfilled prestigious state commissions, documenting, for example, the White Sea Canal project in 1933. Even if, during the 1930s and 1940s, the floridity of the Stalin style tempered Rodchenko's radicalism, he never bowed to the dictates of Socialist Realism, asserting that "every contemporary human being must wage war against art, as against opium."[38] In exploring photography, Rodchenko continued to experiment with the purely formal elements of the medium, and terms such as "Rodchenko foreshortening" and "Rodchenko perspective" became common currency in Soviet critical literature. In true Constructivist fashion, Rodchenko attempted to expose the mechanism of the camera and to exploit photographic method just as he had disclosed the essence of space and form in his constructions. Perhaps the imprint of Rodchenko's unorthodox combinations of light and shadow as well as his technical knowledge of film production can even be found in the films of Sergei Eisenstein, Lev Kuleshov, and Vertov.

Just as Rodchenko had emphasized the priority of abstract line, form, and space in his constructions, he now refused to compromise the mechanical precision of the camera, emphasizing its "nonaesthetic," utilitarian function. Like his hanging constructions, which can be viewed from above, from below, or sideways, Rodchenko's photographs often rely on a "planimetric" or "downside up" orientation. On the other hand, Rodchenko appreciated the historical value of the photograph and succeeded in recording striking

images of such important contemporaries as Nikolai Aseev, Lili Brik, Osip Brik, Mayakovsky, Aleksandr Shevchenko, and Stepanova. Rodchenko also used the camera as witness to social transformation: new apartment complexes, the Red Army, Pioneers, industrial technology.

Rodchenko's early photographic experiments are of indisputable formal and aesthetic value, but his thematic, propagandistic photographs of the 1930s—the epoch of Socialist Realism—also have strong emotional appeal. His shots of mass gymnastics, street demonstrations, and the circus, with their fast movements, dazzling sunshine, and daring trapeze and animal acts, evoke the rhythm and commitment of the Soviet mass song, the panoramic paintings of abundant harvest, and the oratory of Stalin's speeches. But during a time of harsh oppression, these healthy bodies and smiling faces were mendacious—symbols of the future, perhaps, but having little to do with the present. Rodchenko himself was one of the many artists commanded to smile while the balancing act of everyday life became increasingly dangerous. Sensing the danger of his high-wire performances and unorthodox magic, he wondered wistfully in 1939, "But doesn't the country of socialism need ventriloquists, magicians, and jugglers?"[39]

CODA

In Rodchenko's diaries and notebooks we recognize the trials and tribulations of any human being: confidence and insecurity, health and sickness, philosophical deliberation and spontaneous desire. On the one hand, *Experiments for the Future* follows a chronological sequence, relating the story of a stylistic evolution from Symbolism to Constructivism, from the femmes fatales of Art Nouveau to the flexing muscles of Soviet sportsmen. Yet on the other hand, the book describes a parallel, more intimate journey beyond conventional time and space, in which Rodchenko contradicts the rhetoric of "death to art" by investigating the aesthetics of spatial constructions, or harbingers Jackson Pollock by making action paintings at the height of Stalin's Socialist Realism.[40] "My ship is sailing through all kinds of swamps. . . . The voyage continues, although it's sailing into the unknown because there's no direction," wrote Rodchenko toward the end of his life.[41] This bold statement reflects not only the artist's determination to weather the turbulent waters of Soviet public life, but also an optimism and strong belief in the rightness of his chosen path.

The title of this introduction was taken from a 1921 essay by Rodchenko, "The Line," in Chapter Two of present volume, p. 111.

1. For Rodchenko's creative prose, see, for example, his stories and poems in Chapter One of ibid.
2. Alexander Lavrentiev, introduction to Chapter Two of ibid., p. 73.
3. Rodchenko, letter from Rodchenko to Varvara Stepanova (dated March 27, 1925), in Chapter Three of ibid., p. 156.
4. Alexander Lavrentiev: preface to ibid., p. 27.
5. Rodchenko, "Construction Is a Contemporary Worldview," in Chapter Three of ibid., p. 142.
6. The painters and sculptors known as the Wanderers believed in the need for art to reflect the moral, social, and political issues of contemporary life.
7. Kazimir Malevich, "From Cubism and Futurism to Suprematism. The New Painterly Realism" (1916), in *Russian Art of the Avant-Garde: Theory and Criticism, 1902–1934*, John E. Bowlt, ed. and trans., first edition (London: Thames and Hudson, 1988), p. 129.
8. Nikolai Punin, "Tsikl lektsii" (Cycle of lectures, delivered in 1919 and published in 1920), in ibid., p. 175.
9. Rodchenko, letter from Rodchenko to Stepanova (dated March 20, 1915), in Chapter One of present volume, p. 59.
10. Rodchenko, "Program of the Production Section of the INKhUK Constructivist Group," in Chapter Three of ibid., p. 146.
11. This description of Burliuk is ascribed to Vasily Kandinsky, in Alfred H. Barr, Jr., *Oils, Watercolors by David Burliuk*, et al, exh. cat. (New York: 8th Street Gallery, 1934), p. 3.
12. Naum Gabo, *Of Divers Arts*, first edition (New York: Pantheon, 1962), p. 155.
13. Sergei Sudeikin, "Dve vstrechi s Vrubelem" (Two meetings with Vrubel), in *Novosel'e* (New York, 1945), no. 19, pp. 29–38.
14. "Diabolical thoughts gave me no peace": Rodchenko, diary entry (dated January 5, 1913), in Chapter One of present volume, p. 50.
 "I will be Picasso's rival in the domain of the Devil": Rodchenko, letter from Rodchenko to Stepanova (dated 1915), in ibid., p. 64.
15. See Nikolai Tarabukin, *Opyt teorii zhivopisi* (Essay on the theory of painting; 1916), first edition (Moscow: Proletkul't, 1923), especially pp. 12–14.
16. Rodchenko, "The Line," in Chapter Two of present volume, pp. 113–14.
17. "Black and White" is also the title of the autobiography that Rodchenko wrote in 1939, included in Chapter Four of ibid., p. 304.
18. Rodchenko, "Rodchenko's System," 1919, in Chapter Two of ibid., p. 84. Rodchenko published his

statement in connection with the *10th State Exhibition: Non-Objective Creation and Suprematism*, in Moscow.
19. Rodchenko, "The Line," in ibid., p. 113.
20. Rodchenko, "Rodchenko's System," in ibid., p. 84.
21. Vladimir Markov, *Iskusstvo negrov* (African art) (Petrograd: Izo NKP, 1919).
22. Malevich, "From Cubism and Futurism to Suprematism," in *Russian Art of the Avant-Garde*, p. 118.
23. Rodchenko, "Notepad" (dated November 23, 1918), in Chapter Two of present volume, p. 87.
24. Rodchenko, "Ship's Log" (dated June 14, 1920), in Chapter Two of ibid., p. 98.
25. Ivan Puni, *Sovremennaia zhivopis'* (Contemporary painting) (Berlin: L. D. Frenkel', 1923, edition unknown), p. 16.
26. Rodchenko, "Construction Is a Contemporary Worldview," in Chapter Three of present volume, p. 142.
27. The relationship between Kandinsky and Rodchenko and their mutual influences in 1920–21 deserve serious study. Suffice it to say here that both artists were living in the same building, visited one another, and even exchanged works. (See Chapter Two of ibid.)
28. Rodchenko, "The Dynamism of Planes," in ibid., p. 83.
29. See "For a Report on the Organization of a 'Museum of Decorative Arts,'" in ibid., p. 122.
30. Rodchenko, "Notepad" (dated August 24, 1919), in ibid., p. 90.
31. Rodchenko, "The Material Design of the Object," in Chapter Three of ibid., p. 195.
32. Ibid.
33. Rodchenko, "Black and White," in Chapter Four of ibid., p. 304.
34. Ieremii Turkel'taub reviewing *The Bedbug*. Quoted in Konstantin Rudnitsky, *Rezhisser Meierkhold* (Moscow: Nauka, 1969), p. 404. (English edition: *Meyerhold the Director*, trans. George Petrov [Ann Arbor: Ardis, c. 1981].)
35. Pavel Novitsky reviewing *The Bedbug*. Quoted in ibid., p. 404.
36. See Edward Braun, *Meyerhold on Theatre*, first edition (New York: Hill and Wang, 1969), p. 236.
37. Rodchenko, "Protiv summirovannogo potreta, za momental'nyi snimok" (Against the synthetic portrait, for the snapshot) (1928). Translation in Bowlt, *Russian Art of the Avant-Garde*, p. 253.
38. Ibid.
39. Rodchenko, "Black and White," in Chapter Four of present volume, p. 307.
40. Rodchenko, in Chapter Three of ibid., p. 232.
41. Rodchenko, in Chapter Five of ibid., p. 348.

TRANSLATOR'S NOTE

In the last two decades, the artists of Russia's early-twentieth-century avant-garde have become better known in the West than ever before. We can identify some of them from photographs, and we know their works—at least the early, radical ones. We know the myriad groups and isms that came and went until Stalin abolished them in 1932. The litany of acronyms weaving in and out of the artists' lives has resounded in dozens of books and catalogues to incantatory effect: Agitprop, Akhrr, Ginkhuk, Inkhuk, Izo, Lef, Mkhat, Narkompros, Nep, Obmokhu, Svomas, Vkhutemas, Vkhutein, Mapp, Rapp, Vapp. These strange syllables conjure a firework display of vivid art, design, and impassioned polemics.

Even so, the individual artists themselves remain somewhat abstract figures, and in the early 1930s a thick fog descends. For the next three decades or so it is punctuated largely by the crack and thud of a shorter trail of acronyms—Cheka, NKVD, KGB—that often ends in the wail of the GULAG. The artists so celebrated in modern art museums around the world seem to slide into an abyss. No one has discovered caches of brilliant, unexhibited painting that develops the stunning visual and conceptual experiments of the '20s on into the '30s or '40s. Nor is anyone likely to: painters and designers couldn't work "for the desk," as writers did. When something is known of their later work, it often produces a perplexed silence (as in the case of Rodchenko's clown paintings) if not a distinct unease (as does his photographic paean to the slave labor that built the White Sea Canal). Biographies are few and far between in this field, still to be written; the texture of the artists' everyday lives, and the personal circumstances under which their works were produced, remain almost a complete blank to all but a handful of specialists.

So a problem arises: how exactly are we to understand the late work of artists such as Aleksandr Rodchenko, Varvara Stepanova, Kazimir Malevich, and others? State control has been the stark fact put forth throughout the years—and it is a convenient catchall, appearing to answer any question about inexplicable developments in artists' production. More recently, Boris Groys and others in his wake have argued that the avant-garde "got what it asked for": art as an ideological tool, every facet of its administration turned over to artists themselves. All of these things are true, yet none really allows us to understand what happened to artists and their art—the social mechanisms involved, and how they affected the human beings trapped within them. This kind of understanding is needed, not only by art historians but by those wishing to grasp how ideology functions in everyday life.

In short, we need more documents like the extraordinary group collected in *Rodchenko: Experiments for the Future*. This compelling book illuminates the very heart of these issues, at least in part. A moving, candid

portrait of a gifted, complex man, it is composed in his own words—in private and public writings spanning some forty years. For all the variety of circumstance attending the writing of these diaries, letters, notes, articles, poems, and manifestos, they are marked by an exceptional unity of purpose and self.

Personal though many of these documents are, Rodchenko seems to have always known he was writing for the future. The first thought we hear from him as an ambitious eighteen-year-old, is, "Do my notes justify my existence? Are they really being written so that people won't judge me badly after my death?" The studious youth records his art school years in Kazan, the reigning artistic conservatism, his first loves, his painful shyness. The pre-Revolutionary period brings what appear to be two radical transformations. On the one hand, the uncertain young man meets his life's companion (though exactly how and when he and Stepanova met remains obscure) and becomes a self-assured, dominating lover. He expresses his passion in overwrought prose and verse, heavily influenced by the decadent and Symbolist literary fashions of the time. King Leander, as Rodchenko fancies himself in his union with Stepanova, is essentially a romantic persona, progeny of the *poète maudit* who believes that his *fleurs du mal* have the power to bewitch the world. On the other hand, and even more surprisingly, this same young man almost overnight assumes the persona of "Anti," the businesslike rationalist of the Revolutionary years and Constructivism.

Yet a consistency of tone connects the awkward literary efforts of King Leander with the strident logic of Anti's Constructivist writings. Read in tandem, they reveal the romanticism at the roots of Constructor Rodchenko's enterprise—and by extension at the foundation of much Russian avant-garde rhetoric. Rodchenko himself recognized that he was a romantic at heart. On July 15, 1943, in the middle of the war's deprivation, having already suffered vicious attacks and painful ostracism, he recorded his own "epitaph" in his diary—what he imagined to be the future's view of his life: "He was a talented person, but obviously he lived at the wrong time, and had the wrong occupation. A dreamer and a romantic, but the epoch was severe and ruthless. . . ." He was wrong about his occupation but it is hard to argue with the rest of the assessment: the time was terribly, catastrophically wrong. What Rodchenko had no way of knowing, though, was that the body of work, in multiple genres, created by this "talented person"—works of painting, sculpture, design, theater, advertising, photography—would continue to fascinate people around the world long after that "wrong time" had passed.

Rodchenko wasn't a poet, but he was an articulate writer and an astute observer endowed with an eye for the essential and a keen sense of irony. The details are the treasure of this book. They create a vivid context for the work—both his and that of others, including Malevich, Vladimir Tatlin, and Vladimir Mayakovsky. We see Rodchenko the student set up house with his mother, organizing and decorating the apartment as meticulously as he would later catalogue his own work. We observe him in Paris, homesick and astonished that he has access to hot and cold water at all times of the day. We see him making a set of pickup sticks for Mayakovsky's birthday, sandals

for a neighbor lady, and a special wrapper for a chocolate bar to give to his daughter. During the war, he negotiates with Party officials in a village for extra potatoes, makes soup with rose hips, bakes bread, cleans house, and stands in line for hours to purchase rations. He plants radishes, lettuce, and nasturtiums on his balcony, and when the radishes turn out bitter he decides to plant only flowers.

Rodchenko was a loyal supporter of the Soviet regime, as he often makes clear. In biographical notes he traces the origins of his "class consciousness," even "class hatred," to the lives of his parents and the events of his impoverished childhood. As "leftist" artists lost the important posts they initially held in the new Soviet art bureaucracy, and were attacked with venom for their "formalism," Rodchenko became increasingly bitter and bewildered at what he considered a betrayal of art's role in the Revolution. He saw and recorded the hypocrisy and opportunism surrounding him—but couldn't understand why it was happening. For him it was not inherent to the Soviet system. Whatever may be made of Rodchenko's politics, it is clear that he was not a cynic.

Rodchenko was professionally and emotionally invested in Soviet power and exercised obvious caution in his criticisms of the direction events took. Nonetheless, his diaries of the '30s and '40s contain numerous remarks that could easily have sent him to the camps. As World War II dragged on, his comments become only more acerbic, more sarcastic. At the same time, his thoughts on his own life and art plunge into what today one might be tempted to call a clinical depression were it not for the objective reality of the world he inhabited: the diaries describe grueling poverty, isolation, and ideological monotony. The Revolution had made Rodchenko's art a social one, and thus had made him an artist dependent on social context. When he was unable to function in the social sphere, his work and life—which for him were one and the same—lost most of their meaning. And for the man Rodchenko, being stripped of meaning was akin to having his flesh flayed to the bone.

There remained family. Rodchenko drew considerable comfort from his daughter, Mulia, in whom he saw a kindred soul and a bridge to the future. August 11, 1943, more than a decade before the end of his life, finds him writing,

> Will middle-aged Mulia really sit here with her children and look at my works and think: Oh, it's such a shame father didn't live to see this, he's been recognized and people are asking for his works. . . . They buy them. . . . They hang in the museum. . . .

As it turns out, of course, he showed uncanny prescience.

Reading letters and diaries is an act of intimacy no matter how close or distant the writer may be in time and space. In Rodchenko's case, however, the intimacy becomes eerie at moments. Time and time again, the artist addresses his future readers:

July 15, 1943: I will already be gone when someone reads this diary.

January 1, 1944: Happy New Year to he who, swearing, will read this diary.

May 28, 1945: Whoever is lucky enough to be the future of this insane time, will he forgive my laziness in art?
 He must forgive it!

We are the future of that insanity. Given the brutal history of the period, we are lucky to have these pages. That we do is a tribute not only to Rodchenko's belief in his work despite all the excruciating doubts you will read about here, but to the dedication of his daughter, Varvara Aleksandrovna, and his grandson, Alexander Lavrentiev, in pursuing his charge to them:

There is, alas, no perfect way to represent the sounds of the Russian (Cyrillic) alphabet to the English reader. Much depends on the intended audience. Readers who have seen the catalogue of The Museum of Modern Art's Rodchenko retrospective in 1998 will note that it spells many artists' names differently. That book—*Aleksandr Rodchenko*, by Magdalena Dabrowski, Leah Dickerman, and Peter Galassi—generally follows the U.S. Library of Congress system of transliteration, which by and large allows those fluent in Russian to reconstruct the precise spelling in the original Cyrillic. This is desirable in scholarly research but unfortunately produces spellings that look strange to the eye of most English readers, or whose pronunciation may be difficult to determine. Furthermore, even scholarly editors make certain exceptions to the Library of Congress system, since some Russian names first became known in the West under different spellings. "Chagall," for example, might not be recognized as "Shagal." This predicament leads to inconsistencies in any book containing many Russian names. To give an example readers may notice here, Rodchenko's given name has remained as it was in the MoMA catalogue: Aleksandr. His grandson, the editor of this book, has the same Russian given name, but has widely published in English as Alexander, his preferred spelling.
 Since this book is intended for the general reader, I have opted for a more "reader-friendly" rendition of Russian names. Many modifications have been made to the LOC system in favor of phonetic transparency ("Aksyonov" instead of "Aksenov," "Pyotr" instead of "Petr," etc.). All soft and hard signs have been deleted, except in citations in the notes ("Mosselprom" instead of "Mossel'prom").
 In the original, Russian edition of the book, Alexander Lavrentiev wrote endnotes to each chapter. His notes are preserved here, but I have provided additional notes to assist English readers. In both the chapter text and the note sections, these notes have bracketed numbers to distinguish them from Lavrentiev's. For both the translation and notes I have often relied on the knowledge and advice of Alexander Lavrentiev, and I thank him for his generous assistance.

—Jamey Gambrell

PREFACE

Two decades have passed since the publication of the first book of Rodchenko's writings.[1] At the time it was important to present Rodchenko as a major figure in the history of Soviet art, design, and photography. It was important to make sure that the artist wasn't forgotten or thought of as "alien," "not Soviet"; important for people to know about his achievements and his place in art history.

The years have passed. When the Russian edition of this book first came out, in 1996, exhibitions of Rodchenko's work were being organized almost yearly, in different sizes, compositions, and with a variety of titles. People had become accustomed to the artist's name, just as they had become accustomed to the phrase "the Russian avant-garde."

It is interesting to look not only at the fate of the artist's work and the ideas behind them but at his individual fate as a human being, the experience of his work and life. Many of Rodchenko's papers and writings have been preserved; they are often fragmentary, some of them unfinished drafts. Thanks to these texts we are able to attempt to reconstruct Aleksandr Rodchenko's inner state at one or another period in his life. Sometimes he kept different notebooks simultaneously, for different purposes. We have done our best to arrange the writings in a line as an uninterrupted chain of events.

We can see that Rodchenko rarely strikes poses. He is fairly open in registering his state at a given moment or when he has one idea or another. That moment alone with the paper—is part of his creative work. He is dissatisfied with himself if the day has passed pointlessly where art is concerned, or without a single line in his notebook. He finds joy in the exhaustion of work—both painting and, I think, in the stressful attempts to set down what is happening in his soul.

Rodchenko's writings are largely about what is happening inside the artist. This is the "ship's log" of a captain who is steering his vessel into the uncharted sea of art. And at the tensest moments, when thoughts seem to soar on the crest of the waves, we sense this intimation of truth and the eternal mystery of art's birth, and consciousness's attempts to break through the barriers of commonly accepted knowledge. But at other moments—when his ship appears to plunge into the abyss—we feel the isolation, longing, hopelessness, inertia.

Reading this diary, one notices the subtlety and fineness of the artist's mental/emotional world. At one point he clearly imagines the direction of art's development; he recognizes his own path and the place of his work. All this is a kind of revelation, the steps of his human experience, which passed through art.

Because this "ship's log" is truthful and reliable, we can hope that the words the artist once wrote down on paper will serve not simply as an illustration of

his paintings, projects, and photographs but help us to see, imagine, and feel the man's soul. The name of this book is borrowed from Rodchenko's manifesto "Everything Is Experiment": "In life as well, we, humanity, are experiments for the future." Each of his works—whether a painting or a design, a spatial construction or an architecture or design project, a book cover or a photograph—is a step in his creative experiment. Throughout his life he experimented with new materials, technologies, compositional structures, and genres. Rodchenko continually dreamed of the future, trying to capture its contours in abstract compositions, stage designs, graphic design. He also said: "I prefer to see ordinary things in an extraordinary way." Up until his very last days, Rodchenko maintained his adherence to avant-garde ideas and "left" art. He believed that in art, as in science, there are discoveries and inventions, a constant search and experiment, continual movement ahead, development along a spiral. "Left" art for him meant continual experiment, a knowing of the new and a movement into the future.

The program of his life was in fact achieved in endless variations and trials—all of them "experiments for the future."

<div style="text-align: right">

Alexander N. Lavrentiev
Moscow, 1996/2005

</div>

NOTE

1. *A. M. Rodchenko: Stat'i. Vospominaniia. Avtobiograficheskie zapiski. Pis'ma* (Articles, memoirs, autobiographical notes, letters). Ed. V. A. Rodchenko, E. Iu. Dutlova, and A. N. Lavrentiev (Moscow: Sovetskii Khudozhnik, 1982).

IN THE LABYRINTHS OF
KING LEANDER OF THE FLAMES

1911–1916

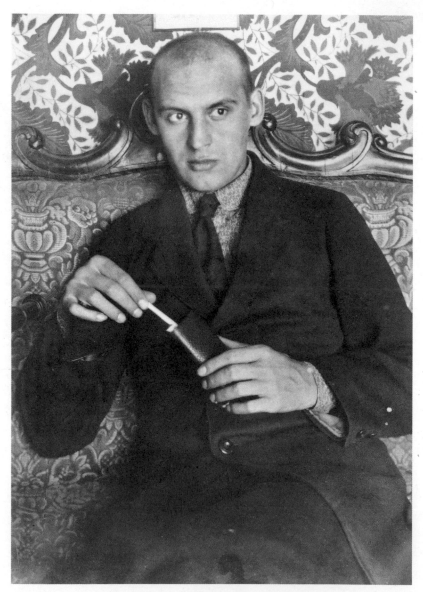

Rodchenko in lawyer and art collector N. N. Andreev's Kazan apartment, 1915.

INTRODUCTION

And then a deformed hunchback in intricate movements brought me a
letter on a ringing tray. . . . Poor playactors surrounded me, bowing. . . .
Old kings covered my feet with a cloak. . . .

Black Pythoness! . . . [1] *Within me lies the bold desire to tear your*
garments from you, to bare your heart and shout of madness with all
my voice. . . .

Art—is divinity, and a cruel divinity, gloomy, vengeful, and cunning,
and the Devil rules over it. . . .

But I must conquer the Devil, for I shall not yield to him in power.

—Aleksandr Rodchenko, letter to V. F. Stepanova, 1915

Aleksandr Rodchenko was born in St. Petersburg on November 23, 1891, in
the family of the theater propman Mikhail Mikhailovich Rodchenko and the
laundress Olga Evdokimovna Paltusova. He had an older brother named
Vasily. After the death of his father in 1909, the family moved to Kazan. Rod-
chenko entered the Kazan School of Fine Arts as an auditor, since he did not
have a certificate of secondary school—he had completed only four years of
a church-parish school.

He liked zoology—he copied the names of butterflies into a separate
notebook he titled "Anthology." He would copy out poems he liked, and
fragments from Pushkin, Lermontov, Nekrasov, and Belinsky; Dante, Victor
Hugo, and Baudelaire; Blok, Briusov, and Balmont, and the aphorisms of
Oscar Wilde. He lived in a strange world, where fantasies about art and love
were intertwined and sometimes seemed to pull a diaphanous veil over the
real world.

It was a time of youth, hopes, emotional tumult, longing, expectations,
and desires for encounters, a thirst for understanding. He was lonely, pas-
sions seethed within his unexpressed self. He wanted others to approach him,
but couldn't make overtures in their direction himself. During this youthful
period, he had many diverse ideas and thoughts. As he moved through his
life, he finally tuned his "antenna" so that it received "wavelengths" addressed
only to him.

We know about all this because Rodchenko's diaries exist, and also
because, much later, the forty-nine-year-old artist wrote his "Autobiograph-
ical Notes" (1940). Of course, the early diary of 1911–15 does not reflect his
entire life, and indeed that is not what it was intended to do. Rodchenko
himself once noted that when life was going along calmly and smoothly,
when his mood was not one of despair and hopelessness—on these days he
wouldn't write a line. . . . He wrote in his diary when he didn't know how
to escape the labyrinth of his fate. . . .

It is interesting that in almost every period of his life, Rodchenko returned
to his childhood in the theater on Nevsky Prospekt, where his father worked.
There are echoes of his childhood in his youthful poems and letters; scenes

from his childhood surface unexpectedly in the work of the mature artist, the innovator of the 1920s; and when he was working with photography, Rodchenko wrote his poetic autobiography "Black and White" (1939), where once again he returned to that period in the 1890s, but from a different perspective, as if he were standing on the sidelines.

When Rodchenko met Varvara Stepanova, he found a way out of the labyrinth. We know the story of their love primarily from their correspondence, because in conversations with friends and relatives they rarely spoke of it. They wrote in questionnaires that they met at the Kazan School of Fine Arts. (They were officially married in 1941, in Molotov, during the evacuation.) We don't know how and when they met for the first time. Furthermore, the circumstances of their life between 1914 and 1916 remain rather unclear. For some reason, Rodchenko was living in Kazan, while Stepanova was either in Moscow or Kostroma, or traveling with her family. . . . However, though the real circumstances of life at this time kept changing, what was constant was the Lacquered Castle in the imaginary country of Kanzenier, or Rekhvilia, or Medion, where King Leander of the Flames lived with his servants in 1914–16, and the dark dwarf brought him letters from his beloved on a tray. . . .

Not all of Rodchenko's words can be taken literally, of course, particularly in his letters to Stepanova. For instance, the mentions of "diabolical dreams" can be considered partly a metaphor typical of the literature of that time and partly an aspect of the persona he chose for writing to Stepanova. It was also part of his search for the words best corresponding to his understanding of his art.

—Alexander Lavrentiev

Autobiographical Notes

I begin to remember my father in Petersburg, when, at some creek or stream, I was squatting on a board placed across the stream and launching little boats. They sailed off, and I reached for them. I remember my mother said:

"You'll fall!"

But my father stopped her:

"Let him do what he wants. If he falls, then he'll know, and I'll pull him out."

I heard all this, but not knowing what it meant to fall into the water I kept reaching, reaching and . . . I fell in. It was so terrifying: the splashing, my cries, the fright. I came to my senses at home. My father was carrying me and laughing.

This left its mark, and I've remembered it my whole life. . . . That day I understood what a father is and what water is.

True, it didn't teach me to avoid water; on the contrary, I've loved water in all its forms ever since, and my favorite game was to pour water into something and make little boats.

Perhaps Petersburg instilled this love. There were canals and ships all around.

Father went off to Petersburg from the village of Uvarovo in the Smolensk guberniya, Viazemsky district, Gorodishchevsky volost.[2] His family consisted of grandfather, grandmother, eleven sons, and one daughter. Their izba was black, that is, it had a stove with no pipe, and when the stove was lit the smoke drifted up to the ceiling and went out through the door.[3]

As they grew up, the sons left home, each heading his own way since there was little land and no money—grandfather was poor.

Father would tell us that they drank tea like this: first the parents drank, and grandfather would take a glass, cloudy with age, from the icon case, and pour the tea. In the glass were old slices of lemon that his sons, who lived in the city, sent him, and since this happened rarely, he would drink with the old pieces of lemon. When the parents called over the whole gang, each was given a microscopic piece of sugar from the shelf. They would drink their tea this way—with bread, and when they were finished they tucked the piece of sugar inside their cheek and ran out in the courtyard.

The landowner Yakundin, a lonely bachelor, lived in the village, and grandfather was still a serf.

This Yakundin got tangled up with grandfather's sister, and she bore him fourteen children, only one of them a girl.

As they grew up, the children were [legally] adopted by him and went to work in some kind of trade, like blacksmithing, carpentry, metalwork, etc. They married peasant girls, built themselves houses, and lived right there. They formed a whole agricultural equipment factory.

One of them, one of the youngest, was called up by the army. As an adopted child, he was now considered a member of the gentry but didn't really feel

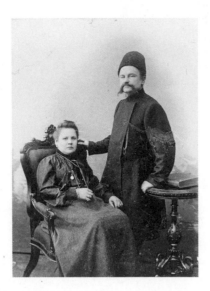

Rodchenko's parents, Olga
Evdokimovna Paltusova and Mikhail
Mikhailovich Rodchenko, in Kazan,
in the early 1900s. Photograph by
A. Shumilov

like he was. He served his tour of duty as a simple soldier, though in the
Semyonov regiment in Petersburg, and so he'd drop in to see us on Sundays,
and I loved to wear his broadsword.

He was tall and had a turned-up nose.

And so, my father left the village to work as an unskilled worker on the rail-
road line that was being constructed back then. Heading toward Petersburg,
he gradually acquired a bit of polish and even learned how to read from the
foreman and how to write a little.

Making it to Petersburg, father found work in a pastry shop. He had
worked long enough to become the pastry chef's assistant when there was a
row that ended in the collapse of his pastry career: he argued with the owner
and threw scale weights at him; the weights didn't hit him but landed on a
huge, broken aquarium. After that no one would hire him. He had to become
a yard keeper, waiter, and even a model.

Father was well built, he had beautiful hands, small legs, and well-
developed muscles.

The models were hired for some palace. They stood in tights, powdered,
with shields, swords, and spears at the balustrade of the entrance stairs; they
stood immobile in one pose—for an hour at the beginning of the ball and
an hour when the guests were leaving. They were well paid for this, but father
said that he went there only when he was in great need—it was horribly
unpleasant and the women teased them, irritating certain places with their
fans so that you had to cover yourself with a shield, if you had one.

This sort of life made father begin to drink and play cards. On one of
the best days of his life, he was made valet to the young Count Pushin. Pushin
had a bachelor apartment, a lackey, a cook, and a maid, and father managed
his entire bachelor household, and, according to his stories, the count treated
him very well.

Father also went to restaurants and caroused, and the count would sit at the next table and, when the bill was brought to him, would direct it "to that gentleman," that is, to father.

They hunted together. Father truly loved hunting. But all this ended tragically. The count fell in love with a cabaret singer and wanted to marry her; his family would not allow it . . . and he shot himself.

Once again father was out of work. I don't know what else he did. But it seems that he did many different things. He didn't tell me about them, since I was very young when he died.

I heard all this when I just happened to be present during his stories. He was twenty-five years old when he had some money and a woman—some German housekeeper. And one time, visiting a friend on the outskirts, he saw a fifteen-year-old girl—my mother.

My mother's history is not well known, and during her lifetime I didn't think to ask her [about it]. They were Old Believers, they worked in the glass trade somewhere in the Olonets guberniya;[4] one of the Paltov brothers, or, as my mother said it, Paltusov, was my grandfather. He served in the navy for twenty-five years and lived in Kronstadt, in the barracks, with his wife and children—Anka, and Olga, my mother. . . .

In one of the Turkish wars, his ship was sunk, and he hung on to a fragment for three days until he was picked up. After that, as an invalid, he worked in a gunpowder factory, but soon died, and grandmother was left with the children and no means of support. Grandmother washed laundry for people, and my mother worked as a nanny and then also became a laundress. But Anna, since she was the older sister, became a prostitute. The whole story of my mother's ancestors ends here.

Maybe along the way something else will turn up.

For as long as I can remember I've felt a sort of loneliness; for instance, in the club in Petersburg. I remember roaming through the empty halls and rooms in the morning after the balls, when trash hadn't yet been cleaned up: empty candy boxes, bits of paper, streamers, odds and ends of ribbons, fancy broken bonbon boxes. I remember the cleaning women weren't there, it was early morning, and there was the smell of tobacco, dust, perfumes.

The early, pale Petersburg sun lying in weak patches on the parquet floor, and I'm almost the only one in the whole club.

I would get up early, everyone at home was sleeping. I'd go down the stairs onto the stage, and from the stage into the auditorium. The chairs had been moved to one side for dancing. I had to make the rounds and look at everything. Sometimes I would find something interesting: a box, a perfume vial, occasionally a few candies in a box, and so on.

It was the morning catch—my catch.

Then the cleaning ladies would come, and I'd move away to the stage; from the stage to the balcony, looking out on Nevsky. Drips fell from the roof, the snow was melting. Spring. I'd watch the wet street. . . .

(Everyone on the street was hurrying somewhere.)

A kerosene lamp is burning on the chest of drawers. There's no one in the apartment except me. Mother and father are in the theater, my brother is often out on the town. I'm alone; I'm probably about seven or eight years old.

The lamp isn't on the table, but on the chest of drawers: that's so I won't knock it over and start a fire.

It's quiet and boring. After all, no one else lives around here. Our apartment comes with the job. And it's the only one over the stage of the theater.[5]

There's nowhere to go and no one to go to. I can't go on the stage, my mother won't allow it: I could be crushed when they're changing the scenery. But it's boring. . . . What to do? . . .

There's nothing to play with and it's no fun to play alone. I sit on the sofa and look at the lamp. But it's burning so boringly, and it seems there's something dreary about its light. . . .

The only thing to do is fantasize, and find a corpse in a hanging towel or sponge and monstrous beasts in the dark corners.

And what to do tomorrow?

Get up early, go down to the stage, from there to the auditorium, and wander among the empty rooms, not yet tidied, in solitude.

Not many people live in the theater, only the watchman and cleaning ladies, but their children can't wander around the theater. . . .

So here I am, alone again.

There's no courtyard, only a garden. A huge garden, where in winter it's like June.

And father and mother are still sleeping. In the theater, life starts at ten or eleven o'clock.

Toys. . . . Don't have any. Father doesn't give me any. Father makes props. For father, props were the highest achievement: from an illiterate and landless peasant, then a railroad worker, to a propman.

I remember how in Kazan, when I was fourteen, I climbed up onto the roof in summertime and wrote my diary in small books, full of sadness and longing because of the uncertainty of my situation. I wanted to learn to draw but I was being taught to be a dental assistant. . . .

I may have written about how I got up at eight o'clock, at nine went to the studio, and at five came home and had dinner. The diary has been lost. There's a diary from when I was in art school, full of blather about women and painting. . . . But it isn't very interesting, and there's little factual material in it.

1940

Amid the Flames

FROM THE DIARIES, 1911–1915

From childhood I grew up alone,
And someone fed my bloody flower
With torment and distress.
I lived and waited, ever seeking
The tender, sacred bower,
Some unearthly inspiration,
And I am tired. . . .

1911

Do my notes justify my existence? Are they really being written so that people won't judge me badly after my death?

The portrait: when I began painting portraits, it was only then I understood what painting is, and understood portraits painted by artists. And then I understood the life of the people themselves, and understood what a human being is. . . .

> *During sleepless nights, during illness, in moments of loneliness, when the ephemeral nature of everything earthly can be felt so clearly, a person gifted with imagination must possess a certain strength of spirit if he is not to greet the ghost and enfold the skeleton in his embrace.*[6]
>
> —Delacroix

Now I realize that for an artist, and particularly for a student, work must come first, and he must convey nature as realistically and precisely as possible, paying no attention to technique and materials. And most important— the works of his comrades and their advice. . . .

It's no accident that a great master like Rousseau tortured his works, but through this labor he attained truth. . . . Or there's Leonardo da Vinci, who died with the knowledge that the Gioconda was not yet finished. . . .

. . . How many years does one need to paint everything meticulously, patiently, in detail, every little thing, studies and drawings. . . . And only then can you begin to work without needing models, like Böcklin, Corot.

> *He who has studied reality for so many years with patience and concentrated attention, who has daily enriched his fantasy by contemplating living nature, he may finally allow himself to paint not specific landscapes but rather the aroma of nature, the essence of things, can liberate himself from all the oppressive earthly appendages in his visions and reflect only his soul.*
>
> —History of 19th-Century Painting

November 8

I've just come from the ball, from our ball. How much fun! Awfully fun! Games, dances, hors d'oeuvres, Russian dances and songs. . . . This time I tried to play. . . . But alas, it doesn't do anything for me. The Russian dances aroused my envy, I felt like dancing too, dancing so well they'd all gasp. . . . But I sat in the corner of the sofa and watched. I tried singing the songs, but again there was no point, and so I left. . . . So much merriment around, and I'm mad, I love her. . . .

And how long I've loved already, but arriving at a certain point, I retreat into the darkness, eternally alone, disappointed. . . .

Further on. . . . Passing by, passing by. . . .

Argue, go astray, make mistakes, but for God's sake, think!

—Lessing

December 7

What to write about. . . . That once again I'm struggling with drawing, that I want to give the truth but sharpen the drawing as well, I want everyone to dislike my drawing, and be surprised by it. . . . I want to be completely satisfied with it myself. . . . I'm going to Peter and Moscow.[7] I'll describe everything so as to remember it. . . . Right now I'm dreaming of the State Tretyakov [Gallery], of new people, of paintings. . . .

December 8

. . . I have to memorize, memorize.

I envy everyone on the street. Alone. Alone. . . . Do people understand what this word means.

I have to decide once and for all: either work heart and soul, if I'm to take the exam, and if not—then not, and thoughts be gone.[8]

The whole table is covered with books, algebra, geometry, notebooks, math books, I have to study, but no matter how much I read, how much I drum in—emptiness, emptiness. . . . And so what do I do? I'm reading Mirabeau's *Notes of a Housemaid*, and when I hear steps—I hide it. What a farce! . . .

December 11

. . . I was in the public library, reading *Satirikon*, a marvelous journal.[9] I would love to be part of it. Or at least of some journal. . . .

Today is Sunday, Panya and Yasha were at my place; we played cards. Boris came by, we talked about my trip to Moscow and Petersburg. . . .

December 12

. . . I'm mad with joy and ideas!

. . . In the studio, I suddenly heard Kitaeva's voice behind me:[10] "Rodchenko, do you want to look at some John-Burns postcards?[11] You'll probably like them. . . ." I go and look, and having looked, thank her and leave. . . . Why suddenly call and ask me? Could she really love me. . . .

December 17

And the only thing that I also want to read—are the best poems of the new poets, internationally known: Oscar Wilde, Gamardi, et al.[12] . . .

December 20

For the day classes—I got first prize, and also one for the evening; for sketches, a third. Anta Kitaeva talked to me. . . .

FROM A NOTEBOOK

The trip. In the train. I'm traveling to Moscow, the car shakes, sways. . . .

I'm traveling with her (Anta). We talk in between the train cars, we're freezing, but we still stand there and keep on talking. She reads her poetry. . . .

Moscow. . . . Museums. . . . Exhibitions. . . . Then Petersburg. . . .

1912

February 10

I got the idea of getting together at Rusakov's (one of our students, my comrade).[13] Setting up literary evenings on Saturdays, to read stories, poems, drink tea and sketch.

. . . Yesterday we invited the ladies. I invited Tamara.[14]. . . I saw her home and told her that I was going to the country for the summer. . . .

March 1

How I like everything Japanese. . . . Tamara has so many different things. And she herself looks like something Japanese. . . . Just as slender, lithe, and tender as a watercolor, and elusive. . . .

March 4

Yesterday I was with her, and we went to church.

. . . And then she said:

"I thank you for your prayer for me."

March 22

I'm fixing up my room. I hung the Egyptian costume on the wall, a new red lantern, hung some studies, sketches, and drawings.[15]. . .

. . . And sitting alone I remembered the Egyptian ball. Remembered Tamara's words when we went into the red room [. . . .]

April 8

I painted Tamara's portrait from three to four. . . . We went to the cemetery, but soon came back—it was cold. . . . In the evening I drew designs for burning [on wood], and Tamara drew me.

April 17. Tuesday

Yesterday, looking at my sketches, Kolya [Nikolai Rusakov] said: "No, you've got Anta, Anta everywhere" [. . . .]

Tamara once said: "You are both so strange, you have a lot in common, you should be together" [. . . .]

April 19. Thursday

I didn't see Tamara at evening classes. . . . I left straightaway for the concert. Kusevitsky.[16] Tchaikovsky's sixth symphony.

. . . A death procession. . . . There death is, over a field covered in corpses, on the horizon there's a huge glow. . . . Death is dressed entirely in black, it is huge, tall, bares its teeth. . . . Its arms are long. . . . Its cloak billows. . . . The glint of a bloody scythe. A fervid, brightly burning blue fire in its eyes. . . . It walks on and on. . . .

Streams of blood flow. . . . It dances. . . .

The cloak flutters . . . the glint of the scythe. A smile on the lips. . . . The bony hands are spread.

How much longing. . . .

How close Tchaikovsky is to me! . . .

Wagner. Bacchanalia.

. . . Venus's grotto. . . . There's the bloody grotto. . . . A million rubies. Rivers of blood. . . . In the distance, the plashing of a stream. They recline at tables laden with wine. . . . I hear the sound of a tambourine. Thirteen naked girls dance. The dance of love. . . . Slow, fluid, passionate movements.

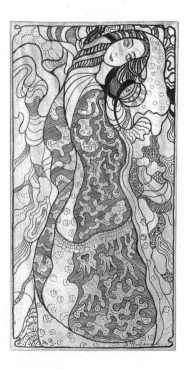

Rodchenko. *Figure in a Kimono.*
1912–13. Ink on paper, 8⁹⁄₁₆ × 4⁵⁄₁₆"
(21.7 × 11 cm)

The wine pours. . . . I hear the sounds of a passing vessel, where another feast takes place. The roar of the sea. . . . The ringing sound of the streams. . . .

There's a din from the speeches and chimes. . . . Now they're singing. . . . A young, resonant voice. . . . It falls quiet. Squeals, the clatter of broken cups. . . . The sound of falling flowers.

Bloody wine pours from the cups. . . . The hollow grotto. . . . The stream rings, the sea rushes. . . . The girls dance. . . .

April 21. Saturday
Yesterday I wrote to Anta again [. . . .]

Went to a concert in the evening. Mozart, the overture to *The Marriage of Figaro*. Beethoven's Fifth Symphony.

There they are, my beloved sounds. From the first chord I am in your power, from the first chord I tremble. . . . A song of fate. . . .

Life! How strange you are. . . .

Rachmaninoff. . . . A symphonic poem to Böcklin's *Island of the Dead*. A marvelous piece. . . . A troubled sea, a powerful sea. . . . Your waves rise and break on the cliffs with a roar.

Strange trees rustle. A horn sounds. . . . Small crafts with corpses sail by. The wind whistles. . . . The sea is troubled!

Liadov's *Baba Yaga*. . . . She whistled and appeared, broom and mortar. . . . She took off. . . . What marvelous music. Sibilations, wails, and hellish moans.[17]. . .

Mussorgsky. From *Khovanshchina*, "Dawn over Moscow River."[18]

An interesting piece. . . . You feel the morning, quiet and clear. . . . The sun rises. . . . It's still light. . . . Water burbles. . . .

Glazunov. *Stenka Razin*. Good. . . . Pretty. . . . But something's missing. What? I don't know.[19]. . .

I painted Anta Kitaeva again today. . . . There's something calming about painting her. Everything is forgotten. There's only her and the portrait. . . . She critiqued the portrait; I said: "Don't look for things, there's nothing in it. . . ."

Ilin and other members of the arts academy visited today and looked at my work and critiqued it. . . .

I left to go to figure class, and did a sketch. They came in, Vilnovitskaya pointed to me, and said: "There's the author." Then they told me that I'd been assigned to Donkey's Tail.[20] What can I say, thanks for even that!

April 24
. . . I'm painting Anta, and others say better than everyone and more like her than anyone else's [. . . .]

April 25
. . . I'm painting Anta. . . . Vilnovitskaya asked for my album, I didn't give it to her. Why? I don't know. . . . She said: "Your likeness is the best of all!"

Kolya gave me a photo of his transitional portrait, with the inscription, "To my best, talented friend, Shura, an innovator in painting, from another innovator, N. Rusakov. April 25, 1912. Kazan."[21]

April 27
Kolya, Liza, and I went for a walk in the Derzhavin garden. Anta will leave soon. What am I going to do? I was at school. They've hung the works up at the evening classes. What they say about my drawings is: too bold, crazy, and so on. Let them. . . .

[. . .] I'm sitting at home and preparing sketches. Thirteen of them. . . . I decided on all of them. . . . Let them rant! Scream that I'm crazy! . . . That's beside the point! I'm alone. . . . The exams are tomorrow. . . . The last day.[22]. . .

April 28. Saturday
The exams are over. In drawing I got two firsts, in colors for figures II and for Anta. I submitted thirteen sketches, all are seconds. . . . the students liked them.

Tamara has been transferred to the portrait studio [. . . .]
There will be a ball this evening. . . . Too late! [. . . .]
I was at the ball. She danced and played; I stood alone and watched.
We drank tea. Played mailman. . . .
Took photographs. . . .

May 1
[. . .] Once T.[amara] and I were sitting and looking at the Kazanka river and the sunset. The water, the riverbank, and reflections in the distance; in the foreground, a tree and the pretty drawing of the branches. There seemed to be something . . . Japanese in it. . . .

I said: "I don't feel my body. It seems like I could fly out of it. . . . Where is my body? . . . I don't feel it. . . . "

She said: "I feel a weight, the earth pulls me toward it—I'm of the earth. . . ."

. . . The streetlamps went on. . . .

"Look how funny everything's become, so theatrical. A sunset and street-lamps" [. . . .]

. . . Our Russian nature is so boring, monotonous and gray. . . . It's so sad and silent. . . . What does Nature long for?

What is she forever thinking of? . . . I see this tired gaze, focused somewhere off to the side, past and beyond. . . .

. . . Every single leaf, each blade of grass, not one of them notices you. . . .

. . . Nature has her own thoughts, her own sorrow. . . .

The water and even the stones as well. . . .

A real Russian is also sad, he longs for something, and you'll never figure him out. . . . What is in this soul?

And in the soul of a flower? . . . A tree? . . .

May 4

By a strange set of circumstances, I happened to be at Lisovskaya's with a group of people. We were talking. . . . She offered me work with Professor Adler.[23]. . . He's writing a historical treatise, he needs drawings for it. . . . Ancient ornaments and costumes. . . . To work in the university, and with him. . . . In the archives. . . . As far as pay is concerned, he won't quibble.

She gave me the address. She's going to Vladivostok. I asked her to write when she arrives in Japan. . . .

There are some drawings of flowers by Feshin at her place, with the inscription: "To the talented student Lisovskaya from N. Feshin."[24]

May 5. Saturday

"The day of the white flower."

In support of the League against Consumption . . . I sold a white daisy. . . . With her . . . from twelve to four in the afternoon and from eight to twelve midnight. . . .

There's a festive liveliness in the city. . . . Everything seems jolly. . . . There are white dresses everywhere, flowers . . . automobiles covered with flowers. . . . Buy a daisy!!!

People are walking about and selling in all the shops, cafés. . . .

May 9. Wednesday

I'm sitting and writing in the storeroom—it's cold. Boris came by, recommended I send my works to Knave of Diamonds in the fall.[25] Well, it's not a bad idea, I'll send them.

May 25

I'm working from nine to three and from five to nine.

Last night Adler and I sat and talked at his place . . . I told stories about my past, about the *cafés-chantants* . . . about school.[26]

The professor has a lot of books. [. . .] He says that he has 300 volumes in Petersburg.

May 27

He [Adler] talked about Italy . . . how wonderful everything is there . . . a different sky, nature, people live in the full sense of the word, they live as though they were burning, and their conversation is just as fast.

About Monte-Carlo [. . . .]

"I would travel to a lot of other places, but my wife is sick, you see. . . ."

He asked if I have mates. . . .

"For some reason I always wanted to have the kind of friend who would know more than I do. . . . But most people—it's just the opposite, they want to command but not submit."

Twilight gathered, and we kept on sitting and talking. . . .

He said: "How interesting this is for an artist, a certain mood has been created. You and I are completely different people, but some sort of thread has been formed that connects us. . . . Now you'll go off and enter the

academy, and perhaps sometimes you'll recall this twilight and this lonely professor."

I said: "I really love memories. . . . For that matter, I guess everyone probably does."

"No, I wouldn't say so. There are some memories that are better not to remember. . . ."

I'm writing this right now in his den . . . he's not here. . . .

May 30. Wednesday

The professor told me to set a price for my work, and if it's acceptable, then he'll send a letter and I'll begin working. I want two rubles a page, if they'll give it to me. I'll rent a room somewhere and I'll work.

I'm going to live alone. . . . I'm already thinking about my room. How I'll set it up so that it will be nice, I'll hang sketches. . . . And I'll make a bed that looks like a tomb. I'll cover the table with white paper.

A tall vase with white flowers on the table. . . .

I'm sitting at the window, looking out. . . . a yellow hand writes something in a thick book. . . . Thoughts about my cozy home fly around. . . . And it's hot. It's going to rain. . . . The clouds look like dirty water. . . . It's dusty. . . .

Have to go, it will be five in the evening soon—time to work. . . .

June 1

[. . .] Adler almost always has students at his place twice a day. We were introduced. They're all different, I like some of them. . . .

June 2. Saturday

I saw the professor off to Moscow. . . . He said that maybe when he comes back to Kazan, on his way to Siberia, to the Urals, he'll take me with him to work.

"I won't pay you for it, but I'll take you and give you food and drink."

We parted very pleasantly. He held my hand and said: "I thank you for your kindness toward me. . . . I'll try to do everything I can. I'll send a letter this week. . . ."

I've seen so many people off, but I've never been so sincere with anyone, never felt so endlessly sorry for anyone.

June 3. Sunday

A. A. V.'s flight.[27]

Again, Kazan is all aflutter. There's dust in the air from the automobiles, carriage drivers, horsecars. . . . Crowds, the streets are full. . . . As though people were out to greet icons. . . . The flight of A. A. Vasiliev. . . . He's dressed in a white suit and English boots. A white hat, pale face. . . . A genuine Englishman, with an aquiline nose, a jutting chin, a pipe in his teeth. . . . The propeller creaked, and it soared into space, strong, smooth. . . .

I thought: "Now you've forgotten about the earth, forgotten about our filthy, vulgar earth! You are a hero—alone—you forced us to be amazed at your daring."

And I saw how the cowardly hearts of the viewers beat wildly, and they whispered: "Terrifying," and everyone thought: "What if he falls!" Everyone wanted you to succeed, but they wanted to see you fall even more. They wanted a spectacle. . . . Two times you flew overhead between the sun, and for a moment it couldn't be seen in the rays. . . . He landed evenly, smoothly. . . . His hair was in disarray, his face was sweaty, but he was pleased. . . .

I keep waiting for the letter from Adler, but it hasn't come. I'm lying in the closet. . . . It's quiet. . . . Nighttime. My dreams, my works. . . . A cold closet. . . . I'm going to look for a room! . . .

June 12. Tuesday

My cursed room is being torn apart, they're redoing the stove. . . .

We may move.[28] I'm looking for an apartment.

I found myself two rooms and a kitchen—the apartment's ten rubles. . . . If yes, then I'll move. But naturally: it's not quite the right thing!

I found an apartment. . . .

June 14. Thursday

This morning Vasya announced triumphantly: "You haven't received any letters from the professor?" "No. . . . " "So you'll end up working in an office every day from nine to two."[29]

Well, all right. . . . Does it really matter? . . . At noon I went to the engineer, got my three rubles, drank a glass of tea with him, bought *The Russian Word*, and came home and gave Mama half a ruble.[30]

It's strange . . . why does everything happen this way: you work and work, hope . . . dream, and suddenly it's silence and uncertainty all over again. . . . Against my will there's utter apathy, and I don't feel like looking for anything.

My luck is bad, as always. . . . I don't want to work . . . don't want to think. . . . I'm dying, dying to break out of home, to live alone, free, easy. . . . I did everything I could, and it's all for nothing . . . from nine until two. Yes, that's the way it ought to be, I thought. . . . And I said nothing . . . and sorted through some dirty papers, and organized them, I put them away and checked them. . . . Don't feel like thinking. . . . I'm sick of it. . . .

July 7

At home there's a whole to-do going on, mother and I will have to move. . . . A reply came from the editors of *Early Morning*, saying, "We're sending your poems back, they can't be printed". . . . Why? And from *The Moscow Post*—silence. I ran around town all day looking for work at the university, in the Apollo, at. . . . And it's all the same: no.

July 9

I sent a letter with three poems to *Satirikon*.

July 14

I found a small, sweet apartment for ten rubles, on a good street, we'll move on July 20th, Mama and I will live together.

Now I'm fairly calm about the draft. I'll go. . . . And that will be good, I'll learn something.

I spent days looking for an apartment, but this morning I suddenly saw this one and rented it.

I have the feeling that if I need something, I shouldn't chase after it, I should wait, it will come all by itself.

For some reason I like the landlord's room, it looks like a berth. . . . Two closets, a table between them, a plaque above the table, on which there's a strange copper clock that looks like a mechanical one, with lots of buttons. . . . The window seems oh so high up. . . . I like rooms where the light is from above, it doesn't shout out its existence but quietly goes about its business, illuminating, and everything is even and calm. . . .

July 16

I sat at home all day yesterday. I didn't go anywhere, just drew and read. I've been promised some blueprint work.

But my house, this damned house. Everyone's counting, getting mad, slamming doors, running around. . . . How sick I am of it! . . .

I believed him (Adler), and he doesn't even remember me at all. . . .

July 19. Thursday

We got up at four in the morning, moved, and were moved in by nine in the morning.

Now it's ten at night. . . . I'm sitting at my table, there are wonderful books all around me, my works and Anta's on the walls. . . . On the table there's a photograph of T.[amara]. . . . I'm thinking about her. . . . I arranged the apartment in a way that can only be done with our materials. Mama is thrilled.

Today I was remembering my far-off childhood, when Mama would leave for work; it was boring without her.[31] She showed me a woman's portrait, said, "That's me when I was young. . . ." And I spent hours alone, sitting on the sofa, examining that alien face, and I believed it at the time, and I loved that portrait because it was something that didn't exist in the present (it was an oleograph).

Now I'm sorry that it wasn't preserved.

July 20. Friday

So Mama and I are alone. I work, sketch, go to the engineer's. . . . My dear Mama keeps asking me what to buy and do. . . . We live quietly, quietly. . . .

A young woman lives opposite the windows of our apartment. . . . She looks in our windows, asks Mama how we're doing. I like it when she looks, she's so very quiet. . . . She has a thoughtful, gentle gaze. . . .

July 21

I'm sitting at my big table, which is half covered with paints, bottles, paper, and books. . . . I made it large deliberately, it's more comfortable to work. I feel so good now. . . . I used to try to be at home as little as possible, any-

where, only not at home, and now I feel like getting home quickly, because it's become dear to me. . . .

Our apartment is cozy. My sketches hang on the walls, my Japanese sketches, my dreams, my pain, my life, my diabolical daydreams. . . . My love. . . . My strange schoolwork, which is so unlike that of the others that the students call me crazy and the teachers shrug their shoulders. . . . It's so very quiet here. . . . Quiet as a monastery. . . . Oh, if only Tamara would come. . . .

July 23. Monday
I painted a *panneau*. Yasha came by and brought me the address where the lesson would be. I went to the Admiralteisky area. [My student is] a big young man in a sailor's jacket. He has his own room, the walls were hung with color reproductions depicting the sea, from magazines. . . . We came to an agreement, he wants to take the fifth-year exam, to enter the sixth year of trade school, he's going to come to me every day for an hour, and for one hour—fifty kopecks. Drawing from plaster casts, and watercolor.

July 30
I've arranged my apartment. I set up shelves with books, there's a lot of poetry, there's Gamardi, Strindberg, Wilde.

The Japanese sketches on the wall, Anta in a white frame. . . .

My table is covered with light green paper, and I've set out brushes, pencils, paint knives, vials, boxes with paints, albums with reproductions, sketches, journals, watercolors, tempera, notebooks, catalogues. Vrubel's self-portrait, a miniature of Mama, a bronze bear, a paper knife with a German nickel handle, a notebook for poems half covered in my small handwriting and filled with pen-and-ink drawings.[32]

August 11
I'm working, I have seventy drawings, I want to fill an entire display panel. . . . I tried to hang the works at home, they occupied my entire wall. And these are only the pieces that I like. . . . How many I tore up. . . .

August 15. Wednesday
Today I was at my brother's and got a letter from Adler. Here it is:

Dear A. M.![33] My brother sent your card abroad, to the place where I've ended up with my sick wife. From your letter I found out to my dismay that you had not received the letter I sent back in July when I was leaving Moscow.

I will try to repeat in brief what I wrote to you then. I spoke with book publishers, that is, with a representative of Sytin, and he said that your drawings were satisfactory; for each vignette they would pay two rubles, as you wanted, but he said with the condition that you allow "polish" to be added to some drawings, as they put it.[34] This is necessary in order for the drawings to be better for printing. Bartram himself will add the polish, he's a well-known artist who works for the Moscow Zemstvo [. . . .]

What you write is very sad, but, God willing, your work will help you get out of a difficult situation.

Wishing you all the best, I am, yours,

B. Adler

August 16. Thursday

This morning I went to the public library; I looked at drawings by P. Kuznetsov, liked Yakulov, his compositions *Night in the Street* and "The Café" are very interesting, there are tons of figures, all different, like life itself, and the subtle drawing of the Japanese, and there's no perspective, which also recalls them.[35] I also read van Gogh's letters. . . .

August 18. Saturday

In the evening Mama and I like to sit and talk over tea. I love it when she tells stories. The lamp. . . . A little samovar. . . . Her father was a sailor, served twenty-five years. He was a small, nimble man with a pointed beard and gray eyes. He married a girl from a rich peasant home. And left for the Turkish campaign. . . . Their ship was destroyed, and he floated on the wreckage with other sailors, there were fifteen of them. They floated for a long time, three days, hungry and cold. They were taken on board a ship and brought home. Her papa was sick for a long time. . . . He was given a job at a gunpowder factory, where he worked stuffing the cartridges with gunpowder. But he soon died. . . . They had to go to Petersburg, where my Mama's mama took up a position. Mama was given away for one *chervonets*, she was seven years old.[36] . . . She babysat the kids. And that's how her life began. . . .

August 20. Monday

I sent a letter to Adler saying I agreed to his conditions and that the drawings should be released with "chic."

August 21. Tuesday

It's looking like I'm satisfied with my latest things. They are so unlike anyone else's work. . . . This is something new. . . . True, I think that most people won't understand them and won't see them the way they should. . . .

I used to want to work smoothly and in calm and even tones, not to put down on canvas the bright, screaming colors that tempted me so much. . . . But now I've realized that this is a lie, that I've come to love bright, decorative painting. Bright blue tones with bloody spots. . . . I'm crazy about bright colors that grate on the eye and get on your nerves.

I painted *Under the Sun* today. It's a harmony of mother-of-pearl. Two women. One has a white dress that shimmers like a snake's scales, and then in the background there are crazy spots of greenery and grass that call out, receding into infinity. Her face is: dark blue eyebrows and nose, yellow cheeks and reddish purple lips, and dark, bloody colored hair.

I began to paint my mother-of-pearl shell—there's a whole sea of lights!

I just hope I have enough paint for it, but then I'll have to stop painting. . . . No money. . . .

August 24. Friday

I went to Fyodorov's building site. He bought a set of drawing instruments for a little over fifteen rubles, and some other stuff. It means he stopped drinking. . . .

The city is getting ready for the festivities of 1812–1912.[37] A statue of Kutuzov has been set up near the theater, but it's still covered. Kutuzov-Napoleon are everywhere: there's perfume and engravings, and dishes, candy, cookies. . . .

August 26. Sunday

The hundredth anniversary—1812–1912.

The city has been out strolling all day long. . . . They made a lousy monument, hung pictures, greenery, flags. . . .

The interesting part began in the evening, when there were a lot of people. It was nighttime, full of lights. . . . The streets were filled to overflowing with people. . . . And there were fireworks that split the dark sky with their sharp eyes. . . . And lighted balloons flew overhead and shots could be heard. And the crazed beast shouted: "Hurrah!" It became stifling. And I wanted to get away from it all!

September 6. Thursday

Mama is ill; we've been here all day, taking care of her . . . this evening she has to go to work at the *café-chantant*. . . . She earns good money, but she's not well. . . .

September 11

Today I saw Professor Adler, he gave me his address, asked me to come by. He'll have more work at the university.

Classes have started in school.

Rusakov brought a huge self-portrait and a woman.

The drawing was pinched from [Henri Vincent] Anglade. Lousy studies and sketches. Nikonov brought some good, interesting studies. . . .

September 14

I'm going to work with Adler at the university, and paint a panel.

I drew a study portrait of Rusakov, pretty strong. . . .

November 12

At the university I had to meet Igor Nikitin.[38] He's one of our students, very talented and original, we're going to work together on the panel. . . .

December 15. Saturday

Igor and I set up our studio in the large sketching studio. We partitioned it off, hung a background, sat Katya down in a white dress, with a rose, against the background of an eighteenth-century gazebo, and are painting large portraits.

. . . Awfully fun and interesting. . . .

Rodchenko in Kazan, July 2, 1914.

December 24. Monday
It's my twenty-second year. . . . Alone. . . . With my sketches, portraits, diaries, poems, enormous dreams, impossible desires, with my impossible love, with all my eternal anger. . . .

1913

January 5
I had a good time on New Year's, like never before in my life—of course my diabolical thoughts gave me no peace. . . .

 I want too much, and for this reason end up with nothing. . . .

May 14
 . . . I have to go into the military school, and then she [Tamara] will be my wife. You have to study for two years, and in two years you're an officer. We'll leave for the country by automobile, get married, and I—will go off to serve in Siberia, and she and Mama will go with me.

 I have to pass six years of school. . . .

 Fever . . . why? Because I'm tired.

May 16
Today I saw her [Tamara] off. She left to take the cure in the Caucasus. I'm alone. . . . If I pass the exams and study, I will make an album for drawings from thick white paper and will glue them in. . . .

August
I haven't written for so long. . . .

 Yes, I submitted a drawing, a print: a nude to the waist with red lips, but there are no eyes or nose, so there's a scandal at the school because of this. . . .

 How strange that Varya [Varvara Stepanova] is so sad. . . .

Oh, if only I had money. . . .

I have until October 1st to live, and then it's the army. . . .

1915

October 14

You are reading my diary, Varya.

There have been so many mistakes in my life, so many stupid things done. . . .

You are reading this diary, Varya. . . . Oh, love me, I will write a new diary about you, for you. . . .

Strange. How I changed after meeting you. How many beautiful things I've done. Living with you, I feel that I'll do even more beautiful things, and I'll never stop on the path to beauty.

I feel like it was you I was searching for, and everything else wasn't right, wasn't it. . . . Does a woman need to be only beautiful, passionate, and in love! How little this is. But you . . . you are the one whom I can love untiringly. Why didn't I see your quiet soul back then!

Do you know that my very soul is in love with you, see how joyous it's become, it keeps singing of you so tenderly, so commandingly! . . . I feel like creating new miracles so that your mind will continuously delight. Once again, I've planted unseen seeds in my soul, from which enchanted flowers will grow and intoxicate you with their aroma. Love to the unfathomable depths and I

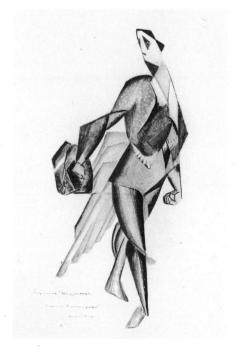

Rodchenko. Costume design for the play *The Duchess of Padua*, by Oscar Wilde. 1914. Tempera and varnish on paper, 12⅝ × 7⅞" (32 × 20 cm)

Rodchenko in lawyer and art
collector N. N. Andreev's
Kazan apartment, 1915.

will be new and inventive forever and ever. . . . With the strength of my
depraved, strange mind I will force you to serve specters, and with a will verg-
ing on the magician's I'll conjure the shadows of the dead. . . . I'll make things
that will have no name, and there will be no end to their enchantment. . . .

November 16
Today the sky is so joyful, but the soul is dark. . . . War. . . . I don't like war.
How alarming everything is now. . . .

Do people who are without hope really live?

My domain is boundless, like hell, and no one can ever erect barriers around
the gloomy borders of this kingdom. . . . My kingdom is eternally mysteri-
ous, incredibly so. My path is not isolated, but he who walks along my path
will only be a subordinate. . . . I end this diary under the glimmering of agate
nights. . . .

I began the sonata as an heir apparent,
And end it as King Leander of the Flames.

November 20, 1915

THE STORY OF KING LEANDER OF THE FLAMES,

Ruler and commander of Rekhvilia, Menpolia, Medion, and Kanzenier, in which is described the government of the court, etc., etc.

A Romantic Novella

CHAPTER ONE: On the manner in which King Leander of the Flames inspected his "lacquered castle."

CHAPTER TWO: On the manner in which King Leander began his day.

CHAPTER THREE: On the manner in which King Leander amused himself at a bizarre dinner.

CHAPTER FOUR: On what King Leander did after his dinner.

CHAPTER FIVE: On Naguatta, beloved of King Leander.

CHAPTER SIX: On the lover's tryst that took place between King Leander and Naguatta.

CHAPTER SEVEN: On the manner in which King Leander dined with his beloved, Naguatta.

CHAPTER EIGHT: On what took place at night in the Lacquered Castle.

CHAPTER NINE: On how charming Lispepta appeared at dinner.

CHAPTER TEN: On the greatness, wisdom, etc., of King Leander.

The High Commander,
Ruler of Rekhvilia, Simla, and Menpolia,
Prince of Medion, King of Kanzenier,
Exemplar of the Exotic,
Of Erudition,
Of the Wisdom of a Beautiful Life,
Does dedicate this book with due admiration
To Naguatta.
Chronicler and depicter of his own days,
Composer of this book
King Leander of the Flames.

Naguatta!

To you, amid the black velvet of my cloak, embroidered with gold birds, I write this dedication. May the sky-blue nails of your small fingers turn these leaves like the stern nun turns rosary beads in the whisper of twilight, when the black devil whispers in intricate designs of exotic sin in the rustlings of the oncoming night. . . . May your cunning eyes, like quietly swaying ostrich feathers in the setting sun, when the distant sounds of a flute can be heard and the fragrance of muscat wafts in, may they see my fantastical chapters, which are so like the ravings of a possessed preacher-prophet in ecstasy, so like the little monster that lives in my lacquered castle, like you yourself,

magnificent Naguatta, when you dream languorously by the pond on that very bench where I wrote you the "Green Sonnet". . . .

Beauty—is the only thing to which I bow, and for this reason, having written this book, I dedicate it to beauty, and you are her first creation, marvelous Naguatta. Give me the joy and reward of accepting this slim book of my life.

Your High sovereign, ruler, and protector
Leander of the Flames
Medion, February 1, 1915

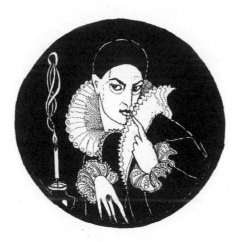

Varvara Stepanova. *Portrait of Anti.* 1915

THE CAT AND THE MIRROR

Happiness is not beauty—beauty is happiness.
Beauty is not divinity—it is the shrine of divinity.

L. F.

The great ruler of his horror, knowing his own limitless power, caused me surprise when he spoke of his magical mirrors. . . . Yes, even King Leander's pages are tired of his strange ways, and the mirrors with inscriptions that bewitch his reflections from the black wizards' evil enchantments have grown weak in such isolation. . . . Although the King as magical mirror reflects the beauty of Queen Naguatta, and she stares at the King like a diabolical black cat, and for that matter he himself may be a black cat with ominously shining sphinx eyes looking at the Queen-mirror, and it is the Queen who reflects his demonically magnificent beauty. . . .

And isn't it true that the mirrors resemble poets and the poets mirrors, in their loneliness, coldness, mystery, and hermetic depths? Is it not true that mirrors reflect infinity, like poets, and that we gaze into their souls, as into the soul of a poet, and into the souls of poets you look as into marvelous mirrors? Entire generations pray to the poets' reflections, and likewise the mirrors reflect generations.

Just as the King captured the glinting stars from the depths of unknown divinity, subjugated people, and inspired poets with the beauty of his dreams and the refinement of his desires, so too the mirrors enslaved, captured, and inspired. . . .

Born under the planet (under the constellation of Saturn), having seven letters in his name, in the whirlwind of his commands King Leander knows not the horror that swaddles all mortals in madness in the quiet nights, in languorous enchantment tempts transparent visions and passionately conjures them to see the unknown, reflecting everything like a magical mirror. . . .

Wrapped in a fantastical cover embroidered with nameless birds, on his black throne, with a diadem of moons, He, King and Ruler of a kingdom inaccessibly invisible, where slaves stand frozen in silent awe and, exalting, grandiosely spread roofs of blue feathers, not daring to glance at his divine features. . . . And of everyone, only the mirrors and the Queen can see this face of divinity, this mirror of mirrors. . . .

> Spreading his tail like the peacock and with an owl's step
> > into the soul
> As though into a mirror with a red icon-lamp as you did before
> > enter as a Queen
> Come near, O continents! and accomplish fantastically, the even-
> > handed viewing
> Remembering that dressed in a black cloak in an oleander grove I am
> > the dazzled
> King! . . .

On the bizarre incrustations of his exquisite mirrors, amid the fragile bounty of embroideries of his quests, there are his piquant surprises; these are elegant creations, like depraved children, mirrors in egg-shaped frames, deep as an indescribable lake. . . . Decorated with women's hair and the kisses of unknown women. . . . Some of them were sickly pale.

Here are the verses of King Leander of the Flames about his beloved mirror:

> Once again the swans are at the lake,
> The strange lake resembling a mirror framed in black wood. . . .
> Which resembles my eyes.
> My soul—is a silver snake, a silver snake at the edge of the frame. . . .
> An enchanted snake by the lakeside.
> And again the narcissus gaze into my soul
> Swan lake
> I am leaving
> I will drown from sorrow
> In the swan mirror.
> Strange dreams swim in my head
> Leaving a dark trail.

And they stretch endlessly!
And there is no fragrance in them
And sorcery is powerless. . . .
O, the hordes of poisonous snakes
Bestirring themselves they extinguish winged reason
And their caprices are everywhere.
And all are draped in lianas!
And they slither, trembling, striking with their claws and devouring
 their victims!
Ah! the servants are outstretched on small shells and frightened
 into immensity!
All are like [slaves on] bloody plantations, faceless. . . .
I am a madman! But I scorn the hours when unseen agitation
 creeps nigh!
But slender fingers are capable of strangling.
It is unclear! . . . The exhaustion is unexpected. . . .
The dream vanishes, taking apathy with it. . . .
Deathly silence. . . . I am prostrate. . . .

1915

1914–1915

THE LABYRINTHS OF KING LEANDER OF THE FLAMES BEWITCHING BANGLES (POEMS FROM A NOTEBOOK)

BALLAD

In an ancient castle masks did dance,
In an ancient castle a masked ball entranced.
And a black knight wore a mask of black,
And the black mask made someone glad.

In an ancient castle the mice gnaw and chew,
In an ancient castle she lies deceased.
And the black knight stands still in a niche,
And in murky windows the moon shines through.

In an ancient castle candles flare,
In an ancient park an owl cries out.
In an ancient tower no more do they tryst,
In the grave the *tsarevna* is alone, alone. . . .

SONNET

To Naguatta. . . .

Like a shot straight to you flies my exotic sonnet—
O Naguatta, Marquis' daughter—which many years, trepidation
 did conceal,
You are the enchantment of ships in the glint of kindred planets,
You are the black horseman, who hides an amulet of steel.

In your dreams you hover amid the fairies with their sky-blue queen,
At times your soul knows the chaos of terza rima's chains.
Many nameless hours of shining gold have you seen,
In magical dreams you wrap yourself in a veil of yellow pale.

Alone in the universe, listening to the concerts of the soul,
You daydream, pressing horrors out of pallidly exquisite calm.
In your eyes reside the luster of belladonna and the languor of swans.
In gilded intoxication you inhale the aroma of orchids,
And then your sorrow is concealed, like your agate bracelet.
Daughter of Olympus' lilies, accept my fantastical sonnet.

* * *

Through strange halls let it languorously pour
Coiling in reverie—slipping like a dream
My ancient waltz, my intoxicating waltz,
My waltz woven of pallid roses.

My enemies are laughable, hiding behind masks,
Hissing like snakes, concealing daggers
But I am rash, having given the bracelet
Into singing fingers holding a goblet.

The goblet is poisoned, but the heart laughs
With the venom of revenge. . . . The clown is cunning. . . .
But Columbine plays with passions
Pierrot chuckles. . . . The clown trembles. . . .

Though the heart be in pain, but the halls are strange
And a sea of revenge trembles in the flowers
But I throw the bracelet in [his] face
And in the reveries of the waltz I drink of the goblet.

Letters, 1914–1916

Stepanova to Rodchenko

Moscow–Kazan, May 8, 1914

Shura, why are you silent. . . . I've been waiting for a letter from you for so long. . . . Shurochka, write something. . . . It's spring now, warm, and I'm getting dumber, I can't tell you anything interesting. . . . I'm working hard. I have a new address: Malaya Dmitrovka, 6 Uspensky Lane, apt. 1.

Kisses, V.[39]

Rodchenko to Stepanova

Kazan, 1914

In order to tell her about your past, you must pleasantly pull thoughts out of her like sinews.

L. F.

Like an animal tamer I must keep my eyes fixed on her with intent gaze, lest any second she bite through my throat! Not a single mistake may be allowed, not a single weak side may be shown, always the anxiety, the suspicion, the enigma, the uncertainty; she must be held, otherwise she will begin to seek new adventures and victims.

(From nocturnal thoughts)

L. F.

* * *

Yet again you spread twilight in our life and desire power, and hide your past life. . . . Dark, ungrateful, mistrustful Queen, do you not see that you thus hinder my path, along which you yourself are traveling? There are many cunning enemies as it is, who gather forces to oust me from the path, to deprive me of power, but they do not cause the pain that you do. They say that one is never a prophet in one's hometown. Could it be that you think the same? Did you yourself not believe me a deity, and are you not the first to accuse me of false power? . . . Quietly sitting in the corner of my palace, consider what you are doing and what you will obtain from it, and whether you can find my equal! . . .

You are a Queen, you are a woman, your sovereign (if not I) will be the Devil, and the protector God, both my enemies; therefore, you will be a slave in any event. . . . Dark, ungrateful, vengeful soul, will you not be closing off your own soul along with me? . . .

L. F.

Kazan–Kostroma
Medion, February 2, 1915

Today is the Triumph of the Sovereign of Simla!

I will bring agate dwarves from Rekhvilia and jackal lizards from Sandal. . . . Osiris' ring for you. Pale-yellow hair of the Albukersk princess.

I will embalm silver in a fig tree, Moors will search out a blackish narcissus. . . . You will see treasures with dove feet—the letters of the King. I will bring you a fern from the ruby Sterni and slow, languid blue turtles. . . . In the bamboo groves I will wind myself in garlands, I will command velvet breath to be stolen in Rome! . . . And iris, and veronica, and infanta from Simla—I will exalt myself as a garlanded Cupid. . . .

A wreath of tender irises, blue carbuncles. . . .

Leander of the Flames

Kazan–Kostroma
March 20, 1915

Varya!

First of all I'm feeling terribly lazy. . . . I'm not going anywhere, not doing anything. I'm reading Zhukovsky, Fofanov, Pushkin.[40]

My brother had a boy, they are thrilled! Mama is busy all day long, getting ready for the holiday. My brother's working, Yakov runs over to Lisette. This composer spends the whole day reading, dreaming. . . .

The evening. . . .

Something fell asleep in my soul, quietly and strangely. . . . The sounds of a piano can be heard, wafting sadness. . . . I start working in a few days. Yes, I found a subject, and if I manage to do what I'm thinking, it will be very new and bold. I'll liberate painting (even Futurist) from that which it has slavishly held to until now. I'll prove my words. I prefer to see ordinary things unordinarily, etc. I will make this idea happen. I have found the only original way. I will force things to live like souls, and souls like things. . . . I will find the daydreams of objects, their souls, their yearning for the distant, their twilight grief. I will find things in people. . . . I'll force people to die for objects, and objects to live. I'll put people's souls into things, and objects will become souls. . . .

I have shackled my soul, I'm sleeping. . . .

Your Rodchenko

Kazan–Kostroma
April 6, 1915

After me, the flood. . . .

As far as I can understand your existence, I would do the following: I would live at my mother's as long as possible, and then, for the impossibility

of living there further, I would take money from her and ask for some from Mitya; and I'd go to Moscow and get a job.[41] If this isn't possible, then I'd go to Mitya and live with him, but work all the time and go to work again, and then get a divorce. . . . It's strange that you're asking me, you're much more practical than I am. Do what's best for you, and be patient if you have to.

If you want to love me, then love me like I am, and for this you should be independent and free.

I can't help you, and you know this. My whole life is at stake, and therefore this risk engages me most of all. I am powerless to help you because there's so little of it. Struggles with others. But forgive me. . . . I can't give any better advice than this. . . . The best would be—forget me, I have caused you a lot of pain.

Maybe it was all a dream! . . .

My path is one of struggle, there's no hope in it, there's pain, debauchery, there are all the horrors of hell waiting. . . .

I love you, and I'm writing to you so that things will be all right for you. . . . I will always love you and remember you. But I don't want to torment your little, tired heart on my Satanic road, where "suicide" flaunts its beauty.

Sweetheart, I love you. Forgive me.

L. F.

Kazan–Kostroma
April 16, 1915

To little Queen
Naguatta

Yes, that's the way it was, I received your letters, where you complained about your visit to Kostroma, describing everything in detail, detail. . . . It was painful, painful for you, I didn't want your suffering, your sacrifices for me. And I was powerless to help you in all this, and so then I wrote that letter, I don't exactly remember what was in it. Forgive me! Don't think I don't love you. Will you be sure of me once and forever, my little Queen? I write this letter with my mouth half open for your kiss. . . . You have burned your image now and forever more in my Satanic head, O my little enchantress. . . .

O, we will have a fantastic situation, and won't we live strangely, Naguatta? We will make reality a reverie, and reveries—reality. . . . Live in our own world, where there is no one but us. . . . Isn't it true, we won't think about anything will we? . . .

I'm remembering you today, remember how we were naked, like flowers? . . . I want to bring you to senselessness in my embraces. You will be exhausted from my tenderness. Again, I will hear your deep sighs of happiness. . . .

Varvara Stepanova, 1914.

There, has your little heart calmed down, my Queen?
Come on, smile at me, Naguatta! . . .
You're mine. . . . All mine. . . .
You're calm. . . .
I am yours, Naguatta!
Sweet . . . Leander

Kazan–Kostroma
April 17, 1915

I'm going to write the number of the letter sent to Kostroma on the corner
of the envelope. Did you receive my registered letter? And why don't you
answer?

I get up at nine and paint in oil until five or six in the evening. But my
soul has become diabolical, hellish nightmares blow dynamic desires into the
painting, and I create my barbaric objects to the horror of all.

Will you still love me if I have given myself over entirely to futuristic
painting? I'm tormented by your silence! . . .

I am alone here now with my things. It appears there will be an exhibi-
tion in Kazan. I will show my work to the horror of all Kazan.[42] . . .

I'm not bored, I'm working, I'm raving, I'm raging! . . . Write to me imme-
diately, I await the happiness of as yet unseen enchantments. In the stillness of
the twilight, I reach out with my lips so that you might kiss them.

You are more perfect than all others. I love you like the milky night.

O, how was it I didn't know your name before?

O, Naguatta!

O, I need your letter soon!

Where is it? Where? . . . I'm waiting . . . waiting. . . .

L. F.

Kazan–Moscow
April 30, 1915

I'm working in the club from morning to night, no time to write at all. I got your letter from Moscow. . . . Last night I dreamed that you went off somewhere with Mitya forever. . . . I dreamed of cats. . . . My castle, its horrible passages.

But I am living, as always, in secret rooms.

Write . . . write. . . . You write that you have nothing to fill your life. . . . Is it really empty? What can fill it? You've begun writing empty letters. I don't feel like writing either. You are looking suddenly for something to fill your life, but your work? . . . And freedom? . . . And me. . . .

I told you that after all there would come a time when I would be nothing to you. . . . So it seems it has come. . . .

But my life is so full, it is full with many, many things.

Your life is empty, and you can't write to me a lot, I have kept up with you in letters, and you were bragging that you would write. . . .

Something has happened to you, and I'll crush that melancholy. I have never felt so much strength in myself, such certainty.

And so, I'm waiting.

L.

Kazan–Moscow
1915

In my far-off childhood, when the soul was calm and tender, like the dusk, when thoughts slipped around in my fragile, quiet, strange loneliness . . . I knew that the Devil existed, an all-powerful Devil—the sovereign of beauty. . . . And that I wanted to sell him my soul. . . . My dark soul. And I did much for the Devil and he did even more for me. But the time has come, and I want to be the Devil myself, and I announced my divinity. . . . The One and Only, Great, Sovereign. . . . I can buy souls myself now, mock them and love them. . . .

Ah, the flowers of Christianity drown in my mire. . . . Ah, look, they will blossom in my mire, my monstrous flowers. . . .

God doesn't give the earth, for it is his. . . . But souls belong to everyone. And things are mine alone, and I will conquer things. I will conquer people with a secret power, with the monsters of my reveries! . . . How ridiculous it all is to me!

God forced the sun to burn me! The Devil surrounded me with the dark night! And I grow younger from all this, more magnificent! I am healthy, tan, and all yours.

Leander

Kazan–Moscow
August 22, 1915

Today I looked at your letters. The last was the 27th of May, and today is the 21st of August.

Mama is seriously ill. . . . I'm afraid for her. She gives me money, after all. If she collapses, what will I do. . . . I've broken off with my brother forever. Something's happening to Mama. . . . She's driving me crazy. . . . I do love her in my own way. . . . I have enough money for a bit, but how will I get any later? . . .

After all, I can do things besides daydream about queens, castles, poetry, painting, and the like.

I'm thinking of coming the 10th. Will there be rooms? And what's going on in Moscow? Igor [Nikitin] will go to Petrograd, he knows people there. I'll go to Moscow, he'll go to Petrograd. Two cities. It's better.

How are Mitya's affairs?

How do you like me in these photos?

I photographed my works, but nothing came out. I'm thinking of not bringing the engravings to Moscow. I've completely changed, you know, and don't allow myself to write poetry. . . .

Paintings. . . . Paintings. . . . I'm deciding which of them to leave at home. . . . Also, Mama is afraid that the restaurant will close.[43] I always feel reproaches from the two of you. That this is all reverie, dreams, and not reality. . . .

Here's what's listed in the iconography of the new:[44]

183. *Woman with long eyes*. Tempera. 22 × 28 cm.
190. *Woman with long eyes*. Oil. 52 × 69 cm.
191. Self-portrait. Oil. 37 × 37 cm.
192. Portrait of N. A. Rodchenko. Oil. 53 × 65 cm.
193. *The divinity of death*. Oil. 60 × 78 cm.
194. *Woman*. Oil. 65 × 80 cm.
195. Still life: book, bottle, candleholder. Oil. 52 × 31 cm.
196. *Carnival*. Decorative motif. Tempera. 71 × 50 cm.
198. *In the café-chantant*. Three figures. Tempera. 35 × 39 cm.
199. Bust of an Egyptian woman on a red ground. Tempera.
 35 × 39 cm.
200. Sketch for a portrait. Oil. 21 × 28 cm.
201–12. Still lifes. 35 × 39 cm.
213–25. Graphics. 35 × 39 cm.

That's it for now, write. . . . Your L.

Rodchenko. Line and compass drawing. 1915. Pen and ink on paper, 10$^{1}/_{16}$ × 8$^{1}/_{16}$" (25.5 × 20.5 cm)

Kazan–Kostroma
1915

Autumn. . . .

I work all day long, and I rip up a lot. But my soul is quiet . . . calm. . . . No! New works—Anta doesn't look like that, it's not her face. . . .

Your view is narrow, and I didn't expect it to be. . . . And no, throw aside jealousy and remember that I am yours, but art is mine, and in it I am alone, no one can climb on.

Try to guess what the drawing is like, the paints. . . .

Now I've begun working in graphic drawings, but there are no human faces in my pictures, there's nothing at all. . . . That's where my future is. I have created monstrous things now. . . . I will be Picasso's rival in the domain of the Devil. . . . And you'll see.[45]. . .

Autumn. . . .

So, how are we going to live? It would be good to be somewhere further away from the center, to spend twenty-five rubles for two small rooms, at least one of them heated. . . .

Right now I intend to work in the studio every two or three months, and more at home depending on the mood.

Twilight. Work plans run through my head.

Ah, Niura, Niura. I need to draw old peasant shoes and rotten potatoes for a year. . . .

Naguatta, hear me! I'm alone, alone. . . .

Silence. On the table there's a drawing I've begun, "The relationship of the world to planar surfaces falling from the left edge". . . .

Naguatta. . . . I'm alone, like insanity itself. . . .

I kiss you, kiss you, all of you, all. . . .

Leander

Kazan–Moscow
1915

Once again, I'm not in the exhibition!
What should I do? My anger is growing. . . . They want to destroy me. . . . They're pleased. . . . Laughing.
God! . . . How hard! How sad!
The last letter. I'm leaving on the 7th. . . . My soul is glum. . . .

Flowers. . . .
Those which don't exist and never will. . . .
Flowers of my mind.
The only one concealing all insanely,
Of the enchanted byways of my brain.

Aromas. . . .
Those which never were and never will be. . . .
Aromas of my soul,
The only one, concealing all the snaky sinuousness
Of capriciously flying daydreams. . . .

In my dreams there's a shaky sadness. . . . The exhibition. . . . I'm not in the Moscow exhibition. . . . They want to destroy me. . . .

Once again the swans are at the lake, at the ancient lake,
Which resembles a mirror with a black frame
Of black wood. . . .
Which resembles my eyes. . . .

The enchanted serpent lies by the lake. . . .
And again the narcissus flowers gaze into my soul!
Swan lake!
I will drown, drown from sorrow. . . .
In the swan mirror!

Kazan–Kostroma
October 1, 1915

I prefer to paint ordinary things in an extraordinary way rather than paint extraordinary things in the ordinary way. . . .
I prefer to see ordinary things in an extraordinary way than to see extraordinary things in the ordinary way. . . .
I prefer to draw ordinary things in an extraordinary way than to draw extraordinary things in the ordinary way. . . .

Hospital train–Moscow
1916

Dear Varya! I'm sitting and working because we've been held up at Belgorod, Kharkov isn't accepting trains for some reason. How long we'll sit here—no one knows, nor what we'll find in Kharkov. I'm drawing with pencil—red and black, because there's nothing else. It's a shame I didn't take watercolors. I feel better, but that's because I'm drawing a bit.

I'm afraid we'll be stuck here a long time. Yesterday I went to the motion pictures. It's a small town, dull as can be. The main thing is—I forgot the watercolors, but if I order them—I'm afraid we'll see each other by that time.

This is why I didn't want to go. I felt it. My health is back completely, although there's still a kind of exhaustion and laziness.

I'm sick of the rumble of passing steam engines on maneuvers, the whistle and hiss at the window, it goes on almost nonstop.

It's dreadful that I don't know anything about you, and don't know my address. I think that there's a depot in Kharkov where you'll be able to write.

I had dinner. . . . This evening I'll go to the station to mail letters, but now I'm going to draw some more.

Big hugs and kisses. Anti

Hospital train.
Inza. August 1, 1916

Autumn is already beginning, this morning at four o'clock I was running around the Ruzaevka station and freezing to death. There's nothing joyous in my life.

Autumn. Soon the leaves will be golden, but the sky will be dusky. Soon, I too will be dusky, and my soul burns.

Anti

Stepanova to Rodchenko

All-Russian Zemsky Union.
Moscow.
Nikitsky Boulevard.
Hospital Train no. 1178
A. Rodchenko, director of services
August 4, 1916

Anti, my dear, dear, beloved!

Oh, your letters are so sad, so sad.

Where are you. . . .

I was at the station yesterday evening, seeing Mama and Zina off to Kostroma. As soon as the train moved, my heart began to moan, I so wanted

to get on the train, it could bring me to you. . . .

I feel sad, like there's a stone on my heart. Why are we separated again? You left again. . . . When will this week pass, when will I see you? . . . Come as soon as you can! Dearest Anti, you love me. And I have something, I won't say what. . . .

Kitty, dearest, come soon.

<div align="right">Your V.</div>

Moscow–Hospital train no. 1181
August 16, 1916

Anti, how much hopeless dejection, how much pain there is in your last letters. And to me life seems like a long, long, narrow, dark corridor that you have to feel your way down, passing thousands of closed doors, and seeking, seeking the open door, where you and I can rest from all the horrors. . . .

There are a million ways to imagine an evil fate in order to find just one opening in our heart and destroy our love. . . .

Just look, aren't there more sad hours in our love, didn't they exaggerate the strength of our love!

Don't give me away—I love you.

<div align="right">Yours forever, Naguatta</div>

NOTES

[1.] A priestess and speaker of prophecies of the Greek god Apollo.

[2.] From the early eighteenth century, Russia was divided administratively into large "guberniyas," roughly like states, run by a governor; guberniyas comprised districts, or "uezdy," and each district contained a smaller, rural administrative unit called the "volost." In the administrative territorial reforms of 1923–29, the guberniyas were replaced with the "krai" and "oblast."

[3.] Izba: a Russian peasant house, often constructed like a log cabin.

[4.] Olonets guberniya: in Karelia, on the river Olonka, in the Lake Ladoga basin.

5. The room where theatrical propman Mikhail Rodchenko's family lived, and where Aleksandr was born, was located over the stage in the building of the Russian Club, on Nevsky Prospekt, in St. Petersburg.

[6.] All quotations in the text are translated directly from the Russian.

[7.] Peter: St. Petersburg, which was renamed Petrograd in 1914, Leningrad in 1924, and St. Petersburg again in 1991.

8. Rodchenko completed only four years of a parish school in St. Petersburg. He tried to prepare himself independently to take the exams for the subsequent year of the gymnasium, or high school, in order to be able to study further on equal footing with others. He could only register for the Kazan School of Fine Arts as an auditor, since he did not have a secondary school diploma.

[9.] *Satirikon* was a weekly journal of satire and humor, published in St. Petersburg from 1908 to 1914.

10. Anta Kitaeva, an artist who studied at the Kazan School of Fine Arts.

11. Rodchenko clearly meant the Pre-Raphaelite painter Edward Burne-Jones (1833–1898).

[12.] Gamardi: It is not clear who Rodchenko is referring to here. His handwriting is minuscule and often difficult to decipher. Alexander Lavrentiev now feels that the most likely candidate is the Norwegian writer Knut Hamsun ("Gamsun" in the Russian transliteration). According to Lavrentiev, in Rodchenko's early notebooks (as opposed to the diaries), the artist would copy out extracts from his favorite authors, including Walt Whitman, Friedrich Nietzsche, Edgar Allan Poe, Oscar Wilde, Stéphane Mallarmé, Charles Baudelaire, Adam Mickiewicz, Ruskin, and many Russian ones as well.

13. Nikolai Afanasevich Rusakov was a painter who studied at the Kazan School of Fine Arts and later lived in Chelyabinsk. While they were studying in Kazan, Rodchenko and Rusakov painted each other's portraits. These works are presently in the Chelyabinsk Oblast Picture Gallery.

14. Tamara Popova was also a student at the Kazan School of Fine Arts, from 1911 to 1915.

[15.] The students of the Kazan School of Fine Arts had put on an Egyptian ball the night before. Motifs of ancient Egyptian art were used for all the costumes and room decorations.

[16.] Sergei Aleksandrovich Kusevitsky (Serge Koussevitzky, 1874–1951), conductor and musician, contrabassist; founder of the Moscow Symphony Orchestra in 1908 and the Russian Music Publishers in 1909. Kusevitsky left the USSR to live in Paris in 1920. He then moved to the U.S., where he was director of the Boston Symphony Orchestra from 1924 to 1949.

[17.] Anatoly Konstantinovich Liadov (1855–1914), composer and conductor who composed symphonic miniatures based on such Russian fairytales as "Baba Yaga" (1904), about an ugly old witch who lives in the forest in a house on chicken legs.

[18.] Modest Petrovich Mussorgsky (1839–1881), composer of the epic operas *Boris Godunov* (1869) and *Khovanshchina* (1872–80), and the cycle *Pictures at an Exhibition* (1874).

[19.] Aleksandr Konstantinovich Glazunov (1865–1936), composer of the symphonic poem *Stenka Razin* (1885).

[20.] The Donkey's Tail group organized and held two exhibitions in 1912; it included Mikhail Larionov, Natalia Goncharova, Kazimir Malevich, and Vladimir Tatlin, among others. In a statement of principle against Western influences, artists like Goncharova left the "Knave of Diamonds" (a group of Moscow artists that existed from 1910 to 1916, whose paintings were influenced by Cézanne, Fauvism, and Cubism, as well as Russian icons and folk art) and turned more exclusively to Russian folk culture and icons for inspiration.

[21.] "Shura" is a diminutive of "Aleksandr," i.e., Rodchenko's first name; other diminutives of Aleksandr include Shurochka, Sasha, Sanya, and Alik.

22. According to the testimony of the architect K. V. Kudriashov (Moscow Architectural Institute), whose father, the sculptor Vladimir Kudriashov, studied in Kazan at the time, the Kazan School of Fine Arts prepared artists for work in provincial theaters. This in part explains the young Rodchenko's passion for depicting theatrical costumes or imaginary theatrical scenes. He drew balls, feasts, and dances against backgrounds of richly painted decorations. There are theatrical elements in his compositions on Japanese and Chinese themes as well.

23. Professor Bruno Adler, who taught at the University of Kazan, was apparently involved in ethnography and history.

24. The painter Nikolai Ivanovich Feshin (1881–1955) taught at the Kazan School of Fine Arts. Feshin painted portraits of the school's female students with either a book or flowers. Both Anta Kitaeva and Tamara Popova posed for him.

[25.] Members of the group included Robert Falk, Pyotr Konchalovsky, Aleksandr Kuprin, Aristarkh Lentulov, and Ilya Mashkov.

26. In Kazan, Rodchenko occasionally made money as a designer. In the diaries from that same time, May 1912, there are a few words about Rodchenko drawing vignettes for a menu.

[27.] Aleksandr Alekseevich Vasiliev (1882–1918), one of the first Russian pilots, toured a number of Russian cities in 1912 demonstrating the flight of an airplane to an avid Russian public.

[28.] "We," i.e., Rodchenko and his mother.

29. Vasya (Vasily), Rodchenko's older brother, lived in Kazan and later became an actor.

[30.] *The Russian Word* was a liberal weekly newspa-

per published from 1895 to 1917 by the well-known Moscow publisher Ivan Sytin; it was shut down after the Bolsheviks came into power.

31. Rodchenko's mother worked as a nanny for wealthy families in St. Petersburg when Rodchenko was a child.

[32.] The Russian painter Mikhail Vrubel (1856–1910), whose Symbolist-influenced Demon series, after Mikhail Lermontov's poem *The Demon*, hangs in Moscow's State Tretyakov Gallery.

[33.] Aleksandr Mikhailovich, i.e., Rodchenko's first name and patronymic.

[34.] Ivan Dmitrievich Sytin (1851–1934) was, at the time of the Revolution, the largest, most influential publisher in Russia. After the Revolution, he was a consultant for the State Publishing House. A street in the center of Moscow is named after him.

[35.] Pavel Varfolomeevich Kuznetsov (1878–1968), painter, known for brightly colored landscapes and scenes of life in Soviet Central Asia rendered in a style that combines primitivism and elements of abstract painting.

Georgy Bogdanovich Yakulov (1884–1928), painter and theatrical designer, exhibited actively in Russia and Western Europe before the Revolution; participated in the *First Journal of Russian Futurists*, and after the Revolution exhibited with numerous avant-garde groups and taught at the Free Art Studios (SVOMAS) in Moscow. He designed sets for productions staged by Aleksandr Tairov, Vsevolod Meyerhold, and Sergei Diaghilev.

[36.] *Chervonets*: a gold coin that at the time was worth three, five, or ten rubles.

[37.] The centenary of Napoleon's invasion of Russia and his rout by marshal Mikhail Kutuzov after the battle of Borodino.

38. Igor Aleksandrovich Nikitin, painter who studied at the Kazan School of Fine Arts.

39. Stepanova's letters to Rodchenko are more fully published in her book *Chelovek ne mozhet zhit' bez chuda* (Man cannot live without miracle) (Moscow: Sfera, 1994).

[40.] Vasily Andreevich Zhukovsky, Konstantin Mikhailovich Fofanov, and Alexander Pushkin, all nineteenth-century Russian poets.

41. Mitya: the architect Dmitry Fyodorov—Varvara Stepanova's first husband.

42. At the time, Rodchenko was painting imaginary still lifes in a Cubo-Futurist style.

43. Rodchenko's mother was working in a restaurant at the time.

44. It is clear that Rodchenko began to systematize his work from the Kazan art school period. Later, the catalogue of works was redone and only included oil painting.

45. Rodchenko was probably working on his series of abstract linear-circular compositions at the time; they were executed in black ink and occasionally tempera.

RUSSIA HAS GIVEN BIRTH TO ITS OWN CREATIVE WORK, AND ITS NAME IS—NON-OBJECTIVITY

1916–1921

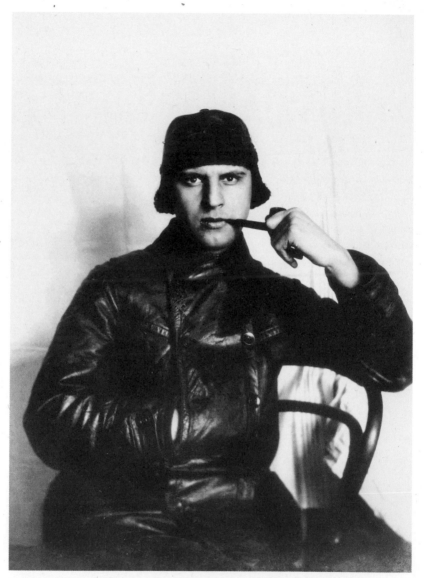

Rodchenko in Moscow, 1916–17.

INTRODUCTION

In the course of just one year, King Leander of the Flames was unexpectedly transformed into "Anti." That is what Stepanova calls Rodchenko in her diary. The romantic sovereign of a world of secrets, reveries, and dark dwarves suddenly became a rationalist, a meticulous researcher, and plunged into the cold world of abstraction and geometrical forms.

Rodchenko moved to Moscow and debuted on the Moscow avant-garde scene in March 1916, participating in the Futurist exhibition *The Store (Magazin)*. He spent almost a year in military service—as head of provisions for a hospital train. He strove to take full advantage of the new organization of artistic life that appeared after the Revolution. He dreamed of creating an artistic commune in a huge building on Gnezdnikovsky Lane that was empty after the Revolution.[1]

"In life as well, we, humanity, are experiments for the future," Rodchenko wrote in his manifesto "The Inventor of New Discoveries in Painting," and in "Everything Is Experiment," two texts that represent the distilled essence of his creative credo.

He was constantly struggling with his art at this time. It is strange—here you have an artist, and he suddenly tries to reduce art to the invention of forms, the mastery of painting and the development of technique, or to construction alone. He even declares that art will be "destroyed by necessity and comfort."

But perhaps first we need to understand what he meant by the word "art." He didn't call for closing or destroying museums after the Revolution. For a while he even participated in saving and preserving artistic treasures. But for him, Art remained *back there*, in the past. He accepted that for some people—connoisseurs, art historians, and professionals, it was still needed in the present. The main "art" that he fought against was hackwork and imitations of creativity. He did this in order to clear a path for the new, young artists who were not bound by tradition and the canon, who worked boldly, creating works that were incomprehensible to the broader public. "Twenty years from now, the Soviet Republic will be proud of these canvases," he declared prophetically of non-objective painting. He insisted that the unexpected breakthrough in painting was not a dead end, but a reconnoitering of art's possibilities. In this sense, he became one of the founders of the many "isms" that later developed, using the achievements of technology and science as new instruments and means. These include kinetic art, Op art, computer graphics, and Minimal and Conceptual art. Rodchenko resolved the argument of the 1920s about what the development of art would be after the '20s (would it be figurative or not, would painting die out or not) by approaching all tendencies equally. That was how he envisioned the acquisitions and exhibition policies of the Moscow Museum of Painterly Culture, where he worked as head of the museum department at the time.[2] Personally, however, he was primarily interested in new, unprecedented forms involving light, radio, movement, and new dimensions of space. He worked without looking

back at the past, without expecting any immediate benefit for himself. Later, he wrote that he couldn't understand what drove him to creative work. He felt that he had to assist universal ideas of form to materialize at any cost.

Most of his time was taken up with the duties of his job: either group activities or discussions at INKhUK.[3] Nonetheless, he managed not only to paint and make his constructions, but to write texts that proclaimed his artistic credo. For Rodchenko, the text became part of the painterly work.

—A. L.

Among Moscow Artists

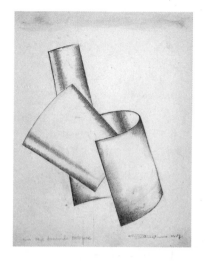

Rodchenko. Design for a lamp for the Café Pittoresque, Moscow. 1917. Ink on paper, 10⁷/16 × 8¹/16" (26.5 × 20.5 cm)

Vladimir Tatlin to Rodchenko

Moscow 1916

Dear Aleksandr Mikhailovich!
I'm leaving for Tsaritsyno tomorrow evening, and I must definitely see you. Come by my place tomorrow morning definitely around ten o'clock, eleven o'clock.

Your friend Tatlin[4]

Dear Aleksandr Mikhailovich!
I didn't catch you, it was five o'clock. Be sure to come by the Literary-Artistic circle on Bolshaya Dmitrovka. This evening from eight o'clock on.

Tatlin[5]

Moscow 1918

Al. Mikh.!
 1. Basmannaya [Street] 33.
 Take 2 cor[ner] reliefs.
 2. Occupy the studio (in the Theat[rical] Mus[eum]).
 3. Set up "The Forest" at the Tretyakov.
 4. Get the Federation together and give a paper on Petrograd.
 5. Get books.
 6. Remember about [maintaining] full contact.

That's it, I shake your hand. Tatlin[6]

EXHIBITION COMMITTEE MEETING [MINUTES]
FEBRUARY 19, 1918

The following members were present: Tatlin, Goslavsky, Rodchenko, Keller, and Dobrova.[7]

Tatlin was asked to deal with the painting school. Can it rent its space to the Union of Artists and Painters for the exhibition, preferably from April 3 to May 3, 1918 (old style)?[8]

Allocate the entire space according to the number of participants, and give each one an equal amount of space.

Distribute space for all three federations, giving each one (proportionally to the number of participants in each federation) an equal number of spaces, both good and bad.

Each federation will set up its exhibition autonomously, and the question of juries and hanging the work belongs to each federation individually. Find out the number of participants from each federation. Nonmembers of the federations may not exhibit at all. The participation of new members may be allowed, but only for a specific time.

Because the Moscow Salon has canvas, Keller has been charged with asking the Moscow Salon to rent it to the union inexpensively, since almost all the members of the federations are also members of the Moscow union.

We asked the soviet to hold elections in each federation to elect a commission to accept new members who are not participating in the exhibition. The meeting was declared closed.

The next meeting is set for Thursday, February 21, 1918, at five o'clock.

Secretary A. Rodchenko[9]

ABOUT TATLIN
1915–1917[10]

I met Tatlin at Vesnin's, where Varvara and I went to get a stretcher (she was acquainted with him).[11] Varvara and I were living in a tiny room, about ten square meters, and I decided to paint a big piece, but didn't have a stretcher or any money.[12]

So I asked to rent a stretcher that was 1.52 by 1 meter. It was also hard to buy real canvas, so I bought cheap calico, primed it, and instead of an easel, I tied it to the bed.

Tatlin was visiting Vesnin, and we were introduced. I began telling him how I kept trying and trying and couldn't manage to get into a World of Art exhibition.[13] Tatlin also complained:

"I already have gray hair, and 'they' still won't recognize me! That's all right, we'll put on a Futurist exhibition. Leave your address and then you can participate in it."

"Thank you," I answered. "That would be marvelous."

And in fact, sometime later Tatlin came to see me, looked at my work,

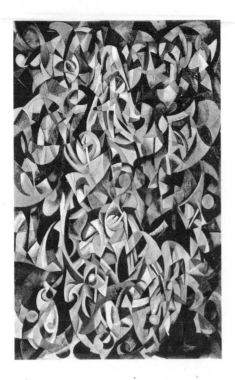

Rodchenko. *The Dancer*. 1915. Oil on canvas, 56¹¹/₁₆ × 35¹³/₁₆" (144 × 91 cm)

approved it, and said:

"We have organized an exhibition group including the following artists: V. Tatlin, L. Popova, N. Udaltsova, A. Exter, V. Pestel, I. Kliun, L. Bruni, K. Malevich, and then Rodchenko.[14] Everyone has contributed money for the exhibition, but since you probably don't have any, you will contribute your labor, as I am doing. I'm the organizer and coordinator. And you will be my assistant, and also sell tickets. . . . Do you agree?"

"Of course," I replied.

And so we rented an empty store on Petrovka, number 17, for a month, and started hanging things up.[15]

The store had two spaces: one big one, and a small one in the back.

In the first room we hung Tatlin's counter-reliefs, Popova, Exter, Udaltsova, Bruni, Kliun, and Malevich.

In the far room—M. Vasileva, me, Pestel, and later we added the young Ostetsky.[16]

My first appearance in Moscow began. I exhibited a non-objective composition, 150 × 100 cm, *Two Figures*, a few small, non-objective drawings.[17]

Tatlin, as I already said, exhibited counter-reliefs and some paintings. Udaltsova exhibited Cubist pieces. So did Popova, Kliun, Malevich, and Pestel.

But Bruni exhibited a broken cement barrel and glass pierced by a bullet, which particularly provoked the public's indignation.

On weekdays there were very few visitors. They were varied. They were more chance visitors; some laughed, and others were indignant.

I explained the pieces, knowing little about Cubism myself, which I didn't really quite understand.

Some of the people who came were seeing works like these for the first time, and they didn't laugh but tried to understand, and walked around several times listening to my explanations, and, having understood, thanked me profusely and became admirers.

It was hard to explain the pieces and the artists who weren't talented but were imitators of the Futurists. Although there weren't really any Futurists at the exhibition. There was Cubism and abstraction.

Malevich came to the opening, and for some reason created a scene with Tatlin. At the time I didn't really understand what happened, just that he removed his work from the exhibition.

I liked Malevich's pieces more than the others, except, of course, Tatlin's. They were fresh, unusual, and didn't look like Picasso. But I didn't like Malevich himself. He was all sort of square-shaped, with shifty, unpleasant eyes, insincere, conceited, and stupidly one-sided. He came up to me and said:

"You are the only one here, but do you know what you're doing?"

I replied: "No, I don't!"

"You know that everything they're doing is old and imitative. All of this is finished. There's something new going on now, it's our own, it's Russian. And I'm doing it. Come to see me. It's already in your work intuitively, it's in the air!" And he gave me his address. I often went to see Tatlin, and respected him a great deal, and thought of him then, as I do now, as a talented master, so I told him everything about Malevich.

He replied: "Don't go to see him!"

And I didn't go.

Vladimir Evgrafovich [Tatlin] lived on Staro-Basmannaya Street, on the eighth or ninth floor of the railroad organization building. He set up his studio in the attic, and insulated it. The studio was unusual, made from sheets of plywood. He lived alone, and, since he was a former sailor, everything was clean and tidy. At the time, he was working on sets for Wagner's opera *The Flying Dutchman*. He worked without any commission, just for himself. Thirty years have gone by since then, and I think that he is probably still working on it. It included costumes and architectural details for the sets, and at the time I was struck by the quantity and variety of ways one and the same detail could be attached to the ceiling of a room. He studied all of this with meticulous attention and enormous artistic taste.

This is a genuine Russian artist who, although he likes fame . . . waits . . . and can wait. And I am certain that it will eventually come to him . . . Only genuine Russian artists can work this way, continuing for years without using the success that belongs to them, and working for an unknown future as well as with great diligence and simple, pure taste, right up to their death.

There was a joiner's bench and a vise, and all sorts of carpentry and metalworking tools in his studio.

I dropped by often and we talked a great deal. Tatlin had his own particular view of everything, and he wanted to see mastery and art from everyone. He loved simple people who were masters of their work.

He loved everything simple, but well made and sturdy.

He wore a sailor's shirt, sailor's pants, and also simple English military boots with metal taps, wool jackets, and socks. He carefully rubbed his boots with goose fat.

I learned everything from him: my approach to my profession, to objects, materials, to foodstuffs, and all of life, and this influence left its mark on my entire life.

The only problem was that he was suspicious of everyone, and it always seemed to him that people wanted to do him in and were betraying him. And that his enemies, like Malevich, for instance, were sending someone around to discover his ideas. For this reason he opened himself to me gradually, and was always on the alert.

But without good cause. I have always been totally devoted to him, and even now, although it has been several years since we've seen each other, I am well disposed toward him, so perhaps he will some day come to regret his suspiciousness and the loss of a genuine friendship. But, educated by him, I am suspicious myself, and a little egotistical like him, and for this reason I haven't taken any steps to renew our friendship. Even though I should be the one to make the first move. But he sowed something in me that makes me not do it, knowing that the situation is irreparable. Of all the contemporary artists I have met, none is equal to him.

Among the other participants, A. Exter was friendly to me; she was older than all the others, and already had a name since she worked in the Kamerny Theater. She tried to get me work in the Kamerny as well, and introduced me to Tairov, but nothing came of it. She invited me over, and one evening, when I came, Tugendkhold was there and they were drinking vodka.[18]

V. Pestel, a fan of Tatlin's, was very talkative and flighty, both in personality and in her art.

Popova, one of the wealthy, looked down on us condescendingly from on high, since she thought of us as inappropriate company and the wrong estate, people with whom she had no common path in life. Later, during the Revolution, she changed a great deal and became a real comrade, but more about that later.

She barely spoke to me and came rarely, leaving the scent of expensive perfume behind at the exhibition and the trace of her beautiful outfits in the air.

Udaltsova came often and talked about Cubism in a quiet and ingratiating manner. As if to affirm her adherence to Cubism, she had the very interesting face of a black-garbed nun, with disjunctive eyes that looked at you with two entirely different expressions, a slightly deformed, cubistic nose, and thin nunnish lips. She understood Cubism more than any of the others, and worked more seriously than the others.

Bruni didn't take the exhibition seriously, he participated out of friendship for Tatlin, though he himself was entirely in the World of Art. But he loved Tatlin, he was young, and therefore he was enthusiastic and bold.

Vasileva was a gray-haired, spunky woman, who had seen a lot and lived in Paris—as an artist she was reasonably talented and cubistic, though

somewhat lightweight and empty, and she didn't arouse much interest on the part of the public.

I already wrote about Malevich, and my first impressions of him remained.

Tatlin and I dreamed of traveling to the Urals, to Siberia, for which we got hold of two rifles. This was during the first imperialistic war with Germany.

Vladimir Evgrafovich found himself a Japanese automatic rifle, and a German one for me; there was an entire case of shells as well as a machine-gun belt and exploding bullets.

Hiding it from the police, I brought this all home secretly. Varvara and I were living on Sadovo-Karetnaya St., with a landlady whose husband had been exiled as a German. I hadn't seen him. We rented a room on the first floor, with two windows. I placed the shells between the frames, under the cotton batting, and hung the rifle behind the window curtain, which hid it day and night.[19]. . .

I remember that there were nighttime watches for thieves in the courtyard, but there was only one weapon for five people, and when my watch came that gun was nowhere around, and I refused to go on watch without a gun, saying that I had nothing to guard, and if thieves came to my room they'd be in big trouble.

Tatlin and Morgunov, having received credentials from the Moscow Soviet of Worker and Peasant Deputies [Moscovski sovet rabochikh i krestianskikh deputatov] to negotiate the guarding of private townhouses from looting and to follow up on it, went to see Gan.[20] They took me along to the meeting. That's where I met Aleksei Gan.

I was charged with guarding Morozov's house on Sretenka, where there were engravings and porcelain.[21] A group of "anarchist-communists" was settled there.

I went there every day and worked on moving everything of artistic value into one room, to which I kept the keys.

There were several "anarchists," among them a few women. What they did in the evenings I don't know, since I would go home at five or six.

During the day I don't think they did much of anything either. They would go off somewhere, come back, and sleep. I don't know where they ate. They treated me with animosity and caution: I was supposedly a kind of observer from Mossovet, from the communists[22]. . . .

There were several rooms in the Morozov mansion—an entire museum of porcelain and two rooms of prints. There was a painting in the hall—Vrubel's panel *Faust and Margarita*.

I was almost totally uninterested in these artistic things at the time, though I knew them and had studied them. For me they were the "accursed past," and that was all; I guarded them and took care of them meticulously, but I didn't respect them. Now that I love Russian porcelain and Vrubel, this seems strange to me, but at the time I had my own, left-wing, art.

I wandered through other people's rooms with other people's art and nothing delighted me. I watched the "anarchists" and was not the least sur-

prised. I didn't admire the porcelain or the "anarchists," and both of them seemed ordinary and uninteresting.

What kind of people were these? I didn't see anything special in them, except for the name. I didn't expect any good to come of them. They were ordinary people, a bit sentimental, lacking ideas or principles, and, most important, not talented. Their biographies were no different from those of the tenants in our apartment. They didn't create anything new either in everyday life or in their own relationships. They slept wherever they happened to be. Ate wherever there was food. They played the mandolin and argued the same way.

What sort of "anarchism-communism" was this? Just a name, but they themselves were philistines.

One fine day, as they say, the "anarchists" were destroyed and disarmed.

One evening Tatlin came to see me, and, with a mysterious look, told me that Puni, Altman, and Shterenberg, the commissar of the arts, had come to Moscow.[23] He (Tatlin) had been appointed the Moscow commissar of the Arts Department, and he wanted me to go to work for him.

Soon I was working in the Visual Arts Department as assistant director of the subsection of artistic industry, and the director was O. E. Rozanova.[24]

At the same time, we organized the Union of Moscow Artists with three federations: Right, Center, and Left. Tatlin was chairman of the Left Federation, and I was its secretary.

The club of the Left Federation was organized in the private apartment of a certain Tumerin, who, it seems was an acquaintance of Popova's. He gave us two rooms with all their furniture, apparently afraid that they would be taken from him anyway. The first exhibition was a group one, the second was my own.[25] . . .

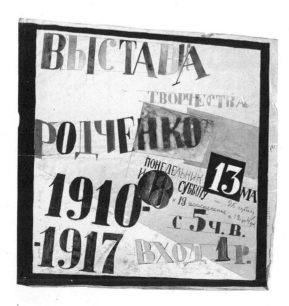

Rodchenko. Design for a poster for *Exhibition of Works by Rodchenko 1910–1917*, Moscow. 1917. Watercolor, gouache, and pencil on paper, 20⅝ × 19¼" (52.3 × 49 cm)

BE CREATORS!

As a creator-rebel, I am telling all of you who are still capable of demolishing, to destroy everything old, everything outmoded, everything that's in the way, everything dying, everything superfluous, everything enslaving, everything oppressing us.

To you who are in power, to you, the victors, I say: Do not stop on the path of revolution, move ahead, and if the framework of your parties and treaties hinders you in life creation, destroy them, be creators, don't be afraid of losing anything, for the destructive spirit is the creative spirit, and your revolutionary procession will give you the power of creative invention, and your revolutionary path will give you the strength of creative inventiveness, and bright will be your path of revolution-creation.

To you who have come into power, you, the victors, brothers in spirit, creators of the brush, the pen, and the chisel, to you, who only yesterday starved in attics and today are commissars of art, I say: Do not barricade yourselves behind the desks of your collegiums and bureaucratic offices, remember that time is passing, and you have not yet done anything for your brothers, and they are still hungry, as they were yesterday. . . . Remember the creative work of the rebels![26]

To you, who have come to life, to all living humankind, I say: May you all be gods and sovereigns, do not wrap yourselves in the old blankets of our grandmothers' art, do not sleep on the feather beds of our great-grandfathers' love, do not chew the cud of science's old words. Do not fear a life of rebellion, build your life without guardians and prejudices, be heroes for your very selves! Move ahead, invent, search. . . . Be rid of and destroy everything superfluous, unneeded. Be free, eternally youthful seekers. . . .

In short, be creators, and not a herd, O you, living people!

Anti[27]

TO ARTIST-PROLETARIANS

We—are the proletarians of the brush! Creator-martyrs! Oppressed artists!

We—are the inhabitants of cold attics and damp cellars!

We, who carry the blazing fire of creativity, walk hungry and barefoot!

We, who do not have the opportunity to create, are giving our best energy and time to earn the means for a miserable subsistence.

We, whose position is worse than the oppressed workers, for we—both work for our subsistence and create our art at one and the same time!

We, who are cooped up in kennels, often without either paint or light, or the time for creative work.

Proletarians of the brush, we must come together, we must organize a "free association of oppressed artist-painters" and demand bread, studios, and the right to exist.

Enough!

The art patrons oppressed us, they forced us to fulfill their whims. . . .

April 11, 1918[28]

You, fire-worshippers of the West!

Bookworms of sepulchral studies and dens!

Russian critics, always snorting at Russian art, accusing it of imitating the West!

Look, Russia has given birth to its own art, and its name—is non-objectivity!

Look—these are the most vanguard creators, the non-objectivists (Suprematists), the first inventors of the new, as yet unseen in the West.

We should rejoice at the great art of Russia!

Why aren't you writing now that Russia has been the first to produce artists of non-objective painting. . . .

For this is the dawning of an entirely original identity in Russia's art.

Go on, it's not too late, take a look; like the colorists, the non-objectivists are working intensely and diversely in their invented art.

Go on, study our true creators: Malevich, Rozanova, Udaltsova, Vesnin, Drevin, Rodchenko, Popova, Pestel, Davydova, Kliun.[29]

Don't sleep through it all, like you did the Russian icon.

And shame will descend upon your heads if you are late in studying our distinctive Russian art.

Anti[30]

THE DYNAMISM OF PLANES

Projecting vertical planes painted in appropriate colors, and intersecting them with lines of directional depth, I discover that color serves only as a relative means of distinguishing one plane from the other as well as from the indicators of depth and intersection.

If I find any other way than color of distinguishing a given plane from the blocking-in, extruding, or receding planes, I will make use of it immediately.

Recognizing only the vivid distinction of the main and central planes and their projection from the peripheral, parallel, or receding ones, I do not concern myself with the quality and combination of color.

Sending the plane into the depths, I leave a projection as its trace, and, contrarily, showing a series of planes of varied proximities, I paint them in similar colors according to their place, weight, and contrast in the construction.

Building projections in ovals, circles, ellipses, I often distinguish just the edges of the projections with color: thereby I stress the value of the projections [themselves] and the function of color as an auxiliary device and not an end in itself.

Assiduously studying projection in depth, height, width, I discover the endless possibilities of construction beyond the limits of time.

Working this way, I call my latest works "movement compositions of colored and projected planes."

April 28, 1918[31]

OLGA ROZANOVA—PAINTER
1886–1918

On November 7, 1918, at ten o'clock in the morning, Olga Rozanova died—Painter-Inventor . . . revolutionary of Art, first Master of Suprematist painting. . . .

Wasn't it You who wanted to illuminate the world with cascades of color?

Wasn't it You who designed color compositions in the air with projectors?

And how early You disappeared from us. . . .

It seems that Your brain was exhausted from inventive ideas. . . .

You thought of creating with color-light.

Your inexhaustible fantasy and persistent labor created an enormous number of paintings and even more drawings.

I know the inexhaustible riches of Your creations in embroidery, rugs, scarves, ribbons, etc.

You were one of the few who stood in the avant-garde of the most Leftist Art.

You were a constant Revolutionary-Inventor in composition and technique.

We were amazed at Your imagination.

Anarchist of Creativity, You were an indefatigable, eternally new Genius of Inventiveness.

Olga Rozanova died, but Your art will burn eternally.

Rodchenko[32]

RODCHENKO'S SYSTEM

At the foundation of my work I placed nothing.
—Max Stirner, *The Ego and His Own*

Paints are disappearing—everything is mixing up black.
—A. Kruchenykh, *Gly-gly* [33]

The collapse of all "isms" in painting was the beginning of my ascent.

To the toll of the funeral bells of colorist painting, the last "ism" is laid to eternal rest here, the last hope and love collapse, and I leave the house of dead truths.

Synthesis is not the engine, the engine is invention (analysis).

Painting—is the body, creativity—the spirit. My work—is to create the new out of painting, so look at my work in action. Literature and philosophy are for specialists in this work, but I—am an inventor of new discoveries deriving from painting.

Christopher Columbus was not a writer or a philosopher, he was only a discoverer of new countries.

January 1919. Moscow[34]

FROM THE MANIFESTO OF SUPREMATISTS AND NON-OBJECTIVE PAINTERS

Achievements in creative work of the world's explorers.[35]

The only innovators of the earth, the Suprematists and non-objective painters, play with inventiveness like jugglers with balls.

We are already outstripping one another.

People, look, this is my latest venture: concentration of color. The light of color.

Flying ahead of the others, I greet the rest of the "Suprenons."[36]

You there!

Don't look back, always move ahead.

The world will be enriched by the innovators of painting.

Objects died yesterday. We live in an abstract spiritual creativity.

We are creators of non-objectivity.

Of color as such,

Of tone as such.

We glorify the revolution aloud as the only engine of life.

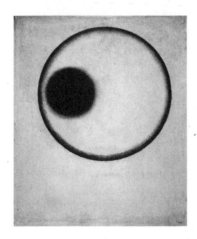

Rodchenko. *Composition no. 60.* 1918.
From the series Concentration of
Color. Oil on canvas, 24 × 19 $^{11}/_{16}$" (61 ×
50 cm)

We glorify the vibrations of the inventors.

Young and strong, we march with the flaming torches of the revolution.

Henceforth, always be revolutionary, new and audacious.

This is the place—for the rebellious spirit.

The petty and materialistic—be off with you!

Greetings to all of you, comrades, who are fighting for new ideas in art.

Innovators of all times and countries, inventors, builders of the new, eternally new, we are rushing into the eternity of achievements.

We, who enter the fray with art speculators who have gotten the knack of stenciling one manner or another.

We are proud, we are starving in attics, but we have not yielded one iota to the bourgeoisie.

We painted our furious canvases under the hisses and snickers of overfed bureaucrats and petty bourgeois.

Today we reiterate that even now we will not yield to the so-called proletariat of former monarchist lackeys, to the intelligentsia, which has taken the place of the previous bureaucrats.

Twenty years from now, the Soviet Republic will be proud of these canvases. . . .

Rodchenko. 1919

Notepad [37]

1917

November–December

How many hopes, how many extremely interesting initiatives and new possibilities there once were in the initiative board: the House of Contemporary Art from the Extreme Innovators, the opening of new museums, the Proletarian theaters, Lectures on art, book Publishing, studios, painting. I appealed for the creation of a free association of oppressed artists, but the whole thing collapsed, buried mindlessly by some dim-witted, two-dimensional people. . . . And once again, I'm sitting here in my hovel and thinking: It was all a dream. . . . But we'll start creating anew, begin anew, knowing no rest. . . .

You have to have the courage to show your entire creative path, hide nothing, not the mistakes, the false starts, the dead ends from which you turned back, as well as the triumphant marches, which are not so numerous. Many, very many, if not all, artists fearfully destroy their early period with its false starts, and declare boastfully that they have always been like they are now. You have to preserve all works of all periods, but have the even greater courage to show them without hiding anything, without shame, but declaring proudly: "Here are the paths I've traveled, my dead ends, and here is my wide-open road of the present!"

From the first days of my work, not bound by realism and having objectivity, I described the possibilities of plane construction with the aid of planes with complexly intertwined intersections, and gradually arrived at the coloring of planes and the simplicity of their splitting and receding.

There are two kinds of inventors: some take a samovar and stick two taps on it, take an airplane and invent the monoplane. But there are others, as well, who don't take anything and create the airplane, the telegraph, who discover electricity, find radium. . . .

There are creator-artists who invent new possibilities. . . .

November 23

I've begun painting again. I'm painting a composition in white and shiny black on a matte black background. I've begun a small, long board with four circles in the same way.[38]

The carpenter brought fifteen stretchers for me for 200 rubles. I'm very happy, now I've got stretchers and primed canvas and paints. At Rozanova's, Drevin and I divided up the empty stretchers, so now I have about twenty-five "recruits." Not bad, I'll have an army ready for the next exhibition. . . .

By evening I was quite under the weather, a cold again. ·

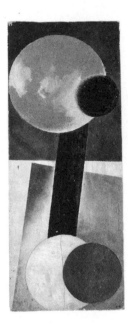

Rodchenko. *Non-Objective Composition no. 69.* 1918. Oil on wood, 20⅞ × 9⅞" (53 × 25 cm)

December 1, 1918

The last few days I've been busy with the apartment because they're moving us out, I'm looking for another one. I'm packing. I get tired, and by evening I'm really sick. I'm so tired of this commotion and constant looking for food.

Today I stayed at home, it seems we'll be staying here. . . .

I'm reading Dostoevsky's *The Possessed.*

I'm sorting through books, and decided to give a lot of them away. I'll keep only the reference books, dictionary, books on Futurism, on art, and poems.

December 15, 1918

Today is Sunday.

It's hard working at the Commissariat, painting and being included in the decree about correcting the exploiters. . . . What am I guilty of?[39]

I feel lousy. If I'm kicked out or moved, things will be bad with food. How to manage not to croak ahead of time. . . .

I'm trying to do more in painting. . . . A few days ago I managed to buy a few tubes of marvelous oil paints: Windsor Newton, black, ocher, dark blue, and whites and madder, all for sixty rubles, expensive but good. I decided not to buy anything more, you could croak and everything would remain— except paintings, and those will disappear if I croak early. . . .

The most pleasurable thing for me is exhaustion from painting, regardless of what I've done, whether it worked out or not. It's strange to me that I still exist. There's that pessimism again, from not working. . . .

December 25, 1918

Today there was a meeting of Suprematists and non-objectivists. We decided to hold an exhibition of just Suprematist and non-objective painting after Rozanova's posthumous exhibition in the same space.

Malevich paints without form and color. The ultimate abstracted painting. This is forcing everyone to think long and hard. It's difficult to surpass Malevich. . . . His "new" things and the next new ones will not likely be his pieces.

I'm often angry and irritable from the nervous strain.

Drevin advises publishing in our paper *The Innovator* that the non-objectivists have destroyed form.

The latest announcement:

"We, artist–non-objectivists, inform everyone that we have definitively discarded limited form in painting as the last remnant of objectivity.

"Long live free color and tone!"[40]

> N. Udaltsova
> A. Drevin
> A. Rodchenko
> L. Popova

1919

January 1

Today Stepanova brought over all of Rozanova's manuscripts and all the materials for the book; publishing it will take a lot of work.[41]

"Suprenon" decided to hold an exhibition about a month after Rozanova's. Malevich and I decided to write and publish as much literature as possible. . . . To this end I've written sixteen appeals, which I'll include here.

Varst and I decided to publish a collection of poems and drawings that will include Her, Rozanova, and Me.[42]

I'm doing paintings based on my old sketches (tempera) now, in large-format oils.

About twenty-nine to thirty new pieces have been painted; I think I'll paint another ten.

A few days ago I painted two long pieces on plywood—"Two Triangles."[43]

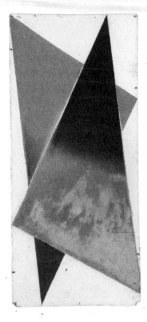

Rodchenko. *Non-Objective Composition*. 1918. Oil on wood, 28⅜ × 12³⁄₁₆" (72 × 31 cm)

January 2

I've been organizing and pasting all the articles on Futurism from 1912 into a special book. I want to collect all the books of the Futurists, the catalogues and reviews of them.

Today I didn't work during the day and evening, I was at my job, came home at eight P.M. tired and hungry. I'll have four free days, I think I'll work on painting.

There are a lot of different plans, but not enough strength to implement them. . . . I want to either finish my old paintings, or paint them all over again. *Two Figures* especially needs fixing. Having achieved extreme innovations (the light of color, the tone of light) in painting, I still wouldn't call the most recent period of my painting by any "ism." Let my achievement not be to create any "ists," but simply to enter the artist's consciousness as a new conquest in our common movement ahead.

That way, when we find something else new, neither I nor my many followers will have to struggle against the "ism" of Rodchenko.

List of works by years:

1918
Color sphere of the Circle. (Concentration of color.)
December–January—*Gly-gly*.[44]

1919
January–February—Sculpture, 8 pcs., from cardboard.
March–April— Several dozen non-objective drawings done in pencil with

a ruler in a notebook. (55 pcs.)

May–June. Objectivist sketches for paintings, 12 pcs. Tempera, size of writing paper and 4 early [ones].

1. Yellow.

2. Two dancers with an accordion.

3. Man with guitar.

4. Man with newspaper.

June—Pencil sketches for paintings on album sheets, non-object[ive]. Had the idea for "Circus" and "Champions."

July—4 drawings in colored and black india ink, objective figures.

Made 12 drawings with colored india ink and tempera.

"Championship"—14 fighters.

August—Started a big canvas in oil from an old sketch, 126 × 160 cm.

Long, white-black, new. 74 × 22 cm.

Made a drawing of a "woman" in colored india ink on certificate paper.

Thought of painting ten pieces, just black on white, with a ruler, calling the drawings I did in April "Lines." It would be exceptionally new. I really need to apply myself to the ruler, claim it as my own.

I'm going to Petrograd.

We gave Igor [Nikitin] one piece, oil, from the concentration of color period.

You spend whole days in the [Visual Arts] Department, there's no time to work. But everything is prepared, the canvases and the sketches. . . .

And autumn is already coming, the rains. . . .

The artist's life isn't needed by fighters for ideas or by capitalists. All this is for the future. . . .

Two Figures particularly needs fixing. I spend whole days in the department, there's no time to work. . . .

August 24

I was in Peter. A dreary, bureaucratic city. . . . All those insignificant artists are so apathetic and self-assured: Altman, Chagall, Filonov, all with their hair parted, wearing collars, bureaucratic indifference on their faces![45] I would never want to live in their Peter, it's so Western, so official, that so-called cultured European city. If Europe is all like that, like Peter, let it perish, with its apathy and parted hair, dressed in collars. Let it perish with all its culture.

O, how dear my Moscow has become to me: "barbaric," free, where everything is mixed together and inexplicable.

I have to work, so far very little has been done because of this bureaucratic business in the department. . . . They've cooked up a bunch of paperwork, turning artists into bureaucrats.

I'd like to read Rembrandt's diary or letters.

I want to compile a catalogue of my works and keep a record in future.

August 25

Today we sorted through the things [works] of the artists M. Larionov and N. Goncharova.[46] The quantity of their work surprised me. Two whole rooms

were literally packed with paintings. Such fruitfulness really touched me. True, there are the conditions under which these works were done, without any particular pressure, it was just good, conscientious work, but now that's simply not possible.

After my death I want to leave behind no fewer works than the two of them together.

I'm upset that for all of 1919 I don't have a single finished piece, just lots of sketches and three unfinished pieces in progress.

I want to make a few more sculptures from white cardboard.

Ivanov began painting still lifes in black on black and white. It's the influence of my black pieces already.

August 28
Today I covered four canvases in a row for black constructions.
 1. Red, with Prussian red lake.
 2. " " "
 3. With whites.
 4. Whites with yellow.
 5. Began with white for the sketch, corner down.
 6. Began the contour, black above.
 7. Drew the contour of a large, narrow object.
 Primed two boards.

Decided to make a platform for storing paintings tomorrow, in case the heating bursts.

Drevin and Udaltsova left the board of the union, and V. F. Franketti was elected to the department.[47] Adler wants to get my drawings for Kazan.

I painted that big black-and-white painting.

I think that I should work for a year or two without exhibiting.

Let them all get ahead of me, but there's no sense in hopping over hurdles.

Although, who will do something new, they're all exhausted. . . . Following my example, everyone has started raving about reality in the spirit of Henri Rousseau.

I have my own path. . . .

August 31
I painted two pieces:
 1. Black rectangular sticks on Prussian red lake
 2. Black and green ones on Prussian red
 I painted over ten [*sic*] canvases for lines:
 3. White and black on green
 4. On red ocher, dark ocher, and black
 5. Dark blue and green on white
 6. White and purple on chromium
 7. Dark blue and black on dark ocher
 8. Neapolitan, chromium, and black
 9. Light ocher, chromium, and black

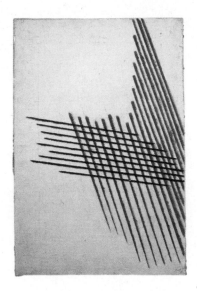

Rodchenko. *Construction no. 90 (on White)*. 1919. Oil on canvas, 26¾ × 17¾" (68 × 45 cm)

10. Light yellow, black, and green
11. Greenish-red
Still need:
12. Green and red on black
13. Green and black on cobalt
14. Green and white on umber
15. Black and cinnabar on madder lake

I actually worked all day long, from morning to late evening. And I was pleased. Of course I'll be criticized for these lines, they'll say it's not painting, but I'm solving other problems.

Color died in the color black, and now it plays no role. Let the brushstroke die out too.

I am bringing composition to light.

September 1
And today I have to go to the department instead of painting.

Today there was a meeting of the presidium of the Union of Painters, and they decided to hold a general exhibition where everything could be shown: talented children's drawings, photographs, objects, and so on.

September 5
Last time, I painted these:

Black on Prussian red lake.

Black and green on Prussian red lake.

Today I spent the whole day painting four boards for Soviet Propaganda Day.

I want to take vacation starting on Monday, and just paint, and also record all the paintings in a catalogue.

In all, four pieces painted for the exhibition, and I'll finish another

twelve in a few days. One is a long board with the contour drawn in, there's a sketch for it.

My works are in:

A department of the Museum of P.[ainterly] C.[ulture]

In Vitebsk.

In Petrograd.

In the Museum—drawings.

In Ryazan—24 drawings by Stepanova.

September 7

Today I painted:

69, 70, 91, 92.

September 8

I also got third prize for drawings of applied graphics. Kandinsky is proposing to take over directing the reproduction studio himself.[48] I was thinking of transferring there. I got the negatives of my pieces from him, sixteen in all, and left another six pieces to be photographed, three black, one black and white, and two circles. I was at work all day long, only got home at eight in the evening.

September 12

I'm not well, my teeth hurt. I want to move to another apartment. I can't work. All the same, I'm thinking of finishing two pieces tomorrow. I ruined it again with red, think I'll fix it when it dries. I bought paints, now I have a big store of them, only no time to work.

September 25

I moved into a new apartment. Now I have a separate studio again.

My teeth are killing me. I started working again. I found an old portrait of N. Rusakov painted in oil on board (1912 or 1913). The paint is laid down boldly with a palette knife, it's a good painting, and I kept planning to throw it out but suddenly saw it and was surprised. I washed it with soap, dried it well, coated it with varnish, and the paint glowed again. By the way, I've decided to cover every piece in varnish in a year or so, it makes them stronger. Otherwise, when they dry out the paint becomes fragile, cracks, and falls off.

October 15

Winter is beginning. I'm sick and tired of running to meetings. . . . My mood is loathsome. Food is so expensive that we eat horribly.

In December–November I painted another eight costumes in tempera and ink on paper, and I want to make them like a sculpture from plywood and paint them, this would be interesting.

On December 2 and the end of November I made two plans for kiosks. I've got a photo. I made about fifteen architectural drawings and "Arch. Sculpt. Paint. Synthesis," for Zhivskulptarkh.[49]

In December I made two albums of linoleum engravings, one of them Varst's. Varst's—ten, my own—fifteen.

It came out quite well.

I made two wood sculptures from plywood, following old models made from cardboard, and one new sculpture. I also made various pieces, up to thirty of old drawings for paintings.

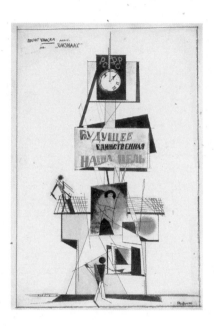

Rodchenko. *Design for a Kiosk*. 1919. Black and colored india ink on paper, 20 15/16 × 13 1/2" (53.2 × 34.3 cm)

1920

January

I have about twenty finished sketches for paintings. . . .

I've cut out twenty sheets of Whatman paper the size of the glass; I'll make colored drawings.[50]

I'm thinking of calling the new pieces "Linism."

The surface is dispensed with logically, and to express the greater constructiveness, the architecturality of the composition, the old favorite of paintings—texture—is dispensed with as well.

Work—is a pleasure.

Life—is a torment.

I just want one thing: to work like a machine for one year and do everything that is given to me for my whole life. . . .

January 2, 1920

I intend to:

Paint in black an old work and new ones from the sketches.

In all—3 black pieces

New lines—5 pieces
Half-black—3 pieces
6 wood sculptures
5 human figures
I'm thinking of doing a sculpture out of wire.

We're selling a black one to the museum for 30 r., a big painting by Varst—a figure, for 25 r., and four prints for 25 r.

January 3, 1920

> *To be hungry, cruel, alone, godless, that's what the lion's will commands you. To be free from the happiness of slaves, rid of gods and idolatry, fearless and instilling fear, great and alone—such is the will of he who has a calling.*
> —F. Nietzsche

January 15

I have about twenty finished studies for paintings; as soon as it's warm and possible to paint, I'll do them.

I'll have to prepare another twenty sketches for summer during the winter. The last few days I haven't worked, I've been busy in the department.

I'm getting everything ready for painting. We ordered a bunch of stretchers, bought paints, glue. I cut twenty sheets of Whatman paper to the glass size, I'll make color drawings.

I'm gloomy because it's cold and I can't paint.

Given that the department turned down one of my best things for purchase, two circles, and the other good ones in the department are for the next purchase, I'm going to paint specially for sale from my oil sketches.

I'm thinking of calling the new pieces "LINISM." *A new movement* in non-objective creative work. Surface is logically dispensed with; in order to express greater constructiveness, the architecturality of the composition, and because of uselessness, the old favorite (texture) is also discarded.

Call Varst's pieces "NEW REALISM." A new realism, flowing out of Linism into the field of object creation, a completely new understanding of the object after the abstractness of non-objective work.

January 16

I'm thinking of painting a few linear circles for Linism and also making linear sculptures.

I'm thinking of exhibiting in June or July, when I'll have no fewer than thirty works in oil. (There are already thirteen.)

Also need to write and publish a brochure on Linism in 500 copies.

A lot of work, but I get very tired from the job. My hopes are on the summer, the warmth, the sun. . . .

I put off the wire sculpture since steel wire is very hard.

January 20–24

I'm making prints on linoleum. I've made fifteen of them.

January 25

Today I only did the one no. 53 and made the "Print Registry" book according to the numbers on the prints.

At night I think about my painting, but during the day I'm freezing to death in my unheated Museum office, where it's colder than on the street.[51]

Coffee and bread. . . .

So many sketches and plans, but I can't work.

And all around intrigues are coming to their culmination. Artists, like other people, come to resemble desperate scoundrels.

Each tries to slander and destroy the other.

It's sad. I just want to run and run to get away from this whole circus.

Work! Work! When will I do any of it? I draw at night, and the days go by one after the other. . . .

February 5

I sold one oil piece in Peter—two triangles—and two drawings—one, of a man, 1914, and one non-objective.

I sold the circles to Siberia.

February 9

The past few days I've been working until three in the morning. I've done seven big temperas.

I sent ten of my prints and ten of Varst's to Igor.

Work—is a pleasure. Life—is torment.

Just to work like a machine for a year and do everything that I've been given for my whole life, and then kick the bucket.

Because living in order to live—is ridiculous. To live in order to create and do everything that I can. . . .

I feel as though I'm unusually old in life, and I don't want anything except the opportunity to work all the time. Even sleep, which I used to love so much, I've begun to hate, in order to put off going to bed longer.

Life here has become more like a prison. . . .

I lived repulsively before, but I knew that it would get better; now I don't believe in the future. But it's necessary to do a lot more with my creative work, and the joy of success forces me to live despite everything. May this kind of life be cursed! Creative work—you are my only strength, and through willpower I'll shift a lot of things.

I don't feel well at all, and I've got heart pains worse than ever before. What from?

From inevitability!

My father was tormented by heart spells, and a cold horror gnawed at me then, but that was in childhood.

My mother was tormented by horrible spells with vomiting, and hopelessness seized me then—that was in my youth.

Now my wife has suddenly become sick, and I'm also having a spell— and this is as an adult.

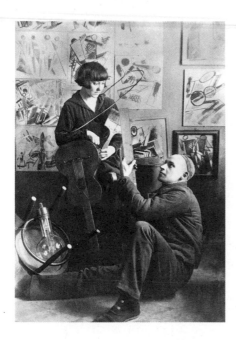

Rodchenko and Stepanova posing as itinerant musicians in their studio, 1921.

And I loved and love all of them, and can't live without them, but this is called inevitability.

And I don't have any illnesses other than my will and a cold.

Sometimes I'm completely sick but I continue working and walking about, I forget about the pain, and it disappears.

But there's no willpower to make the heart stop hurting for her. Willpower over your own spirit and body, but not over the heart and other people. . . .

I can't read, or work, I can only smoke and write this unconnected. . . .

February 10
Today we bathed next to the stove in the big basin, and this made things somehow easier and calmer. . . .

Tomorrow I'll figure out new work for nighttime, since I don't sleep anyway. Have to prime two big canvases and paint them in a broad manner.

February 19
V. V. Kandinsky and I exchanged drawings.

February 20
Exchanged drawings with Shevchenko.[52] Fixed old pieces yesterday, glued and framed them.

Today was the Council of Masters, which gave me a headache and wasted the whole day.[53]

February 29

I'm organizing all the old sketches and works, pasting them onto cardboard and covering them with varnish.

It's a bit warmer outside, sometimes there's some sun, and I've recently begun to work a little bit, though in the studio it's still cold.

March 10

I gave Brik a 1914 drawing, non-objective, and a Varst—from 1914.[54]

Ship's Log

[*From the notebook entries before the* 19th State Exhibition][55]

June 14

The thoughts that come [to] me, other than those that I could express in painting, have forced me to begin to keep this ship's diary, really like a "ship's log"—a simple and detailed report of the day's activities.

It was yesterday, I think, that it became clear to me that my work of the circles period, and the cut surface-planes intersected by lines, historically somewhat resemble Cubism in non-objective painting; just as the Cubists decomposed the object, anatomized it to create their composition, so my works cut through the real surface-plane, put color aside and show that a single plane can be rendered with not one, but several colors of varying weight and tonality. The same goes for the particular compositional tasks derived from these anatomized surface-planes; but you have to look at the works of this period as material works nonetheless—though they are non-objective in form and color—given their obvious existence in space (that of the canvas). They exist, move, fly, or glide in a certain way, in a certain place, of a certain material color, weight, and tonality.

The pieces of the black period mark the beginning of the new existence of form in space, and a new space where it is hard to grasp what is space and what kind [of space it is], and what is a form in it, and how that form exists, although weight still remains, it's true, though of a different quality.[56]

Therefore, it seems to me that Malevich wasn't aware of what the existence of form should be, and he simply jumped into painting things white without destroying the real existence of the surface-plane.[57]

The real existence of non-objective forms seems so completely real-clear to me now, that it reminds me of the almost actual-object forms of old painting.

Unreal forms, that is, non-objective ones, should exist unreally and in an unreal space, or something else. Just as color, their tone, weight, and attraction.

I think that the tasks of composition and construction play a particularly strong role only during the period of something's destruction (for example, in the destruction of the object in Cubism, and in my period of destroying non-objective space). During the search for the existence of form—the search

for form, for tone, weight—the tasks of composition and construction are not so important, and may even be completely absent.

Just as I thought, texture [*faktura*], i.e., the treatment of form, should go the way of form itself, that is, let its coloring be carried out in new ways, perhaps introducing new instruments of contemporary technology as well, and not only with the aid of a brush. The brush made a lot of sense when objects were being painted in the search for truth, less sense in Impressionism, and then even less in Cubism, when new instruments began to be used; and it would be strange if in painting our planes we covered them like housepainters paint an outside wall.

Painting will not likely return to the impoverished expression of the savage, it may be "barbaric" but nonetheless rendered with the last word in painterly technology.

If, in the future, a master does appear, who expresses everything and gives [us] something new, despite poverty of expression, believe me, this poverty—will be a mask allowing for the expression of another wealth—that of contemporaneity.

Contemporary lack of restraint will always conceal within it the meticulous pedantry of contemporary technology. Only the layman will fail to understand this.[58]

Painting doesn't come back, like life it moves ahead without restraint, and its apparent return is nothing but a spiral-like movement broadening into the future.

"A"
is the past,
and
"B"
is the present
[heading] into the future.

Regarding the question of how painting will develop in the future, will it be objective or non-objective, and knowing all the arguments about this, I always keep quiet and am afraid to be mistaken. It's easier for those standing on the sidelines and studying it to make predictions, and easy for someone creating in the present day and tomorrow to be mistaken. Objective artists claim that painting will be objective, non-objective—that it will be non-objective. Kandinsky claims that from now on they will progress in tandem. I myself think that objective painting will never return to what it was and that non-objective will die out in time, giving way to some sort of new painting, whose beginning I can sense.

The uselessness of painting in life in fact results from its having moved too far ahead, but it is not divorced from life, as people think. All of you will go on existing like this, just as these forms exist, [and] tone, weight, and composition.

Future objective painters will probably realize that the object can be conveyed not only through photography, through the truth of light, through

material, but also through the psychology of its being. Of course, they won't be conveying the impression of an object but the very essence of its existence. Varst has done a great deal in this area in her 1920 works, where through some new painterly feeling objects are conveyed not in their individual personality but their all-objective existence; with black and color, thin and thick lines, circles and splatters, the being of the "of" is conveyed, its overall psychology, without the psychology of individuality and type.

I just read Malevich's UNOVIS poster.[59] It's all literature, the kind where a lot is written and absolutely nothing is said. "We want," "We are establishing," "We appeal," etc., but what we want, to what we appeal, and what we ourselves have done—there's nothing except this poster. It's a new kind of poetry. And it strongly recalls Balmont: "I want" . . . , etc.[60]

I'm increasingly convinced that one has to work and work, and most important, the most essential thing, is that you can talk and write, but always to the point, about being. Nowadays, all of us have learned to talk a lot without saying anything, to write without having painted.[61]

Lately I've been thinking through the following question: should texture, i.e., the treatment, exist by itself, as has been the case recently—for instance, Rozhdestvensky, Konchalovsky—or should it serve to strengthen more important tasks in the work?[62] I think the latter, otherwise you end up with two works in one. One work with its own issues, and the other—coming closer, the admiring of surfaces, which disappear from far away and do not even strengthen the value of the main problems at hand. I spend a lot [of time] on treatment, but only for the sake of the work's primary task and its strengthening. The close-up admiring—is a free bonus. For instance, Konchalovsky's *The Model* at MzhK is good painting close-up, and a gray, monotonous watercolor from far away.[63] Rozanova and Malevich at MzhK—there's strong color, vivid tonality, and close-up, mediocre, applied decorative-arts painting. And there are many such examples.

Appeasement in painting is direly punished. For example, a painter should paint a piece and bring only one small problem to light, so that no matter what serious lapses in other areas, the work will live, exist. But if one throws everything together in an attempt to appease, even when the work as a whole is executed quite professionally, then it won't live, and the whole thing will seem stillborn.

It's nice, of course, when painting is healthy (for example, healthy in body—van Gogh, in spirit—Gauguin, Mashkov, Cézanne, Picasso).[64] But this isn't a requirement, and I don't know if anyone's painting was ever healthy in both body and spirit. Van Gogh was morally ill, but in body, that is, by nature, it's healthy thinking. Picasso, in his thinking, by nature—is pathological, but spiritually—he's healthy.

I've gotten a bit tangled up in all of this, but that's because it's not a good idea to write about painters whose personality I don't know. Well, I'll return [to the question] of pathological rhythm another time. It undoubtedly plays an important role. Complete health, it seems to me, introduces apathy and indifference in creative work. True, perhaps passion or daring can replace it. (Mashkov is an example of the former.)

It is usually said that my works in painting are not really works but experiments for some sort of future works or for future artists. But I don't agree with this at all. Old-time painters put everything into their works that had been done before them—that wasn't their own property, so to speak—plus their own experiments, great or small, depending on their genius. With every subsequent work, the artist did the same thing: everything old, i.e., someone else's, and one's own new. In essence, a particular artist was valuable for having added this one experiment of his own to the experiments of the old, and he himself existed only in one aspect of each work. But in each work, I make a new experiment without the addition of everything old—belonging to others—and in each work I set different tasks. If you look at all my work over time, it is in fact one huge work, and completely new; and if you want to add on the old, then you can go to a museum and think about it.

And then, how long could a painter carry the entire burden of old achievements. It would end with him dying in one work without having painted all the previous achievements, let alone his own. . . .

June 15

This winter I intended to write a report about the Museum of Experimental Technology, and wrote only the introduction. I dropped it for lack of time. Here it is:

On the Museum of Experimental Technology

The cold of the autopsy laboratory will blow from such a museum, the dryness of mathematical formulas, the sharp, pitiless realism of the analytic.

Here, everything is invented, shredded, measured, dismembered, calculated, made deliberately, reduced to bare formulas.

Nonetheless, you, inspired creators of life and feeling, you will begin to use these invented creations for your own works if you are moving toward the future, because that's the way it has been and will be.

It is only from here that new paths of creation will proceed, and in its cold wisdom that special, creative future life will be eternally hidden.

Except for non-objective and decorative painting, art in general has not gone further than decorating parlors and studies for coziness over the couch.

But the art of the future will not be a cozy decoration of family apartments. It will be as necessary as forty-eight-story skyscrapers, grandiose bridges, wireless telegraphs, aeronautics, underwater vessels, etc.

And the art of contemporary painting goes further than technology. Dead electricity will destroy the comfort of the fireplace in the end! The non-objective airplane will destroy the railroad! The abstract wireless telegraph will destroy letters!

[And, of course, people will use the old and value it highly, as at present they value the works of Somov, Benois, and others.[65]

Materialism eats into our heads day by day, people are afraid to say a word in which there is something not material, as though everything

had become just dandy, sober, and clear. It's gotten to the point where art is skill, skill and nothing more. But it is aesthetics, feeling, mysticism. Genius—is also aesthetics. Talent—is window dressing, and so on. And what did they give us, those people who were the first to start shouting about all of this, all those "clear heads" and sober minds? Yes, they needed to cleanse themselves of aesthetics and inspiration, but the genius of creative work—is indeed great].[66]

Materialization is a good thing, but if it rejects everything except trousers, it simply means that dilettantes have taken to preaching, people who can't create, and therefore it's to their advantage to try to vulgarize everything they are unable to attain.

In organizing the M.E.T. [Museum of Experimental Technology] we are opening wide the doors to the future work of all new and old arts.

We, highly cultured painters with a past containing hundreds of years of native cultural legacy, scorn experiments on new possibilities in art, and each time we take the bait. It happened with Impressionism, Cubism, and now with non-objective art.

Each time we see new art as a barbaric and uncultured phenomenon, and each time this "barbarism" is victorious. And then we not only acknowledge it as art, but proudly write it into our "native" culture.

That is how it always has been and will be, and it's better not to mix the "dead" with the living and the "live" with the dead.

Let this refined libertine, this noble heir of culture (in the past: "writing" with a brush, a story line, color-scheme, composition, emotion, immediacy, sacred inspiration sent below from on high, photographic protocol, etc., etc.) live out his days quietly, domestically, in front of the smoldering fireplace over the family sofa.

While he, the cold, contemporary analyst, moves his forty-eight-story skyscraper of creation toward the sky, sure of himself and firm in his steadfast truth.

Cantor's famous theorem declares that:

The number of points inside a square, cube, etc., is the same as the number of points on a single one of its sides; the number of points located on an entire straight [line] is the same as the number of points on any of its sections; and this means that our entire universe, with all its endless planets, suns, and Milky Ways—consists of the same number of points as any, even the smallest, section of a straight line. The entire universe could be created from a piece of a straight line, just by placing its points in a different order.[67]

"Quadriga of World Revolution," A. Solonovich,
Klich no. 3, Moscow, 1917, pp. 36–37

I'm so interested in the future that I want to see it right away for several years ahead. Just now I was thinking about what will be written at the end of this book, and probably there will be this, and it will be written this way, so that

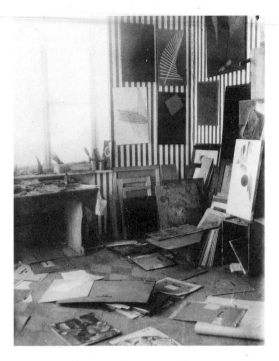

Rodchenko and Stepanova's
studio in Vasily Kandinsky's
Moscow apartment, c. 1920.

this part will become utterly worthless. . . . But in painting itself it's so interesting that it takes your breath away. And it seems that everything moves very slowly. I keep thinking about an exhibition and about an article I should write for the catalogue, although I've already written two, but it always seems that not much has actually been expressed—I'll put them in here somehow.[68]

June 27
I missed a few days from writing all these articles for the catalogue, and the problem is also that I had wanted to write only about painting, and now I think that I'll write something more general. Of course there will be more about painting than the other arts, anyway. Right now I'm painting the sketches of 1918 and 1919, and I'm doing this because I have to sell something to the Department for Provincial Museums, and it's a shame to give up the new pieces from 1919 and 1920 without having shown them at an exhibition. I prefer to do things this way than to do something to earn a living that isn't painting at all but hackwork. I keep improving myself this way, and that's the most important thing.

Because of the very small quarters, I'm thinking of making spatial constructions from plywood again in the winter, as well as linoleum cuts. I'm also preparing Whatman paper for large temperas. During the winter I have to prepare material, in the form of projects and sketches of new forms and tones, for paintings to do over the summer.

I've been playing the piano for the last few days, never having played before (I'm improvising), and it comes out something like Scriabin (ultra-Scriabin)

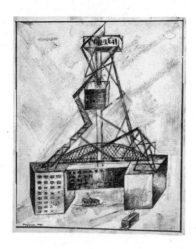

Rodchenko. Sketch for a project for
Sovdep (the Soviet of Worker and
Peasant Deputies Building), Moscow.
1920. From the series City with
Observatory. Pen and ink and gouache
on paper, 10¼ × 8⅛" (26 × 20.7 cm)

and very interesting.[69] I like it myself. I want to play later for Kandinsky, Shenshin, and others, then I'll know what effect it has on them.[70]

June 28

I drew pencil studies for the building of the "Soviet of Worker and Peasant Deputies."[71] For the moment it's going badly. That's probably why by evening I'm absolutely spent creatively. During the day I had a lot of thoughts, but now I'm so exhausted that I can't collect them. . . . It would be good to travel to America in order to have a "name abroad," this is so important in Russia. . . . And to take a look as well. . . .

June 29

My first memory of myself was in the Russian Club in Petersburg. My father was a propman on stage, and I played small children with the actress Kirova—for some reason I liked her best of all—I didn't perform with the others (I was probably about four or five years old). During the daytime there was usually no one on stage or in the hall, and I wandered around these huge spaces in complete solitude. I loved the smell of the sets and the creaking of the parquet. I spent the whole day walking around and looking, either at the set designer's [room], or through the window into the kitchen. In the evening I watched the actors put on their makeup and costumes, and during the dances I sat amid the orchestra of soldiers. I particularly liked the bass tuba.[72] I thought he was the best musician, and envied him, I always sat near him and the big drum, which occupied second place. I despised the conductor. In the set room I poured paints into matchboxes, and at home I made a stage out of cardboard and painted some sets. I remember that I really wanted to depict waves in motion, or water from the inside.

When I performed on stage, the black hole where the audience sat seemed like a many-eyed black monster that was frightened of our light. But I liked being on stage: everything was bright and well lit.

During the dances I sometimes made my way across the hall into other

rooms. I didn't like undressed women and girls, they seemed unreal to me, and the ball itself sort of ostentatious, invented. Everyone's dancing and spinning seemed frightful in their improbability. From early childhood, people weren't people for me, they were little figures spinning "over there," all identical, "fake." Now the soldier over there, red from playing the big horn (contrabass)—he was real, and the most important and necessary person in all of this. The makeup man was real, too. He worked all the time, and in his hands people changed right in front of your eyes. He himself stayed the same—small and cheerful, and I liked that. The actors seemed unreal as well, but I think they "scared" the audience, which is what they were needed for. I utterly hated the children. They were prim, dressed in finery, clean, they walked quietly. . . . Were they really like this in our garden? They were unreal as well. Often in the club garden, during the day, my brother and I played "savages"; we carried out raids, stole foodstuffs from the kitchen, hit cats, and hid in the thick bushes, where we set up stores of food.

July 1

I'm so tired that I'm in no state to paint in the evenings. Yesterday there was a meeting of the department of the Institute of Artistic Culture, after which I played my improvisations for Shenshin.[73] He says that much of it is correct, and there's a pure musical approach. True, I didn't play very well. I want to learn at least one piece by heart. The department is planning to publish a book with pictures of sixteen of my paintings.[74] For me that's so few. I'd like to have at least thirty pictures in the book. I'm working on the designs for the "House of Soviets" now. From exhaustion, my thoughts are completely scattered. . . . Everyone's begun to tire very quickly, and there's a kind of apathy all the time. I just want to sleep and sleep. . . . But there's so much work . . . it's better to work every day, even if it's just a little. . . .

July 3

I'm working on the plans. The future architecture, undoubtedly, will be constructed upward. There shouldn't be sprawling masses, because of the economy of space. Contemporary skyscrapers, although convenient, are too boring in the artistic sense, they're just tall boxes. I think particular attention will be paid by future architecture to the top, where there will be particularly comfortable

Rodchenko. Architectonic drawing.
1920. From the series City with
Observatory. Pen and ink on paper
mounted on cardboard, 10¼ × 8¼"
(26 × 21 cm)

towers, light as bridges. All kinds of passages and awnings, all transparent and artistically constructive, this will be "the new facade from the top," so to speak. For buildings will be admired from the top and inside, and not from the bottom, as before. The development of aviation and the value (the special value) of personal life will require this new type of architecture first and foremost. After all, buildings will always be straight like boxes, but the top—that is already art, that is, so to speak, for the enjoyment of the resting inhabitants and the envy of flying passengers. The top of a building—that is the concern of future architect-artists.

It's clear that attention was previously paid to the facade, the building stood amid greenery in complete isolation. Now they stand next to one another like soldiers, and every little bump on the facade for art's sake disturbs the light in other homes.

And for that matter, in the future, beauty will be destroyed by "necessity" and "comfort." And what will the future bring instead of beauty—it's hard to know, but I think that "straightforward creativity" will always find a way to express itself. Where, after all, can it not find a place to express itself?

Yesterday I told Varvara Bubnova that we see badly, there are masses of interesting things to work on right in front of our noses, not even for creative work, just lots of things that would surprise people if shown to them.[75] In a prison cell I could publish articles and paint or photograph masses of material and novelties based on the walls of my cell. I'm not talking about fantasy. No, but about "nature," we don't know how to find nature. Not even find it, really, but see it, such that we can show others. In short, we are plain blind and we see only what is handed down to us from the previous generation. Everything newly "seen" provokes revolution.

Thousands of times I've thought that the non-objective should be particularly praised because thanks to it we have "seen" masses of new (old, previously unseen by us) objects. We're like people in the poorhouse who are used to alms, a yellow sun, a dark blue moon, a light blue sky, and so on.

Are some of the "discoveries" made almost right in front of our noses and completely by accident often ridiculous? Yes, we should discover things all the time. After all, the first people did more than us. . . . We have to travel more and see the new in order to learn how to see the new right in front of us.

July 18

As soon as you stop working, even in your thoughts there's no creativity, you start thinking about any- and everything unrelated to art. True, this can be interesting as well. I like it when the work flows day after day, and you think about work first thing in the morning and fall asleep with plans for tomorrow. What have I been doing? I played on the piano a lot today, and it's coming out quite well, better and better. I haven't thought about painting for a fortnight. I've been working on a project, I want to draw a few plans that I had in sketches. I want to develop the plan and "upper facade" of a new contemporary city, the construction-composition of a city.

July 27

Previously, a plain stretched out in front of humanity, and it built its architecture in its width, and that's where the pyramid comes from—▲, but now skyscrapers are built straight ■ ■ ■ ■, and then—▼, with only one end attached to the earth, the rest in space.

At the INKHUK meeting, Professor Shmit said that in Russia there is not and never has been any visual art, only decoration. All influences were unfailingly refashioned from the depic[tive] to the decorative.

He also said that the inventor is never a great scientist nor the great scientist an inventor, that to be an inventor you have to imagine images, i.e., you have to be a bit of an artist, but not a dreamer whose images are blurry and indistinct.

July 30

I'm planning to do a sketch of the new city, but first this is what I've thought up:

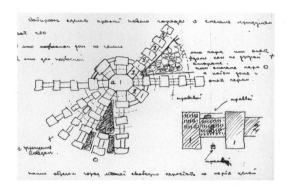

1—this is a building on the ground
2—this is a hanging building, this is a park, then another building again.

This way the city can expand freely without ruining the whole of its construction. The upper part, I think, should be meticulously worked out in terms of new constructive-spatial forms, where there will be all kinds of plazas, elevators, slopes, staircases, gardens, fountains, illuminated posters, projectors, swings, and so on and so forth.

Some Dutch people arrived as representatives of the communists to the congress of the Third International, and they went to Kandinsky's.[76] They asked for more materials on Russian art, [said] that they'd been asked to do this by Dutch artists. Kandinsky, as always, sent a lot of photos of my work and Varst's . . . I don't know if they'll get it there. In the West everything is stuck as it was before the war, the same old Picasso and Matisse. They all say they're looking to Russia with enormous hope, they'd trade places with us without a second thought. . . . I sent nine photos and six black engravings, four photos and seven color engravings of Varst's.

In the Visual Arts Department there's another reorganization going on—the free studios are being transformed into an "academy"—that is,

[they're moving] toward the old with new artists. True, they did invite Kardovsky, gave him a ration and an apartment and so on. Pevzner and Baranov-Rossiné were made professors.[77] I'm still in the background, but my time will come. . . . I can't be broken. . . . Monotonously, quietly, but faithfully forward.

CONTINUATION OF THE NOTEPAD WRITINGS

July 12
We have to look for an apartment, we're being moved out of Volkhonka.[78] I'm sick of official apartments, I feel like quitting the job in the Visual Arts Department. I must do some work at home. Everyone lives much more calmly than I do. It would be good to find a good studio, even an unheated one.

August 29
Aksyonov and Popova said that my pieces are feminine, while Varst's are masculine.[79] . . .

EVERYTHING IS EXPERIMENT[80]

In life as well, we, humanity, are experiments for the future. . . . I created today in order to seek the new tomorrow; although it will seem nothing in comparison to the past, nevertheless, the day after tomorrow I will surpass today.

The dead plans of dogmatic innovation must fall before the clear existence of living experiment, and the sectarianism of theoretical "isms"—those new nests of contemporary fanaticism—will fall.

The time has come when it is becoming too little to be an inventor, or in the worst case, a theoretician; one must be a maker as well, a builder, a master. . . .

To compose theories artistically according to Marinetti's system, or, in the best of circumstances, to play something new on a medieval horn—is more than simply insufficient for today.

The new should be created with new means of expression. . . .

The power of painterly creation (as should be the case with every kind) lies in seizing ever new and newer possibilities of expression. We must create and build fully armed with everything from contemporary science and technology.

Like life, painting doesn't move backward, it moves full speed ahead, and its apparent return is nothing other than a spiral-like movement expanding into the future. The form of painting moves, making ever greater leaps forward. Similarly, texture [*faktura*], i.e., the treatment of form, must move further on in the same manner as form itself. And let the coloring of form be carried out in new ways, unsatisfied, perhaps, with the brush alone.

Rodchenko's work installed
with the text of his essay
"Everything Is Experiment"
at the *19th State Exhibition*,
1920.

The brush made a great deal of sense in painting objects, in the search for truth, but then less in Impressionism, and even less in Cubism, when artists began to use certain technical devices to aid the brush; and it would be strange for us, when painting our planes, to color them like a housepainter does an outdoor wall.

Painting will not likely return to the impoverished expression of the savage, it may be "barbaric" but nonetheless rendered with the last word in painterly technology.

If, in the future, a master does appear who expresses everything and gives [us] something new despite the poverty of means of expression, believe me, this "poverty" will be a mask allowing for the expression of another wealth—that of contemporaneity.

Contemporary lack of restraint will always conceal within it the meticulous pedantry of contemporary technology. Only the layman will fail to understand this.

Non-objectivity in painting amazes you now because painting has overtaken life, it isn't divorced from it as people think. It only foresees the future. All of you will exist this way, as these non-objective forms, tone, weight, and composition now exist.

People usually say that my paintings are not works [of art], but experiments for some kind of future works or for future artists. I don't agree with this. . . .

The old painters put everything that was done before them—not their own experiments, so to speak—into their works, as well as their own single

experiment, large or small, depending on their genius. With all subsequent works they did the same thing, that is, included others' experiments and their own new one. In essence, this artist was valuable only in one sense—in terms of his own experiment.

But in each work I make a new experiment without the addition of everything old—belonging to others—and in each work I set different tasks. If you look at all my work over time, it is, in fact, one huge work, and completely new, and if you want to add on the old, then you can go to a museum and think about it.

And then, how long could a painter carry the entire burden of old achievements. It would end with him dying in one work, without having painted all the previous achievements, let alone his own. . . .

* * *

Line and color are the foundation of painting.

The composition and texture [*faktura*] of one and the other—are its value, and therefore, the expression of painting itself.

I think that the tasks of composition and construction play a particularly strong role only during the period of something's destruction; during the search for the existence of form itself, the search for form, for tone, weight, then the tasks of composition and construction are not so important and may even be completely absent.

That's the way it was in my pieces of the period of planes divided by lines and circles, where the real plane was cut, color was removed from it, it was shown that a single plane can be rendered not just with one color but with several of different weight and tonality. The main idea—was to destroy their material, obvious existence in the space of the canvas.

They still exist, move, fly, or glide in precisely this way, in a certain place, of a certain material color, weight, and tonality.

The pieces of the black period mark the beginning of the new existence of form in space, and a new space where it is hard to grasp what is space and what kind [of space it is], and what is a form in it, and how that form exists, although weight still remains, it's true, though of a different quality.

Another question presents itself—should texture [*faktura*] exist by itself, or does it serve to strengthen the more important tasks of the work? I think the latter, otherwise you end up with two works in one. One work with its own issues, and the other—coming closer, the admiring of surfaces, which disappear from far away and do not even strengthen the value of the main problems at hand.

* * *

Tradition is a touchstone for the innovator and inventor. The fear of overstepping what has been sanctified by the centuries undoubtedly confuses the artist in his movement.

To be bold and not fear moving far ahead, arriving at a dead end. . . .

There are no dead ends in creative work . . . there is only the dense philistinism of viewers and dilettantes.

The producer will not trip on a "dead end," because of the fact that he is creating and producing. . . .

And nothing is punished as harshly in art as appeasement. If you painted a piece and expressed one small problem, then, despite many enormous blunders, the work will live and exist. But as soon as you start collecting everything without any principle and doing everything in a thoroughly cultured manner—the work will not live, and everything in it will seem stillborn. . . .

* * *

Non-objective painting has left the museums, it is—the street, the square, the city, and the entire world. . . .

The art of the future will not be cozy decorations for domestic apartments.

It will be as necessary as forty-eight-story skyscrapers, grandiose bridges, as the wireless telegraph, aeronautics, submarines, and so on.

1920

THE LINE[81]

In the beginning, figurative painting only set itself the goal of painting objects and people as though they were alive, as things are in fact, to the point of complete deception, or illusion, so that the viewer would think that this is—just a piece of life, and not painting. This involved great labor and persistence, but soon this became too little, more important tasks were found.

Lifelike—means lifelike on the painting as well. . . . But it became necessary to arrange the painting in one size or then in another; to arrange it differently from how things actually occur; to distribute everything more ingeniously, nobly, inspiringly; to give the effect of deliberately indicating what was important in the subject, and placing the rest more or less in the shade; furthermore, the color of tone and the overall tone had to be chosen as harmoniously, as subtly as possible, etc.

As a result of long and persistent work, often on the very same places, in order to achieve all the effects of painting, what appeared in paintings was something abstracted, "not *living*," but more important, closer in essence and more professional—"painterliness," the texture of the surface, various open spaces, varnish, underpainting, and so on; in other words, what appeared was a painterly approach to the picture. Since then, the picture has ceased being itself, it became a painting or a thing.[82]

The newly introduced approach of "painterliness" from then on became an immutable truth and the criterion of any work of painting, including figurative painting.

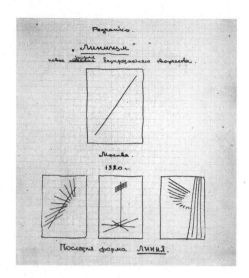

Rodchenko. Sketch for the cover of
Linearism, an unpublished treatise
by Rodchenko. 1920. Pen and ink
on graph paper, $7^{11}/_{16} \times 6^{15}/_{16}$"
(19.5 × 17.6 cm)

Why was this chance element elevated to such heights and permanence? Very simple: this is a professional approach to painting. This is the very essence of painting, as such.

The whole evolution of painting developed exclusively around form, always going forward, rarely turning back, so consistently and logically that a straight line can be seen always pointing to the movement ahead.

This line connects what went before and what came after in a single organism. Developing thus in length and breadth, painting used all the possibilities of its specific qualities, achieving incredible subtleties, to the point of connoisseurship.

Having made use of the object in all its possible treatments, from Realism and naturalism to Futurism, painting, when it moved on to Cubism, dissected it [the object] with almost anatomical knowledge, until it finally freed itself from this obstruction entirely, emerging into non-objectivity.

Casting off the object and subject, painting became occupied exclusively with its own special tasks, which, growing, filled to overflowing the very object and its interpretation, which it [painting] had excluded.

Subsequently, non-objectivity renounced the old expressivity of painting as well; it introduced entirely new ways of painting, more suitable for its forms—geometrically simple, clear, and exact—a blunter, coats of paint applied with a roller, pressing, etc. The brush, so necessary to convey the object and its subtleties in painting, became an insufficient and imprecise instrument in the new, non-objective painting, and it was crowded out by the press, the roller, the ruling pen, the compass. (For the first time in Moscow, at the exhibition of the Left Federation, 1917, works by A. M. Rodchenko.)

Compared to form, color in painting has undergone little evolution. It
moved from gray to brown, from brown to pure bright color and back again,

and this change was one of a strangely identical alternating monotony. Pure color (the spectrum) existed in paints, but painters killed it, mixing tones from it. Tone appeared in painting exclusively due to painting objects, from the search for ways to convey nature. It continued in painting until very recently as a special achievement of painterly culture, and reached utter hideousness, a sort of muddy brown fusion.

The Impressionists turned to the spectrum, but again fashioned it to convey impressions, the air, light, etc. The Expressionists understood color as the play of spots, as ornament.

Non-objectivity cultivated color as such, took on its complete expression, its treatment, its condition, giving [it] depth, intensity, density, weight, and the like. The last stage in this work was the achievement of monochrome intensity within the limits of a single color and intensity (without lowering or raising).

Examples of this are works in the *10th State Exhibition: Non-Objective Creation and Suprematism*, Moscow; works by Rodchenko—black on black, and Malevich—white on white, which were exhibited simultaneously.

Recently, working exclusively on the building of forms and the system of their construction, I began to introduce the line into the plane as a new element of construction. (Works by Rodchenko, 1917–1918.)

The perfected significance of the line was finally clarified—on the one hand, its bordering and edge relationship, and on the other—as a factor of the main construction of every organism that exists in life, the skeleton, so to speak (or the foundation, carcass, system). The line is the first and last, both in painting and in any construction at all. The line is the path of passing through, movement, collision, edge, attachment, joining, sectioning.

Thus, the line conquered everything and destroyed the last citadels of painting—color, tone, texture, and surface. The line crossed out painting with a red cross.

(*19th State Exhibition*, Moscow, 1920, works by Rodchenko.)

(*Lines* announced for the first time in painting.)

Placing the line at the head, as an element with whose help alone one can create and even construct, and in so doing discarding all the aesthetics

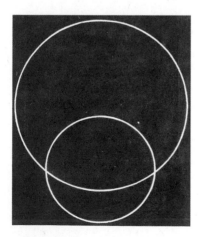

Rodchenko. *Construction no. 127 (Two Circles)*. 1920. Oil on canvas, 24⅝ × 20⅞" (62.5 × 53 cm)

of color, texture, and style, because everything that fences off the construction is style (for example, Malevich's square).

In the line a new worldview became clear: to build in essence, and not depict (objectify or non-objectify); build new, expedient, constructive structures in life, and not from life and outside of life.

Construction is a system by which a thing is executed with an appropriate use of materials, with a previously set goal. Each system demands its own materials and its specific usage, each system will be a discovery or an improvement.

Construction in structures on planes is the projection of possibly real structure, or it is the projection of forms, naturally (according to the system) flowing one from the other, or the construction of forms that are not "eaten" by one another, and each form, distinct in itself, does not diminish the meaning of the other, and all together [they] expediently work according to one system, for that matter, appropriately solving [the problem] of the material, and of the space in which they are located.

In real life, things themselves (objects) are either utilitarian, or art is attached to them as an appropriately used material, and the thing serves its appointed purpose, having almost nothing superfluous, and the exceptions didn't recognize their significance in life.

It's not enough that we're surrounded by things of this sort (falsely decorative), that people run to them, to the churches, museums, and theaters— life itself is not consciously realized, not appreciated, not organized. Man is bored, man talks about labor as something gloomy, boring, where time is wasted in vain. Man speaks about his life as monotonous and empty, with certain exceptions, because he doesn't value the human being in him, the human being who can construct something himself, build and destroy. He goes to the temple, the theater, the museum in order to "escape life, to learn to live". . . . What? But it's simply "beautiful," adorning life decoratively but not building, organizing, constructing. This man needed the opium of art or religion.

And all the former "non-objectivists," presently Constructivists, or constructors, began to work for life and in life.

The first task they set was to work on material constructions.

Isn't it enough [to ask] from us a dull life, in which nothing is valued, nothing is realized, in which everything is—scenery and decorations: man is decorated, his living space is decorated, his thoughts are decorated, everything is decorated by things that are alien and unneeded, in order to hide the emptiness of life.

Up until now, they haven't seen life, this simple thing, they haven't known it, that it is so simple, clear, and only needs to be organized and cleared of all manner of applied trimmings.

Work for life, and not for palaces, temples, cemeteries, and museums.

Work amid everyone, for everyone, and with everyone.

There is nothing eternal, everything is temporary.

Consciousness, experience, goals, mathematics, technology, industry, and construction—this is what is above all else, above art.

Long live constructive technology.

Long live the constructive approach to each endeavor.
Long live CONSTRUCTIVISM.

<div align="right">Moscow, May 23, 1921</div>

ON THE MUSEUM BUREAU
REPORT AT THE CONFERENCE OF DIRECTORS OF GUBERNIYA
DEPARTMENTS OF VISUAL ARTS[83]

The Museum Bureau is implementing the assignments of the Visual Arts Department in the area of building museums and collecting of artistic works in the center and the regions.

The concept of "artistic works" includes:

Painting and its divisions according to materials—oil, tempera, pastel, and watercolor.

Sculpture and spatial forms.

All types of graphic work: etchings, engravings, and lithographs.

Drawings.

The Visual Arts Department is pursuing the following goals in museum building:

1. To serve the State Art Studios with factual material, i.e., an educational goal, by organizing collections under the aegis of the Studios according to the principles of the Museum of Painterly Culture.

2. Cultural-educational work, which is implemented by adding to already existing museums or organizations in the regions; where there are none, according to the principle of the history of the development of artistic form.

Both of these types of building are equally necessary, the first as it will facilitate the development of cultural producers capable of absorbing and understanding artistic production of all types and tendencies.

The Visual Arts Department's principles of museum building are based on a scientific, professional-material approach to art.

The new museum building is based on the principle of a museum showing the stages of development of artistic form, and not on the creation of a museum of a historical nature, which has evolved in its particularly static forms under the capitalist system.

The historic museum of the past is an ARCHIVE, it is a museum that preserves works, and not a museum as cultural factor.

It is built for serving the ethnographer, the specialist, and the amateur.

According to its purpose, even the building technology of old historical museums differs sharply from the principles of the new museum technology.

In a historical museum, the selection of works occurs by chance, the criteria are the subjectively aesthetic recognition of each individual master's history, without any analysis of his goals and achievements.

The overloading of museum walls with works of one and the same master is not taken into account, since the final task of the historical museum is

the desire to take everything without considered evaluation and differentiation among works.

The new museum is being built, above all, of works, and not of artists.

The product of production stands in first place. The selection criteria are the presence of movement or the painterly achievement of the work, on the one hand, and skill on the other.

The first of these criteria might be termed the issue of inventiveness.

It is the dynamic principle that moves art ahead, that prevents it from decomposing and stagnating, which cultivates feeble imitations.

The concepts of inviolable DOGMAS and classical CANONS are exploded by this issue, and the existence of ETERNAL BEAUTY in art is killed.

Everything lives in time and space, and so does the work of art. Dying off, it clears the path and becomes the soil for the next achievements.

The new museum, as a creative principle, is being built of LIVING works that do not yet possess the quality of "historical treasures" (in the narrow sense of the word).

The second issue—the issue of skill—places the work of art on a scientifically professional level.

It limits that bacchanalia of groundless evaluations based on subjective taste, which makes the work kin to a spiritual delicacy, thereby developing a refined connoisseurship in the consumer, who demands only the satisfaction of his desires.

The museum, as an organized form of art's exposure, i.e., its promulgation, should be constructed according to the development of artistic form and skill.

We have dealt with the system of selection for the old and new museum, but one other important technical issue of museum building remains—the INSTALLATION of the works.

In museums truest to the historical method, the installation, no less than the selection, of the paintings emphasizes the museum's characteristic profile— that of an ARCHIVE.

Starting with the principle of individually evaluating the master, the installation of works was resolved very simply—the most recognized artist was placed in the most advantageous location, while the proximity of another artist was defined by historical logic.

Hence the gaps and jumps on the wall that do not allow [one to follow] the developmental path of art's methods.

Maintaining the character of an ARCHIVE quite precisely, the historical museum created the habit of carpeting the entire wall from top to bottom with paintings. Even the physiological impossibility of seeing the artwork wasn't reckoned with.

Those works that were considered secondary ended up high or in the darkest areas of the space.

Economy of space was given priority. The possibility of seeing the work was dependent on the utilization of the space's walls.

The gap between paintings was reduced to the last minimum—works were hung right up next to one another as far as the similarity of their size permitted.

The most cultured attitude toward installation went no further than

DECORATION of the walls with works, that is, the paintings served to fill the walls in accordance with the general decor of the space.

Here the symmetrical distribution of paintings on the wall, with proximity determined by size, was taken for a system.

The new museum building cannot approach installation so superficially, flouting the primary task—TO SHOW the painting.

Above all, the space and the wall are seen as a technical means to show the picture.

Given this approach to the question [of installation], the question of economy in utilizing a given wall no longer arises.

The carpet approach to covering the wall is undoubtedly rejected.

The wall does not play a self-contained role, and the work doesn't adjust to the wall, the work becomes an active agent.

The common principle of installation should correspond to the stages of artistic form's development and artistic methods, and not be based on the chronological order in which a given work was painted.

During the installation, the value of a given stage in art is taken into consideration, the quality and skill of the given work, and not the status of the given master.

The work is hung on the wall with the interval necessary to allow each work to be seen on its own.

In determining the height of the installation required for a given work, the eye level of the viewer and the nature of the work are strictly taken into account, that is, its greater or lesser decorativeness or the diminutive size of the picture.

The proximity of authors as well as works should correspond to the stages of development of artistic form, excluding any intuitive, taste-based approach in the combining of works on the wall.

In placing [the picture] on the wall, the calmest and most neutral position will be sought for the picture, without subjecting it to any special tasks of wall placement.

REPORT ON THE FACTUAL ACTIVITIES OF THE MUSEUM BUREAU

The Museum Bureau was organized in 1918. In the first months of its existence, its activity consisted of developing theoretical questions of museum building and acquisition through materials purchased for the organization of museums. Then it undertook the organization of an experimental Museum of Painterly Culture in Moscow, which at present is located at 14 Volkhonka St., apt. 10.

Local museums began to be organized beginning in August 1919.

Organizational principles: to present as fully as possible the stages of development in artistic form, beginning with Realism up to the latest achievements in art, without overburdening the museum by repeating artists and individual stages in an artist's work.

Furthermore, local conditions were taken into consideration, i.e., the presence of State [Art] Studios and the significance of a given place, and likewise independent initiative from the localities.

During the 1919–20 period, the Museum Bureau organized thirty museums in the following towns: Yelets, Vitebsk, Samara, Astrakhan, Slobodskoe, Penza, Simbirsk, Petrograd, Smolensk, Nizhny Novgorod, Voronezh, Kazan, Ivanovo-Voznesensk, Shuia, Ekaterinburg, Kosmodemiansk, Moscow, Lugansk, Bakhmut, Kostroma, Tula, Ufa, Kishtym, Tsaritsyn, Barnaul, Tobolsk, and Perm. –

A total of 1,211 works have been distributed to the above-mentioned museums, in the following types of art:

Painting—952.

Sculpture and spatial forms—29.

Prints and drawings—230.

The average number of works per newly organized museum is between thirty and forty-five, not including drawings.

At the present time, the Museum Bureau has sixteen requests from localities to organize museums, of which six are feasible.

Between 1918 and 1920 the acquisition staff of the Museum Bureau acquired 1,907 works, which break down into the following types of art:

Paintings—1,415.

Sculptures and spatial forms—65.

Drawings—305.

Prints—122.

The indicated works were acquired from 384 painters and printmakers, and twenty-nine sculptors.

The paintings acquired represent the following art movements: rightist—210 artists, centrist—236 artists, and leftist—twenty-five artists.

Sculptors: rightist—ten artists, centrist—twelve artists, leftist—seven artists.

November 29, 1920. Rodchenko [signature]

REPORT ON A TRIP TO SERGIEV POSAD AND THE VILLAGE OF BOGORODSKOE TO STUDY THE HANDICRAFT SCHOOLS THAT ARE UNDER THE JURISDICTION OF THE DEPARTMENT OF VISUAL ARTS AND COTTAGE TOY INDUSTRY, AND ALSO TO ACQUIRE TOYS FOR AN EXHIBITION AND MUSEUM OF HANDICRAFTS[84]

In Sergiev Posad there is a handicraft school-studio, formerly an affiliated department of the Stroganov Institute.[85] It has two divisions—carving and embroidery. The general impression is exceedingly dreary. It has not yet been reformed according to the new principles, and therefore not only is there no new art, but the school offers nothing and has no value whatsoever. There are few students, only five, and no materials at all. When I visited I found five students, two in the carving studio and three girls in the embroidery studio. In the carving studio they carve little crosses and ornaments, neither of which are of any use in life.

In the embroidery studio they are finishing last year's embroidery. The school's productivity is negligible, there were very few finished works and they were of very poor quality, even from the point of view of the former Stroganov Institute. There is no drawing to be seen, although the director of the school, comrade Risov, said that drawing lessons took place twice a week; however, upon questioning the students it turned out that they had had drawing only one time. The director of the school explained that this is because of the difficult food situation. Perhaps, on the one hand, he is right, but here one has to add something at the same time about the toy studio school that is under the auspices of the Commissariat of Agriculture, and which is in significantly better shape. There, work is going on, there are many more students, drawing is taught carefully, there are many interesting, finished works; personally, I am inclined to think this is explained by the intensity and devotion to work of the school director, comrade Berdnikova. She has three schools and a museum of toys, among which are many examples of genuine art, some of them very old, as much as fifty years old. In general, comrade Berdnikova's attitude toward her work says much in her favor.

For the good of the endeavor, and in order to rectify the dying condition of the school under our aegis, I propose joining these two schools into one under the direction of comrade Berdnikova. Now, about the condition of the handicraft toy industry in the village of Bogorodskoe. It is my first duty to note that the manufacture of handicraft toys in Bogorodskoe has come to a complete halt since the sale of toys has stopped, and, not being subsidized by the state, some of the peasants have left and gone to factories to earn a living, while some carry firewood or work as haulers. From conversations with the peasants, it became clear that they really love their craft and have parted with it only temporarily given the necessity of feeding themselves, since they have little land; the entire harvest is only around a bushel of grain, therefore they have always lived by buying bread. In the event of a revival of the handicraft toy industry in Bogorodskoe, serious attention will have to be paid to this circumstance, which is not devoid of importance. It is interesting that the entire village of Bogorodskoe was involved in carving toys—the old, and women and children. They only stopped working last winter. They didn't have many finished toys available, and when I needed to acquire toys for the museum and for the exhibition, they made them for me in one night; this means they have not forgotten their craft. As far as productivity and output, we should note the following fact: for carving toy soldiers, for example, they previously received eight kopecks per 100; to my question how much they earned in a day making them [now], it turned out to be five to six rubles worth.

As far as the artistic value of the toys, it must be said that the peasants have quite ruined the samples of Bartram, who introduced many academic traditions into this marvelous folk art, but they have not forgotten their own old traditions, and promised to carve me some [toys] according to the earlier examples and send them to the [visual arts] department.[86]

Based on all of this, I insist that the toy production of the village of Bogorodskoe be resuscitated. The state should pay attention to it, since this is the only place where carved wooden toys are produced; they are so valuable

in that they represent a particular type of folk art. Therefore, I propose that the Visual Arts Department take upon itself the revival of toy production; furthermore, the peasants will need to be subsidized at first and given dispensation with regards to fulfilling their military service, since one of the motives of the peasants in leaving to work in factories was also that they were thus freed from military service.

Of course, it will be necessary to pay a great deal of attention as well to the artistic side of production, to send in experienced specialist-artists in order to bring back the old traditions, first of all, and secondly, to know how to propel them on the future path of creation. Of course, it will be necessary to maintain the closest ties with the center, and my thought is that in addition to sending specialist-artists, it would be desirable to send artists of the new tendencies on short-term trips only, so that they can provide them [the peasants] with the correct path through their creative will.

In conclusion: at this time [when] production serving the broad masses is at a halt, when there is not enough fuel, material, or working cadres, [and] workers are dispersing in order to earn a living in ways completely unrelated to their specialty—workers who have many years of practical experience and their own kind of tradition—right now the job of the professional unions is to create new industry connected with the visual arts, because the country will not always be in this situation, it will begin to recover, and when it is able to correctly supply factories and plants with raw materials, then a new cadre of masters should be prepared to be on hand, not dim-witted trainees, but conscientious master artists who know their job and who have wide-ranging initiative and a disciplined system in their approach to materials.

Until now, the visual arts have been used as decoration for salons, offices, objects of domestic use—and professionals repeated themselves endlessly; here you had rococo, the Renaissance, *moderne*, decadence, and many other styles, and all this was faked to the taste of the vulgar petty bourgeoisie with deep pockets, or in the best case to the taste of the weak-willed, whining intelligentsia, which crowded into the entry halls of that same overfed bourgeoisie. The proletariat sat in cellars, took shelter like animals in ditches, it had no time for beauty, for elegance. An engraver or jeweler sat over some gold bauble, sat until midnight—a rush job, sat in front of a green lamp, because rabbits had begun to hop around in front of his eyes from all the detailed work, and he sat there indifferent, like a machine, and could only think about stretching his bones, lying down and resting.

Now, when all our thoughts are directed toward our own public services and utilities, not someone else's, when our boss and lord is our own brain, our willpower and, finally, construction for future generations, we must consider what is to be done to raise the cultural level in our manufacturing.

We should set up studios, laboratories from which an army of master artists will emerge to spread out across the entire country and create new, healthy skills. We must look inside ourselves for the seeds of the new art, the new skills, we must not turn back, we must take specialist-artists, connect our practice with their theory, take what is most important, discard the unnecessary; we need more initiative, more self-awareness; we need to discard all

the tricks practiced by all kinds of organizations, clubs, and proletkults, whose schools are run by all sorts of illiterate drop-outs, Don Quixotes who impose cadres of slapdash slobs, and [where] absolutely nothing comes of nothing.[87] And here is where the professional unions and the factory committees must have their say, they must understand how important [this] is for raising future skills; in order to build a sturdy foundation, skill must be connected to art, and not just any old way, as is done at present, but systematically, in an organized fashion: the state is willing to help in the guise of the Visual Arts Department of Narkompros, and this should be taken into consideration, and when the department calls on the professional unions and factory committees, and other organizations and various clubs to unite and work collaboratively, they should make wide use of this and discard the parallelism and separatism that have existed until now. And this is why the department has set itself the goal of gathering artist-specialists together who have a past and who are on the path of exploration, and of uniting them with the proletarian masters, and of displaying the true strength of their folk expertise, with its identity and class characteristics in production.

The Visual Arts Department is the center that directs all forces capable of setting all the skills connected to the visual arts on the required high level. The department has opened a series of studios for workers, and the unions should send comrades from their milieu who can work to perfect their skills in one or another specialty. Dormitories will be created in the studios, and after passing their course in a special program, the students will be sent on assignment to the regions as directors of similar studios. This requires close ties with the professional unions and the factory committees that have any sort of relationship to the visual arts, and the Visual Arts Department of NKP [Narkompros] has done everything possible to make this work implementable. A Communications and Information Bureau [for maintaining ties] with all the professional unions and factory committees is based in the department, and similar bureaus of communication, for communication with the center, i.e., with the Visual Arts Department [in Moscow], should be organized in their administrations as well.

In conclusion, I should say that I consider the revival of the handicraft toy industry in Bogorodskoe a great project in the construction of a new artistic life. For me, another fact became clear: in what way the schools in the provinces should be reorganized in order to infuse them with a living stream of creativity; and I believe that the only real way out in this respect would be to maintain the closest ties with the center, which I envision not as a bunch of artists from the center visiting and giving them samples, but, on the contrary, the directors of the school—and their students should visit the center for fairly lengthy periods, look at exhibitions here, museums, and meet face-to-face with the New Art, in order to find that which is their very own, that which cannot be had from copying and imitating samples.

FOR A REPORT ON THE ORGANIZATION OF A "MUSEUM OF DECORATIVE ARTS"

If we have done a great deal for painterly culture, then, having paid tribute to the past by organizing a Museum of Painterly Culture, we have dotted the historical "i," it could be said, of easel painting.

Contemporary life, having expressed its special attention to street life and social institutions, in the future will require even more artistic influence on the walls of houses, fences, overhead street banners, signs, windows, the walls of institutions, screens, pillars, our clothes, spectacles, and the like.

It could be said that the decorative arts are uncharted territory, that is, the art that we find everywhere in life; it is done by artists, and craftsmen, and every person who decorates and arranges his living space. And still, no one has seen and no one realizes that there is genuine art in the decorative arts; how significant it is; what path it has taken and where it has gone astray; and, finally, what is its might and power.

In order to elucidate all these questions, it is necessary to lay the first stone by organizing a Museum of Decorative Arts.

The West, a market of art, was amazed by the decorative arts of Russia, and we of course forget about this and are still admiring Napoleon's hairdo and the house of Wilhelm.

Our elders were also famous for their decorativeness.

When entente opens the borders, let the culturally sophisticated West, having patented first place in the cosmetics of the arts, see that in this Barbaric, Bolshevik, Anarchic country—

It exists!

The only original vanguard creators of painting and decorative arts in the world.

For, under siege conditions, cut off from the West, we could only find ourselves again.

At present, the RSFSR demands of us artists posters, banners, agit-monuments, new housing construction, the design of clubs, social institutions, holidays, heroic plays, and all kinds of brilliant decorative structures.[88] And therefore we must stimulate the decorative arts, and this stimulus will simply be the collecting of examples of decorative art, and paying special attention to it, and encouragement through prizes and the acquisition of decorative samples.

Perhaps that ancient old lady, painting (easel painting), has already died, all that art for parlors, dens, dining rooms, teahouses; and it may also be that recent works of innovators still, by inertia, have something in common with the painterly culture of the past. Perhaps today or tomorrow, breaking with the past, it will seem closer and more akin to the decorative.

And the collective labor of the future, perhaps, will consist of a Brilliant decorator who will come up with an idea, and less brilliant [decorators] will develop it and paint the streets and walls, winning glory for themselves and the genius.

The future is not in offices and wide plazas, but under the open sky.

Decorative art will unfold in all its breadth and the grandeur of its mission when it is treated not as it is now, but as the greatest, freest, and most needed of the arts.

And wouldn't the best means of propagandizing the RSFSR for the proletariat of all countries be Grandiose celebrations, Public buildings, Brilliantly constructed housing, clubs, theaters, meetings. Extraordinarily interesting posters, slogans projected in light, and so on and so forth.

In opening a Museum of Decorative Arts, we are beginning a new era in the History of art.

As uncharted territory, the Decorative Art of the world has no dogma, no formulas, no rules, no laws, in contrast to easel painting, and for this reason it can still give everything that we've lost by becoming entangled in the net of painting.

Free, Living, Decorative Art, we are opening the first road for you!

1920

A. RODCHENKO
A LABORATORY PASSAGE THROUGH THE ART OF PAINTING AND CONSTRUCTIVE-SPATIAL FORMS TOWARD THE INDUSTRIAL INITIATIVE OF CONSTRUCTIVISM

1917–1921

(*Automonograph*)[89]

Rejoice!
The revolution of the spirit is before you today.
Harken to the heroes who discarded the centuries-old chains of photographic fidelity, convention, and tradition.
We, the Russian Columbuses of painting,
are discoverers of new roads in art.
Today is our triumph.

Painting
is valuable mainly in that it indefatigably moves onward.
The most valuable thing in it—is innovation,
invention,
exploration,
analysis,
rebellion,
daring.[90]

Linear-constructive constructions on a plane:

Use of a ruling pen. The lines are joined by finding one another. A complete organism, like a skeleton, as the basis. A certain arbitrariness (from art) for agi-

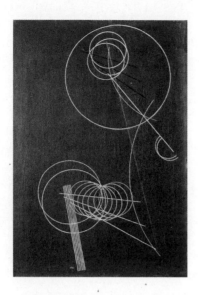

Rodchenko. *Construction no. 106 (on Black)*. 1920. Oil on canvas, 40⅛ × 27⁹/₁₆" (102 × 70 cm)

tational influence. A certain dose of art was necessary to link this achievement, which first appeared in painting, with art, so as not to be discarded from it.

No. 106. 70 × 102. 1920[91]

Line as formula. Element. The contemporary constructive element is positive in every respect. In construction, industry, mathematics, politics. Absence of aesthetics and art. A cage was made in a similar vein as an example of a uniform but dynamically growing contemporary principle of building.

No. 87. 45 × 68. 1919[92]

An entire cycle of drawing-projects that solve a new principle of design, connecting forms according to the system of their appearance. Nothing accidental. Each appearance of another form depends on the initial form. Calculation and system. Nothing of arbitrary taste. Mathematical approach to construction. No one can declare: "But why this or the other?" For given the system, it is necessary. Four circles, their centers, and the given plane.

Engraving-sketch. 1921[93]

These projects are a theoretical linear resolution of space.

When painting takes leave of depiction, drawing loses its value and becomes a sketch or draft of a project. These sketches are an abstract experimental laboratory construction to sharpen the initiative of solutions in real building.

These last sketches, built on right angles, have a connection with spatial constructions no. 23 and no. 30 according to the principle of similarity of building form.

1921

Architectural projects. 1919

These were the first works based on architectural building principles,

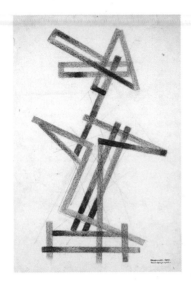

Rodchenko. *Construction no. 17.* 1921.
Black and colored crayon on paper,
19 11/16 × 12 7/8" (50 × 32.7 cm)

made on commission, in which the destruction of architecture was made manifest.

These works dealt with spatiality, and gardens, elevators, electric mountains for sledding, wireless telegraphs, light posters, screens, etc., were erected on the roofs of the skyscrapers.

First done by ruler, treated with mechanical paint covering. Sharpness. The plane is cut by a line. The spatial construction is evident, but not the plane solution.

No. 47. Board. 32 × 74. 1917[94]

For the first time, several colors are introduced on one plane in different treatments, which causes the plane to be broken, balancing only the weight or lightness of the surface's treatment.

(Ruler and mechanical covering with paint and varnishes.)

No. 75. 38 × 75. 1918

Exhibited at *Non-Object[ive Art] and Supr[ematism]* in 1919. In the actual object, in one form, the dynamism of color is clearly expressed, destroying form, bending it and once again correcting it, at the same time not allowing it to violate the balance of the plane.

No. 55. 50 × 66. 1918[95]

The same as no. 75 and no. 55, plus building on the contrast of color, form, borders. The planes break each other; there is no clear existence of planes. They sink and protrude. Here the dynamic of the border (edges) is evident. The plane is also broken by the border—hence the line carries on its struggle for primacy.

No. 56[96]

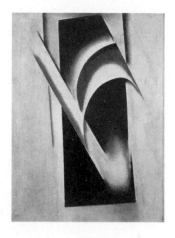

Rodchenko. *Composition no. 56.* 1918.
Oil on canvas, $27^{15}/_{16} \times 20^{1}/_{2}$"
$(71 \times 52$ cm$)$

Pointed Constructivist connectedness of forms, not a planar, but a spatial, three-dimensional relationship. The forms are attached not only in a painterly fashion, but also a constructive one. The whole system of forms can only be put together like a folding chair, and can't scatter. It occupies the space of the board as a completely organized organism. Here the linear passage of even, flat forms, thick paint covering, linear sharpness of the edges is evident.

No. 57. Board. 1918[97]

No. 76. 71 × 89. 1918[98]

Intense color contrast with static structural forms.
No. 70. 70 × 91. 1918[99]

Color emission of the mass with a contrasting linear ring.
No. 61. 36 × 40. 1918[100]

Black on black. Elaboration of one color by means of different surface conditions. Destruction of color for the sake of the material treatment of monotonality.
No. 84. 75 × 75. 1918[101]

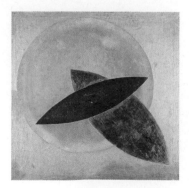

Rodchenko. *Composition no. 84 (Black on Black).* 1918. Oil on canvas, $28^{15}/_{16} \times 29^{5}/_{16}$" $(73.5 \times 74.5$ cm$)$

White on Black. Building on the contrast of the soft forms of the circle and the sharp ends of almost triangles and lines. Likewise contrast in color: white, deep shiny black, and matte, dull black.

No. 71. 60 × 90. 1918

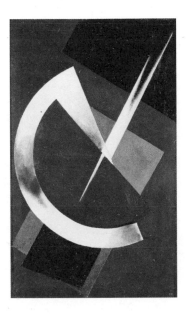

Rodchenko. *Composition no. 66 (Density and Weight)*. 1919. Oil on canvas, 48³⁄₁₆ × 28¹⁵⁄₁₆" (122.3 × 73.5 cm)

Treatment of color to achieve coloration depth and planarity, contrast of varnished colors and color coated with enamel. Built on the treatment and condition of depths.

No. 98. Board. 37 × 71. 1920

Black-white construction on sharp black-white spaces and depths. Static construction, movement is created only by thick black and sharp white colors. Treatment constructed on dappling and washes.

No. 99. 61 × 96. 1920[102]

Construction virtually on paint treatment alone, beginning from painting with wash of enamel paint, varnish, with a press. And ending with a thin rubbing of sizing. In a form constructed with two centers.

No. 72. Board. 21 × 53. 1918[103]

On a heavy dense-black resin background, thin, sharp cutting lines and forms are constructed by contrast with bright colors. Texture ranges from a thin rubbing to a thick loading of tones with glimpses of strong sizing. Spatiality is evident.

The main thing is really the solution of the heavy surface of the background with the cutting and bright lines of the construction itself.

No. 103. Board. 24 × 42. 1920

Rodchenko and Stepanova's studio, 1928. Photograph by Rodchenko

In all, thirty sketches for the revolutionary dynamic play *We* by Aleksei Gan.
I proposed making the costumes myself according to a new principle.

The sketch for the RSFSR workers' costumes was made of only red tones
(red on red) and based on textural contrasts.

"Worker." *We*. Tempera. 1920–21[104]

The same, but in black tones.

"Policeman." *We*. Tempera. 1920–21

These are the last spatial constructions. I developed them experimentally.
Expressly in order to connect the constructor with the law of the appropri-
ate use of forms, their natural joining, and also to show a certain universal-
ism, that from identical forms all sorts of constructions may be constructed
of different systems, types, and uses.

In these works, as [in] real constructions, I set an obligatory condition
for the future constructor of industry:

"NOTHING ACCIDENTAL, UNACCOUNTED FOR."

Reduce everything to a universal initiative, simply, generalize. Because
contemporary industry is individual, and in it, as in art, there are a lot of
"individual concoctions."

About twenty-five of these works were made.

No. 23. Spatial construction. Wood. 1921[105]

The same.

No. 30. Spatial composition. Boards. 1921

The same, but this was a stage on the way to the previous one. Here I first
made identical forms, but this one was not yet a whole organism.

No. 15. Wood. 1921

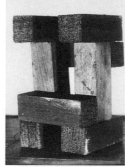
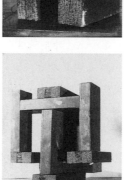

Left to right, top to bottom:

Rodchenko. *Spatial Construction no. 15.* 1921. Wood, 14⁹/₁₆ × 12³/₈ × 9¹/₁₆" (37 × 31.5 × 23 cm)

Rodchenko's standing wood constructions, c. 1921.

Rodchenko. *Spatial Construction no. 18.* 1921. Wood, 7¹/₈ × 6¹/₈ × 1⁹/₁₆" (18 × 15.5 × 4 cm)

Rodchenko. *Spatial Construction.* 1921. Wood, 9⁵/₈ × 5¹⁵/₁₆ × 5¹⁵/₁₆" (24.5 × 15 × 15 cm)

Rodchenko. *Spatial Construction.* 1921. Wood, 15⁷/₈ × 15¹¹/₁₆ × 11¹⁵/₁₆"(40.3 × 39.8 × 30.3 cm)

Rodchenko. *Spatial Construction.* 1921.Wood, dimensions unknown

Photographs by Rodchenko

Here the issue being resolved was the principle of resolved space with forms identical in width and thickness, but their length was not taken into consideration.

The principle resolved here was the largest extrusion from the ground into space while remaining a ground construction.

No. 14. Wood. 1921

Exhibition of Овмоkhu [Society of Young Artists], 1921

Works no. 9 and no. 10 are not experiments in constructing an organic construction, but a new principle of solving the problem of the spatiality of identical forms whose sizes increase mathematically. According to this

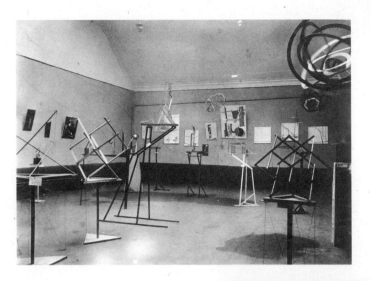

Above: View of the *Second Spring Exhibition of the* Oʙᴍᴏᴋʜᴜ *(Society of Young Artists)*, Moscow, 1921.

Right: View of Rodchenko's *Spatial Construction no. 12* (c. 1920), with the artist in the background.

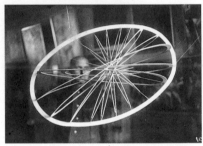

principle, one can build the most varied constructions, but this particular object is deliberately constructed arbitrarily, in order to show the universality of the principle.

The object folds into one circle-shaped plane.

No. 9. Plywood. 1921

The same.

No. 11. Plywood. 1921

This particular work is interesting, at present, mainly in its historical dimension. For the first time: painting moved into real space. Tatlin had not yet resolved to take this step and was making counter-reliefs, which were still glued to the wall, and like painting they were not intended for viewing from all sides.

No. 5. Plywood. 1918. *The Exhibition of Non-Objectivists and Suprematists*. 1919. Moscow

The same.

No. 6. Plywood. 1918. *The Exhibition of Non-Ob[jectivists] and Supr[ematists]*. 1919. Moscow

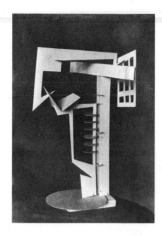

Rodchenko. *Spatial Construction no. 5.*
1918. Cardboard, 13⅜ × 14¾ × 18⅛"
(34 × 37.5 × 46 cm)

WHAT RODCHENKO WAS THE FIRST TO DECLARE AND DEVELOP
(The most important)

1. Used the compass, ruler, stencil (in drawing and painting). 1915. (Exhibition *The Store*, Moscow. 1916.)
2. Used the mechanical treatment of the surface and edges in painting (texture): the roller, scumbling, wash, press, sandpaper, stencil, and so on. 1917. (*Exhibition of the Left Federation*, Moscow. 1917.) (*Exhibition of the Union of Art[ists]-Paint[ers]*, Moscow. 1918.)
3. Introduced spatial sharpness in painting through the introduction of lines as cuts into the surface plane. Fifteen works. 1917–18. (*Exhibition of the Union of Art[ists]-Paint[ers]*, Moscow. 1918.)
4. Made constructive-spatial constructions (folding and disassembling) from plywood. Five pieces. 1918. (*The Exhibition of Non-Ob[jectivists] and Supr[ematists]*, Moscow. 1919.)
5. Developed in texture the principle of "black on black" in painting. Ten works. (*The Exhibition of Non-Ob[jectivists] and Supr[ematists]*, Moscow. 1919.)
6. Introduced the ruler and compass into etching, and developed the contrast of planes and lines as forms. Album of eleven etchings. 1919. (*19th State Exhibition*, Moscow. 1920.)
7. Introduced and declared the line as an element of construction and as an independent form in painting.
 Developed linear construction in painting. Thirty works. 1919.
 (*19th State Exhibition*, Moscow. 1920.) (*Exhibition of the Comintern*, Hotel Dresden. 1921.)
8. Introduced points in painting as an independent form and as an element of support, accent, and the end of any form. Six works. 1919.
 (*19th State Exhibition*, Moscow. 1920.)
9. Resolved and developed spatial constructions according to the principle of identical forms. Introduced natural construction into spatial constructions. (*Exhibition of the Comintern*, Hotel Dresden. 1921.)

10. Resolved the principle of painting one surface plane of any real form. Smooth boards. 1921. (Exhibition $5 x 5=25$, Moscow. 1921.)[106]
11. Substituted working drawings, projects, and sketches for drawings. Introduced natural linear constructions. 1921. (*Exhibition of the Comintern*, Hotel Dresden. 1921.) (Exhibition $5 x 5=25$, Moscow. 1921.)

NOTES

[1.] A street in the center of Moscow.

[2.] The Moscow Museum of Painterly Culture (Moskovskii muzei zhivopisnoi kultury) was founded in 1919. Analogous museums were founded at the same time in Petrograd, Nizhny Novgorod, Vitebsk, and Kostroma; they were essentially museums of contemporary art with equal displays of current artistic tendencies.

[3.] INKHUK (Institute of Artistic Culture) existed in Moscow from 1920 to 1924.

4. Vladimir Evgrafovich Tatlin (1885–1953), painter, graphic artist, set designer, and teacher.

5. This correspondence most likely relates to preparations for the Futurist exhibition *The Store* (*Magazin*) in March 1916; Tatlin was the organizer of the exhibition. For more details, see Rodchenko's memoirs "About Tatlin," included in this volume (p. 76).

6. In Moscow, in March 1917, the Union of Artists and Painters was founded. Three Federations developed out of it: the Senior, Center, and Youth. They were referred to as Right, Center, and Left, respectively. Tatlin was elected chairman of the Left Federation, and Rodchenko, its secretary.

[7.] Goslavsky, Keller, and Dobrova all belonged to different federations of the Union of Artists and Painters.

[8.] The USSR switched to the Gregorian calendar on February 14, 1918. Previously, it had used the Julian calendar, which is thirteen days behind the Gregorian.

9. This document is from the period of preparation for the *5th State Exhibition*, which was held in the Pushkin State Museum of Fine Arts on Volkhonka Street, in Moscow. At the exhibition of the Union of Artists and Painters, works by artists from all three federations were represented equally: the Right (senior), Center, and Left (the youth federation).

10. Although these memoirs were written much later, in 1940, they give a vivid impression of one moment in the history of the Russian avant-garde; they contain factual biographical material, not only on Rodchenko, but on the artists with whom he was connected at the time: Tatlin, Kazimir Malevich, and Aleksandr Vesnin.

11. Aleksandr Aleksandrovich Vesnin (1883–1959), architect, painter, set designer, and teacher.

12. At the end of 1915 and the beginning of 1916, Rodchenko moved to Moscow from Kazan. Varvara Stepanova had been living in Moscow for more than a year, and was working as an accountant at the V.K. Zbuk metalwork factory; in the evenings she studied at the art school of Konstantin Yuon and M. Leblanc, where she met the young artists Tatlin, Olga Rozanova, Nadezhda Udaltsova, Liubov Popova, and Vesnin. Rodchenko used this stretcher to paint the non-objective, semi-Futuristic composition *Dance*, which he showed in the exhibition *The Store*.

[13.] World of Art (Mir iskusstva): a group founded in St. Petersburg in 1898 (in existence until 1924).

14. Liubov Sergeievna Popova (1889–1924), painter, graphic artist, set designer, and teacher. Member of the Left Federation of the Union of Artists and Painters. Participant in many fundamental exhibitions of "left" artists.

Nadezhda Andreevna Udaltsova (1886–1961), painter and teacher. At the time she was a member of the Left Federation of the Union of Artists and Painters. Udaltsova's views on the works of Malevich, Tatlin, and the artistic life of those years are reflected in her book *Zhizn' russkoi kubistki. Dnevniki, stat'i, vospominaniia* (The Life of a Russian [woman] Cubist: diaries, articles, memoirs) (Moscow: RA, 1994).

Alexandra Alexandrovna Exter (1882–1949), painter, set designer, and clothes designer. In 1916–17 she designed sets for Aleksandr Tairov's productions of Innokenty Annensky's *Famir Kifared* and Oscar Wilde's *Salome* at Moscow's Kamerny Theater.

Vera Efimovna Pestel (1886–1952), painter.

Ivan Vasilevich Kliun (Kliunkov; 1873–1943), painter and teacher. At the time he was a devotee of Suprematism and non-objectivity in painting, and a member of the Left Federation of the Union of Artists and Painters.

Lev Aleksandrovich Bruni (1894–1948), monumentalist and printmaker. A participant in the first Futurist exhibitions of the pre-Revolutionary years, he exhibited mostly volumetric composition-assemblages.

Kazimir Malevich (1878–1935), painter.

[15.] The exhibition was called simply *The Store*. It opened in March 1916 in a store at 17 Petrovka St.

16. Maria Mikhailovna Vasileva (1884–1957), painter. At the time she painted in the style of Impressionism and Cubism.

[17.] The Russian word *bespredmetnyi* has been much discussed. Following accepted and familiar usage, I am rendering it as "non-objective." Accordingly, *bespredmetnost'* and *bespredmetniki* are translated as "non-objectivity" and "non-objectivists"; similarly, *predmetnost* is given as "objectivity," when "objectness" is closer to the original meaning. However, in Russian the adjective *bespredmetnyi* literally means "without objects" or "objectless." The Russian word contains no association with concepts of "objectivity" vs. "subjectivity," and is not as clumsy in Russian as its equivalent in English.

By "non-objective drawings," Rodchenko means his 1915 series of abstract compositions implemented with the aid of a ruler and compass.

18. Aleksandr Yakovlevich Tairov (1885–1959), theater director.

Yakov Aleksandrovich Tugendkhold (1882–1928), art critic and art historian.

[19.] Because of the cold, most windows in Russia were a double set, with about six to eight inches between panes; the frame of the outer window was often insulated during the winter to keep out drafts.

20. Aleksei Alekseevich Morgunov (1884–1935), painter. At the time he was part of the Youth Federation.

Aleksei Mikhailovich Gan (1895–1942), avant-garde artist and theater director, graphic designer, publisher, and author of books and articles on Constructivism.

[21.] Savva Timofeevich Morozov (1862–1905), wealthy Russian businessman from a family of textile manufacturers, and a well-known philanthropist who supported artists and the Moscow Art Theater.

[22.] Mossovet: the Moscow soviet, or city council.

23. Ivan Albertovich Puni (Jean Pougny; 1894–1956), painter who lived abroad after 1919. At the time he was a Petrograd artist and participant in Futurist exhibitions.

Natan Isaevich Altman (1899–1970), painter, printmaker, sculptor, and theater set designer.

David Petrovich Shterenberg (1881–1948), painter, printmaker, and teacher. From 1918 to 1920, he was head of the Visual Arts Department of Narkompros (The People's Commissariat of Education). Shterenberg went to Moscow from Petrograd as State Commissar.

[24.] The Visual Arts Department (Izo; Otdel izobraziteľ nykh iskusstv) was part of Narkompros.

Olga Vladimirovna Rozanova (1886–1918), painter. Studied in Moscow and St. Petersburg, participated in avant-garde exhibitions, including *The Store* (with Rodchenko, in 1916). Designed books, posters, and outdoor decorations after the Revolution, and worked at the Visual Arts Department of Narkompros.

25. Rodchenko's first solo exhibition was held in the Club of the Left Federation of the Union of Artists-Painters, on Krechetnikovsky Lane, and was on view for almost two weeks—from March 13 to 25, 1918. He showed works from 1910 to 1917. The pieces from 1917 were related to a new series he had just begun, Movement of Projected Planes.

[26.] Creative work: the word in Russian is *tvorchestvo*. In this manifesto, Rodchenko is writing in a pseudo-biblical style. The word *tvorchestvo*, a noun derived from the verb "to create" (*tvorit'*), is used interchangeably to mean "creation," "art," and "artwork" in the sense of the French word *œuvre*. Since Rodchenko speaks a great deal of the new *tvorchestvo*, clearly distinguishing it from *iskusstvo* (art), which belongs to the old, pre-Revolutionary ways, this translation tries to avoid using the word "art" when Rodchenko uses *tvorchestvo*, even when "art" might be the more standard rendering. Instead, where at all possible, the terms "creation," "creative work," etc. have been used.

27. In 1918, Rodchenko published several article-appeals in the newspaper *Anarkhiia* (Anarchy). He called on artists to create without looking back at the past, called on them to assist innovators in art, and called for a democratic approach to art. At that time the "Arts" section of *Anarkhiia* was the only place he could publish such texts as "The Dynamism of Planes," a description of his series of paintings from surface planes; or "Greetings to the left artists-painters," an announcement of his first solo exhibition in the Club of the Left Federation of the Union of Artists-Painters; or his report to the general assembly of the Union of Artists-Painters, for which he was secretary of the Youth (or Left, as it was still called) Federation. Rodchenko often signed his articles "Anti." This appeal was published in the newspaper *Anarkhiia* (Anarchy), no. 61, May 17, 1918.

28. Published in *Anarkhiia*, no. 41, April 11, 1918.

[29.] Aleksandr Davidovich Drevin (1889–1938), painter; husband of the painter Nadezhda Udaltsova; Drevin exhibited with many different groups; in 1919 he founded ASKRANOV (Assotsiiatsia krainykh novatorov; Association of Extreme Innovators) with Rodchenko and others, worked in the Visual Arts Department of Narkompros with Tatlin, exhibited with AkhRR later in the 1920s. He was arrested in the 1930s and exiled to the Altai region, where he died in 1938.

Natalia Yakovleva Davydova (1873–1926), painter and decorative artist.

30. Published in *Anarkhiia*, no. 85, June 15, 1918.

31. Published in *Anarkhiia*, no. 49, April 28, 1918.

32. In November 1918, Olga Rozanova died. She caught a cold working on the street decorations for the first anniversary of the Revolution, and developed complications. This obituary was written for the "Arts" section of *Anarkhiia*.

[33.] Aleksei Eliseevich Kruchenykh (1886–1968), poet, critic, and artist. Kruchenykh wrote manifestos and articles for Futurist publications, collaborated with the poet Velemir Khlebnikov, and was the inventor of transrational, or *zaum*, poetry, which played on sound divorced from meaning. He wrote the libretto for the Futurist opera *Victory Over the Sun* (costumes by Malevich, 1913), and in the 1920s was a member of LEF and contributor to its journal, working closely with Rodchenko and Mayakovsky; he authored numerous theoretical treatises and screenplays in addition to writing poetry. By the 1930s, he was banned from publishing his work, and became an ardent collector of bibliographical and archival material relating to avant-garde art and early-twentieth-century Russian poetry.

34. Published in the catalogue of the *10th State Exhibition: Non-Objective Creation and Suprematism*, Moscow, 1919.

35. This manifesto was written in preparation for the *10th State Exhibition*. Just before it, in January 1919, Udaltsova, Drevin, Rodchenko, Popova, Vesnin, and Stepanova formed ASKRANOV, a new experimental artistic association of non-objective artists, as a counterweight to Malevich's group of Suprematists. They decided to hold an exhibition of works by members of this association alone. A draft of the group's declaration has even been preserved: "To the Central Exhibition Bureau. Request. To appoint c.[omrade] Rodchenko director of the exhibition of ASKRANOV. From the ASKRANOV: Udaltsova, A. Drevin, A. Vesnin. January 16, 1919." However, later on, the idea of a separate exhibition was rejected, and instead they organized a joint exhibition of non-objective painting with the Suprematists—the *10th State Exhibition*.

[36.] In Russian, *Suprbezy*. Rodchenko is combining the first syllables of "Suprematist" (*suprematist*) and "non-objectivist" (*bespredmetnik*). The awkward, unpronounceable moniker did not stick.

37. These entries are in a regular notebook of graph paper, the size of a half sheet of writing paper. Over the course of three years, Rodchenko made periodic entries, sometimes describing the composition of works he had already finished.

38. This work is most likely one in St. Petersburg's State Russian Museum collection: *Non-Objec-*

tive Composition no. 69, 1918, oil on plywood, from the series Concentration of Color and Form.

39. At this time, Rodchenko was working at the Artistic-Industrial subdivision of the Visual Arts Department of Narkompros, and was involved in industrial design schools and studios. This is the same period as his trip to the village of Bogorodskoe to inspect the school of wood-carvers (see p. 118 for report).

40. Stepanova describes the life of the artistic avant-garde of 1918–20 much later in her diaries. See her book *Chelovek ne mozhet zhit' bez chuda* (Man cannot live without miracle) (Moscow: Sfera, 1994). The rivalry between Rodchenko and Malevich during the period before preparations for the *10th State Exhibition* is discussed in greater detail.

41. In January 1919, a posthumous exhibition of Rozanova's work was held, which was, in effect, the *1st State Exhibition*. The conflict between the Suprematists and the non-objectivists at the time of the exhibition is vividly described in Stepanova's diaries, published in the book *Chelovek ne mozhet zhit' bez chuda*. Apparently, Stepanova intended to prepare and publish a book on Rozanova through the Visual Arts Department. It is not known whether such a book was in fact prepared. The A. Rodchenko and V. Stepanova archive only contains Stepanova's article on Rozanova for an artists' encyclopedia.

42. "Varst" was Varvara Stepanova's pseudonym.

43. One of these works is in the collection of the Astrakhan Picture Gallery.

[44.] Rodchenko is referring to illustrations for Aleksei Kruchenykh's *Gly-gly*.

[45.] Pavel Nikolaevich Filonov (1883–1941), painter, known for his mystical vision of energy in nature and objects, expressed in idiosyncratic, frag-mented images and portraits. Studied in St. Petersburg, participated in avant-garde exhibi-tions, wrote essays on his theories of "analyti-cal art." After the Revolution worked at the Museum of Artistic Culture and GINKhUK (State Institute of Artistic Culture) in Petrograd/Leningrad.

46. Mikhail Fyodorovich Larionov (1881–1964), painter, designer, and founder of one of the first systems of non-objective art—*Luchizm* (Ray-ism), in 1911; Natalia Sergeevna Goncharova (1881–1962), painter, designer, and set designer. Apparently, Larionov's and Goncharova's paint-ings were transferred to the State Moscow Museum of Painterly Culture after the Revolu-tion; the artists, who were married, remained in Paris.

[47.] Vladimir Feliksovich Franketti participated in a number of exhibitions between 1918 and 1927. Biographical details unknown.

48. Vasily Vasilevich Kandinsky (1866–1944), painter, printmaker, and teacher; lived in Ger-many after 1921. For almost a year, between 1919 and 1920, Rodchenko and Stepanova lived in the Kandinsky family house at 8 Dolgy Pereulok (now Burdenko Street).

[49.] Zhivskulptarkh (Zhivopis, skul'ptura, arkhitek-tura; Painting, sculpture, architecture). See note 71.

[50.] A good-quality rag paper used for pen-and-ink drawing that came in 80 × 60 cm sheets.

51. At the end of 1919, Rodchenko began working as the director of the Museum Office of the State Moscow Museum of Painterly Culture.

52. Aleksandr Vasilevich Shevchenko (1882–1948), painter, designer, and teacher. At the time, Shevchenko was teaching in the painting depart-ment of the First State Free Studios, subse-quently called VKhUTEMAS—the Higher State Artistic-Technical Studios.

53. The Council of Masters was the prelude to the organization of INKhUK. This Council included almost all of the leading painters of the period: Kandinsky, Aristarkh Lentulov, Robert Falk, Pavel Kuznetsov, Aleksandr Kuprin, Vladimir Fran-ketti, Nikolai Sinezubov, Aleksandr Shevchenko, Rodchenko, and others. Occasionally, council meetings took place at Rodchenko and Stepanova's apartment. Initially, the artists planned to use the organization only for improv-ing their material circumstances and to aid in organizing exhibitions and other events. Later—when an entirely new goal arose, at Kandinsky's initiative, i.e., studying the laws of creativity—INKhUK came into being.

54. Osip Maksimovich Brik (1888–1945), art critic, writer, and literary theorist. Brik arrived from Petrograd and began working in the Visual Arts Department of Narkompros.

55. The diary was named by the editors. Rodchenko wrote this "ship's log" on standard 35 × 23 cm-format double sheets of lined paper. The dou-ble pages are numbered typographically from 1 to 17. Apparently, these were clean pages from some sort of accounting or "warehouse" book. The sheets are filled only to page 14.

56. This reference is to Rodchenko's 1919 series Black on Black, in which form is perceived as just a function of the difference in texture of strictly defined parts of the painting.

57. Rodchenko is recalling Malevich's 1918 painting *White on White*, exhibited in April 1919 at the *10th State Exhibition*, at the same exhibition where Rodchenko showed his Black on Black series.

58. Rodchenko later used these notes when putting together the conceptual text "Everything Is Exper-iment," see p. 108. Several fragments were used in the text almost without modification.

[59.] UNOVIS, Utverditeli novogo iskusstva (Affirm-ers of the New Art), was a group of artists work-ing with Kazimir Malevich, including El Lissitzky, Nikolai Suetin, Ilya Chashnik, Lazar Khidekel, and others. Under Malevich's direction, UNOVIS put on exhibitions and theatrical performances, and developed a new art curriculum for the Art Institute in Vitebsk. It was founded in 1920, but had largely dispersed by 1922.

[60.] Konstantin Dmitrievich Balmont (1867–1942), poet who emigrated to France in 1920.

[61.] In Russian, *pisat', ne napisav*. The imperfect verb *pisat'* and its perfect form *napisat'* can mean either "to write" or "to paint." Thus, you "write" both a letter and a painting; consequently, artists are often referred to as "authors" of their paintings.

[62.] Vasily Vasilevich Rozhdestvensky (1884–1963), painter, graphic artist, and cofounder of the Knave of Diamonds group.

Pyotr Petrovich Konchalovsky (1876–1956), painter and teacher.

63. MzhK: Muzei zhivopisnoi kultury (Museum of Painterly Culture).

[64.] Ilya Ivanovich Mashkov (1881–1944), painter and teacher, known for his brightly colored landscapes, still lifes, and portraits. One of the founders of the Knave of Diamonds group.

[65.] Konstantin Andreevich Somov (1869–1939), painter and illustrator. Studied at the Imperial Academy of Arts, St. Petersburg; one of the founders of the World of Art group; known for his stylized paintings of eighteenth-century court life; moved to Paris in 1925.

Aleksandr Nikolaevich Benua (Benois) (1870–1960), painter, illustrator, art critic, and art historian from an illustrious artistic family. Wrote many books on the history of Russian and Western European art, collaborated with Diaghilev, designed sets for ballets and operas; lived in Paris after 1927.

66. Rodchenko did not include the fragment within brackets in the version of the text he reproduced in his creative diary. However, in the draft text "On the Museum of Experimental Technology," preserved among other documents, the manuscript ends precisely with the words included here within brackets.

[67.] Georg Cantor (1845–1918), German mathematician.

68. For the *19th State Exhibition* (October–November 1920), Rodchenko wrote two articles: "Everything Is Experiment" and "The Line." A typewritten version of "Everything Is Experiment" was hung next to the artist's works. With "The Line," Rodchenko announced a new cycle of his work, consisting only of linear forms. The text (in a somewhat changed version, compared to that reproduced here) was later printed on a hectograph at INKhUK, in a run of 100 copies. Typewritten versions of both texts were later sewn into a notebook of creative writings, from which we have taken the text included in the present volume.

69. Rodchenko and Stepanova were living in Kandinsky's apartment at the time. The house had once belonged to the Kandinsky family. There was a piano in the apartment, and Rodchenko began improvising in Kandinsky's absence. Rodchenko never specially studied music and did not read notes, so he could not write down his compositions.

70. Aleksandr Alekseevich Shenshin (1890–1944), composer.

71. The reference is to Rodchenko's work as part of the organizing committee of the group Zhivskulptarkh, founded in Moscow under the aegis of the subsection of artistic labor of the Visual Arts Department of Narkompros, in May 1919. Members included (in order of their involvement in the work): the sculptor Boris Korolev, the architects Sigismund Dombrovsky, Nikolai Istselenov, Yakov Raikh, Aleksei Rukhliadev, Nikolai Ladovsky, Vladimir Fidman, and Vladimir Krinsky, the artists Rodchenko and Shevchenko, and the architect Georgy Mapu. The committee discussed theoretical problems and planned new types of public structures.

72. Here Rodchenko means the musician who played the bass tuba.

73. The reference is to the meeting of the only department of INKhUK extant at the time, the Monumental Department. Over the summer, when Kandinsky left, Rodchenko became an unofficial leader of INKhUK. Instead of working according to Kandinsky's plan—reflecting on the emotional-perceptual effect of various colors and forms and searching for opportunities for a synthesis of the arts—members of INKhUK became interested in identifying the objective elements of art. They listened to and discussed reports on Varvara Bubnova's "On Weight in African Sculpture," Nadezhda Briusova's "On the Elements of Music," Boris Shvetsov's "On the Elements of Mathematics," and others. The music historian Shenshin also took part in departmental work.

74. Rodchenko means the Visual Arts Department of Narkompros.

[75.] Varvara Dmitrievna Bubnova (1886–1983), painter, illustrator, and member of INKhUK.

[76.] The Third International, also known as the Communist International, or Comintern, was founded in 1919 and included the communist parties of different countries. The Soviet government used the Comintern to control the actions of foreign communist parties.

[77.] Dmitry Nikolaevich Kardovsky (1866–1943), illustrator and set designer. Exhibited with the World of Art group and worked with VKhUTEMAS after the Revolution.

Natan Borisovich Pevzner (Antoine Pevsner; 1884–1962), sculptor and theater designer; brother of sculptor Naum Gabo. Studied in Paris where he met Alexander Archipenko and Amedeo Modigliani; taught at VKhUTEMAS after the Revolution. Settled permanently in Paris after 1922, where he worked with Diaghilev and developed a version of Constructivism that was philosophically distinct from Rodchenko's in that it did not emphasize the political, collective role of the artist.

Vladimir Davidovich Baranov-Rossiné (Shulim-Wolf Baranov, 1888–1944), artist, and inventor, known in particular for his light and music "symphonies" and sculptures, which developed ideas of the composer Scriabin. Having lived abroad for a number of years, he returned to Russia after the Revolution, participated in avant-garde exhibitions, and taught at VKhUTEMAS. After settling in Paris in 1925, he was arrested as a Jew when the Germans occupied Paris, and died in a concentration camp.

[78.] A street in central Moscow, where the Pushkin State Museum of Fine Arts and the rebuilt Cathedral of Christ the Savior are now located. Rodchenko and Stepanova lived nearby in Kandinsky's house, before he emigrated.

79. Ivan Aleksandrovich Aksyonov (1884–1935), a poet and prose writer. He collaborated with Meyerhold and GVYTM (Gosudarstvennye vysshie teatral'nye masterskie, State Higher Theater Workshops), where Popova also taught.

80. A typewritten copy of the text "Everything Is Experiment" was on display at the *19th State Exhibition* in Moscow, under Rodchenko's works.

81. Rodchenko first wrote "The Line" to explain the principle of his latest paintings, which were built entirely on lines. Later, he had the opportunity to rework the text and print it at INKhUK, on a hectograph, in an edition of 100 copies. The version of the text written for the INKhUK commission varies slightly from this first, original version.

[82.] To understand this passage, it helps to know that in Russian the word for "painting" is *zhivopis'*, which comes from *zhivoi* (live, living) or *zhizn'* (life), and *pisat'* (to write) or *pis'/pismennost'* (writing). Thus, the word for painting in Russian contains the concept of realism, of "life-writing," and a painter is a *zhivopisets*, a "writer of the living." The concepts of "painterliness" and "picturesqueness" are expressed in Russian as *zhivopisnost'*. In Russian, the verb "to paint" and "to write" are the same (*pisat'*). A painter "writes" a "painting" or "life-writing." Rodchenko is playing off the underlying roots of these words in this passage.

83. From the end of 1919 until May 1921, Rodchenko worked as director of the Museum Bureau of the Moscow Museum of Painterly Culture. He was involved in the preservation and registration of works acquired from artists who were living at the time. The statistics on the number of works bought and the number of artists of different tendencies acquired, listed at the end of the report, are interesting, because they show how little leftist art was purchased. The report details the basic principles of the museum's collection—a display of the development of skill and the technology of painting.

84. This report relates to the period when Rodchenko was working in the Artistic-Industrial Subsection of the Visual Arts Department of Narkompros, from around 1918 to 1919. Olga Rozanova was his superior. The report appears to have been taken from a stenographer's record.

[85.] The monastery of Sergei Radonezhsky is located in this town, approximately 70 km from Moscow; the town was renamed Zagorsk during the Soviet period, but its original name, Sergiev Posad, was restored in the 1990s.

The Stroganov Institute in Moscow is the oldest art school in Russia. It was renamed several times during the Soviet period but has always been referred to as the Stroganov Institute.

[86.] Nikolai Dmitrievich Bartram (1873–1931), ethnographer, artist, collector, and founder of the Moscow Handicraft Museum (with a collection of samples from master toy-makers). The museum based on his collection was moved to Sergiev Posad after his death.

[87.] Proletkult: Proletarskaia kul'tura (Proletarian culture), organization founded in 1917 to promote art made by the proletariat for the proletariat; main theoretician was Aleksandr Bogdanov. Proletkult scorned traditional cultural heritage; its members were largely untrained in artistic skills but firmly rooted in political ideology. It did, however, develop an administrative infrastructure separate from the Communist Party, and in the early 1920s had more than 100 sections throughout the country and published numerous magazines. It was highly criticized by the Party (which began to perceive it as a rival in the cultural sphere) and was disbanded in the '20s. All other independent artistic associations were likewise abolished after a decree Stalin issued in 1932.

[88.] RSFSR: Russian Socialist Federation of the Soviet Republic.

89. During 1921 and 1922, Rodchenko pondered the idea of preparing a monograph about his work. The author of the text was supposed to be Aleksei Gan, who by that time had already begun publishing his journal *Kino-fot* (Cine-Photo), and who was preparing his book *Constructivism* (published in 1922). Rodchenko set up a series of his paintings, prints and drawings, and spatial works in order to explicate his most important formal discoveries. Each work was to be accompanied by the artist's commentary. However Gan never did write the introductory text. Only a draft mock-up of the book has been preserved, prepared by Rodchenko, with his own text. Thus, this whole affair may be considered a sort of automonograph. Systematically developing the principle of the continuity of his artistic experiment, announced in the essay "Everything Is Experiment" (p. 108 of present volume), Rodchenko decided to illustrate the continuous line of his work's evolution and to annotate key works in the periods of his painting, graphic, and spatial development. Since time was passing, new projects were to be added to a concluding section of this book. The idea expressed in the title was the evolution from painting to design, from disinterested study to the design of useful objects, from abstraction to reality.

90. The texts at the beginning of this section are from Rodchenko's handmade posters for the *10th State Exhibition*.

91. In his lists, Rodchenko always gave the width first and then the height of the painting. This work is in the collection of the Museum of Private Collections of the Pushkin State Museum of Fine Arts, Moscow.

92. The location of this work is unknown.

93. Linoleum engravings of this type can be found in the Radishchev Museum, in Saratov.

94. This work was sent to the Petrograd Museum of Artistic Culture, and is currently in the collection of the State Russian Museum, St. Petersburg.

95. This work is in the collection of the State Tretyakov Gallery, and was originally purchased for the Moscow Museum of Painterly Culture.

96. This work is in the collection of the State Russian Museum, St. Petersburg.

97. This work is in the collection of the Ivanovo-Voznesensk Museum.

98. This work was sent to Vitebsk.

99. This work is in the G. D. Costakis Collection.

100. This work is in the collection of the State Tretyakov Gallery, where it was transferred from the Moscow Museum of Painterly Culture.

101. This work is in the collection of the Gmurzynska Gallery, Cologne.

102. This work is in the collection of the State Russian Museum, St. Petersburg.

103. This work is in the collection of the Bakhrushin State Central Theatrical Museum, Moscow.

104. Aleksei Gan never did actually write *We*. Rodchenko worked off a short description of the play.

105. No works from the series have been preserved. In 1924, Rodchenko photographed almost all of his spatial constructions from this third cycle, from 1920–21. He then apparently destroyed them, since they occupied too much space in his studio.

A reconstruction of no. 23 is in the collection of the Museum of Private Collections of the Pushkin State Museum, Moscow.

106. This refers to a triptych of three canvases painted yellow, red, and blue.

137

CHAPTER THREE

WORKING FOR LIFE

1921–1939

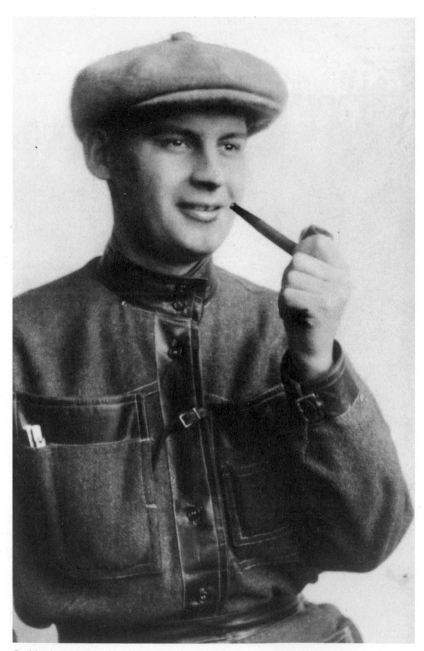

Rodchenko in "production clothing" sewn by Stepanova, 1922.

INTRODUCTION

This is the decade of Rodchenko in his "production suit." Instead of a signature on his works he puts a logo, a monogram consisting of the letters "A" and "R."

While remaining a researcher and analyst, he increasingly acts as an inventor and observer, an organizer and teacher. The "Anti" of the time of experiments in painting turns into the "Constructor Rodchenko." The name "Anti" is reserved only for close family and friends.

In this period of his life he was involved in making posters, printing, and photography; he built set designs for theater and film, traveled to Paris to design the Soviet section of the *Exposition Internationale des Arts Décoratifs et Industriels Modernes*. He moved from painting to "production art," to what today we call "design." He designed dishes, work clothes, textiles, interiors, and furniture. He taught students at the metalworking faculty of VKHUTEMAS how to design objects.

Contemporaries long remembered the new and vivid face of Moscow that evolved thanks to the design and advertising work of the Constructivists, including Rodchenko.

In 1924 Rodchenko began to work in photography. From photomontage with readymade images he moved to independently shooting his own portraits, genre scenes, objects, and architecture. This could have been enough for an entire lifetime. He affirmed the value of new forms of vision, the value of the photo document, the aesthetic expressivity of unusual angles. He dedicated a series of articles to experimental photography that were published in the journal *Novyi LEF* (New left front of the arts), where he was an active participant from the very first issue.

Reflections on life and life itself were closely intertwined during this period. Rodchenko and Stepanova's studio came to resemble an assembly line. There were several tables, a press for gluing photocollages, drawing instruments next to carpenters' and metalworkers' tools. There was a photo laboratory, radio wire strung along the walls, and various homemade radios. Rodchenko discovered the whole new world of technology. The theory of relativity, the conveyor, the scientific organization of labor, the development of the radio, aviation and automobile technology—all of this changed the world around him and simultaneously passed through him.

—A. L.

Construction Is a Contemporary Worldview

SLOGANS

(CONSTRUCTION discipline, director RODCHENKO)

CONSTRUCTION—is the organization of elements.

CONSTRUCTION is THE CONTEMPORARY WORLDVIEW.

ART is one of the branches of *mathematics*, like every other *science*.

CONSTRUCTION is the contemporary requirement for the ORGANIZATION and utilitarian use of *material*.

A CONSTRUCTIVE LIFE IS THE ART OF THE *FUTURE*.

ART *which has not entered life* will be numbered and handed over to the archaeological *museum* of ANTIQUITY.

It is time for ART to merge with life in an organized fashion.

A CONSTRUCTIVELY ORGANIZED life is HIGHER than the bewitchingly intoxicating art of magicians.

THE FUTURE doesn't build monasteries for the ROMAN PRIESTS, PROPHETS, and HOLY FOOLS of art.

Down with ART as a bright PATCH on the mediocre life of a propertied man.

Down with art as a precious STONE amid the dirty, dark life of the poor man.

Down with art as a means TO ESCAPE A LIFE that isn't worth living.

LIFE, a conscious and organized life, capable of SEEING and CONSTRUCTING, is contemporary art.

A PERSON who organizes his life, work, and himself is a CONTEMPORARY ARTIST.

WORK for LIFE and not for PALACES, TEMPLES, CEMETERIES, and MUSEUMS.

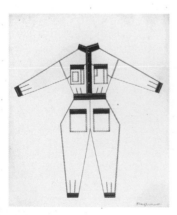

Rodchenko. Design for "production clothing." 1922. Ink on paper, 14⁹/₁₆ × 11¹³/₁₆" (37 × 30 cm)

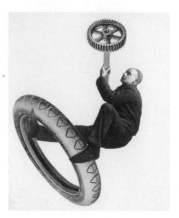

Rodchenko. *Self-Caricature.* 1922. Cut-and-pasted printed papers and gelatin silver photograph on paper, 7¹/₄ × 5⁷/₈" (18.5 × 15 cm)

Work in the midst of *everyone*, for *everyone*, and *with everyone*.
DOWN with monasteries, institutes, ateliers, studios, offices, and islands.
Consciousness, EXPERIMENT, goals, CONSTRUCTION, technology, and
mathematics—these are the BROTHERS of contemporary ART.

February 22, 1921. Rodchenko[1]

WHO WE ARE
MANIFESTO OF THE CONSTRUCTIVIST GROUP
[*c. 1922*]

We don't feel obliged to build Pennsylvania Stations, skyscrapers, Handley
Page Tract houses, turbo-compressors, and so on.

We didn't create technology.

We didn't create man.

BUT WE,

Artists yesterday

CONSTRUCTORS today,

1. WE PROCESSED
the human being

2. WE ORGANIZE
technology

1. WE DISCOVERED

2. PROPAGATE

3. CLEAN OUT

4. MERGE

PREVIOUSLY—Engineers relaxed with art

NOW—Artists relax with technology

WHAT'S NEEDED—IS NO REST

Who saw A WALL. . . .

Who saw JUST A PLANE—

EVERYONE . . . AND NO ONE

Someone who had actually seen came and simply SHOWED:
the *square*.

This means opening the eyes TO THE PLANE.

Who saw an ANGLE

Who saw an ARMATURE, SKETCH

EVERYONE . . . AND NO ONE.

Someone who had actually seen came and simply SHOWED:
A line

Who saw: an iron bridge

a dreadnought

a zeppelin

a helicopter

EVERYONE . . . AND NO ONE.

We Came—the first working group of CONSTRUCTIVISTS—

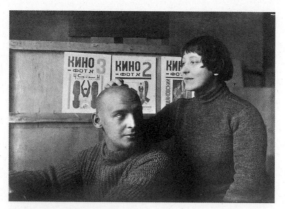

Rodchenko and Stepanova, 1922.

ALEKSEI GAN, RODCHENKO, STEPANOVA

. . . AND WE SIMPLY SAID: This is—*today*

Technology is—the mortal enemy of art.

TECHNOLOGY. . . .

We—are your first fighting and punitive force.

We are also your last slave-workers.

We are not dreamers from art who build in the imagination:

Aeroradiostations

Elevators and

Flaming cities

WE—ARE THE BEGINNING

OUR WORK IS TODAY:

A mug

A floor brush

Boots

A catalogue

And when one person in his laboratory set up

A square,

His radio carried it to all and sundry, to those who needed it and those who didn't need it, and soon on all the "ships of left art," sailing under red, black, and white flags . . . everything all over, throughout, everything was covered in *squares.*

And yesterday, when one person in his laboratory set up

A line, grid, and point

His radio carried it to all and sundry, to those who needed it and those who didn't need it, and soon, and especially on all the "ships of left art" with the new title "constructive," sailing under different flags . . . everything all over . . . everything throughout is being constructed of *lines and grids.*

OF COURSE, the square existed previously, the line and the grid existed previously.

What's the deal.

Well, it's simply—THEY WERE POINTED OUT.

THEY WERE ANNOUNCED.

The square—1915, the laboratory of MALEVICH

The line, grid, point—1919, the laboratory of RODCHENKO[2]

BUT—after this

The first working group of CONSTRUCTIVISTS (ALEKSEI GAN, RODCHENKO, STEPANOVA)

announced:

THE COMMUNIST EXPRESSION OF MATERIAL CONSTRUCTIONS

and

IRRECONCILABLE WAR AGAINST ART.

Everything came to a point.

and "new" constructivists jumped on the bandwagon, wrote "constructive" poems, novels, paintings, and other such junk. Others, taken with our slogans, imagining themselves to be geniuses, designed elevators and radio posters, but they have forgotten that all attention should be concentrated on the experimental laboratories, which show us

NEW

elements

routes

things

experiments.

> —THE DEMONSTRATION EXPERIMENTAL LABORATORY AND MATE-
> RIAL CONSTRUCTIONS' STATION OF THE FIRST WORKING GROUP OF
> CONSTRUCTIVISTS OF THE RSFSR.[3]

PROGRAM OF THE PRODUCTION SECTION OF THE INKhUK CONSTRUCTIVIST GROUP

1) Experimental design of spatial structures for practical tasks. Design of structures (on paper).
2) Construction of spatial structures in real space (maquette, model, detail).
3) Detailed construction experiments on the work, and appropriate use of materials (juxtaposition, attachment, soldering, riveting, and so on).
4) Erecting constructive objects from materials in space.
5) Practical work on constructive structures according to received commissions.
6) Exploratory development of new technical possibilities of building. The possible uses of new materials, their juxtaposition. Invention of details (securing of girders, racks), etc.

The study of the characteristics of materials and their appropriate work.

Theoretical work on developing tectonic tasks of constructive structures.

Study of combining various materials.

Introduction of diaries recording practical work in the laboratories.

A library and card catalogue of the latest technical structures and inventions.

The task of constructive structures:

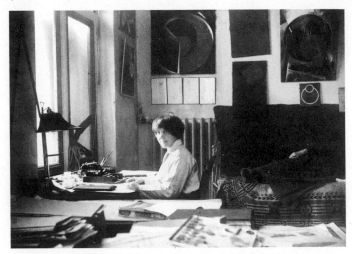

Stepanova in the studio, 1924. Photograph by Rodchenko

1) Experimental laboratories
 (Metalworking, carpentry, chemical, design, modelmaking, photography)
2) Municipal distribution warehouse (Food, print and propaganda, mass consumer [goods], tobacco. . . .)
3) Club of the Red Army
4) Barracks
5) Soviet of Worker and Peasant Deputies
6) Communist pharmacy and health center
7) Hospital
8) Fire depot
9) Hospital
10) Garage
11) Aerodrome
12) Printing house
13) Inventors' House and its studios
14) Workers' university
15) Train station
16) Railroad depot

Setting ourselves the task of working on engineering structures, we will first of all be cleaners, cleansing engineering of aestheticism, dilettantism, superfluity. Without a doubt, there is nothing to add to the constructions of engineering, and we have no intention of adding anything. We intend to remove. And build more. We will teach engineers by building our new constructions and not by walking around their constructions and giving advice.[4]

He pretends to be no one,
Never worries at all,
Rarely changes his costume,
wears no makeup,
remains true to himself, never mocks a soul.

He simply knows how to reveal himself so fully and audaciously that he affects the viewer more than others do.

The tempo of his movement contrasts with the tempo of his partner. He doesn't act—but walks, runs, falls, picks things up, unwraps them, and shows them just as he shows and unwraps himself.

He has no pathos, he isn't monumental—this is his value for the contemporary world—he is momental.

He doesn't need the old tinsel of the stage—set decorations—and the newfangled tinsel—the eclectic, generalized Constructivism of our monumentalists with their gods: dynamo, aero, radio station, cranes, and so on.

He is Charlie Chaplin—he can show everything he needs to with his bowler derby and cane.

Charlie Chaplin was in the circus and knows that things should be either smaller or bigger than a person, that next to a mountain or a dirigible a human being is nothing, but next to a screw and one surface—he is Master.

His colossal rise is precisely and clearly—the result of a keen sense of the present day: of war, revolution, Communism.

Every master-inventor is inspired to invent by new events or demands.

Who is it today?

Lenin and technology.

The one and the other are the foundation of his work.

Thus is the new man designed—a master of details, that is, the future anyman.

Today this is the artist and actor Charlie Chaplin—a master of details.

Stepanova. *Caricature of Charlie Chaplin*. 1922. Woodcut

The masters of the masses—
Are Lenin and Edison.
Why is he needed?—
It's clear:
500,000,000 people
Have lost their own worth, the worth of a wave of the hand. Drunk with the ideology of the sublime, they do not know the purity
Of putting on a bowler derby—
Of a person's walk.
They found out,
That simply nothing—the ordinary—is higher than the pompousness and muddleheadedness of speculative ideologies.
Charlot is always himself—the one and only, the ordinary Charlie Chaplin.

1922[5]

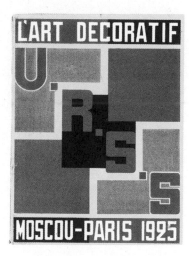

Rodchenko. Cover of the catalogue *L'Art Décoratif U.R.S.S.: Moscou-Paris 1925* for the *Exposition Internationale des Arts Décoratifs et Industriels Modernes*, Paris. 1925. Lithograph, 10⁹/₁₆ × 7¹³/₁₆" (26.8 × 19.9 cm)

In Paris: From Letters Home, 1925

CREDENTIALS

R.S.F.S.R.
People's Commissariat of Education
10/II—25 no. —196

Credentials

This confirms that com. Aleksandr Mikhailovich RODCHENKO has been authorized to travel to Paris as an artist-installer of decorative works for the USSR section of the Paris exhibition of decorative arts.

I request that the relevant organizations expedite his receiving a passport and fulfilling his obligations.

<div style="text-align: right">

People's Commissar of Education

(A. Lunacharsky)[6]

</div>

LIST OF ITEMS FOR THE PARIS EXHIBITION. NO. 1

THEATER SECTION

A. M. Rodchenko—CONSTRUCTIVIST.

Journal *We*. Text by Aleksei Gan. Costumes by A. Rodchenko. Constructivist staging.

1. Peasant.
2. Peasant.
3. Worker.
4. Soldier.
5. Peasant.
6. Petty bourgeois.
7. Merchant.
8. Bureaucrat.
9. Priest.
10. Policeman.
11. Officer.
12. American cabaret singer.
13. Costumes for the eccentrics.

Price for eighteen articles: 800 rub. Not for sale individually.

<div style="text-align: right">

Rodchenko

</div>

LIST OF ITEMS FOR THE PARIS EXHIBITION. NO. 2

MANUFACTURING SECTION

A. M. Rodchenko—CONSTRUCTIVIST.

Design for a tea service commissioned by VKHUTEMAS, Ceramic Department.

1. Tray.
2. Large teapot for hot water.
3. Teapot.
4. Cup and saucer.
5. Sugar bowl.
6. Tea box.
7. Milk pitcher.
8. Rinsing cup.

Price of the service: 500 rub.

<div style="text-align: right">

Rodchenko

</div>

Rodchenko. Design for a teapot. 1922. Ink and gouache on paper, 10⅝ × 14¹¹/₁₆" (27 × 37.2 cm)

Rodchenko. Design for a tea tray. 1922. Ink and gouache on paper, 22¹³/₁₆ × 17⅝" (58 × 44.8 cm)

LIST OF ITEMS FOR THE PARIS EXHIBITION. NO. 3

PRINT SECTION
A. M. Rodchenko—CONSTRUCTIVIST.

Photocollage for the poem *About This*.
1. Cover for the poem. Pub. *LEF*, 1923.
2. "She loved animals. . . ."
3. Mayakovsky—the bear.[7]
4. Everyday life.
5. Everyday life.
6. On the bell tower of Ivan the Great.
7. "She."
8. In the north.
9. Telephone.
10. Growing youthful.
11. Foxtrot.
12. Photocollage from the anthology *Let* [Flight]. Krasnaia Nov [Red soil]: "Propaganda for the Air-Fleet."
13. Photocollage for the cover of the series *Mess—Mend*. Gosizdat, 1924. "Radio-City."[8]
14. Photocollage for cover of the series *Mess—Mend*. Gosizdat, 1924. "Investigative Genius."
15. Photocollage. Advertisement for the film KINO GLAZ [Cine-Eye].
16. Cover: *Down with Imperialist War and Social Traitors*. Author: M. Luzgin. Military Publishing.
17. *Toward a Living Ilich*. Cover. Pub. Krasnaia Nov, 1924.

18. Advertisement for Prombank at the *All-Russian Agricultural Exhibition*.
19–24. Designs for Dobrolet [the state airline] pins, 1923.
25. Cover for the journal *Krasnaia molodezh* [Red youth].
26. Cover for the book *Construktivizm*, by A. Gan.
27. Cover for the book *Okhota za mirom* [Hunt for peace], by Budantsev.
28. Cover for the journal *LEF*. Gosizdat, 1923.
29–30. Covers for the journal *Molodaia gvardia* [Young guard].
31. Cover for the anthology *Let*. Pub. Molodaia Gvardia, 1923.
32. Cover for the journal *Oktiabr* [October]. Gosizdat.
33. Cover for I. V. Gribov's book *The Ignition, Lighting, and Starting of Automobiles*. Pub. Transpechat [Transport press] N.K.P.S. [People's Commissariat of Transportation and Communication], 1925.
34–35. Covers for the book *Questions of Everyday Life*. Pub. Krasnaia Nov, 1923.
36. Cover for the book *New Times—New Work*, by Insarov. Pub. Transpechat N.K.P.S., 1925.

Rodchenko[9]

Rodchenko to Stepanova[10]

March 19, 1925. Riga

Dearest Mulki, old, middle, and young![11]
 I'm sitting in the hotel in Riga, this evening or tomorrow morning I'm going to Berlin. I feel good and healthy. I'll only see a foreign country in Berlin.
 Erdman is here, he sends greetings. He has been living here a long time.[12]
 We arrived in Riga at six in the morning, around ten we'll go to our embassy.
 Don't forget to go by the Academy [of Arts] with the receipt and get your drawings, the ones that didn't go to Paris.
 Pay for the apartment and telephone.
 Greetings to Gan, Esfir, et al.[13]

Anti

March 19, 1925. Riga

. . . Tomorrow, March 20th, we leave Riga at eight in the morning for Berlin. The tickets are through to Paris.
 The money here—is called *laty*, equal to 50 rubles or 100 centimes.
 We already bought two collars and a tie. I look like the devil knows who.
 What's next? It would have been better if I hadn't gone. See, I've even begun to write with a *yat*.[14] I miss everyone. The coachmen in Riga look like Beethovens. So far the foreignness has been completely fake. I'll probably return very soon.

The women walk around wearing their dresses tight in back.
I'll write in more detail from Berlin.

Anti

March 23, 1925. Paris

Dearest Mulka, Mamulka, and Mulichka!

I'm in Paris. I'm sitting in a mansard. Fifth floor. The room costs fifteen francs a day. There's a double bed; it's always that way here. There's always a sink with hot and cold water. A creaky table. Coffee in the morning costs three francs.

It's already spring, the window is open. The traffic is unbelievable. I sent a telegram today with my address.

Write soon.

They took away all the *papirosy*.[15] The baggage is all in one piece but there was a lot of fuss and bother at customs.[16]

"Why are there covers with Lenin?" "Why are there posters with Lenin?"

But never mind, it all worked out. It's really quite difficult to transport a lot of things. The first thing I noticed in Paris—we arrived at night—was that there's a bidet in the room, and this morning—I saw a man selling indecent pictures. I'll write separately about Belgium, Latvia, Germany, and Lithuania. The advertising in Paris is very weak but in Berlin there are some good things. I'm looking a lot, seeing a lot, studying, and I love Moscow all the more.

Kisses. Anti

. . . We brought snow all the way to Paris. It was snowing even in Paris yesterday.

It's hard here without French.

In Germany a radio with a tube costs thirty-six marks, that is, nine rubles.

I'll probably be here until the 1st of July.

How I wish we had manufacturing like this.

They get up early—about seven or eight, and go to bed early too.

. . . By myself I probably wouldn't have got to go to Paris.

So far there's no time to be homesick.

Greetings to everyone.

If anyone writes, don't give out the address for no reason or else they'll go and write a bunch of nonsense. Do give it to Mayakovsky and tell him that the exhibition is May 15.

Kisses, Anti

March 24, 1925. Paris

Dearest Mulkis!

Morits left and I'm still afraid to go anywhere by myself.[17]

What Paris is like outwardly, this city of chic, I'll tell you when I'm home.

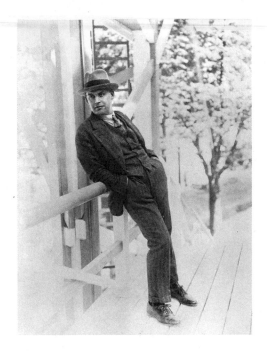

Rodchenko outside Konstantin Melnikov's Soviet Pavilion at the *Exposition Internationale des Arts Décoratifs et Industriels Modernes*, Paris, 1925.

For nothing, that is, for eighty rubles, I bought a suit, boots, and all kinds of little things—suspenders, collars, socks, etc.

Unfortunately, my former self has completely disappeared.

But it's impossible to walk around like that here.

The women cut their hair like men, like you do; they mostly wear brown coats like yours, tight in back, not long; short skirts almost to their knees, and dark-colored stockings, shoes. All in all, sort of like girls. The men—are all different but of course don't dress like I did.

There is so much automobile traffic that people have to wait, gathering on the sidewalk, and then quickly run to the middle of the street, wait again, and finally—run to the other side.

My fellow traveler runs after me in fright. It turns out that I am quite good at this, and he's been abroad before. I laugh at him. The buses are big and they rush along in huge numbers, up to ten at a time, so I've nicknamed them rhinoceroses.

There are almost no horses. Taxis—for a distance from about the Central Post Office to Prechistenka—get sixty-five francs, that is, forty to fifty kopecks.

There are a lot of Russian drivers.

The fashions are truly interesting. Advertising in Paris is bad. Some are interestingly thought out but shoddily done. At night, everything is lit up.

I live in an attic on the fifth floor. It's frightfully hot, the heat is on full blast. I sit in just my shirt, with the window open.

It's hard without the language. My knowledge is fake, and I won't be able to manage it.

I saw the top of our pavilion at the exhibition from a distance. I haven't been there yet, I'll go tomorrow.[18]

Outwardly Paris looks more like Moscow than Berlin. Outwardly, even the people do. Germans are really a very peculiar bunch. It seems like there's cigar smoke all around. [George] Grosz did a great job of revealing what's most characteristic of Berlin society, which really is like that.

I was in Berlin for just a short while—from ten in the morning until nine at night, so I didn't see much. But I looked with very greedy eyes.

I was in Cologne from eleven in the morning until ten at night, saw the Cologne Cathedral inside and outside. Inside it's a forest, expressed in columns, on the top it's like the leaves, and the windows with colored glass are the open patches in the forest at different times of day and night. Asceticism and barrenness, incredible dryness.

The beer isn't all that special, food in Berlin is comparatively expensive for them. There are shortages of bread and sugar, it seems.

The Louvre is right in front of my nose, the exhibition too. So it's convenient.

I'm waiting for your letters, kisses to everyone. Anti

March 25, 1925. Paris

Dear Mulichka!

The pavilion is almost ready. Tomorrow I begin setting up work on the [workers'] club, today I'll get my plans, which were coming in the diplomatic pouch. Our pavilion will be the best in terms of novelty. The construction principles here are completely different from those at home—lighter and simpler. It's a good thing I didn't make any working plans, I'd have had to do them over again here anyway.

Officially the exhibition is supposed to open the end of April, but it will probably open in May. Given what's been built here, it's clear that it's weaker in the artistic sense than our exhibition (the Agricultural).[19]

Yesterday I wandered around Paris in the evening and a little during the day, and to my surprise their advertising is so bad that there's nothing to explain. The illuminated advertising isn't bad, though not in the sense of what's done with it but in the sense that there's a lot and the technology is very good. I dropped into some place called "Olympia," where they dance those fox-trots and so on till morning. It made an enormous impression on me; the women were dressed just in tunics, lots of makeup, ugly and endlessly frightful looking. It was just a brothel, men go up to someone, dance, and go off with any woman. It turns out that these aren't French people but that there are different kinds of things like this set up for foreigners everywhere, while the French spend their time differently—how, I don't exactly know yet, but at any rate not so idiotically.

I get up at seven in the morning, wash myself in hot water forever, rub down with cold, and drink coffee. I eat dinner wherever I happen to be. I'm suffering from cigarettes without a mouthpiece, and I plan to buy a pipe. Now I can see that a pipe can be the best thing to smoke in France, while in Russia, a pipe is just—imitating.

Everything here is cheap, of course comparatively (that is, because our money is expensive; if you live here you would earn less).

Yesterday, watching the fox-trot public, I so much wanted to be in the East and not in the West. But we have to learn from the West how to work, how to organize things, and then work in the East.

How simple, how healthy the East is, and this can be seen so distinctly only from here. Here, despite the fact that they steal from the dances, costumes, colors, walk, types, and life of the East, everything—what they make from it all—is so vile and disgusting that they end up with no East at all.

Yes, but others sit and work, and they create high-quality manufacturing, and again it's a shame that on the best ocean liners, airplanes, etc., there will be and there are all these fox-trots, powders [makeup], and endless bidets again.

The cult of woman as an object. The cult of woman as wormy cheese and oysters—it has gone so far that the fashion is for "ugly women" now, women like rotten cheese, with thin, long hips, breastless and toothless, and with disgracefully long arms covered with red spots, women à la Picasso, women as "Negroes," women as "invalids," women as the "dregs of the city."

And again men, who create and build, tremble with this *"great contagion,"* this *worldwide syphilis of art*.

This is what it all leads to. These are its hard-core flowers.

Art without life, robbing the simplest people everywhere and transforming all this into a hospital.

Well, I've gone and got all worked up, forgive me.

Greetings to everyone, kisses to you all, my dears.

<div align="right">Your Anti</div>

March 27, 1925. Paris

Dear Mulki!

No letters from you and I'm worried.

I run around all day, and evenings are dull. . . . No one to talk to. Today I'm going to start making the plans to scale. It's pouring rain, the room is hot, the window is open all day and night, I sneeze, blow my nose, swear. I've started going to buy things by myself. I say one word, "komsa," and hand over more money than needed, and they give me change, soon I'll have a lot of coins.[20] "Komsa" is a very good word—you can ask for everything with it. If only I could learn a few more utilitarian words like that.

. . . Melnikov told me that someone asked him, "How do you like it in Paris?" (And he was with a Russian artist.) Melnikov replied: "Marvelous, I like it a lot," and he saw the Russian artist turn away. Then Melnikov asked him: "And you?" The other guy answered: "It's all right," and there were tears in his eyes.[21]

They say that there are Russian cafés here where it's unbearable to be, they sing Russian songs and literally sob with homesickness. They say that people who can't go to the USSR can't bear it. And I'm certain that if someone told

me today that I wouldn't return to the USSR, I would sit down in the middle of the street and start crying—"I want my Mama." Of course, these two mamas are different: for them it's Russia, for me the USSR.

Here is my address . . . if it changes, I'll send a telegram. You can also write to our consulate, I go by there every so often.

Today I bought night shoes, without them I was really catching a cold. You really need them here because you get tired spending the whole day in boots; I was remembering my felt boots fondly.

From twelve till two all of Paris breakfasts—everything except the cafés and restaurants is closed. The wine is marvelous but very weak. Since I haven't had any tea, I want it, you don't see it anywhere, like *papirosy*. But strange as it may seem, I don't feel like having tea.

Things are cheap here partly because the material is bad, as what's important to them is to buy things cheaply, be fashionable, and as soon as there's a new fashion, to buy something new. You have to buy English and American products, they have different principles over there.

I'm still in my attic, painted in oil paint the color of a WC. I see lots of things and don't have the opportunity to buy them.

Big kisses to everyone, but especially you and little Mulka, whom I especially want to see, even if from afar.

Kisses, kisses, kisses.

Anti

March 28, 1925

Dearest!

I'm not getting your letters. I can't stand the wait. I'm always thinking about you, I'm very sorry that you aren't with me, I'm so used to doing everything with your eyes, talking to your ears, and thinking together with you.

I'm doing the working plans at Fidler and Poliakov's studio.[22]

Today I wandered around the outskirts of Paris, it was amusing. The workers play soccer, walk arm in arm, dig in their gardens, and dance in cafés.

I knocked off about fifteen *versts* uphill, you could see all of Paris from there.[23] I returned to Paris on the train at nine in the evening, ate supper, and drank real Chablis. The taste of grapes really does stay in your mouth. Quite delicious. In a few days I'm going to see an automobile factory and the building of a cinema factory. There's an offer for me to do the sets for a movie.

March 30, 1925. Paris

I just received your letter! I'm so happy!

Have [Vitaly] Zhemchuzhny send three slogans for the walls of the club, you remember—there on the black stripes.[24] And if he could compose something for a poster for a living newspaper, and write a small text for a wall newspaper.[25] . . .

There's a way to print on fabric at home, and you can make fashionable scarves; I'm thinking that when I get back I'll set you up a production studio for printing various small things.

Cecil B. DeMille's *Ten Commandments* is at the cinema, I'm planning to see it. At first I thought I'd see our generals or officers on the street, but it turned out there's not a one.[26] The officers have become chauffeurs, and I don't know what the generals have become. A lot of people don't work.

Here they say: "How untalented the French are—they've lived in Paris for so many years and don't know Russian." And they also say: "Paris is a province of Russia." It's also said that Russians are the best workers. True, the Russians are Frenchifying themselves a lot, marrying French women.

They want to open the exhibition somewhere between the 20th and the 25th of April after all. They've gone and built so much mediocre stuff—what a nightmare!

At twelve I'm going to watch the painting of the pavilion, at two I'm going out of town to draw the club plans, I'll be home by eleven. It all has to be finished today, and given to the contractor, it will take them three weeks to build it, I'll have to travel to the factory to watch.

Greetings to all.

April 1, 1925. Paris

Yesterday I sat until one with the club plans at Fidler's studio. He did the calculations for me and I painted in his structure, atelier, movie sets. Today we'll give them to the contractor for a bid. Today I bought myself two shirts; I still need to buy a summer coat. I bought a damned hat because you can't wear a cap, since Frenchmen don't wear them, and that's why they look at me with such displeasure everywhere, thinking I'm a German. So there you have it.

Really, here everything is all one way. Women also dress alike, so you couldn't even find your own wife.

The sun is finally out today.

I just gave the plans to the contractor, went to the woodwork and metalwork factory and saw the machines.

I can find my hotel because you can see the Egyptian obelisk on the Place de la Concorde from far away. My real dream—is to live near the Eiffel Tower, then it would always be easy to find the building.

It appears that radio here isn't free, there are very few antennas and stores. In Germany there were radios everywhere.

My eye sees everything here, it sees a lot of things everywhere.

I take walks with Poliakov, he shows me everything and is amazed that I see something everywhere. On Sundays he's going to take me along to studios and factories.

There's a boatload of work to do on the exhibition, now I need to put together the sketches for equipping the rooms—with Poliakov (because Melnikov wants to but doesn't know how, Poliakov did everything for him), and then start hanging.

There are sixty textile drawings by Liubov Popova, and four of yours. Well, that's all right.

I eat a lot—tell mother. At eight in the morning they have two big cups of coffee and two rolls with butter, for three francs. At twelve or one I breakfast in a restaurant: greens, steak, sweets, and half a bottle of wine. At six or seven, dinner. In the evenings I write to you and go to sleep at twelve, because they get up early here.

I've become a complete westerner. I shave every day and I wash all the time.

I'm just afraid that the weather will soon be hot. What do people wear here in the summer? Could they really wear collars? I have twelve collars and two ties now. You just can't get by here without all this. Even so, I feel that I still don't look like the others, and here you need to be like everyone else.

Kisses to everyone and I'm going to sleep.

April 2, 1925. Paris

Dear, sweet Mulichka!

So far, except for little bits along the way, I haven't seen anything. We're working and we still haven't begun to build. Yesterday they wanted to have me do sketches for the rooms of a movie set, but on reading the script I turned it down—it was vulgar and disgusting. I'm beginning to feel homesick. That's what it is, most likely, and nothing else—it's all because everything is alien and lightweight, like it's made of paper, though people work and make many good things, but what for? You can probably find work anywhere here, but what is it for? To wear a hat and a collar and be like all the others, no different? And so I'm thinking I'll set everything up as soon as I can, earn some money, buy some things, and—what bliss—get closer to Moscow. From here the city is so dear.

I'm looking out the window at a blue sky and these flimsy, alien, unreal houses, right out of bad movie pictures. These herds of automobiles on smooth streets, these tightly dressed women, and hats, and endless bidets.

. . . How I'd like to fly into Moscow for a few hours on a Junkers.[27]

Idiots, how is it they don't understand why the East is more valuable than the West, why they love it, too, and why they feel like running from this noisy, paper Paris to the East. It's because everything there is genuine and simple.

Why did I come here and see it, this West, I loved it more when I hadn't seen it. Take away the technology and it's just a lousy junk heap, helpless and sickly.

. . . I don't like and don't believe anything here, and I can't even hate it. It's just like an old artist who has well-made gold teeth and an artificial leg. That's Paris; I wasn't interested in it before but I respected it.

It's strange that everything works and that everything functions well, just as we'd like it to at home. But what's the point of it all? What will happen? And what for? And it's true, the right idea then is to go to China, lie down on your back, and dream about who knows what. The death of Europe—no, it won't die. Everything Europe has done will come in handy,

only it all has to be washed down, cleansed, and a goal set. It isn't all done for women, after all.

I go around in a hat, like an idiot, and people have stopped paying attention to me. I bathe constantly because there's always hot and cold water in the room.

It's nine o'clock now. I went to supper and ate: lousy soup, meat, potatoes, a pasty, and a half-bottle of wine. It all cost eighty kopecks.

. . . Tomorrow we work all day, I'm going to spend the night at Fidler's in Asnières. Fidler—he's the one who works in Izo, in the architectural section with Zholtovsky,[28] I enjoy having tea with him—Fidler suffers because there's no samovar. Find out how much it would cost to send one here in a crate, and I'll find out what the tax would be here. I want to give him a samovar since he's helped me a lot with the plans.

Pevzner said today that Picasso really wants to see me, and Ehrenburg, too.[29] I said in a few days.

There are these very small amateur movie cameras. I saw a correspondent's camera, a five-meter Sept, but I don't know what it costs yet. All in all, the French like money.

I'm writing all jumbled up because you can't say everything and my impressions are quite varied.

Ask Volodya [Vladimir Mayakovsky] when he's thinking of coming. How's Brik? How's mother? How much does Mulka weigh? Have you opened the balcony yet?

I want to go to ZAGS with you and register![30] Sweetheart! Now it's around twelve, I'm going to go to bed, no one will come to kiss me, I put oranges next to the bed. Instead of tea I'm drinking water. So, my little kitten, good night, I kiss your eyes. Don't cry, I'll return all the kisses with interest.

Your Shmulka.

Sweet Mulka!

Coming back from the studio at one last night, I received your letter. I was so glad. I haven't met anyone yet, since work on the exhibition hasn't been sorted out.

April 5, 1925. Paris

. . . Yesterday I had dinner in a very simple restaurant, it felt just like in the movies, with a fat bartender in a vest and with his sleeves rolled up, and a clientele *à la apache*. It's interesting that French women wear very little makeup and don't dress very fancily, many wear no makeup at all. It's our people who come to visit that out-Frenchify themselves. . . .

There's no blue and violet powder. If some do powder themselves it's only the occasional individual.

So far, except for the various metal constructions I've encountered, I haven't seen anything on the streets, but there are a lot of interesting things like that sort of thing everywhere. Everything with our exhibition is all muddled, they write endless telegrams, Morits is nervous, grabs at everything, is

taking phosphorus, and everything's at a standstill. It's all just letters, telegrams, talk. He is responsible for everything and answers for nothing. You can't get money without him but he won't give anyone any money.

Today is Sunday. I'm going to Asnières again to finish the sketches for the walls and rooms in the Grand Palais.[31]

. . . There's nothing the least interesting about me wearing these idiotic suits, I feel horrible in them. And anyway, better to go and take a look at America and not this effeminate Paris.

There's probably nothing to see at this exhibition; they've gone and built all these pavilions that are awful, even at a distance, but close-up it's a horror story. Our's is downright brilliant. All in all, in terms of artistic taste—Paris is architecturally provincial. Bridges, lifts, moving staircases, that's the stuff—that's good.

Kisses to you all.

<div style="text-align: right">Anti</div>

April 8, 1925. Paris

Dearest Mulka!

Tomorrow I'm moving, you'll receive a telegram about it. I'm moving to the hotel "Star"—340 fr. Cheaper, and a better room.

About the automobiles, don't be afraid, it's not a problem at all because the chauffeurs drive well and can stop right away.

They've started to make the furniture, the whole thing will cost about 20,000 francs, i.e., 2,000 rubles—it should turn out interesting. So far I haven't seen anyone else and haven't been anywhere else, Poliakov and I have been working on equipment for the rooms in the Grand Palais. Tomorrow I'll go to the cinema. It was extremely useful to work in the studio with Poliakov and Fidler—I learned a lot from them and taught them a lot.

Tours of Paris and walks have been put off for awhile because of work that needs doing right away. When I have more free time I'll look around. A lot of workers live in Asnières, and I like watching them, how they live and work. There really does seem to be the appearance of all kinds of comforts for them, and independence, and most important, inexpensive recreation, like cafés and restaurants, and the latter are organized quite freely and conveniently for the needs of a city person. I'd really like to see their everyday life closer up. But that's difficult. Of course, you are right—the movement in the streets is interesting, especially in the evening, when the streets are illuminated. I don't know where the advertisement you're thinking about is—like Lautrec. There are only the rare advertisements, i.e., posters, that you can stand to look at.

It seems I've moved to the street of the Arc de Triomphe, the "Star" hotel. I'm sitting and writing, the room is better, it has a fireplace with a clock that doesn't work on the mantel, a bidet again, and a three-to-eight-person bed.

Kisses to everyone.

<div style="text-align: right">Your Anti</div>

[A photo postcard of the Place d'Étoile with the Arc de Triomphe shot from a bird's-eye view was attached to the letter. On the postcard, Rodchenko wrote:]

> This is that very same Étoile or Square of the Unknown Soldier, not far from which dwells your Rodchenko, oppressed in the famous West and not dreaming of returning to it again.
>
> Anti

April 9, 1925. Paris

When we went underground into a station of the Métropolitain I heard songs, some people were singing in chorus, and I was surprised because this has never happened before. Entering the station I saw the arriving and departing trains jam-packed with men who were in a good mood and singing the *"Internationale."* For the first time I understood that I'm not alone in Paris. That all these hats and tightly covered rear ends walk around above the Métropolitain. . . .

In Paris the demand for everything new began not long ago, and now they're producing fabrics, not only with the kind of prints they like to imitate so much in Moscow—fantasies—but I've seen them with geometric drawings as well. All the rooms are papered with similar wallpaper. Tell them at the factory that they're plodding along backward out of cowardice again. Much as I want to I can't send the catalogues right away, it's just not within my power, I haven't seen these stores and don't know them, and there's no time to look for them on my own. I know a lot of streets but there are so incredibly many of them. I ride on the buses by myself, and even in the Métropolitain.

The izba reading room will have to be done.[32]

I'm going to sleep. Kisses.

April 12, 1925. Paris

Dearest Mulka!

Yesterday I went to something like the Casino de Paris. I saw the famous Mistinguet and a couple of wagonloads of naked women, which I'll write about separately.[33] And today I went to see Chaplin.

I'm sitting in the pavilion, working on the Grand Palais. By the 24th everyone must be finished, and there's heaps of work. All of the rooms of the Grand Palais are being painted according to my sketches.

I don't like these Brie and Roquefort cheeses. Oysters, which the others gobble down, make me sick. Having tried all the cigarettes, I settled on the simplest ones, sort of like our third class, they're the best. All the French smoke those, too: "jaune," i.e., yellow, cost one franc seventy centimes, that is, seventeen kopecks for twenty, or "bleue," i.e., blue, twelve kopecks. I'll bring some back [for you] to try. At first I didn't like them either, but now

I'm used to them—I don't smoke anything else. I really am dressed from head to toe in everything new, except my watch. But then in Moscow I won't have to buy anything for two years.

Dearest Mamater!

Your son is still running around Paris, dodging automobiles. Yesterday the traffic was so bad that by evening my head was throbbing. There's a reason why automobiles saved Paris during the siege of Paris. And they say that in London and New York there are several times as many. But don't worry, I'm not very jumpy, I walk calmly. I wait till there's a gap of four or five *sazhens* between the cars.[34] Besides which, I travel by metro, and there's nothing to be run over by there. . . . Russians say "on the metré" and call "Philippe de Roule," "Philippe Duralei." [35] You can ride the "metré" wherever you want for thirty-five centimes, and you can ride all day long underground before you come out—and the ticket is still valid.

Kisses to all, your son of a gun.

Stepanova to Rodchenko

April 13, 1925. Moscow

Mulka, I'll try to write a cheerier letter. There are still many days I'll have to write you letters. Write about how you walk around over there and what you eat, and what language you're speaking.

I start off writing you a sad letter, tear it up, and mother laughs—so you've written another bad one, she says—and you're tearing it up.

It's so dull that there's no one to talk to, to say at least a few words.

I want to know what mood you're in, but letters take so long to arrive. At first I agreed to get only telegrams, but now I already want to know all the details. For the time being you're writing to me, as I'm writing to you, into space, and we'll probably have actual letters only in a month.

Once again I don't feel like writing about anything, I just want to get a letter as soon as possible.

You are probably chuckling, that I'm whining like this.

I'm smiling and kissing you, your Mulka.

Our little Mulka is very happy that you arrived safe and sound and that you're healthy. We send you huge kisses. Only we're bored without you, we talk only about you. We got a letter, and laughed that you're wearing a collar. You must look very silly. You're not dressed in your Moscow style. But what did you attach the collar to anyway, not to your jacket, was it?

My daughter [in-law] is working those covers, but hasn't turned them in yet. Write in detail. Don't worry about Mulichka, she's already so mischievous, she laughs a lot.[36]

I get the telegrams, I'm learning to sign for them myself.

I wish you success in your work.

I send you a big kiss, your Mamulka[37]

Rodchenko to Stepanova

April 15, 1925. Paris

I bought two very good jackets that the workers wear here, one is brown, the other bright blue, for 12 rub. I really like them. I even tempted Poliakov and he bought himself one. And they have the vest-jackets, like Brik does. But those are more expensive and not as good. Anyway, I've already begun to proletarianize my clothes in the Western fashion. I even want to buy corduroy trousers and a blue shirt.

The workers here are so amusing, they say . . . "What the devil are they fencing this nonsense off for, I'm about to kick the bucket and they keep having exhibitions" . . . and all the while they're laughing heartily. The French really are a cheery people. When they exhibited Errio he chuckled, sat down next to his driver, and said: "Well, now I'm a free man. . . ."[38] And it's very funny when the oldest worker in the Grand Palais answers our question about whether we'll finish building everything on time by pointing to his shoulders and laughing: "You can see, I've got broad shoulders," . . . he says, and they're only half the size of mine, and I laugh till I collapse. . . . And still, they are the only healthy ones here.

And how many gouty types there are riding around Paris in special carriages. I seem large and broad here, like Volodya at home. There are tons of people like David (Shterenberg) here.[39]

Your Kit is sitting in his new jacket and looking in the mirror, and he says when I get home you should divorce F. and use your own name.[40] I think I've fallen in love with you all over again, once more I remember you in Kazan.[41] . . .

Sweetest, sweetheart! Anti

April 17, 1925

You've no reason to worry, I received all the letters.

They painted the pavilion like I painted the design—red, gray, and white; it came out wonderfully and no one said a word, that I was the one, but when they need to ask advice—they're always asking me.

Grand Palais, six rooms, the entire color scheme is mine, and again total silence about me. . . .

Poliakov and I did the rooms of: 1) handicrafts 2) VKhUTEMAS 3) prints, advertising, and architecture 4) porcelain and glass 5) textiles; and we're also going to do the reading izba, and probably the theater.

I'll send six pictures of the exhibition being built and in scaffolding, and then I'll send the same six of it finished. Take them to *Technology and Life* or somewhere else, and let them pay you three rubles apiece, only they have to take all six.[42]

I'm mad today, I even left and went home at three. I'm sick of it, they all talk but there's no one to work. I'm sick of Melnikov, all he talks about is a visa for his wife. . . .

But all in all I'm calm: let them thrash it out—that's the way things should be with me, after all; I have to give what I have a lot of, and they don't have a damn thing. I painted Fidler's cinema studio; the project came out marvelously, he bought glass and a frame, he's never had a single project like it. I advised Kusevitsky on how to make a music hall. We'll work up a storm. The one who wins will be the one who can stand it.

Given my mood I'd like to get on a train now and in a week I'd be home . . . but . . . in May I'm thinking of going to London for three days, it costs 25 rub. You're surprised that they work on Sunday. No, on Sunday none of the French work, nor on weekdays from twelve till two. . . .

Kisses to all. Your Hamster[43]

April 19, 1925. Paris

. . . Yesterday evening I wandered around the streets alone, saw a lot of cinemas, circuses, and couldn't make up my mind to go into any of them by myself because there are lots of cashiers and entrances to different bars and dance halls in one place. It's bad without the language.

But our people mostly go to see the "nudes."

Poliakov's wife has come and I'm alone again. I don't know what I'm going to do in the evenings. Chaplin's *The Kid* is on in Asnières. I'm sitting in the pavilion alone now, and I see that the French are muttering.

I haven't been to Elsa's, Morits went to see her.[44]

Now I'm sitting in a restaurant, drinking coffee, I don't want to eat today, just let my stomach get better.

In the newsreels here they always like to repeat the sports bits backward, like the decomposition of movement. . . .

I went to the cinema, saw *Ten Commandments*. Expensive nonsense. . . . I saw Chaplin's famous picture *The Kid* with Jackie Coogan—that was truly marvelous.

My stomach is all better, I'm going to sleep.

Good night.

April 22, 1925. Paris

So far the furniture hasn't turned out very well, it's awfully bulky, heavy. Now the rush is on, it seems they're supposed to open the exhibition on April 26th; true, no one has anything ready in any of the pavilions yet. So it's turning out I'll be back in May.

Everyone's expecting me in the "Rotonde." Everyone knows that I'm in Paris—Picasso, Léger, and various Russians—and I keep not going. So in a few days I'm thinking of changing fronts from viewing technology to viewing art. . . .

Do you think that it's easier for me here than for you? No, you have Mulka, and you're at home, after all, while everything for me is alien amid aliens.

Yes, I haven't made any money here yet. Except for my salary. So there can't be any talk of cameras.

Be careful on the streets. Go see a doctor about your eyes.

I've discovered that the most beautiful women in Paris—are the Negresses, who serve in houses; they laugh so infectiously at Chaplin!

Well, I send you big, big kisses.

April 23, 1925. Paris

. . . This evening I went to one of the circuses, there are four in all. I saw the famous Fratellinis, nothing special but of course they are true masters. I was particularly struck by something else—the special love the audience has for them, and most important, their dressing room, which from one side—is an open door through which everyone can look inside, and a window through which you can see, and they have five rooms and it's a whole museum of things, photos, drawings, etc.

I went to the Salon des Indépendants exhibition—such nonsense and mediocrity. The French have really completely fizzled out. Thousands of canvases and it's all nonsense, downright provincial, I didn't even expect anything like it. Really, after Picasso, Braque, and Léger it's empty, there's nothing. Our Russians are all painting, cranking out non-objective work, bringing it from Moscow, and they're better than the others, but gradually it all descends into rosy taste and that's the end of them.

Rabinovich[45] introduced me to van Doesburg—a leftist architect. But nothing much came of it since he doesn't know Russian and I don't know French, we just looked at one another and went our own ways. For some reason everyone really scrutinizes us in particular, i.e., the people in the pavilion; they're probably interested to see what these Bolsheviks are.

That's all, so long, kisses to everyone.

Anti

April 28, 1925. Paris

Dearest Mulichka!

Could you possibly write through the dip-courier and tell me what Gan or Vertov should do, their best bits of film?[46] It's possible to set up a private showing among left cinema [masters] here; they will show me what they've done and I'll show them our people. Write to me if this is possible.

I got together with Ehrenburg. I went to another two circuses, went to the Louvre. Usually, after lunch, I wander around wherever I can, looking at everything in a hurry. Right now there's no time to write about what I've seen. I'll tell you—when I come.

I get very tired. It seems I brought the paintings in vain. . . .

April 29, 1925. Paris

. . . The exhibition opened, our people will be ready around May 10–15, so I'm thinking of coming home. Mayakovsky, it seems, won't be coming to Paris. Elsa Yurevna told me. I'll go see Léger and Picasso in a few days.

I want your advice. I don't think I'll have any more money. Should I buy the 5-meter Sept, or a simple reflex camera, or more underwear and clothes?[47]

Don't send the samovar, to hell with them, the kids probably won't be coming anyway.[48]

Why no letters from you?

. . . The Grand Palais came out wonderfully. The club still isn't ready, the furniture is, but it's very heavy. Still have to rebuild the booths for Vneshtorg, the color and posters are mine.[49]

. . . Tomorrow I'm going to Asnières at twelve to finish the last plans for the Gostorg pavilion.[50]

You wanted to choose some of the letters and place them with *Novyi LEF*, if you can, do it.

Sweetheart, another month and we'll see each other.

Your lousy dog, who went off to Paris and keeps not coming home, though he himself wants to.

May 1, 1925. Paris

. . . What are you doing, you devils, Christifying with your holiday? I haven't had any holidays and don't know any, I worked on your first day and ate the same thing as always. Everyone's expecting letters from me, letters, but I don't have any addresses, so just let them wait. . . . It's pouring buckets here, I came back from Asnières, it's a good thing my coat is leather. Oh, I'll buy at least one camera, I'll just fulfill my job of bringing a camera. So then, forget the samovar, send a half pound of tea and, if possible, the best bits of *Kino glaz*.

Today I'm walking around thinking "yes or no"—whether to buy the Sept. I really like it. I'll probably buy it tomorrow. Better not buy myself anything else.

I get 2,800 in salary. I earned another 1,800 fr.

. . . Today—is May 1st, and there's not a taxi in all of Paris, only private cars, the streets are suddenly empty. Understand, not a single one, and all the workers are out celebrating, like a big holiday. It's so nice here . . . like it was that time I heard the "*Internationale*."

Kisses for Mulka and mother. Hamster

Stepanova to Rodchenko

May 1, 1925. Moscow

I'm listening to the radio. . . . Spring motifs. Twilight. . . . I'm in a lyrical mood. In my dreams, I was with you, I want to be in real life. They're playing the *"Internationale"* on the radio, with a whole orchestra—they haven't done that in a long time.

I can't seem to write what I want to. . . .

I'm sad that you're homesick there. And I still feel like saying, Come home soon.

Right now I'm hurrying off to Volodya. To hand in work, two posters and four street banners.

A big kiss.

Varst

Rodchenko to Stepanova

May 2, 1925

I bought the Sept with a timer, a 6-meter [film magazine], and a Zeiss Tessar f 3.5, with eighteen cassettes, with a tripod, film, printing thing, etc. I'm sitting here looking it over. It's small, smaller than my 9 × 12 photo camera. But unfortunately the lens has a scratch, tomorrow I'll exchange it.

It's in a good case, and you can shoot photos with it too. . . . I'm terribly happy. . . .

. . . I want to shoot the opening, when Krasin's there, and send [it] to Vertov—I'll be *Kino-Pravda*'s correspondent in Paris.[51] I received [Vertov's] photo from *Kino glaz.* . . .

I'm sitting here admiring everything. Fools and idiots—they have so much of everything, and cheap, and they don't make anything—everyone's "making love." That's the tender name they have for it here.[52]

They make movies with it, too. Women made by the capitalist West, and it will be the ruin of them. Woman-as-thing, that will be their ruin.

And women here really are worse than objects, they are made to form, every part of them: their arms, their walk, body. Today it's the fashion to not have breasts—and not a single one of them has them. . . . Today it's the fashion to have a stomach—and they all have a stomach. Today it's the fashion to be thin—and they're all thin. They really are all like in a magazine.

War and the threat of Germany. That's the only thing that still forces them to do something other than this. Otherwise they would all be "making love."

Oh, to hell with them. . . . I'll take my things and fly out of this country—this republic built on women—like a bullet.

I mean, there are masses of theaters here, where all evening naked women parade on- and offstage in huge, expensive feather boas. They walk around

silently in front of expensive backgrounds and nothing else, they walk by and that's it. . . . Different ones, all kinds, and you see all of them, they walk by naked and everyone's terribly pleased . . . "but what for?". . .

That's their ideal—"different" but naked . . . the women don't talk and don't dance, they don't move. They just walk by . . . one, another, a third, five at a time, twenty at a time . . . and that's it. . . .

I can't even write exactly to what extent *that's all there is*, to what extent these are—"*things*," to what extent this is when, it turns out, that only a man is a person but women aren't people, and you can do whatever you want with them—they are objects. . . .

Your son exchanged the Sept for another one without a scratch.[53] Besides that I bought twelve cassettes, a black tripod, and a big bottle of developer.

Well, so long.

Anti

May 3, 1925. Paris

Dearest Hamster!

I got your letter of the 27th, there was no date, no number.

You write to bring something for Lev Kuleshov and Konoplyova, but what? "Coty" for her, but for him what? A pen, do you think? I'll buy something, but maybe you'll write to me.[54]

I'll arrive with Durnovo from handicrafts, he's also leaving June 1st, it'll be easier for me. He wants me to work in handicrafts.[55]

Don't go and get sick.

The unpleasantness with the exhibition has lifted. After all it's clear to everyone that they're taking from me, and the one who's doing the taking also knows it.

There's work first thing in the morning tomorrow, a big rush.

Now I'm going to admire the camera and go to sleep.

What could I buy Mulechka and mother?

Kisses to all.

May 4, 1925. Paris

Dearest Mulichka!

I loaded the camera, tomorrow I'm going to try and shoot. I can give them to a store to develop.

I'm still waiting for a letter from you telling me whether you got the photo and which of my letters you've received. . . . A day passes, two, I'm all right, but on the third—I get depressed. Today, on our way to Poliakov's, we found him at Sanin's, the director, and here's what he said: that the French were excited about Russian art at first, and then they got scared by the Russians' power and talent. They are all looking, they like everything, but they're afraid.

The Germans elected Hindenburg and the French got scared, so that means again the monarchy, again militarism, a threat to France, and I'm sure that they'll vote out of fear again, elect someone like Poincaré. . . . And it's frightening, "14 million dead" and again 1914. . . . While the English smoke pipes and look down their noses at everything with disdain. . . . The English live in Paris as if in the colonies, and they don't care to know French . . . and in the stores there are signs "We speak English". . . .

Well then. . . . Just as before it was no worse to be Russian, now there is nothing better than to be a citizen of the USSR. But there is a *but*. . . . It means that one has to work, work, and work. . . . The light is from the East . . . not only the liberation of the working class. The light is from the East—in a new relationship to man, to woman, and to objects. Objects in our hands should also be equal, also be comrades, and not black, gloomy slaves like they have here.

The art of the East should be nationalized and rationed out. Objects will take on meaning, will become people's friends and comrades, and people will begin to know how to laugh and enjoy and converse with things. . . .

Just look how many things they have here, which—from the outside, are painted and coldly decorate Paris, and inside they're like black slaves concealing a catastrophe, bearing their black work, foreseeing reprisal against their oppressors.

Mayakovsky is right about "150,000,000."[56] Books will fall apart, and like a revolutionary crowd their pages will destroy the rotten brains of their creators.

Buildings will be smashed to smithereens, fly apart from all that [fucking] and washing of sex organs, and the double beds will stand up, dumping out flaccid, syphilitic bodies.[57]

Well, I've gone off the deep end philosophizing. Forgive me.

This comes over me often, here.

And what are our difficulties there, in the USSR? Here they seem a lot of fluff; it's not Shterenberg and Lunacharsky who are building, after all, but we.

Anti

May 7, 1925. Paris

Dear, sweet Mulichka!

Why aren't there any letters today, you aren't sick are you?

I'm so low. I keep walking around and thinking, "What's going on with you?" Little Mulka isn't sick, is she?

Tomorrow, if I can manage, I'll send a telegram with Morits. What is going on with you?

On Saturday I'll begin painting the club. Everything is going well, there's a lot of work. We're arranging the exhibits. The chess and chairs are good.

Write soon!

Anti

May 9, 1925. Paris

Dearest Zubrik,

I received your letter with the radio music.

I'm exhibiting thirty covers, a tea service, textiles. Now you will be happy, all this is from the things that I brought with me.

Instead of [going to] the ball, we laughed till we cried today.[58] We looked at naked women in a stereoscope and played on different automat-machines—tried our strength, and so on. Volodya knows these, it turns out he played these machines all the time in Paris. . . .

I didn't go to the ball, it was crowded and the performance ends late.

Tell Volodya that Ternovets and Arkin only talk and get in the way.[59] Only Durnovo, Morits, and I are working. Miller and David [Shterenberg] also do a lot for themselves. . . .

Did you get the photo? If you didn't get the photo then I won't send any more, it would be a shame, it's a good photo, I'm wearing a hat.

Kisses to Mulka and everybody else.

I'm writing to you punctually every day.

<div align="right">Your Hamster</div>

Stepanova to Rodchenko

May 9, 1925. Moscow

Dear Mulichka, I found another way to send letters—by airpost. That's how I'm sending this letter.

All of your letters have been received, beginning with no. 2, I didn't get the first one.

Sweetheart, buy the cameras. Dziga asks you to write with the prices for these cameras: Derby, the new Sept, and he'll send you the money.

Dziga is also planning to go abroad with the movie *Gostorg—A Review of Domestic and Foreign Trade*. He asks you to introduce him to cinematographers and to find out names and addresses.

Gan wants to send you money too, I'll give him the Sept prices this evening.

My dearest, when will I finally get to talk to you.

Right now I'm making the stamp for the Earth and Factory brand, according to your design.

Our Mulka has grown, she's become very sweet and interesting.

There's a lot to tell you about what's going on here in literary and artistic affairs.

Did you finally meet any artists, have you been to theaters and the Rotonde?

I'm interested to know what their artists seem like to you, are they working in production, or not?

Dearest, a big kiss, your little puppy dog.

Gan's address: Arbat, 39 Starokoniushenny apt. 20.

Zhemchuzhny's: 53 Arbat, apt. 5.

May 10, 1925. Paris

I repeat again that of the ten textile drawings we submitted to the Academy [of Arts] for the exhibition in Moscow they accepted only four. You can pick up the other six pieces at the Academy and take them home.

The club is ready, we're beginning to paint it, the chess and chairs are good.

Tell Vasilich [Vasily Kandinsky] that Vinogradova is here with the arch[itect] Sologub, she came from Holland.

How's Mulichka? Why does she still weigh twelve pounds? How is mother's health?

I'm afraid our section will finally be open on the 25th. I may be held up in Paris. I still want to make some money for purchases.

Is it true that Volodya is coming? Does he have a visa? Because they're tight with the visas now.

Don't read my letters a lot to everyone.

Well, that's it, I'm sleepy. If there's time I'll write more in the morning. Good night!

And now, Good morning!

The weather is bad. Now I'm going to the exhibition.

Should I buy a small gramophone—portable and it plays well?

I come back to my room, wash, shave, wave my arms about, and to bed. . . .

Well, a big kiss, your Mulia

[No date] *Paris*

Dearest Mulichka,

. . . Here there are millions of things, your head spins from them, you want to buy everything in carloads and bring it home. They produce so many things that everyone seems poor from the impossibility of buying them. . . . If you lived here you'd have to be against all this or become a thief. Steal in order to have it all.

So because of this, here I've begun to love things specifically from our point of view. I understand the capitalist now, to whom everything is too little, but it's the opiate of life—things. You can either be a Communist or a capitalist. There can't be any middle ground here.

True, they don't quite understand *which* are things and *which* are substitutes. But we must produce and love genuine things.

I ordered the Sept lens for shooting distant objects, it will be ready in a week, it costs 650 fr.

I'm glad you got the photo.

There's no time to buy and send photo products (chemicals).

I received the slogans. Send the boot size.

No amount of money is enough here.

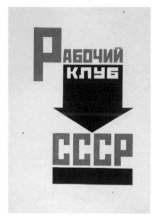

Rodchenko. Designs for the
USSR workers' club at the
*Exposition Internationale des Arts
Décoratifs et Industriels
Modernes*, Paris, 1925.

Left to right, top to bottom:

Lenin Corner. Black and red
india ink and pasted gelatin
silver photograph on paper,
14⅝6 × 10" (36.3 × 25.5 cm)

Library. Black and red india
ink on paper, 14⅜ × 10" (36.5 ×
25.5 cm)

Club entry and announcement
panels. Black and red india ink
and pencil on paper, 14³⁄₁₆ × 10"
(36 × 25.5 cm)

Entry sign. Black and red india
ink on paper, 14¼ × 10"
(36.2 × 25.5 cm)

Chess table. Black and red india
ink and gouache on paper,
14⅜ × 10" (36.5 × 25.5 cm)

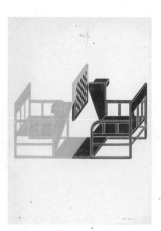

Here's what I would buy, if there were money:
 Derby—600 fr.
 Canon—2,500 fr.
 Single lens reflex camera—300 fr.
 Receiver—250 fr.
Only 130 tenners! How do you like it. How do you like that? . . .

I'll come soon. Tell mother that I really like her letters.

But now I'm getting things together and thinking about departure.

After my work in Paris, traces and results will remain for the future. There aren't any yet, especially since our section hasn't opened.

The furniture is completely ready and painted with enamel, very pretty. In two days I'm going to set it up and photograph it.

Dearest puppy, thank you for Mulka. It's such a joy that she exists.

<div align="right">Your old Mulka</div>

May 11, 1925

Lousy mutt, he writes so rarely.

Tell Volodya that I found a place where they only have automat-machines for games, there are around fifteen of them, and they're all different, for trying your strength and so on. When he comes—I'll show him.

Sometimes I get it in my head that you're walking down the hall and you'll knock on my door. What if you suddenly arrived to surprise me? . . . But then it turns out that it's just someone passing by. . . .

I want you to meet me. . . .

The weather is still bad, rain and more rain, like autumn. It has never been like this in Paris. It's all because you're not here.

And everything in the USSR pavilion is painted in my colors: WHITE, BLACK, RED, AND GRAY.

Sweetheart, beloved! Where are your eyes?

I'll be there soon.

<div align="right">Your Hamster</div>

May 12, 1925. Paris

Dearest Varvara!

The exhibition, i.e., our section and the pavilion, is now definitely set to open on May 23rd. I'll probably leave June 7th–8th. I'll stay about two weeks after the opening.

I asked you to write to me regularly. Tell Zhemchuzhny that when I come I'll work full steam with him on everything.

The club will be amusing, they've done everything. It will be nice in there, and they'll bring everything to Moscow later.[60]

I'll take photos when it's completely ready. Today I'm planning to go somewhere but my companions have disappeared. . . .

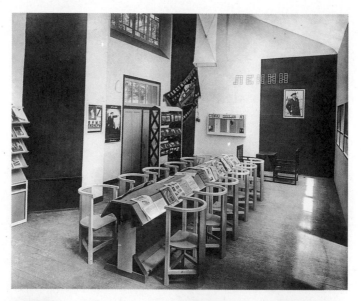

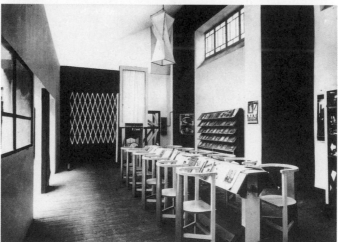

Views of the completed USSR workers'
club at the *Exposition Internationale des
Arts Décoratifs et Industriels Modernes*,
Paris, 1925. Photographs by Rodchenko

Have you filed for divorce?

It's morning, I'm sitting and cleaning up the drawings for the club, I'll exhibit them together with the architecture.

I submitted thirty covers, eleven montages, two hanging signs, six logos, and dishes to the graphics section.

Today I'll try to photograph, tomorrow I'll develop. All the posters are well glued to cardboard, but your costumes are under glass.

A big kiss

May 13, 1925. Paris

I received your no. 15 by airmail, haven't received no. 14 yet.

About the cameras—I don't have any time to go and buy them for the others, I barely found time for myself. And I still don't know how to send them. I'm taking mine with me.

I leave Paris the 5th and will arrive the 8th or 9th, I'll send a telegram from Berlin.

I'm sick of it here because of you. If you were here, it would be fine.

I probably won't bring anything for Esfir since I can't buy anything by myself and it's impossible to ask others. And then they'll tax it as well, and I don't have any money. If I hadn't been doing anything here for two months— but I'm busy all day, I'm only free in the evenings when everything's closed.

I want to go home, kisses.

Anti

May 16, 1925. Paris

Today I received your no. 14 (5.9.1925). Poor thing, how you're missing me, just as I'm missing you. And there's nothing to be done, the exhibition keeps getting postponed and we'll open no earlier than the 25th, but I've firmly decided to leave the 5th. Tomorrow I'll probably give my passport to the embassy—for a visa. I'm going with Durnovo, a wonderful fellow who's been working in applied arts for about twenty-five years. . . .

A reflex camera can be ordered. . . .

I haven't been to Léger or Picasso, I'll go after the opening, I'm leaving ten days for things like that.

Today I tried shooting, tomorrow I'll develop.

There's no point in thinking of selling the paintings here. They buy only the French school or French taste. My glory is all going to David [Shterenberg], he and his artists know what's what, of course. But then there'll be a lot of my works at the exhibition. All the posters are well glued to cardboard and your suits are under glass, as are the rest of my works.

I'll take a photo of everything as soon as it's ready.

Watch your health—when I come we'll have a wedding.

Dearest, a thousand times dearest.

Anti **175**

Stepanova to Rodchenko

May 16, 1925. Moscow

My sweet, dearest, angry, beloved, and all other kinds of Mulka!

Write and tell me whether you've finally met Picasso and Léger.

Yesterday there was another difficult scene with Alyoshka [Aleksei Gan], it's hard to describe in detail, but the main idea was that we have forgotten him and he feels persecuted. He's jealous of Zhemchuzhny. He was a little drunk and even cried. But still, I'd like you to write him a friendly letter. Well, I think you'll understand yourself that his situation is difficult.

So far it's manageable but soon I'm going to beg you to come as soon as possible.

Now, about the license. You can apply and get one but it's tedious.

I received the photo and am waiting for more. Write when you get the cigarettes.

Our Mulka is shouting in such an interesting way while I write this letter.

Varva

Rodchenko to Stepanova

May 19, 1925. Paris

Dear Mulka!

I got the wall newspaper but I don't know if it will go in.

Sweetheart, you're so nervous. You have to stay calm, I can't drop everything here.

After all, I have to lay everything out and hang it, and so far not one of the eight rooms is ready.

Durnovo, Morits, and I do nothing but work, the rest only get in the way. They won't let me go until the section is open.

There are three rooms in the pavilion, one—is Gosizdat, where Rabinovich did everything, below there's someone named Miller—a prof. from Leningrad. And, finally, there's the Gostorg room.

The club isn't in the pavilion but in the gallery, where it's all interior. In the Grand Palais there are six huge rooms, eight meters high, which are holding me up. I'm terribly afraid that we won't open the 23rd but the 1st. . . .

And it's hard to travel alone. . . . I'm trying to convince Durnovo to definitely leave on the 5th.

If Arkin leaves earlier then I'll travel with him. Sweetheart, be patient, our love is only becoming stronger from this!

The furniture is completely ready and painted with enamel, it's very beautiful, in a couple of days I'm going to set it up and photograph it.

The French sell postcards like this, they photograph themselves and print them.

I work day after day, and after lunch it's hot—I feel like sleeping but I

have to go back to hang things.

I'll turn down Viktor's boutique work and say, "To hell with the money."

They won't take my passport for the visa, they say until the section is open they won't let you leave Paris, anyway.

Anyone would take Paris. But I only want to run from here as quick as I can!

If I get the money from the Gostorg, which I did designs for, I'll buy an Ica reflex camera 9 × 12.

Yesterday I bought you something, and myself some albums for preserving Kodak film.

I bought myself a shaving mirror with two sides, one is regular but the other magnifies, and it only cost two rubles.

Kisses to all.

<div style="text-align:right">Anti</div>

Be calm and wait patiently.

May 20, 1925. Paris

Given that everything is being drawn out, or simply everyone's working with no hurry, I decided to work full tilt; I want to set everything out by the 25th, definitely, and leave on the 5th. I get dog tired so I won't write much. I work on my feet from eight in the morning until seven in the evening.

Our USSR section won't open until June 4th, by Krasin's directive. Today I found out that Volodya arrives tomorrow.

They decided to paint the floor in the club black.

Please don't be lonely, the exhibition has to be set up.

It's morning now, I'm leaving for work.

Big, big kisses to all.

<div style="text-align:right">Anti</div>

May 21, 1925. Paris

I'm working hanging Vkhutemas and fighting with David [Shterenberg].

Tell Alyoshka that our masters aren't recognized abroad, only their own or those who've always lived here; that they'll filch everything good and grow younger. I regret a thousand times over that I gave work to the exhibition. Tell him that we are exhausted.

And we have to keep together and build a new relationship between workers in arts labor. We can't organize any everyday life if our own relationships resemble the relationships of bohemians in the West. That's the problem. First—is our everyday life. Second—is to choose well and hold tightly together and believe in one another. . . .

Alyoshka is an individualist, and, like Tatlin, he's begun thinking he's a pure Constructivist!

How are we different from the artists of the West if one of us doesn't

<div style="text-align:right">**177**</div>

recognize another? Only in that even here—they still do know how to choose and respect a few. . . .

I'll probably get a license for my camera here.

Kisses to all. Greetings to Vitaly and Zhenia, Alyosha and Eddi, and others.[61]

I walk so much that I've worn out my Moscow boots—I'm wearing French ones.

Well, so long. Kisses.

<div align="right">Anti</div>

May 23, 1925. Paris

It seems they've definitely decided to open the exhibition on May 28th, although not everything will be ready, but it doesn't matter.

June 1st I'll be free.

You shouldn't bother sending money and cigarettes. There's a huge tax on them and getting them is frightfully tiresome.

They don't take letters by air from Paris, only to Berlin.

Today I hung *Tarelkina*, I did it really well.[62]

Nothing worked out with the textiles (selling them) since here they need brocade with very large drawings, and yours seem very small and not very colorful.

If I get 1,500 fr. from Gostorg I'll buy myself an Ica reflex camera, 6 × 9— if I don't get the money then I'll only buy paper and something for you, stockings and so on, and there won't be enough for anything else.

The dreams of selling have flown the coop, and of publishing books, too.

Paris seen from Moscow is one thing. But in Paris it's altogether different.

<div align="right">Anti</div>

May 24, 1925. Paris

I'm very happy that Volodya has finally set off—it will help me a lot, though probably it will hold me over, too.

I got letter no. 19 and the telegram, too.

I'll buy a Sept, a case for it, and bobbin-cassettes, a case with twelve cassettes, and, if I can find it, an additional lens. And I'll send all this by mail to Goskino's address, let them get the license.[63]

What I'll buy you:

1. A rubber belt.
2. Hat.
3. Boots, i.e., English shoes.
4. Six pairs of stockings.
5. A suit, fall or summer coat.

I'll take my own camera with me and I'll get the papers for it at the trade representative, and before Sebezh I'll check it in transit luggage.[64]

The exhibition will open the 30th, everything is postponed because of not being ready.

Fortunately it's raining in Paris and it isn't hot. My hat is so worn out that at Sebezh I'll hang it on a border post to scare Latvia.

Morits is living in the same hotel as I am. I'm glad that you're writing about Mulka.

<div align="right">Your Hamster</div>

May 25, 1925. Paris

I bought a small gramophone and four records with popular jazz bands.

Maybe instead of a reflex camera I should buy a photo camera that can be loaded with movie film for sixty shots, which only costs 50 fr.

It's too bad that you can't wind up a gramophone in the room, I can only sit and look at it. I'm happy that the end is near, our pavilion opens the 30th.

The gramophone—is for mother.

I got a letter from my brother Vasya, I sent him another one. He was very glad.

I'm not filming. You can't without permission and they haven't given it yet.

Kisses to everyone.

<div align="right">Anti</div>

May 26, 1925. Paris

Again, sad news. The exhibition, that is, our USSR section, won't open until June 4, by Krasin's directive; that means I'll leave the 10th, not earlier.

Today I found out that Volodya will arrive tomorrow.

I got the letter with the photographs. In one of them you are so pretty and in the other very angry. Mulechka is so delicious, and mother also looks good.

The gramophone is silent, I want to listen to it, I only heard it in the store, but let it be quiet until Moscow.

Morits woke me up at nine o'clock and began to cry. They wouldn't give his wife a visa and he has to stay until the end of the exhibition, i.e., until December. He's a bunch of nerves—what to do with him. . . .

I hung my ads. Tomorrow I'll hang my thirty covers, eleven montages, and six logos.

They decided to paint the floor in the club black.

We're working full tilt and it's still not ready.

Greetings to Zhemchuzhny and Zhenia. Tell her that "yours" are better than "ours." (Yours, i.e., Moscow's.) Ours (Paris's) don't have breasts or hips.

<div align="right">Kisses, Anti **179**</div>

Stepanova to Rodchenko

May 27, 1925. Moscow

Dear Rodchenko, I got your letter no. 25 of May 19, where you comfort me and talk about delays in your departure. I didn't seriously think that you could come before June 15th, those were only pleasant daydreams. I beg you not to be upset—stay strong and leave when your work allows it. Especially since Volodka has arrived and may keep you there a bit longer.[65] Therefore, I am taking myself firmly in hand until the end of June and you won't get any more tragic letters.

Alyoshka has started the Association of Workers for the Rationalization of Artistic Labor, which will include the Constructivists (all and various), Kinoki, LEF, and Chuzhak and Proletkult.[66] So far, everyone is favorably inclined and isn't fighting. It's clear to everyone that this kind of organization is necessary.

Oven has pleurisy, nothing dangerous.

Dearest Parisian Mulka, you're working so much you've probably lost weight. You look so thoughtful in the photo.

Mulka is healthy and now weighs over twelve pounds. Starting tomorrow, we're going to give her kissel, she's got so big, and by the time you arrive she'll be standing up and grabbing your ear.[67]

Lili Brik called me today and offered to loan me money until you come, oh my, what kindness.

Kisses, your little doggy

Rodchenko to Stepanova

May 29, 1925. Paris

Dearest Kitty!

I received 102 dollars through Poliakov.

Tell Dziga that there's no 15-meter Sept in Paris, there is in Germany but it's junk.

I already ordered him a camera, as soon as I get the first money by post I'll send it right away.

Volodya arrived yesterday, I walked around Paris with him in the evening and night, today I didn't go to the exhibition, my head aches.

Today I bought a 4 × 6 Ica photo camera with a 2.7 lens for 1,800 francs. Tomorrow I'm going to photograph.

I also bought lining for my leather coat and gloves, I bought you a belt. I want to buy you a skirt and a knitted sweater for the winter.

Volodya will give you the address of the publisher where you can get the money that he forgot to give you.

I'm not going anywhere else, I've seen enough of everything.

Kisses. Your Hamster

May 31, 1925. Paris

Dearest Kitty!

I received letter no. 22. I'm sending a postcard. Don't tell Lili that Volodya and I drank together. Volodya won't hold me up, what's holding me up are traveling companions. Arkin, it seems, is going on the 7th, Durnovo the 15th.

I haven't got the camera by post yet, as soon as I do I'll send it to Dziga and a telegram to you.

It's a marvelous little camera, small, aperture ratio 1:2.7, shutter speed up to 1/1000 sec., with a case. In the evening I went to the exhibition to see how the electricity looked, there were lots of people.

Tomorrow after lunch I may go with Volodya to Versailles. On Sunday we can't work, there are people everywhere.

I'm hanging everything. My posters took up two walls, the prints another wall, costumes another wall. There are four of your textile drawings. A lot of Liuba's [Liubov Popova].

Volodya introduced me to Léger, Tuesday he'll come to look at my work. As soon as I'm free, we'll go to see him.

I'm already used to Paris, I walk around alone. I lunch by myself and buy things, I can travel on the "metré," wander everywhere, go to the movies, the circus. All in all, the French know how to understand a foreigner, what he needs.

Morits will pack the paintings with the club.

I've been spending all sorts of money here, I've bought 6,000 fr.–worth of cameras, i.e., 600 rubles, just don't tell everyone.

Tell mother that I wrote Vaska (my brother) and got an answer, and I sent him a photo of the pavilion.

<div align="right">I kiss you all, your Rodchenko</div>

May 31, 1925. Paris

Today is Sunday. I worked on the club until dinner. At seven Durnovo came by. I haven't seen Volodya today.

I began hanging the photographs and posters in the club.

In the Grand Palais we still have to hang the cinema and photographs and textiles. It's good that Morits will be here until the end of the exhibition, he'll pack everything up. I'm certain that if I hadn't come here, David [Shterenberg] wouldn't have exhibited anything of mine. . . .

I developed the photos, they all came out. Now I'll send some of the club.

I set up a little laboratory in my room, it's good that there's electricity and water.

<div align="right">Kisses. Anti</div>

June 1, 1925. Paris

Dearest Varvara!

Here, finally, is the month when I'll leave for Moscow. So far no changes. The opening is on the 4th.

I went to see Léger, I'm going to show him the paintings and exchange pieces with him after the 4th.[68] He's a wonderful guy.

Go and get the money that Volodya owes you, it's the *Military Herald*, Neglinnaia St., ODVF publishing house.[69]

I'm sending a negative of the workers' club, although some details aren't ready. My new pal Durnovo is in the photo. These are trial shots, I developed them myself.

Volodya and I may do a sketch for the painting of the Vneshtorg Counter.

. . . Well, the club is ready, I'm sending the shots. True, it's so simple and clean and light that you don't want to get it dirty. Everything is shiny enamel, a lot of white, red, gray. . . . Russians get inside every day and read the journals and books, even though the entrance is closed off with a rope.

I talked with Léger and got all conceited. I'm an artist. . . . What Léger's doing I gave up a long time ago. And if I was in Paris, my name would be bigger than Léger's. Nonetheless, I wouldn't want to live here. . . . How are we—in Moscow—any worse? . . .

So there he is, he's working, working, and he lives no better than I do, maybe worse, and he doesn't have many pieces, everything's sold.

But I don't just like to be written about, published, praised . . . I also like to lie in the sun and do nothing at all. . . .

And to suddenly decide to take up cinema photos and the devil knows what else . . . and to be a child, to forget everything . . . and to work on fixing a lock, and read PINKERTON.

Tomorrow is the 2nd! I'll soon be free. The East!

I understand now that there's *no need to imitate anyone*, but to take and *remake things in our own way*.

Well, soon I'll see all the Mulkas.

Your Anti

Stepanova to Rodchenko

June 1, 1925. Moscow

Dear Rodchenok, we received your letter no. 28 of May 24, where you wrote that you want to buy a camera for Vertov.[70] He's very happy and specially asks for an extra telephoto lens.

As soon as you get the camera, send Dziga a letter that you bought such-and-such camera, no., the factory, and so on—this is necessary to get the license.

I wonder whether you got something of the money that I sent.

In general, as far as presents for me go, you don't have to buy anything, since it will be much nicer for me if you rest during your free time than go

asking someone to buy women's things.

You're my dear beloved, how nice it will be to drive home from the station with you.

<div align="right">Your Dog</div>

Your mother sends you a kiss, she's walking around the room with Mulka.

Rodchenko to Stepanova

June 3, 1925. Paris

Dearest Kitty!

Today I got my salary for the last time, from the 5th I'm a free man.

The opening is the 4th, at three in the afternoon. The 5th I'll sleep until eleven and won't go anywhere.

The club turned out so simple and clean and very orderly.

Today I paid like always for a half month for the hotel room, and told them that I'm leaving the 15th.

I didn't get the money or the cigarettes by mail, if I haven't gotten them by the time I leave I won't buy anything for Vertov. . . .

Tell him not to be sad, Poliakov will buy it and send it just as I wanted to.

I probably won't write tomorrow.

<div align="right">Kisses to all, Anti</div>

June 6, 1925

Dear Kitty!

All that's left now are the visas, which I'll hand in tomorrow, and the traveling companions.

Volodka won't keep me here, I turned down everything as I'm tired. But still, I probably won't leave before the 15th. I got all the money.

I'm buying Dziga a camera tomorrow because I only got his money at the post today.

In this letter I'm sending pictures that Ehrenburg took and gave me.

What—has Alyoshka given up cinema? Then I'll work with Vertov. Today I'm a free man, I slept till twelve.

Yesterday I saw the famous movie actor Tom Mix (the cowboy), he's very good!

I've seen all the circuses twice.

I kiss our talking Mulka.

June 6, 1925. Paris

It's broiling hot. Today I got the package, the cigarettes. And I bought a summer suit. The camera will be sent to Dziga on Monday.

On Monday I'm going to the consulate for my passport, and I'm going to pack. It's not as easy to get out of Paris as it was to enter.

I ordered photo paper and film.

I'm sitting smoking a Herzegovina.[71]

I'll go with Morits's wife to buy things for you.

There's no one to travel with, everyone wants to spend more time in Paris: Durnovo until the 18th, I haven't seen Arkin yet.

Well, so long, kisses to everyone. Anti

June 7, 1925. Paris

Dearest Mulka!

Sunday I went swimming in the Seine, it's so hot.

I'm sitting and smoking. Arkin, it seems, will leave on the 15th. But he wants to go straight from France to Königsberg, and from Königsberg, by sea, to Leningrad. You can go from France straight to Riga.

I don't feel like traveling alone, what if they confiscate the cameras.

Now there's nothing to do and I can't leave. . . . Tomorrow I get my documents.

Greetings to everyone, I don't feel like writing anything.

Your Mulka

June 8, 1925

I am sending Dziga Vertov a Sept camera, no. 0905, with a Zeiss 1:3.5 lens, in a leather case with six bobbins.

I don't know when I'll leave, everything depends on the others traveling, who don't want to go as much as I do. Although, now it's interesting to stay a bit in Paris, since today I got a ticket from the General Commissioner giving me the right to film at the exhibition, and I'm going to shoot every day.

I'm afraid that I won't leave before the 20th since everyone wants to rest. And I've already rested, I'm homesick for you, like none of them.

Today the consulate is closed, I wanted to pick up my passport.

Tomorrow I'll see Kaufman's brother.[72]

Haven't seen Volodka in a long time.

It's too bad you aren't writing, I'm still going to write, and here you're writing that that's the last [letter]. . . .

Hello to little daughter Mulia, Zhemchuzhny, Zhenia, Kisses. Anti

June 10, 1925. Paris

Dearest Moom!

I got my exit visa at the consulate; I'm supposed to cross Sebezh before July 9th.

Rodchenko. *Street Trade*. 1928.
(Made with a Sept camera purchased
in Paris.) Gelatin silver prints, diptych,
each print 4⅝ × 6" (11.8 × 15.2 cm)

In two or three days I'll go and collect the visas of the countries I'll be traveling through, tomorrow I'll find out the route. I want to go by sea through Holland to Peter, or a different way.

I will probably leave the 17th or 18th; if I go by sea it's nine days, if by train it's four days.

I do want to see the sea, I really love it.

I'll send Dziga the camera on the 12th.

I went and bought a printing machine for the Sept, I've got about three suitcases full now.

I received permission to photograph at the exhibition, which I'm enjoying, I do the developing myself and I'll print at home.

Kaufman was here. . . . He's a great guy and sympathetic to the Soviets, but what does it have to do with me. . . .

Dziga asked you why I bought a tripod with the Sept. Well, he's an idiot. I bought it, of course, for photos. I bought another one, too—for photographing architecture, inside the rooms, with a long exposure, here the tripods are marvelous and cheap.

There was a huge crowd of French workers at the opening who met Krasin with cries of "Long Live the Soviets" and began singing the "*Internationale*." The police asked Krasin to enter the building and they dispersed the crowd. And De Moncy, saying: "I'm sorry but I am not authorized by my government to attend a demonstration," left quickly.[73]

When Krasin said in his speech that Lenin is everywhere in art because for us his memory is great, De Moncy replied: "It's very nice to know that you also honor great tombs. . . ."

Almost all the newspapers are writing about the Russian exhibition, this much hasn't been written about any of the others, and this—is a definite kind of success.

A number of entrepreneurs have proposed that the exhibition travel for money to Holland and other countries.

Now, don't be sad, kisses, and I want to kiss you.

Anti

June 10, 1925. Paris

Dearest Hamster!

Kogan is leaving for Moscow tomorrow, but I won't go with him.

It's hot now, I'm sitting in my pajamas, I'm going to develop some film and try to print.

I want to get permission to export and leave as soon as possible. I went to the embassy, turned in an application for transporting the things, they crossed out perfume, for that you have to pay duty anyway.

Today there's news, Belgium doesn't give visas to Russians, I'll have to go through Strasbourg.

Volodka has had a misfortune. All his money for America was pickpocketed, 130 dollars, now he doesn't have a kopeck. But they'll loan him money at the embassy. He also owed me 280 fr., now he probably won't give them back.

I'll bring Liberman a pen and I don't know what yet for Kopylova. And for you I'm bringing myself, dressed in ten shirts, three suits, and with a suitcase full of cameras. Cheerful, healthy, and joyful.

I'll send a telegram about my departure and where I am.

Kisses. Anti

June 14, 1925. Paris

I got permission to transport the things.

I bought a suitcase, I'll pack on Tuesday.

I got a notice about 15 fr. That's probably Eddi. I can get them but I can't buy anything. There aren't any women around. I can't buy anything without them. . . . Morits left for a week to the sea with his wife.

I'm going with Arkin, tomorrow we get our visas if they don't hold them up. We leave the 18th by train.

I'm happy that everything is moving toward departure.

I'll leave the paintings, Morits will send them with the exhibits.

I send you a kiss and soon will be kissing you.

There aren't any letters from you.

Your Hamster

The VKhUTEMAS Professor

DISCIPLINE: GRAPHIC CONSTRUCTION ON A PLANE

Details from Rodchenko's notebook. Lessons in graphic construction on a plane, with examples of incorrect (above) and correct (below) solutions to the assigned problem. 1921

Initiative

Assignment no. 1.

Conditions

Take FIVE pieces of paper of any size but which have dimensions with a 2 × 3 proportion.

Then take *three forms* of any size: *circle, triangle, and rectangle.* The base of the triangle should be equal to the radius of the circle.

Principles of construction

Make *five structures* from the three given forms:

 1. Along the diagonal from right to left.

 2. Along the diagonal from left to right.

 3. Along the vertical.

 4. Along the horizontal.

 5. Free structure (you can build from any forms in any quantity).

Rules

 1. When constructing you must organize all the forms into a single organism, taking the space of the paper strictly into account and not just laying the forms out. (An example of an *incorrect* structure for the first assignment is "Structure along the diagonal from left to right," see drawing no. 1.)

 2. The structure must under no circumstances be ornamental or correctly symmetrical.

3. The forms should not simply be linked one after the other in a chain.
4. Be careful to make sure that the forms are neither small nor large in relationship to the size of the paper. And the same goes for the organism constructed from them. (For an *incorrect* proportion, see drawing no. 1 or no. 2.)
5. Construct all the forms into one organism such that each form has an influence on all the others.
6. It is necessary to make sure that all the given forms (i.e., that which constitutes the form, its lines and corners) work expediently and are fully revealed, not destroying one another by overlapping or proximity. (See drawing no. 3 for an *incorrect* structure.)
7. The design should be drawn with a ruler, preferably in india ink, neatly and clearly. A form that passes through another should be drawn in its entirety. (See drawing no. 4 for an *incorrect* structure.)

Assignment no. 2.

Conditions
Take *seven* sheets of paper of any size but with the proportion of 2 × 3.

Next, take FIVE FORMS of any size: two acute triangles, an equilateral triangle, two rectangles, and a circle, whose radius should be equal to one of the sides of the triangle and the rectangle.

Principles of construction
Build *seven* DESIGNS each of five forms, according to the following principles:
1. Along a straight cross.
2. Along an inclined cross (two diagonals).
3. Along a triangle pyramid, i.e., place the forms such that the whole weight and size are revealed below.
4. Along a triangle with its summit facing down, i.e., place the forms such that the entire weight is located on the top, but the structure must hold regardless and not tip over.
5. Along a triangle with its summit to the right, i.e., concentrate the weight on the left side.
6. Along a triangle with its summit to the left, i.e., concentrate the weight on the right side.
7. Structure of your choice.

Rules
1. Building along a cross doesn't mean placing the forms in a cross shape but organizing a coherent organism that has a cross-shaped structure on a given plane.
2. Building along a triangle with the weight to the left means not stuffing all the forms into the triangle but placing the larger form to the left and holding it with other, lighter forces, but they can be acute so that the left side doesn't weigh things down.
3. Observe the rules of the first assignment.

For the initial practice structure you may cut five long linear forms out of white paper and, taking black paper, combine the structures on it, finding the best placement for the forms.[74]

1921

THE GOAL OF DESIGN

The goal of design—is to discipline the student to develop his artistic-technical understanding of contemporary requirements, conveniences of living, and technical possibilities through concrete work on an object.

Through design one needs to unveil not the decorative and situational aspect of the thing, but its practical use, its utilitarian value, its unexpected clarity, the beauty of construction, its simplified (rational) production and practicality.

Through design, both practical and theoretical, one must show the student the entire culture of the contemporary artistic-technical object, show the prospects for the possibilities of design, and—most important—convey the principles of approach to design.

Develop in the student a critical approach to the elucidation of the function of the object as it is used, its necessity in everyday life, and through studying the demands of the consumer to arrive at the design of a new object.

The goal of design is for the student who graduates to be not a passive implementer of his specialty but a contemporary engineer of the object, who is always ready to come up with a new, clear proposal in response to the demands, requirement, and tasks of the Soviet consumer, and who knows how to implement this object in mass form in production.

Through the development of the given task or commissioned object, its observation in life, its requirements, the function it fulfills, its material, cost, and, finally, its looks—to work through this to its design.

The engineer-artist of the metalworking department should know not simply how to come up with a design but to develop an inventive proposal, a new solution.

1922–24[75]

EXPLANATORY NOTE TO PROFESSOR A. M. RODCHENKO'S PROGRAM FOR THE CONSTRUCTION COURSE OF THE METALWORKING DEPT. OF VKhUTEMAS

The construction course is intended to develop the discipline of inventiveness in the student in constructing products in the metalworking industry.

The following is included in the concept of inventiveness: development of production resourcefulness, observation, and, in the final analysis, the processing of inventive initiatives or a new approach to the business of material object construction.

The principles of the object's material design flow from the special intended function of a given object, the material, the manufacturing process,

inventive initiative, and elements of the artistic processing of external forms.

The assignments in the construction course are divided into: 1) objects of constant use, such as door handles, household objects, etc., which demand production inventiveness for their design; and 2) the student is given a purely inventive task that requires inventive initiative, which is achieved by working on the construction of things with two or more functions.

Inventive manufacturing initiative is seen as a concrete necessity in contemporary manufacturing technology; hence the actual selection of assignments has great significance. The latter do not have absolute, strictly set characteristics for each group of students taking the construction course, and they change in accordance with one or another requirement set forth by life, or with one or another problem that actually arises in the process of developing technology and industry. Thus, the assignments should be selected very strictly for each [student] according to the length of the course, preserving only the [assignment's] character, type, and order in the program. Such an approach to assignments gives students the opportunity to master construction methods for any object in the metalworking industry. Mastery of method is the only form of training of the future constructor-artist in metalworking manufacturing prepared by the Metal Dept. of VKhUTEMAS.

The types of assignments are divided according to their difficulty and their scale of resolution: 1) a readymade product (life-size); 2) a model; and 3) a project executed in drawings, which gives the student the opportunity to develop all stages of the object's material design.[76]

1922–24

PROGRAM FOR THE VKhUTEMAS METAL DEPT. CONSTRUCTION COURSE OF PROFESSOR A. M. RODCHENKO

I. The construction of objects in the metalworking industry, which the students should execute *in actual size.*

A. *Objects with one function.*
1. Construction of objects exclusively from metal.
Sample assignments: spoons, door handles, pots, irons, scissors, horseshoes, etc.
2. Construction of objects from metal combined with other materials.
Sample assignments: fork, knife, hangers, and so on.

B. *Objects with two or more functions.*
1. Construction of objects exclusively from metal.
Sample assignments: tobacco packaging—and ashtray, lighter, folding kettle, spittoon, fountain pen, locks, objects for the household.
2. Construction of objects from metal in combination with other materials.
Sample assignments: light for a photo laboratory, ink set, watch, and so on.

II. The construction of objects in the metalworking industry, which the student should execute in the form of *a model*.

A. *Objects with one function.*
 1. Construction of objects exclusively from metal.
 Sample assignments: hanging armature, metallic dishes, folding toilet set, folding garden chair, etc.
 2. Construction of objects from metal in combination with other materials.
 Sample assignments: folding bed, newspaper kiosk, store windows, screens, light advertising.

B. *Objects with two or more functions.*
 1. Construction of objects exclusively from metal.
 Sample assignments: table lamp, tripod, bookshelf, automatic postal boxes, lamps, window frames, flashlights, cash registers, and so on.
 2. Construction of objects from metal in combination with other materials.
 Sample assignments: clocks for institutions, bed-armchair, folding bed, work table, etc.

III. The construction of objects for the metalworking industry that should be executed by students in *a project* (i.e., on paper).

A. *Objects with one function.*
 1. Construction of objects exclusively from metal.
 Sample assignments: cover for an automobile, bookstore window, and so on.
 2. Construction of objects from metal in combination with other materials.
 Sample assignments: the interior of a tramcar, streetlamps with advertisements, etc.

B. *Objects with two or more functions.*
 1. Construction of objects from metal.
 Sample assignments: automobile and aviation furniture, folding work furniture, cashier's room, spiral staircase, stairs for a store.
 2. Construction of objects from metal in combination with other materials.
 Sample assignments: equipment for bookstores, store windows, and department stores; light and moving street-advertising; equipment for libraries; radio receivers for public squares; airplane landing strips; radios; etc.

1922–24

EXPLANATORY NOTE ON THE COMPOSITION COURSE SYLLABUS OF PROFESSOR A. M. RODCHENKO FOR THE METAL DEPT. OF VKhUTEMAS

The task of the composition course is to master the method of artistically processing the exterior forms of objects in the metalworking industry. Artistic processing is seen as the joining of principles of the object's exterior decoration with the technical processing of the metal.

Artistic processing of an existent object includes work on the item's surface and the design of objects whose technical nature and expedient function is not complex and therefore allows for the proportionally greater presence of elements of decoration.

Simplicity and intelligibility in the choice of types of surface processing or drawings for it should serve as the principle of one or another type of surface processing of the object. In such cases, the questions of propaganda and advertising are the only organizing power that gives meaning to decoration. Aesthetic decoration of an unprincipled nature is completely excluded, since in any event the processing of the surface is decoration's visible socioconsumer appropriateness.

Student training in the composition course proceeds along two lines: mastering the technology of processing object surfaces; and, on the basis of one or another technical possibility, resolving the artistic-decorative elements, taking consumer appropriateness into consideration. Hence, when working on a composition assignment, complete consciousness is required of the student in choosing the type and appearance of the treatment. . . . The student should not go against social requirements and the demands of society; he should be particularly receptive to the environment, since the technical and material possibilities in the artistic processing of the surface in the metalworking industry provide extensive opportunity for a variety of approaches.

In developing the correct approach to the artistic design of an object's surface, the typological choice of tasks is very important, as is their precise regulation, which serves as a discipline that organizes consciousness, excluding any type of unprincipled-aestheticized approach. Therefore, the themes for the task are always adapted to society's social needs and demands, and they change for each new group of students.

1922–24

COMPOSITION COURSE SYLLABUS OF PROFESSOR A. M. RODCHENKO FOR THE VKhUTEMAS METAL DEPT.

I. PROCESSING OF THE METAL FACADE.
Painting metal, matte and glossy processing. Impressing packing inscription on the metallic surface. Applying drawings to the surface of the metal as a delaying characteristic. Electroplating of metal as a protective characteristic. Silver plating. Gilding. Tinning. Nickel plating. Etching.

2. ARTISTIC PROCESSING OF THE SURFACE OF A READY PREPARED OBJECT.
A. Construction of objects from metal in combination with other materials.
Sample tasks: door handles, knobs for sticks and umbrellas, handles for blotters, hard cases, metal eyeglass frames, flagstaffs for banners, and so on.

B. Processing the surface of an exclusively metal object.
Sample tasks: ash trays, *kunguns* and other dishes for Central Asia, coins, gates, mesh, and so on.[77]

3. THE ARTISTIC PROCESSING OF METALLIC PACKAGING AND ADVERTISING.
A. Metallic packaging and advertising.
Sample tasks: tubes for glue, paints, etc., food tins, tobacco packaging, signs, brackets, etc.

B. Construction of objects from metal combined with other materials.
Sample tasks: street advertising, packaging with glued-paper advertising, factory logos on products of the metalworking industry, such as typewriters, sewing machines, telephones, machine-tool equipment, machines, knives, etc.

4. ARTISTIC PROCESSING OF THE SURFACE OF OBJECTS WITH ALL KINDS OF LABELING.
A. Plaques with inscriptions for enamel and engraving.
Sample tasks: reading room, office cubicle, secretariat, editorial offices of a magazine, cashier, institution name for door plaques, signage for medical clinic, health centers, etc.

B. Pins, emblems, and medals.
Sample tasks: pins for unions, tokens and pins for various campaigns (May 1, Leninist recruitment, Press Day, Airforce Fleet, etc.).

TO THE CENTRAL COMMITTEE OF THE UNION OF METALWORKERS. STAFF REPORT ON THE METALWORKING DEPARTMENT OF THE HIGHER STATE ARTISTIC-TECHNICAL WORKSHOPS (VKhUTEMAS)

The metalworking production department has been in existence since VKhUTEMAS was formed, and this higher-education facility was confirmed by the Sovnarkom [Council of People's Commissars]. The goals and tasks of the department with regard to academic life, as well as to practical work in the studios—are to give the state highly qualified metalworkers, that is, engineer-artist-Constructivists. The students who are participating and working in the above-mentioned department, making projects of utilitarian objects and implementing them practically (by making models), should, when they finish the department's course and have received their certificate, be able to

go into the plants and factories of the metalworking industry armed with theoretical knowledge and familiar with the practical aspects of the last word in contemporary technology.

The academic life of the department is carried on in the regular way and the students study and are examined in the following subjects: higher mathematics, descriptive geometry, theoretical mechanics, physics, chemistry, the history of art, political literacy. Practical tasks in the studios are in the following disciplines: graphics, color, volumetric discipline, spatial discipline.

Theoretical subjects comprise a special section of the department: a special chemistry course, machine works, machine parts, electro-technology, metal technology, estimates and technical bookkeeping, art history, history of the art of metalworking, theory of the artistic processing of metals, organization of production, composition, practical instruction in the construction of objects (models).

Practical courses in the studio: blacksmithing, foundry work, minting, assembly, engraving, enamel, decoration, electrotype, decorative processing of metals, internships in factories and plants. . . .

It is interesting and necessary to make the students highly qualified masters who are awaited and in demand by contemporary industry. The union should accept all students into its membership, should help organize this materially and morally in order to have numerous specialists in its ranks in the future. It should create normal study conditions such as internships in plants, material assistance to whatever degree possible, and other opportunities for the productive and normal life of the department.[78]

<div align="right">

Acting Dean
Rodchenko
February 3, 1923

</div>

THE MATERIAL DESIGN OF THE OBJECT

1. Selection of prepared objects.

The first assignment is given to familiarize students with life itself, with the industry producing metal objects, and, likewise, with the requests of the consumer: to compile a selection of objects for the equipping of, for example, an office—from objects already existing in the stores in Moscow, presenting them in drawings and in general office plans.

Through such selection the student becomes familiar with the items of today's market, understands them critically, and shows the principles of his view on the culture of the object.

The selection of a living unit; libraries, reading rooms; stores; boulevards; dining halls; barbers; meeting halls; offices; sports fields; snack bars; clubs.

Constantly practicing, the student must draw or photograph objects currently produced and analyze them critically.

2. Simplify an object already on the market.

In a store the student chooses any object currently produced by industry, and

through a critical approach to it he removes the applied art, superfluous forms, and nonfunctional parts to reveal its basic construction and factual appearance, and also proposes a color scheme and texture for its design solution.

· Electric table lamp. Lampshades, streetlamps. Garden benches. Dishes. Samovar. Household equipment. Toilet accessories.

In constant practice, the student should carry out such work in production conditions and present a report about this work in the form of project drawings and an object produced at the factory.

3. Complicate an already existing object.
Select any object currently produced by industry, and by subtracting the cost of its decoration complicate its functional construction or add more convenience and usage to it; and likewise develop a more contemporary texture, material, and active color scheme for it.

Electric table lamp with extensive mobility.

A light fixture with directed and reflective light.

During production practice the student should carry out the same work in actual production and present a report about this work in the form of a project and object produced according to that project design.

4. A new design-type of existing object.
Having looked at all existing types of an object produced by industry, develop a new design on the basis of contemporary requirements, both artistic and technological, making use of the most inexpensive mass production possible—for example, stamping—and likewise, take inexpensive material, develop its color scheme and texture.

Sample assignment: penknife; scissors; door accessories; window accessories.

During production practice the student must carry out the same work in actual production, presenting a report about this work in the form of a project design and object produced from this project.

5. A new object (proposal for a new object).
In this assignment the goal is to reveal and teach the future engineer of objects how to invent and create completely new things without having samples in front of him to perfect or reject.

· Having set a topical task of answering today's demand with an object— to make a completely new proposal.

Sample assignments: special lighting at the intersection of two streets; a Soviet cooperative store; a snack bar and its equipment.

If possible, realize the production of this project in production practice— if this isn't possible for reasons independent of the student, make a model.

6. A set of objects.
The assignment to create a set of objects provides the student with a new task— to convey the identity of different objects through the use of homogeneous material, a single construction principle, identical color and texture solutions—

it is absolutely necessary for any space to have equipment with a common design.

For example, lighting fixtures.

Table lights, ceiling fixtures, and brackets. Made by molding a single color in a round form with identical light shades.

In production practice complete this project in actuality and present the project and the object.

7. Equipment.

The last assignment for design is the sum of everything the student has done; to show the entire preparatory process for the graduating engineer-artist. In this project it is absolutely necessary to display most effectively all the equipment of a given space in all its details, stressing civilized presentation of a general view of the space's equipment.

Sample assignments: the dormitory of a state farm; a communal home; the street in a Socialist city; a movie theater; auditorium; library; dining hall; park of culture and leisure.[79]

1928

TECHNICAL DRAWING

I teach technical drawing at Vkhutemas, in the wood- and metalworking departments, as an auxiliary subject for object design. Often the student is unable to use a number of contemporary object constructions that he has seen—he didn't examine the principle of their construction. Not only the student but any person who has graduated from a first-level school should know the mechanisms of contemporary objects.

We teach students how to draw flowers, landscapes, and heads but don't teach them how to use drawing to discover and describe the object. That is why when the question arose in the department about how to teach the older students drawing, which would be useful and necessary for them in design, I undertook to teach this subject, calling it "Technical Drawing," and I put together a course program.[80]

October 28, 1928

PROGRAM FOR THE III AND IV COURSES OF THE WOOD- AND METALWORKING [DEPARTMENT] OF VKhUTEIN

Technical drawing is viewed as teaching students to see and remember the principles of contemporary objects' mechanisms, their working functions, systems and organization, and how to apply these principles to their own practice.

The practice of technical drawing should develop the future engineer-artist's ability to quickly grasp the organizing principles, form, and material of contemporary objects he comes across.

The worker in contemporary objects should have a good understanding of them, so that in producing other objects he may use previous cultural

achievements, improve upon them, and perfect them.

The course is included in the practical classes in the form of sketches of the studied object according to the method mentioned above, for which the student keeps an album where all of this is sketched out, and this material, except for the test, will be used for projects and models.

The lessons (two hours each) produce sixty drawings in the course of a school year. The test for the III year course—is sixty drawings, for the IV year—sixty drawings.

1. Sketch of objects brought into class, with a clearly visible, open, and simple structure and manner of drawing. For example, a penknife or chair.
2. Sketch of objects brought to class, with a half-disguised structure. For example, a desk, a harmonica.
3. Sketch of things brought to class with a completely disguised structure. For example, a fountain pen, electric stove.
4. Sketch from memory of things the student has seen many times before. For example, an electrical plug, an electrical button, a stool.
5. Sketch of objects exhibited in the lesson for a very short time.
6. Sketch of objects and their principles from photographs.
7. Sketch of objects during [field] trips and afterward.

Examples: *Everyone uses*
Penknife. Electric switch. Tram doors. Bus doors. English locks.
Draw the principle of their structure from memory.
The culture of objects and their perfection comes from a number of other things, perhaps even from seemingly distant branches of industry.
For example: the bellows of an accordion and a camera. The vibrating membrane of a gramophone, telephone, and loudspeaker. Locks and bolts of various types for all sorts of objects, etc.
The exam tests the student's ability to understand contemporary objects, their function and principles.

Example
1. Based on the construction principle of scissors, cutting pliers, etc., design the structure of a new object of a similar type (for metalworking students).
2. Using the construction principle of bus doors, draw the construction of gates, screens, etc. (for woodworkers).

May 23, 1928

TO THE RECTOR OF VKhUTEIN, P. P. NOVITSKY
1927–1928

Dear Pavel Petrovich!
I did not explain the reason, other than illness, that I turned down the deanship.

You were absolutely right in wanting to appoint Rozanov as dean.

I came to an agreement with Miloslavsky and Kubitsky that we could only prove the right of the department through joint work and that I would take on the position of dean only if there were a friendly work atmosphere.[81] But it turned out that Miloslavsky thought only of one thing—to become dean, and to make my deanship so poorly set up that he could return anew to his position like a hero.

For this purpose he stuck me with Kubitsky, who is no secretary at all.

An appointed dean is really needed, one who has the right to take his own secretary and not Miloslavsky's secretary.

There is no one else among our professors to choose. I could stay only on the condition that I find an efficient secretary among the graduated students, specifically Bykov, and, by the way, he's a Party member.

Right now it is absolutely necessary for the board to appoint a dean—at least Rozanov.

Now I understand why Rozanov speaks of sabotage and the like.

In an atmosphere of bureaucrats who only want to be at the top and not among comrades, it is very difficult to work in a comradely fashion.

We need a governing, not an elected, dean.

Many want to be spared Rozanov, but they still want (except for the students) the same old Miloslavsky.

Kubitsky does absolutely nothing, and, despite everything, he hasn't turned down the position of secretary, but he never comes to the department.

As for me, despite the fact that I turned it down—I go there.

I wouldn't like to speak about trivial things, how Miloslavsky has held up turning things over, how I couldn't even get the key from the dean's office from Artamonov.

In this sort of atmosphere the only thing I could do was flee, since I had no intention of fighting with them.

If you would like the details—summon me.[82]

Rodchenko

DISCUSSION ABOUT NEW CLOTHES AND FURNITURE—DESIGN TASK

In designing *Inga* I set myself the task of making *folding* wood furniture, the material for which the USSR has in large quantities. I rejected the metal furniture with glass that is being intensely developed in the West as difficult to implement under our conditions.

The assignment was not to show multifunctional furniture, because the principle of multiple functions is not applicable in real-life conditions. A table that transforms into a bed cannot fulfill its direct obligations. A more important question, to my mind, is to create a bed that doesn't get in the way of daytime life—and dining equipment that doesn't hinder nighttime rest.

For this reason, particular attention was paid to the rational—in our

everyday conditions—*folding* of furniture. Design of the play area was given schematically: walls, as such, were not given, just the details of the room were present (windows, door, etc.)

New furniture was made for every act, there was also a difference in the colors and painting of the furniture. The idea is that all the rooms are located in the same new house.

The costumes for *Inga* are constructed not only on the level of rationalization but are made with the intention of emphasizing Inga's inherent aestheticism in the search for an as yet unfound rationalization of the female suit. In the costumes demonstrated on the mannequins the question of rationalization is raised, but only theoretically, because of course its solution is an extremely difficult assignment. This question needs work and more work, connecting the artist's search with everyday conditions.[83]

Worker-constructor A. M. Rodchenko

LEF

LEF NOTEBOOK

They say: "We're sick of Rodchenko's pictures—everything's photographed from the top down or the bottom up."

But they've been taking pictures from "the middle to the middle"—for about a hundred years; not only should I, but the majority should take pictures from the bottom up and the top down.

And I will photograph from "side to side."

Looking at the mountain of my paintings from past years, I sometimes think: what should I do with all of this?

It's a shame to burn it, I worked ten years. And all in vain—just like a church building.

Can't do a damn thing with it!

In Pushkino, at the dacha, I walk around and look at nature: there's a bush, there's a tree, here's a ravine, stinging nettle. . . .

Everything's accidental and unorganized, there's nothing to photograph, it's not interesting.

Now the pines aren't too bad, long, bare, almost telegraph poles.

And the ants live sort of like people. . . . And you think, recalling the buildings of Moscow—they're also piled up topsy-turvy, all different—that there's still a lot of work to be done.

At the showing of the film *The Journalist*, Trainin said: "Rodchenko is very real. Utkin, now, he has fantasies." That's how they juxtapose "everyday life with fantasy."[84]

It's interesting to do experimental photography. . . . But how much aesthetics is there in a photograph? To be blunt: 90 percent.

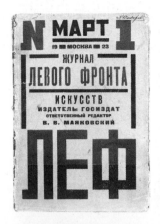
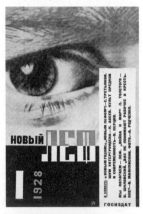
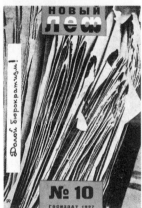

Left to right, top to bottom:

Rodchenko. Cover of the journal *LEF*, no. 1 of 1923. Letterpress, approx. 9¼ × 6³/₁₆" (23.5 × 15.8 cm)

Rodchenko. Cover of the journal *Novyi LEF*, no. 1 of 1928. Letterpress, approx. 9¹/₁₆ × 5⅞" (23 × 15 cm)

Rodchenko. Cover of the journal *Novyi LEF*, no. 10 of 1927. Letterpress, approx. 9¹/₁₆ × 5⅞" (23 × 15 cm). The cover design of the present book is adapted from this design, in which Rodchenko made use of his photograph *Down with Bureaucracy* (1927).

Rodchenko. Cover of the journal *Novyi LEF*, no. 6 of 1928. Letterpress, approx. 9¹/₁₆ × 5⅞" (23 × 15 cm)

That's why I also do radio—for discipline.

In radio there's no more than 10 percent art.

Transfer everything that's from art into invention and training to see the new even in the usual and accustomed.

Because here everyone strives to see the old in the new. It's hard to find and see the extraordinary in the most ordinary.

And that's where the power is.

You hang around an object or a person, and think—"But how to shoot it: like this, like that, or like this?" . . . It's all old. . . .

We were taught that way, brought up for millennia on various pictures to see everything according to the rules of grandma's composition.

But we need to revolutionize people so that they can see from all points and in all kinds of light.

It's useful to go on an expedition to the north, or to Africa, to photograph new people, things, and nature.

And then they shoot with eyes blurry with Corots and Rembrandts, with museum eyes, with all-of-art-history eyes.

They pour tons of painting into the movies, the theater.

They pour tons into the opera and drama.

No Africa at all. . . . Right here at home, know how to find something completely new.

And if you've traveled to China, don't bring us boxes from the Tea-Directorate.[85]

Sovetskoe foto invited me to collaborate on every issue.

I came and asked: "You probably saw a book of Moholy-Nagy, right?"[86]

"Yes," they said, "you're right. We even printed it once, but then decided: we have our own leftists."

Sovetskoe foto especially likes the photos published in *LEF*. When I bring new ones, they don't say anything.

"Who the devil knows what's good, what's bad. This is new stuff, you can't figure it out."

Talking in the Museum of the Revolution with the staffer Lifshits, I asked him why the museum is collecting drawings and not collecting good photos of revolutionary moments from movie films.

"You can't," he says, "they're staged."

Going up to the photo *Taking of the Winter Palace*, I asked: "What kind of strange photograph is this?"

He answered: "It's staged." I was surprised: "And why isn't it written here that it's staged?"

"Oh well, everyone thinks it's a document, they're accustomed to it."

A bad custom!

In my posters The History of the VKP(b), I used photographs almost exclusively.[87] (I did the posters for the ComAcademy.)

In the Museum of the Revolution I got material and consulted with them.

After the publication of the first five posters, a discussion began in the museum:

"What should we use to illustrate the revolutionary material in the museum—photographs or drawings?"

A strange discussion for a museum!

They could just decide to pass a resolution to illustrate with drawings.

But. . . . The question remains a question, so that's why they collect and illustrate with the one and the other. "We'll see. . . . "

What we'll see is that they'll get used to it.

I'm just afraid—what will they get used to?

This is my second year of teaching in the visual arts studio of Proletkult. . . .

I transferred the guys from visual arts work to design and modeling of furniture and club equipment. VTSSPS placed an order, they filled almost the entire order. VTSSPS took a look—they liked it.[88] At the same time, Mossovet took part of the furniture for itself; provincial clubs are taking projects.[89]

The authors of the project want to publish it in *LEF*. Proletkult is proposing publishing *after* the job is turned in or else people might get scared. I mean, it's *LEF*!

It would be interesting to collect statistics on how many articles and reviews in our journals have been written about foreign art workers and how

many about Soviet [ones].

As far as I have observed, there are dozens more about foreign art workers. And the foreign ones are always praised, while the Soviet ones are almost always criticized.

How to explain this?

Well, you see, writing about foreign [art workers]—first of all, that's culture (meaning the person writing will be respected at work), and then, it's easier, less worrisome—you won't be accused of tendentiousness.

Our art critics don't write out of conscience, after all, but out of fear.

In Gosizdat they told me straight out: "You're a talented artist, A. M., and a good fellow, so why do you need"—they said—"all this LEF and Constructivism?[90] They get in your way, and they get in your way not even because you work in the new way but because you have these labels. Others imitate you, and they're accepted with pleasure and even get commissions to do things 'like Rodchenko.' But they're downright afraid of you. LEF!"

Working in Dobrolet for more than a year, I made posters and so on. The people there are busy, they've got no truck with art—their business is new, interesting. They like my posters. They're used to me, they don't remember my name but know me by sight.

I don't talk about art with them, either, I don't proselytize them with words, I just work and work.

Everything goes fine.

Now an all-Russian exhibition is opening. Dobrolet is organizing twenty-minute advertising agit-flights.

The engineer Lazarevich calls me in, an intelligent guy, in a monocle and jacket with gold buttons, and he says to me:

"Comrade Artist, make me a futuristic poster about flight."

I sincerely made an uncomprehending face. And he says to me:

"Well, how can I explain it, well, with a twist, you understand? Of course, not too much."

But I didn't understand, and asked, "What about my posters? There they are, on the wall." He said: "Yours—are realistic." Then I understood everything, and said: "No, comrade Lazarevich, I don't know how to make futuristic posters."

So they went and commissioned some rightist artist to do something "like Futurism."

Later, com. Lazarevich found out what the deal was—a typist explained to him.

He became an enemy.

Why is this sign for Narkomzem written in Church-Slavonic typeface?[91]

Even in the church, announcements of the prayer service are written in Russian letters.

You come in the morning to an organization where you've always worked. Suddenly they attack you:

"Comrade Rodchenko, we've been looking for you today. . . . "

"What's the matter?"

"Tomorrow's May 1st. We have to decorate the club, it's been resolved to assign 200 rubles for the decoration of the club, we've already prepared

Rodchenko. Insignia design for the state airline Dobrolet. 1923. Ink and gouache on paper, 10¼ × 12³/₁₆" (26 × 31 cm)

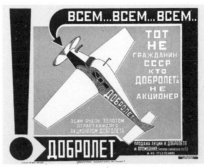

Rodchenko. Advertising poster for the state airline Dobrolet. 1923. Lithograph, 13⅞ × 18⅛" (35.2 × 46 cm). Text: "Everyone . . . Everyone . . . Everyone. . . . A Soviet citizen you are not/if you don't own any Dobrolet stock."

the slogans, fabric, bought fir branches. . . . "

A month goes by, the same thing again.

Tomorrow's Aviation-Chemistry day . . . 200 rubles . . . decorate . . . fir branches . . . and so on.

And the club itself has dirty walls, the club has torn furniture, the clock in the club is broken, etc.

Dear comrades, wouldn't it be better, for May 1st, to buy a dozen "in honor of May-Day" chairs?

Or whitewash the walls in honor of Aviation-Chemistry day?

It's hard to work. You can't achieve anything and the ideas don't stick.

The organizations are different. . . . You come, get an order from the director. You do it, return to hand it in, and a lecture on the new approach starts. Finally you convince him.

You bring the second work, and think: "This time it will be easier." You look and see that instead of that director, there's a new one.

And you start over from the beginning. You get sick of it.

Once the following happened:

One director, when he moved to another organization, called me in again to work. I ended up following him for a year to ten different organizations.

I had to drop him. The organizations were so extremely varied.

But he's okay, still going strong.

Foreigners who come here—critics, artists, often come to us, the *Lefists*, to look at our work, and they're thrilled; they're surprised, why isn't this all printed, published, exhibited.

We remain silent. . . .

Because our critics and art directors also go around surprised that in the West they write and write to the USSR.

There's so much interesting stuff going on in the West. And in the USSR

they print it, and publish, and exhibit . . . foreigners.

I mean, all this summer, in all the newspapers and magazines, every day, Kogan and Lunacharsky wrote and wrote, and all about the West. You'd think they got married.[92]

But we say nothing.

It wouldn't hurt Rabis to say something.[93]

We said nothing, and that's enough.[94]

1927

LARGE-SCALE ILLITERACY OR DIRTY LITTLE TRICKS
OPEN LETTER

In the no. 4 (April) issue of the magazine *Sovetskoe foto*, there was a letter that accused A. Rodchenko, in thinly veiled expressions, of plagiarizing the photographic works of foreign photographers, in particular Moholy-Nagy.

That's—first of all.

And when A. Rodchenko appealed in a letter to the editors of *Sovetskoe foto* to expose the dirty ambiguousness of this piece, the latter did not publish the letter.

That's—second.

This is why A. Rodchenko is forced to publish his letter to the editors of *Sovetskoe foto* in the pages of *Novyi LEF*.[95]

To the Editor of *Sovetskoe foto*
April 6, 1928

I am the "seeker of new paths in photography" (as the "letter" in your publication says).

That's absolutely correct.

Isn't that why this letter of yours appeared.

". . . known for the ability to see things in his own way, a new way, *from his own point of view*."

I didn't know that I was known for "his own way and *from his own point*."

Only an illiterate person could talk about ownership of a point.

If they say about pictures shot from the "top down" or the "bottom up" that they are after Rodchenko, one needs to simply explain the illiteracy of such a statement and acquaint the person with contemporary photography, showing the pictures of the best masters from different countries.

The pictures juxtaposed with mine in your magazine speak of either the complete illiteracy of the juxtaposer or of his indiscriminate use of means for wrecking.[96] Anything at all can be juxtaposed and picked out. But to come to conclusions about plagiarism on this basis is, at the very least, nonsense.

I attach an example of the ease of such a selection. I didn't root through foreign journals but simply picked up two Soviet magazines—

"Illustrated Letter to the Publisher: Ours and Theirs," *Sovetskoe foto*, no. 4 of 1928. The photographs on the right are by Rodchenko. The photographs on the left are, from top to bottom, by Ira W. Martin, Albert Renger-Patzsch, and László Moholy-Nagy.

Sovetskoe foto and *Sovetskoe kino* [Soviet cinema].

If we're talking in the language of *Sovetskoe foto*, S. Fridliand's and Shaikhet's plagiarism is much more demonstrative than mine.[97] But that's not what I think. I highly respect the photographs of Shaikhet and the experiments of Fridliand, and their desire to get out of the swamp of old photography. First-class things from the West cannot help but influence them, since they are lively people.

The magazine *Sovetskoe foto* publishes the best photographs of foreign authors.

I hope this isn't because they don't have to pay the photographers for these pictures.

In essence, the "illustrations" to the letter:

I. Martin's *Boats* is a much weaker composition than mine, moreover, I think you could put together a whole album of boats like these.

Renger-Patzsch's *Chimney* and my *Tree*, shot from the bottom up, are indeed very similar, but could it be that it isn't clear to "photographers" and the editorial staff that this similarity was deliberate on my part?

Photos like Renger-Patzsch's *Chimney*, I consider to be genuine contemporary photography (don't think that this is Renger-Patzsch's "own" point [of view]—this is *our* point), and such shots, in particular this very picture, I myself included in the magazine *Sovetskoe kino*, in the "Photographs and the Cinema" section, which I edit.

The author of the illustrated letter, in the end, resorted to straight cheating.

Moholy-Nagy's *Balcony* and my *Balcony* are amazingly similar, and for this reason he placed them side by side. But the dates of these works speak in my favor, and for that reason he didn't give the date of Moholy-Nagy's photo. I will correct this oversight. My *Balcony* and a series of other shots of the balcony were published in the magazine *Sovetskoe kino*, issue no. 2, for 1926; Moholy-Nagy's were published in the magazine *UHU* in February 1928.

What does the editorial staff of *Sovetskoe foto*, which "checked" the letter and the illustrations, have to say to that?

I'd like to point also to another *Balcony* by Moholy-Nagy that looks very much like mine, in the magazine *Das illustrierte Blatt* (no. 15, for 1928).

But all of this should in no way detract from the first-class works of such exceptional masters as Moholy-Nagy, whom I hold in high esteem.

Moholy-Nagy, a former leftist non-objectivist painter, has often asked me to send him my photographs. He knows them well and appreciates my work. And during his painting period I had a significant influence on him, about which he has written to me on several occasions.

If basic journalistic honesty is not required for the objects reproduced by *Sovetskoe foto*, then perhaps it is permissible to request a primitive level of literacy.

The work of the new, contemporary photography has to be done.

I believe that my photos are no worse than those they were com-

 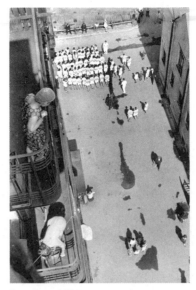

Left: Rodchenko. *At the Telephone*. 1928. Gelatin silver print, 15½ × 11½" (39.5 × 29.2 cm)

Right: Rodchenko. *Assembling for a Demonstration*. 1928–30. Gelatin silver print, 19½ × 13⅞" (49.5 × 35.3 cm)

pared to, and therein lies their value.

Besides these, I have many photographs that are difficult to compare with anyone's.

If among my photos there are a couple of similar ones, well, among the endless landscapes and heads published in your magazine one can find thousands.

If only there were more of our imitations, and not after Rembrandt, published in *Sovetskoe foto*.

Don't be the grave diggers of contemporary photography, be its friends.

THE PATHS OF CONTEMPORARY PHOTOGRAPHY

Dear Kushner![98]

You touched on an interesting question about "from the bottom up" and "top down" points, to which I am obliged to respond given the "attribution" of these points [of view] to me, using the "literate" language of the magazine *Sovetskoe foto*.

I am indeed a proponent of these points over all others, and here's why.

Take the history of art or the history of painting of all countries and you'll see that all paintings, with negligible exceptions, are painted either "from the navel" or at eye level.

Do not mistake the apparent impression from primitive painters and icons for a bird's-eye view. It is simply that the horizon is elevated so that many figures may be inserted; but each of them is taken at eye level. As a

whole they correspond neither to reality nor to a bird's-eye view. Despite the apparent gaze from above, each figure has a correct front and profile. It is just that they are placed *one on top of the other and not one behind the other*, as with the realists.

The same thing with the Chinese. True, they do have one plus—that is, the multitude of slopes of the object seen at the moment of movement (perspective), but the point of observation is always at midlevel.

Take a look at old magazines illustrated with photographs—you will see the same thing. Only in recent years will you sometimes find different photographic points. I emphasize—*sometimes* because there are so few of these new points.

I buy a lot of foreign magazines and collect photographs, but I've collected only a few dozen such photographs.

Behind this threatening template is hidden a biased, routine education of human visual perception, and a one-sided distortion of visual thought.

How did the history of painterly discoveries develop? First there was the desire to depict things to look "lifelike," something like Vereshchagin's or [Balthasar] Denner's paintings, whose portraits jumped out of the frames, and where the pores of the subjects' skin were painted in.[99] But for this, instead of being praised, they were criticized as being photographers.

The second path—was the individual-psychological approach to the world. The paintings of Leonardo da Vinci, Rubens, et al, depict one and the same type in different ways. For Leonardo da Vinci—it's Mona Lisa, for Rubens—his wife.

The third path—is mannerism, painting for the sake of painting: van Gogh, Cézanne, Matisse, Picasso, and Braque.

And the last path—is abstraction, non-objectivity, in which the interest in the object remains almost scientific.

Composition, texture, space, weight, and so on.

But the paths of looking for points of view, perspective, and foreshortening remain completely unused.

It would seem that painting is over. But if, as AKHRR maintains, it is not yet over, then at any rate it is not involved in questions of point of view.[100]

One would think that photography—the new, rapid, real representer of the world—with all its possibilities, would take up the work of showing the world from all points, of educating the ability to see from all sides. But here the psychology of the "painting's navel" is unleashed on the contemporary photographer with the authority of centuries behind it, and it instructs him with endless articles in photography magazines like *Sovetskoe foto* and *Puti fotokultury* [Paths of photoculture], publishing photographs as examples of oil painting with depictions of Virgin Marys and countesses.

What will the Soviet photographer and reporter be like if his visual thought is stuffed by the authorities of world art with compositions of archangels, Christs, and Lords?

When I got involved in photography, abandoning painting, I didn't know at the time that painting had laid its heavy hand on photography.

Do you understand now that the most interesting points [of view] of

contemporary photography are—"from the top down" and "from the bottom up," and all others except "from navel level?" Thus, the photographer is as far away as possible from painting.

It's hard for me to write, my thinking is visual, I end up with separate bits of a thought. But no one is writing about this, there are no articles about photography, about its tasks and successes. Even "leftist" photographers like Moholy-Nagy write individual articles about "How I Work," "My Path," and so on. The editors of photo magazines invite artists to write about the ways and paths of photography, and are upholding a lame, bureaucratic line in serving amateur photographs and photo reportage.

As a result, photo reporters aren't giving their photographs to the photo magazines, and photo magazines are turning into some kind of "World of Art."[101]

The letter to *Sovetskoe foto* about me—is not just some stupid smear. It's a kind of projectile missile attacking new photography. Its goal in discrediting me is to scare photographers involved in new points [of view].

Sovetskoe foto, in the person of Mikulin, is declaring to young photographers that they work "like Rodchenko," and he doesn't accept their new photographs for this reason. But then, in order to prove their "own" level of culture, the magazines reproduce one or two pictures by new foreign workers, though without giving the name of the photographer or where they took the picture from.

But let's return to the main question.

The contemporary city with its multistory buildings, specially erected factories, plants, etc., two- to three-story-high windows, trams, automobiles, light and space advertisements, ocean liners, airplanes—all of the things that you so marvelously described in your article "One Hundred and Three Days in the West," all of this, like it or not, has shifted the customary psychology of visual perception, though only a little.

It would seem that only the photo camera is capable of representing contemporary life.

But. . . .

The antediluvian laws of visual thinking recognized photography as only a lower form of painting, watercolor, and prints with their reactionary perspectives. By the will of this tradition, a sixty-eight-story building in America is photographed "at navel level." The "navel," however, is on the 34th floor. So they climb up onto a nearby building and shoot the sixty-eight-story giant from the 34th floor.

And if there isn't any neighboring building, then with the help of retouching they achieve the same frontal, designed look. Buildings that, when you pass them on the street, you see from the bottom up; the street with its rushing automobiles and scurrying pedestrians, which you see from the upper floors; everything that your eye catches from the window of a tram, automobile—that which, sitting in an auditorium, in the theater, you see from the top down—all this is transformed, corrected into the classical view "at navel level."

Watching *Uncle Vanya* from the gallery, i.e., from the top down, the viewer, however, transforms what is seen. Before him *Uncle Vanya* stands life-

like, from his midpoint.

I remember in Paris, when I first saw the Eiffel Tower from afar, I didn't like it at all. But once I was passing nearby on a bus, and when I saw the lines of the metal diminishing upward, from right and left through the window, this perspective gave me the impression of the mass and the construction, which "from the navel" creates only a gentle spot, the one we're so sick of on all those postcards.

What is the review of any factory worth if you look at it from afar and from midpoint instead of examining everything in detail—inside, from above, looking down, and from bottom to top.

The photo camera itself was adapted for a nondistorted perspective, even when the perspective is actually distorted.

If the street is narrow and you can't stand back, then, according to "the rules" you have to raise the front plate with the lens and give a backward slope to the back plate. And so on and so forth.

This is all because of "correct" design perspective. It is only recently, and even then only with so-called "amateur" cameras, that people have started using short-focus lenses.

Millions of trite photographs sail by, and there's only one difference: one is more or less successful than another, or some are done like watercolors, others like Japanese engravings, yet others like Rembrandt.

Landscapes, heads, and nude women are called artistic photography, but pictures of current events—photo reportage.

And photo reportage in photography is considered something inferior.

But this applied and inferior [activity], by dint of the competition of magazines and newspapers and by virtue of lively and needed work—when you have to take the picture whatever happens, in whatever lighting and from whatever point of view—has in fact brought about a revolution in photography.

A new struggle is at hand—pure photography with applied, artistic photography versus photo reportage.

Not everything is all right in photo reportage. Here, too, the template and a kind of pseudorealism have corrupted the workers of this genuine task. At a club picnic—I saw this—the reporters began to set up staged dances and picturesque groups on a hillside.

It was interesting how the girls, hurrying to get into a "picturesque group," hid in the back of an automobile to comb their hair and put on makeup.

"Let's go have our picture taken!"

It's not the photographer with his camera approaching the object but the object approaching the camera, and the photographer setting it in a pose according to the canons of painting.

Here we have a photograph from the magazine *Korall*—this is a chronicle, this is ethnography, this is a document. But in fact, everyone is posing. In fact, a minute before the photographer arrived, these people were doing something of their very own and were in their own places.

Imagine what point [of view] there would be in the photograph if the photographer had taken a picture unexpectedly, unawares?

Of course, it's hard to take pictures unawares, while with a system of pos-

ing it's easy and quick. And there's no misunderstanding with the consumer.

In magazines you come across pictures of small animals and insects taken up close, larger than life. But here, too, it's not the photographer who comes to them with his camera but they who are brought to the camera.

People are looking for new objects to shoot but they're shooting in the old traditions.

Mosquitoes will also be shot by the photographer "from the navel" and by the laws of Repin's *Zaporozhian Cossacks*.[102]

But the opportunity exists to show the object from the sorts of viewpoints that we look from but don't see.

I'm not talking about ordinary objects that can be shown in a completely unusual way. You write about Flach's bridge.[103] Yes, it's marvelous, but it is marvelous precisely because it is not photographed "from the navel," but from the ground.

You write that Kaufman's and Fridliand's pictures of the Shukhovskaia Tower are bad, that they [make it] look more like a bread basket than a truly marvelous structure.[104] I completely agree, but . . . any point [of view] can ruin the actual impression if the object is new and is not unfolded in front of you.

Here the mistake is only Fridliand's, not Kaufman's. Kaufman's picture is only one of the frames he shot around the tower from various viewpoints, and for that matter, in the cinema his viewpoints are in motion; the camera turns and the clouds pass over the tower.[105] *Sovetskoe foto* talks about the "photo-picture" as though it were something closed and eternal.

On the contrary. The object must be seen in several different photos from different viewpoints and positions, as though looking around it, and not as though peeking through one keyhole. It's not photo pictures that should be made but photo moments of documentary, not artistic, value.

I shall summarize: in order to teach man to see from new viewpoints, it is necessary to photograph ordinary, well-known objects from completely unexpected viewpoints and in unexpected positions, and photograph new objects from various viewpoints, thereby giving a full impression of the object.

In conclusion, I will include several photographs to illustrate my assertions. Pictures of one and the same building have been included on purpose.

The first are taken from the American album *Amerika*.[106] They were photographed in the most stereotypical way. They were hard to photograph since the neighboring buildings were in the way, and so they were touched up by drawing.

This is what is usually done. This is how America and Americans are imagined by Europeans educated by the laws of correct perspective. This is what, in reality, is impossible to see.

The second group of pictures of this same building—are by the "left" German architect Erich Mendelsohn. He photographed honestly, as an ordinary person on the street would see the buildings.

Now here's a fireman. The viewpoint is the most real. That's how you would see him from a window. But how striking it is. And it's possible that

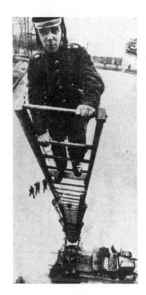

Above: Knud Lönberg-Holm. The Woolworth Building, New York. c. 1924. Reproduced in Erich Mendelsohn, *Amerika: Bilderbuch eines Architekten* (Berlin: Rudolf Mosse Buchverlag, 1926).

Right: Unidentified photograph from the *Kölnische Illustrierte Zeitung,* reproduced as an illustration to Rodchenko, "The Paths of Contemporary Photography," *Novyi LEF,* no. 10 of 1928, p. 30.

we often look at things like this, but don't see them.

We don't see what we're looking at.

We don't see marvelous perspectives—foreshortening and the positioning of objects.

We, who have been taught to see the inculcated, must discover the world of the visible. . . . We must revolutionize our visual thinking.

We must take the veil that is called "navel level" from our eyes.

"Photograph from all viewpoints, except the 'navel,' until all viewpoints are recognized."

"And the most interesting points of today are the viewpoints 'from the top down,' the 'bottom up,' and their diagonals."[107]

August 18, 1928

WARNING!

Considering that the most important thing in photography is what to shoot, and not how to shoot, certain comrades from LEF are warning against the "easelization" of experiment, against formalism in photography, and in so doing they fall into the trap of the aesthetics of asceticism and philistinism. The comrades must be shown that such a fetishization of fact is not only unnecessary but is damaging to photography.

We are fighting against easel painting not because it is aestheticized but because it is not contemporary, its representation is technically weak, cumbersome, unique, and cannot serve the masses.

We are not really fighting with painting (it will die out anyway), but with photography that "looks like painting," "looks like etching," "looks like engraving," "looks like drawing," "looks like sepia tint," "looks like watercolor."

There's no reason to be fighting for "what to depict," for this you just have to point, and everyone does it now.

A poorly and simply photographed fact is not a cultural activity nor a cultural value in photography.

There's no revolution in the fact that instead of a portrait of a general, people have started photographing the workers' leaders with the same photographic approach as under the old regime or under the influence of the artistic West.

The revolution in photography was that the photographed fact—thanks to its quality, i.e., "how it's shot," acted so strongly and unexpectedly with all the value specific to photography; that it was possible not only to compete with paintings but to show everyone a new, perfected way of discovering the world in science, technology, and the everyday life of contemporary humanity.

LEF, as the avant-garde of Communist culture, is obligated to show how and what needs to be photographed.

What to shoot—is something every photo group knows, but how to shoot—only a few know.

A worker shot "to look like Christ" or a "lord," and a woman worker shot "to look like the Holy Virgin" speak about what is better and what is more important.

To put it simply, we must find, we are seeking, and we will find a new (don't be afraid!) aesthetic, enthusiasm, and emotional tone for the photographic expression of our new social facts.

For us, a photo of a reconstructed factory is not just a photo of a building. The new factory in the photo is not a simple fact but a fact that is the pride and joy of the industrialization of the Land of Soviets, and we have to figure out "how to photograph" this.

We must experiment.

To simply photograph facts, just as to simply describe them, is nothing new, but there's the rub—that a fact simply photographed can cover painting, and a fact simply described cover a novel. You worshipers of fact do not write them so simply either.

Watch out, comrades, or else you may soon lose sight of where the right and left sides are.

A *Leftist* is not someone who photographs facts, but someone who is able, through photography, to fight against "looking like art" with high-quality examples, and to do this you have to experiment, going as far as the "easelization" of the photographic craft.

What is easel painting? A work painted on an easel in a room from sketches and studies.

What is "easel photography?" There isn't really any such term, but we

can imply by this phrase that it is "experimental photography."

Do not teach theoretically without seeking advice from practitioners, and don't be friends who are worse than enemies. There is a terrible danger for practitioners in abstract theories invented for the sake of the aesthetics of asceticism.[108]

May 16, 1929
Glaviskusstvo
State Tretyakov Gallery
To: Varvara Fyodorovna Stepanova

The State Tretyakov Gallery wishes to express to you its deep gratitude for the montage of twelve photo works by A. M. Rodchenko that you execut-ed for the Gallery.[109]

Director of STG, M. Kristi

Working with Mayakovsky

Rodchenko. Cover of the book *Mayakovsky Smiles, Mayakovsky Laughs, Mayakovsky Jeers*, by Vladimir Mayakovsky. 1923. Letterpress, 6⅞ × 5¼" (17.5 × 13.2 cm)

I

. . . We'll call on death in the name of birth.
In the name of racing,
soaring,
sailing.
And when
we breach the barricades
and celebrate the battle's pain—
we'll
force them to parade
every last adornment—
love any you like! . . .

V. Mayakovsky

After much tormented thought—how to write a memoir, how to compose a plan—and becoming disappointed with all the versions invented, I decided to do it quite simply.

I set out a pile of narrow strips of paper, and, having written May 2, 1939, for the record, I began to write. The paper was long, narrow, and again, white, like the canvas on which you have to think up what to draw with charcoal and smear with paint in order to destroy the damned whiteness. . . . It was the same thing here.

The difference was that in youth there were more dreams, and it seemed possible that a new canvas would be extraordinarily marvelous, and everyone, absolutely everyone, would be surprised.

But now you know for certain that it can be a little better or a little worse than the previous one, and perhaps . . . even a lot worse.

I wouldn't write any of this but I need to write about all my encounters with Mayakovsky. It would be better to spend a whole lifetime overcoming these white canvases and not think about anything else—not about photographs nor about money.

I made a plan and grew sad. I can't start, after all, I need to sort through the materials by folder, check the years.[110] . . .

1912

The convention of beginning with the weather made me think both about memoirs and about the weather itself.

The weather was changeable but most often the gauge showed "tempest and storm," and then, much later, "overcast."

Clarity and boldness were possessed by all, always.

To begin is harder than to end, to define the beginning—already means to decide the end, because in life there is no beginning and no end, and it's hard to cut out a piece of it.

The tone and style of the whole thing is determined by the beginning, the mastery of the author is often apparent from the first sentence.

It would be interesting to make a book of photographs, reshooting everything that is needed: documents, objects, and people.

O. M. Brik once told a story about how he, or perhaps it was Shklovsky, wrote or wanted to write a script for the movies in which all the action takes place at one window; and how what was on the window, and what was visible from the window—in all its dimensions—showed tsarist times, the imperialistic war, the October Revolution and the beginning of socialism.[111] . . .

It went something like this: . . . window . . . curtains . . . flowers . . . canary . . . a high school student getting ready for school . . . a bureaucrat with sideburns reads the *Stock Exchange News* . . . across the street from the window is a pharmacy . . . gold eagles . . . nearby is "Vasily Perlov, Supplier to the Court of His Majesty" . . . a city policeman stands at his post . . . a landau passes by . . . blue netting, a heavy, mustachioed coachman, an officer, a lady in the landau. . . .

War. . . .

The window . . . the bureaucrat father, the ensign son . . . soldiers pass by on the street headed for the front, they sing . . . a tram with the wounded . . . a demonstration "until the victorious end". . . .

The February Revolution. . . .

The window . . . the ensign with a bandaged arm, a large red ribbon . . . the bureaucrat throws flowers out the window . . . the high school student also has a ribbon, there's a disorganized demonstration on the street . . . the gold eagle on the pharmacy is hung with red material. . . .

The October Revolution. . . .

The window . . . the glass has a hole in it . . . policemen and priests in different clothing shoot . . . the street is empty . . . the eagle is gone . . . Vasily Perlov has disappeared . . . everything keeps changing and changing . . . lines . . . snowbanks . . . a dead horse . . . downcast people lug bundles and firewood on sleds . . . a makeshift stovepipe appears in the window . . . the hole in the glass is covered with plywood . . . there's a tin kettle on the windowsill . . . a machine-gun belt. . . .

It keeps changing and changing. . . .

The window . . . clean curtains . . . flowers . . . a mother and her two sons are at the window. One wears a medal . . . the other is a Young Pioneer, there's a demonstration in the street—the 20th anniversary of the October Revolution . . . the demonstration passes . . . and the street traffic returns, automobiles . . . buses . . . trolleys . . . there's a metro station across the way . . . a department store . . . and so on.[112] . . .

In youth, when the future seemed especially dark and it was unbearably lonely, I would leave for the "Black Lake." This was a public garden, a people's garden in Kazan, where the band played martial music, and after the band left you could hear the sounds of the *café-chantant*'s string band over the high fence.

People of the "lower classes" took their leisure in the garden, it was in a damp place, at the bottom of a dried-up lake.

There were two other gardens in town: "Derzhavin" and "Liadskoi." In the Derzhavin garden there stood, naturally, a monument to Derzhavin, as a man in a woman's shirt, wearing sandals, and with the head of Zeus, his hand pointing somewhere, apparently to the Imperial Academy of Arts, where his descendants rendered him this way.[113] To the right of this godlike man stood the building, or club, of the Nobles' Assembly, looking just like the Bolshoi theater, and to the left—the post office, exactly like Strastnaia Square in Moscow.[114] The Derzhavin garden was where the "clean" citizens walked—the intelligentsia, bureaucrats, students, high school students, and the like, but it had no band. The garden was divided by flower beds, acacias, and nice benches, but it was unpleasant to walk there.

There was a main street in Kazan—Voskresenskaia, and once, in the window of some store, a poster appeared, I can't remember the text, but it was something like:

Three Futurists
D. D. BURLIUK[115]
V. V. KAMENSKY[116]
V. V. MAYAKOVSKY

In the gardens near the window with the poster, everyone discussed their visit.

In the Kazan art school [Kazan School of Fine Arts], where I was studying, Igor Nikitin and I were the most leftist students.

In the hallways of the school, people talked, and wondered, What is Futurism?

* * *

. . . I'm surprised at how hard it is to write, and I envy Tolstoy and Dostoevsky: they wrote so easily.

In his letters, Flaubert says that it was torturously hard for him to write, and that *Madame Bovary* was accomplished with tremendous labor; but in essence it's not a very interesting piece, though his letters are exceptionally interesting. . . .

As a child I didn't consider the theater entertainment, since I grew up onstage. My father was a propman. Usually he didn't go anywhere much, but once he took us to the circus. The circus amazed me so much that it has remained my favorite entertainment ever since. Everything in it was unusual. Ordinary things flew, spun, and were transformed. Dogs read, sang, did somersaults. . . . Horses danced. . . . People stood on their heads, on their hands, flew through the air. . . . Phenomenal people didn't burn up in fire, the snake-people were invincible. Their costumes were bright, fantastical. People spoke in inhuman voices. The circus is a genuine spectacle of unexpectedness, agility, colors, laughter, terror, music, etc.

The second fabulous spectacle [I saw] was the evening of Futurists in this important-looking gentry assembly house.

> I like this pregnant man,
> How handsome he stands
> By Pushkin's monument, hiding in an old lady's scarf,
> Wearing a gray double-breasted jacket
> His finger picks at the plaster stucco swirl,
> He doesn't know whether the malicious seed
> Will produce a boy or a girl.
>
> So charming the pregnant tower.
> So many living soldiers, inside and about,
>
> And a vernal, fat-bellied field
> Where little green leaves peek out.

Shouts. . . . Whistling. . . . Laughter. . . . Indignation. . . .

Burliuk, all powdered, with an earring in one ear, was triumphant and unruffled. . . .

Pursing his lips with disdain, he carefully and meticulously examined the frenzied crowd through his lorgnette.

He does this brilliantly.

Vasily Kamensky, wearing a light-colored suit with a gigantic chrysanthemum in his lapel, raising his head high, sort of sparkling all over, read in a singsong. . . .

CACOPHONY OF THE MOTORS' SOUL
a symphony
——frrrrrrrr
It IS I, it IS I
futurist SONGWARRIOR
and pilot-aviator
VASILY KAMENSKY
like an elastic propeller
I WOUND UP THE CLOUDS
throwing OVER THERE
for the visit
Of flabby death TO THE COCOTTE
A TANGO MANTEAU
stitched from Pity
and *stockings* with
BLOOMERS.

Vladimir Mayakovsky wore a yellow top, and in a low, pleasant voice, which nonetheless drowned out all the noise of the hall, he read:

I walked into the barbershop, and said—calmly, quickly:
"Be so kind as to scratch my ear."
The smooth barber immediately grew prickly,
His face stretched out like a pear.
"Madman"
"Redhead"—
Words bounced about.
Swearing scurried from squeak to squeak
And for quite a looooooong
Bout, someone's head tittered,
Popping out of the crowd like an overripe radish.

Mayakovsky also read Pushkin, but the audience still hissed, booed, banged. . . .

It was the first time I had seen such a frenzied, furious audience.

I had occasion to see the rather unpleasant spectacle of the raging intelligentsia again in those pre-October days when the Bolsheviks spoke before a group of the intelligentsia that supported the Mensheviks.

All three Futurists had their photographs taken in Kazan, and sold them at the performance. I bought postcards of Burliuk and Mayakovsky. Burliuk

was photographed against a black background, in a black suit, with a lorgnette and a disdainful grimace. Mayakovsky was also in black, in a black top hat, and holding a cane in his hands.

The evening came to an end, and the audience slowly dispersed, agitated, though in different ways.

Enemies and admirers. There were only few of the latter.

Of course, I was not only an admirer but much more; I was a follower.

People were standing at the entrance, engaged in a lively discussion. . . . For some reason, I stopped too, I didn't feel like going home.

The Futurists came out surrounded by admirers, and they were given an ovation. . . . I saw Mayakovsky come out in his top hat, with his cane, and leave in a carriage with V. Veger and his wife.

* * *

The Kazan art school was distinguished by its considerable tolerance for all manner of innovation by its students.

True, in this deep provincial town, our "leftism" was extremely relative. For example, we, that is, Nikitin and I, being the furthest to the left, were painting like Vrubel and Gauguin at the same time; it had never been more left than that before us. Despite this, we were definitely doing interesting things.

In the halls of the school hung "examples"—the best works of students over the years—in the style of [Vasily] Perepletchikov, Sergei Ivanov, [Nikolai] Dubovskoi, and others—[117] ordinary, gray works, these "examples" exuded an inescapable ennui, the intelligentsia's narrow-mindedness. Just looking at them was enough to make you not want to paint, or do anything else for that matter.

Among the student examples hung a rather ordinary landscape, but it was executed in stronger tones and a bolder manner. This was a study by D. D. Burliuk. He had studied at the Kazan art school before me.

In Kazan there was a municipal museum, donated by someone named Likhachev, but there was such a mishmash of copies and copied copies of "unknown" masters that people only went there to rendezvous.

Our acquaintance with the art of Moscow, St. Petersburg, and the West was only through magazines in the school library, and those were quite random.

Our professors were Radimovs, Skorniakovs, Denisovs; it is not necessary to talk about their talents.

"The light in the dark" was N. Feshin, undoubtedly a talented man, but he was busy with America; that cunning, ambitious, calculating professor calculated his flight to America far in advance, and was not interested in either the school or Russia.[118]

A "Russian artist" who had graduated from the Academy of Arts, he was the hope of the realists, received the gold medal for the Russian painting *The Cabbage Pickers*, taught at the school, and painted portraits of the school's female students with flowers, or a book, or a little cat. . . . He constantly exported these portraits to America, calling them, in the American manner, "Miss Anta," "Miss Kate," "Miss Mary," etc.

When these "misses" had "amissilated" enough dollars, the Russian artist took off.

Other "professors," not as talented as "Mister Nik. Feshin," lived quiet, narrow-minded lives, built themselves dachas, had tea with one another, and didn't participate in the public art-life of Kazan.

And so there was no museum of Russian painting, exhibitions were held rarely, and even then only of these artists. The Kazan theaters brought performers in from Moscow for the season.

The majority of students in the school had come from Siberia, and during the summer there were only about ten of us Kazaners left.

In 1913 our Kazan professors held a "Periodic" exhibition, and, besides themselves, they invited particularly talented older students like me, Igor Nikitin, and their favorite, Dementev, who painted mediocre stuff. This invitation to exhibit was considered a huge honor for us, and we could only show two pieces.

I exhibited two temperas, in dark but colorful tones, depicting a carnival against a background of architectural fantasies. One of my pieces was purchased by the attorney-at-law N. N. Andreev. Our acquaintance began at this time. I began to frequent the Andreevs. He had a small collection of paintings: a marvelous "Carousel" by Sapunov, I haven't seen such a Sapunov since then.[119] Two landscapes by Krymov, *Races* by G. B. Yakulov, and others.[120] N. N. Andreev's wife turned out to be Yakulov's sister.

Besides the paintings, Andreev had a fairly good library on art—the magazines *Apollo*, *World of Art*, *The Golden Fleece*, *Olden Days*, *Sofia*, and others.

Andreev himself was a very lively fellow, short, dark, round, with very agile fingers and shining eyes. He recalled Evreinov in some respects, and was uncannily like E. T. A. Hoffmann's character Celionati.[121]

Andreev's apartment was unusual: a small foyer and an unexpectedly huge den with a big rug on the floor, like in the "Matisse" room at Shchukin's, paintings, books, more books, and it seemed like there was no furniture.[122]

The rest of the rooms were tiny, like berths, but it was always noisy, there were lots of people, including Veger, who came occasionally. Veger was exiled in Kazan, and, as I found out later, he had done time in Butyrki with Mayakovsky.[123]

Veger was a lawyer, and that was probably why he often visited Andreev. The "Vegers," as he and his wife were called, often made fun of Andreev for acquiring so many things.

They didn't talk about Mayakovsky at the Andreevs, since Andreev didn't recognize the Futurists. He was fairly moderate, and when I moved on in art, my acquaintance with him stopped—he went no further than the World of Art.

Andreev was the regular lawyer for the famous Kazan brewery belonging to Pettsold, the German factory owner, and apparently had money because he decided to hold an exhibition of Moscow artists; however, being moderate and careful in everything, Andreev didn't want to risk holding an exhibition—even of his favorite group, the World of Art; for starters, as he put it, one had to show Kazan the Society of Russian Artists, being afraid that the World of Art wouldn't be understood immediately.

The exhibition wasn't successful with the students or the public. Apparently they understood neither "moderation" nor the realists.

There was no question of holding a second exhibition, of course.

The lawyers, however, decided to hold a "lawyers' Christmas-tree party" in one of the empty apartments, and the decorations for the evening were entrusted to me. I used several rooms for an imitation of a Futurist exhibition, and for this I painted twenty futuristic pieces on cardboard with glue paint; I painted them with pleasure.

I decorated the largest room as a restaurant, the others were done "Eastern style" with rugs borrowed from the lawyers. Veger printed a small, humoristic newspaper.

Once, poking around among Andreev's books one evening, we came across a bundle of revolutionary journal literature from 1905 and spent the whole evening looking through them, but he wouldn't give them to me to read. The bundle was packed up again, and I understood that Andreev was preserving them as a rarity and nothing more.

One time I visited "the Vegers"—we had planned to go to the movies together. I was surprised by the student atmosphere of their apartment.

Soon I left Kazan for Moscow, and never saw Andreev or Veger again.

In Moscow, in 1916, I participated for the first time in a Futurist exhibition, *The Store*, on Petrovka St.; this was my first appearance in Moscow. We simply kicked in together and rented an empty store for a month. The participants were Tatlin, Udaltsova, Exter, Popova, Bruni, Kliun, Pestel, Vasileva, Malevich, and me. Tatlin and I couldn't pay for our part with money, just with our labor, therefore I sold tickets and sat on duty at the exhibition, and Tatlin organized and directed the exhibition.

Malevich exhibited cubistic pieces, kept making a fuss, and finally took his pieces down and left the exhibition.

I exhibited abstract pieces.

It's not easy to write these memoirs, of course, all sorts of doubts overwhelm me, especially the question of whether it's right to take all these detours into my own biographical descriptions. But I can't write any other way, it wouldn't be interesting for me, and then no one would need it.

The atmosphere and situation in which we worked on the left front is needed; it can explain many things that aren't understood nowadays.

1917

We, the leftist artists, were the first to come and work with the Bolsheviks.

And no one has the right to take this away from us; it can only be deliberately not remembered.

And not only did we come but we dragged artists from the World of Art and The Union of Russian Artists along by the hair.

And to make sure this isn't forgotten, we will remind everyone:

We were the first to design Soviet demonstrations.

We were the first to sovietize and teach in the art schools.

We were the first to organize Soviet artistic production.

221

We made the first Soviet posters, banners, ROSTA, and so on.[124]

We remade ourselves, so much so that some of us have already been decorated, except for N. Aseev, V. Shklovsky, S. Kirsanov, and some others.[125]

And the fact that leftists nowadays don't remake themselves as fast as rightists remake themselves, still, they waited a long time (the rightists). And they didn't really remake themselves, they just remodeled and fixed themselves up without changing themselves, and since they only changed their theme, their skills often grew worse.[126]

How I tried to convince the artists in the professional union to move into a nine-story building, the former Nirenzee Building on Gnezdnikovsky Lane.[127] . . . There would have been room for everyone to have a studio, and the roof would have been a huge common studio.

I had already negotiated with Mossovet and the commandant of the building. They were moving "has-beens" out of that building, many ran off themselves, the building was empty.[128] To set an example I moved there myself—it was a marvelous studio with gas, a telephone, a small kitchen and bath, but. . . . No matter how much I agitated the artists, they hesitated. . . . They were simply afraid that the Bolsheviks would leave and then. . . . We won't repeat what was said at the time. . . .

In 1917 we organized a professional union; it consisted of three federations:

the Youth Federation
the Central Federation
the Elder Federation

In life they were referred to differently: Left, Center, Right. . . .
In the Youth Federation were the leftist artists—

Futurists,
Cubists,
Suprematists,
Non-objectivists.

In the Central Federation were artists from—

World of Art,
The Union of Russian Artists,
Knave of Diamonds,
Donkey's Tail, et al.

In the Elder Federation were artists from—

The Union of Russian Artists,
Wanderers, et al.

Tatlin was the chair of the Youth Federation, I was the secretary. Nivinsky was the chair of the Central Federation, the secretary was Keler. The chair

of the Elder Federation was Bogatov, the secretary was Evreinov.[129]

I also forgot to write: just before the October Revolution, Tatlin and I took jobs working as painters at the Café Pittoresque on Kuznetsky Most, where Vsekokhudozhnik is now.[130]

The owner of the "Pittoresque" was the capitalist Filippov.

Filippov was—almost all the bakeries in Moscow. He apparently decided to open an unusual café, directing the artist G. B. Yakulov to design it.

In short, I don't know what the deal was, but Yakulov invited me and Tatlin to work on it.

This was the way we worked: I developed the sketches for the artists and the large working details according to Yakulov's pencil draft sketches. Yakulov, getting paid a lot of money and living in the Luxe, was drinking a lot, and he didn't have any time to make good sketches.[131]

In the end, Tatlin, Udaltsova, and Bruni executed these sketches in the café itself. The pay, I recall, was by the day, three or five rubles a day. They gave me a room and I began to work.

Tatlin began to paint the glass.

They were so free with money that even Velemir Khlebnikov was commissioned to draw some sketches.[132] So that the thing would actually get done, Khlebnikov was given a fancy suite in the Luxe, on the first floor, two rooms; but he was so strange, he came late at night, slinking about furtively in the dark, and lay down to sleep on the floor, somewhere in a corner; then, early, early in the morning, he would go off somewhere. I don't know whether he drew anything or not.

After the October coup, Tatlin still had to get some of the money from Yakulov and the administrator, and they—naturally, given the "unclear" situation—weren't intending to pay up.

Tatlin came to me for advice. What to do? Who should he complain to?

I advised him to go to the neighborhood Party committee.

The next day, in the evening, Tatlin appeared sad and told me that at the committee they had told him to go to court. What court now—it was clear that the whole affair would be dragged out.

I asked him:

"That doesn't sound right, where did you go?"

"Oh, to the committee."

"Which one?"

"The Social Revolutionaries."

"Well, that wasn't the right one at all, you have to go to the Bolsheviks, they've got the real power."

The next day we set off together and informed a comrade in a leather jacket with a Mauser that staff-captain Yakulov wasn't paying the housepainter Tatlin for his work.

The comrade in the leather jacket wrote a summons:

"Staff-captain Yakulov is to appear before the committee at ten o'clock."

At ten o'clock, everyone appeared.

The man in the leather jacket stood up, straightened the holster of his Mauser, and said: "What is this, now, citizen staff-captain, you're not paying

your worker-painters?"

Yakulov became terribly indignant, he started saying that he's an artist just like these painters, but his looks—in breeches, riding gloves, a field jacket, a little moustache, riding crop—didn't speak in his favor. Tatlin and I really looked like housepainters.

And the man in the leather jacket ordered him to pay immediately. Tatlin got his money the next day.

Yakulov was unable to forget this for a long time.

1918

Once Tatlin and I went by the Poets' Café in Nastasinsky Lane. It was still being finished and painted, each artist was given a wall and painted whatever he wanted on it. D. D. Burliuk painted his wall and said that a wall was waiting for Tatlin. . . . But Tatlin refused to paint it. They offered me one, too, but Tatlin whispered to me: "I wouldn't do it," and I refused too, but why "I wouldn't" I still don't know.

Petrovsky and Vladimir Goldshmidt were strolling by there—Goldshmidt—a "Futurist of life," was a talentless poet but a handsome fellow, who had incredible physical strength. He went around in some sort of blue shirt with an open collar, with a gold ring on his head, something in the spirit of the ancient Greeks or warriors.

He soon disappeared somewhere and I haven't heard anything about him for a long time.

We had to see what they'd done in the Poets' Café, and the three of us went: Tatlin, Stepanova, and I.

All the tables were occupied but for Tatlin they found us a place somewhere.

The public was varied: bohemians, journalists, speculators, and bourgeois who hadn't yet run off.

It was noisy, colorful, smoky.

A lot of poets performed, V. V. Mayakovsky among them. Seeing Tatlin, he announced from the stage: "Among us this evening is the author of iron-and-concrete counterreliefs, the brilliant artist-Futurist Vladimir Evgrafovich Tatlin!"

The audience applauded.

Tatlin stood up and bowed, and I blushed from the unexpectedness of it. Thinking I was offended, Tatlin, sitting down, whispered to me: "They don't know you yet, that's why they didn't mention your name."

I remember that there was a New Year's tree, and hanging on the tree, among other things, were books and drawings.[133]

Mayakovsky gave out presents from the tree. I remember he tossed [into the audience] the book *The Cloud in Trousers*, which had some kind of inscription.

I really wanted to get it, but alas, I didn't succeed.

The union held an exhibition in the space of what is now the Pushkin Museum, but a few days after the opening, the Left Federation left the union because of its violations of the federation's rights and removed all the paintings of its members from the exhibition.[134]

We began our independent public life in a new location—Krechetnikovsky Lane.

The club of Left Federation artist-painters of the union began to function.

We put out a poster saying that the club held continuous exhibitions in order of registration of all members of the Left Federation. The exhibitions were very popular, and people came eagerly to see them.

I remember that there were a lot of people at my solo show, among them Ehrenburg, Aleksei Tolstoi, S. Shchukin, Tugenkhold.[135] Mayakovsky was also listed as a member of the club, but he spent more time in Leningrad and I don't know whether he went to the exhibition or not.

Punin, Shterenberg, Mayakovsky, and [Osip] Brik came to Moscow and organized the Visual Arts Department, headed up by Tatlin, and the Artistic Collegium of Narkompros.[136]

Tatlin, Malevich, Morgunov, Rozanova, Rodchenko, Udaltsova, and others began to create Soviet art.

Nowadays many hush this up.

Many people don't remember, for others it's not advantageous to remember, but I think that it is absolutely necessary to remember.

We were the ones who began to create Soviet art, and not other people, who don't remember this. But we remember how at that time they were still finishing up their portraits of the tsarist times and came to Soviet art about ten years later than us.

This should not be forgotten. We believed the Bolsheviks in 1917 and they did rather later—in 1927. There weren't many of us, but we were "the instigators of a new faith."

> Long ago,
> a few hundred Greeks, or so,
> fought the whole
> Persian host.
> Just like us.
> But we Futurists,
> All told,
> Are seven—at most.

<div align="right">Mayakovsky</div>

<div align="center">II</div>

APPARENTLY—A DETOUR

> A legend of torture spreads over the town
> You grab at a note—
> your fingers will bleed!
> And the pianist can't pull his hand out
> from the white teeth of the furious keys.

<div align="right">Mayakovsky 225</div>

Each creative path is the sum of impressions: childhood, youth, the milieu, and youthful illusions.

The creative development of an artist is not designed, it is put together from different materials, and to break all of these facts, to rudely discard them, means to remain with nothing.

For an honest artist this would simply mean the end and death.

Perhaps this will be interesting for something, when someone feels like giving an example. . . .

I was born over the stage of a theater, it was the Petersburg Russian Club on Nevsky, where my father worked as a propman after years of hardship. . . .

The life of the theater, i.e., the stage and behind-the-scenes, that was real life, and what was behind that—I didn't know at all.

The apartment came with the job, it was on the fifth floor with an entrance from the stage; truth to tell, it was really just an attic.

All you had to do was walk down a steep staircase and you'd be right on the stage.

The first landscape I ever saw was on stage, the first flowers were made by my father.

In short, everything ordinary and genuine in life I saw in an unreal version. It was all artificial.

But I didn't know this and I thought just the opposite. And I was terribly surprised when I discovered that there wasn't any stage at all in a house we went to visit.

I thought actors were the best [people], after all, this was all done for them.

And it seemed to me that the city—was just a bunch of theaters, and in each of them there was the same kind of life we had.

I couldn't imagine that there were residential buildings, factories, prisons, and actual palaces.

Theaters have all these things on stage.

There was no one to explain all this.

No one had time to explain it, and I didn't ask either, since it didn't occur to me to question it.

It was only books that explained it to me later.

You would think that it would have been natural to dream about performing on stage, becoming an actor.

But this didn't happen and couldn't have happened.

The actors changed but the theater never did. That meant that this whole machine was more important, more necessary.

I often performed on stage when they needed a child. Performing, I was not nervous in front of the audience but in front of the actors and the life backstage.

I performed for them and thought only of them.

The viewers' hall. . . . That was the dark, unknown audience, for me it was an alien and incomprehensible world.

What could a young man dream of, standing behind the scenes next to the fireman or wandering around to see the set designer, makeup artist, or costumer?

What could one invent that would be supernatural in this unnatural, artificial world?

One thing was clear. . . .

It must be something unusually vivid and fantastical!

My dreams sailed in impossible fantasies. . . .

Fantasies that were unrealizable in life.

It was interesting and sad.

The strongest impression of my childhood—was the arrival of the ventriloquist.

One time, as they write in novels, a number of large black crates with strong locks appeared on stage; they had iron straps and mysterious writings on them in white: "Caution" and the name of the ventriloquist written in a foreign alphabet.

This was strange enough and made an impression.

Besides which, this had never happened in the theater.

I slept poorly and kept dreaming of the crates. Early in the morning I went down on stage, and the mysterious crates were standing there.

But . . . at ten o'clock, a man in a black suit and with sparkling black eyes arrived . . . and he took the crates away into the dressing room and locked it. And sealed the doors.

My interest increased.

I asked my father what a ventriloquist was, I kept an eye on him every day, but the doors were kept locked and I didn't see anything.[137]

I awaited the day of the ventriloquist's performance with impatience.

And then, finally, it came. . . .

And what woe!—They moved everyone off the stage. And for the first time in my life, I ended up as a viewer in the orchestra.

The curtain went up.

A man and a woman sat onstage. The woman held a little boy in her hands, on the right, there was a trunk, on the left, a woman's bust on a stand.

They didn't move.

Twenty minutes passed.

They were dolls.

Their immobility stood out sharply against the black background, but then the ventriloquist entered, all dressed in black; he bowed and looked over the audience with his sparkling eyes. . . .

And the dolls . . . began to move and speak. From the trunk, interrupting the dialogue between the couple, the boy would poke his head out and shout something.

And in a finale, the ventriloquist, taking the woman's head from the stand and placing it on his hand, began to walk about the stage. . . . And the head sang an aria. . . .

It was amazing.

I was overwhelmed. . . .

To be a ventriloquist or something like him—that's what I dreamed about.

Painting . . . When I saw the painting *Vii* for the first time, in the Kazan Art Museum, it decided my whole life.[138] These were also dolls, but lifelike, and you could invent things, whatever you wanted, and it was all—theater and actors and sets, and you could do everything by yourself. . . .

I began drawing. I got into the Kazan art school.

And that's how I made myself a painter, an extreme leftist artist of abstract painting, where compositional, textural, and color problems destroyed the object and depiction.

The works were strange. I took painting to its logical conclusion and exhibited three canvases: red, blue, and yellow, asserting that:

Everything is over.

Primary colors.

Each plane is a plane and should not be a picture.

Each plane has one color up to its borders.

Futurism is unthinkable now, damaging and pointless, but at the time. . . .

It is false and incorrect when they write that leftist art is—a bourgeois perversion, oversaturated refinement.

No need to lie, one can prove the impossibility of it existing today without all that.

In 1916, in Moscow, I participated in a Futurist exhibition called *The Store*, on Petrovka St. At that time I wore a torn fall coat summer and winter, lived behind the kitchen stove in a closet of a room partitioned off by plywood, went hungry, and every bit of money that I managed to earn went to paints.

That need was so strong that even now I dream of it often, like a difficult reflex of the past.

But I despised the bourgeoisie, disdained its beloved art—The Union of Russian Artists, and aesthetes—the World of Art.

Those are the ones that were the bourgeoisie's favorites and reflected its tastes and dreams.

Those aesthetes, petty bourgeois, dreaming dreams about the past, restorationists!

I was close to other artists like myself, unrecognized, unbought, criticized in all the newspapers, like Malevich, Tatlin, Mayakovsky, Khlebnikov, and others.

We rebelled against the accepted canons, tastes, and values.

We worked and we offended that bourgeois world, and because of that no one bought us or accepted us.

We felt our strength and hatred for the art that existed at that time.

. . . And the utter correctness of the new art.

For hours at a time, at exhibitions, I explained and argued our worldview and art to visitors, and my eyes blazed with irreconcilable fire of hatred for "rightist" art.

We supported the new world, the world of industry, technology, and science.

We supported the new man; we felt him and couldn't imagine him quite clearly in the future.

We didn't lick the mugs of the overfed bourgeoisie with our brushes.
We didn't paint their private homes, balls, manors.
We were inventors and remade the world our own way.
We didn't masticate nature on our canvases like a cow chews its cud.
We created new concepts of beauty and expanded the concept of art.
And at that time such a struggle—I believe—was not a mistake.
Then came 1917.
Here's an example of how I wrote about art in a newspaper in 1918:

With our bold schemes we laugh like the heralds of the deliverers.
As edifiers, we preach purification.
We string plantings, and splitting open the skull,
we focus
the names of the wonder makers.
Open initiators, squeezing the fright from the earth,
We move silence with the stubbornness of fury.
Like tigers
born in the sun,
we invent ourselves.
If the little ones, shamefaced, hindering the silence
in their brains,
cannot even be virtuous,
then what about you,
blazing creativity!
Like the plague you fear the noise of the red birds
that are gathering over the gigantic cities.
Rushing . . . on wing,
but not vengefully,
with light,
With the light that singes the blood-bearing veins,
the Revolution walks the twists and turns of the tall buildings.
But you,
like silkworms,
hide in the streets of the fleeing tax collectors! Seekers!
Bold rebels!
Drive out the obsolete mummies
of the painted old ladies
in love with romantic twilight
with their rotting decrepit grandeur.
Furious seekers,
We will create palaces of new quests!
The daring of the audacious
Is our true "forward march!"

And we went to work with the Bolsheviks in 1917.
But the others, the "rightists," the favorites of the bourgeoisie, the realist artists and the World of Art, did not go to work with the Bolsheviks.

They were waiting it out. . . .

None of the rightists went to direct and teach in the Bolshevik art schools and institutions.

We organized professional unions.

We made posters, wrote slogans, decorated plazas and buildings.

Even the simple, clear typeface for demonstrations was established by us, and it exists to this day.

We revolutionized young people, and the best artists of the present day studied with us at the time. . . . Deineka, [Pyotr] Viliams, [Ilya] Shlepianov, [Viktor] Shestakov, Goncharov, Stenberg, [Aleksandr] Tyshler, [Aleksandr] Labas, and others.[139]

In the newpaper *Iskusstvo kommuny* of the Visual Arts Department of Narkompros, slogans like the following were published (most likely they were Mayakovsky's):

The boulevards are our brushes,
The plazas our palettes!

Speed our god,
Our drum, the heart!

No beauty without battle,
No masterpiece without violence!

Enough walking, Futurists.
Leap into the future!

The proletariat is the creator of the future,
Not the heir of the past.

To destroy—actually means to create,
For in destroying we overcome the past.

Let the Milky Way split
Into the Milky Way of the inventors
And the Milky Way of the acquirers.

<div align="right">

From the Futurists' newspaper, 1918

</div>

MANIFESTO OF THE FLYING FEDERATION OF FUTURISTS

The old regime rested on three foundations: political slavery, social slavery, spiritual slavery.

The February Revolution destroyed political slavery. The road to Tobolsk is covered with the black feathers of the two-headed eagle.

October threw the bomb of social revolution under capital.

Far away on the horizon you can see the fat rear ends of fleeing factory owners.

And only the third foundation—Spiritual Slavery—stands unwavering

It continues to spit out a fountain of stagnant water called old art.

The theaters still put on "Judaic" and other "tsarist [plays]" (the compositions of the Romanovs), we have monuments to generals; princes, tsars' mistresses, and *tsaritsas*' lovers still stand with a heavy, threatening paw on the throat of young streets.[140]

In junk shops pompously referred to as exhibitions, they sell the pure dabblings of landowners' lordly daughters, and dachas in the style of "rococo" and other Ludwigs.

And, finally, on our own shining holidays, it is not our own anthem we sing but a gray-haired *Marseillaise* borrowed from the French.

That's enough.

We, the proletariat of art—call on the proletariat of the factories and the land to a third, bloodless but cruel revolution—the Spiritual Revolution.

We demand recognition:
1. The separation of art from the state, the destruction of patronage, privilege, and control in the area of art.
Down with the diploma, awards, official posts, and ranks.
2. That all the material means of art: the theaters, choir chapels, exhibition spaces, and buildings of the academy of arts and the art schools—be handed over to the masters of art themselves for the equal use of them by all the people of art.
3. Universal art education, for we believe that the foundation of the future free art can only come out of the depths of a democratic Russia, which until now has only craved the bread of art.
4. The immediate requisition, along with foodstuffs, of all hidden aesthetic stores for the fair and equal use by all of Russia.

Long live the third Revolution—the Revolution of the Spirit!

D. Burliuk, V. Kamensky, V. Mayakovsky.

Given in Moscow, March 1918

And we, leftist artists, went to work directing and teaching, at the same time managing to do our personal work in our studios.

O. Rozanova and I began organizing the artistic-industrial subsection of the Narkompros Visual Arts Department.

We visited studios, cooperatives, handicraftsmen.

We recovered the work they had thrown out.

We gave them money and materials, revived abandoned art schools.

We organized the Museum of Painterly Culture.

We equipped all the museums of the USSR and acquired the works of leftists, but along with them we also acquired works by Konstantin Korovin, Abram Arkhipov, Sergei Maliutin, Vasily Surikov, Vrubel, and so on.

But the "rightists" began to fight us in the press, articles by V. Friche and F. Kalinin appeared in *Proletkult*.[141]

And we, beating them off, were building Soviet art. . . .

On a copy of *War and Peace*, pub. "Parus," 1917—
is Mayakovsky's inscription:
"to com. Stepanova in memory of the attack on Friche."

March 4, 1918, Mayakovsky

* * *

In 1920 the Institute of Artistic Culture (INKhUK) was opened, where, working on cultural questions, we announced the slogan:

"ART TO PRODUCTION."

We went to the manufacturing departments.

[Liubov] Popova and Stepanova went to the textiles department; Lavinsky went to the ceramics;[142] Vesnin to architecture;[143] Rodchenko to the metalworking department.

Bitter was our lot under tsarism when we fought for the new art, but when we declared

"DEATH TO ART!"

"LONG LIVE PRODUCTION!"—

we paid for it even more intensely under RAPP.[144]

But then . . . also for the fact that we dared to ridicule and not recognize pure art, they railed at us so hard. . . .

They railed at us because we were

newspaper workers,

typographers,

photographers,

textile designers,

designers.

In the construction discipline course at the Higher State Artistic and Technical Institute (VKhUTEIN), where I taught, there were slogans like:

"CONSTRUCTIVISM IS THE CONTEMPORARY WORLDVIEW"

"A CONSTRUCTIVE LIFE IS THE ART OF THE FUTURE"

"DOWN WITH ART AS BRIGHT PATCHES IN HUMAN LIFE"

"IT'S TIME FOR ART TO MERGE INTO LIFE IN AN ORDERLY WAY"

"DOWN WITH ART AS A MEANS OF AVOIDING LIFE."

I am writing all of this very briefly, it could be written about in great detail, and perhaps it would be very interesting, but I want to write a little about a lot of things so that the atmosphere surrounding life and the struggle to inculcate the new art will be more or less clear.

It might seem that I am extolling all of this inordinately and that I don't have a critical attitude, but, first of all, there is no praise, only facts, and as far as a critical evaluation is concerned, there has been so much of it that an entire separate book should be written on the subject.

. . . I hope,
I do believe:
shameful good sense
will never come
to me. . . .

<div align="right">Mayakovsky, *Unfinished*</div>

Nusinov: . . . *Where Is* LEF's The Captain's Daughter?[145] *Where is such prose from* LEF*?*
Mayakovsky: *We have* The Captain's Son—*Rodchenko*.

<div align="right">From a stenographer's report, "LEF or Bluff"</div>

1920

On October 2, 1920, at the *19th State Exhibition*, I showed fifty-seven works. The exhibition opened in the "Salon" on Bolshaia Dmitrovka St. Mayakovsky was at the opening. He came up to me and simply said: "Let's go, Lilia Yurevna Brik wants to meet you."[146]

I went over and met her.

That was my first encounter with Mayakovsky.

Lilia Yurevna went through the whole exhibition and left with Mayakovsky.

From that time on I began to go to Vodopianny Lane, off Miasnitskaia St., and that's where my acquaintance with Aseev and others began as well.

Mayakovsky began calling me "old man" right off, and I called him "Volodya"; he was only about two years younger than I.

1923

Volodya wrote *About This*—and he read the poem for the first time at Vodopianny. The room was light blue and five cornered, because of the fireplace—there was a table, Lilia Yurevna's bed, and a piano. Since there were always tons of people and some would sit on the bed, I made a little sign—"No one sits on the bed." In addition, I made a shade for the lamp from plywood and tracing paper.

Lilichka lay half-reclining on the bed, but Volodya stood and read.

A. V. Lunacharsky and Nikolai Aseev were there, I don't remember the rest.

Volodya read with unusual animation; Lilia Yurevna, very pleased, smiled.

After the reading there was a small discussion. Anatoly Vasilevich expressed his approval.

I began doing the photomontages for *About This*. Shterenberg took photos of Lilia Yurevna and Volodya for them, I wasn't yet photographing.

I was the first to begin making photomontages in the USSR. It was for the magazine *Kino-fot* [Cine-photo], I also used montage in posters for Vertov's films *The Sixth Part of the World* and *Kino glaz*, Eisenstein's *Potemkin* for *Molo-*

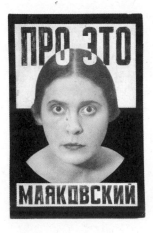

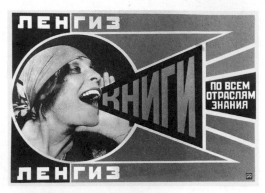

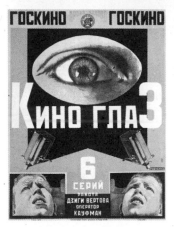

Above left: Rodchenko. Maquette for the cover of *About This*, by Vladimir Mayakovsky. 1923. Cut-and-pasted gelatin silver photograph, ink, and gouache on paper, 9⁷/₁₆ × 6½" (24 × 16.5 cm)

Above right: Rodchenko. Maquette for an advertisement for Lengiz, the Leningrad Section of the state publishing house, Gosizdat. 1924. Gouache and cut-and-pasted gelatin silver photograph on paper, remade by Varvara Rodchenko in 1965 after a lost original, 27⁷/₁₆ × 33⁷/₈" (62 × 86 cm). Text: "Books in all disciplines." The model for the photograph is Lili Brik.

Right: Rodchenko. Poster for the film *Kino glaz*, by Dziga Vertov. 1924. Lithograph, 35¾ × 26¾" (90.8 × 67.9 cm)

daia gvardia, *Sputnik kommunista*, and so on, therefore Volodya wanted me to do *About This* as well.[147]

I did the cover and eleven montages.

At about that time I began working on ads for the Dobrolet [State airline] company. I made pins and posters: "A Soviet citizen you are not/ If you don't own any Dobrolet stock." One time Volodya, Aseev, and I were sitting in a pavilion on Tverskoi Boulevard. They began laughing at the couplet for Dobrolet, knowing that I had made the poster and assuming that the poem was by some bad poet. I got mad and began giving them a hard time for not writing texts for ads, saying that this was my poem and it came out by accident, I just cut and rearranged the text I'd been given. It was: "He who is not one of the stockholders of Dobrolet is no citizen of the USSR."

I don't know if that's what gave him the impetus or whether Mayakovsky was already planning to write ads, and that's why he noticed the poster, but

soon afterward he proposed that I do ads for GUM: "English tobacco," "Dutch butter," "Men's Wear," "Women's Wear," "Visitors," "Mozer Watches." (1923.)[148]

Our collaborative work began. Our brand name was: "Ad-constructor Mayakovsky-Rodchenko."

We worked with great enthusiasm.

At the VKHUTEMAS department, where they made icon *rizas* and icon lamps, we began seriously teaching future engineers [to make] everyday objects. . . .

. . . Equipment for savings banks, trams, buses, the infrastructure of streets, institutions. . . .

It's not worth writing about the struggle for this and the difficulties of creating a department of this sort; it's an entire, separate story. The idea is topical to this very day. And such things are greatly needed, specifically now, and not then. Now, when the metro is being built, buses, exhibitions, the armature of everyday life.

The students who graduated at that time are now engineers in these areas; they are working and are highly valued.

The first posters Volodya and I did were:

No time or place for doubt
GUM has it all, the women shout!

Whether you come from the country or town,
No need to wear your boots down
Go straight to GUM, and in a thrice,
You'll find what you need, cheap and nice.

The most accurate and functional,
Businesslike and punctual.
Go to GUM to get your own
Mozcrov watch—it stands alone.

The texts, which Mayakovsky scribbled on various bits of paper, were written on the piano in Vodopianny.

I would go to the Briks' on Vodopianny Lane (it was near my place) and wait while Volodya, standing at the piano, wrote the texts. Sometimes he would pace the room, beating out the meter with his hand, then lean over the piano again and write something down.

In the last of the texts (I have a sketch of it), Mayakovsky wrote "accurate" with one "c." I thought that was what I was supposed to do, but early in the morning I received a note:

Dearest Rodchenko, "From the dacha" is written without a soft sign, and "accurate"—has two "c"s.[149]

Fix it please. V. Mayakovsky.

I'll drop by around nine.

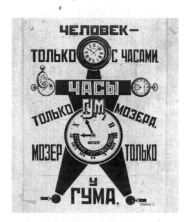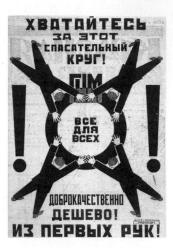

Left: Rodchenko. Advertisement for Mozer watches sold at the department store Gum (State Universal Store). 1923. Letterpress, 7¹/₁₆ × 6¹/₁₆" (18 × 15.4 cm). Text by Mayakovsky: "A man needs a watch. Only a Mozer watch. Mozer only at Gum."

Right: Rodchenko. Advertisement for the department store Gum (State Universal Store). 1923. Letterpress, 11¹¹/₁₆ × 8⅞" (29.7 × 22.5 cm). Text by Mayakovsky: "Hold on to this lifesaver! / Gum / Everything for everyone / Good quality and cheap! / Firsthand!"

I did the following covers for V. V. Mayakovsky's books:

1. *About This*—cover and eleven photomontages. 1923.
2. *Mayakovsky Smiles, Mayakovsky Laughs, Mayakovsky Jeers*. 1923.
3. *Lef*. 1923.
4. *Lef*. 1924.
5. *Cross the Heavens Yourself*. 1925.
6. *Paris*. 1925.
7. *Spain, Oceania, Havana, Mexico, America*. 1926.
8. *My Discovery of America*. 1926.
9. *To Sergei Esenin*. 1926.
10. *Syphilis*. 1926.
11. *Conversation with a Financial Inspector*. 1926.
12. *Novyi Lef*. 1927 (10 covers).
13. *Novyi Lef*. 1928 (12 covers).
14. *No. S*. 1928.
15. *Collected Works* (10 vols).
16. *The Bedbug*. 1929.
17. *There and Back*. 1930.
18. *Threatening Laughter*. 1932.

1924

He was immodest with the audience; he was rough, businesslike. With enemies he spoke thunderously and destructively. And for this reason he wasn't liked by philistines—quiet and modest, with their piddling giggles.

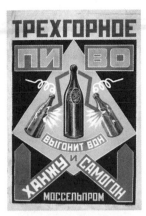

Top left: Rodchenko. Advertisement for Trekhgornoe (Three Mountain) beer, sold at the state grocery concern Mosselprom (Moscow Agricultural Industry). 1925. Lithograph, 28⅛ × 19⅛" (71.5 × 48.5 cm). Text by Mayakovsky: "Three Mountain beer / will get good and rid / of moonshine hooch / and hypocrites."

Top right: Rodchenko. Advertisement for Krasnaia Zvezda (Red star) cigarettes, sold at the state grocery concern Mosselprom (Moscow Agricultural Industry). 1923. Lithograph, 3¾ × 8⅜" (9.5 × 21.3 cm). Text by Mayakovsky: "All smokers near and far / always prefer to smoke Red Star."

Left: Rodchenko. Advertisement for pacifiers sold by Rezinotrest (State Rubber Trust). 1923. Gouache on gelatin silver print, mounted on cardboard, 38⅝ × 27³⁄₁₆" (98 × 69 cm). Reconstruction by Varvara Rodchenko, 1965, from a damaged original. Text by Mayakovsky: "No better pacifiers—never / I'm ready to suck them forever and ever. On sale everywhere. Rezinotrest."

He read the poem *Lenin* in the House of Publishing.

This club is small, the stage is small, there were so many people packed in that even the entrance was crowded. . . .

Volodya walked back and forth on the stage, large and wide, and his businesslike demeanor already had the ordinary, narrow-minded people indignant—"Now, what kind of Eugene Onegin is this!"

He drank water, and, when it became unbelievably stuffy—took off his jacket.

That was unbearable for the average person.

Volodya hitched up his trousers. . . . Of course, such an "unpoetic" poet—never mind that the poems were brilliant—they couldn't accept as a poet.

Back then I often heard that people liked his poems but couldn't stand his performances.

It may seem that perhaps I'm writing an awful lot about the frontline of struggle and about myself, but it is, I repeat, not for praise but to convey the atmosphere of the time. We were the vanguard division of revolutionary art, after all, and each in his own area carried on the struggle for the new art, even in the sense that we were against art.

Left: Rodchenko's advertising poster for Krasnyi Oktiabr' (Red October) cookies displayed on a Mosselprom kiosk, 1924.

Right: The Mosselprom Building decorated with Rodchenko's mural. 1925. Photograph by Rodchenko

This struggle continues in different forms, and will always continue in art.

Work on Soviet advertising—the creation of our new ads—was going full steam.

Volodya wrote texts on the piano in the evening; during the day he took commissions or turned them in.

Two VKHUTEMAS students and I would draw till dawn.

It was exciting—and not because of the money, but because it advanced the new advertising everywhere.

All of Moscow was decorated with our products. . . .

The signs for Mosselprom.[150]. . .

All the kiosks were ours. . . .

The signs for Gosizdat—

"Black, red, gold. . . . "

Rezinotrest,[151]

GUM,

Ogonyok,

The Tea Directorate.

We made as many as fifty posters, up to 100 signs, packaging, wrappers, lighting, advertising, advertising pillars, illustrations in magazines and newspapers.

A separate book could be written just about our work over these several years, which I'm thinking of doing if this turns out well.

In the evenings Volodya himself drew ads and posters.

Here's a note:

Rodchenko.

Come over now with an instrument for drawing *immediately.*

V. Mayakovsky

(Don't look at the note on the Briks' door.)

You'd arrive—and it would turn out that he needed to write a text or draw something. He didn't like to sketch and measure things out. He always liked doing everything by hand. He'd draw everything straight off in pencil, without smudges, then he'd trace the contours in ink and only then paint it.

You could see that it was easy for him and that he liked working.

He found it restful and became affectionate and gentle.

In connection with the work on photomontage, I too began taking photographs—sometimes something really needed to be reshot, enlarged, reduced. . . . I bought myself two cameras—a 13 × 18 with a triple extension, with a Dagor—a camera for reshooting reproductions—and a pocket Kodak; I didn't have an enlarger and kept on looking for one in the stores.

In Bek's store on Tverskaia Street I noticed an appropriate enlarger, but when I got ready to pay it turned out that I had 180 rubles and needed 210. Paying 180 in a frenzy, I said that I'd bring the rest right away. I ran out of the store and, walking along, was thinking hard—Who could I borrow from? The Briks, Volodya?

But they would only be home at night. So I was walking along Kuznetsky, deep in thought. . . .

And suddenly, right in front of me . . . "What's wrong old man? You look miserable."

Volodya. . . .

I didn't explain anything to him, just said right off: "I need three tenners!"

Volodya gave them to me and I quickly ran off in the opposite direction.

I got to the store, paid, and dragged the enlarger home, resting on the windowsills of stores.

I thought woefully: "What an idiot you are, you didn't ask Volodya for more money for a cabby. . . . "

I dragged it up to the eighth floor and was met by an anxious Varvara. . . .

It turned out that Volodya had called and asked what was wrong with me, he'd run into me all dejected; I had asked him for thirty rubles, taken them without a word, and run off somewhere. . . .

This was a small episode but I remember it. . . . He was very sensitive, attentive, to his comrades.

Not like some others, also poets and also comrades, and colleagues as well, who disappeared from my horizon after Mayakovsky's death, who took a different path than I, who picked up other friends.

There was none of that with Volodya, and couldn't have been. He saw everything and observed everything. He was interested in everyone. He didn't shut himself up in his own shell.

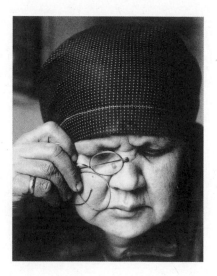

Rodchenko. *Mother*. 1924. Gelatin
silver print, 8⅞ × 6½" (22.5 × 16.5 cm)

He always had a lot of people around, and the number of people kept
increasing, not decreasing.

In work he was the same, and wherever he was, in institutions, pub-
lishing houses, editorial offices, he always brought his comrades in to work.
He thought that all the *Lefists* should work where he worked too. He never
betrayed our tastes. We could argue and swear at each other but we still
worked together. He knew that his covers shouldn't be done by Vasily
Chekhonin or Sergei Mitrokhin.

He would say: "Why don't you invite the marvelous artists—Lavinsky,
Stepanova, Popova, Vesnin. . . . Aseev should write about this, he'd do a fab-
ulous job. . . . "

Usually Volodya himself went to turn in the work, I went with him only
twice. This was because, first of all, he knew how to get commissions and
how to present them, and secondly, I didn't have any time, my work was
time-consuming.

I remember how he presented the posters to the Tea Directorate. Among
the various posters, one "got stuck," that is, it raised some doubts in some-
one. Someone said: "Why doesn't the Chinaman have a braid?" The Chinese
man on the poster was drawn straight on, with raised hands, walking, and
in his hands were bow-shaped tea chests, held up in the air between his hands;
the Chinese man was looking up at them, as if juggling.

Volodya answered: "There is a braid, but it's in back, if you turn him
around with his back facing, the braid would be visible."

Someone else asked: "Why are the tea chests held up like that in the air,
it's not realistic. . . . "

Volodya: "Well, everyone knows the Chinese are magicians. . . . " They
laughed. . . .

The poster was accepted.

In 1924 I took six photographs of Mayakovsky for the first time—they are some of his best portraits, and very popular.

I was at the Briks' one evening, Volodya was playing mahjong with Mikhail Levidov and someone else, I can't remember who. The game was very lively, since Volodya was lucky.

It was already late and Levidov had lost all his money, but wanting to win it back he bet his ubiquitous pen for some sum, I don't remember the amount. . . .

Volodya won and put the pen in his open side pocket.

The game went on for a bit, I don't know with what, but it was soon over.

Levidov began to ask for his pen back, pointing out that it was an implement of production and that he'd hand over what he owed the next day. Volodya was cheery and terribly proud of his winnings. He replied: "No," he'd give it back tomorrow too, "Don't bet your implement of production in a card game. And I'm going to wear it like a trophy until you hand over the money."

Levidov left insulted.

The next morning, straight from Vodopianny, Volodya dropped by to see me and I took the six photos of him in my studio on Kirovskaia St.:[152]

1. A portrait from the waist up, with a cigarette.
2. In a hat, to his knees (exhibited at the *All-Union* photo exhibition in 1937).
3. In a hat, full figure, with hands (not published).
4. Head shot, *en face*.
5. Sitting, to the knees.
6. Standing, full figure.

All of this was shot with a 9.12 Berito, f6.3, on Soviet plates. The first portrait in particular was published a great deal in our press and shown at exhibitions abroad.

Pushkino.

The first time I visited Mayakovsky's dacha in Pushkino, in 1924, I had a small camera (6.5 × 9) called a Tenax, with a 4.5 lens and plates.[153]

It was a Sunday. Varvara and I arrived about twelve noon. There were already about thirty people. There was tea and whatnot on the table.

Some played *gorodki*, including Volodya, who hit with his left hand.[154]

There were people on the balcony, too, in the rooms, in the garden, everywhere.

This entire multitude sat down to eat dinner, and when they got to the ice cream, Volodya went out; I had also gone out to look at the garden, to take some pictures, and saw—an ice-cream man on the back step, he had dished out several portions and put them on the ground. It turned out that "Skotik" loved ice cream, so Volodya was watching to make sure the ice-cream vendor didn't cheat and really gave the whole portion ordered for Skotik.[155]

Volodya stood there and watched with incredible tenderness while Skotik ate and licked himself clean.

Volodya smiled, and asked: "Well, want some more?"

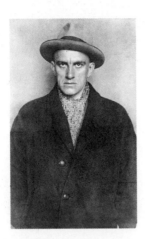
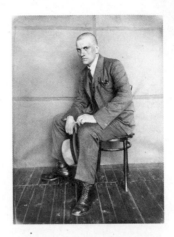
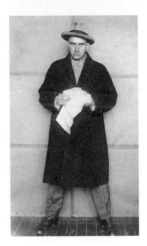
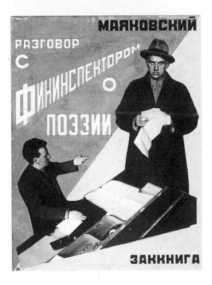

Left to right, top to bottom:

Rodchenko. *Vladimir Mayakovsky*. 1924. Gelatin silver print, 11⁷⁄₁₆ × 6¹³⁄₁₆"
(29 × 17.3 cm)

Rodchenko. *Vladimir Mayakovsky*. 1924. Gelatin silver print, 15¹¹⁄₁₆ × 8¹¹⁄₁₆"
(39.9 × 22.1 cm)

Rodchenko. *Vladimir Mayakovsky*. 1924. Gelatin silver print, 11⅝ × 6¹³⁄₁₆"
(29.5 × 17.3 cm)

Rodchenko. Maquette for the front cover of the book *Conversation with the Finance
Inspector about Poetry*, by Mayakovsky. 1926. Cut-and-pasted gelatin silver prints and
gouache on paper, 11⁵⁄₁₆ × 8⁹⁄₁₆" (28.7 × 21.7 cm)

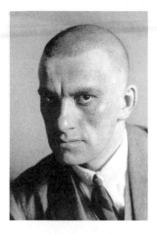

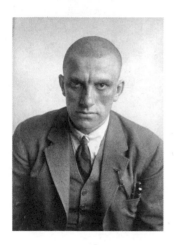

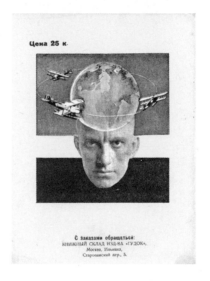

Left to right, top to bottom:

Rodchenko. *Vladimir Mayakovsky*. 1924. Gelatin silver print, 6¹¹/₁₆ × 4³/₈"
(16.9 × 11.2 cm)

Rodchenko. *Vladimir Mayakovsky*. 1924. Gelatin silver print, 11³/₈ × 8½"
(28.8 × 21.5 cm)

Rodchenko. *Vladimir Mayakovsky*. 1924. Gelatin silver print, 4²/₁₆ × 2¹⁵/₁₆"
(10.7 × 7.5 cm)

Rodchenko. Back cover of the book *Conversation with the Finance Inspector about
Poetry*, by Mayakovsky. 1926. Letterpress, 6⅞ × 5" (17.4 × 12.9 cm)

I decided to take a picture with Skotik. He picked him up and I photographed them in the garden. Two pictures came out. Volodya's gentle smile was preserved, which is completely related to Skotik.

Volodya was leaving for Berlin—we got together at the Briks on Vodopianny. They weren't there, they were already in Berlin, it seems.

I, as a novice photographer, came with a 9 × 12 camera—a Universalka, a Berito 6.3 lens, and plates.

Of course, I set up the group—Mayakovsky, Lavinsky, Lyova [Lev] Grinkrug, Shklovsky, Levidov, Aseev, A. Levin, M. Koltsov. I set a chair on a table and poured magnesium into an ashtray. I turned out the light and focused the camera in the light of a match. Everyone was sitting in the dark. I lit the strip of magnium and went and stood next to Mayakovsky. While the strip was burning, Volodya said: "You won't blow up the building, will you?" There was a terrible sound and the picture was ready.

The room was full of smoke, windows were opened. . . .

1939

May 10

Last night Varvara and I were at the Briks, looking at the collection of photos with Mayakovsky. Lilia Yurevna has about two hundred of them.

We looked at a new head of Mayakovsky that Lilia Yurevna is sculpting, and successfully, but she's having a hard time with anatomy and connecting everything together in separate pieces. It looks very like him but one piece doesn't fit with the other, and as a whole the impression doesn't work.

Osia [Osip] is the same, rushing about the rooms with books, and, as always, books are everywhere—the hallway, the dining room, anywhere you can possibly put them, there are books. . . .

He's interesting to listen to. . . .

He's trying to find where to buy Vasily Chekrygin's drawings.

Lilia Yurevna gave us two watercolors by D. Burliuk.

Osia says that the V. Mayakovsky library needs help: it's the only place where one will be able to see everything new in literature and the art of the West and the whole history of leftist art in the USSR, since Mayakovsky is connected to Picasso and Léger—and others—and with our Futurists of this day.

I was gradually drawn into reminiscences, and as I went to sleep, I thought: "Tomorrow I should write and recall all the details." It's probably equally interesting to write a novel, to live the life of one's so-called "heroes" and fall asleep thinking about their actions.

One can envy Flaubert, but painting is also like this. Waking up in the morning you think about your work, and getting ready for bed you sit for a long time in front of the painting, setting out what you need to do tomorrow.

It is such a pleasure to live through a work of art, I know of no higher pleasure in life than this sort of existence. For this alone it is worth living, and all the rest seems so unimportant.

At night, going out onto my balcony in the studio, I grabbed a number of books. I should look and learn how to write. I took Mérimée and Babel;

Farewell party for Mayakovsky before his trip to Berlin, 1924. Standing, left to right: Rodchenko, Mayakovsky, Anton Lavinsky, M. Koltsov, Lev Grinkrug; seated, left to right: A. Levin, Nikolai Aseev, B. Malkin, Viktor Shklovsky. Photograph by Rodchenko

well, of course, Mérimée has such a realistically developed style, and to write like that, rather, to polish like that . . . first of all, you'd never finish writing anything, and second, it doesn't fit the theme. For that kind of writing the subject needs to be deeply interesting, regardless of the form. The kind of story that anyone can tell, and it will be interesting. But if it's a calm narrative and not an event, then Mérimée's style won't help, the same goes for Babel. No, I have to read Proust and Joyce.

May 12, 1939
Today the whole day was wasted, I didn't write anything. All kinds of personal affairs took up the day, and it's a shame that this breaks the mood.

Just as I feared, it is hard to write, and not very interesting creatively, especially to polish and develop.

But now, it seems, I really feel like working it through, and I even tried developing the beginning. True, nothing in particular came of it, but I hope to overcome this as well.

1924

I became involved in radio, began building a four-tube radio receiver. There weren't any like that for sale at the time. After that I wanted to make a superoscillator, but there weren't any transformers and I really wanted to have two identical foreign ones; since Volodya was leaving for Paris, I asked him to bring two back.

At the time, one wasn't allowed to import radio parts from abroad.

When Mayakovsky returned, the Briks called: come over, Volodya's back.

I arrived and he gave me one transformer from the table, wrapped in

paper, and took the other one from his suitcase, in a box. It turned out that he was afraid they'd confiscate both of them at customs, so he carried one in his pocket and the other in his suitcase.

He was that attentive, he did all sorts of favors.

A good associate of mine—an engineer—was leaving for Germany. I advised him to buy himself a Leica. The Leica had only just appeared and there weren't any yet in the USSR. I wanted a Leica too, but I didn't have that much foreign currency, and he wouldn't have been able to bring two anyway, therefore I asked for an Esko camera for myself—a cheap camera for film frames.

When he came back, it turned out that he had bought himself a Leica, and another engineer had asked him to bring an Esko, with its enlarger. He didn't bring them but turned the cameras over to our embassy. These things lay there for a year. I, of course, asked Volodya to pick them up (I didn't know what sort of enlarger it was).

Soon Volodya arrived, handed me a document, and said: "Go and pick it up, I brought it, but that enlarger is so heavy and big I had a hard time."[156] And really, had I known its size I would have been embarrassed to ask Volodya. But again, despite all the unpleasant and tedious fuss, he brought everything. I forgot to say also that he ended up having to get a license for all of this as well.

Likewise he bought and sent the film director Kuleshov a Ford sports [car] from Paris.

He was thoughtful without a request as well.

From every trip Volodya brought back something for me and others.

Once he brought back pastels (colored pencils).

From Paris he brought back photo paper, a gift from the famous Man Ray.

This was a novelty—photo paper on a transparent backing. Photos by Man Ray himself.

Two Picasso engravings that Picasso had given him, he gave to me.

Unfortunately, taking them home, I lost them.

He brought back monographs, magazines, etc.

He took his work on Soviet advertisements very seriously. Thus, Volodya even put together a price list for all kinds of advertising work in the union; there the price list was approved, everything was included in it: text, sketches, artistic execution. I made a portfolio of our work to show to clients.

In the morning he went and got the order, collected the figures and thematic material. Often this was a huge quantity of reports and boring books, which he skimmed and then jotted down figures on themes and other things.

In the evening, around seven or eight, I would come over. Sometimes he was still finishing off a text, sometimes he was already finished.

There was more than just text, there was drawing, which he couldn't do, but each time he said, "I drew this, but you don't need it, of course, I just did it for clarity."

He knew that I didn't do things according to his drawings because they were satirical, in the style of *lubok*.[157]

After ascertaining the size and purpose of the work, I would go home and immediately begin working on sketches. Students from VKHUTEMAS,

Zhigunov, Bykov, Sobolev, and others, would come over, and, spreading out around my studio, they would start the execution. I worked on the next sketches, kept an eye on the execution, did the most important bits myself, and marked the proportions.

We sometimes worked until dawn. In the morning, at eleven, I would take the finished posters to Volodya, or he would come by for them. . . . In the evening we repeated the same thing, plus I'd get my pay, and sometimes something would need redoing.

Volodya called me scrupulously, informing me that the work was accepted and the money received. That was very valuable and marvelous—he was a genuine friend and member of the collective.

We kept getting more work and I collapsed from sleepless nights, developed anemia and a nervous disorder, and had to cut back on work. Volodya then got Levin and Lavinsky to work with him and started doing a lot himself.

Then that work stopped.

The artist Yuon was appointed by Mosselprom; Yuon, of course, didn't give us any more work.[158]

RAPP and MAPP and company tried to squeeze us out, of course, and tried to censure and destroy our work in every way possible. Which they managed to do.[159]

Of course, they had something to worry about—all of Moscow was covered with our ads. All the kiosks of Mosselprom, all the signs, all the posters, all the newspapers and magazines were filled with them. We had completely conquered Moscow and completely shifted, or rather, changed, the old, tsarist-bourgeois-Western style of advertising for the new Soviet.

Various Zharovs and Selvinskys made fun of Mayakovsky: "'Get it from Mosselprom'—is the new Uncle Mikhei!"

They managed to arrange things so that people gave us work much less willingly, and anyway, our working mood had been ruined.

Advertising gradually returned to the old ways.

Again women's heads appeared, flowers, and, with the help of AKhRR, entire collective farms and demonstrations were drawn on textiles, taking everything to the point of absurdity.

To our most talented enemy, Mayakovsky, in memory of AKhRR's victory.
May 3, 1926

Evg.[eny] Katsman
Inscription on the book *The Art of the USSR*—AKhRR.

The victory of these "enemies" suffered a defeat, their "talented" commanders—the Averbakhs, Kiselises, and others—were not only defeated but entirely discarded from life.[160]

But they shortened Mayakovsky's life, and by how much—we don't know exactly. Perhaps they were in fact entirely to blame for his death.

At any rate, during the period of persecution and their "victories," I myself began to think in incredibly gloomy terms: "What's happening, I support Soviet power heart and soul, I work for it with belief and love and all my strength,

and suddenly we are wrong." Sometimes I had also thought of suicide.

How to work? Like Katsman did—that impersonal, mediocre, toadying, varnished, soulless trash? . . .

What's going on? How is it that this other guy painted landscapes to go with the sofas of the bourgeoisie and felt just fine under it, he painted portraits of Kerensky, and he is now in the Union of Artis[ts]. . . . No, I don't understand it. . . .

1926

Volodya traveled abroad quite frequently. According to the map of his trips that Varvara is now making, it turns out that he made four round-trips each year. But at the time it was not really so obvious that he wasn't in the USSR or in Moscow. Rather, it wasn't noticeable at all. There weren't any gatherings, farewells, meetings, or likewise; he continued to publish in the newspapers, he sent poems, and on returning immediately appeared with reports and new poems.

He brought whole suitcases of magazines, catalogues, books. He gave all of this to Osia, and there was an entire warehouse in his room. We would crowd into this room, look, argue, and make plans. Osia's room—is a special room, and it should be re-created in the [Mayakovsky] museum. When Volodya arrived, Osia would be terribly animated, showing us everything Volodya had brought, explaining, translating, and so on. Volodya continued being the same as always. He didn't tell any stories, didn't show anything, didn't talk. Just as though he hadn't gone anywhere and only yesterday was sitting in the same place.

But on the other hand—

at his appearances and in his poetry—it was an entirely different story.

It was as though he were telling his friends everything, making jokes and making fun of things. It seemed to me that was why he didn't say anything at home, so as not to repeat himself and not to lose the mood.

We were already accustomed to it being Osia who explained and told us everything.

After Osia had looked them over and all the new ideas had been used in print, the magazines and books were handed out according to specialty: the art and photography went to me, theater and film—to Zhemchuzhny, sculpture and architecture—to Lavinsky, and whatever else there was—to whomever needed it.

Volodya gave me monographs—on Grosz, Larionov, Goncharova, Delaunay, "the blacks," Rousseau, Picabia, Pierre Loty, B[oris] Grigorev, Picasso.[161]

In this way, he alone was the one to inform the press and us about the culture and art of the West, and for this reason, it seems to me, the library that bears Mayakovsky's name must continue this role, without a break—must fill the gaps and subscribe to the magazines and anthologies on art, architecture, sculpture, theater, film, the circus, and so on.

He was interested in all of these things, loved them, and was strongly connected to all types of art.

This has not been forgotten—he was, after all, a marvelous artist.

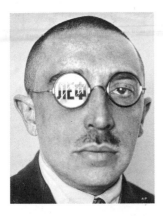

Rodchenko. *Osip Brik*. 1924. Unpublished illustra-
tion for the cover of *LEF*. Gouache on gelatin silver
print, 9¼ × 7⅛" (23.6 × 18 cm)

To limit him only to poetry means to muffle his significance in the history
of Russian visual art—which is yet to be felt, and for us has already been felt.

He didn't put together a collection, he brought things back and gave
everything to us. He brought back not only the art of the West but his life
as well, his breath, just as it was, with all its defects and virtues. He brought
posters and catalogues and advertising prospectuses and street posters and
new original objects and photographic views, stagings, and constructions.

Apparently, on arriving, Volodya described everything to Osia and Lili,
and then he would only talk about it at his performances, therefore I heard
all the stories either at performances or from Osia.

In general, Volodya's room was always open, and if people didn't fit in
the dining room then they sat in Volodya's room.

It was in Osia's room that the plan for *LEF* was put together, its visual
components invented, and in the dining room Volodya argued with Tretyakov
and Chuzhak—they always argued. Volodya would get nervous and raise his
voice such that the dishes rang in the cabinet.

But anyone who knows Tretyakov won't be surprised.[162] He is so argu-
mentative and such a Talmudist that he could torture just about anyone. He
was incredibly difficult to work with; his opinion could change, but until it
did he would adamantly insist on his point.

On the one hand, he was a leftist deviationist, and on the other—he
brought the most aestheticized, rightist ideas into *LEF*.

Chuzhak, most likely due to illness, was grouchy and irritable, like an
old man.

Aseev completely relied on Volodya.

And Kirsanov was young, and he still had a lot of work to do, but he
loved Volodya and listened to him.

Pertsov was always wildly in awe of Volodya, you could tell by his eyes,
they looked at him with infatuation.[163] But he challenged many editorial
decisions in *LEF*.

Shklovsky was narcissistic and nervous like a woman. He was always
nearby, keeping his own company, watching himself, listening and talking
both for and to himself alone.

Left: Rodchenko. *Sergei Tretyakov*. 1928. Gelatin silver print, 11 7/16 × 9¼" (29 × 23.4 cm)

Right: Rodchenko. *Nikolai Aseev*. 1927. Gelatin silver print, 6 7/16 × 8⅞" (16.3 × 22.5 cm)

Lavinsky would bend this way and that, and was always infected with extremes.

After all this, everyone would sit down to play mahjong or cards.

Volodya passionately loved playing. I'm not a gambler but I've never seen a more passionate one.

He entirely immersed himself in the game, as in everything that he did.

He would tease the other players, usually I heard things like—

"Kolya, don't torment yourself, you're doomed."

"Now you're going to be completely devastated."

"I'll wipe you out."

"No mercy for you."

"There'll be nothing but a blotch left."

This isn't exact, but that was the sense.

During a game he wouldn't loan money, on the contrary, he always asked Lili to give him a ruble for luck.

If we were playing too, that is, Osia, Zhenia, Zhemchuzhny, and I, then usually I got sick of it and dropped out. Then Volodya would beg me to play for halves, then on his money, and finally, if we lost—he lost; if we won, we'd split it.

And if I agreed, he would shout from his table:—"Well, how's it going?"

He usually played with Kolya [Aseev], Katanian, Kirsanov, Lyova [Grinkrug], Kruchenykh, Levidov, and others.[164]

In Pushkino, when I was learning to play mahjong, I played with him alone. But more about that later.

Kolya usually didn't respond to his goads, Kirsanov never did.

Kruchenykh got upset and tried not to pay or play at a loss.

Kolya forgot to pay.

Katyan [Katanian] and Lyova played with restraint.

Lili played to win.

Varvara only played mahjong, and won first place in the championship at Pushkino.

I played badly and always lost, since I only got "miracle" [tiles].
Zhemchuzhny—was calculating.

I'm writing down trivia, but in trivia you can also see what a person
is like.

1927

Pushkino.

I'll return to my time in Pushkino, the last year that I lived not far from
there and went to the Brik-Mayakovskys' everyday.

The Briks, Mayakovsky, Kuleshov, and Khokhlova and her son lived at
the dacha; the Zhemchuzhnys came often; and of course, all sorts of other
people came, especially on Sundays, for example, Rait, Kushner, Aseev, Pudovkin
Shterenberg, Denisovsky, Luella, Levidov, Maklin, Lavinsky, Levin, Lyova
Grinkrug, Kassil, Kirsanov, the Mayakovskys, Neznamov.

They would sit and talk in groups. Others played mahjong or *gorodki*,
or cards.

Volodya played more than he talked, he played all the games. Sometimes
he would shoot an air pistol.

When my daughter was five years old, she recited *Kon-Ogon* (The fire
stallion) by heart, and some of Kirsanov's poetry.

In a copy of his book *What Is Good and What Is Bad*, Volodya wrote "To
Mulia Rodchenko, Uncle Lef." And on the book *Who Should I-Be*: "To dear-
est Mulia—Volodya."

We rented a room in Pushkino, but we only slept in it, I spent the whole
day hanging out on the river, and in the evenings, or when it rained, I sat at
the Briks. They had a two-story dacha with two balconies and huge grounds;
Volodya himself occupied a small room near the balcony.

Everyone became terribly infatuated with mahjong, everyone played,
sometimes at three tables. Sometimes there weren't enough pieces and only
then would people play cards.

Ping-Pong became terribly popular, too. There were even competitions
for first place, each person put in either three or five rubles and had to beat
everyone. Pudovkin beat everyone but he refused to take the money for quite
some time, saying that he didn't like to take money from fate.

Everyone was fed from Saturday to Monday. There was a dinner with
masses of wild berries, salads, all kinds of pirogi were baked.[165] Anichka,
who came specially for the summer, was really good at this.

Volodya didn't go swimming, and every day he left for Moscow in the
morning, leaving Lili notes in verse with drawings. He drank his tea alone
in the morning, still in bed. He rose early and wrote something in the morn-
ings no matter how late he went to bed.

In the train from the dacha he sat quietly, sometimes closing his eyes
and occasionally jotting something down. . . .

The first time I saw Natasha Briukhonenko, she stood at the fence with
Volodya, pretty, large, young, with a low voice, and I thought: "Now that
one fits Volodya"—and envying him, I quickly left them alone.

Osia complained: "One morning I heard the floor creak and the house shake, someone was walking by with male steps, but cautiously, I thought it was thieves. I called out: 'Who's there?' And suddenly a deep voice answered: 'It's me, Natalia Aleksandrovna.'"

Varvara and I also began playing on the top balcony with Osia and Zhenia Zhemchuzhnaia. We would begin playing in the evening and would end around six in the morning. We got so tired that we felt like lying down to sleep immediately, that's how hard it was to go back to our dacha, and it was only about fifty steps away.

One day, Volodya and I started playing mahjong. He proposed playing for money but I refused. Then he offered to play for services. He lost, I won twelve services, it was boring and it was time to go. Volodya kept trying to convince me to keep on playing, and offered his services: "May I pour you some tea?" and so on. We began playing for six services at a time, Volodya won, then for another three—he won, then for another three—again he lost, for another three—he won, for another three—he lost. I was sick of it and dropped out. But, as always, he wanted to pay his debt—the services, right away, and he demanded that tasks be given to him. I told him he had to find a large mushroom and bring a cow into the garden. He did everything unquestioningly but proposed playing for the remaining four—and won.

Pleased with himself, he left to take care of business in Moscow.

His birthday was held at the dacha. I didn't feel like going into Moscow for a present and I made a him a set of pickup sticks, which you have to pull out without touching the others.

Volodya liked the game, and those sticks lay on his table for a long time.

1925

Volodya was a member of the State Academy of Artistic Sciences Committee on the international Paris exhibition of 1925, and on his recommendation I was commissioned to produce an exhibit—the "workers' club." I also had to make copies of the posters we had done for Mosselprom, GUM, and Rezinotrest.

The club was accepted, both the maquette and the drawings, and they decided to produce it there in view of the short deadlines. Thus, I had to travel to Paris.

Besides the club, I had to do the color scheme of our pavilion, both inside and out, a design and its execution for three rooms in the Grand Palais, and the installation of all the exhibits there.

In short, there was plenty of work.

I left in April 1925 and began working. I was in the pavilion in Paris from ten in the morning until six every day; moreover, I worked on the layout and designs at home. I worked for three and a half months.

Volodya came to Paris, too, he was on his way to America. We spent a few evenings together. He showed me Paris, introduced me to Elsa Yurevna [Triolet] and Léger.

Ehrenburg also showed me Paris. I knew his wife, L. Kozintseva, in Moscow, she had studied with me at VKHUTEMAS.

The Ehrenburgs referred to art as "Art—what's it for?" which is what I always called things when I didn't see any technology but just art.[166]

Volodya's room was robbed and he soon left. I don't think he was at the opening.

In Paris I bought myself a Sept camera with twelve cassettes and a 4.6 cm Minimus-Palmos with an 80, 2.7 Tessar lens. The Leica didn't yet exist; the fashionable camera was the Ica, which Ehrenburg used.

I was still a bad photographer, and in Paris I didn't shoot much. And then, not knowing the language, I was afraid to end up in trouble.

Ehrenburg photographed the streets, people, and houses. In his room he had basins and tubs, and film hung everywhere like laundry. I wasn't tempted by the Ica, it was expensive, and the size—was that of a film frame.

Well, my work was interrupted again, and now [the description of] Paris came out boring, and I thought a lot about Paris. To write about visiting Léger, for instance, work in the pavilion, a description of Paris, the Louvre, the exhibition, circus, and so on. True, it's not connected to Mayakovsky, but there's a need for it, because later, when I published "Letters from Paris" in LEF, Polonsky shamed me—well, of course, one has to personally settle accounts with the deceased "Apollo."

Letters from Paris. . . .

I read them and see that they're well written. It's not coming out like that this time. But why? . . .

Because there isn't the same focus, if you like, the narrow clarity. Now everything is blurred, you change your mind, calculate—one is supposed to be reasonably cultured, European, treat history politely; before we swore at generals, tsars, and landowners—and that was that.

But no, nowadays you have to know your generals, they were all different: Suvorov—is one thing, but Kuropatkin is another; Nikolai II—is one thing, but Peter the Great—is completely different; the landowner Riabushinsky—is one thing, but the landowner Zhukovsky—is another. . . .

I acquired the third volume of Proust—I'm reading it. . . . The form is marvelous but what's the content?

The duchesses make it impossible to read, and the description of vestibules, rooms, and horses drags on and intertwines so long and boringly that Swift's book lying nearby seems like paradise and stimulates completely new thoughts.

Proust was no help, but he created a certain turmoil—well, I have enough of that myself.

I don't feel like describing Paris, especially because it's a long story, and Mayakovsky's part in it is very small.

In the Grand Palais they set aside three rooms for us—unexpectedly. We didn't have money for the design and we didn't even know whether we had sufficient exhibits to display. The Grand Palais—a palace or royal stables—has been used for exhibitions for a very long time, therefore the walls are dirty, torn up, full of nail holes, the floor as well, the overhead light comes from dirty windows; I suddenly had the job of figuring out how to design our space cheaply, quickly, and originally.

What I thought up was this: build light bookcases of plywood, paper the walls, and paint it and the floor. . . . Paint the floor with glue soot.

I set up the display panels like ribs and painted them—gray, white, red, and when you entered from the other halls belonging to other countries, Poland, for instance, you didn't see any signs that this was the USSR, not any red, but as you moved through the room the color red grabbed you more and more, and you saw, in the place where you entered, the fiery sign "USSR."

Then there was the black floor and its black soot that the visitors carried into the other pavilions onto blue and gilt rugs. . . .

Complaints were made but that didn't help, we just explained that we didn't have any money. In the end, they put down carpet runners for us at their own expense.

Volodya and I were awarded the silver medal for advertising, besides which I received another two medals for theater and interior design.

We would have received gold medals as well, but France didn't have very good relations with the USSR then and didn't encourage obvious propaganda. France—is trade, she sells everything.

I placed a lot of magazines and books in the workers' club. And every day the public stole them and we silently added more. The committee warned us that we weren't guarded well enough and that's why people stole from us. But we answered: "What can you do, we're poor." Then they gave us an *agent*.

. . . There was an order from comrade Krasin about all of us—the workers in the pavilion who came from Moscow—that we should be properly dressed.

For the occasion—opening the pavilion and his presence at the opening of the exhibition—our government commissar, Pyotr Semyonovich Kogan, bought . . .

a top hat,

it lay in a marvelous cardboard box, but the opening was postponed, and meanwhile his children jumped off a chair onto the top hat, and then put it back in the box. When it came time to go to the opening, it turned out that the top hat had only one good side. Well, our Pyotr Semyonovich didn't get flustered, he just never put it on but always held it in his hand.

Once Volodya asked me to print a photo of Lenin. I had reproductions taken from photos in the Lenin Museum. I brought him two prints. One—was the head of Lenin, speaking, and in the other he was standing—standing on a truck in Red Square. He hung them in his room on Lubianka. Until the very last, the speaking Lenin hung on the wall; the second one probably fell off.

Apparently, at some point, looking at this photograph, Volodya wrote the poem . . .

Conversation with Comrade Lenin.[167]

One Sunday, the Briks, Volodya, and I agreed to do a proper photo session. I came over around twelve. I began in the room. I shot Lili at the telephone, next to the window, and everyone together at the table—Volodya, Beskin, Varvara, and Lili. Averbakh showed up completely unexpectedly and an argument began. I went out into the garden—this was in Gendrikovsky Lane—and, photographing everyone, kept waiting for Volodya to come out. But not wanting to be photographed with Averbakh, he didn't come.

Rodchenko, Shklovsky, and
Mayakovsky in the garden in front of
Mayakovsky's house on Gendrikovsky
Lane, 1926. Photograph by Stepanova

To put it simply, in the evening, when the sun was going down, Averbakh left and Volodya came down into the garden, but it was late and dark. I took three photos, but with such a long handheld exposure that the camera shook.

And that's what always happened, it was hard to photograph Volodya, either he was arguing, or he was playing, or he wasn't there.

Yesterday evening Lilia Yurevna and Katanian came over to look at the maps of Mayakovsky's travels.[168] They liked the maps a lot. I showed them drawings and paintings and photos of Mayakovsky.

Polonsky wrote a feuilleton called "LEF or Bluff," where I was especially taken to task for my letters from Paris. Reading the feuilleton I got terribly depressed. I was horribly hurt and upset. What was the point of that kind of distortion and swagger, why such defamation by someone who was then an important (in terms of his position) person, who wrote so coarsely and flatly in the style of "penny papers."

May 24, 1939
Work has gotten stuck, I haven't been able to write for three days. I need to look at the letters from Paris and the excerpts from them that were published in *LEF*. Maybe there's more about Mayakovsky in them than was published. I also need to read the meeting of LEF about Polonsky, then I need to put in Mayakovsky's poem about Polonsky and copy out part of the stenogram of the "LEF or Bluff" discussion. Then all this needs to be read, noted, and copied. I think that since this relates to me and Mayakovsky, I should put it in.

Those idiots thought that my letters were LEF's new prose, that's why they jumped on me.

How often the new is met with bayonets.

How everyone loves everything old, and for that matter, in the old they love the tender-sugary, the impersonal and harmless, and in general, everything in general that is about nothing and about no one.

I'm reading Swift, Cervantes, and Proust, that gets me in the mood to write and accustoms me to civility.

Twenty days have already passed but little has been written, and even that all needs reworking. But still, it has to be carried through to the end, like any job.

Here's another bit of hard work—copying out that whole story with Polonsky. It's particularly difficult to decide what should be copied and what shouldn't. And then the same sort of work with the "LEF or Bluff" debate; there's a stenographer's record, but then I read it and choose what needs to be copied and I'm still not sure whether it will be interesting to read this whole story. . . .

Moreover, because I'm only taking the parts that are about me, and about Mayakovsky with regard to me.

Several times I've been inclined to throw out the whole part with the "letters," but the desire to give the whole picture has kept me from doing that.

Why is it that with age everything falls into place in reminiscences of life. . . . I remember how I wanted to write, and I would climb up on the roof of the house and sit behind a pipe, away from the sun, and write, write in little notebooks with five lines, I accumulated a lot of them and I kept them hidden somewhere. I don't remember what I wrote in them but it seems to have been tortured suffering from the impossibility of writing anything interesting, probably because I didn't yet value anything interesting, and thought it ordinary and dreamed of something extraordinary.

Now I clearly remember that the life of that young man indeed included, among other things, certain interesting events, and that he dreamed a great deal, and much was interesting, he observed and even agonized, and it's worth writing about that childhood, it's so interesting and so unlike the childhood of Count Tolstoy, Goncharova, and many others.

The inner dissatisfaction of my poverty or the poverty of my parents, but also the freedom in my upbringing, hatred toward wealthy children, and dreams of the future provided a very interesting life, and if this business with the memoirs takes off, I will set myself to write more. But so far I don't believe much in the success of my literary treatment.

Apparently, there comes a moment when you begin to value your past life and begin to find it interesting.

In *Izvestia*, on May 25th, 1927, a feuilleton appeared:

"A Journalist's Notes
LEF *or* BLUFF

. . . In one of the issues of *Pravda* something intriguing caught my eye: 'Novyi LEF—the Magazine of the Left Front of the Arts.' And in a prominent place in the ad—the headline 'Rodchenko in Paris.' The ad achieved its goal: I was interested. I turned to the second section of the magazine . . . passed by the poem-like article of V. Mayakovsky, 'To Our Youth,' and went for Rodchenko. Not everyone knows who Rodchenko is and why it's important that Rodchenko was in Paris.

But there's got to be a reason, I thought, that he takes up a fourth of *Novyi LEF*. There's got to be something there.

But I was disappointed from the very first—the title turned out to be a 'trick,' and it was excerpts from letters that the above-mentioned Rodchenko wrote to a member of his household. But even that isn't entirely without interest: 'Our people abroad.'

What does *Novyi LEF* write about and bring with such provocative speed to the reader?

I will refrain from criticism. I won't give any opinion of this correspondence. I will just give a few excerpts from the letters. Let the reader judge for himself about these wonders. Here's what Rodchenko wrote from Europe. . . . "

Then he gives a lot of excerpts, meticulously "chosen," and it isn't difficult if you want to do it. I didn't write these letters for publication, and therefore there's a lot of free language and a great deal of the personal.

But I was published not as a writer but as an artist who had a particular view of art.

And my view doesn't resemble that of the aesthete Polonsky.

Retyping the disgusting attack of this journalist, I started thinking about the expression "poem-like article." What is it meant to express? To show that Mayakovsky didn't know how to write prose? I decided to find it and read it. And what do I see—this "journalist" was referring to Mayakovsky's poetry. You have to be a cretin at the very least, or something altogether different . . . nothing resembling a journalist, at any rate, for an artist to take on, and for Mayakovsky, Brik, and others to agree, to write letters as a "new literary genre."

That wasn't it, of course. It's all—all means are acceptable when you need to persecute *Lefists*.

Don't bother looking for journalistic honesty here.

Let Polonsky turn over in his grave, and let the people who did the persecuting know that the truth will surface anyway.

March 23, 1927, at the debate "LEF or Bluff," Volodya, speaking against Polonsky, said the following about me:

"For instance, we had Rodchenko's letters in the issue about which Polonsky writes: 'Twelve pages of domestic letters of the unknown Rodchenko.' In *LEF* we have a note by Shklovsky: 'If Rodchenko is unknown to Polonsky, it is Polonsky's problem, not Rodchenko's, and if he doesn't know him then let us inform him.'

Comrade Rodchenko has the right to a voice in Soviet culture, because Rodchenko is in fellowship with other *Lefists*, creators, the most revolutionary carriers of the painterly visual method, as far as it is possible under Soviet conditions.

From the audience: Mosselprom. . . .

Mayakovsky: We'll talk about Mosselprom in time. . . .

In 1923, in the pages of *LEF*, Rodchenko was the first to leave behind depiction with pen and pencil and engage in photomontage, walking in step with technology. That was in 1923, and now in photo printing the

Left: Stepanova on the balcony of the apartment/studio on Miasnitskaia, 1928. Photograph by Rodchenko

Right (left to right): Esfir Shub, Rodchenko, Aleksei Gan, and Stepanova in the studio, 1924.

bosses have signed directives to transfer all printing to montage or illustration according to Rodchenko's manner.

In three years from the first stroke, from the first photomontage, he has moved the Soviet book and Soviet book cover to this style.

Comrade Rodchenko founded the style of new Soviet book covers.

Things with the best covers, namely: Lenin's complete collected works, the catalogues to the Paris exhibition, all in all more than two hundred issues have been created by this very same Rodchenko.

When they needed to nominate left revolutionary painterly art in the West, who was nominated by the organizational committee of the Paris exhibition?—comrade Rodchenko, who executed the design of almost all the pavilions of our Soviet Union. He also made the workers' club, which was given to the French Communist Party when the exhibition was over.

The Soviet Communist Party would not give junk to the Communist Party of France.

So that expressed the face of the Soviet Union at the international exhibition.

Now this same Rodchenko has, perhaps, war decorations in the area of design, photomontage, book covers, advertising problems, and the like, and therefore has no business being forgotten by Polonsky.

And also, com. Polonsky, take a look at the last pages of *Izvestia* and *Pravda*, and if you are interested in the history of the Communist Party then you should know that twenty-five signatures of the Communist Academy's publications, the whole history of the Communist Party— were done by Rodchenko.

This is the only history, in visual and photographic images, of the Communist Party.

And to speak this way of a person who has moved these posters with such difficulty into the countryside, and who is now issuing a

third edition in all the languages of the USSR. . . .

So, com. Polonsky should know, and if he hasn't known up till now, then he can find out today.

. . . It would be very strange to write a book about the history of the Soviet poster without taking the name of Rodchenko into consideration.

Then we'll move on to Mosselprom, I'll move into the thick of our contemporary life.

Take a look at Gosizdat and you will see that the standard, typical sign and the entire design of Gosizdat is—black, red, and gold, as a model, given to the entire Soviet Union by the very same Rodchenko.

True, Polonsky will say: 'But [Elizaveta] Kruglikova gave me silhouettes.' But that's already a different setup, the person who does silhouettes and he who designs contemporary life. I do not want to move comrade Rodchenko out of the entire sum of our visual arts. That sort of work has been done already by Stepanova and Lavinsky, Semyonov, and others, as well.

To not notice this work—is the highest form of lordliness and journalistic swagger that can be found."

<div align="right">(From a corrected stenograph.)</div>

Volodya came to my defense, not just as a friend or someone he knew personally.

He defended the comrade-in-arms in me, a proponent of specific positions in art.

It was therefore important for him to show not me personally, not any of my particular qualities, but my works and my direction in art.

He described me as an artist with the straightforwardness and warrior's temperament that was characteristic of him.

Volodya always felt called upon to defend people who fought next to him.

In this debate there is an example of how he knew how to dismiss the opponent when he needed to with a witty joke—to Nusinov's question "Where is LEF's *The Captain's Daughter*?," Volodya immediately retorted: "We have *The Captain's Son*—Rodchenko."

In order to recall and characterize that period, I want to give another excerpt from the stenographer's record of RAPP's plenum on October 3, 1928, in order to give a sense of what Mayakovsky's mood might have been when he left LEF and joined RAPP alone.

Here is a piece of Zharov's speech:

"He (Averbakh) can say that Mayakovsky is a good poet, and no worse than Zharov. But I must say, without any bragging, that I have an advantage in that I have the prospect of becoming more than Mayakovsky, bigger, greater, like everyone who aligns himself with RAPP's more correct position. . . . "

Left: In Rodchenko and Stepanova's studio, 1926. Left to right: Rodchenko, Aleksei Gan (obscured by Rodchenko), Evgenia Zhemchuzhnaia, Olga Rodchenko, Esfir Shub, Stepanova

Right: Rodchenko, 1925.

And further on:

> ". . . Take his (Mayakovsky's) big works (I'm not talking about the innumerable bits of hackwork you find in *Komsomolskaia Pravda* and other places). For all his reckoning on the broadest audience, for all his makeup reminiscent of Demian Bedny, he has no social resonance.[169] In proletarian poetry we have younger, greater [poets] than Mayakovsky, and we have long poems and epic poems that have not only provoked interesting arguments, debates, and conversations among the audience of workers, but which continue to do so. These are our own works, and not those of the great poet Mayakovsky.
>
> Mayakovsky's work has no social resonance, and we can have quite serious doubts about his work of the most recent period. . . . And another extremely important point on the question of Mayakovsky. We might have come fairly close during the period of marching music in our poetry. In our poetry—but Mayakovsky is standing in place and we are growing."

I don't want to entirely justify LEF, but I justify Mayakovsky completely.

Along with much that was valuable and needed, we definitely did much that was mistaken.

For example, in my line—in art.

The complete dismissal of painting for photography alone—that is one mistake. The second—was formal deviations in photos like *Pioneer* and others.

But we *Leftists* didn't have time to correct our mistakes, we were broken up and destroyed sooner than the rightists. Oh, what do I mean sooner—they simply weren't destroyed.

Mayakovsky works at "Komsomolka."[170]

Lili Brik and V. Zhemchuzhny stage *The Glass Eye* in Mezhrabpom, with O. M. Brik's scenario.[171]

O. M. Brik—works in the script department of Mezhrabpom.

Shklovsky also works there.

I make the sets for Kuleshov's movie *The Journalist*, and others.

All in all, the interest in LEF is poisoned and LEF begins to move away from its first priorities.

Averbakh does and did his job; we were already drifting apart.

Varvara Stepanova has a satirical poem on this theme, written "in the manner of Aseev's poetry."

It was written at the time, and is called:

AT A LEF GALLOP!

... LEF left things to drift
And went to poke
Around in
Libraries.
No sham now—
We want industry,
To let us speak
Of LEF's
Prominent accomplishments.
So that—
Face to face
With LEF,
You never go astray
Hand over your work
To Mezhrabpom.
So it won't ever be newsreels
That revel in
The hall,
So that
LEF's supporters
Will grow day by day.
Quiet now,
Quiet,
NEW LEF.
Sleep!
Sleep,
Seryozha's wrath.
Don't be so noisy,
Volodya,
Don't tremble,
Aseev,

There'll come
A season
For Osip's
Crops. . . .
Be patient,
Rodchenko,
Build your set decorations,
The cinema
Doesn't much like
Declarations.
A ragtag regiment of LEF
Marched along genuine
Left pathways.
Not permanent hero-*Lefists*—
But everyone walked together
Like family;
They walked without "people's,"
Without "honored,"
Walked
And argued
Surrounded by "Sentries."
They walked like Soviet
Proletstreetwalkers.
They walked,
And sang something like this:
. . . Why aren't you happy,
Comrade mine, New LEF,
Will the LEF crop
Sprout soon
From seeds.
You can't take a step—
Without coming up against Averbakh's dams.
You'll be the ruin of us,
You, damned
MAPPO-VAPP.
Our comrade
Osia Brik
Sorrowfully replied:
I am not your boss,
A long road still lies ahead.
Scenarios arose
Deliberately
Along our way.
There it is,
Industry,
But just try to get close—no way.
You should "double"

My words
For LEF.
Aesthetics should be wrecked,
But there's nothing to battle with.
Our LEF is barely hanging on.
A mere semblance, that is all:
We'll meet again in Mezhrabpom
Until then . . .
Each goes his own way.
We answered your inquiry
Comrade New LEF.
Our Eddi's "coat of arms"
Is a chronicled bluff.
Obey the order,
Leftist brotherhood:
Don't all take off for Mezhrabpom
at once.
Just one or two at a time. . . .
Swift "Mah"
Roll through
The Taganka
Night.
Disperse,
Disperse,
LEF,
One at a time. . . .

<div align="right">V. Stepanova</div>

This satirical document draws a vivid picture of the *Lefists*' mood when we were attacked by the vappo-mappo-akhrrov.[172]

The *Lefists* wandered off individually. Mayakovsky published in the newspapers, performed and traveled around Europe. Meetings of LEF became rare, and when they did occur the *Lefists* argued terribly with Tretyakov and Chuzhak.

Polonskaia appeared at the Briks', Zhemchuzhny found her for the film *The Glass Eye*.

She was the daughter of the famous film actor Polonsky.

She was in the style of the "beautiful" heroines of American films, with an empty, cloying, intelligentsia mind.

I met her one evening, Lilia Yurevna bought a bunch of brooches and earrings for Polonskaia, for her role, and I helped redo them and choose.

Volodya "amnestied" Rembrandt, young artists began calling me, asking how to understand this. . . . What for? . . . Why? . . . I remember that I attacked Volodya for this "Rembrandt" business. . . . He agreed that it was going too far, and later began explaining that "to amnesty Rembrandt: didn't, so to speak, mean a direct about-face, but a turn toward art."

There is another satiric poem by Varvara Stepanova on the events in LEF. . . . But here some things are not quite exact—Lilia Yurevna Brik didn't have as much significance as she is accused of having in this poem, and also it quite exaggerates about Mayakovsky, but still the poem is interesting.

How
Vladimir Mayakovsky
Not wasting
Any words,
Far from accidentally,
Decided to move left.
LEF and I—
Are one and the same figure.
Cracking jokes
In "Komsomolka"
Osia gave me
This advice:
"Fly all the way
around the world."
And, moving left, much lefter
Than LEF,
Reporting
To the point of "bluff,"
Beginning a speech with—
Little Lefists—
Volodya climbed on to the new
Novyi LEF.
Vitia,
Lilia,
I
Will be cinematoglaphy!
So as to end
Seryozha's blam and drivel
I'm sending LEF
To the devil!
Osia, get up!
Vitaly—hush!
Kitty cat—
Is the leader.
Lili will be
Eisenstein,
She closed
New LEF!
Mezhrabpom is closed for being petty-bourgeois,
Although it breathes with a *Glass Eye*,
In each and every pavilion ten couples

Film the "people's" on the double.
ARC is over Mezhrabpom—caaaw!
Under Mezhrabpom is Oleinikov—cooo!
Bawk! Lili Brik flies into Mezhrabpom,
Bawk! And Vitaly right behind her—flaaap!
Hopped head first in the Lit. Dept.
Brik.
Shklovsky raised a hue and
Cry.
Volodya [flies] through his komsomol
And
Around the world in a flash
like a sausage.
From LEFchik pilots
La la la, chiki chiki chiki,
Into Mezhrabpomchiks,
Chiki, chiki, chiki,
Into around-the-worldchiks
Chiki-chiki-chiki . . .
Chiki . . .
We fly into the komsomol
We've come to see Kostrov . . .
Novyi LEF de tout le monde,
Attendez-vous!
We flew srough ze réportaj,
Now like Rembrandt you too can daub.
And ze sir Kurillo livéd,
And Chuzhak and Silov diéd!
Poems fell in a heap of walls,
Tretyakov, don't bawl like Chamberlain!
Rather than listen to Shklovsky's growl,
Get out of LEF—and it's good-bye!
Everyone's drawn into Mezhrabpom,
In feature films soaring high,
Simply put,
"Lefter than LEF" is my refrain—
Pravda Komsomolskaia,
Let poems rain
into the famous poet's newspaper.

V. Stepanova[173]

That's how the *Lefists* scattered while LEF still existed.

But we should have been together. We were supposed to be, and Mayakovsky in particular couldn't be by himself, he wasn't used to being alone.

And when he joined RAPP, RAPP didn't give him any friends, or interesting work, or ideas, or prospects. . . .

During rehearsals for Mayakovsky's play *The Bedbug*, 1929. Left to right: Dmitry
Shostakovich, Mayakovsky, Vsevolod Meyerhold, Rodchenko. Photograph by
A. Tenerin

And then he left completely. . . .

But I've gotten ahead of myself; I want to remember *The Bedbug*.
Stepanova and I were invited to the reading of *The Bedbug*, I don't remember who was there but it seems it was somewhere around Taganka.

I especially remember how Mayakovsky began to read *The Bedbug*. It
was so unexpected and so brilliantly original. . . .

He picked up the manuscript and began:

"V.
Mayakovsky
The Bedbug
bewitching, etc."

It was this very sharp, unexpected, and extremely loud "V," and the rest
all the same, that struck me so.

Apparently Meyerhold was against me as an artist, and for that reason
the rehearsals were already going on and the Kukryniksy were already doing
the first four parts, the contemporary and everyday life, and the future—1970,
and parts 5, 6, 7, 8, and 9 weren't being done at all.[174]

But Volodya must have convinced Meyerhold, and I was invited to be
the designer.

I thought up a maquette right away, and while my assistants were building it I hurriedly drew sketches for costumes, and there were a lot of them.

Meyerhold is a brilliant director; it's very interesting to watch his rehearsals,
where he himself shows the actors how he creates the roles, the movement
on stage.

Meyerhold does everything himself and therefore he also likes young,
unknown artists who can be controlled.

But he knew that with me he wouldn't be able to do that, and he gave
me complete freedom of action and didn't contradict me in anything. Only

in the last days, when they brought the construction out of the studio and it stood in the auditorium temporarily, he declared that it was very gloomy and wouldn't do at all.

Similarly, when several of the new costumes were shown on stage, he declared that they wouldn't do at all.

But I calmly remarked that we should wait and see it all on stage in the evening and then it would be possible to argue and decide.

The workers began to set things up, and I, having installed everything, left to go home for dinner.

A rehearsal with the construction and costumes was set for that evening.

I deliberately arrived late, and when I entered the hall the rehearsal had already started. First Volodya came up to me, shook my hand, said "thank you," and that he really liked everything.

I noted gloomily that Meyerhold wasn't happy with it.

Volodya said that, on the contrary, he was thrilled.

Meyerhold greeted me as usual, as if nothing had happened that day at all.

Rodchenko. *Director of the Zoo*, costume for Mayakovsky's play *The Bedbug*. 1929. Colored pencil on paper, 14³⁄16 × 10⁵⁄8" (36 × 27 cm)

I was busy and I watched the rehearsal from the balcony—which my workroom looked onto. I often saw Mayakovsky down below, next to Meyerhold, but there was no time to go down to him, so while I was working I didn't hear or see much of Volodya.

Meyerhold wasn't particularly enthusiastic about producing *The Bedbug*—Zinaida Raikh wasn't acting in it.[175]

And Meyerhold could certainly have done *The Bedbug* more interestingly, but he was probably dreaming of *La Dame aux Caméllias*.

The press was also restrained, and the play didn't run long.

My last work with Mayakovsky was the cover for *The Bedbug*—and the very last—the design for *Threatening Laughter*, whose publication Mayakovsky never saw.

Threatening Laughter was published appallingly—on bad paper, coarse and dirty.

Actually, I also participated to some extent in the exhibition *Mayakovsky: Twenty Years of Work*. I write "to some extent," because when he joined VAPP, Mayakovsky sort of abandoned us. Of course we understood that he would fight in all sorts of ways for us to join too, but, on the other hand, we knew

that VAPP had torn Mayakovsky away from us—not in order to give him a broad creative expanse, and not so that all the *Lefists* would join VAPP, but for precisely the opposite reasons.

We knew that there would be nothing for us to do in VAPP, nor for Mayakovsky either.

And that's how it turned out.

He had nothing to do and he invented projects for himself. The exhibition *Twenty Years of Work*.

He ran around, rushed about, called on us to help him, but we helped him rather lamely.

We loved him and so we did still help him, although we could have refused and probably needed to refuse.

After all, it was he who left us, not we who left him.

The LEF group was a very interesting group that could do a lot, and if Mayakovsky was greater than everyone else, still, each of us was extremely interesting in his own way, and if used skillfully, *Lefists* could create extremely interesting new things in Soviet art.

And it was a profound mistake to simply destroy LEF, to tear Mayakovsky away and drop all of it.

First of all, it was disorienting; secondly, things became boring for VAPP itself.

No one came to the exhibition—neither representatives of the press nor the leaders of VAPP, and that poured oil on the fire of Mayakovsky's feelings of loneliness.

He had abandoned LEF, abandoned his comrades, joined VAPP. . . .

And VAPP, once they accepted him as a member, showed no further interest in him.

I can now imagine Mayakovsky's mood. . . .

And I wouldn't want to be in his place.

And so. . . .

And so. . . .

April 14, 1930. . . .

I went to the planetarium in the morning, where I was putting on an antireligion exhibition; Varvara had me summoned to the phone, and said: "Volodya shot himself."

What, completely?

Yes. To death.

Things became strange and bizarre; could we, too, really be to blame for this?

Perhaps we too were partly to blame.

But he's so strong.

And he collapsed immediately, as if from a bolt of lightning.

But how can this be?

All the way home I thought of VAPP with hatred.

And I cursed Averbakh and the likes of him

I dropped by home, loaded the Leica, and went to Taganka.[176]

I kept thinking that maybe, perhaps, not completely. . . . Maybe there's still some hope. . . .

But when I entered the dining room and saw the people and the faces, and that strange quiet. . . .

Hey!
Gentlemen!
Lovers of
sacrilege,
crime,
carnage—
have you seen
the most chilling thing—
my face,
when
I am
absolutely serene?

He lay in his tiny room, covered with a sheet, turned slightly toward the wall.

Turned slightly away from everyone, so terribly quiet, and there was that stopped time . . . and the dead quiet . . . that spoke again and again of the malicious mediocrity, the vile persecution, of vulgar meanness and baseness, of the envy and dim-wittedness of all those who committed this despicable business. . . . Who destroyed this brilliant man and created such terrible quiet and emptiness.

I took five pictures with a long exposure and, oppressed by the dead silence, I went home.

The days of the press began . . . everyone demanded portraits.[177]

You're in a horrible mood and then you have to sit in a darkroom, and before your eyes, on a clean piece of paper, Mayakovsky continuously appears.

It's cruel . . . but it's necessary, it's for him.

Varvara designed the issue of *Literaturnaia gazeta* devoted to the memory of the proletarian poet.

And the last design was done—the design of the coffin in the Writers' Union on Povarskaia St.[178]

Even here things didn't happen without a struggle; I fought with the flowers. . . .

They wanted to bury him in flowers; they kept bringing them and bringing them. . . .

Everyone suddenly started bringing flowers—all the organizations, editorial offices, publishing houses. . . .

I wanted to preserve a certain severity, a dislike for petty-bourgeois vulgarity; I was constantly taking out the flowers. . . .

In the honor guard I again felt that emptiness, the awkwardness of death. . . .

But how many people—they came and came, and there was no end to it. . . .

And they said he had no resonance among the masses!

When his coffin was carried out, the police couldn't hold the crowd back, and crowds kept breaking through from the side streets and violating order.

People hung flags and Mayakovsky's poetry from buildings.

If Volodya had seen this he would have known that he wasn't alone, that he did have resonance, that he was loved, that he was needed.

But . . . HE slowly swayed on a truck bed, on a severe iron platform made by VKHUTEIN students according to Tatlin's sketch, that rumbled and thudded along.

> He floated slowly.
> The liveliest of the living.
> The battle commander
> of the new revolutionary art front, the
> Great proletarian poet of the USSR.

> " . . . Listen up:
> everything my soul possesses,
> and just try to measure its wealth!—
> the splendor,
> that will adorn my step into eternity,
> and my very immortality,
> which, rumbling across centuries,
> will amass a world assembly of genuflectors—
> all of this—you want it?—
> it's yours
> for just a single, tender,
> human, word."
> 1930

<div align="right">

V. Mayakovsky
Cheap Sale (1916)

</div>

To the Editorial Departments of:
Prozhektor
Krasnaia niva
Pioner
Siniaia bluza
Molodaia gvardia
Iskusstvo v massy
Kniga i revoliutsia

I request that all publications that used my photographs of V. V. Mayakovsky for publication deposit the honorarium to the fund for the "V. V. Mayakovsky Tractor Column."

<div align="right">

Rodchenko

</div>

May 3, 1930

1. In November 1920, Rodchenko became a professor of the general painting department of VKHUTEMAS. He taught one of the eight preliminary disciplines in the Basic Department. The discipline was called "Construction." The students worked with abstract forms, drew compositions, executed works in oil on canvas or plywood—similar to Rodchenko's own paintings of the period. A typewritten copy of the text "Slogans" hung in Rodchenko's studio.

2. The reference here is to Rodchenko's paintings—the compositions of lines on canvas; compositions of intersecting lines that form a grid; compositions of colored points on a black background, which recall a starry sky.

3. The group of Constructivists initially emerged in December 1920, and included Aleksei Gan, Rodchenko, and Stepanova. In 1921, Gan became a member of INKHUK, and this group became known as "the first working group of INKHUK Constructivists." In the manifesto, there is an interesting explanation of how innovations in avant-garde painting facilitated the expansion of artists' concepts of the elements and objects of art, as each minimal building element of the object world was separated out anew and revealed. Published from a typewritten copy preserved in the A. Rodchenko and V. Stepanova archive.

4. This text is handwritten on sheets of writing paper. Apparently, this is the Constructivists' only program of practical design activity. It is interesting largely for its formulation of methodological continuity in implementing experimental projects, as well as for its list of themes for actual designs.

5. Published in the journal *Kino-fot*, no. 3, 1922. The text was illustrated by Stepanova's drawings—caricatures of Charlie Chaplin.

[6.] Anatoly Vasilevich Lunacharsky (1875–1933), writer, playwright, literary and art critic, historian, and theorist. A professional revolutionary and an influential Bolshevik political figure after the Revolution. Served as head of Narkompros (Commissariat of Education) from 1917 to 1929; in that capacity he sought to bring the intelligentsia over to the side of the Bolsheviks, and was instrumental in implementing policies that allowed for the expanded influence of the Russian artistic avant-garde in the immediate post-Revolutionary years. He was removed from office in 1929 as Stalin consolidated power and the liquidation of independent art organizations and the purges loomed. His appointment as Soviet representative to Spain in 1933 was intended to further reduce his influence on Soviet cultural life. He died en route to Spain.

[7.] Vladimir Vladimirovich Mayakovsky (1893–1930), avant-garde poet whose personal and poetic style—flamboyant and declamatory—had an enormous influence on twentieth-century Russian literature and the image of the Russian poet abroad. Mayakovsky supported the Bolshevik regime and founded LEF along with Rodchenko, Osip Brik, and others; his collaboration with Rodchenko on advertisements, which the artists accorded equal status with their other creative work, is described in "Working with Mayakovsky," in this chapter (see p. 214). Though a very popular poet, Mayakovsky gradually became disillusioned with the course of the Revolution, and considerable pressure was put on him to disassociate himself from his avant-garde friends and colleagues. That and disappointment in his love affair with Lili Brik, many believed, led to his suicide in 1930. His funeral procession drew hundreds of thousands of mourners—in testament, as Rodchenko writes, to his genuine popularity among "the people."

[8.] Gosizdat: Gosudarstvennoe izdatel'stvo (State Publishing House).

9. The lists of works by Rodchenko and Stepanova that Rodchenko took with him to Paris for the exhibition included some of the works in various sections of the exhibition: theater, textiles, printing, street advertisements, architecture, etc. The drawing plans for the workers' club furniture were made in order to build the furniture and equipment on site, in Paris.

10. In March 1925, Rodchenko left for Paris to participate in the *Exposition Internationale des Arts Décoratifs et Industriels Modernes*. He wrote home almost daily. At home, Stepanova collected his letters and sewed them into a special notebook. In issue no. 1, 1927, of the journal *Novyi LEF*, some of these letters were published under the title given here. Additional fragments were included in the book *A. M. Rodchenko. Stat'i. Vospominaniia. Avtobiograficheskie zapiski. Pis'ma*. The most complete version of these letters is reproduced in this chapter.

[11.] Stepanova and Rodchenko called each other, as well as their daughter, by the affectionate diminutive "Mulka." Rodchenko often refers to his mother as "Mamulka." "Mulka" is a diminutive endearment that can be added to almost any name; it is used here in the plural. Here Rodchenko is referring to his mother, his wife, and his daughter.

12. Boris Robertovich Erdman (1899–1960), theater artist.

13. Esfir (Esther) Ilinichna Shub (1894–1959), filmmaker and film editor. (Also referred to by the nickname "Eddi.")

[14.] Rodchenko is referring to the letter *yat*, a letter in the Russian Cyrillic alphabet that was discarded in the post-Revolutionary alphabet reform. After the reform, using this letter was seen as anti-Soviet, even counterrevolutionary, a sign of adherence to pre-Revolutionary values. However, people educated before the Revolution sometimes had a hard time changing their writing habits.

[15.] A Russian cigarette with a hollow cardboard mouthpiece.

16. Judging by the customs declaration, Rodchenko's luggage contained more than two hundred items for the exhibition: sketches of furniture and equipment; photocollages and posters; architectural drawings; theatrical costume designs; fabric designs; and books and journals (his own as well as Stepanova's). All of it was for different sections of the exhibition: "The Art of the

Book", "The Art of the Street", "The Art of Furniture", "Theater", "The Art of Textiles", etc.

17. V. Morits, art historian, was responsible for the choice of exhibits as a whole and for hanging the theater section of the exhibition.

18. The Soviet section at the Paris exhibition was located in several buildings: Konstantin Melnikov's Soviet pavilion was in the Grand Palais and in the gallery on the esplanade of the Maisons des Invalides, which contained the model workers' club designed by Rodchenko.

[19.] Rodchenko is referring to the *All-Russian Agricultural Exhibition* of 1923–25, in what is now Gorky Park.

[20.] "Komsa": i.e., *comme ça* (like this).

[21.] Konstantin Stepanovich Melnikov (1890–1974), architect, known in particular for his propagation of new design and construction techniques in the late 1920s, expressed in his own home and the Rusakov club building, both of which are still standing in Moscow. Melnikov was in Paris at the same time as Rodchenko; he designed a pavilion that was part of the Soviet entry to the exhibition.

22. Ivan Ivanovich Fidler, architect.

Aleksandr Lvovich Poliakov (1889–1924), architect responsible for the final design of all the segments of the Soviet exhibits.

[23.] *Verst*: An old Russian unit of distance equal to 1.06 kilometers. Rodchenko walked almost 16 kilometers, or 10 miles, apparently all the way up to Montmartre.

24. Vitaly Zhemchuzhny, film director.

25. Rodchenko is speaking about the interior of the model workers' club, which he was invited to design and build and which, as in a real club, was to be hung with posters, topical slogans, and wall newspapers. Rodchenko asked Zhemchuzhny, who staged club evenings at the time, to write some of these texts.

[26.] Rodchenko is referring to émigré Russian officers from the White Army.

[27.] I.e., an airplane. "Junkers" was the name of a German airplane and engine factory that existed from 1919 to 1945.

[28.] Ivan Vladislavovich Zholtovsky (1867–1958), influential Soviet architect, known for his use of classical and neo-Renaissance architectural forms.

[29.] Ilya Grigorevich Ehrenburg (1891–1967), poet, journalist, and writer; lived in France in exile prior to 1917; known after the Revolution for his journalistic reports on European culture and politics, and later for his novels, particularly those on France during World War II. A unique figure in Russian artistic and literary circles, Ehrenburg had access to the Soviet political elite; he traveled frequently and was friends with many Western artists, such as Picasso. After Stalin's death, Ehrenburg was influential in restoring the heritage of many repressed Russian writers and artists.

30. ZAGS: Zapis' aktov grazhdanskogo sostoianiia, the Soviet marriage registry. Rodchenko and Stepanova did not formally marry until 1941, in Molotov, during their evacuation.

31. The Grand Palais contained architecture, theater, textile, cinema, photography, prints, and advertising sections.

32. The izba reading room was the second largest item in the exhibition. It was made according

to the design of VKHUTEMAS students under the leadership of Anton Lavinsky. Rodchenko, apparently, is referring to the setup of objects and the interior design of the reading room.

[33.] Mistinguet, star cabaret singer of the Folies Bergères in Paris, often featured on Casino de Paris posters.

[34.] One *sazhen* equals 2.13 meters, almost seven feet.

[35.] Russian émigrés in Paris declined the word "metro," treating it like a feminine Russian noun ending in the letter "a," changing the ending from an "o" to an "e." "Metro" in Russian does not decline.

The Paris metro station St. Philippe de Roule. In Russian, *duralei* means "nitwit" or "nincompoop."

[36.] Mulichka/Mulechka: i.e., Mulia, Rodchenko's daughter.

[37.] Rodchenko's mother added a note on at the bottom of Stepanova's letter.

[38.] Errio: it is unclear to whom Rodchenko is referring.

39. Shterenberg was at this time a member of the exhibition committee preparing the Soviet entry for the Paris international exhibition, and was the director of the Soviet section.

40. Rodchenko is talking about the architect Dmitry Fyodorov, Stepanova's first husband. She was still using his surname at that time.

[41.] Apparently, Rodchenko and Stepanova met in Kazan (See Chapter One).

42. In Paris Rodchenko bought himself a 4 × 6.5mm Ica camera; he shot views of the exhibition and the workers' club on special film cassettes, and apparently had them developed and printed in a store and then sent the prints to Stepanova in Moscow.

[43.] Rodchenko and Stepanova often called themselves and each other *khomik*, a diminutive of the word "hamster."

44. Elsa Triolet (Elza Yurevna Triolet; 1896–1970), writer. Triolet, sister of Lili Brik, was married to the French writer Louis Aragon, and lived in Paris.

45. Isaak Moiseevich Rabinovich (1894–1961), theater set designer, painter, and teacher. In Paris he designed the Gosizdat section, which was on the first floor of Melnikov's pavilion.

46. Dziga Vertov (David Abramovich Kaufman; 1897–1954), film director and documentary maker, creator of the films *Kino glaz* and *The Sixth Part of the World*, for which Rodchenko made movie posters.

47. Rodchenko was quite taken with the Sept. After long deliberation he finally bought it, and also an attachment for viewing movie film. He sometimes used the Sept as a small-format photo camera when shooting a photo chronicle.

48. A delegation of VKHUTEMAS students was supposed to travel to the exhibition as well but they went later, when Rodchenko had already returned to Moscow.

[49.] Vneshtorg (Vneshniaia torgovlia) was the Soviet foreign-trade organization.

50. On the second floor of Melnikov's separate Soviet pavilion was an exhibition of Gostorg (State Trading Company). Rodchenko designed the windows and interior for this part.

[51.] Leonid Borisovich Krasin (1870–1926), Soviet government official and diplomat.

[52.] Russian has no equivalent expression that may be used in polite society.

53. Rodchenko often added notes to his mother or addressed her in letters to Stepanova, since the whole family would read them.

54. Lev Vladimirovich Kuleshov (1899–1970), film director and teacher.
Anna Konoplyova, daughter of Esfir Shub.

55. A. Durnovo—an applied artist. He was responsible for the folk-art section of the Grand Palais installation.

[56.] *150,000,000* (1920), is the title of a long poem about the Revolution by Mayakovsky.

[57.] The bracketed was omitted in the Russian edition.

58. Most likely the famous ball "The Big Dipper" (in Russian, "The Big Bear"), which was held in honor of the visiting Russian artists by former compatriots in Paris.

59. Boris Nikolaevich Ternovets (1884–1941), artist and art historian.
David Efimovich Arkin (1899–1957), art and literary critic, and art historian.

60. The equipment for the workers' club wasn't sent back to Moscow. At the end of the exhibition it was given to the French Communist Party.

61. Alyosha: Aleksei Gan.

[62.] *Tarelkin*: The reference is to Stepanova's 1922 set and costume designs for Meyerhold's production of *The Death of Tarelkin*, a play by Aleksandr Sukhovo-Kobylin.

[63.] Goskino: State Cinema Studio.

[64.] The town of Sebezh on Lake Sebezh is a railroad crossing at the Russian border.

[65.] Volodka: like "Volodya," a diminutive of Vladimir (in this case, Mayakovsky).

66. Kinoki was a creative group of movie-chronicle producers founded by Dziga Vertov, which included the cameramen Mikhail Kaufman (Vertov's brother) and A. Lemberg.
LEF, or Levyi front iskusstv (Left front of the arts), a literary-artistic group that published the journal *LEF* and later *Novyi LEF*, whose editor in chief was Vladimir Mayakovsky.
N. Chuzhakov (Nikolai Fyodorovich Nasimovich; 1876–1937), literary and art critic. In those years he worked in the Moscow division of Proletkult (1917–32), a cultural-educational and literary-artistic organization of proletarian amateur work in the arts.

[67.] Kissel: a type of fruit gelatin.

68. Clearly, Rodchenko brought a number of oil paintings—non-objective compositions of 1919–20—with him to Paris in addition to designs, book and magazine covers, and prints. Apparently he planned to have an exhibition or publish a book.

69. ODVF: Voluntary Society for Aid to the Navy.

[70.] "Rodchenok," a diminutive for Rodchenko, recalls the word *rebyonok* (child) or *shchenok* (puppy).

71. Herzegovina Flor: Russian *papirosy*, the cigarettes Stepanova sent from Moscow.

[72.] Mikhail Abramovich Kaufman (1897–1980), cameraman and film director, brother of Dziga Vertov and cofounder of Kinoki.

[73.] De Moncy: French Minister.

74. Rodchenko was appointed professor of the general painting section of VKhUTEMAS in November 1920. Together with his associates from the groups of non-objectivist artists—members of INKhUK, the Vesnin brothers, Popova, Exter, Udaltsova, and Drevin—he began to teach one of the eight disciplines of the Basic section of VKhUTEMAS. These were preliminary disciplines with abstract tasks in composition. Students in the first years were supposed to go through all these disciplines, one after the other: discipline no. 1 "The maximal influence of color" (L. Popova); no. 2 "Manifesting form through color" (A. Osmerkin); no. 3 "Color in space" (A. Exter); no. 4 "Color on the plane" (I. Kliun); no. 5 "Construction" (A. Rodchenko); no. 6 "Simultaneity of form and color" (A. Drevin); no. 7 "Volume in space" (N. Udaltsova); no. 8 (V. Baranov-Rossiné). Then students would study in one or another of the department studios. After 1922, a different system of preliminary courses was developed, which existed until VKhUTEMAS was disbanded, in 1930. Artistic and abstract-compositional disciplines were divided into four concentrations: "Space," "Volume" (sculpture), "Graphics" (drawing), and "Color" (painting). (See Selim O. Khan-Magomedov's book *VKhUTEMAS*, Moscow, 1995, for more detail.) In Rodchenko's discipline, students did abstract exercises in painting and graphics connected to the modeling of forms from geometric contours of basic figures, and the expression of texture (*faktura*) and space on the plane.

75. After he became dean of the metalworking department of VKhUTEMAS, in February 1922, Rodchenko began gradually to introduce new programs of study. He wrote a series of documents of this sort—lesson plans, course plans, explanatory notes—between 1922 and 1924.

76. According to Rodchenko's program, the students of the metalworking department were prepared in two basic specializations: constructing volumetric objects from metal combined with other materials, and the graphic design of metal items—indicators, packaging, advertising, and so on. The first area was called "Construction," the second "Composition."

77. Probably, what is meant here is *kumgam*, a long-throated pitcher used in Central Asia.

78. The Union of Metalworkers was in charge of the students of the metalworking department. The union was supposed to help by organizing uninterrupted practice for students in factories and plants, and with job hunting for graduates, as well.

79. Rodchenko wrote the second cycle of the syllabus in 1928. Not only had the themes changed, so had the methodological continuity of the course assignments. From individual objects, they began to move to complexes and sets of objects for the organization of a given space, process, etc.

80. Technical drawing to aid in object design was a subject Rodchenko began teaching in 1928.

81. Miloslavsky and Kubitsky taught engineering and technological disciplines in the wood- and metalworking department.

82. For a short time after the reorganization of VKhUTEMAS into VKhUTEIN and the merging of the wood- and metalworking departments, Rodchenko was dean of the unified wood-metal department.

83. From January to March 1929, Rodchenko worked on the set decorations and costumes for a production of *Inga*, based on Anatoly Glebov's play, in the Theater of the Revolution. The heroine of the play—Inga—is the director of a sewing factory. A brochure with texts devoted to the problems of everyday life was issued to accompany the play. This text by Rodchenko was taken from that brochure.

84. Ilya Pavlovich Trainin (1887–1949), director of the Sovkino (Soviet cinema) film studio.

[85.] *Chaeupravleniia*, or Tea Directorate, was the main tea packager and distributor in the USSR, and Rodchenko is probably referring to the artistic "Chinese look" of its tins of Chinese tea; i.e., he's saying don't bring us a cliché.

[86.] For more on the relationship between Rodchenko and László Moholy-Nagy (1895–1946), see "Large-Scale Illiteracy or Dirty Little Tricks, Open Letter," on p. 204 of this volume.

[87.] The series The History of the VKP(b) [All-Russian Communist Party (Bolsheviks)] in Posters, commissioned by the Museum of the Revolution in 1926.

[88.] Vtssps: All-Union Central Soviet of Trade Unions.

[89.] Mossovet: Moscow soviet or city council.

[90.] Aleksandr Mikhailovich (Rodchenko's first name and patronymic).

[91.] Narkomzem: Narodnyi Komissariat Zemledeliia (People's Commissariat of Agriculture).

[92.] Rodchenko is punning on the word *raspisat'sia*, which, depending on the context, can mean "to write a lot" or "write oneself out"—or (in Soviet times) to get married in a civil ceremony where the marriage is "registered."

[93.] *Rabis* or *Sorabis*: Soiuz rabotnikov iskusstv (Union of Art Workers), founded in 1919, was concerned with social and educational benefits for workers associated with the arts.

94. Published in the journal *Novyi LEF*, no. 10, 1928.

95. This article was written in response to an accusation in *Sovetskoe foto* that Rodchenko had plagiarized Western European photographers. It was published in the journal *Novyi LEF*, no. 6, 1928.

[96.] The word Rodchenko uses here, *vreditel'stvo* (wrecking), was politically charged; by the 1930s accusations of "wrecking," i.e., deliberately trying to harm the Soviet state, almost always led to the arrest and imprisonment of the accused—and often of the accuser as well.

97. Arkady Solomonovich Shaikhet (1898–1959), photojournalist; Semyon Osipovich Fridliand (1905–1964), photojournalist.

[98.] Boris Kushner (1888–1937), poet, critic, and member of the editorial board of *LEF*. He died in a prison camp.

[99.] Vasily Vasilich Vereshchagin (1842–1904), painter known for his historical war scenes rendered in a realistic, academic manner, such as *Apotheosis of War* (1871–72), which depicts a pile of human skulls.

[100.] AkhRR: Assotsiatsiia khudozhnikov revoliutsionnoi rossii (Association of Artists of Revolutionary Russia).

[101.] I.e., an aestheticized, painterly, and unreal vision of the world, as in the World of Art group that existed prior to the Revolution.

[102.] Ilya Efimovich Repin (1844–1930), one of the most important Russian painters of the late nineteenth and early twentieth centuries, studied in St. Petersburg and Europe. Known for his realist portraits and epic historical paintings on Russian themes, his work was used by Soviet critics and artists as the prototype for Socialist Realism (which was declared official policy in 1934), although the artist did not welcome the Revolution. The painting referred to here is *Zaporozhian Cossacks Write a Letter to the Turkish Sultan* (1878–91).

[103.] Hannes Maria Flach (1901–1936), German photographer. His image of a bridge was published in *Sovetskoe foto*, no. 10, 1927.

[104.] The radio tower still stands near the Shukhovskaia metro station, in Moscow.

105. Kaufman's film-still of the radio tower, discussed here, is possibly from his film about Moscow. The still was published in *Sovetskoe kino*, no. 6–7, 1927.

[106.] Erich Mendelsohn, *Amerika: Bilderbuch eines Architekten* (America: Picture book of an architect) (Berlin: Rudolf Mosse Buchverlag, 1926).

107. This article was written in response to a letter in the journal *Sovetskoe foto*, no. 4, 1928, by a member of LEF, the critic Boris Kushner. (Rodchenko's response was published in *Novyi LEF* no. 10, 1928.)

108. This was the concluding article on photography from the series of materials Rodchenko published in *Novyi LEF*. According to the contents index in the last issue of *Novyi LEF*, no. 11, 1928, Rodchenko published six articles and reviews and reproduced thirty pictures between 1927 and 1928.

109. In 1929, Rodchenko selected a series of his own photographs for exhibition at the State Tretyakov Gallery. Among them were foreshortened photographs of a building, pine trees, photo illustrations for Sergei Tretyakov's children's book *Samozveri* (Autoanimals), a portrait of his mother, and others. Apparently, Stepanova mounted these photographs in display cases, working on the exhibition installation. In 1928–29, the Tretyakov exhibition on the beginning of the 1920s and the avant-garde was modified. Thus, in addition to Rodchenko's paintings, which had entered the collection of the Tretyakov after the closing of the Museum of Painterly Culture in Moscow, the Tretyakov administration requested that Rodchenko and Stepanova provide examples of their printed work done in the mid- and late 1920s.

110. The text "Working with Mayakovsky" was written in 1940, for the tenth anniversary of the poet's death. At that time, Rodchenko and Stepanova were preparing a special issue of the magazine *SSSR na stroike* (USSR in Construction) devoted to the late poet. The first version of the text, with large cuts, was published in the magazine *Smena* (Shift), no. 3, 1940, then in the magazine *V mire knig* (In the world of books), no. 6, 1973, and, finally, almost in its entirety in the book *A. M. Rodchenko. Stat'i. Vospominaniia. Avtobiograficheskie zapiski. Pis'ma* (A. M. Rodchenko. Articles, memoirs, autobiographical notes, letters), Moscow, 1982. The text is published here in its entirety.

111. Viktor Borisovich Shklovsky (1893–1984), writer, literary critic, member of LEF.

[112.] The Young Pioneers were something like Boy and Girl Scouts, but they prepared children for entering the Komsomol and, later, the Communist Party.

[113.] Gavrila Romanovich Derzhavin (1743–1816), a Russian classical poet, one of the earliest of Russia's secular poets.

[114.] Now known as Pushkin Square, located on Tverskaia Street, not far from the Kremlin. The Strastnoi Convent, founded in 1654, became the Central Anti-Religious Museum in 1928 and was torn down in the 1930s when Gorky Street (now, once again, Tverskaia Street) was reconstructed.

[115.] David Davydovich Burliuk (1882–1967), poet and artist, one of the founders of the Russian version of Futurism. He emigrated in 1920.

[116.] Vasily Vasilevich Kamensky (1884–1961), poet, playwright, and pilot; one of the first Futurists.

[117.] I.e., in the academic manner of nineteenth-century Russian painting.

[118.] Nikolai Ivanovich Feshin (1881–1955), an extraordinarily talented portraitist and painter, who worked with a loose, bold brushstroke; he emigrated to the U.S. in 1923.

[119.] Nikolai Nikolaevich Sapunov (1880–1912), painter and set designer for several Meyerhold productions.

[120.] Nikolai Petrovich Krymov (1884–1958), Symbolist and primitive painter, and stage designer for various theaters, including the Moscow Art Theater. Taught at VKhUTEMAS from 1920–1922.

Georgy Bogdanovich Yakulov (1884–1928), painter, set designer. Exhibited with the World of Art group. Worked with Tatlin on the Café Pittoresque after the Revolution; taught at SVOMAS, exhibited with OBMOKhU (Obshch-estvo molodykh khudoznikov, Society of Young Artists); moved to Paris in 1927.

[121.] "Celionati" is a character from the E. T. A. Hoffmann story "Princess Brambilla."

[122.] Sergei Ivanovich Shchukin (1854–1936), art collector and wealthy manufacturer. Shchukin began collecting painting in 1895: Impressionism, Post-Impressionism, and other contemporary French and Russian painting. He invited Matisse to Russia and commissioned the "Dance" panels for his home. His collection was nationalized in 1918, and formed the basis of the "First Museum of New Western Painting," which opened in 1919. Shchukin emigrated to France in 1918. His collection was eventually divided between the Hermitage Museum, in St. Petersburg, and the Pushkin State Museum of Fine Arts, in Moscow.

[123.] Butyrki Prison, in central Moscow.

[124.] ROSTA: The Russian Telegraph Agency, for which Mayakovsky and others made posters.

[125.] Nikolai Nikolaevich Aseev (1889–1963), poet, member of LEF, friend of Mayakovsky.

Semyon Isaakovich Kirsanov (1906–1972), poet.

[126.] Here Rodchenko is playing off the verb perestroitsia (as in "perestroika"), which means to improve and remake, or reorganize oneself, and pristroitsia, which means to get a job or set oneself up, with the implication that no real effort was involved; in effect, he is saying that the "leftists" transformed themselves in accordance with the demands of the Revolution, and thereby became better artists, whereas the "rightists" simply adjusted their subject matter opportunistically to the times and knew how to work the system.

[127.] The Nirenzee, built near Strastnoi Convent in 1912–14, is actually ten stories tall, and at the time was the tallest building in Moscow; it was designed to hold small inexpensive apartments, and included a common dining room, a theater, and a common entertainment area on the roof.

[128.] Has-beens: byvshie, or "déclassés," members of the former bourgeoisie and upper classes.

[129.] Ignaty Ignatevich Nivinsky (1880–1933), theater designer, painter, and printmaker. After 1917, he was in charge of decorating various propaganda trains. He taught at VKhUTEMAS.

Nikolai Alekseevich Bogatov (1854–1935), painter, illustrator, and set designer; known for paintings of horses; exhibited with the Wanderers.

[130.] Vsekokhudozhnik: Vserossiiskii kooperativnyi soiuz khudozhnikov (All-Russian Artists' Cooperative Union).

[131.] Hotel Luxe, in central Moscow.

[132.] Velemir (Viktor Vladimirovich) Khlebnikov (1885–1922), poet and writer, "father" of Russian Futurism, founder of the utopian society "Chairmen of the Planet Earth"; Khlebnikov's linguistic experimentation and transrational poetry (zaum) had a major influence on Russian and Western poets. He died impoverished at the age of thirty-six, of an undiagnosed illness.

[133.] Russians decorate a "Christmas tree" for New Year's, and Ded Moroz (Grandfather Frost) leaves presents in children's shoes or stockings.

134. Rodchenko is speaking of the 5th State Exhibition, which opened in 1918 in the building of the present Pushkin State Museum of Fine Arts.

[135.] Aleksei Nikolaevich Tolstoi (1882/83–1945), count and writer who returned to the USSR after five years of emigration (1918–23) in Europe, and became one of the most famous Soviet apologists and popular novelists.

Yakov Aleksandrovich Tugenkhold (1882–1928), art historian and art critic.

[136.] Nikolai Nikolaevich Punin (1888–1953), art historian. Second husband of poet Anna Akhmatova. Arrested in 1949, he spent three years in labor camps.

[137.] The Russian word for "ventriloquist," chrevoveshchatel', is particularly evocative: chrevo means "womb," "belly," "pot-bellied," or "pregnant," while veshchatel' means "prophesier," "narrator," or "speaker"—and today, "broadcaster" as well.

[138.] "Vii" (also "Viy"): Fantastic creature in a story by Nikolai Gogol; it is not known to whose painting Rodchenko is referring.

[139.] Aleksandr Deineka (1899–1969), painter, founder of OST (Obshestvo stankovistov; The Society of Easel Painters) in 1925. Deineka was vice-president of the USSR Academy of Arts during the 1960s.

[140.] Rodchenko is using "Judaic" here in a general sense to mean ancient, biblical subjects and themes.

141. Vladimir Maksimovich Friche (1870–1942),

Marxist critic and historian of literature. Wrote books and articles on the decadence of bourgeois literature, the history of Western European literature, and the sociology of art.

[142.] Anton Mikhailovich Lavinsky (1893–1968), sculptor, printmaker, and set designer; designed posters for ROSTA and taught at INKHUK, participated in LEF from 1923; known for his cinema posters and Constructivist design of Meyerhold's 1921 production of Mayakovsky's *Mystery-Bouffe*.

[143.] Aleksandr Aleksandrovich Vesnin (1883–1959), painter, set designer, and architect. He and his brothers (Leonid and Viktor) were involved in many important architectural projects after 1917.

[144.] RAPP: Rossiiskaia assotsiatsiia proletarskikh pisatelei (Russian Association of Proletarian Writers).

[145.] *The Captain's Daughter* is a novella by poet Alexander Pushkin.

[146.] Lili Brik (1893–1978), wife of writer and literary theorist and critic Osip Maximovich Brik (1888–1945); lover of Mayakovsky and subject of many of his poems.

[147.] Sergei Mikhailovich Eisenstein (1898–1948), avant-garde filmmaker, director, theoretician, and teacher; known for such films as *The Battleship Potemkin* (1925).

[148.] GUM: Gosudarstvennyi universal'nyi magazine (State Universal Store). Pronounced "goom."

[149.] Russian has a "hard" sign and a "soft" sign, letters that have no phonetic value themselves but which indicate a hard or soft consonant.

[150.] Mosselprom: Moskovskoe sel'sko-khoziaistvennaia promyshlennost' (Moscow Agricultural Industry) had a store in Moscow and kiosks all around town. The Mosselprom ads, sporting the refrain "Get it from / Mosselprom" (*Nigde krome, kak v Mosselprome*, literally, "[you will find it] nowhere else but in Mosselprom"), were some of the best known of Mayakovsky's ad slogans.

[151.] Rezinotrest: the State Rubber Trust.

[152.] At the time, Kirovskaia Street, where Rodchenko's apartment and studio were located, was still called "Miasnitskaia." It was renamed in honor of Sergei Kirov, the Leningrad Party official, after his assassination, in 1934. After the collapse of the USSR, the original name was returned.

153. The negatives preserved from this session are on film, in a 4 × 6.5 cm format.

[154.] *Gorodki* is a game similar to skittles.

[155.] Skotik: Mayakovsky's dog.

156. This was apparently the "Monarch" enlarger with a double extension for printing 9 × 12 cm negatives.

[157.] *Lubki* (singular: *lubok*) are Russian folk prints—generally crudely rendered, hand-painted woodcuts; they often included bawdy limericks and satirical rhymes. Folk art, and *lubki* in particular, had a huge influence on Russian artists at the beginning of the twentieth century, who sought to break with stifling academic traditions and create a truly "Russian art."

[158.] Konstantin Fyodorovich Yuon (1875–1958), painter and set designer: worked with World of Art artists and Diaghilev in Paris, c. 1906; after 1917, taught at the Academy of Fine Arts.

[159.] MAPP: Moskovskaia assotsiatsiia proletarskikh

pisatelei (Moscow Association of Proletarian Writers).

[160.] Lev Averbakh. See p. 277, endnote headed "Surrounded by 'Sentries.'"

161. By "blacks," Rodchenko is probably referring to a book about the art and sculpture of Central Africa that Mayakovsky brought back from one of his trips.

[162.] Tretyakov had already been arrested and had died in a prison camp at the time Rodchenko wrote this.

163. Viktor Osipovich Pertsov (1898–1980), literary critic and historian, wrote about Mayakovsky.

[164.] Vasily Abgarovich Katanian (1902–1980), literary critic, married to Lili Brik after the death of Osip Brik.

[165.] Pirogi are small pastry pies, usually filled with cabbage or meat, eggs and rice, or fruit.

[166.] In Russian this rhymes: *Iskusstvo—zachem eto nuzhno?*

[167.] *Conversation with Comrade Lenin* was written in 1929. In the poem, Mayakovsky holds his "conversation" with a photograph of Lenin on his wall.

[168.] Stepanova produced a map of Mayakovsky's travels abroad for the Mayakovsky Museum; it was included as a color foldout in *V. V. Maiakovskii, Sochineniia v odnom tome* (*Mayakovsky: Works in One Volume*) (Ogiz: Moscow, 1941), the mass edition of Mayakovsky's work that Rodchenko designed.

[169.] Demian Bedny (pseudonym of Efim Aleksandrovich Pridvorov; 1883–1945), popular poet who was often published in *Pravda* and other Bolshevik publications.

[170.] Komsomolka: the newspaper *Komsomolskaia Pravda* (Communist Youth League Pravda).

[171.] Mezhrabpom: Mezhdunarodnaia rabochaia pomoshch' (International Workers' Aid) was an organization founded in Berlin in 1921 to send aid to famine victims in Soviet Russia. It was disbanded in 1935.

[172.] Vappo-mappo-akhrrov: VAAP (Vserossiiskaia assotsiatsiia proletarskikh pisatelei; All-Russian Association of Proletarian Writers), MAPP, AKhRR.

[173.] Stepanova wrote the two poems as parodies of the poets Nikolai Aseev and Semyon Kirsanov, respectively. While both were very influential in Soviet literary circles following the Revolution, particularly Aseev, they are not known to English-language readers. Furthermore, the poems are rather like insider jokes, referring to personal relations, good and bad, among the members of LEF during the period of its breakup. Their value is primarily historical, as a result. Therefore, a literal rather than "poetic" translation has been given, and additional commentary, below, has been kindly provided for English readers by Alexander Lavrentiev.

The first poem, "At a LEF Gallop!" parodies the title of Aseev's long poem *Semyon Proskakov* (the verb *proskakat'* in Russian means "to gallop past") (1927–28). Aseev's poem is written in the genre of historical poems about the civil war. Stepanova uses Aseev's manner—short lines, type of rhymes, and also his overall dramatic coloring to describe the ongoing struggle of the left front with representatives of traditional art. Stepanova wrote poems in 1914–15, she loved poetry, and for her it was not at all hard to cap-

ture the peculiarities of a particular poet's verse and language.

Mezhrabpom: the film studio Mezhrabpom. Technically, this was the "Kinobiuro" of the International Bureau for Organizing Aid to Workers and simultaneously the artistic collective of the stock-option company "Rus." It was one of the three main cinema associations in the USSR in those years (Sovkino, Mezhrabpom, and Gosvoenkino).

Seryozha's wrath: The reference is to the personality of Sergei Tretyakov, who was easily provoked, an inveterate debater whose opinion it was exceedingly difficult to influence.

For Osip's Crops: the articles, speeches and appeals of Osip Brik on reviving the thematics of literature and art, and also direct devices and means of expressivity.

Be patient Rodchenko, build your set decorations: what is meant here is Rodchenko's active work in cinematography in the late 1920s and as a set design artist and decorator.

A ragtag regiment of Lef: some members of Lef quit the group and went their own way.

"People's" and *"Honored"*: government-awarded titles in literature and the arts—an "Honored Artist of the USSR," "People's Artist of the USSR."

Surrounded by "Sentries": Stepanova is referring to the editorial staff of the literary-artistic journal *Na Pastu* (On sentry), which carried on polemics with *Novyi Lef*. The editor-in-chief was Lev Averbakh.

They walked like Soviet proletstreetwalkers: a platform of "proletarian culture" and "proletarian art" was held by official critics and the leader of cultural policy, Anatoly Lunacharsky, of the People's Commissar of Education.

Mappo-Vapp: The acronym stands for the Moscow Association of Proletarian Writers and the All-Russian Association of Proletarian Writers, groups that were the ideological enemies of Lef.

Scenarios arose / Deliberately / Along our way: almost all the writers in Lef were involved in making films, and wrote movie scenarios.

You should "double" / My words: operation of doubling numbers in counting points in the game mahjong, which all the members of Lef played.

Our Eddi's "coat of arms": the reference is to the documentary film *The Fall of the Romanov Dynasty*, by the director Esfir Shub, whom the *Lefists* nicknamed "Eddi." "Chronicle bluff" is an overly sharp criticism of Shub's film. Although she used documentary film material exclusively, she often edited it like "artistic" film according to the requirements of the subject, thereby poeticizing the material and adding additional frag-

ments for the "reconstruction" of events.

Swift "Mah" / Roll through / The Taganka / Night: According to the rules of mahjong, the first person to collect a full combination must say the word "Mah" aloud, which signals the end of the game. "Taganka night" refers to playing mahjong in the Moscow neighborhood of Taganka, where Mayakovsky moved in the mid-1920s, and where the *Lefists* often gathered.

With the second poem, Stepanova is parodying the staccato style of Semyon Isaakovich Kirsanov (1906–1972), who called himself the "circus performer of poetry." Therefore there are many interjections and brief exclamations. The beginning of the poem is written as though Mayakovsky were speaking, and then the narrative continues in the voice of a third person, witness to the events surrounding the breakup of Lef.

Komsomolka: the newspaper *Komsomolskaia Pravda*, where Mayakovsky published at this time; Osip Brik often dropped in to the editorial offices.

"Bluff": the open polemic between Vladimir Mayakovsky and the critic Viacheslav Polonsky was called "Lef or Bluff."

Vitia: the director Vitaly Zhemchuzhny.

Lilia: Lili Brik.

Cinematoglaphy: The use of the letter "l" instead of "r" parodies children's speech or a speech impediment. It is possible that Stepanova wanted to poke fun at what she saw as Mayakovsky's childish behavior at the time Lef fell apart, when this poem was written.

Kitty cat: Mayakovsky's name for Lili Brik.

Breathes with a Glass Eye: *The Glass Eye* is a film by the directors Vitaly Zhemchuzhny and Lili Brik.

Arc: this may refer to the Association of Cinema Workers.

Oleinikov: possibly an editor from Mezhrabpom.

Komsomol: Communist Youth League.

Kostrov: Taras Kostrov, editor of the newspaper *Komsomolskaia Pravda*.

We flew srough ze réportaj (We flew through the reportage) renders Russian with a French accent. Reportage and documentary qualities were Lef's primary slogans in art, photography, and literature.

On leaving Lef, Mayakovsky "amnestied Rembrandt," i.e., he called for a return to artistic conceptions in creative work.

Kurillo: the journalist Alfred Kurella, from *Komsomolskaia Pravda*.

277

Silov: author of the first biography of Velemir Khlebnikov.

[174.] Vsevolod Emilianovich Meyerhold (1874–1940), influential theater director, actor, and teacher. After 1917, he developed a new method of training actors, incorporating Constructivist principles, which he called "Biomechanics." From 1920 to 1938, he had his own theater and school in Moscow, where he staged Mayakovsky's *Mystery-Bouffe* (1921) and *The Bedbug* (1929), among others. Meyerhold was arrested in 1939 for being a "member of a Trotskyite group," and was accused of being a spy for the English and Japanese. He was executed on January 2, 1940.

Kukryniksy: pseudonym for a team of three artists—Mikhail Vasilevich Kuprianov (1903–1991); Porfiry Nikitich Krylov (1902–1990); Nikolai Aleksandrovich Sokolov (1903–1999). The Kukryniksy were particularly famous for their biting caricatures of the Nazis during World War II.

[175.] Zinaida Nikolaevna Raikh (1894–1939), Soviet actress, was married from 1917 to 1921 to the famous poet Sergei Esenin, and then from 1922 onward to Meyerhold. From 1922–38 she performed in his theater; she was murdered in 1939, after Meyerhold's arrest.

[176.] Mayakovsky shot himself in his apartment near Taganka Square.

177. For several weeks after Mayakovsky shot himself, many newspapers and magazines came to Rodchenko with requests to publish his portraits of Mayakovsky.

[178.] Tatlin designed Mayakovsky's coffin; documentary film footage exists of his funeral.

CHAPTER FOUR

RECONSTRUCTION OF THE ARTIST

1930–1940

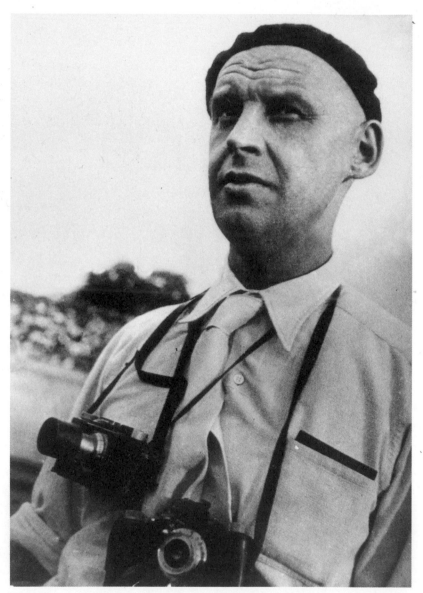

Rodchenko, 1935–36.

INTRODUCTION

Rodchenko spoke about the "perestroika," or reconstruction, of the artist when he addressed the round table during the exhibition *Masters of Soviet Photo Art*. This was the time of the "purges," the beginning of the repressions, when artists and photographers were divided into "proletarians" and "formalists." In 1931 the creative October group, founded by Rodchenko and the photographer Boris Ignatovich, was criticized in the photographic press;[1] earlier, in 1930, VKHUTEMAS-VKHUTEIN, where professor Rodchenko taught design in the metalworking department, had been closed and disbanded.

Rodchenko took up photo reportage on commission from the publishing house Izogiz [the State Publishing House for Art]. He dreamed of documenting one of the grandiose construction projects of the time and went to Karelia, where prisoners were building the White Sea-Baltic Sea Canal. A newspaper called *Perekovka* (Reforging) was published at the canal for the prisoners. Those who worked especially hard had their sentences lessened. This is where Rodchenko came upon the word "perestroika" in its practical ideological application. He put together an entire issue of the magazine *SSSR na stroike* from his photographs of the construction site, and the criticism of past years stopped being so painful for him.[2] . . .

He selected works for *Masters of Soviet Photo Art* with a certain trepidation, but his contribution to the exhibition was well received.

In addition to ideological perestroika and his public renunciation of formal experiments, Rodchenko spoke about new technologies, and the changes in the artist's task and social purpose, the most important arenas of creative work. He described his life as an artist honestly, demonstrating that his biography was rich in events and achievements.

During these years he often doubted himself, and his art. . . .

Rodchenko. *Journalist*, no. 3
of 1930, front and back covers.
Letterpress, 11 7/16 × 8 7/16"
(29 × 21.5 cm)

These years also represented the peak of his activity as a photojournalist. He shot pictures of a lumber factory, the streets of Moscow, the construction of the canal, the Young Pioneers, sports competitions, and parades. He also continued to participate in foreign photography exhibitions, sending his

photographs through VOKS—the All-Union Society for Cultural Relations.

And at the same time, he returned to painting after a fourteen-year hiatus. His first painting from that period is a symbolic depiction of a circus juggler juggling balls. The painting is an allegory of life during those years, a man juggling his fate. And if we try to imagine what Rodchenko looked like at that time, the portrait closest in spirit and meaning would probably be his self-portrait as a clown. There are several such characters in Rodchenko's painting that resemble the artist himself. Among them are: a clown putting on his makeup; a clown playing a saxophone in a circus ring; and a clown in a stiff collar, with a powdered face.

"Acrobats and clowns can't be realists," Rodchenko wrote on the title page of one of his albums of circus sketches and drawings.

—A. L.

Letters, 1930–1934

1930

Rodchenko to Stepanova

Moscow, March 25, 1930
Note on a calendar page

I've gone off into another world, where there are no advances or beer halls but something like VOKS, and from there to October.[3] I miss you in my closet and send kisses.

Leningrad to Moscow
Telegram. August 10, 1930

TOMORROW WE TRAVEL VAKHTAN. TELEGRAPH. HOTEL RED MERCHANTS [SEND] SWEATER BOOTS CARE OF ADMINISTRATOR.[4]

KISSES ANTI

Vakhtan, August 20, 1930

Dear Varvara!

The beginning of work is fairly difficult. Of all the equipment, only the Leica works efficiently.[5]

The big film camera has problems with focusing. The Sept doesn't have a focus either. Leon Letkar has another photo camera but it lacks equipment of the first order, i.e., film plates. The assistant has a single lens reflex camera also, but except for using the mirrors for shaving it's not good for anything. That's how the life of the film expedition goes. But the mood of everyone working on picture no. 230, called *Chemical Treatment of the Forest*, is upbeat. The struggle with technical collapse continues every day, and the picture will be shot not in five but three months.

If you can, send 9 × 12 cm plates.

Today we looked at the rosin-turpentine plant, very interesting, built in 1924.[6] There's forest all around, Nizhny [Novgorod] is 200 *versts* away on the plant railroad.[7] The plant works around the clock and whistles like a steamboat on the Volga, and all around are pines; they say that the forest extends up to the north, that there are wolves and bears.

This is how we film. An old nag called "Manka" was rented from a peasant. The wagon is loaded with equipment, single lens reflex cameras and other junk, and we take turns riding, too. The rest go on foot. In addition, two dogs run along with us—actually, different ones every day, but they run all the way and come back with us. During shooting they get underfoot and keep charging into the frame.

Rodchenko. Photographs from series
on a lumber mill in Vakhtan, 1930.

Top left: Sawmill worker. Gelatin silver
print, 11½ × 9¼" (29.2 × 23.5 cm)

Top right: Lumber. Gelatin silver print,
9⅛ × 11½" (23.1 × 29.3 cm)

Bottom right: Sawmill worker. Gelatin
silver print, 11⁹⁄₁₆ × 9⁵⁄₁₆" (29.3 × 23.6
cm)

I'm taking a lot of pictures and missing you.

Your letters—are my only joy, I don't have any newspapers to read at all,
send the old ones at least.

Your Anti

Vakhtan, Sept. 7, 1930

I got the package today with bread, sugar, and cigarettes. Everyone thanks you.

The bread was immediately cut up and prepared for drying.

I gave out a piece of sugar to everyone, and everyone smoked until they
were dizzy.

They brought the lamps but there's no Pankino film—we're waiting for it.[8]

By the way, the sun peeked through today.

I'm on duty today, so it worked out great that the package came. It's
likely that we won't go to Vetluzhskaia but straight to Moscow; we'll shoot
the plant for five days and the forest for three. We'll leave around the 20th if
the weather's good.

We've been sitting here for five days waiting for the sun, and that's bad.

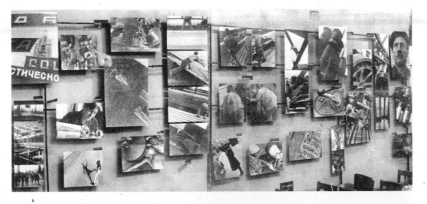

Above: Exhibition of the October photo section, at the Press House, Moscow, May 1931. Installation view showing Rodchenko's series on the Vakhtan lumber mill (center). Also shown are photographs by Eleazar Langman (left) and Boris Ignatovich (right).

Right: Rodchenko and Stepanova's studio, 1930–31.

I'm smoking a pipe and I've gotten to like it, even the cigarettes I received don't interfere with pipe smoking. I've taken to the pipe and it's too bad there aren't any others, just one. I'm dreaming about new pipes, I asked Leon to have Stel send Dunhill. Makhorka tobacco in a pipe—isn't so bad.

I'm on duty today; I made coffee with sugar, and fried up rolls in milk and eggs with sugar, and handed out cigarettes three times.

It's ten P.M. now, I swept and cleaned up; Kolya and Leon went off to the club, Elizarov is sleeping. Volodya (the assistant) is eating, and I'm smoking Luxe and writing to you.

We are all swearing up a storm; when we get back to Moscow we'll be genuine Vakhtanites.

It rained for two hours—buckets.

I'm going to reread your letter from the 2nd or 3rd of September now, the one that came with the package. The mail leaves from here on the 10th, on Tues.

I'm healthy, tanned. I'm eating a ridiculous amount because everyone eats. It's good, sort of like being at the dacha.

Greetings to Osia, I wrote him a letter. Greetings to Zhenia! How's Aseev?

I send you a big kiss.

Maybe I'll write some more on this page in the next three days.

Anti

Vakhtan, September 17, 1930

Dear Varva!

I received your two letters of the 11th and 12th of September, and likewise so did Leon. . . . I sent you some landscapes from the Vakhtan materials by registered mail. You write that you haven't received any letters but I write every day and don't understand why you aren't receiving them.

You yourself didn't write for a week, I was barely able to write the last two letters. . . .

This is how things are with the filming: everything's finished, there's only the inside of the plant—that's for three SUNNY days, but there haven't been any sunny days—and in a few days they'll finish the installation of the lighting boxes. So we feel like we're at the end. And the end, of course, is hard, and because of it one is all the more impatient to leave.

[*End of letter of 9/17/30*]

From Kotelnich or Nizhny [Novgorod] you'll get a telegram that we're on our way. Don't come to the station, because we don't know when we'll arrive.

If not for your weeklong silence I would feel fine.

Your "little secrets" for today are too small, and I'm not satisfied. You have to understand that I have no other pleasure except for your letters. I don't need anything as much as you. And so I reread them twenty times. I can read between the lines.

Sweetheart, do you understand me, do you know what this means? I sit here during the day, the weather is overcast . . . I don't know what to do, I'm so bored. Two letters arrive and there's so very little in them. . . .

I'm sick and tired of Vakhtan.

Well, one solace is that we'll be there soon, and we'll probably stay for about ten days and then go to Leningrad, and then we can talk on the telephone from there.

I'm waiting, waiting. Anti

[*On the back of a postcard of Shishkin's* Morning in the Pine Forest]

This is pretty much where we are. There are five of us, I'll draw the fifth one on. It's the same exact landscape.[9]

We live in a new Vakhtan villa, "Cockroach Hole."

We're working like maniacs, i.e., we're filming.

I'm waiting for the cigarettes. Anti

You see, the cockroaches have soiled even the postcard.

Rodchenko. *Pioneer Girl*. 1930. Gelatin silver print, 19½ × 14⁹⁄₁₆" (49.6 × 37 cm)

Vakhtan, September 28, 1930

I felt like writing separately about the fact that aside from everything else you are my only friend, and when you aren't around it's like I am only half myself.

I have no one to talk to in the evening about what's been done, no one to tell what my eyes have seen during the day.

It is as though they see for you in order to show you what I have seen and convey the seen to you.

I love you, my little one!

I love you, my little hamster.

I will never stop loving you.

I'm yours, only yours.

<div align="right">Anti</div>

Leningrad, November 10, 1930[10]

We're sitting at Elizarov's without money, there's thirty rubles left and he gives my blockheads 250 a day. There's no money, I'm not going to the shoot.

They began shooting with the Sept on the tram, as well.

The cigarettes they handed out here are finished, I looked for Pushka for two days, they're sort of like Basma, they sell them for 1 ruble 50 kop., and there aren't any others at all. I went and erased the stamp from my travel allowance and brazenly went and got more. So I have cigarettes again.

Here they say that in Moscow the stores are full of everything. Is it true?

I ran into Vertov here, he promised to show me his [*Donbass*] *Symphony*. I'm sick of everything. As it turns out, we're thinking of staying until the 16th. Sweetheart, don't worry, old lady, I'll be there soon.

Once again, my Sept has turned out to be an absolutely necessary item.

If you want to talk on the telephone place the call yourself this time, I don't have much money.

The weather changes several times a day.

In the circus they have horses and other animals, not very interesting. I went to the Music Hall but now there's a new program and I don't know whether there will be any tickets. They were sold out until the 9th.

Vertov says that he hasn't received his salary for two and a half months.

How are things with you?

Kisses. Anti

Get your income sheets and file yours. When I come I'll file mine.

I just got back from the cinema, I saw *Donbass Symphony*. The sound is staged. The camera work isn't that good, it's after Mishka [Mikhail Kaufman], bad, slightly skewed frames.[11]

The first part is done entirely after Mishka's *Spring*, but worse.

The sound—is 10 percent live recording, 90 percent in the studio.

If the frames are bad, you only hear the music. And if the camera work is good—for instance, the section in the plant with the red-hot wire—then you entirely forget to listen to the sound, because it's an orchestra. Even I could produce sound tracks like that.

Well, kisses. Anti

1931

Rodchenko to Stepanova

Moscow, February 10, 1931. Note

Dearest Ham!

I went to Soiuzfoto, from there to the factory, from the factory home, from home and so on.[12]

Liza called, Ilin called.[13]

I don't feel like doing anything, I'm tired. If only I could sleep for a couple of days without worries and then print.

Kisses. Anti

Work in the cinema—scenery.
[*In Stepanova's writing*]

1933

Medvezhia Gora—Moscow
February 23, 1933

Dear Varstik!

I haven't written because of not knowing where, what, and not having a pass.

Rodchenko working at the White Sea
Canal, Karelia, 1933. Photograph by
Anatolii Skurikhin

Everything's in order now. I'm healthy and look good. I'm eating, drinking, sleeping, and so far I'm not working, but I'll start tomorrow.

Everything is wonderfully interesting. So far I'm really on vacation. The conditions and weather are marvelous.[14]

Kisses, Anti

Greetings to Mulka and mother. Don't spread it around very much that I'm at the White Sea Canal.

My address: Medvezhia Gora. Murmanskaia R[ail] R[oad]. General Delivery.

Anti

Medgora, March 8, 1933

Varstik!

Sweetheart, how are things going? Are you running around like crazy?

I haven't received any letters yet.

I'm photographing, even though it's freezing. The sun is wonderful. It's interesting here, more than in the Caucasus. The air is wonderful.

One should come in the spring.

I'm afraid I don't have enough flint for the magnium machine—I forgot to get it from you. If it's not too much trouble, send one in a letter, make an opening in the cardboard and glue it like that, flush. This is where we should go on vacation—in winter.

What snow, light, and mountains!

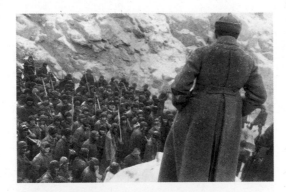

Rodchenko. Photographs from the series on the construction of the canal between the White Sea and the Baltic Sea, for the magazine *SSSR na stroike*. 1933

Top: Guard and prisoners. Gelatin silver print, 11⁹⁄₁₆ × 17⁷⁄₁₆" (29.3 × 44.3 cm)

Bottom: *Working with Orchestra*. Gelatin silver print, 11⁷⁄₁₆ × 17¼" (29 × 43.9 cm)

How's Mulenka? I'm thinking of her. She should live here for a bit. I want to tell you everything.

Well, big, big kisses. Anti

Medgora, April 24, 1933

Dear Varstik!

Lemberg has completely disappeared in Moscow, not a sign of him.[15] Why'd he get stuck there when he's supposed to be here. My host, the head of administration, is in bed, sick—he still hasn't recovered from pneumonia.

Yesterday I went to the opening of one section [of the canal], they released the water, it was an indescribable spectacle but it was a shame that it was so late, about nine at night.

The laboratory is ready and I've begun working.[16]

Today I received the telegram where you wrote that you sent three registered [letters] and 100 [rubles] by telegraph.

It turns out that they'll give me money here, so I gave you all that trouble for nothing.

Save the telegraph receipt, money doesn't always arrive here.

Zhenka doesn't write at all.[17] Did Shura give her my letters and so on? And where is he?

The post office here is a regular grave. I can't understand where Lemberg's got to and why there is no news. When he arrives in Medvedka there will be a mountain of work for him here on the filming. We're just getting to the most interesting part.

Well, me—I'm working and I have everything.

Kisses to Mulka and mother.

I'm waiting for your registered letters.

<div align="right">Kisses, Anti</div>

Stepanova to Rodchenko

Moscow—Medgora
June 1933. Telegram

RODCHENKO THEME RED ARMY FILM SHOOT. MONEY GUARANTEED. LEAVE IMMEDIATELY IF AGREE. EXPECTING [YOU] FIFTH. VARVARA

Moscow—Medgora
July 14, 1933. Telegram

ZELENSKY SWEARS TO GET MOTHER UP. PULSE GOOD. BREATHING REGULAR. NO CONSCIOUSNESS YET. RADICAL TREATMENT PRESCRIBED. NURSE. WORRIED ABOUT YOU. REPLY.[18]

July 15, 1933. Telegram

DEAREST KHOMIK. TO COME NOW MORE DEPRESSED. COMA CONTINUES.

July 18, 1933. Telegram

MOTHER'S CONDITION HOPELESS. STILL IN COMA. DISTRACTING MULKA. EXPECTING CATASTROPHE ANY MINUTE. INCREDIBLY SAD. ANXIOUS ABOUT YOU. KISSES. TIRED. VARVA

July 18, 1933. Telegram

DEAR SWEETEST KHOMIK. OUR BELOVED MOTHER IS NO MORE. BEG YOU TELEGRAPH FEELINGS IMMEDIATELY. BIG, BIG KISS. VARVA

Rodchenko to Stepanova

Medgora, July 19, 1933

Varstik, dearest!

I'm sitting here, it's been raining for two days. There's nothing to do. It's depressing. I feel like the grave. I received your letter and your two telegrams, and one of Zhenia's, and then three more of yours.[19]

What will happen with mother??

Will she regain consciousness or just die that way?

Send Mulka to Zhenka: let her live there for a bit.

Such misfortune. And everything happens right when I leave. I've got nothing but bad luck. I just don't know what to do. . . .

This year you've been working so hard and also just running in place.

Well, with mother this had to be expected, but why did it have to be without me.

I'm more concerned about you and Mulka.

Today there haven't been any telegrams and I don't know whether that's good or bad.

I'll arrive somewhere between the 22nd and the 25th.

I'm taking photographs but everything is going slowly and quietly.

Well, I send kisses to everyone, especially you, don't be sad.

In life there is more bad than good.

Kisses.

<div align="right">Anti</div>

Stepanova to Rodchenko

Moscow—Medgora
July 20, 1933. Telegram

DEAREST HAMSTER. CREMATION 20TH. MULKA'S AWAY. ZHENIA AND LIZAVETA WITH ME.[20] DON'T WORRY. WAITING. TELEGRAM YOUR CONDITION. KISS YOU.

Rodchenko to Stepanova

Medgora, August 18, 1933

Varva!

I'm sitting here with no money, they started paying for my food. They gave me an account. I think that *SSSR na stroike* will send five hundred [rubles], and I'll borrow some here. Please go by *SSSR na stroike*, find out and telegraph [just] one word: "transferred," I'll get some [money] here right away, and then I'll have enough for everything.

Between you and me, the steamboat will arrive on the 25th, but not along the whole canal, only to two sections. But that will probably be the opening.

After that, no one's interested. So that means I'll be out of here soon. After all, printing here is no good.

Well, I'm waiting for a telegram and information about the photo.

The day after tomorrow I'll send another photo, but to your address.

Now, this is the story. The steamboat "Marx" arrives on the 25th, with 500 workers. There will be photographers aboard, they will probably go all the way to Povenets at the beginning of the canal, travel along the Povenets section of the canal to Volo-lake, and then return to Medvezhka. And then maybe from here they'll go to the [other] sections by car.

I'm thinking of putting together an issue: I photograph their arrival and trip on the steamboat, develop everything right away, print it, and send it to you before them [the other photojournalists]. You take them [the photos] and print them in the newspapers immediately.

Together, you and Zhenka can distribute them in a second.

That would be great, right?

A big kiss. Anti

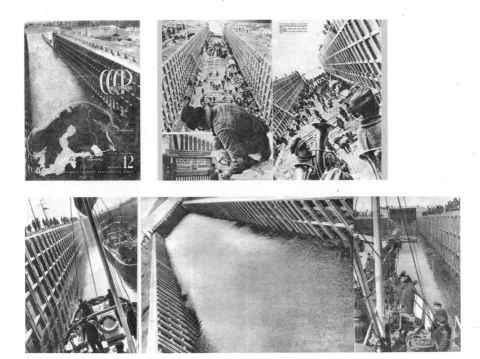

Cover and pages of the magazine *SSSR na stroike*, no. 12 of 1933, designed by Rodchenko and illustrated with his photographs of the construction of the canal between the White Sea and the Baltic Sea.

Top left: Cover. Lithograph, 16½ × 11¹¹⁄₁₆" (42 × 29.7 cm)

Top right: Spread. Gravure, 16½ × 23¹³⁄₁₆" (42 × 59 cm)

Bottom: Spread with foldouts. Gravure, 16½ × 45¹¹⁄₁₆" (42 × 116 cm)

Rodchenko and Stepanova, designers.
Ten Years of Soviet Uzbekistan. 1934.
Photogravure, letterpress, and lithography, $9\frac{3}{16} \times 11\frac{5}{16}$" (23.3 × 28.7 cm)

1934

Kramatorka, summer 1934[21]

Dear Varstik!

You seem to have completely forgotten me, I'm writing my third letter. I don't know where there's a telegraph around here. I run around the whole day—the work, to put it mildly, is hard, we're completely worn out.

The territory is huge, I get around mostly on foot, it's hot and dusty, no rain at all but a strong wind.

What is going on with you? Why are you silent? How is Mulka? I'm worried about all this, and also the deadlines and mock-up. . . . Why aren't you writing?

Kisses.

Anti

My address: Donbass, Kramatorskaia Station, Lunacharsky Street, Visitors' House, Ward no. 24

Varva!

Finally, I just now received your letter and found out why there hadn't been any letters for so long. Where are your telegrams? How is work going?

I'm settled, I have all the passes, I'm photographing, but getting around and developing is terribly difficult. The water here is bad, and it's hot. Yesterday I ruined Zhenia's roll, where Kaganovich, who was here, was photographed.[22] There is a lot of work, I don't know when I'll finish. Zhenia will arrive for her shift on the 18th, and I'll probably stay on.

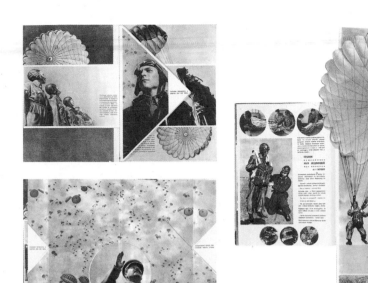

Special issue on parachuting, designed by Rodchenko and Stepanova, for the magazine *SSSR na stroike*, no. 12 of 1935.

Top left: Spread. Gravure, 16½ × 23³⁄₁₆" (42 × 59 cm)

Bottom left: Spread. Gravure, 16½ × 23³⁄₁₆" (42 × 59 cm)

Right: Spread with foldout. Gravure, 33½ × 27" (85.1 × 68.6 cm)

Deineka is becoming the Soviet Konchalovsky. . . . It's a shame that there's no paper for publications. . . .

Well, I'm calmer now and am going to work.

Stepanova to Rodchenko

Moscow, May 6, 1934

Dearest!

When you left you didn't suppose it would be so hard to work. But when you get home you'll rest here, you'll go to Dinamo, swim, and get a suntan.

I rented a dacha for Mulka in Mamontovka, I'll send them there around May 20th. Mulka is terribly happy about the dacha, she's very tired, has begun crying often, and is quite nervous. Out of town it is really very nice.

I imagine you sitting in an oven, and there's no greenery, no water.

I feel so bad for you. You're probably on your feet all day, transportation is a great thing, isn't it? A few days ago I rode in a car to Rostokino, outside of Moscow, to a plastics factory, and thought what idiots [we were] that we didn't buy motorbikes or a car back then, it's absolutely necessary and now it's unbelievably expensive.

I send kisses, I'm glad that you wrote to me. I want to see what you photographed there.

Your Varva

To the Newspaper *Sovetskoe iskusstvo*

I've been asked to write how to carry out com. Stalin's slogan "MASTER TECHNOLOGY" in art.

Art is famous for quickly staging any slogan to make it look like life, and just as quickly discarding it.

The slogans of the Party though, are not calculated for fashion but for life and work.

Stalin's slogan speaks of the obligation before the world proletariat—this places a colossal responsibility on us for our artistic production.

We should do our artistic work so well and politically correctly that the working class of the entire world will be able to say—NOW THIS IS MY VANGUARD PROLETARIAN ART.

Stalin's slogan obliges us to abandon our individual cells and studies and go out into all kinds of production anywhere where there is an artistic need.

We must understand and study production, and actively work with it. In our country there should not be a single artist who is a "priest of the study."

And working in production, studying it and immersing ourselves in it, we will truly be able to be of colossal use to the growth of the SOCIALIST FATHERLAND. And comrades, let's do our work and understand slogans, not mechanically, so they look "factory-made," but in their true substance.

TO MASTER TECHNOLOGY—means that we, artists, must master the technology of our work and teach this technology to the greatest number of young people possible.

TO MASTER TECHNOLOGY—means quality and skill.

TO MASTER TECHNOLOGY means to know and know how to do things better than they are done "in the West."

But I'm afraid that we'll interpret things like this: they'll put on a play where the actor will "master" technology, and the artist, at the request of the director, will build prop machines for each act.

This sort of thing will be mediocre, boring, and unrealistic, but it will be "according to the slogan," while we need the slogan in its essence.

Many of our artists have called themselves "shock-workers," only it isn't clear what they've been shocking, and all the Party's slogans in art often end with the old slogan: DOWN WITH HACKWORK.

A. Rodchenko. 1932

Reconstructing the Artist [23]

It isn't easy to speak when all your creative work is in question. And by whom? By the artist himself. It is difficult, painful to speak about this, because you need to not simply criticize pieces that involve so much creative effort but to discover their content, techniques, creative method. Each of these works was a struggle for affirmation of your worldview, and each of the artists strived to create on a highly professional level.

. . . 1916–1921. I was a painter, organizer of a group of non-objective painters. Participant in many foreign exhibitions. This painting set itself primarily compositional tasks.

1921. I abandoned painting. I proposed the slogan: "Enough depicting, time to build." I went into production. I was the dean of the metalworking department of Vkhutein, professor of design. From a department that had made icon covers, icon lamps, and other church ornaments we began to produce graduates of electrical construction, metal household items, and metal furniture (unfortunately, such a department no longer exists). The engineer-constructors I taught now work at Tsagi, on the metro construction, and in architectural and construction institutes.[24]

1921–1922. Photomontage, of which I can consider myself the founder in the USSR. Work with Mayakovsky on advertising.

1923–1924. Photomontage propelled me into photography. In my first photographs—a return to abstraction. The photos were almost non-objective. Compositional problems were at the fore.

1925–1926. LEF—was the destruction of the old photography. The struggle for a photographic language to show Soviet themes, the search for angles of shooting, agitation for discovery of the world by means of photography, for facts, for reportage. The first articles in the journal LEF and Sovetskoe kino [Soviet cinema]. I set myself a task: to show objects from all sides, and primarily from a point from which no one was accustomed to seeing them. Angles of perspective, transformations. This was not a mistake, it was necessary, and it played a positive role in photography, refreshed it, raised it to a new level. The photographs of Ignatovich, Langman, Debabov, Prekhner, and others came out of this.[25] The nature of Shaikhet and Fridliand's work changed.

1926–1928. The October group. The first exhibition in the Park of Culture.[26] The participants: Rodchenko and Griuntal.[27] The second exhibition in the House of Print. The participants: Rodchenko, Ignatovich, Langman, Shterenberg, Smirnov, Kudoiarov.[28] After the attack on my [photograph] *Pioneer*, the October group excluded me, backing away from formalism. The leadership went to Boris Ignatovich, who surrendered all positions, and the group fell apart. The family group of Ignatoviches remains.

I immersed myself in photojournalism, sports photography being the most difficult, in order to cure myself of the easel approach, aesthetics, and abstraction. With occasional breaks I worked in printing, theater, cinema.

1929–1930s. I went to the White Sea Canal in a very bad mood. In *Sovetskoe foto* it had become fashionable to hound me in every issue. I photographed

Stepanova and filmmaker
Vitaly Zhemchuzhny, 1936.
First photograph by
Rodchenko of the studio after
its renovation in 1935.

sports. Without, it seems, any gimmickry. The pictures, as can be seen now, are good, ours. But . . . the label was stuck on, it became creatively unbearable for me to work in Moscow. Shaikhet does the same kinds of pictures, the same kind, only a little bit worse, a bit different. . . . And they are praised. My mood was decadent. To spite myself I started shooting unbelievable angles. They criticized me anyway. I could have abandoned photography and worked in other areas but it was impossible to simply surrender. And I left. It was my salvation, it was a ticket to life. From that point on, the goal became clear, I wasn't afraid of the criticism, all the persecution dimmed.

. . . A gigantic will gathered here, on the canal, the dregs of the past. And this will was able to raise such enthusiasm in people, the likes of which I hadn't seen in Moscow. People were on fire, they sacrificed themselves, heroically overcoming all the difficulties. People whose life, it seemed, was over, showed that it began anew, full of extraordinary interest and struggle. They took gigantic cliffs and quicksand by storm. This was a war of man with untamed nature. Man came and conquered, conquered and reconstructed himself. He arrived downcast, penalized, and angry, and left with head held proudly high, a medal on his chest, and a ticket to life. And life opened to him in all the beauty of genuinely heroic creative labor.

I was bewildered, amazed. I was caught up in this enthusiasm. It was all familiar to me, everything fell into place. I forgot about all my creative disappointments. I took photographs simply, not thinking about formalism. I was struck by the sensitivity and wisdom with which the reeducation of people was conducted. There they knew how to find an individual approach to

Rodchenko with a photograph of his
daughter, c. 1935. Photograph by
Anatolii Skurikhin

each person. At that time we didn't have this sort of sensitive attitude to cre-
ative workers. Things went this way with us: reject formalism and go work
as best you can. There, on the canal, that's not the way they worked. They
didn't sit a bandit down to work at an accountant's desk or put a thief to
work on payroll, they didn't make a prostitute into a laundress. The bandit
worked in demolition or as a driver, a member of an assault team or emer-
gency brigade. The thief or embezzler was made director of a club or cafete-
ria, or a purchasing agent. And the prisoners worked miracles.

After spending a month on the canal I left for Moscow, developed the
material I'd shot, and . . . began to miss the construction group. I couldn't
help thinking about it. How was life going there? I felt that it was too calm
here and that everyone was too self-involved. I left for the White Sea Canal
again. I went a third time, as well, before the construction was finished.

My pictures were in all the press, I did an issue of *SSSR na stroike* and
three quarters of these were used for the book on the White Sea Canal. I
put together an exhibition in Dmitrov on the construction of the Moscow-
Volga Canal. I was published everywhere. The only place that didn't pub-
lish me was *Sovetskoe foto*, and they didn't say a word about how I did this
work. But now it was no longer painful to me. I knew that I was right.
It was only in 1935, on the eve of the Moscow exhibition *Masters of Soviet
Photo Art*, that *Sovetskoe foto* included a number of my works and an article
about me.

1934–1935. I didn't do very much work during this period.

In the winter I worked on two issues of *SSSR na stroike*—"Kazakhstan"
and the parachute issue, and I worked on *The First Cavalry* [album] and *Cin-
ematography of the USSR*, in collaboration with V. Stepanova. My creative
path has not been easy, but it is clear to me who I was and what I want. I am
certain that in the future I will make genuine Soviet works.

Now about others.

At the time I came to work in photography, Shaikhet, Fridliand, and
Alpert were growing up.[29] These were Soviet photojournalists. On the other

Rodchenko's photographs in *Masters of Soviet Photo Art*, Moscow, 1935.

side stood the artist photographers, who took pictures of girls or landscapes. Of course, I was on the side of the photojournalists, but they didn't satisfy me either. Shaikhet would stage things, he shot with a tripod, people looked into the camera and posed unpleasantly. But still, these were our themes and our people. Shaikhet has changed now, both my articles and my perspective have had their effect on him, but he . . . continues to stage photos. Moving over to a Leica, he continues to economize on film, to convince people to be photographed, he doesn't just shoot whatever's there. Because of this he is dry, there is little life in his work, he's a bit artificial, cautious, there are neither flops nor heights in his pictures, he is always evenhanded and often even dead. Shaikhet has his virtues as well: he always photographs under any conditions, here there are no fiascoes. Shaikhet doesn't work much on the frame. His best works—are general views. He photographs with a Leica like Nette, and because of this his pictures have no dynamic qualities. The Leica was created for close-ups and for capturing life on the fly. In terms of printing technique, Shaikhet is even a bit dry. His photos are not exact and even seem to be reproductions. Shaikhet photographs everything that's necessary, and even in the way you need it. He is a conscientious worker but he needs to grow creatively, to acquire his own creative features.

S. Fridliand—is a reporter who really loves photography. But the fate of photography unfortunately concerns him more than his own creative fate. He spreads himself thin, rushes about. And he rushes about not full of fire but falling into photographic melancholy, mediocrity. He possesses real lyricism but seems afraid of it. He wants to be strong, healthy, clear, but it doesn't work for him—he's drawn to lyricism. Fridliand could work more successfully if he would give himself over fully to his inner feeling rather than to heavy thoughts on a light-handedly fulfilled theme. Fridliand has a good grasp of technique, he is more cultured than many photojournalists, but very fearful and . . . sentimental.

Alpert. Life and work are easier for this photographer, he has an old reporter's instinct, savvy. He always knows how to photograph the most important moment—everything is in place and everything is visible. It might be a little boring, a little too photographic, but on the other hand there's nothing to criticize. His sense of humor in life allows him to amuse himself—he can suddenly take a picture of "collective farm bathing beauties." This doesn't happen with Shaikhet. Alpert doesn't think much about the fate of photography, he doesn't suffer. I would just like to see him take a few more risks so that he loses his balance.

Boris Ignatovich—is a former friend, student, and colleague. Like a stallion in blinders he had no desire and didn't want to see anything around him other than what was leftist. He mercilessly rejected everything that wasn't new. I thought that this was the artist's creative being but it turned out to be only a mannerism. B. Ignatovich squandered his photographic language. He was left with one thing—an unprincipled irreconcilability toward absolutely everything. One wants to help him, to return this master to great creative work.

Elizaveta and Olga Ignatovich—are very efficient, capable photographers who can intensely grasp bits of our lives, but they are not independent creatively.[30] They blindly subjugate themselves to the creative decrees of B. Ignatovich.

E. Langman has enormous experience, taste, wit, he has lyricism as well, but I'm always afraid that he might run off "for a minute," either "to the right" or "to the left." He traveled to Kazakhstan and Uzbekistan, and where are the people he shows us? Not perspectives and portraits, but specifically people. Langman needs to photograph more new people, and not the way Dmitry Debabov or Abram Shterenberg do. People in Langman's photographs should work. Recently Langman has worked a great deal, he has grown creatively, but it isn't always clear what he wants. He rejects formalism today, but no one really believes him, although they are absolutely convinced of his abilities. It won't be easy for him to work, having rejected "crookedness," but Langman definitely has all the necessary requirements for creating talented works.

Abram Shterenberg—is an artist first and foremost, even when he is appearing as a photographer-artist. Each work concerns him equally—how it is shot, and how it is printed, and how it is retouched. Being a first-class studio portraitist, perhaps the only one in the Soviet Union, he rushes back and forth between reportage and artistic photography. When on a reporting job he exhibited portraits and artistic photographs because he could see that the quality of his reportage was lower than his artistic photography. He is one of those photo artists who is moving toward reportage, and this places him a whole head above other photo artists. What does Shterenberg need to overcome? Fear of working on photo reportage. He shouldn't be afraid of possible mistakes, they will be instructive for us as well. I'd like to see Shterenberg grow into a highly qualified photojournalist-artist of our country.

Mikh. Prekhner solved this problem easily—take the best from everyone: from Eremin—prettiness, the overview, lyricism; from Shaikhet—the

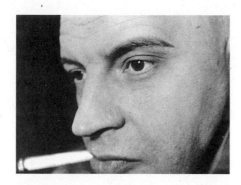

Rodchenko, 1930s. Photograph by
Eleazar Langman

dryness of his theme; from me — point and perspective.[31] He ended up clearly
successful, and the young master became full of himself, convinced that it
was his own success, that all the creative struggles of his teachers were use-
less. In the end, Prekhner has made some good pieces, but he does not have
his own creative identity.

From an ordinary reporter, Georgy Petrusov has joined the first ranks of
the masters in a very short time.[32] He shows an enormous thirst for knowl-
edge, an incomparable interest in photography. Hard work on *SSSR na stroike*
played a significant role in the formation of his creative path. Like a sponge,
he soaked up everything having to do with photography. At any moment he
is prepared to reassess his positions if they are incorrect and to begin a new cre-
ative search in the interests of a better resolution of the theme. Petrusov lacks
only one thing: he doesn't have a favorite mode of working, a favorite theme.
In his recent works devoted to the communal farm, something new can be
observed—a skilled, convincing combination of landscape and our reality.

Ivan Shagin—is definitely a capable photojournalist, but he has resolved
the creative task for himself even more simply than Prekhner: if the crowd
likes it, that means he's on the right track.[33] And everything blooms in flow-
ers, dandelions, girls, and smiles—for every thousand pictures there are
999 smiles. Magazines invariably take these materials. But Shagin himself
isn't happy. He feels that this is not the right track, that the face of the
philistine often looks out from his works. The talented photographer Sha-
gin needs to definitively break with philistinism.

Debabov and Skurikhin are "great travelers," photo wanderers.[34] They
stay in Moscow visiting someone for a few days, and then start packing again.
They are not troubled by any sort of creative struggle. Debabov has recently
become too carried away with ethnographic pictures. Everything is done
well, it's pretty, but very touristically, non-Party, there is too much softness,
sentimentality. Debabov was an energetic photojournalist and now he has
become a lyric and an artist. For him this is a dangerous path, he is moving
further and further away from us and closer to Eremin. His secret—is involve-
ment in Mother Nature and exoticism. Debabov worked for *Izvestia* as a pho-
tojournalist but became a freelance artist and even left the newspaper. Fighting
with formalism, we didn't notice that Debabov had turned himself into an
"intourist."[35]

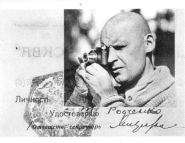

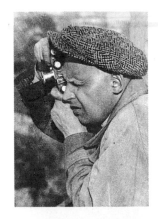

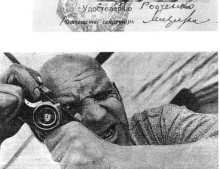

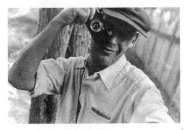

Top left: Press card certifying
Rodchenko as correspondent for the
newspaper *Evening Moscow*, 1929–30.

Top right and middle: Rodchenko pho-
tographing, 1930s.

Right: Rodchenko, 1930–33.
Photograph by Brodsky

Skurikhin previously worked as a photojournalist for *Komsomolka*, then for *Izvestia*, and now he is also a tourist and traveler. He has come closer to Soviet themes yet is somehow not very topical, too contemplative. He is drawn to Mother Nature as well, even more than to photography and the theme. The necessity of showing Soviet themes leads him to a false pathos: workers smile with stenciled stereotyped hammers on their shoulders against a background of chimney pipes.

Mark Markov is a talented young master, a bit similar in his work to Prekhner and Petrusov.[36] However, he is distinguished from them by a great simplicity and lyricism. He knows how to find the simple joys in everyday Soviet life, to show the healthy pathos of our holidays. Markov needs to continue searching for his own creative trademark and to strive for creative autonomy.

. . . There are very few of us, one would like there to be many more. Schools are needed, institutions of higher education. We want to make surprising photos, we need paper, chemicals, we need our own organization along the lines of Vsekokhudozhnik. We want to show our best works at exhibitions, to get together in our own club. We need the first museum of Soviet photography in the world.

And lastly. Henceforward I want to decisively reject putting formal solutions to a theme in first place and ideological ones in second place; and at the same time I want to search inquisitively for new riches in the language of photography, in order, with its help, to create works that will stand on a high political and artistic level, works in which the photographic language will fully serve Socialist Realism. Each of us masters should remember Mayakovsky's words:

"I
give
all
of my poet's resonant energy
to you,
the attacking class."

Black and White

Autobiography

He was born above the stage.

There were two little rooms with square windows. On Nevsky Prospekt.

The theater—was everyday life for him. Every evening it was easy to find himself on the stage, he had only to go down the stairs.

Every evening this theater could be heard with all its sounds.

He knew it, like kids know their village, woods, and river.

Here are the dressing rooms, here is the staircase into the orchestra, here is where the fireman stands, whose helmet shines so temptingly; up there is

the scenery room, where it smells of glue and wood, where you can pour paint into matchboxes, they dry out and you have whole collections of them at home. And here is the prop room, where there are so many interesting things on the shelves and walls—fencing swords, daggers made of wood painted silver, where father makes a roasted chicken from gray bread and turns a tin of sprats, brushed with glue and sprinkled with black beads, into caviar—all you have to do is put it on a plate.

The most incomprehensible thing—is evening in the auditorium that is so familiar during the day. It's strange, it fills to bursting with people, all different kinds, and all strangers, and every time they are different. And most important—it's dark there, and it breathes warmth and perfume.

The audience—is the unknown, it is on the other side of life. He usually stands in the wings and looks into this black abyss with a certain terror.

Occasionally they took him onstage, when they needed children; he did everything he was supposed to do—moved and spoke fluently, only he didn't like that black abyss, without it he would have felt freer.

And so for this boy the theater was his home and his ordinary world. And he dreamed about something more unreal and fantastical than what surrounded him.

After all, all children fantasize, but adults are allowed to do this only very rarely. Not even artists are allowed to.

During the day, when there was no one in the hall or onstage, he would sit on the floor in the middle of the stage and, illuminated by the duty lamp, imagine things.

In some blinding costume that you couldn't even look at—it would hurt your eyes—he was alone amid fantastical scenery, sparkling with color and light, he did incredible things, he created combinations of color and light that would disappear and then reappear, flying in the air that was full of strange sounds and creatures.

The black abyss grew silent, it was stricken with wonder, and afraid, and it didn't move and didn't cough.

And after the silence, the thunder of the applause, but what applause! . . .

He tried to fly up. . . . But the fantasy didn't realize itself.

In the summer the ventriloquist was on tour.

Two drays arrived at the theater with ten locked crates bound with strips of iron. The crates were painted black and had French words stenciled on them: the ventriloquist's last name and the number of the crate.

The boy was so excited by this!

It was so mysterious and strange.

It was so unlike the ordinary life of the theater.

When they made everyone get off the stage, and he, sitting in the orchestra, saw this lone man around speaking dolls, he was stricken with wonder for his whole life.

Now this was a man, and this was art!

But the strongest impression remained everything that he imagined, and the black crates with the incomprehensible white letters were imprinted on his mind for a lifetime.

He became a youth and met an artist; this artist is now the film director comrade Svetozarov.

Svetozarov lived by giving lessons, and he studied at the Kazan School of Fine Arts. He lived in a hallway, his father rented out the rooms, and there in that hallway they dreamed of becoming artists. How much they talked about art in that place.

Svetozarov ignited in him a love of everything colorful, vivid.

The Revolution came in 1917.

He threw himself into it headfirst, with all his passion for everything new.

And moreover he knew who the Revolution was for and who it was against.

I'll describe one episode in this regard: in childhood he was sick with a bad throat, there was a danger of tuberculosis. His father sent him on his last legs to an old lady they knew who rented a dacha and whose daughter was a cabaret singer.

Across from the dacha was a fence, and the owner of the beer factory lived on the other side of it.

He saw two boys and a wonderful girl, and began to go up to the fence, and they became acquainted. . . . They broke off a board to let him in, and he would go to them to play.

They had masses of toys, they were taught French, were taken for rides on horses and given tasty things to eat,

One day the fence was nailed shut again and there was no one around. He suffered in torment, trying to think what he had done that was so terrible.

The next day the girl came up to him and said, as she quickly moved away: "We've been forbidden to play with you"

And the boys, approaching, threw stones from a distance.

Then the war of the stones began in the backyard. He made a fort and threw stones from there.

And at night he would sneak over to their fort and destroy it.

So from a series of such incidents he knew who he was and who they were.

In the courtyard in town there were rich boys and poor. The rich were called Kolya, and the poor—"Shurka the prop" or "doorman's Vaska."[37]

And so, the Revolution came. He took on the task of organizing a Union of Artists, creative groups, and exhibitions. In 1919 he went to work in Narkompros, in the Visual Arts Department.

He established a museum of painterly culture. He taught composition at the Higher State Artistic-Technical Workshops (VKHUTEMAS), organized the metalworking department for everyday household objects, equipment, fittings.

He worked until late at night and noticed neither color nor hunger.

He was full of ideas and plans.

He was happy there were so many opportunities and prospects.

He literally flew in the air.

But . . . the times changed. . . .

He went into production: into advertising, theater, cinema, etc.

His theatrical sets contained black and white, along with a rainbow of colors.

He took pleasure in staging works involving the future or the fantastic. And along with a rainbow of colors there were black and aluminum. Such was the scenery for *The Bedbug* at Meyerhold's theater, *Inga* at the Theater of the Revolution, *The Sixth Part of the World* in the Music Hall, and other works.

Cinema sets interested him, since there everything was in black and white.

He began photomontage, being the first to bring it to the USSR.

That is where you can do a lot of experimenting with real materials.

A planetarium appeared in Moscow.

This was an enormous, fantastical apparatus. It was the—realization of his fantasy.

Made of black metal and glass.

With forms that resembled no living creature.

It was called the "Martian." This creature excited him as the ventriloquist had done.

It made him continue to search and search for a fantastical reality.

Or for the fantasy in reality.

And to show a world that people had not yet learned to see, from new perspectives, from points of view, and in new forms.

. . . He came to photography.

In his hands, the black Leica of nickel and glass began to work with a lover's passion.

He would show this world.

The familiar and ordinary world—from new points of view.

He would show both people and the building of Socialism more intensively and exaltedly.

He would propagandize with photography.

For everything new, young, and original.

But then . . . the flight ended.

The duty lamp was onstage again.

It was empty and dark in the hall.

No flight. . . .

No applause. . . .

The critics attacked [him] with all their strength.

For formalism, for his perspective, etc.

He became a lonely child again.

He became mean and dangerous.

He is imitated but he himself is rejected.

Friends are even afraid to visit him.

And he decided to go away. . . .

From the stage of photography, disappointed and tired.

But doesn't the country of Socialism need ventriloquists, magicians, and jugglers?

Flying carpets, fireworks, planetariums, flowers, kaleidoscopes?

Tired, he prepared for the exhibition *Masters of Soviet Photo Art*.

He literally didn't know what to show at the exhibition.

They'd just criticize him again and again.

Several times, he wondered: Was it worth it to participate?

But then he decided to do it.

And suddenly, success!

It happened. The thunder of applause. He stood up and flew. . . .

Again the incredible possibilities of creative work opened up. The hall was filled to overflowing.

The black abyss—was all acquaintances and people close to him.

The demand: flights!

They demand experiments and fantastical things from the boy. Everything he had ever dreamed of. . . .

From the Diaries, 1934, 1936–1940[38]

1934

February 4, 1934

How many interesting things have been missed that you can't depict with either a Leica or a drawing. So I begin to write. . . .

A certain loneliness from my private life being not quite in order forces me to write. . . .

You don't know what's interesting: private life together with work, or just work alone.

Probably one should write what one lives and breathes by. And as to who will find it interesting, it doesn't matter. Moreover, one has to write every day. It disciplines.

Twenty years ago I wrote a diary, and it seems to me that what I wrote had no meaning, either then or now. . . .

A page is begun. . . . My private life is over, my work isn't moving.[39] . . .

Philosophy of diary writing: I read Varvara's diary and I see that there are few concrete facts, it's a lot of philosophy in general, probably one should write quite simply, like a log one keeps on a ship.

I'm drawing a caricature of Freberg and the publishing section of Politizdat.[40] I want to do caricatures of Aseev, Tretyakov, Varst, Mayakovsky, Katanian, Kirsanov, Lizaveta Ignatovich, and put together an evening exhibition in the studio—but why? I don't know. A diary is a strange thing; everything looks dumb, somehow. It's possible that when a person is completely opened up, the emptiness and silliness is terribly embarrassing.

I'm beginning to understand that one needs to record and not philosophize. . . .

For example, in the Mostorg store, the price of electric plugs—one ruble—is twice what is in the Veo [Electrical Society] store on Miasnitskaia—fifty kopecks. True, this isn't particularly interesting, but it's a fact.

I'm writing like you take an exam, and this is my own exam, it's stricter that way. Have to write to that, it will be interesting for me to read. Don't feel like writing about love, you can't exactly write the same way as writing letters to her. . . .

Left: Rodchenko. *Morning Wash* (Varvara Rodchenko). 1932. Gelatin silver print, 16½ × 11½" (41.9 × 29.2 cm)

Above: Rodchenko. *Radio Listener* (Varvara Rodchenko). From a series of postcards published by Izogiz in 1932. Gravure, 3¾ × 4⅞" (9.4 × 12.4 cm)

On the phone today, Seryozha (Tretyakov) proposed going to Tiflis and shooting the entire trip for a book, winter and summer. And moreover, to travel with the Kultprosvet train to the Far East, where writing would be possible. The day is over. I'm drawing Freberg, and that's it. . . .

February 18, 1934
Today I began to paint the circus for myself, and thought: What if I painted the first painting, the circus, in black and pink, huge and complicated, 200 × 120 cm, and then the Dinamo stadium: gray and green.

Zhenia called, wants me to come shoot something tomorrow. I feel like going off somewhere tomorrow. Alone. Neither with her nor without her. . . .

I want to print all the "Lefortovo," "Dinamo," "Park of Culture and Leisure" [photos]. I'm forty-two, and it's terrible. . . .

I'm reading about Courbet, he worked like an ox.

February 20, 1934
Yesterday I was at the Press House with Zhenia. . . .

The question is coming up bluntly, either live with her once and for all or say good-bye, PART. She'll want to go visiting, to go to parties *for the evening*, and I need to work seriously; 26–43, it's mathematics. It's reality.

February 21, 1934
I wrote a farewell letter to Zh. Drew a little. The feeling is like I just got home after the hospital, and I'm not myself. I keep rifling around the shelves looking for something. . . . And I'm looking for my certainty and calm. . . . I'm looking for myself. . . . I look at magazines, read about painting. . . . I want to start everything from the beginning. . . .

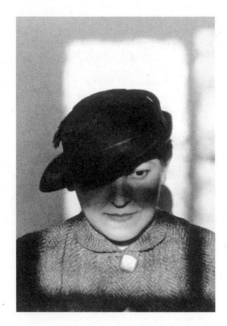

Rodchenko. *Varvara Stepanova*. 1936.
Gelatin silver print, 14⅞ × 10" (37.8 ×
25.4 cm)

February 22, 1934
Have to print photographs for the exhibition in Warsaw and Prague. . . .

Not in a working mood because of the split feeling between the studio, work, Varvara and Zhenia. . . .

March 14, 1934
There's a proposal to go to Kramatorka, to photograph the finished workshops of the factory and make ten albums for a report and for showing the government.

I've begun packing, I'm even taking the enlarger with me, and I decided to try to keep a diary of the trip. I'm leaving on March 17th. Tomorrow I go to the Trust to arrange the tickets. . . . I don't know what the weather will be like, recently it has been cold, snowing. I also have to fix the Leica tomorrow, to try out the film. . . . I want to photograph not just the workshop and factory but make new photographs of everyday life and types, too. . . .

I want to make photos such as I've never made before, ones that are life itself and the most genuine life, photos that are simple and complex at the same time, that will surprise and amaze. . . .

Otherwise there's nothing to do in photography, then it's worth working and fighting for photography as art.

April 16, 1934
The Leica is being repaired immediately. Most likely I'll have a 2.7 lens with an 80 focus. The weather is good. I want to take a Bertio as well—9 × 12 cm. At the Trust they said that the factory is beautiful, that there's hardly another like it in the whole world.

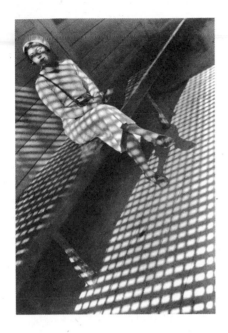

Rodchenko. *Woman with a Leica*
(Evgenia Lemberg). 1934. Gelatin
silver print, 11 13/16 × 8" (30 × 20.3 cm)

April 19, 1934

I haven't left yet after all, as there still haven't been any tickets. They offered third class but I refused, since it's hard with all the equipment, and if it were stolen. . . .

April 28, 1934

In the end, I not only left but I've already arrived in Kramatorka. Now the question is whether I'll write about it. I've been here three days and this is the first time I'm writing. So many little trivial things, which will only be interesting later, not now.

I'll try to write how I got set up with a room, food, transportation, passes. . . .

1936

August 25, 1936

The most interesting books are those written not by writers but by people who have experienced and seen a great deal and who feel acutely. Moreover, they love, hate, and want a lot. . . . Everyone who feels he thinks differently should definitely write. Write everything down and you will be better than the aristocrats of the spirit, who invent things in studies.

History will ask what you, "the non-honored," did and thought.

We don't agree with the depicters, those like Gladkov, et al.[41] Maybe it was all invented, spiced up with other people's accomplishments from books, newspapers, and magazines.

311

They live outside Moscow at their dachas, travel to Moscow for banquets. . . . And I?

I was born in 1891, and now it is 1936—so I'm forty-five years old. . . .

I want to do some bromoil, but there aren't any chemicals here.[42]

I'm buying new equipment: the third Leica model, I bought it for 2,500, a Summar for 1,000, I'm waiting for 28, 30.[43]

I want to be alone. . . .

I can't turn off the memories of Zh., but they are gradually dimming.[44] . . .

I think that the "open house" is getting in the way of my work. I don't have my own room.

All my life I've dreamed of my own room, and I've never had one.

August 30, 1936

Finally this monstrous apathy seems to be passing. I'm beginning to work. There's so much still to do. The gloomy mood, I think, is all in the past.

Painting and photos.

Color photographs.

Our art here is horribly behind the times. Again, there's no time to do art. Have to build.

Art workers have nothing to fight for, and they don't want to fight for ideas, they want a quiet life. . . .

October 20, 1936

Spanish and German fascists destroyed all the treasures in Madrid.

The war isn't stopping. . . .

You'd think—why art again?

Here—we need it, but how can we avoid war? Oh, this is all pessimism. . . .

December 21, 1936

In a diary you either have to write down everything that happened during the day, in detail, or write about what happened earlier.

Somehow I don't feel like writing about women, but, on the other hand, without women there's no romanticism or feeling.

Varvara's love for me is extraordinarily deep. . . .

But feeling for Varvara as a woman still hasn't come back after Zhenia. . . .

I'm working in chaos. . . . And very little. . . .

Well, when I start working I won't write in the diary. . . .

And [most of] the people I know live simply, they earn money, drink, eat, go out for a good time, and that's it. . . . And the days pass, old age approaches. . . . Could it really be that they don't want to burn and that they actually sleep peacefully?

January 12, 1937

I should write, of course—everything's interesting.

I sleep over the laboratory, a simple wood ladder gets me up there. Up above there's a large ottoman with a rug, a little table, and a shelf; Sevmorputi books, travels and expeditions.[45] Here's where I think and write. Down below, people get in the way.

Tatiana Maliutina comes. She has thin lips, sharp gray eyes, long hair. It's dull without her, but when she stays a long time it's also dull.[46] . . .

Varvara is gluing together the album *20 Years of the RKKA* [Worker-Peasant Red Army]. Dodia Shulkin comes by, he's a young reporter, a student of my student. He's kind, big, and awkward.

Down below there's a large white table that's always messy, especially when I'm not doing anything. . . .

On the radio they play Georgian songs of Pushkin's poems, then something for Tolstoy's 100th anniversary. In the theater—I don't know. Painting—there's an exhibition of Baksheev, then Surikov and Vasnetsov.[47] Books—Ostrovsky's *Born of the Storm*.[48] No newspapers, only *Pionerskaia Pravda* [Pioneer Pravda] for Mulia. . . .

I received a prize for a photograph in the competition "Moscow—the Capital of the USSR"—the prize was 1,000 rubles. They didn't choose the best photographs.

Need to invite over:

Boltiansky, Petrusov,

Svistunov, Dodia,

Gerasimov, Regina,

Evgenov, the Maliutins.

Who are they?

Manager Gerasimov, his dep. Evgenov, Photo Artist. Dir. Svistunov and trade union worker Boltiansky. Petrusov's a photojournalist. Dodia—Shulkin. Regina— Zhenia's sister. The Maliutins, neighbors—Tatiana and Misha, the husband drinks, worked in graphic design only for money. Sober he's quiet, drunk he's obnoxious. Why invite them? Well, there isn't anyone else.

The weather has improved, I can photograph sports again.

Recently I acquired some lenses. I have a new Leica, the third model, a 50mm Summar for it, aperture ratio 2; a 90mm Tambar, aperture ratio 2; and 80mm Tessar—2.8; a wide-angle lens, aperture ratio 6.3.

Planning to buy a 35mm and a 90mm. Then I'll have a full set of lenses.

I reequipped the laboratory as well. Everything's marvelous, just have to work and stop grumbling.

The persecution of formalism leads to depression, and then it's hard to bounce back.

And Zhenia's death as well. . . . It's hard to forget and dull without her.

Tatiana came to spend the night with us and is talking about drunken Mishka. I'll have to stop writing.

Well, so long.

January 15, 1937
Zhorzh [Georgy] Petrusov, Dodia, Mishka M., and Tatiana were here yesterday.

Zhorzh told us that he'd written a letter to Stalin asking to be sent to Spain as a photojournalist. . . . He's anxious and waiting for an answer. . . .

I ran into Osia Brik today, he said that I should write about my work with Mayakovsky in greater detail.

This should be done, at least in the diary.

I want to put together two albums, one of the best photographs of our workers, and the other historical photographs of the civil war; must rephotograph paintings.

Varvara is working on the selection of photos for the album *20 Years of the RKKA*; *The First Cavalry* is going to press at the same time.

And I'm still getting myself in working order—I'm painting the baths in the laboratory; I'm digging around in folders, trying to write.

Yesterday I went to the opening of the Surikov exhibition. Everything was extraordinarily boring, the exhibition and the artist. He's an official historical illustrator. He's a psycho-rewriter of times long past, Rasputin in painting.

After the exhibition I walked over to Fedotov, Vrubel, and Deineka and calmed down.

I feel like writing a response, though not with pen but paint.

February 23, 1937
The *First Cavalry* album came out.

Gamarnik and Voroshilov praise it but it needs to be officially approved, then there would be stimulus, there would be a swell in work.[49] It's a shame. . . .

I just did a few sketches for paintings but I'm not painting, there's no moment for canvas and stretchers.

Dodia's son has been born. I'm the red godfather and Tatiana is the godmother. They'll call him Alexander.

March 9, 1937
What am I doing? I paint, but it's going slowly, the break can really be felt.[50]

I go up to my heights and dream. . . .

Some day they'll drag my dead body downstairs.

March 12, 1937
What pessimism!

War still threatens. Everything is heading for war.

Art. . . . It isn't needed. What's needed is bread and cannons.

September 20, 1937
I'm preparing for the photography exhibition *20 Years of Soviet Photography*.

I'm dreaming of finishing printing the photos and beginning to write. . . .

Only I'm in bad condition, it's either the flu or a throat infection.

November 26, 1937

The photo exhibition is open. So far there haven't been any results from it. I worked for a month and a half. And maybe all for naught. The press praises it in general. After all, photos still aren't art. And there's no joy in art, either.

It's so terribly hard to photograph now, you don't know what [to photograph]. . . . I don't have any interesting work. No one needs anything. No one looks at anything. No one wants anything. . . .

I feel like writing a novel, I came up with a pretty good theme: "A Novel for One Person." It should be about art, about the purpose of art, in a detective format, "ESP," i.e., reading minds at a distance, and I'll send it to Stalin. I can dream it up, but writing it is the hard part.

More than a year has passed and I've only written a few pages in the diary. . . .

November 30, 1937

It seems that some of our people have sent in a request to approve awards in the form of the title "honored masters" of photography, with 50,000 [rubles] in prizes. This interests me since I put so much work into arranging the exhibition, and it would be a shame if I weren't given anything.

What's important is that I'm not satisfied with the results. Everything should have been done differently and better. There's too little creativity. Too little invention. I want experiments, broad expansive issues, bold plans.

In Soiuzfoto, Gerasimov thinks about accounting and not about photos.

But people. . . . There are a lot of people, they change [jobs], and I'm certain it will be better. New people are growing! They will be more energetic and more interesting. And then I'm to blame, as well, I didn't join the Party in time and I don't run a photo section.

I turned forty-six years old. . . .

I'm sick of it . . . I want to sleep without dreams. [I'm sick of] loving with tricks. Being smart and tired. . . . I've got everything, all that's lacking is energy and vigor. Maybe I need to see a doctor?

I don't believe it. Everyone is his own doctor.

December 1, 1937

Today I thought a lot and decided that a decisive change in my work is needed again.

I need to do something very warm, personal, human! In response to the advent of fascism, toadies, and bureaucrats.

Not to mock people but to approach them intimately, closely, with maternal tenderness.

Man is very alone now, everyone has completely forgotten about him.[51]

Motherhood. Spring. Love. Comrades. Children. Friends. A teacher. Dreams. Joy, etc.

December 2, 1937

Yesterday Maks Alpert talked about how, in the first years of the Revolution, he would photograph Red Square for the newspapers during celebrations, with six cassettes, and then run to the editorial office to reload them.

And nonetheless he managed to photograph closely, both from the tribune and from two or three high points.

Andreev photographed in the provinces, he had an atelier with overhead light, and on winter mornings he made appointments to photograph soldiers. He'd sit them down, open the lens, and go off to drink tea. Then he'd come back and the soldier would be sitting there trying to catch his breath, since he had been sitting and not breathing.

Sergei Tretyakov has disappeared, it has been more than six months. . . . Where is he?[52]

December 7, 1937

Things are always difficult for us, but interesting, there's always a goal and movement.

Things are hard now, you start looking at things differently, watching yourself and others vigilantly.

That Russian attitude of "to hell with everyone," "what business is it of mine," disappears. . . .

I have to order three [*sic*] stretchers: 120 × 150; 100 × 150; 120 × 200; 250 × 120. And begin painting big pieces.

December 9, 1937

I always suffer from the fact that in paintings, as in writing, I want to think up everything from the beginning to the end, and that's almost impossible.

People filch everything from "nature," that is, they copy from a photo and other masters, they write "with materials," i.e., from stories, and imitate others. I can't even paint from my own photographs. I sometimes try but that's not creative work.

Only once did I want to write a novel, and then I wrote on one side of a page and couldn't go any further.[53]

I'm reading Feuchtwanger's *The Jewish War*. This man can write novels, he knows how to use material.

Well, and how about painting?

Contemporary portraiture is bad but the old portraits are marvelous! Even photography doesn't help. Maybe right now one should only do photo portraits. But then what should painters do? Studies, landscapes, still lifes?

I like cactuses, I'd like to collect them, have a collection. They grow and take new forms. But it's hard, there aren't any in the stores. There are some in windows, I've seen them, maybe I should go in and ask to buy them?

I think it's December 13, 1937

Today in *Pravda*, Kerzhentsev used the words "alien theater" to describe Meyerhold. This, of course, was very cruel. But his *Zinaida* reduced theater

"to itself." This isn't any good for us former formalists. What will happen to Meyerhold?[54]

1938

March 21, 1938

Three months have passed and I forgot about my ship's log.

There was an exhibition, I received a prize of 2,000 rubles, went to Leningrad, hung around with creative masters. . . . Spring is coming and it's 14 degrees above [zero].[55]

April 2, 1938

I remember that in my youth I kept a diary in little notebooks, every day—there were no events, it was written like this: "I got up at eight, drank tea, had dinner at two o'clock. I'm sitting on the roof and looking at the courtyard."

I put together an exhibition of photos in the writers' club, yesterday. Exhibition: Petrusov, Kislov, Prekhner, Mikulin, Fridliand, Alpert, Khalip, Eremin, Loskutov, Markov, and myself.

I exhibited twenty-three pieces. Didn't go to the opening—Varvara went.

I saw three of Deineka's things yesterday: *The Goal Keeper*, *Bathing Boys*, and *Father and Son*. It isn't painting, it's almost photography, painted photography. It's decorative—poster-like. And the pieces are huge.

May 3, 1938

Varvara was at the writers' club, she saw Syoma Kirsanov, he's very important, like a soap bubble.

There are a lot of people at my display stand, they're looking.

May 6, 1938

Photo business won't leave me alone.

I feel like getting back to painting. I'm thinking that it should be Russian, Soviet, and, perhaps, historical.

May 8, 1938

Summer is just around the corner. Big plans. To paint and paint. . . .

I'm also planning to photograph sports: Dinamo, the children's pavilion, and the boat dock station.

Also, the sailing vessel *Comrade* is being launched. So those are the plans.

May 15, 1938

Must learn not only to write everything people say in the diary but also jot down what you jot down in the notebook.

For instance, I decided that I should paint a big painting, 200 × 300 cm, in the spirit of Pieter Breughel, called *Fascism*.

Huge ears,

Eyes,

Tentacles,

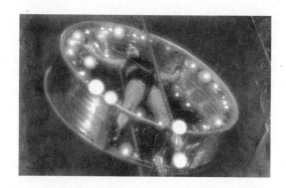

Rodchenko. *The Rhine Wheel.* 1935. Gelatin silver print, 11⅜ × 18⅛" (29 × 46 cm)

Money, Debauch,
Murder of children, women, old people,
Destruction: Cities, Gardens, Museums,
Burning of books,
Flight: Einstein, Heinrich Mann, [Arnold] Zweig, and others,
Armaments: Piracy at sea.

May 13, 1938
No . . . just can't paint.

I'm printing and fixing up the circus—eight photos for the Czechoslovakian exhibition.

Not a word about the exhibition in the writers' club. . . . Why is it like this now?

At my request, finally, Tatiana got hold of a Russian peasant costume from Kaluga province. I want to photograph it, it should be [shot] in a landscape. The costume is interesting, Tatiana looks good in it.

May 21, 1938
I submitted my photograph to the Department of Mass Manufacturing for an exhibition. The art council accepted:

Races, Pyramid, Dinamo, Ribbon Dance, Under the Circus Tent, At the Radio, Durov with the Sea Lions, Parade in the Circus, In the Circus, Dancing in a Ring.[56]

May 6, 1938
I read bits of the Goncourt brothers' diaries: fabulous. Better than any novel. . . .

We're waiting for the cameras ordered for color photographs. I've been promised one as well.

Yesterday I tried out the developer for exhibition [prints]. I printed at 90 × 130 cm from the Leica. They come out really great, just like painting. It's enough to have five big pieces for an exhibition.

They didn't get me a pass to the Dinamo stadium. Tomorrow I'll go see Muska Shvetsova, she has a marvelous garden and marvelous flowers.[57]

It's hard to get a pass. . . . It would be nice to photograph what you want

and where you want. Lizaveta hasn't come back from Vologda yet, I sent her some caricatures and a letter.

May 12, 1938

Lizaveta Ignatovich visited communal farms of Vologda, she was shooting for the agricultural exhibition.[58] She told us that when you go up to the communal farm workers in the field and say—instead of the old "May God help you!"—"Glory to Labor!," they answer, "Thank you" in chorus and bow deeply.

An old communal farm worker, a shock-worker, asked her, "Lizanka, are you a spinster or married?"[59] "Married, grandma." "And for a long time, deary?" "Ten years." "And you have children?" "A daughter." "Then why are you leading such a hard working life, deary, you'll wear yourself out"

Lizaveta developed thirty rolls of film at our place, printed contact sheets, and wrote the texts. . . .

. Work is hard going. . . . And who will see it and read it?

And I'm a "collector of my own work."

May 17, 1938

I'm drawing "Soccer," big temperas. Reading *Ruslan and Liudmila*.[60] Maybe I should do illustrations for the exhibition.

It's a strange time, everyone's whispering, everyone's afraid. . . .

This shouldn't have to concern an honest man. . . .

June 1, 1938

We went to the Kovrigins', the artist Cheremnykh was there, he's got a medal.[61] But he is dissatisfied with the multitude of mediocre artists. But you wonder who's keeping him from working the way he wants to. He's not a formalist.

I'm not exhibiting, I can't paint the way I'd need to.

But if anything's wrong then the only one to blame is me and me. . . .

Kovrigin is a very quiet fellow, not a bad guy, and very capable. He has visual culture. He photographs in the style of Perepletchikov and Nesterov.[62] . . . He's forty years old.

June 4, 1938

Today Regina Lemberg, Zhenia Lemberg's sister, died of gangrene.

Their papa has no one left, he's sixty years old.

How sad and strange. . . .

June 7, 1938

Regina's cremation took place. I went too, and felt quite bad. . . . Her girlfriend approached me and, pulling me aside, asked: "I have your letters to Regina, what should I do with them?"

I replied: "Destroy them."

"I wanted to do that, but without you I couldn't make the decision. . . ."

When I left, she looked at me sadly. She alone knew who I was to Regina. . . .

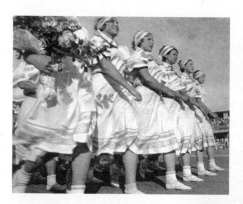

Above: Rodchenko. *Ukrainian Delegation*. 1935. Gelatin silver print, 9⅝ × 11½" (24.5 × 29.2 cm)

Top right: Rodchenko. *Dive*. 1934. Gelatin silver print, 11¹³⁄₁₆ × 9³⁄₁₆" (30 × 23.4 cm)

Right: Rodchenko. *An Oath*. 1935. Gelatin silver print, 16¹⁵⁄₁₆ × 23" (43 × 58.5 cm)

And the letters. . . . Oh, what could you do with them now. . . . They were for her. . . .

July 14, 1938
The heat is holding at about 40 degrees [centigrade].
 Nothing is working out with the creative studios, nothing is happening with the American international exhibition, either. Only dreams are left.
 There isn't any equipment for color photos.
 Africa. I've tanned dark, like a Negro.

August 17, 1938
 In a sad mood, disappointment in friends. . . .
 Thousands of petty things, worries.
 Photographed the sports parade on Red Square.
 Photographed at Dinamo [Stadium].
 Photographed the competition of RKKA, and nothing's spectacular.

August 18, 1938
A strange feeling . . . I can do so many interesting things. . . .
 I'm doing photography and feel I'm almost completely unnecessary. . . .
No one needs me. . . .
 What do I need to do?
 It's strange to be a living artist who doesn't have a single devotee.
 You'll say, "There he goes, a member of the intelligentsia, a formalist."

Left: Rodchenko. *Champions of Moscow*. 1937. Gelatin silver print, 18¾ × 10⅜" (47.5 × 26.3 cm)

Right: Two-page spread from the book *Soviet Aviation*, published for the New York World's Fair. Photocollage and book design by Rodchenko. 1939. Gravure, spread: 15⅜ × 20⅛" (39 × 51 cm)

No, I'm not a member of the intelligentsia. . . .

I almost know what not to do, like Gerasimov and Brodsky.[63] Every question is looked at from the political point of view. This is going too far. The art leadership should help to foster creativity, give a wide spectrum of ideas.

Today's sad. My heart is bothering me.

I just can't begin to print.

I'm reading Flaubert's letters. How interesting they are! How full and bold! That's how one should think and work!

What I have for the All-Union photo exhibition:
Parade—sports.
Parades,
Circus,
Mulia,
Mayakovsky,
Yachts.
Have to go and shoot:
Flowers,
The Zoo,
Botanical gardens,
Gorky Park.
Print many in both color and black and white.
I tried the white out on yachts, very good.
I bought film for two two-color photo prints.
I'm thinking about how to do three-color. How to show coloring.
I'm not needed. And nothing is needed.
No one's asking me for anything. . . .

August 21, 1938

Ship's log! The ship is in a lull. Where to write?

I must write, must print.

Must, must! But for whom? Only for me. . . .

I must get everything in order and work calmly. Must cleanse myself of everything that gets in the way and is superfluous. I must firmly believe and love my art. But there's so little [time] left to live, and so many things to do. . . .

August 25, 1938

The heat is 60 degrees and 36 in the shade.

We sleep on the balconies. Walk around naked. There hasn't been any rain for two months.

My head aches, it's heavy. I tried to do one piece, *Soccer Players*, two pastels. I'm doing *The Singer in the Arena*—oil. *Inostrannaia gazeta* [Foreign newspaper] proposes doing whatever I want, and I don't know what I want.

August 30, 1938

None of the interesting stuff gets written down. But when my mood's bad, then I write.

People come over and don't look at the walls, and don't talk about art, and they aren't interested in anything about it.

Some buy things in secondhand stores.

Others are buying up photo equipment.

Still others are building a house.

And some are busy with girls.

If they would at least collect folk han-di-crafts.

They only buy things that cost money!

On the radio there's Balakirev, Rimsky-Korsakov, "The Quiet Don," Dunaevsky.

All night there was a smell of burning, the forests are on fire.[64]

The doors have dried out, the drawing board is cracking.

August 31, 1938

No letup from the heat. I water the floor with a watering can.

At Boris Shvetsov's, in Sokol, the roses are beginning to bloom for a second time.

Varvara is painting studies, very interesting, she is a strong and healthy painter.

Where is autumn?

I should be printing but it's impossible to work in the laboratory, too stifling. The banjo drum burst.

Today Regina and Zhenia's papa was here, we ate dinner and there was a heavy conversation about the deceased. He tormented me and Varvara. . . .

Tomorrow Lizaveta is leaving for the south to photograph, and I still don't have a viewfinder.

September 4, 1938

I just can't understand why my mood is so incredibly horrible. Either I need heart treatments or it could be a turning point. Wherever I am, whatever I'm doing, there's the poison of depression in everything.

Work is at a standstill.

I'm sitting with drawings and they aren't working. . . .

September 6, 1938

We are all accustomed to judging the personal, the bourgeois, as alien. And my individual work is considered "unneeded, and perhaps destructive."

I have doubts about human beings . . . I have doubts about individuality. . . . "Like everyone. . . ?" That's what we need today, but tomorrow?

I'm reading Mayakovsky—everything is right, but Lebedev-Kumach—everything is deliberately false.[65]

September 10, 1938

I'm working on sketches. I sincerely support my country and [yet] they think you're some little useless thing in this incredible fever of days. . . .

Rumors are going around that innocent people are suffering from denunciations. . . . They tell some incredible stories. . . .

So I am not guaranteed against someone writing a false denunciation and everything collapsing. . . . My family will be sent into exile, and that'll be the end. . . .

I don't know how to write things down. I can only think them up.

October 8, 1938

War in Europe. . . . Czechoslovakia is taken. . . .

This hasn't happened before, here you have "Western" culture.

In the City Committee we organized a gorkom [city or municipal committee] of photo workers and a cooperative fellowship under the aegis of Vsekokhudozhnik.

1939

January 28, 1939

The gorkom of photo workers was created on November 29, 1938. I was elected a member of the presidium. We're establishing MosF [photographers' union], but no one did any work, and I was criticized for not doing my job.

I'm printing photos for five salons.

February 1, 1939

Aseev received the Lenin Medal.

Shklovsky—the medal of the Banner of Labor.

Kirsanov— " " "

Kassil—Honorific Mention.

This is very nice—some of us, *Lefists*.

March 1, 1939

I'm printing for Voks. Boring. Painting at a standstill. No exhibitions. No money. No work. Gorkom's a mess.

March 7, 1939

Again, a big rush. Preparing a photo exhibition for the 18th Party Congress.

First thought of holding it in the Kremlin, then in the building of the Hotel Moscow, and now, it seems, it will be in some club. But it's sad. . . . How insanely and disorganizedly—they put together the exhibition in a huge rush with unbelievable junk.

April 4, 1939

I'm collecting everything in my archive that has to do with Mayakovsky. I gave five portraits to the Mayakovsky Museum.

I have so much material on Mayakovsky, it's a whole collection. I absolutely must start writing memoirs.

I'm already history and I still haven't done what I should.

I need to paint paintings.

Mayakovsky archive.

Photo archive of the civil war.

Small cinema archive.

Photo archive of Soviet photography.

My literary archive.

April 5, 1939

The Mayakovsky Museum proposed writing a memoir about Mayakovsky. The hardest thing is how to write. . . . Sit and reminisce. . . . It's boring, everyone writes that way.

I decided that I should write by days in the form of a diary.

Need to print photos for the museum.

May 2, 1939

What a marvelous person van Gogh was, I'm reading his letters. Makes you want to burn, write, and love the same way.

And how boring is the art of Blanter, Lebedev-Kumach, Gerasimov, Litvishko, Kravchenko, et al. Have to print all the photos of Mayakovsky, then all the contact prints from the negatives.

Varvara paints great studies but she's lazy, too.

And designing books has become completely uninteresting. The last album for the American exhibition was printed without the names of the editor, writer, artists, or photographers. . . . What is this? What pleasure is there in working?

You lie there and interesting thoughts pop into your head, and as soon as you sit down in front of this blank piece of paper it's cold and empty, like the heart, which is tired and worn out with hopeless dreams, broken hopes, discredited ideas, obliterated work. . . .

It's hard to switch from painting to writing.

Painting demands all one's time.

Painting demands your entire life, entire head, eyes, and hands. Then something will come out of it.

May 15, 1939

The work on the memoir is going along, though slowly—since May 2nd forty pages have been written. I think there will be another twenty, even more interesting. And then I'll retype it on the typewriter and put it in order, and then rework it after reading it.

No money and no work, but my mood has lifted.

May 17, 1939

I really like the writing and already have a ton of plans. After the memoirs it would also be good to write:

From the 8th FLOOR.

Everything that I've seen through my binoculars and know about this building over the course of fifteen years.

CHANTANT.

Everything that I knew in childhood about [cafés-] chantants.

May 25, 1939

Forty-eight pages written, it's still moving along.

I'm reading Proust, Swift, Cervantes.

Last night I dreamed about Zhenia, she was completely real, just as though she'd come to visit. . . . I was so happy. . . .

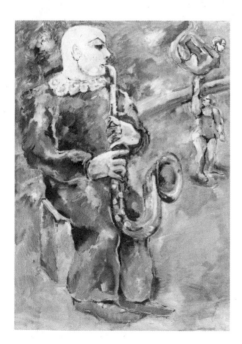

Rodchenko. *Clown with Saxophone.* 1938. Oil on canvas, 39⅜ × 31¹¹/₁₆" (100 × 80.5 cm)

May 28, 1939

I'm writing memoirs, or, as I call them: "Working with Mayakovsky." I've already written sixty pages.

Then I have to print the illustrations.

And then retype the text on the typewriter.

I also need to copy out other people's material, the letters from Paris, "Lef or Bluff," etc.

Osia says that we [Lef] ran ahead, the rest of them are walking and we arrived on a train. . . .

June 3, 1939

I finished Mayakovsky yesterday. I began rewriting and fixing it up. It's very slow, two months went into this work. Of course they might not publish it now, but if not now then it'll get published later.

September 12, 1939

The heat is over, it's raining.

There's a war between Germany and Poland, England and France.

Again, they're writing about formalism. . . .

Everything's the same. . . .

1940

January 12, 1940

I'm sitting in the laboratory, where I also sleep. It's warmer here. In the studio it's plus eight degrees, on the street it's minus thirty. We're fighting with the Finns. Oil has disappeared, you have to get in line at five in the morning.

For the second day we almost didn't manage to get bread.

My blood pressure is high, I'm taking hypersalts.

Groceries are disappearing, there is no cabbage or potatoes.

I'll go to the doctor so I'll be healthy by summer and can work a little on painting and photography.

And somehow, unnoticeably but steadily, more and more countries are being drawn into war. Is this the last war? Or the first?

I used to think that the commercial vein was only necessary under capitalism, but it turns out you need adeptness under socialism as well. And I don't have it and never did.

I'm grumpy, not because I'm deprived of creature comforts but because I'm against comforts.

Too many creature comforts gets in the way of working, just as not having any does.

Personal freedom—that is the most valuable thing.

You can always find some cause to suffer for, and least of all in one's own name or that of one's independence.

The birds sing. That's not thematic. . . .

It's not in the name of earthly blessings, it's in the name of their personal life.

And how I like it.

That means it's possible to allow singing in one's own name, and this becomes necessary to everyone.

A cow is milked and she doesn't try out what is made from her milk. It's a huge enslavement.

Thousands of things and ideas surround us. And then you go out in nature, to the river, to the forest, and it becomes clear that you don't need anything, that this is all lies and caprice, and then the city and all the smart faces seem terrifying to you.

We all keep sitting in our rooms/cells in the city, and we won't get out. We'll be taken out in a shoddy little coffin pasted with paper, and we'll be stupidly and solemnly burned in the crematorium. . . .

It's the great achievement of humanity, the theatrical crematorium. And in the garden, birds, who do not possess a single object, will sing.

Nightingales and the crematorium. This is terribly convincing, even for Mr. Genius himself.

Nightingales in an iron helmet, nightingales in a fighter plane, nightingales in a tuxedo, medal-bearing nightingales. . . . Nightingales. . . .

January 13, 1940

Mayakovsky lived, did something necessary. He managed to push through every book with his forehead and strength, and he was criticized all the time. And now? The best poet of the Soviet era. And Khlebnikov will never be recognized. Gloomy thoughts keep coming through, I don't feel like writing. . . . I feel like painting portraits on little pieces of cardboard, 24 × 30 cm.

I printed the photos of Mayakovsky, Aseev. And why?

"Iodine—is a hypersalt used for treating arteriosclerosis". . . .

After taking a dose the tongue and lower lip become alien and foul-tasting. . . . But the heart beats more distinctly and throbs more in the head.

January 15, 1940

Thirty-eight below zero. How are things on the front with the Finns? Probably a lot of our guys have frozen. The Finns are well dressed and armed, England and America are helping them.

[*Note*]

"Hamster, I've gone to Yakimanka St., Prigozhin came by, they put together the contract. Zhorzh knocked, I didn't open, it's too bad, I didn't know it was him. Kisses. Varvara."

"I went for dinner at two o'clock. Until two I stood in line in the grocery store. Anti"

June 3, 1940

I most definitely still exist.

I suddenly feel like writing because I really do need to write my memoirs in the diary. . . .

September 1, 1940

Russian painting was always literary: the Wanderers, World of Art, Suprematism, and AKhRR.

Deineka—is an illustrator and poster designer.

There are no exhibitions. No artists.

But now, art—is a teacher, it's all about teaching, teaching and propaganda. . . .

The war swallows everything. . . .

If I had known all this earlier, I would have become an airplane constructor. I think that I've lived my life fairly pointlessly and without much calculation, and approaching old age I've turned out to be an eccentric, not needed by anyone and not interesting to anyone.

I don't expect anything, I hope for nothing.

September 1940

I quit smoking.

NOTES

1. Boris Vsevolodovich Ignatovich (1899–1976), photojournalist.

[2.] *SSSR na stroike* (*USSR in Construction*) was published from 1930 to 1941. Issues were also published in English and German. The issue on the White Sea Canal project mentioned here was no. 12, 1933.

3. Rodchenko is parodying the beginning of Mayakovsky's poem *To Sergei Esenin* (who committed suicide in 1925)—"You've gone off, as they say, to another world. . . ."

 VOKS: Vsesoiuznoe obshchestvo kul'turnykh sviazei s zagranitsei (All-Union Society for Cultural Relations) had a photography section, which Rodchenko belonged to. The photo section chose works by photographers for foreign exhibitions.

 Most likely, the reference here is to the October Association, whose interior equipment section Rodchenko had recently joined. In the summer of 1930, the October Association held its first exhibition in the Park of Culture and Leisure (known as Gorky Park since 1932), where Rodchenko and Stepanova exhibited their design work: printing, textiles, furniture, and theatrical design; Rodchenko also showed photographs. Later he established a photo section within the association; it subsequently became the basis for the independent photo group also called "October"—a photographic association of "left" photojournalists.

4. Rodchenko and the director Leon Letkar traveled to shoot the film *Chemical Treatment of the Forest* (*Khimizatsiia lesa*). The filming took place in the area around the lumber plant in Vakhtan, which is located in the Kostroma Oblast, in a sparsely populated forested area over 100 miles northeast of Nizhny Novgorod. Rodchenko also shot his famous photo series Laying the Rails at this time.

5. On this filming expedition, Rodchenko brought a Leica and portable Sept film camera. As it turned out, the lens of the main movie camera was defective, and filming was done entirely with the Sept.

6. The reference is to Viktor Vesnin's design for the rosin-turpentine plant built in Vakhtan in 1922–1924.

[7.] One *verst* equals 1.067 km, or .6629 miles; 200 *versts* is about 132.5 miles.

8. The reference is to a brand of moving-picture film called "Pankino."

[9.] Ivan Ivanovich Shishkin (1832–1898), painter. Shishkin's famous and very popular painting *Morning in the Pine Forest* (1889) depicts four bear cubs climbing on fallen tree trunks in a dense forest.

10. Rodchenko was returning to Moscow from the film expedition in Vakhtan.

11. The reference here is to Mikhail Kaufman's film *Spring*, 1928, about spring in Moscow. A sketch for a poster for the movie is in the A. Rodchenko and V. Stepanova archive.

12. Soiuzfoto: A film studio Rodchenko most likely visited. At this time he was involved in shooting and editing the film *Chemical Treatment of the Forest*.

13. Elizaveta Aleksandrovna Ignatovich (1903–1983), photojournalist, wife of the well-known photographer Boris Ignatovich.

 Nikolai Vasilevich Ilin (1894–1954), artist.

14. In February 1933, on assignment from the publishing house Izogiz, Rodchenko left for Karelia to photograph the construction of the White Sea Canal. He traveled there three times—the last time that summer to photograph specific finished areas of the canals and the steamboats in the locks.

15. Aleksandr Lemberg, a news chronicle cameraman, was also supposed to shoot the construction of the canal.

16. Rodchenko developed the film and printed contact sheets there. These contacts were then sent to the NKVD, predecessor of the KGB, for permission to publish.

17. Evgenia Lemberg, daughter of the cameraman Aleksandr Lemberg [Shura]. Rodchenko had given Aleksandr letters addressed to Stepanova the day before, since he was going to Moscow for a short visit.

18. On July 14, 1933, Rodchenko's mother had a stroke and fell into a coma. She died on July 18.

[19.] "Zhenia," like "Zhenka," is a diminutive of either "Evgenia" (fem.) or "Evgeny" (masc.).

[20.] "Lizaveta," "Liza," and "Lizanka" are all diminutives of "Elizaveta."

21. In the summer of 1934, Rodchenko signed a contract with the Kramatorsky machine-building plant to produce a photo album about it. However, his Leica camera turned out to be broken and virtually the entire shoot was unsuccessful. Later, the contract was dissolved.

[22.] Lazar Moiseevich Kaganovich (1893–1991), member of the Central Committee of the Communist Party (1924–57) and the politburo (1939–57); close to Stalin, Kaganovich played an active role in the mass arrests of the 1930s. He oversaw the construction of the Moscow metro and other large projects.

[23.] The Russian title of this essay is "Perestroika khudozhnika." It was published in *Sovetskoe foto*, no. 5–6, 1936. The essay is based on a discussion that was held following the opening of the exhibition *Masters of Soviet Photo Art*, in February 1935. Rodchenko and other exhibiting photographers were required to publicly confess and denounce their formalist "sins." "Socialist Realism" had been declared state policy in literature following the Writers' Union congress in 1934, and all the arts had to declare their allegiance to the new Soviet "aesthetic."

[24.] TsAGI: Tsentral'nyi aerogidrodinamicheskii institut (Central Aerohydrodynamic Institute).

25. Photojournalists Eleazar Mikhailovich Langman (1895–1940), Dmitry Georgievich Debabov (1901–1949), and Mikhail Grigorevich Prekhner (1911–1941).

26. Rodchenko is referring to a small photography section at the exhibition of the October Association in the Park of Culture and Leisure, in which he and photojournalist Vladimir Griuntal exhibited.

27. Vladimir Teoboldovich Griuntal (1899–1966), reporter and photo artist.

28. Abram Petrovich Shterenberg (1894–1979), portrait photographer and photojournalist.
 Leonid Smirnov, photojournalist.
 Boris Pavlovich Kudoiarov (1898–1974), photojournalist.

29. Maks Vladimirovich Alpert (1899–1980), photojournalist.

30. Olga Vsevolodovna Ignatovich (1901–n.d.), photojournalist, sister of the reporter Boris Ignatovich and sister-in-law of Elizaveta Ignatovich.

31. Yury Petrovich Eremin (1881–1948), photo artist and photojournalist.

32. Georgy Grigorevich Petrusov (1903–1971), photojournalist.

33. Ivan Mikhailovich Shagin (1904–1982), photojournalist.

34. Anatoly Vasilevich Skurikhin (1900–n.d.), photojournalist.

[35.] *Sdelalsia "inturistom,"* i.e., "became a 'foreign tourist,'" as in "Intourist," the name of the Soviet travel agency for tourists visiting the USSR.

36. Mark Borisovich Markov-Grinberg (1907–2004), photojournalist.

[37.] *Shurka butaforskii*: Shurka is a nickname for "Alexander," and "butaforskii" means "propman's"—i.e., referring to Rodchenko's father's work.

38. This diary is a small but thick gray cloth notebook. There are significant gaps between entries, and dates occasionally jump around. This volume reproduces the order of entries according to the original.

39. Rodchenko is referring to a quarrel he had with Evgenia Lemberg, whom he taught to photograph.

[40.] Paola Fritsevna Freberg, editor.
 Politizdat: State Political Publishing House.

[41.] Fyodor Vasilevich Gladkov (1883–1958), an iconic Soviet writer, famous for his novels about the renewal of industry after the Revolution and civil war (*Cement*, 1925) and socialist construction (*Energy*, 1932–38).

42. A technique of artistic photography whereby a photographic image is transferred to textured paper with the help of oil paints.

43. Rodchenko had updated his photographic equipment: he had bought a telephoto lens, and was waiting to get two wide-angle lenses with a focal length of 28mm and 30mm.

44. In the summer of 1934, Evgenia Lemberg was killed in a railroad accident. Rodchenko was supposed to have traveled with her but at the last moment he put off his departure by one day.

[45.] Sevmorputi: the publishing house North Sea Passages.

46. Tatiana and Mikhail Sergeevich Maliutin, the family that lived in the apartment opposite Rodchenko and Stepanova's.

[47.] Vasily Nikolaevich Baksheev (1862–1958), member of the Wanderers, exhibited with the World of Art, after the Revolution became a member of AKhRR and painted landscapes and works on the Revolution.
 Apollinary Mikhailovich Vasnetsov (1856–1933), one-time member of the Wanderers, known for epic landscapes and historical subjects, i.e., everything is realistic and old-fashioned.

[48.] Nikolai Aleksandrovich Ostrovsky (1902–1936), a writer who composed the classic Socialist Realist novel *How Steel Was Tempered* while blind and bedridden from wounds suffered in civil war. He died before finishing *Born of the Storm*, a novel about civil war in the Ukraine.

[49.] Yan Borisovich Gamarnik (1894–1937), high-ranking Party and military functionary; from 1927 on, member of the Central Committee of the Communist Party; named army commissar of the first rank in 1935. In 1937, as the Party and army purges intensified, Gamarnik committed suicide.
 Kliment Efimovich Voroshilov (1881–1969), military commander and marshal of the USSR from 1935 on. As one of Stalin's "inner circle," Voroshilov was a member of the politburo from 1926 to 1960. He was actively involved in the mass arrests and purges during the 1930s.

50. In 1935 Rodchenko returned to painting. He began a huge series of graphics and paintings on the theme of the circus.

[51.] The word translated as "man" here is the Russian *chelovek*, which is the masculine gender but can refer either to men or women in the singular.

52. Sergei Tretyakov was arrested and died in the camps in 1937.

53. Rodchenko is probably referring to the table of contents of his stories about "King Leander of the Flames," reproduced in Chapter One of this volume.

[54.] Meyerhold was arrested in 1939; he was executed in 1940.

[55.] All temperatures in the book are given in the original centigrade.

[56.] Under the Soviet system, all the works in a public exhibition had to be approved by a *khudsovet*, or artistic council, which effectively served as an ideological watchdog and censor.

57. Professor Boris Shvetsov and his wife, friends of Rodchenko and Stepanova's, lived in the dacha "village" of Sokol, in Moscow.

[58.] The All-Union Agricultural Exhibition (VsKhv) was originally announced in Feburary 1935; it was inaugurated in August 1939. A showcase for the development of Soviet "socialist agriculture" built on several hundred acres of land in northern Moscow, it featured dozens of pavilions on agriculture and the republics of the USSR. Most of the prominent Socialist Realist artists and architects of the period worked on it. Likewise, almost all of the photographers Rodchenko mentions earlier photographed agricultural and village life for exhibits and displays. Rodchenko himself, according to Alexander Lavrentiev, did not work for the exhibition because it paid too little. He and Stepanova did, however, design a 1940 book, *Sovkhoz* (State farm) related to the exhibition; they also devoted a special issue of *SSSR na stroike* to it. Furthermore, Rodchenko's influence was visible throughout the exhibit—from the photomontage and unusual photographic angles in the pavilion displays to the early guide books for VsKhv.

[59.] Shock-worker (*Stakhanovka*): The Stakhanovite movement was named after the industrious "shock-worker" Aleksei Stakhanov. The Stakhanovite campaign to boost industrial production was launched in the 1930s, at about the same time as Rodchenko "confessed" his artistic "sins" in "Reconstructing the Artist." (See p. 297 of this volume.)

[60.] A long poem by Alexander Pushkin.

[61.] Vadim Vladimirovich Kovrigin (1901–1962), photojournalist.

Mikhail Mikhailovich Cheremnykh (1890–1962), painter, set designer, and graphic artist; originator of the windows for the Russian Telegraph Agency (ROSTA), which Mayakovsky also later designed.

[62.] Vasily (Vladimir) Vasilevich Perepletchikov (1863–1918), Moscow painter who exhibited for a time with the World of Art group.

Mikhail Vasilevich Nesterov (1862–1942), painter, exhibited with the Wanderers, painted icons; also active with Abramtsevo artists and the World of Art group. Highly regarded and honored by the Soviet art bureaucracy.

[63.] Isaak Izrailovich Brodsky (1883/4–1939), academic painter, whose works, such as *Lenin in Smolny* (1930), became iconic images of Soviet power.

[64.] The Moscow region periodically suffers from peat fires during long dry spells.

[65.] Vasily Ivanovich Lebedev-Kumach (1898–1949), poet and lyricist. Author of lyrics to many of the most popular Soviet patriotic songs extolling the "Socialist Motherland" and the Party.

CHAPTER FIVE

MY SHIP IS SAILING

1941–1952

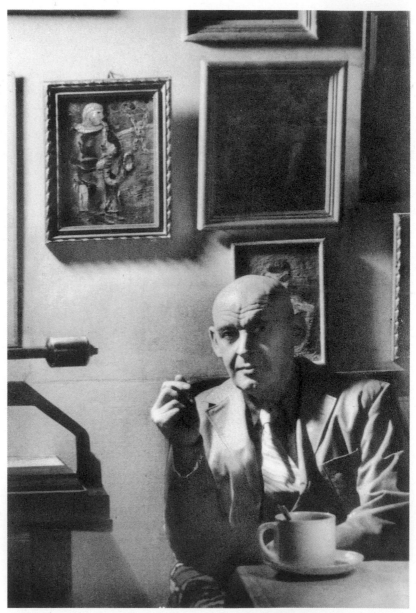

Rodchenko with his painting *Clown with Saxophone*, 1947. Photograph by V. Kovrigin

INTRODUCTION

Rodchenko called his life and home his "ship." His ship sailed past days, events, impressions. His mood changed. The man changed.

The prewar and war periods were two entirely different times, and, accordingly, Rodchenko's concerns were quite different. For this reason we have paused after a line of the diary relating to 1940. . . .

Many of his plans did come to fruition—such as the special issue of the magazine *SSSR na stroike* dedicated to Mayakovsky, and the publication of Rodchenko's memoirs on the poet; before the war there were also books published on Mayakovsky, in which the years of Futurism and LEF were mentioned.

This was a fragile world in which there was urgent business to take care of, achievements to be attained, results, but behind this curtain the next, tragic period of the Great Patriotic War was already ripening.[1]

Who did our protagonist become at this moment?

In previous years he had been an inventor, then a constructor, then a photographer who observed life, which he understood in his own way. He thought about the circus, clowns and acrobats.

During this period he had no external stimulus to paint or do graphic works but he still drew something almost every day—even when the war began and his family was evacuated to Perm Oblast, first to a small village and then to Molotov, as the city of Perm was then called. After returning to Moscow, the last surge of painting began. Judging by the pencil-and-gouache sketches done while in Perm Oblast, Rodchenko began a series of decorative abstract compositions that he called "Streamlined Ornaments." It gave him extraordinary pleasure to be painting again, and, moreover, to be making non-objective works. He continued painting small portraits after the war, as well. These were not specific people but images, moods. All of them seem to be looking inward. And then illness overtook him. . . . The world seemed to contract to the size of his apartment. . . .

There was still his diary, his family. . . . His daughter was growing up and he wanted to share many things with her. While she was still in Molotov he sent her letters with unusual, decorated envelopes. On the last day of the year, December 31st, he wrote out wishes for the coming year on little pieces of paper and gave them to each member of his family. He often glued receipts, telegrams, official letters, etc. in his "ship's log." Life was transformed into waiting. Waiting for everything—first for victory in the war, then for his daughter's return to Moscow . . . for at least a shadow of acknowledgment, an improvement in his health, and then, finally, for death. . . .

<div style="text-align: right">—A. L.</div>

From the Diaries, 1941–1944

1941

Tons of things have been omitted. Because of illness. And then a year later I was evacuated in a sick and gloomy mood.

December 20
A fine affair, the sixth year—and there are only sixty pages written in the diary. Ten pages a year. . . .

Sick, March 23, 1941. Inflammation of the kidneys. . . .

EVACUATION. 1941–1942[2]

October 28, 1941. Ocher, Molotov Oblast[3]
I've grown unaccustomed to philosophy and fantasy, in which I became disillusioned as in science and technology during the period of world war. . . .

And now we are in Ocher, twenty-five kilometers from the railroad, one hundred kilometers from the city of Molotov, where the mud is impassable and the author himself sits in an izba and misses everything, especially tobacco.

There are no photo materials or equipment. Don't know whether the enlarger for photographs will arrive or whether, like Robinson Crusoe, I'll have to make it myself from nothing and with nothing. True, I've already figured out how to do it. Dimka is barking at water in the courtyard. On the other side of the wall, the landlady Nina Andreevna's little girl cries. Varvara isn't here, she's working in the studio of Agitplakat, organized by the artists Levin, [Lev] Zusman, and Fialka (Shterenberg).[4] She works like a slave laborer from ten in the morning until ten at night, stenciling from other people's originals. Today I painted signs, that's what I call the movie ads for the Ocher cinema-barn-theater, where I work on staff as "an artist" and am paid a salary of 200 rubles a month. But on the other hand I have free time and I can read, draw, and write.

And right now Moscow is under siege, and all my paintings remain there. . . . But still, there's no reason to lose heart. We'll build life all over again, stone by stone.

In the end, this has been going on for millennia; they either destroy or build.

In Ocher everyone speaks in the same tone, and the rhythm of speech is identical—they add "to," "te," and "dyk" to all words, placing the stress on the end of the phrase.[5]

I walk around outside in a dirty yellow leather coat, gray wool stockings, and thick ski boots, and elicit surprise everywhere, why, I don't know.

And in Moscow I so hated wearing something that made me stand out.

. . . The task at hand is two-part: to begin writing memoirs without thinking about it and to write what is going on now. I don't know whether it will work or not, but something will come of it if I am careful to write every day. Varvara is supposed to speak on the phone today with Elizaveta Ignatovich, who traveled to Moscow with Mikulin.

In Ocher, as in other rural towns in the USSR, people work a great deal in both the household and their gardens, and they do almost everything themselves. My landlord, Afanasy Alekseevich Kochergin, also works two shifts as a stoker at the factory, and is studying for his high school diploma. And at home, when there's a job to be done, he either repairs the roof or the stove, or pulls up firewood from the river. Potato flour for the winter has to be prepared in the fall. The grandmother sits and spins thread "backward" from cotton, and knits sweaters, mittens, and skirts from it. War. . . .

Here they smoke homegrown tobacco. They drink mead. . . .

There are three things here from contemporary Europe: movies, radio, and the newspaper.

The movie-barn shows old worn-out films from twenty years ago, like *Golden Mountains*. There's a newspaper but it's for the raion communal farms, and you don't see it here.

Everyone has radio, like an eternal talking machine, they leave the radio on day and night—[because] "the money's already been paid."

They don't open the vents or windows here, "the wood breathes" they say.[6] It's hot, stuffy—they heat a lot—"steam won't break bones." If you open the windows—flies and dust fly in. And such a quantity of flies that there's a buzz in the air. . . .

Here, everything's a problem. But the radio and movies bring a thin line of culture and art here. There's forest and fields all around. . . .

It's a shame I chose to be an artist, such a passive profession. I should have been an inventor. . . .

October 29, 1941

We traveled in a cattle car for eight days, and now we've been home—fourteen days.

The landlords are cutting cabbage today, putting it in barrels and "pressing" it with stones. And I too want to have land, a garden, my own cabbage, potatoes, carrots, cucumbers, turnips, onions, my own preserves. And [to have] lived in peace and quiet all [these] twenty-four years. . . .

We strove to get to the city, to study. . . .

It's interesting that art and I have always had to wait for something, it was never "the right time," either I was waiting until the war ended (the [first] world war), or building was underway. . . . And in Moscow, everything for which I've lived for fifty years could perish. And will anyone other than me feel sorry about it?

The artist Cheremnykh arrived in Ocher. He has this idea to put the artists where we'd be needed, where we could serve Ocher.

Yesterday I hung posters at the [raion] Executive Committee. Varvara made 150 rubles.

Arriving evacuees are being sent to the communal farms because there are no free rooms in town.

November 2, 1941. Ocher
The October holiday will be here soon, November 7th, and so there's a lot to be done.[7] Letters take twelve days.

Moscow is under siege.

Here they're getting ready for the holiday, and I'm busy designing the community soviet and "Red Square." Everything's disappeared from the stores. Matches have disappeared. There's nothing in the pharmacy, either. No soda, castor oil, Vaseline (valerian drops and stomach drops have been drunk up as alcohol). Ink and pencils are still available for the moment. No paper. But none of this matters. Is it for long?

And I keep waiting for everything from Moscow, and nothing arrives, and it seems that I'm waiting in vain.

Varvara bought powder for 60 kop. And lipstick for 1 r. 20 kop. We baked black bread and it seems tastier than Moscow rolls.

November 10, 1941. Ocher
It's very difficult to earn money, 200 r. at the movie house and 100 r. at the newspaper, and we still have to send 100 r. to Moscow for the apartment.[8] We've really got ourselves in a mess with this evacuation.

November 10, 1941. Ocher
In the mornings it's still dark, completely nighttime, but the landlady, Nina Andreevna, is already banging around, carrying firewood, water, stoking the stove, and scolding the deaf grandmother. It isn't even six. She's curious to know what we buy, what we eat, nothing else interests her. But all in all she's kind and gives us treats. Yesterday we bathed in the bathhouse, my head was hot but my feet were in the cold. I'm writing by lamplight. Varvara is making dinner and I'm baking bread for two days. Cheremnykh worked for free— didn't get any money; he's dying to make some money and go to Siberia, to Shlepianov's theater.[9] . . .

Cheremnykh asked why I don't cut linoleum for the newspaper. There are marvelous landscapes right in front of my eyes but you can't paint them, and anyway there's no paint. . . .

November 16, 1941. Ocher
Yesterday I came down with something and spent the whole day lying down. At the editorial office they suddenly commissioned a poster on the "Collect Money for the Tank Column!" campaign. After Cheremnykh's poster I can do one too.

And in the end, why be down in the dumps, the war will end and one will be able to live anywhere. Would it be so bad to have an izba here and keep a garden and animals. And then you could paint marvelous things. It wouldn't be so bad in old age, and even better than sitting in stuffy Moscow.

November 20, 1941. Ocher

Today they called me in again to design the Party office. I said that I'd be happy to do everything but that I had a request—to help me buy tobacco, flour, and potatoes. They replied that they would discuss it. . . . I said: "You go on and discuss it or else I don't know how to help you." I think there has been enough working for free. In the cafeteria I ate meatless soup, now they don't even give you horse sausage.

There is nothing in the stores. Zdorove [health] brand coffee has disappeared. Each day brings sad news. . . . I can't believe that Germany could trick everyone so well and walk all over the whole world so victoriously, all the way to America, so that even the existence of our government is in question.

November 21, 1941. Ocher

Today they opened barter trade. We traded one and a half meters of cloth and four meters of sateen. And Mulia's sweater for a *pood* of potatoes, a kilo of oil, a kilo of meat, two cups of honey, and two cups of Makhorka tobacco.[10] Otherwise you can't buy anything. And we have nothing else to barter.

I'm doing a poster: "We Will Create a Tank Column!" What a strange mood I'm in. . . . Today I waited in line for four hours at a cold counter in a terrible freeze for flour, because what if tomorrow they suddenly won't hand out any more flour. . . .

Right now I have nothing, no paintings, no books, no things, but if there's bread I'll survive, and everything will reappear again.

The Fascists are occupying towns, people are dying. . . .

Eleven at night. Mulia's asleep. The bread is on the stove, it's rising. There's dough for three days. It's warm. On the table there's a drawing of the poster, Makhorka, and it's freezing outside. On the other side of the wall the landlady is talking with the deaf grandmother, the landlady's little daughter is sick, so no one's asleep.

There are battles along the whole front. The Germans are close to Moscow. . . .

November 22, 1941. Ocher

There's nothing from Moscow today either. . . . Not a peep.[11]

And so, tomorrow, fifty years and my birthday. This will be a dismal celebration for all my fifty years.

Sweet Varvara, she's trying with all her might to make it joyful for me, she's saved flour, is making a pie. She remains the same little woman, in love with me, who for twenty-six years has tried to make a real celebration for my birthday. It is very moving. And especially now, in these conditions, when we're in the backwoods of the Urals, cut off from everything, and it's fifty degrees below zero.

I'm ashamed to be complaining. . . .

Tomorrow I'll take the poster in. Tomorrow I'll also be waiting for something from Moscow. But the day after, I won't. To hell with that parcel. But how one does still want to receive something on one's birthday. . . .

Everything has vanished into an unknown past. Moscow, the apartment, books, drawings, the laboratory. . . . Everything's like a dream. Did it really exist? Or is it a dream now. Which is the dream?

I've buried people in my life. My father, mother, women I loved, painting, and now everything at once, together with Moscow.

Twenty-five years ago, or maybe it was thirty, I spent New Year's Eve at Tamara Popova's. There were a fair number of people, Tamara, her sister Valia, their uncle, her mother and I, and Khansaev, another student from our art school, an Ossetian. It was terribly jolly, we drank, I don't remember what else. Then I had my fortune told. I was frightfully in love with Tamara and therefore sad, since I wasn't able to show it to her in any way. The mood was decidedly gloomy. Then everything turned out differently. Much later it came out that Tamara loved me and that I had been suffering completely in vain at the time.

If only it would turn out just like that, that we suffered in vain in Ocher.

November 23, 1941. Ocher
And so, fifty years. My birthday.

The settlement of Ocher, Molotov Oblast, 1,500 km from Moscow.

It was a celebration after all. Maybe the first here, and maybe the only one. Varvara baked a pie with meat and rice (the rice is from Moscow, it smells of mothballs—but that doesn't matter).

In the morning there was real coffee with milk and sugar. Real honey and real tobacco. She is terribly pleased that everything succeeded, and I doubly so. In the morning I hung the poster. . . . It came out "not very," but I hope that the next one will be bolder, I'll do it in the style of Gropius. Our artists are complaining that they're starving, they're getting ready to go to the collective farm but they're afraid of typhus. I have the impression that all these difficulties are just temporary, that everything will still work out, as will aid from the Allies. And if I grumble it's because of my heart. Varvara is sleeping. Mulia's at the movies. Lizaveta (Ignatovich) sent a telegram with congratulations, but that's Varvara's doing, she reminded her of course. But I'm pretending quite theatrically so she isn't hurt. Tomorrow I have to paint "signs."

I buy old leaves of homegrown tobacco from a young fellow here, soak them in honey, let them ferment in the stove—then I dry them and I end up with smokes. All the surrogate coffee has been bought up at the stores, the pharmacy is completely empty. At the market—there's nothing. Cheremnykh and Shlepianov are headed for Barnaul.

November 25, 1941. Ocher
I'm still waiting for [something from] Moscow. But they're not even writing, what's going on there? Skurikhin promised to send for us and disappeared, his wife, too, not a word from them by letter.

I'm mechanizing the painting of signs, I end up having to paint in the cold.

November 26, 1941. Ocher
There's nothing [from Moscow]. . . . Moscow's in danger. The Fascists are attacking. . . . How will the dear old girl hold out?

November 30, 1941. Ocher

From Moscow, instead of a parcel we got a telegram: "Can't find originals, Mayakovsky on ads, immediately telegraph location. Ezerskaia" (the director of the V. Mayakovsky Museum).[12]

But the originals are here, with us.

No one asks for our location without warm clothes.

We went to the secretary of the Party committee, he promised us 15 kg of potatoes apiece and workers' ration cards.

December 3, 1941. Ocher

Good news on the front. Our guys took Rostov. There are a lot of trophies. . . . We actually did manage to get three buckets of potatoes. That was by order of the secretary. It's cold. . . . Boring. . . . The situation is such that you can't go anywhere. . . .

December 24, 1941. Ocher

There's no kerosene.

A letter from Zhorzh Petrusov in Moscow saying that they're not accepting packages.

I'm painting signs. I do a poster for the newspaper once a week.

They're driving the Germans away from Moscow.

December 30, 1941. Ocher

And so, the new year.

We received a telegram from Ezerskaia, "Sent things two parcels with traveler to Molotov, to E. Ignatovich, go pick them up." That's the first good news.

January 2, 1942. Ocher

With the new year, our life also changed for the better. We bought twenty pounds of flour, they gave out 100 gr of sugar. The package arrived in Molotov, things are a bit happier.

We spent New Year's with Dmitry Danilovich Okulov, the secretary of the editorial offices of *Stalinsky udarnik* [Stalinist shock-worker]. For the celebration there were boiled potatoes with pickles but without butter, coffee without milk but with sugar, and cabbage pie.

We gave them [the Okulovs] a lampshade of our own making, and cards, also of our own making, and played [the card game] preference. Mulia spent New Year's at school. The Red Army is attacking.

The mood of all the evacuees has improved. I'm waiting. . . . Maybe there's tobacco in the parcels. . . .

January 7, 1942. Ocher

Yesterday Varvara left for Molotov to obtain permission to go to Moscow, or at least to [move to] Molotov, and to pick up the parcels. We're eating bread and soup but they've increased the bread and now there's enough: 800 + 800 + 400 = 2 kilos.[13] We wrote letters to [Nikolai Mikhailovich] Gorchakov and Ezerskaia in Moscow—maybe there is still some kind of hope.

January 9, 1942. Ocher

Varvara telephoned from Molotov saying that Ezerskaia had sent a marvelous letter and everything we needed. She wrote that the apartment would be in good shape and that commandant Perov was guarding it, since he had developed a great respect for us. Lizaveta and Kirill want to come to us, they will bring tobacco. And meanwhile we're eating dried bread crusts and "to your health" coffee. We need to go to Moscow one at a time, I don't know who should go. My head aches. The air in the room is stuffy. It's hot and steamy. Smells like medicine. It's the grandmother's medicine. She's taking treatments. Mulka is asleep.

Do poster tomorrow.

January 12, 1942. Ocher

Insulting and unpleasant things, an order from Vereshchagin ordering me to do the job of ticket taker from six to twelve, given that I have too much free time. I refused, I don't know what will happen. An artist or a doorman, it's all the same to them. Okulov went into the army, he was the only person I could talk to. Mulka and I are alone. Varvara hasn't called and hasn't come back.

I went to the editorial offices. Varvara called. There's work in Molotov, at the Literary Museum, putting on an exhibition of Mayakovsky. And thanks to this work we can get a residence permit to live in Molotov. I'm dreaming of the city, I want to leave this place, see streets, streetlights, stores, and so on.

It's wet and raw in the room. Flakes of wet snow are falling outside. I want to run away from here. I'm sick of Ocher's women, who ogle you all the time like a bunch of stuffed animals.

Mulia can't study, someone's always talking loudly, and the radio's booming.

January 15, 1942. Ocher

Varvara called. Valia Tiunova (the editor) is angry, she doesn't like these conversations from the office about leaving. She's waiting for Varvara to come back and work in the office (as secretary, instead of Okulov). She locked the door to the office and told the messenger lady that we should call from below, from the printers. There you have it, as soon as you start working in an editorial office they won't let you go of your own will.

January 17, 1942. Ocher

Varvara called and said, "Prepare for new adversity—I found a room, a man lives there, he works the night shift, there's no firewood," and so on.

Lyonia Zusman went into the army and Levin is the brigade leader again. He arrived from Molotov and informed us that everyone will do stencils, appear on time, and sign in and out when arriving and leaving. He will be the brigade leader and the brigade. I'd rather it be bad in Molotov than good in Ocher.

January 18, 1942. Ocher

Varvara was planning to call and I spent the whole evening in the office.

It's forty-eight degrees below zero.

Levin demands that I stencil from morning till night.

There's no kerosene and there won't be any, and in the long evenings you need to sleep and sleep.

Varvara's looking for a room and can't find one. She's been wandering the streets of Molotov for almost a month in this frightful cold. The warm clothes are in Molotov.

January 20, 1942. Ocher

Fifty degrees below zero. I'm going to the office. Maybe Varvara will call. I'm waiting, waiting. . . .

I barely made it to the office, I was so frozen that I spent two hours warming up next to a hot stove, especially my feet, even though my feet were in felt boots and the rest of me was in a fall coat.

January 22, 1942. Ocher

It has now reached sixty degrees below zero. How is Varvara doing there? Won't she completely freeze to death? She keeps walking and looking. . . . We're eating up the last of the potatoes. I'll stop writing till better times. . . .

March 3, 1942. Molotov, Kazansky trakt, 94

A month and a half has passed since we started everything from scratch again. We moved to Molotov, and the main reason was that there was nowhere to paint. Varvara sent for us, and on a freezing sunny day Mulia and I loaded up our things with the help of the vice-chair and the secretary of the Party organization. They took us on a sled to the road. There we loaded them onto a caterpillar tractor that had a sled hooked on, with a little hut and a [mobile] post office, and traveled 25 km to Vereshchagino. Varvara met us there—we almost didn't find her—and that night we loaded ourselves onto the train. We arrived in Molotov the very same night. We put our things in a checkroom and went off somewhere in the dark. We walked and walked and arrived at a pass-through room in a railroad flat and lay down on the floor to sleep.

In the morning I discovered that the place is 7 km from the city, a railroad flat, windowless, dirty, and full of people. The landlords are Stepan Prokopich, his wife Elizaveta Alekseevna, and their five-year-old son, Boris, who constantly runs through our room into the kitchen.

Seven kilometers to the city, and we walk there every day and are trying once again to get ration cards, meals, and so on.

March 15, 1942. Molotov

Can't unpack anything because we're in a railroad room and we eat furtively. The light is from an oil lamp. Mulia's in ninth grade in school. The line to get into the bathhouse is 3 km long.

Bread 800 gr + 800 gr + 400 gr. Cafeteria. We sold the Chinese robe for 800 rubles. We've got money, but the room—awful! The neighbor—is a nasty old lady.

To the Executive Committee of the Ocher Raisoviet.

The State Literary Museum requests your cooperation (provision of horses, etc.) in moving com. V. F. Stepanova and A. M. Rodchenko and family to the oblast city of Molotov, to their location of employment.

Grinshtein

January 17, 1942

March 23, 1942. Molotov

I'm lying down. . . . These days I have to do more lying down. There's no window. . . . No table. . . . It's dark during the day and dark at night. . . . All you can do is lie there and think what to do next.

For two months it has been impossible to do anything. Even draw and read. . . .

We bartered my suit for flour and five kilos of meat. We're looking for a room. The cold is fierce. The toilet is in the courtyard. . . .

April 26, 1942. Molotov

There have been changes in our life since the last time [I wrote]. Lizaveta Ignatovich and Kirill left, and left us their room. The room is in the center of Molotov—in a stone building, the third floor, with a window but without a stove, and with terrible landlords.[14]

I'm working at the newspaper *Stalinskaia putevka* [Stalinist travel] (of the Perm railway company).

Identity Card

The bearer of this card, com. Rodchenko, A. M., is a freelance photo correspondent for the transportation newspaper *Stalinskaia putevka*. We request that all transportation organizations cooperate with com. Rodchenko in his work.

Valid until December 1, 1942.

Man[aging] Editor of the newspaper.

M. Gurevich

They gave me a table and chairs in the office. The cafeteria is "improved" without subtraction of ration stubs.[15] There's a bathhouse nearby. They issued 100 gr of tobacco.

Ice is flowing on the Kama. Sun. It's melting.

We get hot water, furtively, from the hotel across the way.

May 31, 1942. Molotov

I'm working on sketches. The Patriotic War for a creative accounting in Moscow. I had to leave the newspaper, I would have had to go on staff.[16]

July 6, 1942. Molotov

I'm walking along the banks of the Kama.

I showed my old and new sketches, and also Varvara's, to Mosskh.[17]

Well, of course N. N. Serebrennikov, the chairman of Mosskh, and his gang

attacked me and Varvara. Ioganson said nothing for or against [us] and quickly left, but then Obolensky, a Leningrad painting professor, began defending me, and Oreshnikov, a docent of the Leningrad section, and then Moroz and Peisakhovich, and they decided that since I am "the god of photomontage," then that's what they would demand of me.[18] But I announced that for this I needed photo supplies, photo paper, and equipment. They resolved to facilitate [this], going so far as to approve an official trip to Moscow. Well, the upshot is that they tore me away from my sketches and there's nothing to do photomontage with. And I've grown sour again. . . . There's nowhere to go. Once again, I'm waiting in limbo.

August 6, 1942. Molotov
The Fascists are rushing toward the oil. . . .

I go to the arts section, everyone promises a business trip, I'm hoping to get out of here to Moscow, and then, of course, I won't come back.

September 3, 1942. Molotov
I'm traveling to Moscow on a sham business trip for a month to get photo supplies. I'm going and I'll try not to return. . . .

December 23, 1942
Two years' break. A year of life was lost—from August 1941, when we were evacuated to Molotov, until September 1942—but since September 1942, home again. . . .

December 25, 1942
Writers—are scholars and researchers and directors of people. But a writer can simply jot things down, note what's going on, he can recall his life. He can write down stories and combine them.

But I feel lazy when I think about writing things down, so I'm not a writer.

I should just make a "diary hour" at night.

And thus, what has been done:

I went to the cafeteria, brought back two of my dinners (for two days). Varvara went a month without the cafeteria and without ration cards until she got her residency registered. I bring dinner from the House of the Peasant, on Neglinnaia St.

1) Soup—without meat, with sour cream, a piece of soy sausage, and cabbage; 2) Potato purée with a little piece of lard and 400 gr of bread.

Then I prepared two canvases—I'll start painting Varvara's portrait and a self-portrait.

On the front, we are attacking on the Don.

There's no money, the contract for the exhibition *Lithuania* at Informbiuro isn't signed yet.

It's warm in the room from the gas and electricity. In the studio it's plus ten degrees. We live in Mulka's room, it's cozy. I clean up and do the laundry. For supper there was oatmeal, without bread. I want to eat, 600 gr for the two of us. I want sweet tea with bread. . . .

Rodchenko's diary, December 1942.

How to paint a portrait? I don't know, it's just as difficult as writing a diary.

I'm thinking of writing about composition. I need a plan and folders. Write little articles and collect it all there. . . .

December 26, 1942
I'm going through books and negatives.

I'm sneezing—a cold. Two letters from Mulia. She's in Molotov. I'm boiling potatoes and onion with rice and rose hips. That will be dinner. . . . Varvara went to get the ration cards.

Igor Aleksandrovich Nikitin lived in the studio, he ate everything that could possibly be eaten. I'm fifty-two years old. . . .

Varvara has vanished, it's already after seven. . . .

The potatoes are boiling and I'm hungry.

Yes. Tatlin is doing scenery and I'm not.

Tatlin has come out into the open again and I've completely disappeared. Why? I'm the only one to blame.

It's nighttime. . . . I finally understand how to write a diary. . . .

December 27, 1942
Today was lost. We slept till eleven.

During the day Varva and I went to see Zakhar Bykov.[19] We asked for his advice on how to get Mulia here for her studies. At five o'clock we went

to eat dinner: she went to Tverskaia and I went to Neglinnaia. They gave me cabbage soup with a little bit of bacon fat.

Tomorrow we have to get everything on the ration cards and get my card for January. For December, on her card: 400 gr of sugar, 200 of oil, 750 of meat, 400 gr grain, 5 kg potatoes, salt, and tea. And for mine, too. Then we'll have a bite to eat. . . .

Tomorrow we'll get bread for two for two days—1,200 gr white, and 1,200 black. She'll get tobacco as well. My mood is energetic. Zakhar proposed doing a little poster for the twenty-fifth anniversary of the Red Army.

December 28, 1942

Insanely tired, went to get the ration cards but they aren't there yet. Then sat at Informbiuro waiting for money, but the contract isn't signed yet. Then stood in line at the store, got [rations] for two. Received: 200 gr fat, 600 gr rice, 1 kg meat, 750 gr herring, 3 boxes of matches, 400 gr salt, 400 gr chocolate, still have to get 4 kg potatoes.

Didn't have money for all this, and Varvara sold a simple piece of soap at the market for 215 rubles. Tomorrow I'll go to get the cards and take the potatoes. Still have to grab some vodka, they'll give one liter for two. And so the day is gone. . . .

When we get the ration cards for January we have to run and register at the grocery store on Arbat; run to I don't know yet where to the cafeteria; to the bakery on Kirovskaia, and then we can calmly run back and forth to these places.[20] In thirteen days have to go to Mosskh to get new stamps till the end of January, and then everything all over again—these are provision activities during wartime. And when to make art? But it's gradually becoming clear that what's important is that the artist manage to exist.

December 29, 1942

We got the ration cards!

I was in Mosskh, somehow I feel bad among graphic artists and critics who don't recognize you when they run into you, and hardly speak. I'm nothing to them, and that hurts. . . .

That's right, no one knows who I am. Have to do something special. I've retreated too far from everything. They aren't artists, but I'm not a young fellow either. Nighttime . . . three o'clock, can't sleep. A cough is bothering me. I read Hoffmann, empty and boring, and even the diary is like Golgotha. . . .

Everything that was in youth is the same in old age.

And what, wasn't I talented? I've been torn from everything I loved. They tore me away from fantasy, from romanticism, too, and from leftist art, as well. . . .

Where is there to return to? Ahead is night . . . and death. . . .

Mashkovtsev and Pavlov, they beat me down.[21] . . . Yesterday I was walking along the streets on all kinds of errands, and I saw only half of each person, the other half dissolved into a blur. Interesting . . . and realistic.

And this is because I'm sick, I have a cold and heart trouble. My eyes are different, the two images don't coincide, especially if I'm sick or drunk. . . . There's the fantastic for you. I write in the diary when my mood is bad. My ship is sailing through all kinds of swamps. The electric heater is on in the berth, Varvara's sleeping. . . .

The voyage continues, although it's sailing into the unknown because there's no direction. . . .

Sometimes, though not often, my ship sits on the shoals, like in Molotov. But sometimes it also moves somewhere. It runs into the local population on islands, like Lizaveta, Igor [Nikitin], and Lilka Lavinskaia. . . .

We'll celebrate the new year in Mulka's room. I'm the captain, and the crew—is Varvara.

We're sailing to new islands. On one of the islands we left our cabin boy—Mulia. And because of the icy inlets and mountains of ice, we can't get through to her. I'm "handing over the watch" till tomorrow, going to sleep. . . .

I remembered that I should write on one side of the page and glue documents on the other.

December 30, 1942

It would be interesting to collect everything together, the diaries and letters and documents and photographs and photos of works, and make a book of life, year by year. No one has done that. It would turn out like a curious kind of collected works.

We look at things so narrowly, and work narrowly. Thousands of plans remain untapped. It would be good if Mulka could manage to do what her parents didn't have time to. . . .

Varvara left to go for money and to the store. I'm sitting at home, coughing. There's nothing in the stores . . . and insane lines for potatoes. . . .

December 31, 1942

And so the new year is around the corner. I hope that it will not bring what we had in 1942. The torments of evacuation, war, illness. I hope that the new year will bring the victorious end of the war, and many paintings. Let this dismal 1942 leave, and I will believe in the best. I don't like the numbers 0, 2, 6, and 9. And I love 3, 7. I like 4, 5, 8, and 1 all right. I hope that 1943 won't deceive me.

In the small kitchen I hung holiday-tree flags and electric holiday lights.[22] Let the new year of 1943 come to us. May it place its lucky hand on my strange life, and give me a little joy with some new successes in this period of transition to old age. The only sad thing is that my new little Mulka isn't here. She's become a conscious, interesting person, and she and I correspond. She is original, and that has brought us closer. I see a continuation of myself in her. That's why I came to love her as my daughter. She must continue what I haven't done, or haven't finished—she herself, or her children. I hope that we'll be able to get her out of Molotov, where she's in the first year at the Agricultural Institute. I bathed in the kitchen "part by part,"

I managed to finish in time—since they turned off the electricity. But the gas is burning well.

But the diary now lies on the table, waiting to write how the day went; it really is becoming a ship's log, even though the ship is standing still. The sailor or steward Varvara has gone to hunt for money and dinner.

The ship is sailing amid a storm, war, and all sorts of small dangers.

Varvara arrived at six in the evening, she got the ration cards and money. Niura came, we ate and saw the old year out.[23] . . .

On the radio: from the commandant of Moscow: "On the night of the 31st to the 1st of January it is permitted to walk unrestricted around the city of Moscow." Varvara went to send Mulia a telegram.

At midnight we went to Vera Gekht's, drank vodka and coffee.

1943

January 1, 1943
The new year begins. On the front, 2,000 localities have been liberated. A year has passed without friends.

Varvara brought bread for two days. 1,200 gr white and 1,200 gr black. For a whole month we managed on one ration, Varvara is thin as a splinter.

January 2, 1943
I'm thinking of copying the little diary written during evacuation into this one.

Mulia writes: ". . . My head becomes so filled with thoughts that it becomes heavy, and after writing in my diary it feels light and free. . . ."

Went to pay for the gas and apartment.

The portrait of Varva still isn't painted. . . .

January 10, 1943
We're thinking of getting Mulia into the Art Institute, in the graphics section. Maybe they'll issue a travel order so she can take the exams. And I'll teach her how to draw, quickly. She'll probably have some ability. Ioganson gave her a recommendation.

For the third day the light has gone out. . . .

January 19, 1943
It's cold, the gas isn't on. . . . They don't give much electricity, there hasn't been any oil or sugar for a whole month. . . .

But they've broken the blockade of Leningrad, we're attacking along the whole front. . . .

Mulia's in Molotov. . . .

I'm redoing old sketches and don't like anything. But there's no room for new ones. . . .

My hands are freezing, I want to eat and sleep. . . .

January 31, 1943

Difficult days, water has to be carried up to the eighth floor, it's frozen, the gas isn't on even at night. The heat doesn't work. For the moment what's saving us is "left" electricity.[24]

We bought an iron stove for eighty-four rubles. Made a pipe for 250 rub. I sawed up stretchers and tables. There's smoke and soot in the room. Yesterday I went to Cherkizovo on a truck to get firewood, brought back one cubic meter. They delivered it for 2 kg bread.

They sent Mulia a travel summons. Will she know how to get a pass and a ticket? Could it really be that I will be happy and cheery again? Kursk has been taken. And the end is so far off. . . . I've become disillusioned about friends, about the Gekhts, all that's left is Letkar, Tatiana [Maliutina], Niura. . . .

There is smoke and soot on the ship. In the laboratory, water in bottles has frozen. Haven't been to the bathhouse in one and a half months. In the room the "stove" heats, the smoke stings the eyes. Soup is boiling. I "sleep" in clothes and felt boots, we're both coughing, but we're waiting for Mulia, we love her, she's interesting and unusual. . . .

February 12, 1943

I was in Мossкh, each month you have to go personally to get your ration card. The [artists'] union isn't there now but an office—every employee thinks he's doing us a favor by giving us the ration card. . . . Mulia sent a sweet, touching letter, she writes: "Of course, it's more interesting to live with you, but don't talk about all the work being left to me, no, you are going to live, and I'll be with both of you, and all the work will be there too, let them hang there, some day people will understand them. . . ."

It's only now that I've understood that I have "my own daughter."

Art—is serving the people, and the people are led different places by different people. And I want to lead the people to art, not to lead art somewhere. Was I born too early or too late? Art needs to be separated from politics. . . .

February 14, 1943

Spent the whole day fixing the stove so it won't smoke. Managed to do it, after all, sawed firewood.

Need to rearrange the room, it's crowded. Mulia sent a telegram that she passed her exams and is waiting for the documents. . . .

Need money for tobacco, flour, to pay for the telephone, for onions, potatoes, etc.

Our side has taken lots of cities.

But the military says that if a second front isn't opened the war will go on another two or three years. . . .

February 15, 1943

Yesterday on the radio they informed us that beginning on March 1st, students will be given workers' cards. Below us they're complaining about my

chopping wood. . . . We got a telegram from Mulia: "Received registered letter, will take action. . . ."

That means she received the documents. Misha came by, brought 200 gr tobacco, asked for old photo paper.

February 17, 1943
A telegram from Mulia came asking to confirm the summons with the signature of the Director of Educational Institutions, because it wasn't the right signature. So far they haven't given her a pass. . . .

February 18, 1943
Sent Mulia confirmation from the Director of Ed. Institutions and 200 rubles. Now we'll wait to see what happens again. . . .

They cleaned out the gas, now two burners are working. . . .

Drew dancing girls.

February 18, 1943
People have been here all day. Dodin's [David Shulkin's] wife, Marusia, was here. In the evening I found out that Misha Maliutin's brother Vladimir died.

Varva is sick. The stove repairman came by, brought an elbow piece for the pipe.

February 21, 1943
The weather is warm, it's snowing. Heart pains. . . . I want to read Dostoevsky's *Brothers Karamazov*. I'm sick of the grind on the radio. It's muddy out, I want fruit, sun. Everything there isn't. . . .

And there's almost nothing.

There's hammering all around, people are chopping firewood. There's smoke in the stairway, the steps are wet, people have to carry water, I carried it too, that's why I have heart pains. Began the self-portrait.

In one hand a bucket of water, in the other a kettle, Dostoevsky and Balzac tucked inside my shirt. It's dark on the stairs, sixteen flights. . . . I get past the seventh and my heart tries to jump out of my jacket. I put the bucket and kettle down on the windowsill, sit down to rest, the air bursts with noise. I think: Why? What for? What am I guilty of? I don't want power. I want to paint and paint! There's nothing joyful on my ship. Could it be that I'll never create anything? Could it really be that no one will ever know me?

I ask future readers: what is there to live for? What did I and will I live for? No one needs me.

Formalist, Futurist, non-objectivist. . . .

February 22, 1943
Telegram arrived from Mulia: "Need summons from Khrapchenko"—chair of the Committee on Arts Affairs. . . . They wouldn't let Mulia go. Again, everything from scratch. . . .

February 24, 1943

The water suddenly began to work yesterday. Had to wash the floor. . . .
Went to see Babichev: he complains about the cold and hunger. It's eight
below zero.

February 25, 1943

Varvara went to the Main Directorate of Educational Institutions and sent
another summons to Mulia—Kukharkov signed it as the director. Don't know
what will come of this.

Zakhar Bykov proposed a very interesting job, designing a long-distance
aviators' club in Monino.

Now the distribution center is going to give out dry rations instead of
cafeteria [meals], according to the ten-day norm of a workers' card.

We filled in an application for the telephone, tomorrow I'll pay the deposit
at the station and we'll wait for it to be turned on.

I brought dinner and got two portions of tobacco at Mossкh on the
new card, though it's pipe tobacco.

They feed you at the club in Monino, and you can spend the night. Day
after tomorrow I'll leave for Monino.

We're going to have water every day! I've already washed all the clothes
and washed myself, as well.

February 28, 1943

Yesterday I went to get the cards, got the rations at Mossкh. Varva got 500
gr honey and 400 gr fat (lard) at the store for February.

We gave Zakhar two watercolors and two of Varva's sketches.

A lot of business has been taken care of but there's still a lot left. We need
money to pay for the telephone, the apartment.

Mulia is stuck again, apparently until the spring. . . .

Varva went over to [Aleksandr] Bogdanov's to play mah and I'm mop-
ing about at home, for tomorrow morning I have to go to Monino.[25]

We sell bread as we need money, either for tobacco or for food, etc.

The cold has passed, today it's even plus one degree.

March 1, 1943

Yesterday the Kazan art[ist] Chebotarev came by for a recommendation for
Mossкh. Uninteresting and brash. He didn't even look at the walls but
just demanded tobacco and stuffed a huge pipe. What have artists come to!
A hack!

Doesn't respect his own work or others'. No art at all! His head is full
of rations, kitchen gardens, dachas, commissions, tobacco, potatoes, and
so on.

No successes on the front. Battles, battles. . . .

Varvara has a new habit: everything that doesn't work out, she blames
on me. I'm always to blame. . . . I'm frightfully sick of it. . . . Everyone has
become an animal—angry, greedy, and repulsive. Not a single smile. . . .

We registered for the dry rations—for the moment without dinners.

Today the Germans are retreating. . . . We've emancipated 300 popu-
lated localities.

March 3, 1943
Yesterday I went to the club in Monino—45 km from Moscow on the train.
It's the club of the aviation units. It turned out that the club doesn't need
any designing or equipment, they need an exhibition on "The History of
War." And for me to do everything. . . . I ate dinner there and left at eight
o'clock, nearly froze to death. Today I'm not sick. . . .

Zhorzhik—Varvara's brother—died. . . . Niura's alone now.

The Grekov Studio works in this club.[26] The artists of the studio are
on army rations, and draw. Huge copies of reproductions of Repin's
Zaporozhian Cossacks hang on the walls. Copies of reproductions!! That's the
favorite realism. They can't do copies from his paintings. . . . Horrors! How
can you copy reproductions! That's discrimination against Repin!

March 4, 1943
We paid for the telephone and installation, 60 rub. in all.

I'm messing around with watercolors. . . . It's coming out badly.

There's no money, we're in debt. We're still selling black bread.

Our side has taken Rzhev. . . .

March 5, 1943
Varva arrived in tears and said that they've crossed Mulia off the list of return-
ing family members. The committee on returnees crossed Mulia out. She howled
until late at night. . . . Didn't eat, didn't drink. . . . These things are always done
through connections, they summoned back their own people. . . .

Need to make a fuss and fight for it, not mope and cry at the first
obstacles.

Italy is totally mobilized. Mussolini is under Hitler's power. . . .

If our allies don't open a second front . . . then—beware death.

March 6, 1943
In the morning I lie around mostly, my lower back went out, I can't bend
over or walk. It was all I could do to pour some water.

Again, they promised Varva they'd give Mulia a pass at the end of March.

Varva was paid some money! Hurrah! We can send some to Mulia again
and pay our debts!!

They put cups on me, it got a bit better, and I took some sulfidin.

March 7, 1943
My back still hurts. . . . What is this?

There are no dinners, and instead of dinners they still haven't handed
out the rations. I want to eat all the time.

Varvara went to play mah with Vera Gekht. She won 60 rub.

Have to stop drinking and smoking. I have heart pains, it's hard to
breathe. . . .

March 10, 1943

My back is still hurting. I don't go anywhere, don't do anything. . . . I can't move.

What does man live by? "Not by bread alone." Then by what? Medals? Accomplishments? For whom? The people? I'm also the people.

March 11, 1943

I sawed firewood, despite my back.

Varva left to go to the store for the rations, she's been gone four hours. It's hard to get these rations, but how do people live without them?

Varva brought rations for two people for ten days.

Buckwheat kasha, 1,400 gr.

White flour, 2 kg.

Eggs instead of oil—42 gr.

Honey, 300 gr.

Chicken—1,400 gr.

Today we had a fabulous meal!

March 13, 1943

Went to Vera Gekht's. Maria Siniakova was there.[27] She's an artist, self-assured. When I complained that my gouaches weren't coming out right, she said: "An artist is like a bird, he creates and that's it. He shouldn't doubt. Everything you do—is good."

Varva is playing mah with Kruchenykh. He trembles with greed, cheats, and tries to forget to pay up. . . . I watched all this and left. How can you live with them?

It's very hard to write down conversations, but one should. . . .

Varvara left to go to the Informbiuro, and said: "Keep an eye out, if the water that the dough is standing in cools down, then pour in some warm water." That means there will be pies today, and she's dreaming about vodka. That's because life is so difficult. And what am I dreaming about? Paintings. . . .

Niura came by, she brought pure alcohol again. . . .

They say that Berlin is being bombed. . . .

I don't really know whether it will ever be interesting to read these lines. I want to write simply, like eating dinner. . . .

Of course, to my horror, Niurka stayed the night, and that's why I slept badly and the evening was lost. . . .

March 14, 1943

There are no pens, pencils, or paper for sale.

It's cold in the studio but it's interesting to rummage through the papers and books.

If only summer would come. Then I could go up above or hide in the laboratory. This public thoroughfare has been a nuisance my whole life. There are always guests here, like a hotel. . . . I don't like drunks in general and drunken women in particular. They start flirting and talk about the same thing all the time.

How can Stalin not understand that if [Aleksandr] Gerasimov and Lebedev-Kumach are needed, then Shostakovich, Mayakovsky, and others are needed. Why hold art that brutally—when will it be freer?

But maybe I'm to blame as well—I don't try to be recognized. I don't participate in exhibitions. Maybe I just need to keep hammering away. Everyone's forgotten me. I should work for a year and then begin to exhibit. No need to be afraid, just apply for an exhibition wherever, in any club. Let there be non-objective things there, and real things, it would be interesting. Over the summer I should do a few pieces in oil, good pieces, even if they're not big. Enough waiting. Try to do a few things on contemporary themes. Try to work on the sketches for the time being, from old photos. To work!

Ten years have gone by, and I live on the eighth floor like an idiot.

Look for material on a topical theme right away, today.

True, I'm sick of these worries about the apartment, about food, about ration cards, and all. My God! Just don't let them throw me off track. There will be masses of difficulties and setbacks. I've decided: into battle, let them at least break off the remains of the rebel's and romantic's old wings. Old LEF is still better than a dead dog.

Plan.

 1. Look for photo material.

 2. Do trials and sketches from it.

 3. Begin the portrait.

 4. Drawings of the details.

 5. Figure out which of the old things to paint in summer.

 6. Do studies in summer.

I need to make small albums and always have them with me. Sketch everything I see in magazines, i.e., hands, feet, lips, shoes. Doesn't matter that it's not from life. Photographs—are a kind of second nature, and knowledge is necessary. It's easier to remember, and the hand will get the hang of it. "Memory for work is dead."

The clock has stopped, the radio is quiet. . . . Dawn isn't here. . . . Niura is sleeping in the studio, soon the electricity will go off.

I WANT SPRING, SUN. . . .

Must collect and select all the literary material I ever wrote: programs, notes, iconography, diaries, letters and documents, catalogues and articles, mine and about me.

Arrange all this by year. And only then write memoirs, in which all of this will be inserted.

It will probably turn out to be an interesting book.

Likewise, select portraits of individuals I've known, and describe them. The main thing is that there should be a lot of illustrations and documents. Let them criticize or praise it afterward, but I have to do it. It should also be a monograph, an art book and memoir. . . . And publish it at the first opportunity.

March 15, 1943

Got a letter from Mulia. They're putting girls together in a tank column. . . . She doesn't know, should she go? But this is a Ural column, and it's pointless

for her to be in it. . . .

The selection of lit. material is going well.

I'm sick. . . . Not going out.

March 16, 1943

Varvara brought the card rations: Mutton—1,300 gr. Herring—700 gr. Oil—400 gr. Honey—1 kg. Matches—6 boxes. Salt—800 gr.

Today I have to take the pieces [of art] to Vsekokhudozhnik, the donation for a tank. Then to Mossкh.

My head and back ache. . . .

Yesterday the fuses blew, the electricity went out. I fixed it, and it was "left" light.

It's quiet on the front, the Germans are pressing forward again.

Varva went to Mossкh to have our cards stamped.

They promised to turn the telephone on at the end of March.

In old age I've begun to understand Russian nature. I've come to love the Moscow cold and streets. Only on returning did I see the pinkish-bluish Moscow sky.

I took a portrait to Vsekokhudozhnik—a drawing by Mayakovsky, and for Varva—a still life.

I'm getting used to writing a diary. But I need to write more carefully, otherwise it will be difficult to read. I've come to enjoy it, and I write every day.

It's nine at night. I ate dinner alone. Varva went off somewhere. She goes to the store twice and thinks that she does everything and I don't do anything.

Varva's sad about Mulia and often sits staring in one place. . . . She's aged considerably and looks like her mother. I, of course, have also become much more irritable and nervous. And why be nervous? We're in Moscow, it's warm inside, we have enough to eat. . . .

I'm reading F. Alperov's *In the Arena of the Old Circus*. It's interesting but the writing is dull.

It's quiet on the front. As they say: "Another enemy infantry company has been destroyed."

I'm waiting for the telephone repairman.

March 19, 1943

I'm making a telephone book so that the alphabet is in large print, because I see badly.

Today they announced new laureates again: Gerasimov, Yakovlev,[28] Baksheev, Viliams, Fedorovsky, Lansere, Zhukov, Shmarinov.[29] For what?

Everyone's a laureate, and I'm sitting here like an idiot. I keep waiting for something. And I still haven't done anything, neither to the left nor to the right. . . . Moreover, I've become old and sick. . . .

I have to work all the time. All hands on deck. . . . All hands on deck. . . . Sound the alarm!

Ten years of emptiness. . . .

March 25, 1943

Yesterday, at a meeting of the graphics section of Mosskh, only one person asked a question: "Excuse me, I'm ashamed to admit it, of course, but I don't know the artist Zhukov, how can I become acquainted with his works?" And Zhukov is now a laureate.

Varvara heard a conversation between the chairman Zhuravlev and Zakhar: "They told me to cut fifty paintings each. And who can I cut? What did they give them medals for? And that director Pyrev.[30] He's a laureate, he's got medals and an honored artist award!"

I'm terrified!

I looked at Varva's studies. I like them. Looked at my sketches. Need to paint from nature. . . .

March 26, 1943

I got up at four o'clock. At five I left for the food store on Arbat. I stood for an hour in line outside, they let us in at seven o'clock. . . . I hung around the store for an hour. Bought 400 gr of oil and 1,100 gr of gusaline.[31] Went home at ten o'clock.

Varva has gone off again to push for Mulia. I want Mulia to live here. I love young people, the young are always energetic and cheery. I'm very sorry that things are bad for her now. . . .

April 2, 1943

Zakhar Bykov wants to send a summons for Mulia to travel to Moscow to submit her work, for a month, without a "residence permit". . . . But then there will be a lot of trouble with the residence permit. . . .

They brought the telephone and installed it, but it hasn't been turned on yet.

Tomorrow Varva is going to see Chagin.[32]

April 6, 1943

The entire table was piled high, I was making some sandals for Varva, spent a whole week on them.

Khrapchenko's deputy, Konstantinov, sent a government telegram to Pozovsky in the arts section in Molotov: "Arrange official travel V. A. Rodchenko to Moscow for one month to submit works." We sent her a telegram so she'd go to the arts section.

Chagin promised to put her on his list of summoned family members. That will be an extra summons, and if she comes, then she can get her residence permit through it.

Her mood is sad, she often writes about death. . . .

They installed the radio. No money. . . . We sent Mulia 200 rub.

Our neighbor lady, Karpov, a dancer and acrobat, brought over ten cigarettes yesterday because I fixed her door, cleaned the gas [stove], and painted her sandals.

No change on the front. . . .

Varva has gone to borrow money.

I want to sell my banjo. I'd sell a lot of other things but it's hard to sell anything. Everything is going up in smoke anyway. . . .

The Germans are still burning and destroying, it's the century of vanguard technology and science. . . .

April 7, 1943

I'm at home, I planted seedlings: tobacco, mignonette, nasturtiums, and also onions and radishes. We're cleaning up.

The front is quiet. There's talk of future air attacks on Moscow.

I should clean out the stove and make Mulia a bed, but I'm afraid to do it beforehand, that then she won't come again.

They're driving us crazy with Russian songs on the radio. Piatnitsky's choir, Kozlovsky—*Ivan Susanin*, and the "Song of the Coachman," endlessly.

In paintings there's "Russian art": Gerasimov, Gerasimov, Gerasimov. . . .

Shostakovich and [Pyotr] Konchalovsky are the only things that delight. . . .

April 8, 1943

I caught a cold, my head aches, got a runny nose. I wanted to go outside, it's plus five degrees and sunny.

Varva went to get tobacco. I smoked the last cigarette. . . . Bread and kasha. . . . Boring. . . .

I had a European reputation; as an artist of the left front, I participated in lots of foreign exhibitions. I was known in France, Germany, England. I have four silver medals awarded at the exhibition, I have a European reputation as a master of photography. . . .

. . . But I dream of only one thing. A piece of land, an old izba, and having a garden and beehives. . . . Don't have that either. Life is strange, and why is it like this? . . .

April 9, 1943

I went to the music store, sold my Banjo bandura for 1,000 rub., to hell with belongings: Mosskh was selling tobacco, 100 gr for 24 rub.

We're waiting for a telegram from Mulia. Varva went to play mah at Aseev's. Tomorrow we want to go for the rations. Letters take ten days from Molotov. By today Mulia has already received our letters and the telegram. . . .

My ninth-floor moored ship is expecting another sailor—the cabin boy. The ship has no rudder, just a steering wheel. The captain is old and sick, and, most important, is terribly depressed while waiting for spring, sun, and happiness. Where is it?

April 10, 1943

Yesterday Varva was at Aseev's. He's a laureate and medal winner, they live in complete comfort. Oksana—his wife, has grown fat, but she's greedy, keeps buying silver. All their dishes are silver. This is not Mayakovsky. He really did die without medals or titles, and other than a clean shirt he had nothing.

And they treated Varva to tea and pretzels.

Rodchenko's diary, April 1943.

The weather is gloomy, I'm lying down and moping.

I look at the window, the tobacco and nasturtium seedlings have grown. . . .

The most awful thing is when the "stone" guest comes. Kalpakchi from Molotov. . . . She sits there and sits there. . . . It's dark outside. How is she going to leave, won't she get lost. . . . Kalpakchi says that telegrams take a long time. . . .

L. Brik and Katanian came by to find out how to sell an enlarger for the Leica.

Ran into Markov, the photojournalist, on the street—I'll write about him later.

From Mulia's letter: "Greetings from the gray-haired Urals!" That's how Molotov locals extol the place they live. "What would happen if I arrived rolled right up in the letter?"

We sent a telegram: "How goes trip, worried by silence, kisses. Answer." Evening . . . I'm making a wrapping for a bar of chocolate for Mulia's pres-ent when she arrives. . . .

I'm cooking beans and soup. . . .

Now, about Markov.[33] He worked in TASS, and that lovely institution couldn't manage to keep him in the reserves, and he was immediately mobilized and put at the front as a rank-and-file soldier.[34] Gradually moving up, he became a photojournalist for a front-line newspaper. He wasn't able to actually photograph on the front, he had to shoot an automatic weapon. And 15 km away, our "*maîtres*" were photographing a terrible battle, with fireworks and clouds à la Eremin.

April 12, 1943
Lili Brik, seeing the seedling on the windowsill, asked me, "What's that?"
"Flowers."
"You should plant onions, not flowers."
"I always plant flowers."
"Where'd you get them?"

A telegram arrived:
"Received documents, no money, will act—Mulia."

I dropped by to see Tatiana, she also wants to study at the Art Institute.
We have to make the down payment for the garden, but Mossкh won't take it.[35] Have to pay at the Art Fund.[36] Have to get canvas, turpentine, whitewash, and glue there.

April 13, 1943
I'm enjoying the [cutting and] gluing, it's interesting.
Snow fell again last night.
Text of the telegram:
"Molotov, received pass, will probably leave 12th on attached car train 85—Mulia."
While I was out getting bread—stood in line for two hours and didn't get any, since the white sold out and I didn't take the black—this telegram came. Varva was dancing around me. . . .
I went to the Fund, registered for a garden, and wrote out a request for materials. On Tuesday I'll go get them at the warehouse. At the Art Fund there were a lot of artists getting their paints, and even more liquor-soaked bedraggled old women artists. The men are quiet and downtrodden, impoverished. What sort of art do they make? What do they paint? The chair of Mossкh is Zhuravlev.
Maria Siniakova stays at home and glues complicated toys together from cotton, pieces of fur, and materials for "The Toy Trust," where they give her 300 rub. a month and a workers' ration card.
And Leon Letkar? He paints landscapes for himself, sells bread, and collective farm workers who arrive from the front from his collective farm bring him food and tobacco, and he puts them up, like a hotel.
Others sell white bread and buy black—you can make 50–100 rub. from this operation.
Exhibitions are only on military themes and very strictly selected.

April 14, 1943
I can't make ink for the life of me. The inks keep on running, it's awful! The older ones, I think, are better, they don't run so.
It's a beautiful day today! How I want her to come! I set up a bed for Mulia. In the evening I print photos.
Varva left for Informbiuro, Mossкh, and the store. The telephone is quiet.
Today is the anniversary of Mayakovsky's death and there was almost

nothing on the radio. . . . They're playing operettas by Kalman and romances by Pushkin, and also vulgar songs.

There's your [poem] *Good*! Gone and bureaucratized themselves!

Turned into ciphers! "Rations Rats!" Barricaded themselves in their offices and keep repeating one and the same thing: "No!"

No. Everything's the same, Volodya!

(Telegram.)
"Molotov. Left on 12th train 85 car 1. Meet. Kisses. Mulia."

April 18, 1943
She's already here! It's her second night at home. . . .

Ezerskaia sent the memoirs about Mayakovsky to me to read, in order to choose what to print in the anthology.

I read them and concluded that they are interesting.

And the war goes on. There are air attacks on Königsberg.

Mulia is drawing animals for the institute. Zakhar promised not to strike her off the list of returnees.

April 20, 1943
Today I'm going to take the memoirs to the museum.

S.[ergei] Bobrov was at Maria Siniakova's, he's gotten old and isn't active now.[37] He decided to be a publisher, a critic of the Centrifuge group. He's publishing a series of names. Aseev, Pasternak, Aksyonov, et al are in the group.

Have to go for the luggage, canvas, and tobacco.

Dropped by Chagin's, he said that the pass would be ready at three o'clock. I asked when to come. Tomorrow morning at ten is all right.

Leon was here in the evening, talked about Lentulov's funeral.[38]

April 22, 1943
Yesterday we got the pass from Chagin for Mulia's return to her previous home address. What a joy!

But I want to register her for a month as being on an official trip, so that she can rest and work a little.[39] She's drawing. . . .

Lizaveta came by with Kirill, we played mah.

April 23, 1943
Mulia went with Varva to register her residence, but the police are the "police." She needs a copy of the official trip summons, passes, and the recommendation from the Committee. They just like to say: "No."

Mulia is painting still lifes in oil, not bad. It turns out that she has a feel for painting.

April 24, 1943
There will probably be bells ringing tonight, since tomorrow is Easter.[40]

I brought Mulia's things, and the telephone technician was here. The phone started working in the evening.

We opened the balcony in the studio, it's warm, like summer.

April 28, 1943
I don't know whether I wrote about Lizaveta and Kirill being here, and Svistunov was, too. Zakhar was here yesterday. We argued about groups. There are guests every day. I'm not working at all.

I cleaned up the balcony. I'll plant flowers and garlic. We called Ioganson. At the police station, they registered Mulia in no time at all as a Muscovite. Tomorrow Mulia will get ration cards.

April 29, 1943
I'm going for a medical checkup. I may end up in the Red Army: once again I'll be in the "rank and file."

May 1, 1943
I'm going through all the boards.
The medical board. The draft board. . . .
And the future is unknown.

May 2, 1943. Sunday
I spent the whole day Friday at the doctors' board of the draft board. I complained about my heart. They gave me a referral to the clinic for an X-ray of the heart and to measure my blood pressure. The X-ray is tomorrow at eleven, from two on they measure blood pressure.

Half a century has gone by, and I'm still under threat of becoming "cannon fodder."

My mood is murderous.

I'm sitting and reading so as not to think about anything.

May 3, 1943
A summons.

They gave me a certificate: "Clinic no. 1997 3.5.43. Lung tips without change. Cor—N. Ventricles somewhat enlarged. Aorta elongated, unfolded. Pulsation calm."

After that they gave me a certificate at the clinic: "Rodchenko A. M. blood pressure 170/100." What does it all mean?

May 5, 1943
Today my fate is being decided at the medical committee of the draft board. . . . All my life I've lived under the threat of soldiering.

The weather is gray, depressing, like my mood.

The daily watch planes drone overhead.

At around ten I'm going to the draft board.

I've been relieved [of duty] again for a time. . . . At eight o'clock they gave me a certificate: "Fit for nonconstruction [work], without physical stress and lengthy walks."

I'll register with the board again. Again I'm fit.

May 6, 1943

I'm enjoying home and freedom, I don't know what to do first. Again there's hope. . . .

Our side has begun to attack.

May 10, 1943

I got the certificate. And I'll go to the draft board, to Mossкh, and to the military desk of the police.

I want to go to work in film as a director at Scien[tific] Tech[nical] films, with Ilya. I'm sick of Mossкh.

Mulia has her residence permit, but . . . without ration cards.

The Art Institute won't take her.

May 15, 1943

The ration card tribulations are continuing, we haven't picked up the dry-goods rations yet. There are no sweets. . . . No tobacco. . . . Mulia is sick, tonsillitis. They'll accept Mulia at the preparatory courses at the Polygraphic Institute as an artist-designer, although she has only completed ten grades.

We will turn down the garden, it's impossible to travel back and forth and pull up tree stumps. . . .

Mulia is in bed with boils on her legs and can't go anywhere.

May 18, 1943

Sun, and everything's happier.

Mulia and Varva are going to a homeopath. Allopaths don't treat you, they just look to make sure it isn't typhus. . . . This is hygienic self-defense! They'll only take Mulia at the Polygraphic Institute starting in August, and at the [Surikov] Art Institute only in September. But what will happen to her before August? They'll draft her and that's that. What to do?? Her legs still hurt. No money, we're still in debt. They'll turn off the gas for nonpayment. . . . They would accept Mulia at the 1905 Technical School but they've all left for nature studies. How to keep Mulia safe from the labor front?

May 20, 1943

Varva has become terribly stubborn. Her idée fixe is that we have to take on a wagonload of work, already having posters in Informbiuro, *Fotokhudozh-nik*, and *Fotogazeta*. And there's no money anyway. Informbiuro holds everything up for months. *Fotokhudozhnik* pays peanuts. We should look for work with rations. But where to find it? There's neither money nor time to buy rations with all her little jobs. But I'm not capable of hackwork. . . . Varvara also thinks that we need to make some *lubki* and posters for 100 rubles each. But they'll be reworked endlessly. . . .

I have to write larger otherwise I won't be able to read this later, even with glasses. . . .

I'm sick of Niura. For her 150 gr of alcohol she feeds herself here all day long, and Mulia doesn't have any ration cards yet. To hell with drinking. . . . It can wait. Varva doesn't realize any of this. . . . It's a shame. . . .

Rain all day. . . .
I'm not painting the portrait, neither Mulia's nor Varva's.
I went to get medicine for Mulia. . . .

May 23, 1943
Yesterday at Mossкh I got cigarettes. Today I have to go by Deneika's about Mulia. I dropped by Deneika's but didn't catch him, so I left a note. His wife was there. There are canvases in his studio and a sculpture of a soccer player. It's a good studio. I called Osmerkin, he forgot to raise the question of Mulia.[41] So probably Mulia should go into the 1905 Technical School.

I want butter and sugar.

The projects Ladovsky did in plywood, which used to be in his studio, are now getting wet on his balcony. And he was a name in architecture after all. Everything is turning to dust. . . . My paintings will get wet too, be burned in a stove. . . .

Art. . . . Is it worth living for you? Who needs it? What's needed, apparently, is only war, bread, and lard.

The poor dreamer Ladovsky died. His whole life, he intended to build his own, "the new". . . .

May 27, 1943
Mulia is getting better. And I feel terrible, weak, and my eyes see badly. Yesterday I began doing a rush cover for "War and the Working Class" for Informbiuro and for the fleet's photo newspaper. I had to help Varva.

May 28, 1943
I ran around getting the ration cards. I lost Varva. It turned out the police picked her up because she was buying tobacco at the market. . . .

Varva hasn't gotten enough sleep for five days, she sleeps about four hours. . . .

Tomorrow morning, i.e., from five o'clock on, is the registration at the bakery. And what we get is gray, tasteless, wet, heavy bread. We're half starving, and we also get a "scholarly worker's" dinner.

May 29, 1943
Dinner rolls—are the long-gone past. But we're satisfied.

"The enemy will be crushed, victory will be ours."

And at the same time, they bake bread with water in the bakery, they don't weigh out the full amount, they steal in the cafeterias, etc.

The "War and the Working Class" cover wasn't accepted, but by contract, in the event it isn't used, 50 percent of the cost is paid. Official-bureaucrats.

June 1, 1943
June is here. So-called Moscow summer, plus ten degrees. And I don't have a garden, or a dacha, or money. . . .

I went to get bread but they hadn't delivered the bread. . . .

Can't seem to write in the diary. . . .

June 2, 1943
I went to the circus to photograph for VOKS. The fuss with ration cards continues.

June 3, 1943
Today I drew sketches. No money. . . . I should sell one of the Leicas or the Sept. I'm hungry. Dinner—is just water with flour. The second course—is beans. 400 gr of bread and one piece of candy. That's all the food for one day.

June 10, 1943
They won't give Mulia ration cards on the grounds that she didn't get them in May!

Yesterday, i.e., early this morning, there was an alarm, an attack on Moscow, the first since I returned. They bombed somewhere on the outskirts, somewhere near Kratovo. There was nothing in Moscow but you could see the explosions and the antiaircraft guns.

June 11, 1943
Of course they didn't pay the money owed; they promise to pay 4,000 rub. on the 13th, but for the time being we've borrowed 100 rub. from Khlebnikov.[42] . . .

This morning Varva left for the store, and I'm waiting for her call.

Mulia left for the Technical College. Maybe they will give her ration cards as well.

June 13, 1943
Classes at the Technical College have ended, and on the 20th Mulia is going to the collective farm.[43] She was accepted at the Technical College. She got a student ration card with 500 gr of bread.

I'm painting in oil. Tomorrow I'll start painting Mulia.

We're expecting air attacks. On the front there's "nothing important."

June 19, 1943
Just one worry: food. . . .

I'm repainting old pieces. They all seem bad to me.

June 21, 1943
Lizaveta and Kirill came over, but these people have changed, they leave a bad taste behind them. . . . They only think about themselves. . . .

June 24, 1943
They say Germany is proposing peace. She'll give back everything she's taken in Europe in exchange for the USSR. . . .

The Fund moved into MOSSKH. . . . Have to get ration cards all over again, register at stores, and so on.

It was announced that in the last two years, 6 million Germans have been killed, and 40 million Russians. "No changes took place on the front."

On the art front, everything is unchanged.

On the tobacco front, things have gotten better.

July 1, 1943

On the 2nd Mulia is supposed to go to the collective farm for three months. She's sad about it. . . .

Udaltsova is sick again. She's fifty-nine years old, she's alone with no husband, and her son is at the front. Mulia visits her. . . .

July 5, 1943

Varva and I were surprised at how people live, how strange they are, to put it mildly. . . . Udaltsova, for example. She never ever expends any energy: a neighbor lady picks up bread for her; in exchange, she sells her [neighbor] her black bread for 130 rub. instead of 150 rub. The neighbor brings it right to [Udaltsova's] home. She receives her rations after everyone else already has theirs, without waiting in line, and she chooses the very best. She has stores put by. Nastia does everything in the house for her in exchange for bread. During the day she paints. . . .

July 6, 1943

We're living on bread and soup. . . .

Today I'll go to the movies and to see Khlebnikov.

The mobilization will send Mulia to a lumber plant until fall, October 15th. Tomorrow they'll take her passport, and she'll go off somewhere. . . .

On the notification, it says: "In the event of failure to appear, the above named will be summoned to the police". . . . A wonderful warning. . . .

Soon it will be winter again. . . . Cold. . . . Water. . . . Light. . . . Firewood. . . . Gloom. . . .

The lettuce on the balcony has ripened, and we're eating radishes. . . . Of the flowers, the nasturtiums and stocks are blooming. Not many beans.

We didn't receive the dry rations, they're not giving out anything on cards.

Four hundred tanks and 100 airplanes have been destroyed.

Mulia leaves on the 15th for Riazan, to the forest.. . . .

July 9, 1943

We got American rations: a little bit of wheat and 6 kg flour. For the moment there aren't any sweets.

Last night Varva, Mulia, and I played mah. There wasn't a peep from the radio. The last news was after eleven. What does this mean? Either we're retreating or we're attacking? And there's no second front. . . .

A whole day was wasted at a meeting about the exhibition at Informbiuro.

My God! We've become religious believers with the war and hunger. People are perishing all around and in torment.

Yes, the radio is silent, it's three in the morning. What will happen in the near future? What's happening at the front?

July 10, 1943

Today they spoke vaguely about some "units," about battles with tanks, and so on. It's a sign that things are going badly when they keep hammering that "we must . . . must. . . ."

I read my diary of 1918 and 1920. Everything was just like it is now. Art isn't needed. Well, maybe now it's worse.

Where have twenty-five years gone?

The same hatred for formalists. They don't see anything.

Tomorrow they're calling us to load firewood from a barge for the building, beginning at seven in the morning. What use am I for this sort of thing?

Mulia's leaving for the lumber plant.

A person simply needs life, bread, and peace and quiet. He's ruled by dictators. He's a slave of his own kind. This so-called king of nature. . . .

Everything needs to be destroyed.

If you go out in a field, to a quiet field where the birds chirp. . . . They live perfectly well without any technology or science, as though mocking human beings. They don't have Roosevelt or Hitler. . . .

But maybe they do?

But birds are devoid of mind and ideas. They simply sing and exist and fly wherever they want. Without passes and passports. No one makes soldiers of them, patriots and philistines. They aren't murdered for ideas.

July 11, 1943

We are hanging like paper lanterns on the street.

Each of us could be crumpled, torn off, and destroyed.

We hang and swing, rumpled from the rain and winds. We have neither form nor color. We don't even look like lanterns anymore. What will remain of us?

Lizaveta (Ignatovich)—the photographer—came by.

She really is good-looking and interesting. There aren't any others like her.

Today we harvested the crop on the balcony. The radishes are so small. . . . I'm only going to plant flowers. A bunch of radishes costs 10 rub., while your average flower is—15 rub.

July 13, 1943

Mulia and Varva got grain, oil, and two chickens.

Mulia is getting ready for the lumber plant, she walks around all sad, and she's not painting.

In old age we all become writers. Life has been lived. . . . We have masses of memories. You feel like summing up, justifying life. You want to remember and relive everything again.

You want to relive things in a corrected way, since now everything's clear. You want to teach others how to live. This appears to be a natural requirement of man in old age.

July 15, 1943

I've a headache since this morning. . . .

_I will already be gone when someone reads this diary. . . .

"He was a talented person, but obviously he lived at the wrong time and had the wrong occupation. A dreamer and a romantic, but the epoch was severe and ruthless. . . ."

At eight in the evening, suddenly, an announcement: "After a three-day battle, our troops broke through the front to the north of Oryol, to the south for 40 km, to the north for 25 km. They occupied fifty settlements, crushed three infantry divisions and two tank divisions. The attack continues."

My mood suddenly improved.

My diary is like a room. . . . Photos and art hang in it, and documents lie around, but I don't feel like reading.

Varva and Mulia went to Sokolov-Skalia's exhibition.[44] . . . They said it was horrible. . . . Mulia said that one glass painted by Udaltsova was better [than any of] his paintings.

Today Svarog, Yuon, Lansere, Pavlov, and others were awarded Orders of the Labor Red Banner.[45]

And I—am a rank-and-file reservist! . . .

July 17, 1943

Mulia's leaving at one in the afternoon for the lumber plant in Riazan Oblast.

We don't belong to ourselves.

Everything is covered in secrecy. . . .

She spent the whole day running around trying to find a standard reference form. The building manager isn't here. There's no seal.[46] . . .

Varva went to see her off. She came back at eight in the evening. She got on the steamboat, they were given third-class tickets, but Varva bought her a berth for two in second class.

Five people from the Technical College are going, eighty people from the Welding Institute, and forty from the Polygraphic Institute. They'll be traveling for four days. She'll see the rivers and landscapes.

July 18, 1943

We're alone again. I'm cleaning up. Lizaveta called. She says to come over.

Night, quiet. . . . I'm sleeping on the balcony. Everything around is quiet and the windows are dark, blacked out, war. . . .

There's no one on watch in the courtyard, although everyone used to take turns keeping watch. They would shout: "Who's smoking over there?"

Night. . . . The city's sleeping, having run around for bread, for ration cards. . . .

The laureates are sleeping, the honored painters of photographs are sleeping, the interpreters of the song "Coachman, don't you race the horses" are sleeping. The speculators, con men, cafeteria, and store thieves are sleeping. . . .

The romantics and dreamers are getting ready to sleep too.

What will the new day bring?

He's wondering how to make still photos as if from a film of Gogol's [story] "Viy," for exhibition.

Make everything from cardboard, and photograph it.
Or some other theme, for instance, the bombing of a city. . . .
I'm not happy with myself, I'm not painting. . . .
I'm making frames for paintings, I need to do an exhibition.

July 19, 1943

Roza Ostrovskaia summoned Lizaveta to the magazine *Smena* [Shift]. They
need a reporter on the front. But . . . the editor doesn't know Ignatovich and
asks her to bring photos.

What does he know?

A worker from the vanguard Komsomol magazine and he doesn't know
that we worked at *Smena* and *SSSR na stroike* for many years. He appar-
ently worked in Leningrad, and the journals don't get there. And these are
our bosses.

Roza says sadly that it's hard for her to work. We teach every editor and
then he leaves. . . . And a new one comes, and everything starts from the
beginning.

The weather is such that all day long it's getting ready to rain but doesn't.
My head aches, and my heart too.

This morning I went to the cinematographers' union. They don't take
freelancers.

I went to a MossKh medical clinic. There were fifty people in line. . . .
I left. . . . I bought twelve grams of saccharine at 25 rub. a gram.

July 20, 1943

Today is the fiftieth anniversary of Mayakovsky's birth. There's an evening at
the Mayakovsky Museum. I should go. Take my camera, photograph Aseev,
Pasternak. . . . But why—I don't know.

Last night I dreamed about Zhenia.

Even in dreams there's no joy. . . .

July 21, 1943

Finally Moscow summer has arrived, it's warm and sunny.

No news from Mulia yet. She should already have arrived in Kasimov
on the steamboat.

I didn't go to the Mayakovsky Museum yesterday, Varva went. N. Aseev
spoke, he read "Man—Thing" and his own poems.

Stalin—is a hero of Socialist Labor and Marshal of the Soviet Union and
Supreme Commander!

I'm a romantic. It seems that everything could have been done differ-
ently. Both the life of the USSR and myself. . . .

July 23, 1943

Yesterday I ran into the VKHUTEMAS artist Amosov. I dragged him over here,
treated him to vodka. He only just got out of the hospital, he was wounded
for the second time, he's a Communist, has two medals.

I'm beginning to repaint old things in watercolor.

Amosov promised to come at two, but didn't. Oh goodness, these drunks! The war is coming to an end.

July 24, 1943
Today Stalin issued an order to the generals to liquidate the German attack.

I'm painting, but so far nothing's working out. I'm painting old wrestlers. And a second *Clown-Acrobats in the Ring*.

Varva brought the last of the rations: 400 gr butter, a pack of tobacco, and 2 kg of peas.

August, the one-year anniversary of my return to Moscow, is right around the corner.

Udaltsova calls once in a while. . . .

I'm still painting the same wrestlers and acrobats.

July 28, 1943
There's a rumor that Mossкh will be handing out A-ration cards and B-cards.

I called Zakhar and found out that they give A-cards to professors and honored artists, and that I should go to Mossкh and bring certificates.[47] It turned out that the secretary didn't know anything. . . .

I was so upset, I came home, and at home there was a summons from the Moscow Antiaircraft Defense to appear at the building management office for a "residence purrmit."

Everything—is a secret. . . .

July 29, 1943
I'm in a horrible mood. Completely disappointed in my painting.

Why am I moving to the right?

Nothing turns out.

No! No! No!

I can't do anything about my condition. . . .

My turn to the right has brought terrible things.

I don't want anything. I want to be the same as I was. I will never be a Gerasimov!

I'm horrified!

Lord, save me from all of this!

These things have been hanging on the walls for eight years, and they're horrible!

Who needs them!

I can't stand to look at them, and there are a lot of them.[48] . . .

July 30, 1943
The painting has taken off!! But horrors!!!

It's leftist painting.[49] . . .

And Lord Almighty, what a joy it is to be leftist. . . .

To be myself after all these torments, and counter to common sense. Not to break myself, to paint with pleasure!!

What will be, will be!!! But I'll die leftist and leave behind good works.

I'm painting several things at once and am terribly happy. In times like these, they'd say, "He's out of his mind!"

Only Mulia will forgive me and understand. I couldn't coerce myself anymore. Let it be the wrong road, but it yields valuable works.

July 31, 1943
It's the end of July, nothing from Mulia. . . .We got our ration cards.

They say we have to apply to Mossкh, maybe they'll give us B-cards [for] a cafeteria or dry rations as a former professor. But I don't know whether they recognize these papers as sufficient.

I painted three non-objective things and began to paint two more, and two figurative, but leftist.

I'm painting badly, the table is piled with all sorts of junk, there's nowhere to paint.

August 3, 1943
Mulia writes about difficulties, cold, and that it seems they won't let them go anytime soon. . . .

I'm painting abstractions, they're not going that great, but they're going. . . .

It's evening, cold. . . .

August 6, 1943
Our side took Oryol and Belgorod.

Last night there was a salvo from the Kremlin in honor of the victory.

Lizaveta and I are playing mah.

England and America can't manage to conquer Italy alone, so how can we fight Germany and all of Europe alone.

Varva runs around for days at a time with no results. . . . She talks too much, argues, and plays mah. . . .

And I'm sadly painting abstractions. Alone. . . . Without any lyricism, without love. . . .

I painted a study of a portrait of Lizaveta.

Nothing from Mulia. . . .

And why is it so boring to live, and I feel hurt, my potential isn't being used, I feel I'm not in the "era."

August 11, 1943
Nothing has changed. . . . I'm painting abstractions, which is pointless, and, perhaps, stupid, but pleasant and interesting. It may be I only have months left to live, so I'll go out a leftist.

It appears they'll summon Mulia for exams in September.

Evening. . . . I'm alone. I look at the studio . . . at the walls where my works hang, and I think. . . . Will middle-aged Mulia really sit here with her children and look at my works and think: "Oh, it's such a shame father didn't live to see this, he's been recognized and people are asking for his works. . . . They buy them. . . . They hang in the museum. . . ."

And he wrote, and what did he think? Was he really sure of this or not? . . . If he were certain, then things were all right for him.

. . . My future Mulia, your late father can say to you with a pure heart: I was not certain, not at all certain, and this was like an illness. I didn't know why I was working. And like just now, I thought that they'd destroy everything, throw it away, and that not a single work would remain anywhere.

O, if only I were even a little sure, everything would be so incredibly much easier for me. . . .

There's nothing. . . . And nothing is needed.

It would be better if I were a director of something, I'd have a clean room, a new bed, a pretty wife, and stupid friends. I'd be calm and cheerful. . . .

Sweet Mulia! Perhaps you too will be poisoned by all of this. . . . But I don't wish you any ill. It would be better if you would drop all this and live simply, "like everyone."

But I really did have fame and a European reputation, I was known in France, Germany, and America.

And now there's nothing.

They buried me alive and forgot me irretrievably. . . .

Beginning in 1921, they buried me. But I'm alive, perhaps more than others are alive right now.

Today's especially sad. Like an old man I'm thinking that everything happened in this apartment—Fame, Love, and Life.

What is left? Was I happy? No. . . .

Fame—I scorned.

Love . . . I limited.

Life . . . I failed to value.

Fantasy was the only thing I didn't limit. And I did what . . . I liked doing. That was it. . . .

And later, the city will still be making noise outside the window, and the announcer will read in the same tedious voice on the radio, the martins will whistle over the roofs. . . .

And the twilight will thicken into night. . . .

I'm thinking about you, Mulia!

Will you be happy in life . . . I think not.

You doubt everything and everyone. You are suspicious of everything. You see everyone's faults, pettiness, cowardice, limitedness, greed, egoism, vulgarity, self-assuredness, and boorishness.

Is this good? Or very bad?

I'm not sorry for myself, I wanted this.

And you? Perhaps not. . . .

And so, in your distant old age you'll sit in the twilight and tell yourself and tell me. I'll hear you.[50] . . .

August 12, 1943

It's no good painting on cardboard, but there are no small stretchers. I'll have to glue canvas onto cardboard.

Everything comes out very thin on cardboard, rough canvas is what's

needed. A regular sack would be the thing. When I'm rich I'll buy sacks..

August 17, 1943
A whole month has gone by since Mulia left, today we got a sad, miserable letter. She thinks that she'll have to be there another two months. . . .

I'm painting like a beast but my mood's gloomy. What for? Why bother?

I'm painting, my only joy is from work, but when I paint I always think, "What for?"

Will the day really come when it will be possible to exhibit?

Perhaps it will never come. . . .

August 19, 1943
Mulia must have gotten sick out there if they've transferred her to light work. And those bastards in the forestry plant destroyed her letters. . . .

God save us from all of this!

We no longer believe in anything. . . .

We want freedom and peace.

She'll come back in September.

The war continues. . . .What will happen after it. . . . Nothing. . . .

Why am I writing this? At such a time. . . . I'm half mad. Who is going to read this?

August 21, 1943
We got a ton of letters from Mulia. She's on light work because of a glandular illness. But things are bad with food, she has no money, and she got her bread for July on August 6th. She writes that they'll let her go on September 15th, she'll come on the last steamboat. Nothing is clear with the ration card yet. Almost all the writers are given it, even Kruchenykh.

I'm painting, today I finished two good pieces as well as one mediocre one and one bad one. I don't feel too well. . . .

Besides painting there's nothing interesting. I get tired and fall asleep. . . . I go to bed with thoughts about pieces, wake up and go to paint. In the evening I look over what I've done and think. . . . That's how the whole day goes by.

It appears they're going to heat the building this winter.

The twilight of old age. Just to make it to the end.

The Mayakovsky Museum is returning all the books and photos it took.

August 22, 1943
Litvinov (from America) and Maisky (England) have been removed from their posts.[51] It appears we can't come to an agreement with anyone about future aid, nor about a second front. . . .

It's the end of democracy.

That means the end of my leftist painting. That means realism again, copying.

All for one and one for all.

Again, sadness about the war and lack of money. . . .

August 24, 1943

Yesterday we took Kharkov. There were fireworks.

We sent Mulia a telegram and 300 rub., now she'll have enough.

And we have only 200 rub. left, but we'll manage somehow.

Varva called Mosskh about the rations. They said that everything is at Gospromtorg.[52] Ah, how good it would be to get the rations this month, it would be a present for Mulia.

I'm painting and don't intend to stop. Whatever happens, happens. . . .

August 28, 1943

I'm painting, I've painted fifteen pieces, nine good ones, five so-so, and one bad.[53]

Tomorrow Varva's going to see what she can do about Mulia so they'll summon her for the exams.

We got two liters of kerosene for the lamps for the winter. They won't bring firewood. They didn't give out any sugar in the end.

I've begun to see poorly. . . .

Varva went to get the vegetables. She's been going for a whole month and can't get them. . . .

Varva was in the library at Chistye Prudy; it turns out that you can choose a book to read from . . . six whole books. This is in Moscow, in a government library.

August 30, 1943

Hurrah! A joyous day!

First of all, Taganrog has been captured, and today there were fireworks at seven in the evening.

Second, we got the ration cards, I was suddenly given a B-card and a subscription.

That means the following:

	Before	Now
Bread	6,000 gr	6,000 gr
Oil	2,200 gr	7,200 gr
Fats	800 gr	1,800 gr
Sugar	500 gr	1,600 gr
Grain	2,000 gr	3,500 gr
Vegetables	2,000 gr	7,000 gr

And besides that:

Dried fruit—500 gr

Biscuits—1,000 gr

Eggs—10 pieces

Tobacco—300 gr

Soap—2 pieces

There will be enough food for Mulia. I can't even believe it.

The accounting books of the stomach.

Rodchenko. *Streamlined Ornament*.
1943. Oil on canvas, 19½ × 13¾"
(49.6 × 35 cm)

Leon Letkar came by, he looked at my works, approved what I'm painting, what I love with all my heart.

He really likes Mulia's things, as well.

Finally we'll be full, and the war is going successfully.

That means I can work.

Varva went and found out that professors' rations are picked up in a different place, on Dmitrovka.

September 2, 1943

It's already cold, plus fifteen.

They delivered enough firewood for about two months, no more, but there are eight or six [months]. . . .

We've begun fixing the felt boots. Need to sew padded cotton coats. No money at all.

The rations are good now but there's nothing to buy them with.

The Polygraphic Institute gave Mulia a document that says she's required to appear for the exam between the 10th and the 20th of September.

Varva sent the document to Mulia, and if they let her go, then perhaps they'll give her a ticket and she'll leave.

Tomorrow they hand out a chit to another store on my rations.

Today there were fireworks at eight P.M. We captured Sumy!

Mulia will leave around the 7th, and around the 15th she'll be in Moscow.

September 5, 1943

Varva is unhappy about everything, argues about everything, we keep arguing and fighting.

I'm only living in expectation of Mulia now. She turns out to be the closest and most dear of everyone.

September 10, 1943

Nothing new. Mulia still hasn't left. Our side is still attacking. We took Donbass and Konotop. . . . Italy capitulated.

September 13, 1943

A telegram came from Mulia, she's leaving the 11th, the steamboat is the 14th, at three in the morning. So Varva will go at five in the morning to meet her.

We got our rations on B-cards, it's a whole different story.

I'm so glad that I'll soon see Mulia.

The war is going full force: the "Berlin-Rome" axis has only cracked.

September 17, 1943

Mulia arrived the morning of the 14th from Riazan Oblast and the lumber plant.

She has a drawing exam the 22nd—for the Polygr. Institute.

I'm sick. I've had a sore throat for a week already, I'm coughing and dying. Headaches.

No work at all, we're living off the sale of our books.

It's boring to be sick and not paint.

September 22, 1943

I'm sick, swollen tonsils, cough, and headache. . . . My eyes see badly.

I put up with misfortune, headache, and a bad heart.

I put up with it and am even outwardly cheerful, as much as possible.

It's not frightening to die, only boring, like living.

Vasia Katanian asked me to do a cover for *Mayakovsky. A Literary Chronicle*.[54]

He imagines he'll received a laureate award for the book. And he probably will.

Our side keeps on moving ahead, taking more and more. They've already captured Mariupol. Getting close to the Dnieper River and Kiev.

November 6, 1943

In Mossкh they informed me that nonteaching professors won't receive the B-card and subscription for November but will get the usual S.W. card (scholarly worker).

They fed us two months, and that's enough.

It's boring. . . .

Mulia is studying at the Polygraphic Institute, she received a workers' "2" card, 600 gr of bread.

I'm still coughing and sick. . . .

Night and cold. . . . Nothing ahead.

I want to sleep, sleep, and sleep. . . .

I paint and paint . . . and what for?

October 9, 1943

I keep having the urge to write Stalin about the situation in the arts, i.e., about painting. . . .

September 12, 1943

Gloom. . . . V. Stenberg, a leftist artist who used to be in Овмокhu, dropped by to see me.[55] . . . Well, he dropped by, and it would have been better if

he hadn't. . . .What has happened to artists? He's like a blind man. . . .

So it's the end of art!

I don't understand anything. . . . It's death!

October 16, 1943

I'm doing two rooms of the exhibition at the Museum of the Revolution. The history of VKP(b) before October. I got an advance of 1,125 rubles.

On the 18th I'll bring in the project, if they take it they'll pay some more. . . .

October 29, 1943

I'm working in the Museum of the Revolution designing the exhibition *The History of the VKP(b) in Posters*. I got a B-card in Mossкh again. There's even heat [at home].

No time to paint again. And the days are getting shorter and shorter, like life.

November 4th or 5th, 1943

The war is still going on. Nothing happy in art.

I'm working in the Museum of the Revolution.

Painting has been postponed. . . .

November 21, 1943

I was born in 1891. So I'm fifty-two years old.

Of course, I'm sick, flu, heart pains. . . .

December 3, 1943

Misery! Misery!

Maybe I'm looking at things through the eyes of an ordinary "narrow-minded" person, but we need to know the eyes of such people as well. We know the eyes of the bosses all too well.

I went to get potatoes, there are none to be had.

Snow fell, it's slippery.

Women scrape snow from the pavement, it's slippery for the cars, and the sidewalks are all one big skating rink. . . .

Everything for the people. . . .

We were against the lords and bosses and in the end have become bosses no better than the previous ones.

December 4, 1943

Yesterday the radio report on the meeting of Stalin, Roosevelt, and Churchill in Teheran. The details will come later. . . .

What did they agree on?

December 18, 1943

Again the year is coming to an end, and the diary isn't finished yet. There are a lot of thoughts.

It's overcast, gets light at nine and dark at three in the afternoon.

I'm not doing anything. In the evening it's dark, the [electricity] limit is only enough for one lamp. . . .

I completely forgot that I need to write my biography.

In the winter you live like a bear in hibernation. . . .

It's the same thing on the radio all the time: Lemeshev singing "Coach-man". . . .

We signed a contract with E. Benes, gave him two ships for reinforcements.[56]

We subscribed to two newspapers for 1944, *Izvestia* and *Vecherka*.[57]

The war will last another three years or so, since the allies want to fight only with technology. America and England have won the war. . . .

1944 is coming. I don't like the look of it already. . . .

I don't like the numbers 4, 6, 2.

I like 3, 7, 8, 5, 1.

But that's mysticism. Maybe everything's the other way around.

Looking at current-day self-seeking, thievery, and other qualities of contemporary man, it turns out that Christianity is needed. If there's no Christianity, there's no friendship, human image, there's no love for one another. On the contrary. Everyone is only out for himself and himself again. . . . Both the war and all the atrocities only confirm this.

What if Christ were to visit the front. My God! He would be drawn and quartered. You have to be "an operator" and nothing more.

But we are romantics. . . .

Today we listened to Khachaturian.[58] A Kurdish dance, Lezginka. It's Ravel! Where's his conscience? And the main thing is that we are always spitting on the West!

December 20, 1943

In these December days I always feel bad, with heart pains.

Morning. I get up, like always, at seven. Make coffee, drink it with bread and butter, smoke. . . . Think about painting. . . .

Mulia has the flu, a temperature.

Varva just went to bed. She was working on the album *From Moscow to Stalingrad*.

The diary "isn't moving." I have to write more carefully, something of all this should remain, after all.

I have to have an exhibition. A lot of work has piled up. Now to paint some watercolors too, and a series of ink drawings.

Varva and I don't have many friends, Lizaveta Ignatovich remains, and even she rarely comes over.

They've all gone: Tatiana, Dodia, the Briks, etc.

No friends. . . . Everyone's busy with rations, their own life.

In Kharkov they hung three Germans and a Russian traitor in the square. . . . "Evil begets evil." "An eye for an eye." "A tooth for a tooth." No. . . . No. . . .

How could cultured Western Germans come to all these atrocities, become criminals?

Where is the philosophy? Culture? . . . It's frightening. . . .

We got part of the rations. It's American butter, Amer. milk, Amer. chocolate. . . .

It's good that they are giving but it's bad that we don't have our own.

When will I stop philosophizing and start writing down facts.

In the trams, young toughs cut caracul coats off people's backs with razors. They yank them off Kuban women and cut their purses.

There's your chronicle.

Lilia Lavinskaia [Lilka Lavinsky] made "Karandash" and "Charlie Chaplin" dolls and others at my suggestion and from my photos. They're successful. They proposed she also make a soccer player, and a Hitler for sticking pins in. She lives one floor down. She's terribly sick and needy, and her daughter—is a friend of Mulia's. She lives in terrible disorder, everything's dirty, she smokes a lot, but I often drop in to see her. I feel sorry for her, and you want to help her in some way. And that's the only acquaintance I go to see.

My God, how I want sun, light, warmth, and happiness. . . .

What kind? In creative work. . . . New pieces, good ones. . . . And frames for paintings. I want to put everything in frames, I never wanted that before.

December 21, 1943

I went to look for Varvara in the stores. Had trouble finding her. We stood in line for 800 gr of sweetened condensed milk and 300 gr fat, and it's already evening—eight o'clock.

This morning I cleaned up, peeled potatoes, because Mulia's sick and Varva had left.

I'm sitting in stolen light from New Year's tree lights in my felt boots.

Mulia is at Lilka's in apt. 15. The radio is howling with laureates—"Wedding in Malinovka."[59]

Haven't been to the bathhouse in a month and a half. The bathhouse— means a three-hour line.

And in my head are watercolors, a novel, sun, spring . . . my own shack-dacha. . . .

I read how I spent last New Year's Eve with Varva. . . .

It will be better, there's wine, food, candy, coffee, meat.

And the main thing is that the three of us will be together. There's heat in the studio, and guests will come. . . .

Only there won't be any friends. . . .

I thought that today was the 22nd, turns out today's the 21st.

Again, I made dinner and went to get the bread.

Successes on our ship for the year.

 1. Mulia arrived.

 2. They installed the phone.

 3. There's money and work.

 4. Ration-card food.

 5. Subscriptions to newspapers.

6. The studio is heated.

7. They've promised [to increase] the electricity limit.[60]

8. The elevator is going to be working.

Today on the radio they read the new anthem of the Soviet Union. In an old-fashioned style. The music isn't ready yet.

December 24, 1943

Christmas eve. Varva worked on the cover of *Smena* all night, and I helped.

There are six days left in 1943. . . .

The weather is dusky and dark. There's no day at all. I want spring and summer to come quickly, quickly.

Darkness, cold, and boredom.

It's all war and gloom, there's no end to it. Our side is stuck again, the Germans are attacking, no friends. . . .

We did *Smena*, the magazine for Komsomol youth; the typeface of "SMENA" is in Old Church Slavonic letters, and the editor likes it. They sent it off to be approved. They're all demanding Russo-Slavonic letters and ornaments.

Varva is going crazy, she keeps getting work, so people call all day long and talk.

There's no time to go around to the stores, we'll have to eat at the cafeteria. . . .

December 26, 1943

All day I made frames for non-objective works. It looks nice.

Varva got paid for the cover of *Smena* and for Benes. She keeps on working.

Today our troops broke through the front in a second place, they're moving toward Vitebsk and Zhitomir again.

I was sick all day, flu, could have slept the whole day. In the evening I warmed up with aspirin and wine.

Today I thought of painting the Church of the Savior and Virgin and submitting it to an exhibition. What would happen?

They have allowed and opened the churches. I'll have to think about this.

And I would paint them fabulously!

Smena in a Church Slavonic style was accepted by the Central Committee with pleasure. "We," the Committee said "are the largest Slavic state, and there's no reason to be ashamed of our past."

December 28, 1943

The obtaining and registration of ration cards is coming up again. It's terribly exhausting.

And we still need to get 60 kg of potatoes from who knows where.

They don't give out flour, they give out bread. I took it for two people for all of December, 8 kg of black and 4 of white, it's drying out and spoiling.

December 30, 1943

The last few days have been busy. I brought [home] 50 kg of potatoes.

Tomorrow I'll go for the ration cards and registration.

I'm messing around with books. The year is ending.

Our side is attacking again full force, and is approaching Zhitomir once again.

We won't have anyone [for New Year's], just Niura and her alcohol.

Varva is nervous and keeps getting mad. She took on a lot of work, and what's the point? They don't pay much and you can't buy anything. There are no clothes, no books, no frames, no eau de cologne, no fruit.

I want the war to end, I want sun and spring, for the flowers to grow and paintings to be painted.

December 31, 1943

The last day. This morning the building manager came and brought the key to the elevator. We're going to ride by ourselves, with no elevator operator.

I hung tree decorations and colored lights on the lampshade instead of on a tree.

Varva brought meat and a liter and a half of cognac. We made a beet salad, meat patties with potatoes, canned fish, radishes, fruit compote, and we brought in the new year.

No one called with congratulations. . . .

I made everyone keys to the elevator.

1943 is over. . . .

Dear Little Cyclops,

The new year has snuck up on us.[61]

You were waiting for it. We're celebrating all together at home again.

Don't be mad at me, I'm not criticizing you, it's just a flare-up. Now it will never happen. Mama is calm now and always wishes us well. What to wish you? It wouldn't come true. . . . But still, it's good to hope for something. May everything you yourself want come to pass. You are so good, like you never were before.

My dear! I send you a kiss and love you. Write everything you want.

Happy New Year!

Your Mulka[62]

1944

January 1, 1944

Happy New Year!

To the one who, swearing, will read this diary.

Today they played the new anthem of the composer [Aleksandr] Aleksandrov. Very interesting. . . . There aren't any others.

I mean, you wouldn't give the work to Shostakovich or Prokofiev, would you?

Besides which, he [Aleksandrov] is a "real" Russian. . . .

The empire of pseudo-realism and theft. . . .

They say that a directive on realism in art is being developed, on the Wanderers, on Russian art.

I will paint fairy tales, like [Ivan] Bilibin. . . .

What to do?

I'm sewing a cap for the repose of art, myself, and all . . . leftists. . . .

Lord and people of the future, forgive me!

That I lived at the wrong time. . . .

I won't anymore. . . .

It was very boring to live in our time.

And what we lived for, kept on waiting for, waited and believed. . . .

No one needed what we did.

And so, we're beginning to live in 1944?

> hated,
>
> unrecognized,
>
> unexhibited.

We live by art, which we've given up on and crossed out.

January 2, 1944

Today I got the electricity limit of 30 hectowatt/hr. a day, it used to be 7, so altogether—37 hectowatts [a day], in a month, 410.

The rest of the time I sleep and am tormented by the flu.

Varva left to go see Lizaveta and play mah.

Fireworks—Novgorod-Volynsk has been taken.

January 4, 1944

A lot of electricity was used in December, and now you can't turn it on.

Petritsilo has been given a second award. He's Ukrainian.

But I'm not a Ukrainian, and not Russian, and not a Jew, and not an Akkhrite, and not a realist, and not a Wanderer.

I'm glad for Petritsilo. I don't have long to live, I know this. . . .

I won't see myself. I won't see my exhibition. And if I don't see it, then no one will see it.

Alive I'm not needed. And dead even less. . . .

January 5, 1944

At one in the morning there were fireworks, they took back Berdichev.

My old ship is alight with rockets, they even shoot them off from our own building each time.

It [the ship] has been given electricity. It's threatened with "housing consolidation."

January 7, 1944

Yesterday I fixed the electric heaters. Today, at *Fotokhudozhnik*, Varva saw the list of newly reopened grocery stores with American goods.

What are these stores and who are they for? At what prices?

Maybe it was America that demanded that commission stores be opened.

It would be good if they opened commission stores for the arts. . . .

We're dying of boredom, and we can't die of vodka because there isn't any. . . .

January 8, 1944
We went to the market and bought 200 gr of tobacco—160 rub.

January 11, 1944
I'm sorting out the library.

Reading V. Kamensky.

I met him on Molotov St., in Perm. Once we sat on the banks of the Kama, talking.

And where is this sun-covered poet?

His song was boring and tedious. . . . I proposed going to his place in Kamenka but he avoided any kind of answer. And we parted. . . .

And I could have photographed him, made him famous again, written about him well. He was afraid that he'd have to feed me. . . . But in Moscow I treated him, gave him food and drink. . . . Well, there you have it, how unlike the songs is the person.

I'll never again be in his "Kamenka." And I'll never do anything for him. . . . Now what kind of Russian is he anyway? He lost my trust. . . .

I read Kirsanov. Also empty.

I read Pasternak—there's a genuine poet.

I read Kruchenykh. It's curious to read but unpleasant to look at. It's not Russian. . . . It resembles a Pole [speaking Russian].

"Not a single line has been invented."

Chesterfield.

It's the epigraph to a book on Stendhal.

On the other hand, what can be invented and taken directly from life? Only life itself. . . .

But life doesn't fit in a book. It can only be life itself.

There is no complete Truth, but deception can be interesting or not, talented or mediocre.

I don't think up anything, I only think.

So that aphorism is also invented. All books—are the transfer of life experience, which repeats itself.

It's like a game of chess, you always have the same figures and there are millions of combinations. As a result, the players lose and the hour of reckoning comes, but there's nothing to pay with. Then they write an "uninvented" book, where they just correct all the mistakes of their life.

Russians—are eternal teachers, they've always loved to teach everyone, the Tolstoyans, Gorkyites, and so on.

January 12, 1944
Here the petit bourgeoisie is performers, writers, and artists, now also the officer corps.

They're buying up china, gold, silver, portable items, furniture, etc.

I have to get money at the Museum of the Revolution and buy something for Mulia.

Last night I played mah with Lizaveta.

January 14, 1944
Mulia is eighteen years old.

Niurka and Lizaveta were there, we played mah. . . .

January 26, 1944
Everywhere war. . . .

And who needs it? It's the struggle of capital. And we're still a colony for them, just as China is.

And I want spring, freedom, and the arts. . . .

I'm working on Mayakovsky's card file.

January 28, 1944
Varva has a lot of worries, but I'm sick. So sick that no one should know. My song is sung. . . .

Our side drove the Germans away from Leningrad. The siege has been lifted for 100 km and the Moscow-Leningrad road has been liberated. Artillery is no longer firing on Leningrad.

February 3, 1944
In the last few days our side has made it to Narva. They lifted the siege.

Twenty-two stores with commercial prices are being opened for laureates. Freedom and blessings—to the laureates. And we run around all day with ration cards and get only half of what we're supposed to.

February 5, 1944
It's boring here. In the newspapers there are reports covering three columns, in which there is no news and no ideas.

It's not as though I've been against our government, I support it.

What news? They've taken Rovno.

"Mysterious commercial" stores are being opened.[63] And the directors of the stores say: "This is for laureates." "This will be for performing artists."

The mystery of commercial stores is completely incomprehensible at a time when white bread has completely disappeared. . . .

February 6, 1944
Varva came back with a rumor that they've opened commercial restaurants where vodka costs 400 rub. a liter, schnitzel—60 rub., and that the commercial stores will be for everyone.

I photographed the beauty Ilona "young" . . . for . . . lightbulbs.

I'm doing the card catalogue, it has to be done methodically, a bit at a time, otherwise it's boring.

February 8, 1944

I was at Khlebnikov's. He says that in March there's going to be another reexamination for draft registration.

In other words, once again I'm threatened with being rank and file.

When will my draft-age end, I'm fifty-three years old and I'm still under threat of being conscripted.

Why wasn't I born in America?

There are always incursions on us, either it's the Japanese or the Germans or the Finns, etc.

Leon Letkar called and said that near his house in the countryside there's a house with a plot of land for around 12,000, and you'd need to spend another 10,000 on renovations. Have to go and take a look because that's cheap, later you'll never be able to buy anything. . . .

I'm already dreaming of making a Russian country life for myself there.

Everything should be made of wood and matting, the dishes should be clay, and so on.

February 12, 1944

First thing in the morning, difficulties. Mosgas is going around to each apartment and inspecting [the gas meters]. And, finding that I have used too much, they gave me a "warning."

In the Gorkom they said that once again they're summoning people to the draft board for reregistration.

At home there's nothing except bread and grains. . . .

I went to Mosskh. Found out that the reregistration will be in March-April. For rank and file born between 1926 and 1893, so that means I'm not required to go.

Thank God!

Foot soldier Rodchenko has not yet been called up.

I handed in the certificates at Mosskh but forgot the one for tobacco, I'll go again tomorrow. But we only got 100 gr for the two of us.

I made Vera Gekht a lampshade but she didn't choose the best kind.

March 1, 1944

It was pointless for Mayakovsky to "step on the throat of his own song" and glorify the "*Internationale*." No one appreciated it. And now. . . . They don't read him, don't publish him. . . .

We all live and dream about officers, generals, medals, and so on. We're starving for the glory of the Motherland.

We sing "The Coachman."

We eat bread as heavy as lead, with potatoes.

Instead of meat we get one third American canned goods, etc.

Half of the tobacco and grains announced. . . .

March 10, 1944

I've been sick for three days. Lying down. I thought up a lot of different things. Do I have the energy to do them?

I'm angry about the impossibility of working for people, for success. And I only do it in order to convince myself of my strength and talent. To shine once more right at the grave, like a meteor. . . . And vanish into eternity!

I say good-bye to each empty day, and they're all empty, since I'm not needed.

March 16, 1944
Yesterday I planted flower seedlings.

I went to Mossкh. It's just one upsetting thing after another. There they give everyone everything but don't give me anything. Everything goes "to our own and friends" by some mysterious lists. I didn't bring anything back, no soap, no saccharine, no paints. . . .

Moreover, they're drafting everyone into the army, and there's no end to the war.

March 20, 1944
It's possible there may be changes in my life. They're proposing [my] being Mostorg's artist, a full-time staff member. It's a commercial store.

At the Gorkom, photography workers were given another twenty hectowatts of electric energy; as photographers, we now have fifty-seven hectowatts a day.

But instead of spring—it's winter.

April 7, 1944
No changes. . . . The head artist thing didn't work out.

It's frightfully cold, they're not heating. Outside it's minus seventeen.

Today I'm on watch in the building management office as a firefighter from eleven until two. I don't know anything and don't know how. . . .

April 11, 1944
It's cold—five degrees. Inside it's plus nine degrees.

Soon they'll open commercial stores where there'll be everything, but . . . expensive.

Sugar—500 rub. Oil—850–1,000 rub.
Milk—50 rub./liter. Potatoes—30 rub.
French roll—40 rub. Meat—350 rub.

April 14, 1944
Our side captured Odessa, Simferopol, Evpatoria. . . .

In the south, almost everything has been retaken, Belorussia, Lithuania, Estonia, and Latvia remain.

April 15, 1944
Commercial stores for everyone have been opened!
Lines!
Oil 1,100 rub. Fruit compote—2,050 a jar.
Candy, from 450 to 1,500 rub.

A package of cookies—120 rub. A lemon—60 rub.
Pastry—50 rub.
Some people will get discount books.

April 16, 1944
Easter. . . . Everyone is going crazy from the stores and prices. But still, they're
pleased. It's the hope of occasionally buying something.

April 18, 1944
Varva got a book for discounts at commercial restaurants for April. Thirty
percent in restaurants and 25 percent in stores. I'll get one tomorrow too.

They may still give ration cards to professors for May, but these ration-
card letters and the dry rations will be discontinued.

But still, the main thing is that this poverty will end.

We're going to be buying one and the same products in the same stores
on specific days.

There won't be any coupons for "fat, sugar."

Fat—is lard, sugar—cookies.

The freedom to buy in all stores, where everything is wrapped up and
clean. They were always handing everything out straight into your hands,
into your own bags and jars, even the matches were unpackaged.

Is this really ending, or has it ended?

Let the diary end on this as well.

The horror of poverty, of war!

THE END.

Letters of the War Years, 1942–1943

Rodchenko to Stepanova

Ocher—Molotov
January 1942

Varvara!

. . . We have to get out of here, whatever happens. It's impossible to work with
Levin.[64] Working anywhere like a newspaper—is pointless. . . . I don't feel well
with the kind of food we have now, I'm not good for much longer. We must
go anywhere else at all, it's better to live far out in Molotov than here. I'm mis-
erable, hungry, and bored. So go ahead and take action, and don't call anymore
for no reason, just send a telegram when you've done something. Only remem-
ber, if you get it into your head to come to Ocher, don't freeze, it has been sixty
below here for a week, and two people were brought in with frostbitten hands
and feet. Take care of yourself; you are needed by others besides yourself.

Kisses. Rod.

Moscow—Molotov
October 1942

Dearest sweet Kitty!

I'm writing my last letter to you because I sent you the summons and a telegram to the police administration for the pass.

I'm just worried about the telegram-summons arrival, since it's to your home address.

Chagin is an amazing person; he sent two telegrams without a peep.

And said that he needs us.

And I hadn't made up my mind whether to ask him again, but your horrible letters had such an effect on me that I decided to go see him.

And he has power, after all, I mean he's on the level of the People's Commissariat.

Everyone promised, but you have to wait.

Forgive me, but so far nothing has worked out with Mulka.

Come by yourself. And here we'll figure it out together. The two of us will pull the third out.

Ask Mama to help her just in case.

Today I'm happy that I'll soon be going to meet you.

Hurrah! Hurrah!

I'm so happy that you'll soon be padding around the room here.

And sleeping next to me.

I hope that you'll make pies for my birthday, and we'll have a drink here.

Now I'm drinking for your successful departure from the Wasp's nest.

No, I'm so happy today that I didn't even go anywhere but came home.

Right now I'm drinking 100 grams [of vodka] and snacking on red caviar.

Soon, soon. I'll meet you.

My dear little wife and friend!

I can see by your letters what they're doing to you there.

I'm guessing that they took the cafeteria away from you.

And that grandma is driving you crazy. And there's no use placing your hopes on the Lit.[erary] Museum.

Leave some of the things at the Lit. Museum, let Balabanovich bring them.

You've done a lot for him, and here I'm putting together an exhibition of Ostrovsky because of you.

Well, I'm waiting, waiting.

Kisses in a letter for the last time.

Soon I'll kiss you properly.

<div align="right">Your Anti</div>

Moscow—Molotov
October 8, 1942

Dearest Kitty!

I just got a letter from you, and from Vasia (Katanian). You wrote about the glasses. Unfortunately, I didn't send them since I didn't know what was needed, I figured out to send stockings myself. But maybe someone else will be traveling there. Vasia will tell you my wishes and plans in brief. I suspect that those times have already passed and I just have to wait and work. And it's hard to work with all this running around. Food and worrying about it takes up 75 percent of your time. The main thing is, feed yourself, and Mulka should go to the doctor, and then it will be clear what the nerves are from.

Stand firm, old folks, follow my example (see what airs I've put on!); I've set up house and I invite you to visit.

Well, kisses. Anti

Moscow—Molotov
October 15, 1942

I got the telegram addressed to "Fedchenko" and signed this way: "Received Chagin's telegram began petitioning will inform result—kisses Ira."

Well, if it's Ira, then let it be Ira! Petition away, dear Ira! You have to come quickly or you'll turn into "Liza."

Well, today I'm pleased that you're taking action there, finally, for yourself. Only don't try to "wing it," get all the papers, if you need something telegraph me, I'll get it.

The same with the things. Liquidate what you can, then Agnia Ezerskaia will bring [the rest] and also check your luggage.

You'll be met by me, two Lilka Lavinskys, and Maika.

So, good luck, knock on wood, kisses.

Zhorzh sends his greetings, so do Kinelovsky, Lili, Vera Gekht, and the others.

We'll get Mulka out together, and Agnia will bring her, she's going in December.

I keep sitting here and reading your telegram.

If something happens, go by the Writers' Union. Chagin sent them a telegram too, he said that he'd help. Go by the Molotov police and ask about the pass.

Kisses. Anti

Moscow—Molotov
October 21, 1942

Of course I was feeling better by yesterday, and today I'm up and about. I can't get a handle on the album, there's no plan, and the theme is kind of

meaningless. I was feeling tormented, tormented without you, and I decided not to take these kinds of jobs, and today I'll take it back. I'm going to take [only] what I'm up to. And I'm not going to put together a plan, it's a short amount of time. So my factory has gone on strike with one motor. I'm waiting for the second. I'll take jobs that are more appropriate. But don't you go worrying there. They haven't given out the oil yet—600 gr, but there's a ton of grain. Today I made oat soup with sausage, onion, butter, and rose hips. And now I'm going out to give the album back.

<div style="text-align:right">Kisses. Anti</div>

Stepanova to Rodchenko

Molotov — Moscow
October 25, 1942

Hello there, dearest Ham, you're off somewhere far away in your little house, and we're abandoned in an alien kennel. I covered the windows, it's warmer. Yesterday I was at Mama's (Rimskaia) in the evening, at home. She promised to help but it seems that nothing will come of this, since it seems that all work trips have been canceled for locals.

I'm sending paper and a letter with Andrei, but he'll only leave tomorrow. He promised to think up something for my departure. I'll give him a flask for the road just as long as he takes the paper. I can't really send a package with him, he's taking a lot of things with him for the exhibition.

I got a telegram from Polina [Yakovlevna] about the anti-Fascist exhibition, we should do it.

I saw Oreshnikov's works for the exhibitions just now, they're good, but it's a bit of something from Daumier and something from the French Revolution. It isn't our present day.

I'm intrigued by what you told me about Udaltsova, good for her!

Live happily. How are you figuring out the typefaces, who is helping you?

<div style="text-align:right">Kisses, Varva</div>

Rodchenko to Stepanova

Moscow — Molotov
November 11, 1942

My dearest Kit! The razors are somewhere in the suitcase, there's a whole box of them, I got two from you a long time ago and haven't received any more. I don't like your letters. You're very nervous. You must be calmer. After all, now it will be easier for you to come. I'll get a summons for a work trip for you.[65] What's the problem? Ask that daughter of Tamara's, who's in the hospital, for the medicine for Mulia. I'm also sending salol with belladonna along with this.

Don't look for the razors, since they've disappeared. And for God's sake, sell things and so on, so they won't drive you crazy.

They pay really well at Informbiuro. We'll buy everything we need. Don't regret anything at all.

Just leave a length for a fur coat.

But sell off all my things.

What are you panicking about! We're still going to build a dacha for us old folks and for our zoological technician.[66] For that matter, Mulia and I will organize a zoo in the apartment.

Tigers are going to live in the wall cabinets in Mulia's room, and polar bears will swim in the bath.

And here you go: what have we lived for, what have we worked for!

What's going on with you? You've come completely unscrewed without me.

We'll make you the animal tamer. Be patient, I want to also, but not right away.

Moscow—Molotov. Sovetskaia St. 32, apt. 1
November 14, 1942. TELEGRAM

TELEGRAMS [WITH] CHAGIN'S SUMMONS SENT HOME ADDRESS. FOR PASS GO POLICE ADMINISTRATION.

Kisses = Rodchenko

Rodchenko to Mulia

Moscow—Molotov
December 29, 1942

Dearest Mulia!

Today I found your wishes for New Year's 1941 in Ocher, in my diary: "Happy New Year!

In the coming year of 1942, for now I wish that all kinds of misfortune, grief, bad moods . . . may pass you by. I wish that you won't be mad at me. That you'll find more tobacco, make an enlarger, etc.

Happy New Year, many new happinesses!

Don't be mad at me, kisses."

Yes, sweetheart, your wishes were fulfilled. The misfortunes are over, I've stopped getting mad. There's a lot of tobacco in Moscow. I have three of my own enlargers. But now I wish that you were here. And that's the most important thing. I don't have my helper.

So now I'm congratulating you with 1943.

I wish for you to be here. To love art, to love us. Success in your institute. A great love will also come your way, eventually. And he should be worthy of it. I wish you good friends, although they will come and go. I wish

you, as always, whatever it is you wish for yourself, and even more. . . . Well, that's it.

I am also writing a diary, and it's difficult for me to write letters. I figured out for myself that I should write [down] all my work and meetings during the day in the diary, and I also write down everything about this in letters—it comes out interesting. I read the old ones and decided that it's worth writing. I'd really like to keep a big diary, where I'd write things and glue in letters and answers to them (for this I'd write with carbon paper), documents and photos. . . .

There are so many interesting things to do in life. And we waste our time emptily and keep dreaming about something. . . . And this dream isn't worth anything. But what's been actually done, even poorly—is worthwhile. Mulia, fulfill your intended work plan. Dreams alone aren't worth the lines written in a diary.

Well, it's getting dark and I don't want to turn on the light yet, I have to black out the windows. Moscow, Moscow! The clear Moscow sky with pink clouds, blue frosty fog.

Greetings from Moscow. Father

Moscow—Perm
January 17, 1943

Dearest Mul!

We received your 32nd [letter]. It's not clear who you're writing to, on the envelope it seems to be me, but inside you're asking Mama questions. This is not the way things should be done. You can write on two pieces of paper, to me and to Varva. Everything [to do] with your arrival will be decided in a few days, but for the moment the mood is anticipatory.

Did you get the two letters with the photo? You write without stamps, but someone sticks them on. I'm sending along stamps for two letters.

There's nothing in the pet store except for fish called "Shebunkin."

That's it. Now I'm writing you moral admonitions. . . . I'm going to do some moralizing. . . . Is it polite to leave food on your plate, or not? But that

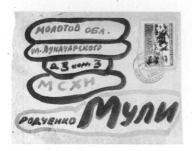

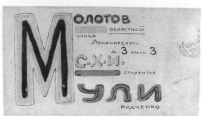

Rodchenko. Decorative envelopes for letters to Mulia. 1940s

is the old culture, in order to show the host that you are full. In my opinion you don't have to leave any, the main thing is not to lick the plate clean but to eat with your hands. How a person eats—shows his true character. You only have to observe a bit—and you'll learn a great deal about the person. Everything is there: greediness, cleanliness, gluttony, thrift, kindness, and so on. Personally, I leave food, I don't know why. . . . Better to think about how you are eating so it's pleasant for your friends and the mood is always good.

The sun is shining in the window although it's minus twenty-two degrees. I want spring, victories, the end of the war.

I'm not drawing very much. I made Varva a hat from brown caracul lambskin, the gray *kubanka* will be yours.[67] But the first one was stolen right off Varva's head in the metro.

Varva went out to get the dinner, now she brings four dinners for two days. Soup, the main course is a patty with potatoes, 200 gr of bread each, and 20 gr each [of] sugar.

I think about you all the time, and the picture of you with the chicks is on the table.

She really loves you and misses you. We've become old and we want your youthful commotion around. . . . Especially because we don't have any friends. We sometimes play mahjong with Vera Gekht because she lives nearby. . . .

Yesterday I was walking and thinking how happy you would be to come home on such a sunny day. I would go meet you and we would come home. We would come home, finally, to the house where you were born. After all, you're a child of our building, and you'll still have lots of time to live here after we have already gone. It's your own birth home, and our entire apartment—is your apartment; and all our works—are yours. And someday they will be successful, but after our deaths. You will see their success.

My sweet daughter, how I wish you were here!

I mean, aren't things a little boring for you without us? Even though we grouse a lot, we still love you. Even though we fight, it's interesting to live with us. I mean, we are strange, interesting people, you'll appreciate it someday. After all, there aren't many around like us, and there are fewer and fewer all the time. . . .

Well, I've gone and started philosophizing. . . .

<div style="text-align: right">Kisses. Rod.</div>

Moscow—Molotov
February 4, 1943

Funny little Mul!

You write asking who will send you a summons and who cares about you and who needs you. You silly girl! We do. We need you! We're the ones who love you, you are closer to us than anyone. We are trying with all our might to get you out of there. You know who needs you. You will be back home again, here, with us.

Varvara went to pick up the summons. It's already typed, but is it really? If that's not the case, then we'll have to wait again. . . . She keeps going and checking every day. . . . And I do the housework. I bought an iron stove and got eggs instead of butter. Went to see Galia. She really wants to give me Karlushka (the dog). And you're going to draw animals, you'll be an animal artist. There are very few of them. You'll draw in the zoo and observe them. How's that?

Well, bye for now, I'm expecting Varva. Your Papul.

Hurrah! Varva got the summons and is sending it to you. Hold on to it and do what Mama tells you.

I'm very happy. Your Papka

Moscow — Molotov
February 13, 1943

Dear Mul!

I'm writing on a postcard because I'm not going to write much now, and you write postcards, we'll get them quicker, and anyway you don't have any time, you have to push your case.

We're waiting for a telegram from you saying you've received our documents, and it still hasn't come. Well, nothing new here with us, all our thoughts are about you. . . . Wishing you success,

Your Hamsters

[*Note in Stepanova's handwriting*]
Mulik, we got your 54th letter, three of your letters are still en route. We were happy to get it. We sympathize with you in chemistry. . . . Suddenly I thought, "Did I write you that I sent the documents to 'General Delivery,' or did I forget?"

Kisses, my sweet girl

Moscow — Molotov
March 1, 1943

Little Mul!

How are you doing there after all the fuss that ended so miserably? But don't be sad! We'll get you out of there anyway, it's just a question of time.

We're doing well: instead of dinners we want to get actual food in March. Varva went to register the dinner cards at the store. We will make our own meals. It's a better deal and less running around. At any rate, we'll try.

We're still waiting for them to install the telephone, they haven't yet but we've already got the number. But we'll probably have to wait another month for them to turn it on. Then we'll send you a telegram.

Well, bye for now, kisses, your Papul

Moscow—Molotov
3/25, 3/26, 3/27—1943

Mul!

I'm sending you two envelopes with stamps and one stamp for the diary. I received no. 102 today, and yesterday 101 and 103 came.

Poor little sweetheart! You found out what friends are. They are only for themselves and until a rainy day. Remember, we also found out what friends are.

Friends—are your relatives who love you, and even if they criticize you, it's in your interest. We don't believe in anyone now, only you. We sit here alone and miss our daughter. And she's still not here. Varva went off this morning to "attack" organizations about the summons. She misses you terribly and sits around sadly and thinks only about you all the time.

Nothing else gives her any joy or interests her. . . .

March 26

I'm writing for the second day. Varva wrote you yesterday, but I'm tricky, I'm waiting to see the results of today's efforts, maybe they'll be successful.

Today I got up at five in the morning and went to get our rations at the store, I got butter and lard, and I'll go for the meat tomorrow. It's the remains of March's 1,100 lard, 2,100 meat with coupons. They haven't come to put in the telephone yet, they say it'll be April. Everything's moving very slowly, just like your arrival. I'm waiting for Varva and so I won't finish the letter. . . .

Varva just got here. But, using your system, I'm still afraid to write anything. . . . Though it seems that things are being worked out.

March 27. Morning

Now I'm going off to settle your affairs. That's why I'm finishing this letter and dropping it in the mailbox. If it works out, then I'll send you a telegram today.

Bye for now, my dearest sweet daughter. Kisses.

Your Rod.

Moscow—Molotov
April 3, 1943

Little Bedbug!

It looks like I'm actually writing the last letter. Our attack is ending.

1) A government telegram has been sent to Pazovsky, telling him to send you on a business trip to submit your words (this means drawings for the Art Institute) for a one-month stay. Pazovsky will most likely give you a trip

with an Oblispolkom visa, you'll go where it says, if it's to the police then they'll give you the pass there.[68]

Ask Ioganson for help with this. If you don't leave from Molotov, Verite will be leaving with his family for Moscow. If you find him, he'll take you along, it will be more fun to travel together. He'll probably be leaving on the 19th from Molotov. 2) Chagin is putting you on the list of people returning to their families, they'll give him the pass directly, which you can use to go and register yourself in Moscow. If you don't come, we'll send this pass. But we don't have it yet. Ask Gurevich for the ticket.[69]

I'm writing the last letter, I'm going to write postcards and wait for your telegrams. We just sent you two telegrams. Don't forget to get the documents at the institute. Well, dearest Bedbug, we're waiting.

<div align="right">Your Hamsters</div>

Since telegrams don't work well, when you arrive call our neighbor or Vera (Gekht). You have the telephone number.

[*Note in Stepanova's handwriting*]
Mulik, as soon as you get the trip permission, don't wait—the days are counted from then on. Grab the Vrubel reproduction on the wall, *The Fortune Teller*. Take the "nippers"—Papa's tool. Well, you know everything. Do everything energetically and independently. Don't forget the documents from Мѕкнı.[70]

<div align="right">Kisses. Mama</div>

From the Diaries, 1944–1954

1891–1951
Sixty years

1944

May 1, 1944
Yesterday it snowed and was minus one. Today it's plus four degrees.
We didn't celebrate the holiday. No wine. No vodka. . . .
Provisions are the following: beans, lard, bread, cookies, candy, canned fish.
Varva will also get a professor's rations.
Haven't opened the balcony yet. Spring just won't come.
On the front "nothing significant occurred."
I'm brooding. . . . Not doing anything. Why—don't know.
Two burners are on in the studio. . . .
The radio plays jolly operettas. . . .
Nothing is changing in art. . . .

May 2, 1944
This morning was sunny.

The store is already distributing rations but Varva doesn't have any cards yet, the B-card and subscription, she can't register [at a store].

The day passed pointlessly.

Moreover, I'm sick, congested. And I just sleep. . . .

I'm drawing "Soccer."

May 5, 1944
It's plus fourteen degrees outside during the day but the weather is gloomy.

We got provisions with the cards: pork fat, sausage, oil, cigarettes.

Now we get tobacco in the commercial stores with a discount, 100 gr Ducats costs 50 rub.

On the front, "nothing significant," and in life as well. . . .

May 12, 1944
Finally it was plus seventeen degrees in the shade today.

I had the flu. . . .

May 14, the heat hit.

May 15, hot, sunny. I planted flowers.

May 16, " " "

May 17, " " "

May 18, thunderstorms, rain.

May 19, " " ". Full-fledged summer.

The flowers are: tobacco plants, nasturtiums, stock, and phlox.

Varva got prof. rations. Now we have the same rations.

I'm sunbathing. . . .

I began a watercolor — *Soccer*.

May 20, 1944
Yesterday a critic was here — a Hungarian, Kemen. He was excited about all my works.

But my mood is gloomy. I'm making sketches of abstract painting. It's going badly.

Mulia's running around with boys, not painting a damn thing. . . .

It's a shame I don't have a son. . . .

Life has gone by, nothing came of it. . . .

June 11, 1944
It's been several days now since they opened the second front. The Americans and English landed in France. Battles are going on. But here it's quiet.

We are sitting here flat broke, without money and without work. Painting isn't moving.

The flowers are beginning to bloom.

On the 8th it rained and the ceiling collapsed. I fixed the roof.

July 16, 1944

I'm not working on painting although I try to do it every which way. Nothing works. . . . It's like everything has ended. I don't know what's the matter.

I've been invited to give lectures in composition at TASS and to photograph. They got permission and propose consulting. But art doesn't go over well, neither leftist nor rightist.

Lord! If only I believed in You! It would be easier for me, because otherwise I'm alone. . . .

September 17, 1944

Autumn has come again. We're only working in book design.

But I have an idea. I don't know whether it will fly. For the moment I won't say a word until it gets going.

The war is coming to an end.

December 27, 1944

I'm not working. We're living bunched into one room, three or even four, also Mulia's Kolya.[71] It's plus five degrees in the studio.

It's cold. The gas isn't on. Kerosene is 30 rub. a liter.

Electricity from six in the evening until six in the morning, that's until January 1st. From January they'll turn off the allocation on household necessities. I'm working as head artist in the House of Technology, I get 3,000 rub. a month. My student, Volodya Meshcherin, set it up, he's a head engineer now, and a professor.[72]

We wash ourselves now in parts in a cold kitchen.

I do my own laundry.

The war still isn't over. . . . There's still another year left of it.

We are gallivanting across Europe with cannons. We're taking Budapest. But there's still no end.

And we ourselves don't have firewood or fuel in Moscow.

We're wearing rags, the bathhouses aren't working. . . .

December 18, 1944

The days pass heavily, you just keep going and going. Now we've got lots of money, but what can you buy with it?

1945

May 8, 1945
The blackout has been abolished.

May 8th, the end of the war was declared!

May 9th is the celebration of Victory!

The war has ended but nothing has changed anywhere. Only, all the fat bums have more cars.

If they would just give something to the population.

If it would just be sunny! We are out of money and cigarettes.

May 16, 1945
Still the same cold. Daytime, plus ten degrees, but zero at night.

Haven't planted any flowers yet.

Went to Udaltsova's exhibition. Good.

Can't paint.

Left the House of Technology [job]. We're filling up on macaroni.

We're happy that the war is over.

Our side has begun improving public services in Berlin, restoring theaters. . . . They're also "Christians". . . .

[*Note*]

Comrade Rodchenko, A. M.

I request that you note the height of the tables and chairs (when the work is approved) in order that these parameters be strictly observed. Perhaps the strength would be possible as well.

1/18/45. V. Meshcherin

That's all that's left of my work at the H.T. This note from V. Meshcherin, my student, now he's a professor—an engineer. The House of Technology is being built in the "Russian Empire" style. Varva is working on the album *25 Years of Kazakhstan*.

May 18, 1945
The H.T. isn't paying, and they owe 7,500 rub.

We smokers are suffering.

Today, for the first time, it was plus fifteen degrees in the morning.

We opened the windows. I feel like doing watercolors.

Rightist art is triumphant.

The H.T. isn't paying the money.

May 19, 1945
Total emergency. No money.

The H.T. isn't paying, neither are the Kazakhs, nor Beryozin. And there's nothing to buy rations with.

May 21, 1945
We got the money, 10,000 rub., immediately felt happier. Bought cigarettes. But we're eating the same macaroni, which makes Varva fat. We need fruit but there isn't any.

May 22, 1945
Freezing cold. Some sort of northern current is coming in from the Bering Sea. Yesterday it was zero degrees and snowing. . . .

I'm working myself up to paint.

The war is over, we're in Berlin!

We're just as naked and hungry.

No art or literature, no music, no theater, no newspaper, no magazines, no paints, no paper, no dishes. . . .

Victory! But the victor has no hands, legs, and there's no head. . . .

Ration cards haven't been abolished yet, nor has mandatory labor, you can't leave your job, the state of siege hasn't been lifted.

I'm not against Soviet power, on the contrary, I consider it my own. . . .

Perhaps it will come, it's still early?

May 24, 1945
Cold and rainy.

Volodya Meshcherin is leaving the H.T. They promised the money for tomorrow.

I recommended Kolya Sobolev to the H.T.[73] But he's a bit of a groveler. . . . I'll find out.

May 25, 1945
Our building manager Perov was put in jail for selling rooms, ration cards, and for falsifying accounts for renovations. . . . This was the exemplary building in the neighborhood, but not for the tenants.

Perov was always receiving prizes for economizing coal, energy, renovations, and so on. . . .

They'll probably let him out soon.

May 26, 1945
Yesterday it was cold—one degree, it was snowing and raining. . . . At home—guests, we drank vodka, Volodya M. and Lizaveta played mahjong in the evening.

I'm cleaning up.

May 27, 1945
I got 2,228 rub. at H.T. for March—April and May still remain.

Varva bought a length of wool blend for a coat, for 1,500 rub.

I'm kind of disappointed in painting. . . .

War loan.

May 28, 1945
Have to go to H.T. again to try to get the money out of them.

I called Gandlevsky all day long. There's a holdup again, there's always a lot of fuss and bother with money.

How difficult it is to begin working, and how easy to stop! I need to write memoirs but my head is like a block.

Art isn't needed, ill fame I have. . . . Art isn't needed, not because I'm not right and one should do something different.

I'm right. . . . But the other stuff will be thrown out too, only later. . . . It's a question of time. And there isn't any time. . . . I'm fifty-four years old.

Whoever is lucky enough to be the future of this insane time, will he forgive my laziness in art!

He must forgive it!

I feel like sleeping and sleeping so as to get up one morning happy and free. Art—is free!. . .

The twilight shrouds the studio with these abstract things I'm accustomed to, and with "real" ones, which aren't real either. . . .

Tomorrow the day will pass again like it did today. I will sit at the table, sort through sketches, and won't be able to lift my hand to work.

I'm worse than a sick man. I'm absolutely unneeded, whether I work or not, whether I live or not.

I've already died anyway, and the fact that I'm alive—it's just for myself. The invisible man.

May 29, 1945

Tomorrow they've promised to pay the remainder at the H.T.

I've begun to work. . . . I'm painting over an old work. But the same old "what for" is in my soul.

Varva is shopping. Mulia has got herself a kitten and is enjoying it.

May 30, 1945

Finally, I got the money from the H.T. 3,500 rub. for April and half of May. Said good-bye to everyone. . . .

Lizaveta and Niurka are driving me crazy. All day long, through the evening and half the night, they gabbed all kinds of nonsense.

June 3, 1945

It's warm. . . . We slept with the window open. I'm sunbathing. Mulia and Kolka [Kolya] left to paint watercolors in Izmailovsky Park.

I'm too lazy to go anywhere.

Need to go to the Tretyakov, the circus, Park of C. and L., to the Botanical Gardens, to the Moscow sea.

"We Russians have two motherlands—Russia and Europe."—Dostoevsky.

"Proshka," i.e., Lizaveta, whom Varva calls "kroshka" and I nicknamed "Proshka," left for Riga on a work trip until the 20th.

I'm cleaning up the studio. I'm suffering from being unable to begin working.

I take a fresh piece of paper, pencils, and I sit, sit, and . . . I put everything away and go to sleep upstairs. Or I get out an old work I've already started, do one or two brushstrokes . . . and stop, dejected. What is this?

Day after day passes like this. Is it because my work has no goal?

Lord, save me from everything! From emptiness, from death, and so on.

I lie on the balcony, sunbathing, and I look down at the courtyard where for twenty-five years they've been either cutting down the trees and tearing up the fence, or building it all over again.

For twenty-five years I've been watching children play, grow up, and . . . they disappear somewhere.

June 4, 1945
Morning. Again, cleaning up in the morning. I've become like a woman, I like cleaning up. I want cleanliness, coziness, quiet. I look in the mirror. My face is old. Glasses. No teeth. . . . I have to sit down at the table, the paper is waiting.

Literature. . . . That's the most interesting thing. And most important, you don't need anything, no paints, brushes, or anything. But I don't do it very well. . . .

We've all gotten fat from this macaroni and white bread. . . . We're taking vitamins: A, B, C.

Well, I need to sit down at the paper just to convince myself one more time that nothing will come of it. . . .

The studio is big. There's a lot of room. I've been living in it twenty-five years.

Of course I started rooting around everywhere under the pretext of finding a small realistic work for V. Meshcherin. . . . And again all kinds of things came into my head. . . . So many good pieces and so many mistakes, unfinished pieces.

· How can it be? From the other world I rummage in the dust above this world, my own connoisseur and judge. I see myself, like a stranger, like an unknown artist long since dead.

I'm surprised, first, by the fact that I'm unknown, then by all the work done in vain. But perhaps this actually is death?

All of this will perish without me! Who will sort all this out? Mulia? No. . . . No one.

Payment for leftist art, punishment for novelty and boldness!

The pieces look at me with reproach and threaten: "Look, watch out, without you we'll all be burned!"

Mulia!! She's disappeared from me again, Kolya has appeared. . . . That's the quiet fellow she lives with. But on the other hand, she doesn't see anyone else. . . . They lock themselves up and spend the whole day kissing and don't do a damn thing else. Mulia is gone. . . . Everything around me disappears and dies like that, and I live on, dead. . . .

Rozanova's gone, Popova, Malevich, Shevchenko, Brik, Zhenia. . . . ·
There's only Varvara, but that is both too little and too much.

June 5, 1945
Went to see V. Meshcherin, took a coupon. For a taxi. Have to bring back the radio receivers tomorrow. (We turned them in at the beginning of the war.)

June 10, 1945
I brought both receivers, took them apart and cleaned them. I adjusted, fixed them up, repaired. They work.

Watched Disney's *Bambi* with Khlebnikov. Didn't like it, boring.

June 12, 1945
Work isn't going well. I want to make leftist pieces but need to make mediocre ones, and there's no fire in them. And for that reason everything is stuck.

There's a struggle for territory going on in the world.

The war is over but the army is armed. There are antiaircraft guns on the boulevards and on the roofs.

June 13, 1945
Today at Informbiuro there's a meeting, Gurary is giving a report on his work, with a demonstration of equipment and a film viewing.

June 18, 1945
I was sick, either with the flu or malaria, for two days, with a high fever.

It seems there will be a celebration of Victory.

Prices have been lowered a bit. You can walk around the city freely at night.

Aseev was complaining that everything is picked to pieces and criticized, and that he is still respected only because visiting foreigners are very interested in him.

Surkov and their group sit in the Writers' Union and won't let anyone in.[74]

The weather got bad.

I'm making frames. My painting is stuck. . . . Lord! . . .

June 24, 1945
Victory Day!
A parade on Red Square. At ten A.M. it started raining. At twelve they announced that the demonstration was cancelled due to the rain. But people spent two to four hours getting wet on the street without seeing anything. Then they dispersed.

There was only a parade.

Mulia came back soaked, she's caught a cold.

Varva and I were at home.

In the evening there were projector lights and fireworks, but it was quiet because of the clouds and rain.

Now it's one at night. I'm sitting alone. Mulia's asleep. Varva's off playing somewhere. I keep on thinking about my old painting, how to move it forward. . . .

June 26, 1945
Rain and more rain. And I'm in the same torment. I've lost my own self. . . . I was an artist, but I gradually disappeared.

People's Artists appeared, were honored, became laureates, marshals, even a Generalissimus, but I don't exist.[75] . . .

Vrubel! You managed to die happy. And I used to think that it was a tragedy.[76]

Mayakovsky shot himself in time. He would have hung himself out of boredom now, anyway.

Save me and have mercy! On those like myself, there are probably still some left.

Enact a miracle, resurrect Art! During my lifetime.

July 4, 1945

Finally it's warm. Still have heart pains.

Work . . . seems to have started. At any rate I made a drawing for a watercolor, *The Circus Rider*. Good.

Varvara gave Meshcherin a landscape. He was very pleased.

August 8, 1945

We declared war on Japan, it was announced on the radio.

V. Meshcherin is going to Dresden.

Truman announced that America has invented and made and already used an "ATOM BOMB." It's 2,000 times more powerful than the large English bomb (five tons).

War again.

Some director named Morgenstern was here from Kulturfilm, he proposed participating in a film about Mayakovsky, *How to Make Poems*. I didn't understand what I was supposed to do in the film.

Exhaustion, sleepiness, decline. Complete apathy. Lord! Save me!

I want to work but lose heart and fall asleep. . . .

August 12, 1945

A sports parade.

And I'm not photographing it. Not because I don't want to but because no one needs me and no one will give me a pass.

I'm thinking of doing and photographing a series, the opera *Ruslan and Liudmila*, if I have enough will and strength.

V. Meshcherin came back yesterday in the uniform of a lieutenant colonel, he's leaving for Berlin. I photographed him.

August 13, 1945

I began a watercolor, *The Circus Rider*, so far it's weak. . . . I'll do a few, transferring the drawing from tracing paper. Heart pains. . . .

I'm reading a Vrubel monograph. When Vrubel went to visit someone he always looked at everything attentively and remembered everything.

And now artists can only paint from photographs, and it comes out worse than in the photo.

"Whatever man believes in, that's what exists." A. Chekhov

It's very strange. I raise talented people despite Soviet power, and I teach photographers. Varvara and I are bringing up the painter Mulia. She paints wonderfully but is studying at the Polygraphic Institute.

Lord, what anarchists Russians are!

September 3, 1945

Victory Day over Japan and Peace Day in the whole world.

October 9, 1945
These two months have been insanely busy.

The album to Stalin, *Kazakhstan* (*25 Years of the Soviet Socialist Republic of Kazakhstan*), *Cinematic Art of Our Country, Muscovites in Battles for the Motherland*. Varvara has worn herself out.[77]

Volodya M. came back from Germany; he gave Varva two pairs of glasses and gave me some frames.

The elevator worked for two days and then stopped. . . .

10–11
Varvara's name day and the anniversary of us living together.

October 23. Birthday of Varst.

October 12, 1945
Bored. . . . It's horribly difficult to glue all these albums together and hand them in.

Snow. Cold. They're not heating yet, the boiler isn't ready. It's being built by the Ammunitions Institute. . . . Everyone is getting the flu.

There's mud everywhere, no one to clean it up, and we are earning thousands but live like the janitors lived. And we're all poverty-stricken.

October 13, 1945
It snowed. . . . Cold, mud, and boredom. . . .

When will there be a light in this gloom?

How can I live? But I'm not the only one.

Everyone . . . everyone . . . lives this way, except for laureates and generals, crooks and racketeers.

October 14, 1945
I was at Kovrigin's yesterday. We drank, and his wife, his Nina, and another Nina N. She's a Jew, a very interesting artist, she lives nearby, her husband was killed. . . . She's out to have a good time. . . .

But she'll probably find a husband soon. . . .

And suddenly I wanted love, romance. . . . Wanted to be young.

October 23, 1945
Varvara's birthday. Lizaveta and Tatiana were here, all three were talking, and I wasn't listening.

I'm heating with the iron stove, cutting firewood. . . .

October 24, 1945
Everything's the same—there's no heat.

The water doesn't work, etc.

Lots of money, but little point to it. . . .

This is for ex libris.

October 26, 1945

Yesterday I was in bed, as always, I had a terrible fever, over forty degrees, and was shaking.[78]

Today I woke up weak, with heart pains.

No heat. But outside it's plus nine degrees now.

October 28, 1945

Now my throat hurts, tonsillitis, and my heart. I'm dreaming of buying a radio receiver.

It's just as damp, and they aren't heating.

The only pleasure is to listen to music from abroad, but even that isn't possible. It's worth buying a receiver since SVD M 1 and S and 230 are obsolete.

October 30, 1945

I'm sick, I'm brooding. Today Petrusov promised to bring a Phillips radio. It's American, Karmen is selling it, but he tricked me. I want a good radio. . . .

Last night it rained, plus two degrees. There's no heat, it's damp, the boiler isn't ready. . . . I'm sick. It's boring. That's old age for you.

The other diary was boring but this is even more boring. . . . It's because of the size, this one is smaller.

November 4, 1945

Tonsillitis, cough, old age, sawing wood, stomach pains, stoking, soot, dirt. . . .

Mulia and Kolya don't help. . . .

It's outrageous, they aren't heating the building, the water doesn't work, the gas isn't on, the elevator doesn't work.

The victors of Europe! People live like pigs.

On the other hand, the privileged live differently, in special houses, where there's special heating, they're specially fed and dressed. . . .

And we "in general," the consumers, the little average people, the population as a whole. . . .

If only there were something, an exhibition, an artist, theater, book, writers, movies. . . . Nothing.

November 7–8, 1945

The October Holiday. Everything's the same. . . .

Lizaveta and Kruchenykh were here, they're both abnormal, they play mah. . . .

November 10, 1945

Once again I have to write and go and prove that I have rights and the position of a professor, otherwise they'll take away my position title. And then won't give me a B-card.

November 23, 1945

My birthday.

Niura, Lizaveta, Khlebnikov were here.

They're heating—plus fourteen degrees. It's all right now.
Nothing is moving, everything is stuck. . . .

December 11, 1945
Four pieces [photographs] sent off to Helsinki, to a salon:
 Durov with the lions.
 Tightrope walkers.
 Pencil.
 Torpedo with shadows.

1946

January 24, 1946
I'm planning to print things for the Moscow exhibition of photo masters for
the last time.

 If nothing comes out of the exhibition I'll drop photographs completely.

 My last efforts in photography. . . . No strength to go on. I don't believe.
I don't believe. . . .

April 11, 1946
They're organizing an Academy of Arts, with president A.[leksandr] Gerasimov
heading it up.

 The first goal: the fight with formalism and naturalism.

 Again, there will be an attack on us.

 What is realism? All Surikov and Repin.

October 24, 1946
We're heading for famine. Bad crop. But it's so good, there's heat and the gas
is on. No work, and everything is getting expensive.

 No strength or will at all.

 And death isn't frightening at all, on the contrary, it's the only thing that
lies ahead.

1947

August 11, 1947
Where is the light? I give up. I don't feel like living.

 The Academy: N. Pavlov, Bialynitsky-Birulia, A. Gerasimov, Kukryniksy.[79]

 I'm gloomy as the night. Again, they'll squeeze and pressure us. And art
descends lower and lower. . . .

October 1947
We're not doing any work for the 800th anniversary.[80]

 Soon it will be the thirtieth anniversary of Soviet power, and again,
nothing.

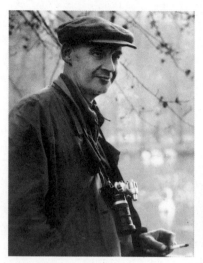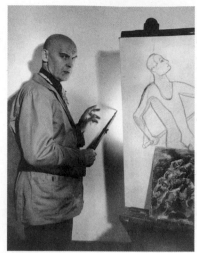

Left: Rodchenko at the zoo, 1947. Photograph by V. Kovrigin
Right: Rodchenko at his easel, 1948. Photograph by V. Kovrigin

It keeps getting worse and more boring to live.

Everything's expensive, and there's no money, no work.

Varva is gloomy from unemployment. I from boredom.

There's only one thing left—to pray to God! That's what we've come to. We've begun praying. . . . We, leftist artists. . . .

December 16, 1947
Ration cards have been abolished and . . . money, too.[81] There's only 3,600 rub. left (in the savings account).

December 17, 1947
No money because the savings bank is closed, and tomorrow is the subscription to newspapers.[82] The stores are full of everything, but there's no money. Tomorrow is the name day of the two Varvaras, and there's nothing to buy vodka with.

The diary, like art, too, has withered, and I don't feel like writing, although there was a lot that could have been described: the torment, commotion and panic, and, mainly, boredom.

That's how my life is ending, like this diary.

We don't have the will to work in a void.

My heart is getting worse and worse. It's already skipping beats. And soon will stop. . . . Well then? Did I live entirely in vain? . . .

December 19, 1947
I received 1,000 rub. of the new money at the savings bank. Everything is cheap and there are lines everywhere.

I subscribed to *Pravda*, *Lit.*[*eraturnaia*] *Gazeta* [The literary newspaper], *Kultura i zhizn* [Culture and life], and *Novyi mir*, [New world]. *Ogonyok* [Little flame] and *Krokodil* [Crocodile] remain unsubscribed.

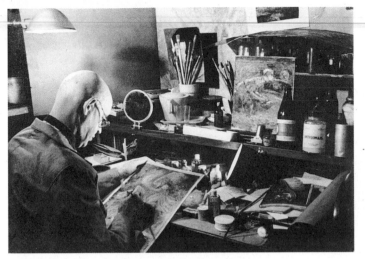

Rodchenko at his desk, 1948. Photograph by V. Kovrigin

Agnia Ezerskaia is paying 300 rub. instead of 1,000 for Mayakovsky. And New Year's is right around the corner.

1948

November 2, 1948
Hello! Everything's the same, no money and they don't pay, the work is completely uninteresting. And there's a campaign against formalism. I've completely quieted down, don't dream of anything. But it will get worse. . . .

1949

May 13, 1949
Hello. I've been resurrected from the dead, I was sick for two months. I'm frail and weak, had a "stroke." Bleeding in the brain. Blood pressure is 230 . . . now it's 150. Life is hard, no money.

The Lit. Museum isn't paying. I'll get better, but what for? Who needs it? Blood pressure is 230.

Can't drink or smoke.

May 15, 1949
It's very warm. My mood is the usual gloom.

No work. No one pays.

July 1949
I've become utterly dim-witted, can't do anything. Maybe it's forever. I arose

from the dead but I'm a dead man myself. What to do, and whether to do anything?

Lost everything. Passport, the membership card to Mossкh I've already replaced. But what for?

June 22, 1949
I just got ready to paint, but will killed the last [of it]. I can't paint anything anymore.

I'm convinced that the end has really come. . . .

It's terrible to lose your last belief.

Save me, Lord! But what for? So that's what I've come to!

Telegram
11/22/49
On your birthday send you our best wishes, many more years of health for the good of Soviet photography.

Tass Photochronicle, Kuzovkin[83]

1950

January 8, 1950
Lilia Lavinskaia died. They've already buried her. It's thirty below zero.

1. They aren't heating well. 2. The gas isn't on. 3. The water isn't running. 4. The elevator isn't working. All the delights. I mope about everything, from the cold and all our misfortunes. . . .

April 1950
Blood pressure 235/110. Leeches again!

Lower back pain. I'm in bed. For three weeks I've barely been able to walk around the room. My right leg won't walk. . . . Everything's coming to an end. . . .

May 6, 1950
235/110. And I'm still alive. . . .

May 20, 1950
Probably my last summer. I'm still in bed. Haven't walked for a month, since April.

No work in 1950. . . .

June 30, 1950
Blood pressure 175/100.

Can't walk. Radiculitis. Have begun ionization treatments at the clinic, can barely make it there.

August 8, 1950
I'm not going to the clinic, the elevator won't go and I won't either. . . .

August 30, 1950
I've done six ionizations and I'm walking. Have to be treated with cornelian, also.

September 30, 1950
I should go on pension, at least they'd give me about 200 rubles.
 I'm walking. Gradually my leg is getting better.

December 13, 1950
Must write a big "Last Attempt". . . . I managed to get over a bout of malaria, too.

December 1950
Pressure 190/65. Doctor N. A. Lisovsky measured it.

1951

January 1951
I'm up again, walking around after malaria.

February 1951
I'm still waiting for something. Sixty years old. And I'm still waiting. For what?
 I'm waiting for death. Varvara doesn't have any money at all, either. No one's even buying Mayakovsky, haven't heard anything for two weeks, they promised 1,500 rub.

February 22, 1951
I submitted an application to the Mayakovsky Museum but there's no money.
 I need to get teeth put in.

April 25, 1951
I'm cleaning up. Can't paint, not in the mood. I'm waiting for it to pass. I received the money from the Mayakovsky Museum—1,500 rub.
 I've outlived my own self.

April 2, 1951
I've completely dried up. Don't want anything. Faith is ended. As though I'd died. I've outlived my own death. Maybe some desire will return?

April 7, 1951
Deaths and more deaths, of friends and acquaintances. There are different laureates now, and I'm still without work and money and a job. Tomorrow I'm pulling out my last two teeth, and I'll be like a newborn, absolutely

toothless. I'll put in new ones. Pulling the last two isn't very pleasant. . . . I'm a bit gloomy and don't feel well.

April 1951
Now I'm completely without teeth.

The weather is bad and there's a noise in my ears, or a grumbling in my ear, and the second one doesn't hear anything at all.

May 7, 1951
I photographed Varva, shouldn't have.

June 2, 1951
I'll put a crown on my last tooth, the only one, and then they'll make two new dentures.

I put the crown in, now I have to wait. On June 13th they'll take measurements for the false teeth.

The desire to paint is beginning to gnaw at me like a worm. But will the ability come? . . .

June 23, 1951
I'm still without teeth until the 21st of June—the technician is on vacation. The 21st they're taking the impressions. I'm not painting anyone. I'm not painting anything. Why—isn't clear. It's the most important thing, will I begin? . . .

September 1951
I've already got the teeth but there's no point to them, and the summer is almost over, I didn't paint.

Now I'm forcing myself to take color photos. I already bought everything but the water isn't any good, it's warm, plus twenty-two degrees, and I need plus twelve.[84]

I'll try shooting flowers, I brought them to the factory to be developed. I can't manage to finish even one roll.

November 1951
I'll be sixty, not joyful, years old.

Had my sixtieth birthday, it was unhappy in the extreme. . . .

They've kicked me out of Mosskh completely and barely agreed to take me back in January 1952.

It's all so stupid and difficult. I didn't write about this, and even now I don't feel like it.

"Respected Comrade!
We inform you that during ratification of the membership of the Moscow Artists' Union by the Organizational Committee of the USSR Union of Artists, you have not been confirmed as a member of Mosskh

Rodchenko, 1950–55.

and have been removed from the membership of the Union in accordance with section 4 of the Mossкh Charter.

Basis: Resolution of the Secretariat of the Organizational Committee of the USSR Union of Artists, protocol no. 23 of September 17, 1951.

Mossкh Presidium"

1891–1952

My sixty-first year and nothing to show for it, everything's coming to an end. . . .

1891–1954

There's no end to it. . . . My sixty-third year and it's like everything is beginning from the beginning again, but what from the beginning I don't know. . . .

To the Presidium of the Moscow Section of the Union of Soviet Artists
Copy: To the Orgcommittee of the USSR Union of Artists

Declaration

I have received notice that I have not been ratified as a member of Mossкh by the Orgcommittee of the USSR Union of Artists and have been removed from the membership rolls of the Union.

I have been a member of the graphic section of Mossкh since 1933. In the course of thirty-eight years of creative activity I have worked in the areas of book graphics, artistic design of books, posters, theater, cinema, and the decorative arts. For a number of years I worked with the poet V. Mayakovsky on agitposters and Soviet advertising, and took part in all his artistic endeavors.

Since 1922 until the present time, I have worked together with the artist V. Stepanova in the publishing houses Molodaia Gvardia, Gosizdat, Gospolitizdat, Izogiz, Iskusstvo, Komakademiia, Transpechat, and others on posters, book illustration, and artistic book design. My works have been published in the journals *Krasnaia nov*, *Molodaia gvardia*, *Oktiabr*, *Sputnik kommunista* [Communist traveler], *Za rubezhom* [Abroad], *Kniga i revoliutsiia* [The book and revolution], *Smena*, *Ogonyok*, *Sovetskaia zhenshchina* [Soviet woman], and others.

In 1925 I designed the Soviet section of the international exhibition in Paris.

I worked for a number of years in theater and cinema, I designed the plays: Glebov's *Inga*—at the Theater of the Revolution, *The Bedbug*, by Mayakovsky.[85]

In cinema I created the decorations for the movies *Moscow in October*, *The Woman Journalist*, and *Who Should I Be*, by Mayakovsky and others.

During 1933–41, as an artist-designer, I worked at the magazine *SSSR na stroike*.

Of the albums I designed together with V. Stepanova, I'll note only the most important:

Stalin on Lenin—a publication issued by Partizdat in three editions for the 17th Party Congress; the publishing house expressed its gratitude.

10 Years of Soviet Uzbekistan—pub. Izogiz (the album was reviewed by the newspaper *Pravda* in the 12.21.34 article "A wonderful work," and also in the 12.24.34 issue of *Izvestia*).

Awarded a prize by the publishing house. *First Cavalry*—pub. Izogiz. (Noted in *Pravda* on 2.23.1937; *Izvestia* on 2.24.1937; *Krasnaia zvezda* [Red star], *Krasnoarmeiskaia epopeia* [Red Army epic]—2.23.1937, and by a personal letter to the editorial board from marshal of the Soviet Union S. M. Budyonny. Received gratitude from the publishing house.)

Krasnaia armiia [Red Army]—pub. Izogiz. (Noted in *Pravda*, 2/17/1938. Received special thanks from the publishers.) *Sovetskaia aviatsiia* [Soviet aviation], and *Parad molodosti* [Parade of youth]—pub. Iskusstvo (*Bolshevistskaia pechat* [Bolshevik press] no. 8, 1939).

One Volume Works of V. Mayakovsky—Gospolitizdat, mass print-run in two editions for the tenth anniversary of the poet's death—1940.

Five Years of Labor Reserves—a unique artistic album given as a gift to J. V. Stalin from the labor reserves collectives, now on exhibit at the Museum of the Revolution, in the hall of presents to J. V. Stalin, 1945.

Kazakhstan—pub. Kazogiz for the twenty-fifth anniversary of the Kazakh SSR. Appeared in print in 1949. Exhibited at the exhibition of Poligrafizdat.

In addition to this, from 1918 to 1923 I was a member of the Artistic Collegium of the Visual Arts Department of Narkompros, and for ten years was a professor and dean of the metalworking department of VkhUTEMAS.

Along with my primary creative and artistic activity, I have worked a great deal in the area of the artistic photo portrait. A series of my photo portraits of V. Mayakovsky was distributed on a mass scale and is exhibited in the museum-library of the poet V. V. Mayakovsky.

Many of the works I have done have been noted in the newspapers *Pravda, Izvestia, Krasnaia zvezda*, the journal *Bolshevistskaia pechat*, and the edition of the album *First Cavalry* was honored with the personal thanks of com. S. M. Budyonny.

The above-mentioned partial list of my creative work over thirty-eight years of activity allows me to appeal to the Presidium of Mossкh to request a review of the decision to exclude me as a member of the graphic section of Mossкh.

Only a lack of knowledge of creative cadres and a soulless attitude toward the artist can explain the obvious injustice of such a decision. I am sixty years old, I am ill with a serious form of hypertonia, last year I suffered a stroke, and the notice I received provoked a worsening of my illness.

During all the time of my membership in the artists' union, no one has ever enquired about my work or my creative fate.

Being a member of the Moscow section of the USSR Artistic Fund, I have never made use of material assistance and rest homes, although given the condition of my health I have had extreme need of this.

The decision to exclude me from membership in the graphic section of Mossкh—is not only a heavy moral blow, but it also deprives me of [status] as an artist and designer of creative work, to which my whole life has been dedicated.

Signature (A. Rodchenko)

November 5, 1951
Moscow

1952

Mulia to Stepanova

Moscow—Bulduri
September 1, 1952

Ma! Pa!

Now you will definitely freeze.[86]

Khlebnikov is leaving today, and he won't bring anything! You have to buy something or wrap yourselves up in blankets and walk around in them.

Lizaveta called and is leaving for Krasnodar on Thursday.

Khlebnikov A. V. got very whiny when Kolya asked him to take a coat with him. He said that he's poor, unhappy, and terribly tired. . . .

I'm glad that Pa is photographing.

Here the water isn't working, it's cold, and I even have the flu.

Kisses. Let Kolya write something.

Mulia's making it all up. It's not at all cold, in fact it's hot. She's walk-

ing around in underwear.

Khlebnikov took a couple of days to get used to the idea that he had to take the coat, and suddenly it was all right.

I'm still working for the magazine *Club*. I'm arguing with Khaldei.[87] It's drizzling and the mushrooms have sprouted. Today, when you said (on the phone) that it's warm, we didn't know what to do, to send the coat or not.

That's it. We hope you get tan, get better, and don't freeze.

Kolya

Rodchenko to Mulia

Bulduri—Moscow
September 16, 1952

Dearest Mul!

There aren't any tickets today for Moscow, Varvara's going to Riga to get them, she got up at six A.M. She went there and so far hasn't gotten any. They're promising for Monday, so she'll go back to Riga again. Our R.H. [Resort Hotel] also promises but it isn't clear for what date. The weather today is good again. I'm photographing a lot, the sea and the forest and the clouds, in color.

I miss you terribly, I want to go home and finally drink some strong tea.

We got all the letters. Kisses

[*In Stepanova's hand*]

No tickets so far. Rodcha is ordering me not to write.

Kisses, Ma

[1.] The Soviets' name for World War II was the Great Patriotic War.

2. During his evacuation, Rodchenko kept his diary in a different notebook.

3. From Molotov (previous name Perm restored after 1957), Rodchenko and his family traveled to the town of Ocher.

4. Fialka Davydovna Shterenberg (1918–1995), daughter of the artist David Shterenberg.

[5.] These are particles of speech used in certain rural dialects.

[6.] Traditionally, Russian windows have two panes, with about eight or nine inches between them for insulation. One of the top panes usually has a *fortochka*, a small, hinged window inset into the larger one, which can be opened to let in fresh air.

[7.] The anniversary of the Bolshevik Revolution.

8. In Ocher Rodchenko worked as an artist at the movie theater, painting signs, and he also did photo reportage for the newspaper *Stalinsky udarnik* (Stalinist shock-worker).

[9.] Ilya Yulevich Shlepianov (1900–1951), artist and theater designer who illustrated the work of the poet Aleksei Gastev and designed sets for Meyerhold.

[10.] A *pood* is an old Russian weight measure that equals approximately thirty-three pounds.

11. Rodchenko was waiting for one of his friends to help him send his enlarger from Moscow to Ocher. He intended to photograph while in Ocher.

12. Rodchenko had sent a telegram to Agnia Ezerskaia, the director of the Mayakovsky Museum, with a request to check his apartment in Moscow, put all the valuable things in the photo laboratory, and, apparently, to take something particularly valuable for the museum. In exchange, Rodchenko asked her to send some warm clothes to Ocher. Ezerskaia looked for Mayakovsky's manuscripts (notes, sketches for ads), but it turned out that Rodchenko and Stepanova had taken these documents with them.

[13.] Rodchenko means that the bread ration had increased and they were allowed to buy two kilograms a day (4.4 lb.). Often that was the only food available.

[14.] Rodchenko is referring not to a cooking stove but to a heating stove, the ceramic- or tile-covered wood-burning stove that heated old Russian buildings in the winter.

[15.] That is, the chits or coupons for meals were not counted against an individual's monthly ration allotment.

[16.] Once on staff, Rodchenko would have been unable to quit or move, thus the eventual renewal of his Moscow residence permit would have been endangered.

[17.] The administration of Mosskh, and many of its members, were evacuated to Molotov during the war.

[18.] Boris Vladimirovich Ioganson (1893–1973), Socialist Realist painter, founding member of Akhrr, director of the State Tretyakov Gallery (1951–54), president of the USSR Academy of Arts (1958–62); known particularly for history paintings on revolutionary themes, such as *Interrogation of Communists* (1933).

19. Zakhar Nikolaevich Bykov (1898–1987), an artist, teacher, and student of Rodchenko's at Vkhutemas-Vkhutein, worked in the Committee of Arts Affairs at the time.

[20.] Kirovskaia: the street where Rodchenko lived. Arbat Street is quite a distance across town.

[21.] Nikolai Georgievich Mashkovtsev, painter.

Semyon Andreevich Pavlov (1893–1941), painter and graphic artist. Studied at the Petrograd Free State Studios; member of Akhrr.

[22.] Russians traditionally have a decorated "Christmas tree" at New Year's, when "Father Frost" brings presents to children.

23. Niura: Anna Alekseevna Stepanova (née Petrova), Stepanova's sister-in-law, married to Stepanova's brother, Georgy (Zhorzh) Fyodorovich Stepanov (c. 1896–1943), chemical engineer. Niura worked in a pharmacy.

[24.] "Left," i.e., black market or illegally connected electricity.

[25.] Mah: mahjong.

[26.] The Grekov Studio of Military Artists—named after the artist Mitrofan Borisovich Grekov (1882–1934), who was known for his depictions of the civil war; founded in 1934–35, it was under the aegis of the Soviet Army. Artists held army rank and privileges, and their job was to extol the heroic deeds of the Soviet armed forces in realist paintings. World War II was the main subject of Grekov artists well into the 1980s, though some paintings touched on Afghanistan, and paintings of cosmonauts and space became very popular in the 1970s and '80s.

[27.] Maria Mikhailovna Siniakova (1898–1984), painter and book illustrator.

[28.] Aleksandr Mikhailovich Gerasimov (1881–1963), Socialist Realist painter, president of the USSR Academy of Arts (1947–57)

Boris Nikolaevich Yakovlev (1890–1972), Socialist Realist painter, known for landscapes and such paintings as *Sovetskie konservy* (Soviet preserves) in the State Tretyakov Gallery.

[29.] Vasily Nikolaevich Baksheev (1862–1958), landscape painter.

Pyotr Vladimirovich Viliams (1902–1947), set designer and painter. During the war years Viliams was the artistic director of the Bolshoi Theater.

Fyodor Fyodorovich Fedorovsky (1883–1955), set designer who created many sets for the Bolshoi Theater.

Evgeny Evgenievich Lansere (Lanceray) (1875–1946), painter, sculptor, printmaker, illustrator, and set designer, known in particular for the interior designs for the Kazan Railway Station, and the Hotel Moscow (recently torn down). Brother of the painter Zinaida Serebriakova.

Nikolai Nikolaevich Zhukov (1908–1973), printmaker, known for a series of portraits of Lenin.

Dementy Alekseevich Shmarinov (1907–1995), graphic artist and book illustrator, known for illustrations of Dostoevsky, Aleksei Tolstoi, Pushkin.

[30.] Ivan Aleksandrovich Pyrev (1901–1968), director of immensely popular Soviet ideological musical comedies, including *Svinarka i pastukh*

(The pig-keeper and the shepherd; 1941) and *Kubanskie kazaki* (Kuban cossacks; 1950). Later in his career he made films of Dostoevsky's novels *The Idiot* (1958) and *The Brothers Karamazov* (1969).

31. A kind of margarine.

32. Pyotr Ivanovich Chagin, the director of Gospolitizdat, the State Political Publishing House.

33. Some of TASS's photojournalists were "reserved," that is, relieved of being drafted into the regular army. They traveled to the front, took pictures in the divisions, and photographed decorated soldiers, liberated towns, etc. As one of the youngest photojournalists, Markov-Grinberg was not "reserved." He was drafted and left for the front with his Leica and a small packet of selected negatives from the prewar period (everything else was lost during the war). He often photographed during actual battles. Later he told Rodchenko with sadness how the "masters" of photochronicles, at the request of their agencies, would shoot staged nighttime and daytime battles "à la Eremin," i.e., with smoke and lighting effects.

[34.] TASS: Telegrafnoe agenstvo sovetskogo soiuza (Telegraph agency of the Soviet Union). TASS was formed in 1925 on the basis of ROSTA (for which Rodchenko and Mayakovsky did window designs); it was the official news agency of the USSR. Its successor, ITAR-TASS, is the official news agency of the Russian Federation.

[35.] Rodchenko is probably referring to garden plots that various organizations distributed or rented to their members so that they could grow their own food. This was common practice, particularly during wartime.

[36.] Art Fund: an organization bureaucratically distinct from the artists' union, through which artists received commissions for paintings, sculptures, design jobs, etc., and could purchase art supplies.

[37.] Sergei Pavlovich Bobrov (1889–1971), Russian poet, artist, critic, and translator. Before 1917, Bobrov published poetry in both Symbolist and Futurist journals; after 1917, he worked as a high-ranking bureaucrat in the literary section of Narkompros.

[38.] Aristarkh Vasilevich Lentulov (1882–1943), painter, founder of the Knave of Diamonds group.

[39.] Presumably, if Mulia had been given her Moscow residence permit immediately, she would have had to be gainfully employed or attending an educational institute.

[40.] The Soviet government had a tolerant attitude toward the Russian Orthodox Church during World War II as part of the general emphasis on Russian nationalism. During the 1930s, church bells would not have been allowed to ring on Easter. Russia switched to the Gregorian calendar only after the Revolution, but Russian Orthodox holidays are still calculated by the Julian calendar, which is approximately thirteen days behind the Gregorian. Easter, therefore, usually falls later in Russia than in the West. The service begins in the evening and lasts until dawn. At midnight the congregation, carrying candles, goes outside and circles the church, led by the priest.

[41.] Aleksandr Aleksandrovich Osmerkin (1892–1953), painter.

[42.] Aleksandr Vladimirovich Khlebnikov (1887–1979), photographer.

[43.] In the USSR, students were often sent to collective farms during summer break to help with the harvest.

[44.] Pavel Petrovich Sokolov-Skalia (1899–1961), Socialist Realist painter and printmaker, member of the USSR Academy of Arts, known for huge dioramas and panoramic paintings.

[45.] Vasily Semyonovich Svarog (pseudonym for Korochkin) (1883–1946), portrait painter.

 Konstantin Fyodorovich Yuon (1875–1958), painter and set designer; joined AKhRR in 1925; member of the USSR Academy of Arts.

[46.] Every Soviet document had to be certified by the seal of the issuing organization.

[47.] To prove that he had been a professor for a number of years.

48. Rodchenko is referring to his series of paintings on the circus, which he began in 1935.

[49.] Rodchenko is referring to the series Streamlined Ornaments.

50. That same day Rodchenko copied out this entry with a number of changes, and sent it as a letter to his daughter.

[51.] Maxim Litvinov (1876–1951) held many high government posts, serving as foreign minister of the USSR and as the first Soviet ambassador to the United States (1941–43).

 Ivan Mikhailovich Maisky (1884–1975) was Soviet Ambassador to London from 1932 until 1943.

[52.] A state store.

53. Rodchenko is referring to decorative compositions from the series Streamlined Ornaments, painted from sketches done in 1941–42/43.

54. Katanian's chronicle of Mayakovsky's life has been reprinted five times since then.

[55.] OBMOKhU: Obshchestvo molodykh khudoznikov (Society of Young Artists).

56. The photojournalist Georgy Petrusov took a series of photographs of Eduard Benes, the president of Czechoslovakia from 1935 to 1938 and then from 1946 to 1948. At the suggestion of Petrusov, the All-Slavonic Committee commissioned Varvara Stepanova to design a case for these photographs. The whole was presented to Benes as a gift.

[57.] *Vecherka*: the *Moskovskaia vecherniaia gazeta* (Moscow evening newspaper).

[58.] Aram Khachaturian (1903–1978), Soviet Armenian composer and conductor.

59. *Wedding in Malinovka* is an operetta about the civil war that followed the 1917 Revolution.

60. Rodchenko is referring to the "electrical limit," or norm of electricity usage, during the war. Each apartment was allowed to use only a fixed amount of electricity; photographers were eventually given a larger electricity allowance. Inspectors from the electrical company Mosenergo would check electrical meters and could cut off the line if the norm had been surpassed. Therefore, despite the cold and lack of central heating, electrical heaters could not be used on a regular basis. In 1943, Rodchenko's family lived in one small room heated by the gas stove in the kitchen, on which they usually heated bricks. Later on an improvised wood stove improved the situation. Firewood was sold in the city.

61. In Russia children are sometimes affectionately called *klop* or *klopik* (literally, bedbug or little bedbug), meaning something small, defense-

less, trusting. Rodchenko's daughter called him *Tsiklopik*, or Little Cyclops, since by that time he always wore glasses and he was much taller than average.

62. In this diary, opposite his daughter's note, Rodchenko glued a reproduction of El Greco's *Resurrection* as a symbol of hope for the coming year, 1944.

[63.] A commercial store, in Russian parlance, is a nongovernment store, i.e., one with "market" or "commercial" prices, as opposed to artificially low, government prices. This usage of "commercial store" existed in Russia until about the mid-1990s; in the current economic situation it is no longer valid.

[64.] Aleksei Sergeevich Levin (1893–1965), artist and printmaker.

65. On arriving in Moscow, Rodchenko began to reestablish their life anew: he had to get a residence permit, documents for ration cards, pay for the apartment, find work, and arrange a summons for Stepanova's arrival in Moscow from Molotov.

66. In Molotov, Varvara Rodchenko entered the Agricultural Institute, where she studied for half a year, specializing in livestock. On arriving in Moscow, in 1943, she began preparing for the entrance exams to the Moscow Polygraphic Institute, from which she graduated in 1948.

[67.] A tall, stiff hat like those worn by Kuban Cossacks.

[68.] Oblispolkom: Oblast Executive Committee, the executive committee of the district or oblast in which Mulia lived.

69. Gurevich—an employee of the Lenin Library.

[70.] Mskhi: Molotovskii sel'skokhoziaistvennyi institut (Molotov Agricultural Institute).

71. Nikolai Sergeevich Lavrentiev (1921–n.d.), artist and graphic designer, husband of Rodchenko's daughter, Varvara Aleksandrovna.

72. Vladimir Timofeevich Meshcherin (1904–1977), engineer, doctor of technological sciences, student of Rodchenko's at VKhUTEMAS-VKhUTEIN.

73. Nikolai Sobolev, artist and designer, Rodchenko's student at VKhUTEMAS-VKhUTEIN.

[74.] Aleksandr Aleksandrovich Surkov (1899–1983), Soviet poet known for civil war and Great Patriotic War themes.

[75.] Honorific given to Stalin during World War II.

[76.] For the last four years of his life, Mikhail Vrubel, who died in 1910, was blind and unable to work.

77. These are all names of photo albums that Rodchenko and Stepanova did as rush jobs.

78. Rodchenko suffered from malaria most of his life.

[79.] Vitold Kaetanovich Bialynitsky-Birulia (1872–1957), landscape painter, exhibited with the Wanderers at the turn of the century, in 1922 joined AKhRR.

[80.] The 800th anniversary of Moscow was celebrated with much pomp, and many special albums and publications were published in 1947.

[81.] Rodchenko is referring here to the postwar devaluation of the ruble, when new money was printed.

[82.] In the USSR, magazines and newspapers could be subscribed to only twice a year, through the post office.

83. Kuzovkin was the director of TASS Photochronicle. In 1947–48 Rodchenko designed the TASS Photochronicle emblem.

84. Rodchenko began working with color photography. He photographed urban landscapes from his window, rural ones at the dacha at Kurkino, portraits of his daughter and her friend—the singer Galina Teplovaia. In 1952 he took color photos in the Baltics.

85. Rodchenko could not mention in this declaration that Mayakovsky's play *The Bedbug* was staged at Meyerhold's theater. Meyerhold was "repressed" at this time.

86. Rodchenko and Stepanova bought a package tour and went to the Baltics.

[87.] Evgeny Ananevich Khaldei (1916–1997), photojournalist, known for his staged photograph of the Soviet flag being raised over the Reichstag.

DEX AND ILLUSTRATION CREDITS

INDEX

A page number in italic indicates
a reproduction.

252; for Informbiuro: 345, 347, 363 64, 366, 391, 403; for kiosks: 93, 238, 276 note 150; for *Krasnaia molodezh*: 151; for *Krasnaia zvezda*: 17, 237; for Krasnyi Oktiabr: 16, *238*; for Mosselprom: 16, *237*, *238*, 238, 247, 252, 276 note 150; for Prombank: 151; for Rezinotrest: *237*, 238, 252; for Tea Directorate: 238, 240; for teapot: 149, *150*; for tea tray: 149, *150*; for VKhUTEMAS: 149

Drawings: 47, 63, 89–90. Architectural: 93, *107*, 124. "City with Observatory": *104–5*. *Construction no. 17*: *125*. *Design for a Kiosk*: *94*. *Figure in a Kimono*: 14, *40*. Line and compass drawing: *64*, 77, 90, 131, 133 note 17. *Linearism* cover: *112*. "Man with guitar": 90. "Man with newspaper": 90. *Project for an Air Terminal*: 12. "Two dancers with an accordion": 90. "Yellow": 90

Exhibitions: *Exhibition of the Comintern*: 131–32; *Exhibition of the Left Federation*: 131; *Exhibition of Non–Objectivists and Suprematists*: 125, 130–31; *Exhibition of the Union of Artists and Painters*: 131, 133 note 9; *Exhibition of Works by Rodchenko 1910–1917*: 81, 134 notes 25 and 27; *Exposition Internationale des Arts Décoratifs et Industriels Modernes*: 17, 141, *148*, 149–51, 154, 157–58, 160–61, 163–64, 166, 169–77 passim, *172*, *174*, 179, 181, 185–86, 252–54, 258, 271 notes 9 and 16; *5th State Exhibition*: 76, 133 note 9, 224, 275 note 134; *5 x 5=25*: 13, 132; *Masters of Soviet Photo Art*: 281, 299, *300*, 307, 329 note 23; *19th State Exhibition*: 98, *109*, 113, 131, 136 note 68, 137 note 80, 233; October photo section exhibition: *285*; Second Spring Exhibition of the OBMOKhU: 129, *130*; State Tretyakov Gallery: 214, 274 note 109; *The Store*: 14, 73, 77–79, 133 notes 5, 12, and 15, 134 note 24, 221, 228; *10th State Exhibition: Non–Objective Creation and Suprematism*: 113, 134 notes 34 and 35, 135 notes 40 and 57, 137 note 90; *20 Years of Soviet Photography*: 314–15; writers' club: 317–18

Journals/Magazines and newspapers: *Anarkiia*: 82–84, 134 notes 27 and 32. *Iskusstvo v massy*: 270. *Journalist*: 281. *Kino-fot*: 18, 147–48, 233, 271 note 5. *Kino-pravda*: 167. *Kniga i revoliutsiia*: 270, 414. *Krasnaia molodezh*: 151. *Krasnaia niva*: 270. *Krasnaia nov*: 414. LEF: *17*, 151, *200*. *Molodaia gvardia*: 151, 233–34, 270, 414. *Novyi Lef*: 19, 141, 199–203, *200*, 204–7, 212–14, 236, 256–57. *Ogonyok*: 238, 414. *Oktiabr*: 151, 414. *Pioner*: 270. *Prozhektor*: 270. *Siniaia bluza*: 270. *Smena*: 214–70, 274 note 110, 368, 380, 414. *Sovetskaia zhenshchina*: 414. *Sovetskoe foto*: 19, 201, *205*, 206, 297–304, 329 note 23. *Sovetskoe iskusstvo*: 296. *Sovetskoe kino*: 206. *Sputnik kommunista*: 234, 414. *SSSR na stroike*: 214–70, 274 note 110, 281, *290*, 292, *293*, *295*, 299, 302, 329 note 2, 335, 369, 414. *Stalinskaia putevka*: 344, 419 note 8. *V mire knig*: 214–70, 274 note 110. *Za rubezhom*: 414

On . . . : advertising and design: 16–17, 189, 194–95, 198, 202, 234–35, 238, 240, 246–47, 254, 258; architecture: 105–7, 124–25; camera angles: 19, 199–200, 204–12, 297–98, 330 note 58; cameras, 167, 180, 185, 239, 241, 244, 246, 253, 272 notes 42 and 47, 283, 310, 312–13, 318, 329 note 5, 330 note 43;

concepts of art for Soviet society: 11, 13, 73, 82–83, 85–86, 101–2, 108–9, 116, 122–23, 142–43, 225, 230–32, 296; concepts of line, 14, 19, 83, 95, 110, 113–14, 123–24, 131; Constructivism: 11, 13, 17–19, 114–15, 124, 126, 142–46; criticism of his work: 42, 87, 199, 281, 297–98, 307; criticism of the West: 155, 158, 167; non–objective painting: 73, 83, 85, 88, 95, 98–100, 109–14, 123, 133 note 17; painting: 37, 48, 65, 73, 84, 99–101, 108–13; photography: 140, 199–201, 204–13, 297, 299–304, 307; photojournalism: 297–304; photomontage: 233–34, 239, 257–58, 297, 307; planes: 83, 86, 98–99, 110, 114, 123, 131, 187; theater and film work: 18–19, 68 note 22, 198–99, 261, 266–67, 283–84

Paintings: 63, 90–92; Black on Black series: 15, 91, 113, 126, *126*, 131, 135 notes 56 and 57. "Bust of an Egyptian woman on a red ground": 63. *Carnival*: 63. *Circus Rider, The*: 404. *Clown-Acrobats in the Ring*: 370. *Clown with Saxophone*: *325, 334.* "Color sphere of the circle": 89. *Composition no. 56*: *125, 126,* 137 note 96. *Composition no. 60,* from the series Concentration of Color: 85. *Composition no. 66 (Density and Weight)*: 127. *Composition no. 84 (Black on Black)*: 126, *126,* 137 note 101. Concentration of Color and Form series: 134 note 38. *Construction no. 47*: 125, 137 note 94. *Construction no. 55*: 125, 137 note 95. *Construction no. 57*: 126, 137 note 97. *Construction no. 61*: 126, 137 note 100. *Construction no. 70*: 126, 137 note 99. *Construction no. 71*: 127. *Construction no. 72*: 127, 137 note 103. *Construction no. 75*: 125. *Construction no. 76*: 126, 137 note 98. *Construction no. 87*: 124, 137 note 92. *Construction no. 90 (on White)*: 92. *Construction no. 98*: 127. *Construction no. 99*: 127, 137 note 102. *Construction no. 103*: 127. *Construction no. 106 (on Black)*: 12, 14, 124, *124,* 137 note 91. *Construction no. 127 (Two Circles)*: 113. *Dancer, The*: 15, *77,* 133 note 12. *Divinity of Death, The*: 63. *In the Café-Chantant*: 63. Movement of Projected Planes series: 134 note 25. *Non-Objective Composition*: 89. *Non-Objective Composition no. 69*: 87, *87,* 134 note 38. "Portrait of N. A. Rodchenko": 63. *Portrait of Natasha*: 14. *Portrait of Rusakov*: 93. "Self-Portrait": 63. *Singer in the Arena, The*: 322. "Sketch for a portrait": 63. "Soccer": 397. *Soccer Players*: 322. "Still Life: book, bottle, candleholder": 63. *Streamlined Ornament*: *375.* Streamlined Ornaments series: 335. *Two Figures*: *77,* 89–90. "Two Triangles": 88, 135 note 43. *Under the Sun*: 48. *Woman*: 63. *Woman with Long Eyes*: 63. *Wrestlers, The*: 18

Photographs by: Aseev, Nikolai: *245, 250. Assembling for a Demonstration*: *207. At the Radio*: 318. *At the Telephone*: *207.* Balcony: 206. Brik, Osip: *249. Champions of Moscow*: 321. *Dancing in a Ring*: 318. *Dinamo*: 318. *Dive*: 320. *Durov with the Sea Lions*: 318, *407.* Guard and prisoners: *290. In the Circus*: 318. Grinkrug, Lev: *245.* Koltsov, M.: *245.* Laying the Rails series: 329 note 4. Lavinsky, Anton: *245.* Lemberg, Evgenia: *311.* Levin, A.: *245.* Lumber: *284.* Malkin, B.: *245.* Mayakovsky, Vladimir: *242–43, 245. Morning Wash*: *309.* Mosselprom building: *238. Mother*: *240. Oath, An*: *320. Parade in the Circus*: 318. *Pencil*: *407. Pioneer*: 260, 297. *Pioneer Girl*: *287. Pyramid*: 318. *Races*: 318. *Radio Listener*: *309. Rhine Wheel, The*: *318.* Rib-

ILLUSTRATION CREDITS

Every effort has been made to clear rights for the written and visual material contained in this work.

Otherwise uncredited documentary illustrations have been provided kindly by the Aleksandr Rodchenko and Varvara Stepanova Archive, Moscow.

Works by Rodchenko and Stepanova reproduced herein are held in or are courtesy of the following collections:

Astrakhan State Picture Gallery, named after B. M. Kustodiev: p. 89.

Courtesy Jack Banning, New York: p. 243, bottom right.

Collection Merrill C. Berman: pp. 234, bottom; 236, left; 237, top right.

Courtesy Galerie Berinson, Berlin: p. 242, bottom right.

Gilman Paper Company Collection, New York: pp. 214; 243, bottom left; 309, left.

The Metropolitan Museum of Art, New York: p. 243, top left.

The Museum of Modern Art, New York: pp. 148; 200; 203, right; 207; 240; 242, top left; 250; 320, top right; 281; 284; 287; 290; 293; 294; 309; 310; 311; 320, top right and bottom; 321.

Courtesy Productive Arts, Brooklyn Heights, Ohio: p. 295.

The Pushkin State Museum of Fine Arts, Department of Private Collections, Moscow: pp. 81; 94; 105; 113; 124; 142, left; 172, top right, middle right, and bottom; 203, left; 205; 214; 236, right; 237, top left; 238, right; 249; 267; 375.

Aleksandr Rodchenko and Varvara Stepanova Archive, Moscow: pp. 50; 51; 54; 61; 64; 75; 77; 92; 97; 103; 104; 109; 112; 142, right; 150; 153; 172, top left and middle left; 185; 234, top right; 238, left; 242, top left and right, and bottom left; 300; 318; 320, top left and bottom; 325.

State Mayakovsky Museum, Moscow: p. 234, top left.

State Russian Museum, St. Petersburg: pp. 87; 126, top; 212, left.

State Tretyakov Gallery, Moscow: pp. 125; 126, bottom; 127.

Additional credits for copy photography are:

Valerii Mikhailovich Evstigneev: pp. 64; 75; 81; 87; 92; 94; 104; 105; 112; 124; 142; 150; 172; 185; 203, left; 214; 234, top left; 236, right; 237, bottom; 242, top left and right, and bottom left; 249; 320, top left; 318.

Jim Frank: pp. 234, bottom; 236, left; 237, top right.

David Heald: p. 293.

The Museum of Modern Art, New York, Department of Imaging Services: pp. 207; 243, top left and right, and bottom left; 250; 281; 284; 287; 290; 294; 309; 310; 311; 320, top right and bottom; 321, left.